*Children's Emotions in Europe,
1500–1900*

Children's Emotions in Europe, 1500–1900

A Visual History

Jeroen J. H. Dekker

BLOOMSBURY ACADEMIC
LONDON • NEW YORK • OXFORD • NEW DELHI • SYDNEY

BLOOMSBURY ACADEMIC
Bloomsbury Publishing Plc
50 Bedford Square, London, WC1B 3DP, UK
1385 Broadway, New York, NY 10018, USA
29 Earlsfort Terrace, Dublin 2, Ireland

BLOOMSBURY, BLOOMSBURY ACADEMIC and the Diana logo are trademarks of
Bloomsbury Publishing Plc

First published in Great Britain 2024

Copyright © Jeroen J. H. Dekker 2024

Jeroen J. H. Dekker has asserted his right under the Copyright, Designs and Patents Act,
1988, to be identified as author of this work.

For legal purposes the Acknowledgments on pp. xiv–xv constitute an extension of this
copyright page.

Cover Image: Rembrandt's *Woman with a Child Frightened by a Dog* © Fondation Custodia,
Collection Frits Lugt, Paris.

Bloomsbury Publishing Plc does not have any control over, or responsibility for,
any third-party websites referred to or in this book. All internet addresses given in this
book were correct at the time of going to press. The author and publisher regret any
inconvenience caused if addresses have changed or sites have ceased to exist, but can
accept no responsibility for any such changes.

Every effort has been made to trace the copyright holders and obtain permission to reproduce
the copyright material. Please do get in touch with any enquiries or any information relating to
such material or the rights holder. We would be pleased to rectify any omissions in subsequent
editions of this publication should they be drawn to our attention.

A catalogue record for this book is available from the British Library.

A catalog record for this book is available from the Library of Congress.

ISBN: HB: 978-1-3501-5070-6
PB: 978-1-3501-9868-5
ePDF: 978-1-3501-5071-3
eBook: 978-1-3501-5072-0

Typeset by Newgen KnowledgeWorks Pvt. Ltd., Chennai, India

To find out more about our authors and books visit www.bloomsbury.com
and sign up for our newsletters.

For my grandchildren.

Contents

List of Figures ix
Acknowledgments xiv

1 The Making of a Visual History of Children's Emotions in Europe 1
 Rembrandt's Eye 1
 A History of Education and Emotions 3
 A Psychological Category in Historical Research 6
 Concepts and Theories about Children's Emotions across Time 9
 Sources and Reality 13
 Interpreting the Artist's Eye 16

Part 1 Belief in the Child as *Animal Educandum*: Children's Emotions in the Age of Renaissance and Reformation

2 The Big Talk on Education and Emotions in the Age of Renaissance and Reformation 21
 "As the Old Sing, so Pipe the Young:" A Call for Parental Responsibility 21
 The Emergence of a Communication and Knowledge Society 22
 About Earth and Hereafter: The Discourse on Passions and Affections 26
 The Discourse Down to Earth: Visualized Lessons in Moral and Emotional Literacy 30
 Adaptation of the Christian Discourse about the Emotions 35
 The Educational Turn 43
 A Classic Discourse in a Modernizing Emotional and Educational Space 49

3 The Expression of Children's Emotions in the Age of Renaissance and Reformation 51
 Introduction: Looking through the Changing Eye of the Artist 51
 The Educational Relationship: Breeding Ground for Children's and Educator's Emotions 57
 In the Child's World 80
 Conclusion: Child's Emotions to the Forefront 99

4	The Birth of a Mission: Educating Emotional Literacy in the Age of Renaissance and Reformation	101
	A Mission Born	101
	Good Parenting by "Natural Instinct, Parental Love, Divine Law, and Custom"	105
	Coming of Age Properly	119
	Conclusion: A Mission by Instruction and Seduction	125

Part 2 Between Child and Education: Children's Emotions in the Age of Enlightenment, Romanticism, and Science

5	The Big Talk on Education and Emotions in the Age of Enlightenment, Romanticism, and Science	129
	From Playing to Learning: A Crucial Transition in Child's Development	129
	Educational and Emotional Space in a Continuously Modernizing Society	132
	Filling the Tabula Rasa	134
	"To Awaken and Develop ... All the Powers and Natural Gifts of the Child"	136
	The Disenchantment of the Child	139
	Complementary and Competing: The Discourse on Emotions	140
	Conclusion: A Discourse Marked by Incompatibilities	150
6	The Expression of Children's Emotions in the Age of Enlightenment, Romanticism, and Science	153
	Introduction: Looking at an Adapting, Innovating, and Almost Evaporating Source	153
	Children's Emotions within an Educational and Emotional Relationship	157
	In the Child's World	176
	Conclusion: Children's Emotions and Images of Childhood	191
7	Training Children in Emotional Literacy in the Age of Enlightenment, Romanticism, and Science	193
	Introduction	193
	Training the Emotions through a Visualized Lexicon of Emotions	194
	Crossing Turning Points of Emotional and Moral Development	197
	Conclusion: Emotion Training around Turning Points of Emotional and Moral Development	213
8	Conclusion: Changing Discourses, Continuing Emotions	215
Notes		223
Bibliography		275
Index		313

Figures

1 Rembrandt van Rijn, *The Naughty Boy* (*c.* 1635), drawing, 207 × 142 mm (Berlin: Staatliche Museen zu Berlin, Kupferstichkabinett). 2

2 Jan Steen, *The Merry Family/"As the Old Sing, so Pipe the Young"* (1668), oil on canvas, 110 × 141 cm (Amsterdam: Rijksmuseum). 22

3 Philips Galle after Pieter Bruegel the Elder, *Temperance* (*Temperantia*) (1560), engraving, 225 × 294 mm (Vienna: Albertina, inv.no. DG 1955/115). 34

4 Hugo van der Goes, *Worship of the Shepherds/Portinari Triptych* (1476), oil on wood (Florence: Galleria degli Uffizi). 54

5 Bernhard Strigel, *Portrait of Konrad Rehlinger of Augsburg with His Eight Children* (1517), oil on wood, 209 × 98 cm (Munich: Alte Pinakothek). 59

6 Diego Velázques, *Las Meninas, or The Family of Philip IV* (1656), oil on canvas, 318 × 276 cm (Madrid: Museo del Prado). 60

7 Bernhard Strigel, *Saint Mary Clephas and Her Family* (1520–8), oil on panel, 125.4 × 65.8 cm (Washington, DC: National Gallery of Art). 62

8 Jan Steen, *The Feast of St Nicholas* (*c.* 1665–8), oil on canvas, 82 × 70.5 cm (Amsterdam: Rijksmuseum). 64

9 Rembrandt van Rijn, *The Star of the Kings* (signed *c.* 1645), drawing, 20.4 × 32.3 cm (London: The British Museum). 65

10 Albrecht Dürer, *Rest on the Flight into Egypt* (1511), drawing, 27.9 × 20.8 cm (Berlin: Kupferstichkabinett der Staatlichen Museen zu Berlin). 66

11 Simone Martini, *Stories of Blessed Agostino Novello. Miracle of the Child Falling from the Balcony* (1328), part of triptych, tempera on poplar, 200 × 256 cm (Siena: Pinacoteca Nazionale). 68

12 Bartholomeus van der Helst, *Young Boy on His Deathbed* (1645), oil on canvas, 63 × 90 cm (Gouda: Museum Gouda). 71

13 Jan Van Eyck, *The Virgin with the Canon Van der Paele* (1436), oil on panel, 122.1 × 157.8 cm (Bruges: Groeningemuseum). 72

Figures

14 Frans Hals, *Catharina Hooft with Her Nurse* (c. 1619–20), oil on canvas, 86 × 65 cm (Berlin: Gemäldegalerie Staatliche Museen). 74

15 Nicolas Poussin, *Massacre of the Innocents* (1625–9), oil on canvas, 147 × 171 cm (Chantilly: Musée Condé). 76

16 Rembrandt van Rijn, *Sample Sheet with an Old Woman and a Screaming Child and Five Half Figures* (c. 1638–9), drawing, 218 × 185 mm (Berlin: Staatliche Museen zu Berlin, Kupferstichkabinett). 77

17 Domenico Ghirlandaio, *A Grandfather with His Grandchild* (c. 1490), oil on panel, 62 × 46 cm (Paris: Musée du Louvre). 80

18 Fra Angelico, *Saint Lawrence Giving Alms to the Poor* (c. 1447–51), fresco, 410 × 271 cm (Vatican: Cappella Niccolina). 82

19 Raphael, *Sistine Madonna* (c. 1512–13), oil on panel, 265 × 196 cm (Dresden: Gemäldegalerie Alte Meister, Staatliche Kunstsammlungen). 83

20 Anthony van Dyck, *The Balbi Children* (1625–7), oil on canvas, 219 × 151 cm (London: The Trustees of the National Gallery). 84

21 Bartolomé Esteban Murillo, *Children Eating Grapes and a Melon* (1645–50), oil on canvas, 145.9 × 103.6 cm (Munich: Alte Pinakothek). 85

22 Cornelis Saftleven, *Children Making Music* (s.a.), drawing, 28.5 × 20 cm (Berlin: Kupferstichkabinett, Staatliche Museen zu Berlin). 89

23 Titian, *Clarissa Strozzi* (1542), oil on canvas, 115 × 98 cm (Berlin: Gemäldegalerie Staatliche Museen). 91

24 Cornelis de Vos, *Susanna de Vos* (1627), oil on panel, 80 × 55.5 cm (Frankfurt am Main: Städelsches Kunstinstitut, Städel Museum). 92

25 Johannes Verspronck, *Girl in Blue* (1641), oil on canvas, 82 × 66.5 (Amsterdam: Rijksmuseum). 93

26 Giuseppe Cesari, *Child Next to a Horse's Head* (1635–40), 42 × 28 cm (Berlin: Staatliche Museen zu Berlin, Kupferstichkabinett). 95

27 (After) Albrecht Dürer, *Study of an Infant* (1525), drawing, 262 × 170 mm (Berlin: Staatliche Museen zu Berlin, Kupferstichkabinett). 97

28 Matthias Grünewald, *Head of a Crying Child* (1515–20), drawing, 24.7 × 20.2 cm (Berlin: Staatliche Museen zu Berlin, Kupferstichkabinett). 98

29 Anonymous, *Girl with a Dead Bird* (c. 1520), oil on panel, 36.5 × 29.5 cm (Brussels: Musées Royaux des Beaux-Arts de Belgique). 99

Figures

30 Jan Steen, *When Living in Wealth, Beware* (1663), oil on canvas, 105 × 145 cm (Vienna: Kunsthistorisches Museum, Gemäldegalerie, KHM-Museumsverband). 108

31 Jacob Cats, Emblem I, "Rami correcti rectificantur, trabsminimè," or "A young twig can be bent, but old trees not" (1632), *Spiegel Van den Ouden ende Nieuwen Tijdt*, 1–3. 110

32 Anonymous, *Family Portrait with Mother Who Reads in Houwelick by Jacob Cats* (1650), oil on canvas, 85.5 × 107.5 cm (Budapest: Museum of Fine Arts/Szépművészeti Múzeum, inv. no. 3928). 113

33 François Clouet, *Diane de Poitiers* (1571), oil on panel, 92.1 × 81.3 cm (Washington, DC: National Gallery of Art). 114

34 Pieter de Hooch, *The Pantry* (*c.* 1660), oil on canvas, 64 × 60 cm (Amsterdam: Rijksmuseum). 115

35 Jacob Cats, Emblem XXXI, "Met onwillige honden ist quaet hasen vangen" ["With unwilling dogs it is difficult to catch hares"] (1632), *Spiegel Van den Ouden ende Nieuwen Tijdt*, 96. 118

36 Jacob Cats, Emblem XXV, "Qui captat, capitur," *Sinne- en minnebeelden*. In *Alle de wercken* (Amsterdam: Schipper, 1665). 124

37 Jacob Gerritsz. Cuyp, *Two Children with a Lamb* (1638), oil on panel, 78.5 × 107.5 cm (Cologne: Wallraf-Richartz-Museum). 125

38 Jean-Baptiste Siméon Chardin, *Boy with a Spinning-Top (Auguste-Gabriel Godefroy (1728–1813))* [L'Enfant au toton] (1738), oil on canvas, 67 × 76 cm (Paris: Musée du Louvre). 130

39 Hieronijmus van Alphen, *Joyful Learning* [Het vrolijke leren]. From: Hieronijmus van Alphen, *Kleine gedichten voor kinderen* (Utrecht: Wed. J. van Terveen en Zoon, 1787, pp. 10–11). 131

40 Francisco Goya, *The Duke of Osana, Pedro de Alcantara, and His Family* (1788), oil on canvas, 225 × 174 cm (Madrid: Museo Nacional del Prado). 160

41 Edgar Degas, *Portrait of the Family Bellelli* (in-between 1858 and 1869), oil on canvas, 200 × 250 cm (Paris: Musée d'Orsay). 166

42 Claude Monet, *The Cradle: Camille with the Artist's Son Jean* (1867), oil on canvas, 116.2 × 88.8 cm (Washington, DC: National Gallery of Art). 170

43 Matthijs Maris, *Woman with Child and Little Goat* (*c.* 1866), oil on panel, 14.5 × 19 cm (The Hague: Kunstmuseum Den Haag). 171

Figures

44 Carl Gottfried Pfannschmidt, *Mother Kissing Her Child; Gubbio* (1875), drawing, 14.1 × 15.9 cm (Berlin: Staatliche Museen zu Berlin, Kupferstichkabinett). 172

45 Jacob de Vos Wzn., "Papa spanks the boys with a slice of cake" ["Papa geeft de jongens plakken met een koek"], drawing F.5 from Jacob de Vos Wzn, *The Fourth Book of Willem & Gerrit de Vos* (1805), HS 73 (book 4), 180 × 115 mm (Amsterdam: Koninklijk Oudheidkundig Genootschap). 175

46 Auguste Renoir, *Marguerite-Thérèse (Margot) Berard* (1879), oil on canvas, 41 × 32 cm (New York: The Metropolitan Museum of Art). 177

47 Vincent van Gogh, *Portrait of Marcelle Roulin* (1888), oil on canvas, 35.2 × 24.6 cm (Amsterdam: Rijksmuseum Vincent van Gogh/Vincent van Gogh Stichting). 178

48 Philipp Otto Runge, *The Children Hülsenbeck* (1806), oil on canvas, 131 × 141 cm (Hamburg: Kunsthalle). 180

49 Willem Bartel van der Kooi, *The Disrupted Piano Playing* (1813), oil on canvas, 147 × 121 cm (Amsterdam: Rijksmuseum). 181

50 Isaac Israëls, *Donkey Ride along the Beach* (c. 1898–1900), oil on canvas, 51 × 70 cm (Amsterdam: Rijksmuseum). 186

51 Paul Gauguin, *Bathing Breton Boys* (1888), oil on canvas, 92 × 72 cm (Hamburg: Hamburger Kunsthalle). 187

52 Félix Vallotton, *The Ball, or Corner of the Park with a Child Playing with a Ball* (1899), oil on canvas, 48 × 61 cm (Paris: Musée d'Orsay). 189

53 Adolph Menzel, *Children Sitting on Barrier Chains in Utrecht* (1876), drawing, 15.0 × 8.8 cm (Berlin: Staatliche Museen zu Berlin, Kupferstichkabinett). 190

54 Jean-Honoré Fragonard, *The Visit to the Nursery* (c. 1775), oil on canvas, 73 × 92 cm (Washington, DC: National Gallery of Art). 199

55 Jean-Baptiste Siméon Chardin, *The Morning Toilet* (1741), oil on canvas, 49 × 41cm (Stockholm: Nationalmuseum). 201

56 Berthe Morisot, *The Cradle* (1872), oil on canvas, 56 × 46 cm (Paris: Musée d'Orsay). 202

57 Jean-Baptiste Siméon Chardin (1699–1779), *The Young Governess* (c. 1737), oil on canvas, 61.6 × 66.7 cm (London: National Gallery). 204

58 Jean-Baptiste Siméon Chardin, *Girl with a Racquet* (1741), oil on canvas, 82 × 66 cm (Florence: Galleria degli Uffizi). 205

59	Sir Thomas Lawrence, *The Angerstein Children* (1807), oil on canvas, 184.3 × 148.8 cm (Berlin: Gemäldegalerie-Staatlichen Museen zu Berlin).	206
60	Bernard Blommers, *Playing School* (1868), oil on canvas, 92.7 × 112.4 cm, VBL/13 (Dordrecht: Dordrechts Museum, in loan from RCE/collection Van Bilderbeek, 1951).	207
61	Jean-Baptiste Greuze, *Broken Eggs* (1756), oil on canvas, 73 × 94 cm (New York: Metropolitan Museum of Art).	210
62	Willem Bartel van der Kooi, *Love Letter* (1808), oil on canvas, 131 × 108 cm (Leeuwarden: Fries Museum, in loan from Rijksmuseum Amsterdam).	211
63	Edgar Degas, *Young Spartans Exercising* (c. 1860), oil on canvas, 109.5 × 155 cm (London: The National Gallery).	212
64	Jozef Israëls, *The Timid Lover* (1883), aquarelle, 83.4 × 63.3 cm (Montreal: The Montreal Museum of Fine Arts).	212

Acknowledgments

The first ideas for this book emerged during the preparation, together with Inge Wichgers, of a presentation for the conference of the International Society for the History of Education (ISCHE 38) on "Education and the Body" in August 2016 in Chicago. It was reworked into an article, "The Embodiment of Teaching the Regulation of Emotions in Early Modern Europe," for *Paedagogica Historica* 54, no. 1/2 (2018), 48–65. In 2017, I started to develop those first ideas in more detail during a sabbatical leave for which I am indebted to the dean of my Groningen Faculty of Behavioral and Social Sciences, Professor Dr. Greetje van der Werf. I got the opportunity to spend this sabbatical leave at the Max Planck Institute for Human Development within The Center for the History of Emotions. I am very grateful to the research director of the center, Professor Dr. Ute Frevert, for having admitted me as a visiting fellow and for inviting me to give a lecture in the center's Lecture Series. It was a wonderful experience to stay in this inspiring academic environment with so many excellent and enthusiastic researchers and with stimulating research meetings and conversations with members of this internationally reputed center of excellence, among them Dr. Bettina Hitzer, Dr. Max Stille, Dr. Juliane Brauer, and Dr. Soňa Mikulová. My stay in Berlin was also particularly valuable through the opportunity to do research in the exceptionally rich collection of the Kupferstichkabinett. I could study the original drawings by artists such as Rembrandt van Rijn, Albrecht Dürer, Matthias Grünewald, Hans Holbein the Elder, and the nineteenth-century Adolph Menzel and Carl Gottfried Pfannschmidt. The experience of being almost literally face to face with the emotions of children and their parents in the past through the filter of the observations of the artists evoked in me a historical sensation. That's the notion coined by the historian Johan Huizinga for that typical experience of seemingly being face to face with people in the past. I am grateful to Dr. Holm Bevers, then director of the Kupferstichkabinett and an internationally reputed expert on the drawings of Rembrandt, for permitting me to study Rembrandt's original drawings. I would in particular thank Katrin Warnecke, responsible for the reading room of the Kupferstichkabinett. Thanks to her great knowledge of the iconography of the child in drawings of the Kupferstichkabinett and to her valuable suggestions and advice, I could fully profit from the richness of the drawings of the Kupferstichkabinett.

After a year mainly filled with management tasks, I could take up the project again during a second stay at The Center for the History of Emotions, thanks to the hospitality of Professor Ute Frevert. Apart from continuing my research into literature and sources, I wrote a first draft of the introductory chapter and prepared a detailed outline and proposal of what eventually would result into this book. I would thank Mark Richardson, commissioning editor for education and Rhodri Mogford, publisher

of history at Bloomsbury Publishing, for their belief in the proposal's potential; the three anonymous reviewers of the book proposal; four years later, the anonymous reader of the whole manuscript, and the anonymous copyeditor for their positive assessment and very useful suggestions, which made the book considerably better. I am grateful to Rhodri and the editorial assistants for history, Laura Reeves and Gabriella Cox, for their stimulating support during the writing and production process of the book.

I would also thank Manja Alsema, Miriam Scheltens, Herman van der Molen, and Liesbeth van der Weerd from the administrative center of the Groningen Department of Theory and History of Education for their support in an earlier stage of the research; the anonymous librarians of several libraries for their support; and the many museums for the reproduction of paintings and drawings. Many colleagues contributed in one way or another to my thinking of children's emotions. I would in particular thank Professor Dr. Willem Frijhoff, an internationally renowned cultural historian who introduced the "histoire des mentalités" in the Netherlands; Dr. Joseph Wachelder, who put me on the track of Jean-Baptiste Siméon Chardin; and Professor Dr. Johannes Westberg, the head of the department of Theory and History of Education and of the research group Education in Culture, who asked me frequently about the book's progress and invited me to give a lecture in one of his courses and within the Groningen Summer School on Historical Analysis, Presentation, and Narration, so that I could try out some of my ideas in a group of critical and creative students.

Most thanks are for my family. My wife read all draft texts first so that I could immediately identify the weak spots. And without my children, children-in-law, and grandchildren, this book about children's emotions would never have been written. The book is dedicated to my grandchildren.

1

The Making of a Visual History of Children's Emotions in Europe

Rembrandt's Eye

Rage of a toddler is the dominant emotion in *The Naughty Boy* (*c.* 1635), a drawing with imaginational power by Rembrandt van Rijn (1606–1669). The boy expresses his rage so loudly that you can not only see his behavior but also almost hear it. Not only the boy's face, as seen from his open mouth crying and his tangled hair, but also all other parts of his body seem to express rage. As a result, his right slipper shoe shoots from his foot and his left hand touches the ear of the woman who tries to hold him in her arms. The boy is not alone. Four other persons participate in the scene in an early seventeenth-century Amsterdam house, firstly the woman, probably his mother, who tries to hold him in her arms and restrain his emotions. That is a difficult task. She has to bend her head to the right and hold the child strongly while the raging little boy almost slips out of her arms and resists strongly his mother's efforts to restrain him. She seems to be irritated, visible by her clenched eyebrows, about the strong effort needed to control the child's behavior and about the child's pulling on her ear. Yet she does not seem to be angry, for the child's rage is not answered by punishment but by restraint. An elder woman next to the mother warns the child with her left hand lifted for his behavior. She seems to support the mother, but in vain, for the child can neither see nor hear her. Apart from that, he would not have observed her anyway, for he was completely obsessed by his rage and anger (Figure 1).[1]

Behind the child and the two adults, two elder children try to observe the situation curiously from outside through the open door. They cannot see much from their place, but they can hear the scene. Perhaps they came down to the sound of the rage of the child. Also the warning by the elder woman—perhaps also intended for them—is not visible to them. The drawing tells nothing about the reason behind the boy's rage. Perhaps he would play together with the other children outside but was forbidden to do so because of being too young—the scene must be Amsterdam, so dangerous water in a canal cannot be far—or he wanted to eat something that was not admitted. Anyway, it seems that the boy wanted to do something that the mother found necessary to prevent him from doing, with which he did not agree and which led to his outbreak of rage.

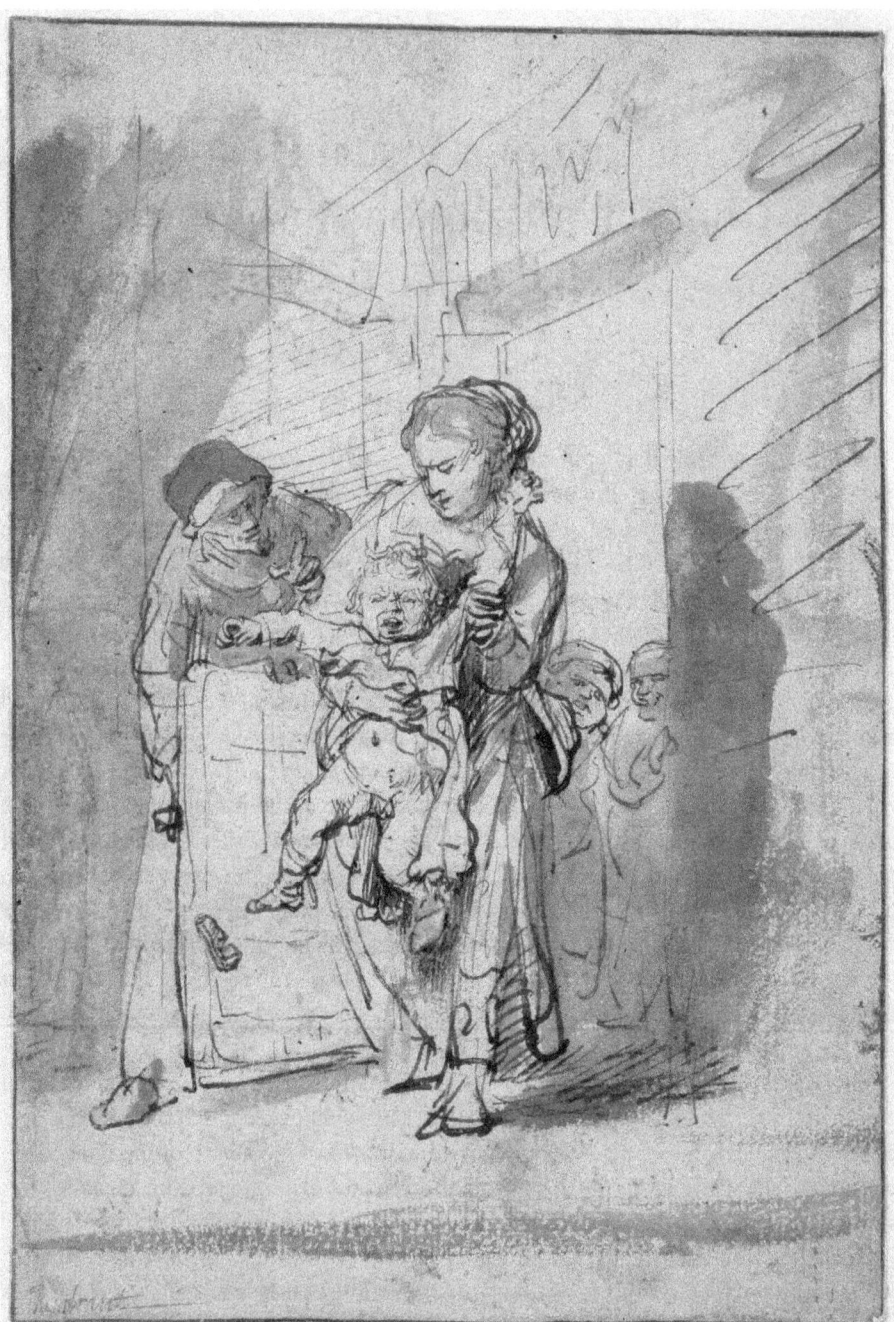

FIGURE 1 Rembrandt van Rijn, *The Naughty Boy* (*c.* 1635), drawing, 207 × 142 mm (Berlin: Staatliche Museen zu Berlin, Kupferstichkabinett, KdZ 3771). Credit: Staatliche Museen zu Berlin, Kupferstichkabinett/Jörg P. Anders Public Domain Mark 1.0.

Rembrandt's brilliant drawing shows an educational situation, which is contemporary and timeless at the same time. While situated in the seventeenth century, the outburst of the boy's rage and the mother's restrained behavior can be imagined in a grocery store or supermarket nowadays too. The drawing evokes historical sensation in bringing us almost face to face with the child's emotion of rage and the mother's attempt to restrain that in the seventeenth century. The drawing brings together the two aspects of children's emotions addressed in this book: the representation of its bodily expression by showing the extreme emotion of a toddler, and the mother's controlled behavior and emotions in coping with and channeling the emotions of her child, which is the first stage of teaching emotional literacy. The visualization of those two aspects of children's emotions in Europe 1500–1900 will be approached in this book in a multidisciplinary way. It combines history of education and history of emotions with art history and intellectual history, and its main source is visual.

A History of Education and Emotions

This study is situated at the crossing of history of education and childhood[2] and history of emotions, which both developed strongly in the past fifty years. History of education, traditionally focused on the history of ideas of great thinkers, transformed from the 1960s and 1970s into a social and cultural history of education. This resulted into new topics, theories and concepts, and new sources, including visual ones.[3] *L'Enfant et la vie familiale sous l'ancien regime* (1960)—published in English as *Centuries of Childhood* in 1962—by the French historian Philippe Ariès (1914–1984) played an important role in this innovation.[4] Its significance for this study is apparent, apart from its innovating impact on the history of childhood and education, from its pioneering role in the use of visual sources and from its attention to parental and family emotions. The book influenced historians of education and emotions, psycho-historians, social and cultural historians, historical anthropologists, and historical demographers, and it created a scientific agenda for many years.

Educated at the Sorbonne as a demographic historian, Ariès worked mainly outside the academic world. He managed the Institut de Recherches sur les Fruits et Agrumes, a tropical fruit trade information center, and did his historical research in the weekends. Only after his retirement in 1978 this "historien du dimanche"[5] as he described himself, was appointed as director of studies at the prestigious École des Hautes Études en Sciences Sociales (E.H.E.S.S.) in Paris, founded in 1975 as the successor of the Sixth Section of the École Pratique des Hautes Études from 1947 and the powerhouse of the new French history with its journal *Annales Économies Sociétés Civilisations*, founded by Marc Bloch (1886–1944) and Lucien Febvre (1878–1956). They transformed the historical sciences into a social science, which covered, apart from economic and social history, also the history of collective feelings, that is, *histoire des mentalités*. Albeit an academic outsider until 1978, Ariès became one of the most creative and innovative French historians with epoch-making books on *longue durée* history of the life cycle,

including histories of childhood, parenting, schooling, death, and mourning. He also laid the foundation for the five-volume *Histoire de la vie privée* [History of the Private Life], edited together with the mediaevalist Georges Duby (1919–1996) and published in 1985–7, after his death.[6]

In *L'Enfant et la vie familiale*, Ariès was in search of the genesis of the modern, child-oriented nuclear family. He concluded that the *sentiment de la famille* and the *sentiment de l'enfance*, concepts coined by him, almost disappeared after the end of the Antique World, but experienced a rebirth in the late Middle Ages.[7] This rebirth went together with a missionary movement from the sixteenth century of humanists, moralists, the church, and school reformers who all wanted to tell parents and schoolmasters how to make children ready for adulthood by taking educational responsibility and by emphasizing regulation and "discipline."

L'Enfant et la vie familiale was appraised, criticized, and refuted. Ariès's thesis about the absence of the *sentiment de l'enfance* was often interpreted as the absence of parental love and the obviousness of child neglect and abuse. Ariès, however, explicitly wrote that this absence did not mean that children were neglected, but that the conscience of the specificity of infancy and childhood, or childhood's *sui generis*, did not exist.[8] While family historian Jack Goody in his criticism pointed at medieval images of the Madonna and the Child to discover "that positive sentiments of attachment between mother and child were not an invention of modern man," Ariès, as an art connoisseur aware of that, emphasized that the transformation of the artistic representation of the Holy Child during the Middle Ages should be seen as the start of the representation of young children in European art.[9] It should, however, be noted that until the twelfth century, European artists simply were not able to adequately represent children.[10] That this later changed is evidence of the presence of the *sentiment d'enfance*. Its absence until the twelfth century, however, is no evidence of the absence of the *sentiment de l'enfance*. Ariès's idea that "an awareness of childish particularity" was only reborn in the late Middle Ages was therefore rightly refuted in many studies that made the early Middle Ages no longer a "dark ages" for the history of childhood.[11]

It seems to be more fruitful to focus not on whether or not the birth or rebirth of the *sentiment de l'enfance* could be attached at a specific period, but on its time-bound manifestations.[12] *L'Enfant et la vie familiale* triggered people who embraced his main conclusions as well as his critics to either confirm or refute Ariès's conclusions. This resulted into a new and vast body of knowledge on the history of childhood, parenting, education, and schooling, reason for Lawrence Cremin to describe Ariès's book as "path-breaking both in its use of sources and in the arguments it advanced."[13] This was in particular the case in its use of visual sources, its attention to emotions such as love and affection, and its historicizing of emotions.

Ariès was thus in a sense an historian of emotions *avant-la-lettre*. His studies on childhood and the history of death, among others, addressed collective emotions[14] during the life cycle on childhood, on parenting and education, and on sadness. The above-discussed *Histoire de la vie privée* is a gold mine for the history of emotions.

It deals with human emotions in the historical and spatial context of the private life, in particular the family and the domestic, a "zone of immunity" from the public life, which in early modern Europe had to cope with stronger influences from outside with the increasing power of church and state on people's daily life, for example, through education.[15] Ariès referred to the founders of the French *histoire des mentalités* with their innovative classics like Marc Bloch's *Les Rois Thaumaturges* (1924) and Lucien Febvre's *Le problème de l'incroyance au XVIe siècle. La religion de Rabelais* (1947)[16] and to *The Autumn of the Middle Ages* (1919) by Johan Huizinga (1872–1945), who from the first page pointed to the fierce emotions, or passions, of people in that period. In fact, those pioneering historians started the scientific study of the history of emotions.[17] Many decades later, they were followed by, among many others, Jean Delumeau with his concept of "emotional climate" and his attention to fear and sin;[18] studies of Jacques Gélis on pregnancy, birth, childhood, and identity;[19] Alain Corbin's *Le Territoire du vide* about the genesis of modern beach-life; best-seller *Montaillou* by Emmanuel Le Roy Ladurie; Peter Gay on the emotions of the Victorian Age; Robert Darton on eighteenth-century France; and Carlo Ginzburg and Italian *micro storia*. Also Norbert Elias's (1897–1990) *The Civilizing Process* (1939), widely known since its English edition in the late 1960s, contributed to the history of emotions, in particular emotion regulation. Those studies were not labeled as histories of emotions, but when looking back, it seems that their authors opened the field of this research and thus could be considered as the ancestors of the modern history of emotions.[20]

This modern history of emotions was born in the late 1980s with as pioneers Carol and Peter Stearns through their publication on "Emotionology" (1985) and their proposal to make "the history of emotions ... a territory of research in its own right" by assuming that each society did have standards of emotions that could differ from "actual emotional experience and expression." They also focused on childhood and emotions, in particular happiness in modern and contemporary history.[21] According to Reddy, Michel Foucault's looking at "the self as a construction of discourse" without space to "deviate from the standards of his or her cultural context," and Jürgen Habermas's attention for rationality, prompted historians to focus on the role of the variety of emotions in history. For while "standards and ideals are always expressed," the "style achieved in practice is a compromise."[22]

History of emotions caused an "emotional turn" within the historical sciences as part of a more general emotional turn in Western society. *Emotional Intelligence: Why It Can Matter More Than IQ* (1996), the bestseller by the American psychologist Daniel Goleman, is a symbol for this turn with sometimes a belief in the power and importance of emotions as emotional intelligence that surpasses logical and intellectual intelligence (IQ). Emotions became hot in applied psychology and in self-help books to which Goleman also contributed, and in the social media with the use of so-called emoticons, a standard tool in smartphones.[23] As a result, the already existing study of emotions in history was resumed, intensified and institutionalized, and renewed.[24] It was resumed by building further on *histoire des mentalités*. It was intensified and institutionalized

with book series on the subject, journals, (inter-)national societies like the Society for the History of Emotions, influential scientific leaders and agenda-makers, among them Peter and Carol Stearns, William Reddy, Barbara Rosenwein, and Ute Frevert, and several research centers specializing in the history of emotions.[25] Among them are the Zentrum für die Geschichte der Gefühle (Berlin, 2008), part of the Max-Planck-Institut für Bildungsforschung, the Queen Mary Centre for the History of Emotions (London, 2008), and The Australian Research Council Centre of Excellence for the History of Emotions (2011).

Modern history of emotions also became an innovative movement in historical science, apparent by a focus on emotions only and by a great attention for its psychological approach. From the start of psychology as a science, emotions and its regulation were studied within psychology with, among others, the founders of scientific research into the emotions, Charles Darwin (1809–1882) and William James (1842–1910). While emotion research in the twentieth century remained outside the core of academic psychology for many decades, it made a revival in the 1980s with Nico Frijda's *The Emotions* (1986), one of the first covering scientific psychological emotion books.[26] This went together with steamy neuropsychology, and while history of emotions could profit from new psychological research on emotions, psychological (and philosophical) theories that assumed an a-historical and unchangeable pattern of emotions across historical time brought the historian of emotions Plamper to the rhetoric question: "Do emotions have a history?"[27] The question remains therefore if and how could psychological categories and concepts be used for historical emotion research, with historians like Jarzebowski remaining skeptical about that for early modern Europe.[28] In the next section, we briefly turn to this issue.

A Psychological Category in Historical Research

Idiographic and Nomothetic Approaches

The study of children's emotions in the past starts unavoidably with asking the question one hundred forty years ago discussed by William James in his famous article "What Is an Emotion?"[29] Apart from his specific answer, on which more in Chapter 5, there is understandable skepticism among historians about the use of psychological categories in historical emotion research because of the ambition of psychology to approach its topics with a "natural-science point of view."[30] As a result, research on emotions runs the risk of ending up in a polarity between universalism, on the one hand, and social constructivism and antideterminism, on the other, with life sciences, including biology, evolution theory, and psychology, with a nomothetic gaze searching after general laws, while humanities, like anthropology and history, are focusing on the individual and the unique.[31] This polarity recalls the classic dichotomy described in 1894 by Wilhelm Windelband (1848–1915) as nomothetic natural sciences and idiographic humanities.[32] However, this dichotomy should not be taken too far. It should be possible

to use psychological categories and classifications together with a high sensitivity for variations over time, and this should start with the very history of "emotion" as a category. After all, only from mid-eighteenth century, "emotion" started to be used more frequently as a synonym for passions.[33] Moreover, from the end of the nineteenth century, "emotion" was used to cover states of mind, which before were considered as states of the soul.[34] It was not just a change of words: it was also a change of the basis for the understanding of emotions.[35] The introduction by philosophers, biologists, and psychologists of "emotion" in the course of the nineteenth century as an overarching category for states of the mind went together with a change from a theological and moral understanding of passions and affections, or states of the soul, into a seemingly neutral and scientific understanding of emotions.[36]

According to Thomas Dixon, the use of emotion as a covering category in historic research would implicate anachronism and presentism. Therefore, he is opposed firmly to its use for a time span that includes those periods in which it was not yet used as a category. Still there are also reasons for using it as a covering category for longer periods, albeit with caution. Julie Ellison defends a pragmatic approach. She uses "'emotion' as a catch-all term covering a wide variety of past and present uses of 'passions,' 'sensibility,' 'sympathy,' 'sentiment' and 'affection.'" In that way, she combines "emotion" with the variety of categories used in the past.[37] This approach corresponds to the usage of emotion as overarching category for states of the soul and states of the mind in early modern and modern Europe among most historians of emotions.[38] For the rest, the use of modern concepts, categories, and theories for historical research is rather common in many studies within social, economic, political, and cultural history, for example, in studies on economic growth fueled by modern economic theory. The most important condition in this approach is that the use of "emotion" as an overarching historical category would not affect the leading role of the time-bound discourses with its specific terminology, the approach we will follow in this book.[39] Before turning to this approach, some controversies on emotion among psychologists deserve attention.

Psychological and Historical Categories

Psychologists are the emotion experts par excellence. The tricky thing is alone that the experts do disagree massively about some fundamental issues. This disagreement is not new. When Dixon in 2012 wrote on the definition of "emotion" in *Emotion Review*, he spoke of "the history of a keyword in crisis ... at the heart of modern psychology" since James's answer in 1884 on his famous article "What Is an Emotion?" Because there was "little scientific consensus on the answer to his question," the problem "is the very category of 'emotions.'"[40] Dixon is not alone in this view. William Cunningham and Tabitha Kirkland sighed: "The scientific study of emotions faces a potentially serious problem: after over a hundred years of psychological study, we lack consensus regarding the very definition of emotion."[41] One of the reasons was that James and his colleagues let "the relationship between mind and body and between thought and

feeling ... confused and unresolved." Moreover, "emotion" was used so broadly that it did "cover almost all of human mental life,"[42] which is by the way a good argument to use "emotion" heuristically as an overarching historical category.[43] Controversies also exist about the difference between feelings and emotions, with some authors excluding feelings from the definition, while others making them the distinctive feature of emotion as a state of mind,[44] about the causes of emotions with the bodily hypothesis by Darwin and James contested from the end of the nineteenth century but revived in the last decades through the popularity of the neurosciences,[45] about the categorization of emotions in distinct or basic emotions, about the number of emotions, and about the cultural variety of emotions. Those controversies turned out to be that lasting that even the removal of "emotion" from the psychological terminology was seriously proposed. Still, the "many rather disparate and often unspecified meanings" of emotion did not prevent the growth of "interesting research on emotions," resulting into numerous books, several scientific journals "with 'emotion' in their titles," and thousands of articles.[46] For the rest, the concept of affection, often rather associated with early modern Europe, did not disappear from psychological research. It was, for example, apparent from publications such as the voluminous *Handbook of Affective Sciences*[47] and from several editions of the long-time popular academic textbook by Ernest Hilgard and Richard and Rita Atkinson, who use the category of affective state to refer to the "affective tone" of "pleasantness or unpleasantness of experiences."[48]

While taxonomies of emotions did not interest William James, before and after him many studies dealt with taxonomies and attempted to organize them in so-called basic emotions.[49] While skepticism about such taxonomies remained and while the universality of basic emotions is contested,[50] an elementary classification between pleasant and unpleasant emotions is mostly used with "six basic emotions (happiness, sadness, fear, surprise, disgust, anger) that are universally accepted." Other emotions are "considered to be a part of these basic emotions"[51] with, for example, Tracy and Randles adding next to those six basic emotions other emotions such as interest, contempt, seeking, lust, care, enjoyment, relief, and love.[52]

In a new chapter on emotion in the 2016 fourth edition of *Handbook of Psychophysiology*, the various divergent positions are combined. Authors in this *Handbook* follow the above-discussed discrete theories in distinguishing a limited number of basic emotions but combine this discrete model with dimensional theories that accept "a large (perhaps unlimited) number of emotional states." The resulting two-dimensional model would include valence (negative-positive) and arousal (low-high) and would result into four possibilities of negative-low, negative-high, positive-low, and positive-high.[53]

The above-sketched discussions are about human emotions generally. For children, the acquisition of insight into their own and other's emotions and the mastering of emotion control are part of their development. This is narrowly related to the acquisition of what is often described as a theory of mind.[54] The idea behind this is that people in interaction with the mind of other people, and aware of their own mind, do not simply act

in reaction to the other's behavior but also try to understand the actions and emotions of the other. In other words, they try to understand the other's mental state. This presupposes the awareness of the other's mind. While developmental psychologists generally agree about the relationship between the acquisition of language and of a theory of mind,[55] also in the preverbal stage, the development of a theory of mind is already present albeit in an incipient and budding stage, for example, by mirroring the emotions of adults.[56] The theory of mind's further acquisition does have major consequences for the education of emotion control, or emotional literacy. This will be discussed further. First we will conclude about that tricky issue of how to use the psychological category of emotions in this book on the history of children's emotions.

In this book, "emotion" will be used as an overarching historical category by covering all main categories for states of soul and of the mind common in early modern and modern Europe. Also the distinction in basic emotions will be used as a heuristic tool. If the sources make that possible, those basic emotions will be combined with a distinction of negative-positive valence, also to be considered as unpleasant-pleasant, and of low-high arousal, or intensity. This approach asks for sensitiveness and flexibility for historical change, for individual diversity, and for social and gender differences. This will guarantee space for varying affective states of the soul and the mind and of basic emotions across time, and also enable the comparison between the periods studied. The emotions in the period c. 1500–c. 1900 will be primarily approached by looking through the filter of pictures, mainly paintings and drawings, and thus analyzed in its visual and thus bodily manifestation.[57] In some cases, this visual filter will be supplemented by personal documents together with textual sources used for the discourse on emotions, education, and childhood.

Concepts and Theories about Children's Emotions across Time

In this study children's emotions are examined over a period of four centuries within a varying educational space. In the following we will briefly deal with some concepts and theories used in this study: about educational space and about child's development of emotional literacy. But prior to this we will introduce the aspects of children's emotions that are central in this book.

Discourse, Expression, and Emotional Literacy

Children's emotions are studied for two aspects: their bodily expression and the process of learning emotional literacy, or emotion formation and regulation. We look at emotions of children aged until adolescence, with, however, most attention to younger children within the family and the domestic. This, together with the reality that European iconography on children is mainly focused on the domestic, is the reason that the school, as an educational institution, in particular from the nineteenth century, very important for the teaching of emotional literacy by discipline, was not included in this study.

Because of the emotional dimension of the educational relationship, adult emotions are also involved: within that educational relationship, children evoke adult's emotions and vice versa, as we saw in Rembrandt's *The Naughty Boy*.[58]

To understand the visual representation of those two aspects, we have to know how people thought about emotions and about childhood and education. Therefore, the two periods distinguished start with a chapter about the discourse, followed by chapters on the expression and the formation of children's emotions. The discourse on emotions changed over time from states of the soul with passions to be controlled and affections to be developed as part of a Christian discourse, into emotions as a covering concept of a scientific discourse. Also the educational discourse changed substantially during the two periods distinguished, Renaissance and Reformation Europe, and the Europe of Enlightenment, Romanticism, and Science. The transition from one period to another is traditionally often considered crucial, not to say radical, for a change in both discourses. By studying children's emotions over a *longue durée*, it becomes possible to see to what extent this interpretation would also emerge from a study into the visualization of the subject.

The bodily expression of emotions of children will be studied through contemporary, mainly visual, sources, and interpreted by following—almost literally, for the main sources are visual—the eyes of the contemporaries. In that way we could come almost face to face with children and their parents in the past. This approach will be combined with a heuristic use of the categorization of emotions in basic emotions—the so-called discrete model—and with attention to the emotional tone of the emotions—the so-called dimensional model—from modern psychology. Emotions will be observed within the emotional and educational relationship in the domestic and within the child's world.[59]

Within the domestic also the process of emotional formation, or the education into emotional literacy, an essential part of enculturation and cultural transmission, took place.[60] The question is how contemporaries visualized the teaching of children in emotional literacy, that is, in coping with emotions and in learning to express the right emotions at the right moment, within the right circumstances, and according to time-bound emotional standards. The range of this activity, from emotion education to self-regulation, seems to be rather similar to the concept of emotion formation.[61] In psychological theory, this phenomenon of learning to express, understand, and control emotions is distinguished in coping with and in controlling emotions,[62] to be understood as "the capacity to influence one's experience and expression of emotion."[63] In this book the emphasis is on how adults try to stimulate that capacity of children and youngsters and, if considered necessary, how to regulate children's emotions. This could include the understanding of child's emotional developmental stage and coping with adult's own emotions, as the mother in the drawing by Rembrandt did.

The Educational Space in the Longue Durée

The physical places where the expression and the learning of emotions took place were part of a time-bound educational space, that is, the quantitative and qualitative

space available for childhood and education. This space is characterized by limits that could "get in the way of or even obstruct child rearing," and by positive conditions and opportunities that could "promote, generate or enable child rearing and education."[64] This description of the concept of educational space was inspired by definitions of culture that consider culture as a dynamic process with limits and conditions, and it makes it possible to study how across time people cope with their educational ambitions in this book focused on the teaching of children's emotional literacy.[65] For insight into the limits and opportunities of the educational space during the period c. 1500–c. 1900, four indicators with crucial impact on limiting or stimulating the educational space are distinguished: the demographic situation, the socioeconomic circumstances, the educational power balance between private and public, and, last but not least, the impact of the educational mindset, that is, attempts to understand child's world. This mindset, as such not new, got a boost under the influence of movements such as Humanism, Reformation, Enlightenment, Romanticism, and child sciences. The educational mindset seems to be often decisive in using or not using the available space determined by demographic and socioeconomic developments. In Europe in this period, demography was the most fundamental limit for the educational space with high infant and child mortality and the early death of many parents dominating until far into the nineteenth century.[66] For the other indicators, the balance between limits and positive conditions and opportunities was historically more complex, to be seen in Chapters 2 and 5.

Educational space in history means space in time. Fernand Braudel's concept of *longue durée* is helpful in getting insight into the impact of the indicators of educational and emotional space over a long period of time. In his classic article "Histoire et sciences sociales: La longue durée" (1958), Braudel (1902–1985) wrote about the plurality of historic time and distinguished between the short term (*temps événementiel*), the medium term (*conjuncture*), and the long term (*longue durée*).[67] He discussed for cultural and mental processes how limits or, in his words, *cadres mentaux* could behave as prisons of the *longue durée* with hardly any opportunities to escape. Bernd Roeck describes those limits as "insurmountable walls of the spaces of possibility."[68] Early modern and modern Europe until c. 1900 was marked by a continuing process of modernization of culture and society, in particular in the region most addressed in this book, the so-called European Megalopolis, which roughly covers (parts of) England, the Low Countries, and parts of France, western Germany, Switzerland, and Italy. In this region, also described as the "Blue Banana," the economy, the state, and the social and emotional relations modernized earlier than elsewhere. According to Max Weber (1864–1920) this was the result of the joint impact of modern economic growth, state formation, and an accelerating rationality through Humanism and the Reformation.[69] Within this European Megalopolis, modernization differed in pace and character, for example, on literacy and on the importance of the domestic. While, for example, the nuclear family in the Netherlands became already early a central agency of emotions as visible in the country's iconography, elsewhere in Europe the open lineage family, or domestic, often continued to dominate.[70]

The parental materialization of the belief in the child as *animal educandum*, as such not new, depended on the educational space's limits and opportunities, with less limits and more opportunities from *c.* 1800. Whether or not the idea of the child as "eminently makeable: *tabula rasa* in terms of knowledge, but innocent in terms of emotions" was a "particularly modern assumption about the emptiness of childhood," and whether or not the idea of "children as innocent blank slates, to be protected from fearsome discipline, rather than slaves of original sins" coincided with "modern emotional trends" from the Enlightenment[71] is a question to be addressed further in this book. Thereby, taking a *longue durée* approach would make the Enlightenment a somewhat less strict historical limit and would hopefully increase our sensibility for a variety of children's emotions in the past.

Children's Development of Emotional Literacy

Individual emotions are always embedded in a group with its emotional standards. Otherwise, argues Reddy, people could not share their emotional styles, which is necessary for communication between group members. For this process, often the concepts of emotional culture and emotional community are used.[72] Although, suggests Barclay, the "idea of an emotional culture overlaps in important ways with both the idea of emotional communities and regimes," emotional culture, the "way that particular societies have produced rules to regulate emotional behavior, expression, and experience,"[73] mostly refers to larger groups. Emotional community refers to smaller entities, such as the family and the domestic, which are connected to specific educational places and characterized as "spaces of feeling."[74] Within those educational places, emotional formation took place.

Emotional formation, among others, proposed as a concept by Olsen, points to the process of teaching and learning the implicit and explicit standards and rules of specific emotional cultures and communities. Some examples are to learn to relate a funeral with grief and to receive a gift with gratitude. This is learning the use of the right emotions for the right event.[75] In this book we use the concept of emotional literacy as the goal of emotional formation. Emotional literacy is an analogical literacy beyond the strict and primary sense of literacy as reading and writing.[76] Among those "analogical literacies" are "historical literacy," "citizenship literacy," "artistic literacy," "scientific literacy," "geographical literacy," and "emotional literacy,"[77] to be defined as the capability of recognize, express correctly, and control emotions according to the emotional standards of a time-bound emotional culture or community. Often emotional literacy goes together with moral literacy, about the practice and knowledge of how to behave according to moral rules.[78]

The passage or transition during crucial events in child's emotional development can be approached by the concept of emotional frontiers as a "barrier" and "a contact zone."[79] Those frontiers are very similar to the so-called liminal events known from cultural anthropology, and are crucial for the emotional and moral development of children.[80]

Emotion formation and regulation were practiced by means of cultural transmission, a classic concept from cultural history and "the sine qua non of the phenomenon of education." During this reciprocal process between the child and the educator is selected, what to transmit to the other generation, including which emotions and how and where to express them.[81] The degree of reciprocity differs across time and place, social class, and gender and is related to child's stage of development.[82] Educational cultural transmission connects two worlds: the educators' one and the child's one. Because the "child is *not* merely ignorant or an empty vessel, but somebody able to reason, to make sense, both on her own and through discourse with others," children could "influence their own environment," including parental behavior and education.[83]

The next section on sources and reality will address the value of the theory of representation and the methodological habitus of historical sensation in approaching sources. It also will deal with some methodological aspects of pictures as the main source for the expression and formation of children's emotions.

Sources and Reality

Materialities and Interests

"Children have not remained silent in history," and they are worth to "read their tracks" and "making their voices speak," for the options are "larger than expected and claimed," argued Jarzebowski in her book on childhood and emotions in early modern Europe.[84] Admittedly, sources about children are scarce until the nineteenth century, and they are mostly produced by adults. Those sources have, apart from their specific materiality, specific views and interests of the people producing them. The power of all those sources lies in their ability to answer the questions posed.[85]

Sources about the educational and emotional discourse were produced by theologians, philosophers, moralists, educationalists, and scientists, with each group having its specific interests. Also the sources on the bodily expression of children's emotions, namely paintings, and drawings that can bring us almost face to face with children's emotions were influenced by interests of the commissioner, mostly a parent, the artist, and also the art market. People's stories in personal documents like autobiographies, letters, and diaries are used additionally and with a preference for personal documents that combine text and image because of the emphasis in this book on a visual history. Those "first-person accounts" were in contrast with advisory sources mostly not published during the author's lifetime. They were written for the private and intimate circle and can tell us about child and parent in a pedagogical relationship. Those sources give a subjective interpretation of the self, often as a reflection by an adult reflecting on his or her own childhood.[86]

Also emotion formation and control will be approached primarily through paintings, drawings, and emblem books, which will bring us closer to the regulation of children's training in emotional literacy. Images in emblem books and other combinations of

text and image were initiated by the authors of those books with a specific view on childhood and education, while paintings and drawings are expected to strongly mirror the artist's view, as a matter of course also influenced by the commissioner's wishes and by contemporary educational and emotional cultures and discourses. The advice produced by the clergy, philosophers, moralists, and educationalists will be used as a supplementary source. This genre transformed remarkably in content and in style across historical time, but it remained popular until nowadays.

In the following we will discuss the use of the theory of representation for the assessment of the relationship between source and reality, and the methodological habitus of historical sensation in letting the sources bring us to the expression and regulation of children's emotions.

Representation and Historical Sensation

According to Ankersmit, sources have a strong relationship with reality, but they do not mirror reality and only refer to aspects of reality.[87] This view is close to Carlo Ginzburg's proposal to consider sources as *spie*, that is, traces.[88] A representation thus lays down specific aspects of the past, and the uniqueness of a representation is the specificity of those aspects. The visual sources selected—in the period before the popularization of photography paintings, drawings, emblems, and sculpture—have the potential of showing both aspects of real children and their parents in individual and group portraits, and of patterns or standards of emotional behavior in genre art.[89] The latter genre has similarities with nowadays TV soaps that also show what goes wrong when standards of behavior are not followed.[90] Sarah McNamer makes a plea for combining the model of representation with the theory of practice by Pierre Bourdieu (1930–2002) to explore "how literary texts functioned not only to replicate, reflect, or represent ideas about emotions in culture, but how they participated in the making of emotions in history."[91] This applies also to images. In the next chapters, it will become apparent that images could make people laugh or cry, make them happy or sad, angry, or even furious, but also making them compassionate with grief, often directly. And this was often an intended effect.

Looking at visual sources can result in coming almost face to face with the historical reality by experiencing what is called historical sensation.[92] This concept about the illusion of direct observation of the past was coined by the historian Johan Huizinga in an essay titled "The Task of the History of Culture" (1929).[93] Huizinga experienced such a historical sensation when coming face to face with late medieval Flemish art by Jan Van Ecyk, Rogier Van der Weijden, and Hugo Van der Goes on an exhibition in Bruges (1902), which inspired him to write *The Autumn of the Middle Ages*, the book that made him famous.[94] According to Huizinga, "Historical sensation ... [,] that is accompanied by the absolute conviction of complete authenticity and truth, can be provoked by a line from a chronicle, by an engraving, a few sounds from an old song. ... Historical sensation does not present itself to us as a re-living, but as an understanding that is closely akin to the understanding of music, or, rather of the world *by* music."[95] A moment of historical

sensation results from "what happens between the historian and the past," and all sorts of historical objects could contribute to such moments of historical sensation, not only masterpieces of art.[96] It is true that when we are face to face with a masterpiece and, as in Rembrandt's *The Naughty Boy*, almost hearing the rage of the toddler, the historical sensation and thus reference to reality could become really strong.[97] However, pieces of art are in this book used as historical sources. This means that not aesthetic or art historical quality or style but the subject of the picture is the main criterion of selection. For the rest, historical sensation will forever remain an illusion, even with images of real people, because of the absence of a time machine for historians. But this approach could serve as an important methodological habitus to support the interpretation of sources that could deliver clues or traces about the expression and formation of child's emotions in the past, and this in particular with visual sources.[98]

Selection of Visual Sources

Apart from getting certainty about the authenticity of the image and its belonging to the period and area studied, the European Megalopolis *c.* 1500–*c.* 1900, the main criterion of selection was its capacity of showing children's emotions. Sacral images were selected because they are the first to represent the child and the family. Those sacral images set the configurative norm for the first generation of profane family portraits, mother-and-child portraits, and also child portraits. Next to those sacral and profane portraits, genre art was selected for its depiction of patterns and standards of emotional behavior. Comparable with them are seventeenth-century emblem books, a Europe-wide phenomenon with a large audience, and the rather comparable eighteenth-century popular books with text and image for the training of children's emotional literacy.[99] Drawings have a special value for this book. They have the potential of giving a direct impression of reality with the artist acting as a photographer *avant la lettre*, and not influenced by customers as is the case with expensive paintings.

The selection of such images happened by search into art history and iconographical literature, digital sources, catalogues of libraries, museum collections, and exhibition books with also art from private collections, all referred to in the following chapters. Many images have been observed in real life, including the drawings from the Berlin Kupferstichkabinett. "All are equal, but some are more equal than others," George Orwell's famous statement in *Animal Farm* (1945), applies also to art as a historical source. While aesthetic quality or the artist's fame were not decisive for the selection, work by some top artists did have specific value because of its expressiveness as a source, in particular in getting insight in the bodily expression of children's emotions.[100]

In the next chapters, a great number of images will be analyzed and discussed with reference to a still greater number in order to guarantee more representativeness. But, as a matter of fact, in this kind of research, this remains a select sample. The hope of making an a-select and representative sample for such sources must remain a never-ending dream. Bogart argues that "paintings accessible in today's museums and art

galleries do not accurately represent the paintings of any given period" and that "their survival and movement from private to public collections have been affected by wars, disasters, population movements, changes in taste and in the economics of the art market."[101] This, however, is not so much a problem as a fact of life. Any ambition to compose a representative sample has therefore to fail.

Interpreting the Artist's Eye

Understanding and portraying children's emotions asks from artists the capability of recognizing with empathy the emotions of other people. Apart from the artist's technical skill, therefore, the "transmission of emotion from canvas to view" asks for "a shared language of gesture and expressive codes." The scientific challenge is to understand that shared language, which can change across time in a way that "paintings which once were considered deeply moving, may now appear stagey and unconvincing."[102] And also the opposite is true. This means the assumption of a theory of mind by the artist. When using art as a source for insight into the emotions of children in the past, we look at art produced by the artist's specific capabilities in craftsmanship and by the artist's empathic ability.[103] While the historian's theory of mind is necessary to come nearer to the other people's emotions in the past, the production of the visual sources used presupposes a theory of mind of the artist. Of course, good craftsmanship was important. According to the Italian art historian Gian Battista Armenini (1530–1609), in a text from 1587, images for the church should be "painted by the best masters." Then they could arouse strong emotions so that the viewers were "more moved by suffering and inflamed by the fire of charity and divine love."[104] This good craftsmanship should go together with a theory of mind in order to represent other people's emotions in paintings and drawings. Also specific preferences of the customer, mostly children's parents, could influence the representation of emotions, which the historian eventually is observing. In sum, without working theories of mind at those several levels of historian, artist, and customer, looking at emotions in pictures from the past would come to nothing.

In interpreting the artist's eye, the iconographic method, that is, the description, analysis, and interpretation of the subject of images, can be helpful. Its focus on art's meaning and subject matter makes art important for cultural history.[105] Understanding symbols in art gives more insight into art, but it also "helps the present-day spectator to see it as the artist's contemporaries saw it." As a result, "the elements of a picture … contain a unity of meaning."[106] In order to understand this meaning, the iconographical analysis knows various stages, which in practice often merge.[107] The first stage is stylistic and historical research into topics such as style, artist, and date, the classic work of the art historian. The second stage, the pre-iconographic description, contains the enumeration of the image's main elements, such as the persons in the image, the color, and the furniture. The third stage, the iconographic description, forms the stating of the subject matter by interrelating the image's various elements. This assumes knowledge of the contemporary symbolic language, which varies across time and was in the sixteenth

and seventeenth centuries dominated by symbols from ancient Greece and Rome and Christianity. This symbolic language used personifications, allegories, and symbols in images of real people to enforce a character, and in images of patterns and standards of behavior to enforce a message.[108] The fourth stage, iconographic interpretation, the search for deeper layers of the subject's meaning, in particular in genre paintings and drawings, is important but also tricky because of the risk of overinterpretation. Bedaux makes this clear in his *The Reality of Symbols*.[109] The fifth and final stage, iconological interpretation, relates the image to its cultural context. This is in essence what cultural historians normally do, namely getting knowledge about the aspects of reality represented by the subject of the image.[110]

The interpretation of pictures in this study aims at insights into the bodily manifestation of children's emotions in the past.[111] Psychological research into the bodily expression of emotions has tried to distinguish specific actions of facial muscles for basic emotions, although emotions such as love, desire, and hope, and generosity and empathy, seem to be more difficult to see in faces. According to this research, happiness should be expressed by raised cheeks, pulled lip corners, and an open mouth; sadness is associated with a raised inner eyebrow, lower eyebrow, tight eye lids, stretched lips, and a raised chin; and angry people raise their outer brow, can have a lower inner brow, tight lid, wrinkle in their nose, raised upper lip and depressed lower lip, stretched lips and dropped jaws. When people are in fear, a raised upper eye lid and dropped jaws are common.[112] However, this approach assumes the existence of general, quasi-ahistorical emotions. It therefore should only be used in a heuristic way and subordinated to contemporary ideas about the bodily manifestation of emotions. Early modern Europe knew painter's guides on this subject, among them *Iconologia* (1593) by Cesare Ripa (1555–1622). This guide, soon translated into several languages, was a bestseller with about 1,250 personifications and served as a travel guide for artists. It was mainly based on Ovide's *Metamorphoses*, made use of some other classic texts, and was mentioned the painter's bible.[113] In the seventeenth century, "a pictorial lexicon of the passions of the soul" was *Méthode pour apprendre à dessiner les passions* (1698) by the French painter Charles Le Brun (1619–1690).[114] Inspired by René Descartes's *Les passions de l'âme*, Le Brun, on whom more in Chapter 3, was of the opinion that the passions are most clearly expressed in the face, particularly the eyebrows. Such texts could help historians to try to do as the contemporaries did, namely look at the picture through their eyes and with their symbolic language.

In the following chapters we will look through the artist's eye into the expression and regulation of children's emotions in the context of the discourse on emotions and childhood in the European Megalopolis of early modern and modern Europe from *c.* 1500 to *c.* 1900. The two periods studied—the Renaissance and the Reformation, and the Enlightenment, Romanticism, and modern science—are structured in three chapters in, respectively, Part 1 and Part 2 along the three topics: the Big Talk about emotions, childhood, and education, the visualization of the bodily expression of children's emotions, and of the education of emotional literacy.

PART 1

Belief in the Child as *Animal Educandum*: Children's Emotions in the Age of Renaissance and Reformation

2

The Big Talk on Education and Emotions in the Age of Renaissance and Reformation

"As the Old Sing, so Pipe the Young:"
A Call for Parental Responsibility

Jan Steen (1626–1679), son of a Catholic brewer, pupil of Adriaen van Ostade (1610–1685), and the most important Dutch genre painter of the Golden Age, eminently and frequently visualized the popular proverb "As the Old Sing, so Pipe the Young." The painting from 1688 shows a three-generation family with seven children in the age from about twelve months to school child, with two parents and two grandparents around the table in an atmosphere of happiness with tipsy adults. Central figures are the mother together with her cheerful baby who waves a spoon at her/his brother who sits on the table, and a girl on the front who lets her younger brother—a boy because of his cap type—smell from a glass of wine. Next to the mother is an elder woman, probably her mother, who reads or sings from a text that makes both mother and daughter laugh. The grandfather seems completely idle and is in an excellent mood. Five children pipe on several musical instruments, including the boy sitting at the table, some others who are standing behind him, and another hanging in the window opening. The children mimic the drinking and smoking of their parents. On the ground we see an organized disorder of pans and jars, which refer to drinking and eating. As a contrast to this symbol of bad behavior, a dog as a symbol of good education looks up to the drunken old man. The painting tells that lack of parental responsibility means lack of control of children's behavior and emotions. To avoid any ambiguity about the painting's meaning, Steen attached the proverb's text to the chimney at the right corner (Figure 2).[1] The proverb and the painting tell that when it goes wrong with the child, the parents should blame oneself, not their child. But there is hope. Children imitate adult's behavior anyway, so the proverb says. When they see decent and responsible behavior, they will imitate that. This belief in the child as *animal educandum* increased in the Renaissance.

Steen was just one of many who visualized the popular proverb, which is present in countless pictures, prints, and emblem books on unruly households. He was inspired by predecessors such as Pieter Bruegel the Elder (1525/30–1569) and Jacob Jordaens (1593–1678) from the Southern Netherlands. Jordaens, influenced by emblem books of Jacob Cats (1577–1660), showed decent companies with children and youngsters who mimicked adult's behavior.[2] Steen transformed the genre in paintings on unruly

FIGURE 2 Jan Steen, *The Merry Family/"As the Old Sing, so Pipe the Young"* (1668), oil on canvas, 110 × 141 cm (Amsterdam: Rijksmuseum). Credit: PHAS / Contributor (Universal Images Group Editorial).

three-generation households with titles as *Unruly Family* and *As the Old Sing, so Pipe the Young*. They emphasized, together with many other contemporary texts and pictures, the responsibility of parents to teach and regulate their children's behavior and emotions. This was the visualization and popularization of the view on good parenting as filling appropriately the *animal educandum*'s blank sheet, an educational view that resulted from the Big Talk on education and emotions in the Renaissance.

After a brief sketch of the emerging communication and knowledge society in the Renaissance, we turn to the classic Christian discourse about passions and affections, primarily developed by theologians such as Augustine and Aquinas. It gained wide influence through popularization in text and image and through adoption and adaptation by Humanism and Reformation. Those movements transformed the classic Christian discourse into a framework for the education of children in emotional literacy. This educationalized version answered to an increasing call from churches, the economy, and bureaucracies for more regulation of emotions.

The Emergence of a Communication and Knowledge Society

The Renaissance Discussion Table

Europe became the most innovative and modernizing region in the world thanks to its development into a communication and knowledge society. It revealed itself as

a Big Talk,³ a concept coined by the historian Bernd Roeck. In this society, almost every subject came onto the discussion table, including education, child-rearing, and emotions. People explored the unknown and developed a world of new possibilities with a tremendous curiosity in almost all fields of knowledge.⁴ Many options that before were unthinkable now were tested in experiments. The arts succeeded in the ability to represent real human beings with, in particular in Italy, a focus on human beauty in sacral and emerging profane art,⁵ and philology went back to the original texts of the Bible and of Greek and Latin classics. In science the prevailing Ptolemaic view on the place of the world in the universe was reversed radically in *De revolutionibus orbium caelestium* (1543) by the Polish Nicolaus Copernicus (1473–1543) and supported empirically by the Italian Galileo Galilei (1564–1642) with his self-constructed telescope, possible through the new lenses technology. The knowledge of the human body and of medical science was radically changed by the anatomical discoveries of the Swiss Paracelsus (1493–1541) and the Flemish Andreas Vesalius (1514–1564) with *De humani corporis fabrica libri septem* (1543).

Man was upgraded in texts such as *De dignitate hominis* (1486) by the humanist Giovanni Pico Della Mirandola (1463–1494), and human beauty was considered as the Creator's piece of art and visible in paintings such as *Primavera* (1481–2) by Sandro Botticelli (1445–1510).⁶ This view on the Renaissance is characteristic for Jacob Burkhardt's (1818–1897) classic study *Die Kultur der Renaissance in Italien* (1860). This study concentrates on its aesthetic and innovative performances, and it considers man, politics, and state as works of art. It, moreover, by assuming the emergence of the individual, presupposes a sharp cut between medieval and Renaissance man, an interpretation contested in, among others, *The Problem of the Renaissance* (1920) by Johan Huizinga.⁷

Europe's Big Talk was based on two rather incompatible representations of man in his relationship to God: that of the individual with man's body glorified as a Platonic shadow of God, and that of man thrown back to utmost humility and dependence on God, in a world of high tensions and contradictions characterized as "life's fierceness" by Huizinga in *The Autumn of the Middle Ages* (1919). He interpreted the second part of the fifteenth century as a fall season instead of Botticelli's—and Burckhardt's—spring season.⁸ Hieronymus Bosch (1450–1516), a northern contemporary of Botticelli, in *The Garden of Earthly Delights* (1490–510), did not focus on corporal beauty. He depicted an end-of-history time and in that way anticipated Martin Luther's (1483–1546) worldview with God deciding about the fate of man in a world dominated by death, destruction, and emotions of guilt and fear of hell and hard punishment by God, visible and palpable in the frequently occurring devastating plagues.⁹ This almost surrealistic painting mirrors the emotional culture in the Little Ice Age that started *c.* 1300, which was characterized by high mortality, continued in the fifteenth and sixteenth centuries, and that knew devastating religious wars in the sixteenth and seventeenth centuries.¹⁰ Some phenomena could together clarify how people in a world full of threats, nevertheless, could transform limits and boundaries into challenges and possibilities and so realize

the miracle of an innovating communication and knowledge society: overcoming the limits of climate change, the spirit of competition, the role of cities, the changing role of the churches, and the invention of printing.

An Innovating Society

Climate change is now a major political, cultural, and economic issue in the form of global warming through human actions. Then it was a major issue too, but in the form of global cooling by natural causes. Europe's Little Ice Age started *c*. 1300. It continued until mid-nineteenth century with the lowest average temperature in mid-sixteenth century. Lower temperatures in the fourteenth century caused smaller harvests, which resulted in disasters such as The Plague with its exceptionally high mortality. This complied with the Malthusian law that exponential population growth went together with only linear growth of food supply and thus had to result in shortage of food and eventually high mortality.[11] After The Plague, Europe recovered with more money available for less people. The plague worked as a medieval neutron bomb, which destroyed people but not their material resources. Moreover, food scarcity stimulated innovation in agriculture and in long-distance trading to relieve food scarcity in one region with the surplus in another, both ways to overcome the Malthusian law.[12]

Overcoming limits went together with an increasing spirit of competition. On the political level, all tricks of competitive and, when considered necessary, ruthless power play were explained and justified by Niccolò Machiavelli (1469–1527) in *Il Principe* (1532). Its application contributed to the birth of modern states in countries such as France, Spain, and England, and albeit differently also to the confederal state of the Dutch Republic.[13] Competition in arts and sciences resulted in startling scientific insights and stunning paintings, sculptures, buildings, and cities.[14] Artistic competition occurred not only in Italy but also in countries such as the Southern Netherlands, France, parts of Germany, and, from the late sixteenth century, the Dutch Republic.[15] This was only possible through a flourishing art market made possible by the first phase of modern economic growth. Commercial capitalism based on competition became the main motor of this growth with profits regionally and socially unevenly distributed. While, until about 1550, Italy was booming, from around 1600 the economies of Scandinavia and the North Sea Region, the Dutch Republic and England, grew faster. Elsewhere, as in Germany with its devastating Thirty Years War, the economy stagnated.[16]

Cities formed the nodes of competitive commercial capitalism and the Big Talk.[17] In some regions such as the Dutch Republic, the majority of people, often migrants from elsewhere,[18] lived in cities with much of the countryside economically participating in the urban economy because of small distances and transport connections over water.[19] Initially Renaissance popes, cardinals, and princes dominated the commissions for painters and architects and also contributed to the Big Talk, as, for example, the humanist Cardinal Nikolaus Cusanus (1401–1461) with his broad interest from philosophy to theology and astronomy.[20] Increasingly, however, burghers of the booming cities became

important art clients too. This led to a change of artistic style and topics, in particular resulting into portraits of families and of individual children and adults, on which further in Chapter 3. The relationship between cities and state and between burghers and rulers was complex, and the emergence of modern central government bureaucracies in countries such as Spain, France, England, and Habsburg Austria was a challenge for a potential threat to the previously obtained urban freedom. It was also an opportunity for wealthy families such as the Fugger dynasty, wealthy burghers with their financial powerhouse that financed princes, and the church in their expensive political power play.[21]

Indeed, the church was next to the state the other major power player and ready to intervene in the lives of burghers. Wealthy power of the church declined and got a huge blow with the Reformation with princes such as the English King Henry VIII (1491–1547) confiscating the money and goods of the church and founding a state church headed by him.[22] But the church's decrease of wealthy power was compensated by more cultural power. The modernized post-Reformation churches strengthened their influence on the daily life of their believers through a catechetic and educational campaign. This campaign was materialized through church services, supervision of the believer's moral behavior by the local clergy, catechisms for adults and children, religiously founded child-rearing books for parents, and schooling.[23] In a sense this process seems to confirm the famous and also contested thesis on the birth of the individual by Burkhardt, summarized as follows: "The subjective rises with full power; Man becomes a spiritual individual and recognizes himself as such."[24] Individual identity appeared more manifestly in personal documents such as letters and autobiographic texts, in *belles lettres*, and in family and individual portraits, now as a class of its own instead of as a part of a late medieval altarpiece.[25] The domestic emotional space became more important for identity formation of children.[26] Also Luther's conviction that the individual believer could reach God only by believing, without the intermediary role of priests and rituals, fitted Burckhardt's thesis. But the political history of the Reformation seems to nuance this with rulers trying to decide what probably in this period was the most important part of emotional identity, namely people's choice of faith. After the first wave of religious wars, most rulers in and outside the *Holy Roman Empire of the German Nation* followed the principle of *cuius regio eius religio*, agreed at the Peace of Augsburg (1555). This meant that the ruler, and not the individual believer, would decide about this most important part of emotional identity, unless the believer left in time for another region where his religion was accepted. This led to religious homogeneity according to the ruler's taste or conviction, except in some German States and the Dutch Republic with remaining religiously heterogeneous populations.[27] This was also the case in France because of the Edict of Nantes (1598) until its revocation (1685) by Louis XIV (1638–1715), which caused a flight of Huguenots to countries with Protestant rulers, such as England and the Dutch Republic.[28]

The greater impact of churches on their believers' daily life through catechisms and other religious texts intensified faith for more people than before. It also stimulated

literacy. This was possible through the invention of the printing press, which accelerated communication in a hitherto unprecedentedly fast manner.[29] It was worked on in various places in Europe, but the breakthrough happened in Mainz on the River Rhine in the urbanized European Megalopolis region. Johannes Gutenberg (1400–1468) brought together already available technologies,[30] and after testing his procedure, he decided to print the Vulgate, the Latin version of the Bible. Within two and a half years, a period previously needed to make one single manuscript, Gutenberg had printed almost two hundred Bibles.[31] His invention allowed for a great variety of content to be printed and spread by books and leaflets and other printing matter, comparable only with the invention of scripture and alphabet six and three-and-a-half millenniums earlier and with nowadays digitalization and the internet.[32] The "rise in total book production was as dramatic as the fall in book prices."[33] This increased the impact of Humanism, made the Reformation a success, and decisively facilitated the Big Talk about passions and affections in the perspective of earth and hereafter.

About Earth and Hereafter: The Discourse on Passions and Affections

Notwithstanding tensions and conflicts with the church, the Big Talk's participants did not really cross the borders of religion. Their discoveries would, argued the Dutch biologist Jan Swammerdam (1637–1680), give insight in the "book of nature" as God's Creation, a view fitting Lucien Febvre's *Le problème de l'incroyance au XVIe siècle* (1942) about the unsurmountable limit of religion in early modern Europe.[34] Also the Big Talk on emotions and the necessity of emotional literacy were profoundly influenced by the seemingly incompatible Humanism and Reformation views on man that, however, both dealt, one way or the other, with the classic Christian discourse on passions and affections. After discussing the main elements of this discourse and its popularization and visualization, we will turn to its adoption and adaptation by Humanism and Reformation, and to practical rules and recommendations on emotion regulation and emotional literacy in an educational turn by, among others, Erasmus of Rotterdam.

The Augustinian and Thomistic Fundament

Two formidable theologians laid the foundation for a discourse on emotions, which remained leading far into the eighteenth century. The first, Church Father Augustine of Hippo (354–430), of major influence on both Catholic theology and the Protestant Reformation, in particular Luther, and strongly influenced by Neoplatonist Plotinus, wrote on emotions and on how to control them. He did this not only as a scholar in famous theological works such as *De civitate Dei* [The City of God] (413–426), in particular books IX and XIV, *De libero arbitrio* [On Free Will], and *De Magistro* [On the Teacher], but also as a man who struggled with his passions in the autobiographic *Confessiones* [Confessions].[35] The second, Aristotelian theologian Thomas Aquinas

(1225–1274), a professor of theology and philosophy at the Sorbonne University of Paris and one of the most influential philosophers of the Middle Ages, wrote the *Summa Theologiae*. In this work, he, the master of philosophical classification, transformed the Aristotelian metaphysic into a rational theology with ingenious proofs of the existence of God, according to Max Weber an important contribution to the rationalization of the world.[36] His *Summa Theologiae* became part of the *Codex Juris Canonici*, the official doctrine of the Roman Catholic Church at the Council of Trent (1545–63), and "provided the background for many discussions of the passions during the seventeenth century."[37] His *Summa Theologiae* was not an appendix to Augustine,[38] but Aquinas, who was strongly influenced by the man to whom he referred as "the philosopher," Aristotle, dealt systematically with man and the passions in a natural philosophical and a moral context.[39]

This moral Christian discourse distinguished two main groups of states of the soul: the negative emotions to avoid as sins such as passions, appetites, lusts, and desires; and the positive emotions to develop such as affections to pursue as virtues, among them love and compassion. Augustine's view on the passions "as modifications of a will that may be rightly or wrongly directed" remained a central part of the Catholic doctrine. It also became of major influence on Luther, a former Augustinian monk, and it was visible in Puritan texts "on the need for selfabasement and the constructive role of passions such as self-hatred and despair." Aquinas put "the passions in a familiar and orthodox world-view,"[40] followed Augustine in taking position against the Stoa's ideal of living a life without emotions, and distinguished between negative movements of the soul, among them appetites, lusts, desires and passions, and virtuous and Godly affections of love and compassion.[41] Earlier, Augustine argued that human beings needed feelings or emotions as "necessary to this life," because only "God, the angels and perfected humans" were not bothered by passions or emotions generally.[42] Against the Stoic intention of banning all passions from human life, Augustine did not want to "exclude passions and affections altogether," although he, for a proper affect, mostly used "affectus" instead of *passiones*.[43]

Augustine and Aquinas categorized so-called basic emotions such as anger, love, desire, hate, jealousy, hope, and fear and ordered them on a moral fundament. Augustine distinguished four main emotions, namely desire (cupiditas), fear (timor), joy (laetitia), and sorrow (tristitia), so-called *perturbationes animae* or perturbations of the soul, united by him "under the single principle of love (amor)."[44] As a typically scholastic theologian, Aquinas transformed the complex world of emotions in a logical structure of categories.[45] His eleven passions were distinguished between six concupiscible or lustful appetites, which moved people toward pleasant goods and away from nonarduous evils, namely *amor* (love), by far the most important, and *odium* (hatred), *desiderium* (desire) and *fuga* (aversion), *gaudium* (joy) and *tristitia* (sorrow), and five irascible ones, which moved people toward arduous goods and away from arduous evils, namely *spes* (hope), *desperation* (despair), *audacia* (courage), *timor* (fear), and *ira* (anger).[46] Apart from the distinction between concupiscible and irascible appetites, he also

distinguished between present-related (love, hatred, courage, anger, joy, sorrow) and future-related (desire, aversion, hope, despair, fear) passions. Four of them, joy, sorrow, hope, and fear, are principal passions or basic emotions. His theory, a "combination of joyful salvific optimism and post-lapsarian pessimism," offers "both occasions for joy, as well as pitfalls for sin."[47] Crucial for the taming of passions in response to daily life's temptations was not the classification but the direction of the will in relationship to the body.

The Will, the Body, and the Taming of the Passions

With passions being "naturally good" and "in themselves, morally neutral," not the distinction between good affections and bad passions, but the role of the will is decisive, so Aquinas.[48] In this he followed Augustine, who wrote in *City of God*: "Man's will, then, is all-important. If it is badly directed, the emotions (*motus*) will be perverse; if it is rightly directed, the emotions (*motus*) will be not merely blameless but even praiseworthy." He rhetorically asks: "what are desire and joy but the will in harmony with things we desire?" and "what are fear and sadness but the will in disagreement with things we abhor?"[49] This means that both involuntary passions and voluntary affections with a bad direction of the will would result into sinful affections, while a passion with a good direction, namely toward God instead of worldly objects, would become a virtuous instead of a sinful passion.[50] Augustine contrasts affections of the "citizens of the City of God and those of earth-bound citizens" and concludes that "every passion and every affection had two forms, an active and a passive," respectively acceptable and not acceptable. As a result, emotions such as "anger, love, desire, hate, jealousy, hope, and fear," now considered as basic emotions, could be appropriate or positive and inappropriate or negative depending on the direction of the will.[51] Aquinas agrees with this decisive role of the will with its two outcomes. When the corruptible body and the immortal soul in their joint movement are directed by a good will, passions "can orient our immortal souls closer to enjoyment of the God," but if not because of a deformed will, passions can "urge a movement ... to mindless pleasures of the flesh" and become sinful.[52]

This approach made the role of the body secondary. Augustine wrote in *City of God* that the flesh could be "disobedient, but only because of the corruption of the will." With this, he implicates that "the sinful soul ... made the flesh corruptible," and not the flesh the soul, and that as such flesh "is good."[53] Against the Manicheans who considered the flesh as evil he emphasized "the disordered soul" instead of the "corrupted flesh" as the root of evil passions such as jealousy, anger, envy and licentiousness," considered as "acts of the will."[54]

The regulation of the passions by pushing them in the right direction by the good will was a lifelong struggle as the preparation for a second life in the hereafter in an environment comparable with the Paradise before the Fall, that is, without any passions or affections. Augustine frequently wrote about "the soul journeying inwards and

upwards away from the works of the flesh and the earthly city towards the works of the spirit and the City of God," in particular in *Confessiones*.⁵⁵ After the Fall, man became "punished for Adam's original sin of pride" and the human lot came in "the state of sickness in which the rational mind was besieged by evil passions."⁵⁶ But there remained hope to find in man's rational soul "the *imago Dei*," referring to Augustine's Neoplatonic idea of duality between soul and body, later enforced by René Descartes.⁵⁷

In *De Libero Arbitrio Voluntatis* [The Free Choice of the Will], about a subject that many centuries later became a topic of a discussion between Erasmus and Luther, Augustine passionately wrote about the passions' power: "The cruel tyranny of evil desire holds sway, disrupting the entire soul and life of man by various and conflicting surges of passion (*libido*); here by fear, there by anxiety; here by anxiety, there by empty and spurious delights, here by torment over the loss of a loved object, there by a burning desire to acquire something not possessed."⁵⁸ Still, the "cruel tyranny" of the passions could be overcome, if tempered and tamed by the "reason and the will."⁵⁹ This taming was in particular necessary for the passions of lust and anger, respectively related to sex and to violence. In *City of God*, Augustine wrote about sex as his own demon: "lust is a usurper, defying the power of the will and playing the tyrant with man's sexual organs." Lust and anger were "defective parts of the soul," which needed rational control and should be "bridled and checked by the restraining force of wisdom." If bridled, lust could be used positively for "parental duty," that is, procreation.⁶⁰ It should never be used for enjoyment only, as was true for all "sensual created objects," including literature, drama, and music. Those objects should be enjoyed only when related "to the higher goal of the enjoyment of God," a view with major impact on the Protestant Reformation and the Roman Catholic sexual doctrine.⁶¹

Control was not only necessary for lust and anger, but also for sadness. Augustine considered his grief on his mother's death as a "theologically incorrect grief," and he blamed himself because he should be happy with his mother now in heaven: "I blamed myself for my tender feelings (*affectus*). I fought against the wave of sorrow and for a while it receded, but then it swept upon me again with full force. ... It was misery to feel myself so weak a victim of these human emotions, although we cannot escape them, since they are the natural lot of mankind, and so I had the added sorrow of being grieved by my own feelings, so that I was tormented by a twofold agony."⁶² Although blaming himself, he also knew that this human emotion could not be controlled by him as "the natural lot of mankind," result of the Fall.⁶³ Aquinas does not show a personal struggle with the passions. He basically agrees with Augustine and even seems to be stricter. While he states that "the root of all human goodness lies in the reason" and that passions if controlled and regulated could become "part of the virtuous life," as in the example of limiting sexual lust to marriage,⁶⁴ he emphasizes the risks of passions in subverting the reasons, for a "passion is a movement of the irrational soul, when we think of good and evil."⁶⁵

In different ways Augustine and Aquinas emphasized the control, taming and bridling of the passions, which are part of man's natural lot and symptoms of the fallen soul because

of Adam and Eve's original disobedience to God. Eventually, thanks to the rational will man can eventually become "a unified, ordered self, experiencing no passions but only the pure affections of love and joy" in another life.[66] Blaming yourself for sadness about your mother's death as Augustine did, seems for us to come from another planet, and the acceptance of sadness as belonging to man's emotional equipment, which was also part of the classic Christian discourse, is more understandable. The tension between daily life emotions and such emotional standards was usual for many people, also between parental sadness about the many children passing away prematurely and the joy about their eternal life in heaven. People were permeated by this discourse, not so much by reading the works of Augustine or Aquinas, which were reserved for the learned elite, but through popularized versions in text and image.

The Discourse Down to Earth: Visualized Lessons in Moral and Emotional Literacy

The above discussed texts about the discourse on the passions were not accessible for the majority of the people. Apart from a low literacy level most people would never read Augustine, Aquinas, or other theologians and philosophers.[67] The discourse had to go down to earth and explained to the people. To make the discourse understandable for the masses, it was translated through the easily understandable and at the same time frightening model of virtues and vices, with the message that coping with passions in daily life meant living according to the virtues while avoiding the vices. This moral framework of seven virtues and seven capital sins or vices appeared in numerous moral texts and was visualized in paintings, frescos, and drawings. It so continued to remain an essential part of Europe's collective emotional mentality until far in the nineteenth century.

A virtue is "an enduring quality of character or intellect, through which an individual is enabled to act in praiseworthy ways or to live a morally good life." While many virtues are distinguished, the basic ones are the cardinal and the theological virtues. The four cardinal virtues, *Justitia* (Justice), *Prudentia* (Prudence), *Temperantia* (Temperance), and *Fortitudo* (Fortitude) are well known through Aristotle's *Nicomachean Ethics*. They are called so because they play a pivotal role in a virtuous life and generate and support other virtues. Temperance supports the virtues of Abstinence, Chastity, Humility, and Sobriety, Prudence as practical wisdom makes possible what to do for "a virtuous life in a particular situation," Justice enables us to treat other human beings fairly, and Fortitude enables us to "pursue the good in the face of contrary fears."[68] Aquinas, paying tribute to Aristotle and Augustine, considered the cardinal virtues as "necessary to living a good life." He combined them with the three theological or Christian virtues, *Fides* (Faith), *Spes* (Hope), and *Caritas* (Charity or Love), inspired by St Paul, New Testament, 1 Corinthians 13. He incorporated them in his *Summa Theologiae* and this combination of virtues became "the basis for organizing the ideals and duties of the Christian Life" and remained the backbone of Christian moral thinking until the Second

Vatican Council (1962–5).[69] Other virtues, such as intellectual, moral, and heavenly virtues, can be considered as additions to this framework.[70]

In contrast with virtues that enable us to live a morally good life, capital sins deal with transgressions against God's law. Different from mortal sins, they are not so much "sins properly speaking" as "dispositions toward sinning." They were according to Aquinas the "fountainhead for other sins" such as mortal and venial sins. Starting with eight "malicious attitudes that engendered sin" from Eastern monasticism, the lists of vices or sins was transformed by Pope Gregory I the Great (c. 540–604) into a "theological moralizing filter through which good and evil might be evaluated."[71] Aquinas stated the list by merging Pride and Vainglory at seven capital sins: *Superbia* (Pride), *Ira* (Anger or Wrath), *Invidia* (Envy), *Avaritia* (Greed), *Desidia* (Sloth), *Gula* (Gluttony), and *Luxuria* (Lust). In 1215, during the Fourth Lateran Council, those capital sins "became a part of the ordinary experience of popular piety" by making them together with the Ten Commandments the instrument for the now obligatorily made annual confession of all mortal sins. So the learned theological discourse descended to ordinary daily religious life.[72]

When people expressed emotions and showed behavior according to the dispositions of the capital sins they could endanger societal cohesion, for the moral framework of virtues and vices determined the emotional standards of late medieval and early modern Europe. Because from 1215 the list of capital sins was used for the yearly confession, father confessors were instructed by confession manuals how to do their job, with *On the Art of Hearing Confessions* (c. 1400) by the theologian Jean Gerson (1363–1429) one of the most famous manuals. A skilled father confessor "should be familiar with all varieties of sin." In particular with carnal sins he should act as a trained Freudian psychiatrist *avant la lettre* in let speak them so concretely as possible, for "penitents were reluctant to reveal indecency without persuasion." Eventually, the confession could result into individual guilt. The struggle "against the decay of Christian virtues" was thus done "by effectively transferring responsibility for self-control onto the individual."[73] Apart from the impact of confession, the dissemination of this framework of virtues and vices got from the late fifteenth century an enormous boost with the invention of printing. Many religious texts now enabled ordinary people to contemplate and to interpret religious issues and to assess their individual behavior. The popularized framework also directed education into emotional literacy,[74] often in a combination of text and image as in emblem books about child-rearing, to be discussed in Chapter 4. From Erasmus to Luther and from Thomas More's (1478–1535) *Utopia* to Brant's *Narragonia*, moralists "admonished readers to control their emotions and behavior" by "recommending an emotional regime ruled by egalitarian love and self-control."[75]

Believers could also undergo the visual power of this framework of virtues and vices. The framework's visualization was part of a long tradition of church's belief in the power of images in communicating its religious message, the more when a great part of the believers was not yet literate.[76] This happened in churches in frescos and paintings and elsewhere in drawings and engravings. Those pictures brought the theological and

scholastic discourse, already part of the ordinary experience of popular piety, even nearer to the common people. Through appealing and didactic visualization people of all ages now immediately saw what to pursue, namely the virtues, and what to avoid, the capital sins. This encounter with the basics of the theological discourse was possible for the rich and the poor alike each time when they attended church. Inside the domestic it was also possible for who possessed drawings, engravings, paintings, and religious books, visible for family members and personal. During the Catholic or Contra Reformation, this visualization was continued and strengthened, while the Protestants preferred the power of textual dissemination.

This visualization started before the devastating Black Death in the 1340s in sacral and profane buildings and was revolutionized by Giotto di Bondone (1266/7–1337) with frescos in the Paduan Scrovegni or Arena Chapel (*c.* 1305). Fifteen years later, Ambrogio Lorenzetti (1290–1348), who like his brother Pietro (1280–1348) died of the bubonic plague, painted *The Allegory of Good and Bad Government* by applying the framework of vices and virtues on public government in the Sienese *Palazzo Pubblico* (*c.* 1320).[77] This iconographic attention for virtues and vices went together with the publication of literary masterpieces such as in Mediterranean Europe the *Divina Comedia* (1307–21) by Dante Alighieri (1265–1321) in which he described the terraces of the Purgatory according to the seven capital sins,[78] and in the north Geoffrey Chaucer (*c.* 1340–1400) with "The Parson's Tale," the last part of *Canterbury Tales* (1387–1400), a famous sermon on penitence with the confession going along pairs of capital sins to avoid and virtues to pursue.[79]

Giotto used the new fresco technique, with more plasticity than "fractured mosaic tiles" used for visualization of the sacral in the traditional Byzantine style, to paint "lifelike scenes directly onto wet plaster." He contrasted the two sidewalls of the Arena Chapel with the seven virtues and capital sins in "a novel intensity of feeling," with "the faces of the vices contorted in anger, shame, and fear … while the virtues sport cheerful, composed, and stalwart visages." He so educated the worshippers in "an emotional code" based on the patristic emotional theory,[80] so matching their acquired emotional literacy with the dominant emotional culture. In further intensifying his educational message Giotto confronted the people when leaving the chapel and looking up above the exit with the *Last Judgment*, evoking fear when confronted with the consequences of following the vices, namely sent to hell. The virtues and vices symbolized the "daily struggle for salvation" and "provided a basic register of emotional intelligence," necessary for living according to the emotional standards. Indeed, those frescos "equipped viewers with a pictorial index for the performance of their own emotions" with "behavioral stereotypes" that echoed the "Augustinian mind/body dualism of the *contemptus mundi*."[81]

The visualization of the scholarly discourse was also frequently expressed by moral personifications and allegories.[82] Personifications make visible abstract ideas including emotions by bodying them through human figures, mostly female because of the female concepts in Latin or Greek, like the cardinal virtue of *Prudence*, signifying wise conduct

and represented by a woman with a snake and a mirror.[83] The leading contemporary source for those personifications was Cesare Ripa's *Iconologia* (1593) (see Chapter 1). In allegories, stories with several personifications who play their role, for example, in the struggle between virtues and vices, symbols refer to an abstract concept, for example, a skull symbolizing *memento mori*, a dog emphasizing good education, or fruit symbolizing a fruitful marriage. There are also symbols as attributes belonging to specific persons, for example, the lion and Hieronymus.[84]

The sixteenth-century Southern Netherlandish artist Pieter Bruegel the Elder (c. 1525–1569), living in Antwerp during its Glory Years, made a series of drawings on virtues and vices for which his publisher Hieronymus Cock saw "favourite market conditions."[85] Bruegel was influenced by Giotto, Hieronymus Bosch, and by late fifteenth-century northern France illuminated books of hours. His drawings of the seven capital sins (1556–60), the seven virtues (1559–60), and *The Last Judgement* (1558) are an adaptation of earlier example. They symbolize the making up of the moral account of the earthly life by weighting the balance between virtues and vices, both clarified by the use of personifications. The drawings, made available for a larger public through engravings by Philips Galle for the virtues and by Pieter van der Heyden for the capital sins, show a dynamic narrative structure with the allegory representing the story and a female figure in the center personifying the specific vice or virtue. The personifications of the capital sins participate in the narrative while those of the virtues are more staged and detached from the narrative in the tradition of the rhetorician's play. To avoid any ambiguity about the meaning of the drawings, Bruegel added clarifying captions in Latin, for the capital sins supplemented with a translation in vernacular Middle Dutch. He used extra attributes for each personification to strengthen the dynamics of the story.[86]

In Bruegel's visualization of the four cardinal virtues *Prudence*, with the caption "If you wish to be prudent, think always of the future and keep everything in the forefront of your mind," shows people who are diligently engaged in daily activities such as doing the laundry and lugging things around, with also one youngster participating. *Justice*, with the caption "The aim of the law is either to correct him who is punished, or to improve the others by this example, or to provide that the population live more securely by removing wrongdoers," reads as a "pictorial encyclopaedia of late medieval practices of torture and punishment." It communicates the terrifying message of the consequences of misbehavior. *Temperance*, with the caption "We must look to it that, in the devotion to sensual pleasures, we do not become wasteful and excessive, but also that we do not, because of miserly greed, live in filth and ignorance," is about *Bildung*. People are teaching and learning the seven liberal arts, and children join the adults in making music and in diligently learning grammar (Figure 3).[87] *Fortitude*, with the caption "To conquer one's impulses, to restrain anger and the other vices and emotions [in Latin: affectus, JD], this is the true fortitude," points to the victory of the virtues over the capital sins, which are referred to through seven attributes in the form of "seven slain animals."[88]

The theological virtue *Faith*, with the caption "Above all we must preserve faith, particularly in respect to religion, for God comes before all and is mightier than

VIDENDVM, VT NEC VOLVPTATI DEDITI PRODIGI ET LVXVRIOSI
APPAREAMVS, NEC AVARA TENACITATI SORDIDI AVT OBCVRI EXISTAMVS

FIGURE 3 Philips Galle after Pieter Bruegel the Elder, *Temperance* (*Temperantia*) (1560), engraving, 225 × 294 mm (Vienna: Albertina, inv.no. DG 1955/115). Credit: Sepia Times / Contributor (Universal Images Group Editorial).

man," shows a newborn during its baptism. *Hope*, with the caption "Very pleasant is the conviction of hope and most necessary for life, amid many and almost unbearable hardships," refers to children through the pregnancy of the praying woman. In *Charity*, the most important theological virtue, Bruegel depicts by following a long tradition a woman with two or three small children as attributes. But he makes the two small hungry children part of a broader narrative that is based on the seven acts of mercy and accompanied by the caption "Expect that happens to others to happen to you; you will then and not until then be aroused to offer help only if you make your own the feelings of the man who appeals for help in the midst of adversity."[89] Together, those drawings on the virtues show the route to a morally good life with two cardinal virtues, *Justice* and *Fortitude*, referring to capital sins.

Bruegel's visualization of the capital sins, with no children in the pictures, was done in a Hieronymus Bosch-like style of densely populated scenes with monsters and demons. *Pride*, with the Middle Dutch caption "Pride is hated by God above all / at the same time God is despised by Pride" (there is no Latin caption), in fact a combination of pride and vainglory, is accompanied by the peacock and placed in a scene of vainglorious adult people. *Anger* (or Wrath), with the Latin caption "Anger makes the face swell up, and the veins brow black with blood," followed by the Middle

Dutch caption "Anger makes the mouth swell, and embitters the mood. It disturbs the spirit, and blackens the blood," is a perfect description of the emotion's bodily expression and shows explicitly what anger does with other human beings in causing fear, anxiety, panic, and even dread. The woman personifying *Envy* eats her own heart while accompanied by a turkey. The drawing has the Latin caption "Envy is a horrifying monster, and a most severe plague," and this is followed by the Middle Dutch text "Envy is an eternal death and a terrible plague / a beast which devours itself with false troubles." *Greed* is personified by a young woman who counts coins and is accompanied by a toad while other people, some barely or not clothed, are seeking coins too in a scene with human beings, animals, and monsters. The Latin caption "Does the greedy miser ever have fear or shame," followed by the Middle Dutch text "Scraping greed does not see honour, courtesy, shame nor divine admonition," confirms the drawing's message. *Sloth* offers a Hieronymus Bosch-like scene of resting and sleeping adult people with *Sloth*'s female personification exhausted lying on a donkey as the representation of slowness. This capital sin is explained in the Latin caption "Sluggishness breaks strength, long idleness nerves," and the Middle Dutch "Sloth makes powerless and dries out the nerves until man is good for nothing." The woman who personifies *Gluttony* drinks beyond measure while sitting on a pig, a "symbol for uncontrolled scoffing." In the picture gluttony is shown by people, part of them naked, who lost their ratio and are crossing many behavioral borders including sexual ones. The accompanying texts, "Drunkenness and gluttony are to be shunned" (Latin) and "Shun drunkenness and gluttonous eating, for excess makes man forget God and himself" (Middle Dutch), are warnings. They anticipate the most dangerous passion according to Augustine, *Lust*. This capital sin is personified in a naked woman, accompanied by a cock and seduced by a male monster in the most Bosch-like scene of all fourteen personifications, with sexual acts happening everywhere by animals and human beings. The picture was inspired by Bosch's *The Garden of Earthly Delights*.[90]

This visualization of virtues and capital sins remembered people to the moral and emotional standards to follow and to the horrible effects when instead following the capital sins. The drawings are explicit and frightening, even for viewers today. They show what could happen when people were not morally and emotionally literate. This educational turn by translating the theological discourse for a broad public developed into a mission for emotional literacy by humanists and reformers alike. Before addressing that educational turn, we will look at the adaptation of the classic Christian discourse on emotions.

Adaptation of the Christian Discourse about the Emotions

Strong Emotions and New Medical Insights

While in the Renaissance no new and strong emotions were developed,[91] "significant transformations in ideas about emotion" took place against the background of

Augustine and Aquinas, through a revision of Platonism and ideas of the Stoa, and by new medical insights. The discussion about topics like the nature, mapping, number, and the identification of basic emotions, the body-soul issue and the bodily expression of emotions, and the balance between expression and control took place in a context of more attention for strong emotions in text and image, and it was fueled by new medical insights. Strong emotions, eloquently put forward by Huizinga in *The Autumn of the Middle Ages*, got more attention in a period with exceptional economic, demographic, social and cultural transformations. Those included the *Little Ice Age* from about 1250, the *Great Famine* and *Great Bovine Pestilence* in 1316–17 resulting into food shortage and a poorly fed population, extra vulnerable for the following *Black Death*, which reduced the European population with at least one third, and the *Hundred Years War* between France and England. In particular the *Black Death*, a disaster in every way, was interpreted by the people as a punishment from God for their behavior and a token to change this behavior.[92] Although the impact of the recent Covid-19 pandemic on mortality was not comparable with the devastating result of the *Black Death*, this recent experience with a pandemic could make us better understand the emotional effects of a pandemic also in the past with, for example, authorities forbidding people to be with a dying loved one or to attend the funeral because of the risk of contamination. The physician Gui de Chauliac (*c.* 1298–*c.* 1368) wrote that during The Plague "people died without servants and were buried without priests. Father would not visit son, nor son, father; charity was dead, and hope prostrate."[93] Such disasters led to individual and collective fear and, when searching after a scapegoat, also to pogroms against Jews. The succeeding catastrophes were "widely understood as supernatural in origin, that is, as divine emotions exhibited through the natural world." Therefore, the solution should be spiritual, "including processions, flagellation, and prayer," in short, more need for faith.[94] Fear of God's judgement was an Augustinian concept and part of his theory of "contempt for the physical world (contemptus mundi) with longing for a metaphysical utopia (Civitas Dei)," by Delumeau summarized as fear and guilt.[95] Anger was both a human passion, to be controlled as vice or capital sin and visualized in frescos and drawings, and, so Augustine, a divine anger to be afraid of.[96] Francesco Petrarch (1304–1374) when reaching the summit of the Mount Ventoux on April 26, 1336, wrote in his letter *Ascent of Mount Ventoux* that he "opened his copy of St. Augustine's *Confessions* to a passage berating the pursuit of earthly pleasures in favor of the inner search for human virtue." Referring to the fall of Pope Boniface VIII (1230–1303), he "recalled how even pagan authors overcame emotional adversity by looking within and learned not to fear any cross or prison or sting of fortune."[97]

This longing for virtue through inner search resulted into religious movements directed on the interior self as with the *Devotio Moderna* in the fifteenth century and with the Reformation in the sixteenth, itself a highly emotional edge-to-edge fierce battle over the truth of faith with the excluding of all false believers. Not only fear and sadness dominated emotional early modern Europe: with great resilience the society after the *Black Death* surprisingly fast recovered with historically unprecedented economic

growth and modernization, and also "community confidence, hope, and optimism, especially in medical knowledge, increased as mortality decreased during subsequent plague events."[98]

The representation of those emotions changed during the medieval Renaissance in texts like the Arthurian romances of Chrétien de Troyes (c. 1135/40–1190) and paintings like those of Giotto (1270–1337). They brought people in contact with new models "for intimate loving relationships between people, or between God and the soul," and they increased a "praise of passion" or "deep feeling" among people as with the love between mother and child, visible in new and humanizing representations of the Madonna.[99] The existing tradition of religious and secular texts from before 1300 stimulated "the cultivation of an intense interior self." This development continued in devotional texts like fifteenth-century books of hours, got a boost through the printing press,[100] and was continued in the Reformation with people like Elizabeth Cary who read "Calvinist theology in bed at night even though her mother had forbidden it."[101] People trained their feelings and emotions through devotional texts and images by the power of word and image.[102]

In medical literature it was uncontested that emotions were experienced in the bodies. While theologians approached emotions morally, medical scholars discussed emotions "for their impact on health and disease."[103] This did not prevent them from also joining theological discussion like those on passions' categorization, as with the Dutch professor of practical medicine Franciscus Sylvius (1614–1672) who distinguished seven groups of passions in an Aquinas-like system of opposites.[104] Practicing science was generally done until far in the eighteenth century within a religious discourse. Science, as in the strongly Calvinist-impregnated seventeenth-century Dutch Republic, was a way to God and to insight in God's creation.[105] The physician's balance act was performed within the contemporary religious codes with emphasis on the role of the soul on the emotions. At the same time "the impact of dissection and the art of anatomy saw emotions also located within specific organs of the body, most commonly the brain or heart." Contemporaries such as the Spanish anatomist Andrés Laguna de Segovia (1499–1559) in *Anatomica methodus* (1535) or the French Nicolas Coëffetau (1574–1623) in *Tableau des passions humaines, de leur causes et de leurs effets* (1620) believed "that the beat of the heart affected emotional disposition."[106]

The visibility of emotions was mainly to be found in the face and the eyes, a view shared by all participants in the discussion, from theologians to medical doctors, and from philosophers to artists. The surgeon Gaspare Tagloacozzi (1545–1599) in *De Curtorum Chirurgia per insitionem* (1597), a text on facial surgery, considered the face "an indicator of character" and a "true image of our souls" that "exposes most fully our hidden emotions." According to him in no part of the body "has Nature supplied greater signs of the state of mind, that is, of temperance, mercy, pity, anger, love, sadness, and happiness, than in the eyes themselves."[107] Reading man's eyes was thus reading man's emotions. Control of them would be healing spiritually and physically, in particular in times of epidemic. Such effects were reported in tractates of medical doctors such as

Regiment de preservacio de pestilència [Regimen for Protection against Epidemics] (1348) by the Catalan medical doctor Jacme d'Agramont (...–1350), who argued that in particular fear and imagination should be avoided, for "from imagination alone, can come any malady," and you should, therefore, never "give up hope or despair, because such fear only does great damage and no good whatsoever."[108]

Descartes and the Rethinking of the Passions

The reputation of René Descartes (1596–1650) is built on his statement *Je pense donc je suis* in *Discours de la méthode* (1637).[109] But with his last work, *Les passions de l'âme* (1649), he put a step toward a new way of thinking about the passions. In the book's first article, he wrote that because "the defectiveness of the sciences we inherit from the ancients is nowhere more apparent than in what they wrote about the Passions," I "shall be obliged to write here as though I were treating a topic which no one before me had ever described."[110] The text was dedicated to Princess Elisabeth of Bohemia (1619–1680) as he did before with *Principia Philosophiae* (1644), and it was the result of a frequent correspondence on moral and emotional issues with Elisabeth, who lived in exile in the Dutch Republic just as Descartes.[111] He was aware of a potentially larger audience for this text than his philosophical treatises and wrote in the introduction that just the title "may perhaps invite more people to read it."[112] In *Les passions de l'âme*, Descartes deals in Part 1 with the passions in general and its embedding in the relationship between mind and body. In Part 2 he develops a taxonomy of six so-called primitive passions, and in part III he analyses physiologically each of the forty-one particular passions that are "composed of some of those six or are species of them."[113]

After defining passions by referring to the classic philosophers, according to whom "whatever is done or happens afresh is generally called by the Philosophers a Passion with respect to the subject it happens to," he points to the first meaning of the Latin *passio*, namely suffering. Then he turns to its relationship with body and soul. Passions can be caused by the body or by the soul with the body or the physical *res extensa* belonging to the extended world, obeying the laws that govern all physical things, while the incorporeal soul, the *res cogitans*, has neither extension nor spatial properties. Both *res* exist in perfect harmony to constitute the human being.[114]

The resulting dichotomy of mind and body, a basic issue for Descartes, was solved by joining the nonphysical soul to the body. Although "the soul is joined to the whole body, there is nevertheless one part in [the body] in which [the soul] exercises its functions in a more particular way than in all the others." This part is not situated in the heart as commonly thought "because the passions are felt as if therein," but in "a certain extremely small gland" of the brain, the pineal gland, the seat of the soul that itself is noncorporeal but still placed in the body.[115] This escape from the body–mind dichotomy is sometimes considered as innovative[116] but mostly as unscientific. Gary Hatfield, however, warned that "an overemphasis on his dualism would be misleading," in particular when suggesting a Cartesian disdain for the body as in

Damasio's *Descartes' Error*.[117] Indeed, explaining the passions by the body's role was done by "both Descartes and William James."[118] In considering the passions as natural instead of moral and approaching them almost "as a physicist,"[119] Descartes even prepared the way for Jamesian psychology and American behaviorism.[120] Descartes's body–mind dichotomy is founded on his *je pense donc je suis*: "because we do not conceive the body to think in any way, we do right to believe that every kind of thought within us belongs to the soul."[121] The passions of the soul are defined as "perceptions or sensations or excitations of the soul which are referred to it in particular and which are caused, maintained, and strengthened by some movements of the spirits." Those spirits "are nothing but bodies; their only property is that they are bodies which are very small and which move very rapidly ... [they can] move the body in all the different ways in which it can be moved." In other words, the body acts on the mind and so causes passions.[122]

Descartes followed and adapted the classic Christian discourse in several ways. He considered passions as "basically good" if regulated by training and moved to virtues, and he even advised that "the exercise of virtue is a supreme remedy for the passions," so following Aquinas and differing from the Stoa.[123] In summarizing the effect of the passions at the end of his book Descartes tried to comfort people among them Princess Elisabeth and his friend Constantijn Huygens whose wife had died in 1637. Article 211, "A general remedy for the Passions," has that tone of comfort: "And now that we understand them all, we have much less reason to fear them than we had before. For we see that they are in their nature good, and that we have nothing to avoid but misuses or excesses of them, for which the remedies I have explained could suffice if everyone had enough interest in putting them into practice."[124] The philosopher of *Discours de la méthode* emerged in his last book as a helpbook author who advises us to "make use of experience and reason to distinguish the good from the evil."[125]

Descartes also followed Augustine and Aquinas in distinguishing basic passions. He defined six primitive or basic ones, "Wonder, Love, Hatred, Desire, Joy, and Sadness," with forty-one passions being "composed of some of those six or are species of them."[126] He analyzed those in detail as with sadness, defined as "an unpleasant languor, wherein consists the distress which the soul receives from the evil or defect which the impressions of the brain represent to it as belonging to it."[127] He deviated, however, from the tradition with the addition of Wonder. He built the other five passions on wonder in a seemingly comparable way as Aquinas when relating concupiscible and irascible passions.[128] Wonder is the necessary condition for the other basic passions, for "it seems to me that Wonder is the first of all the passions ... [for] if the object presented has nothing in it that surprises us, we are not in the least moved by it and regard it without passion."[129] While in Aquinas's discourse the passions are directed to either good or evil, Descartes adds with wonder not only an extra basic passion, but also a third direction of a passion, next to good and evil, namely to what could be important. He so weakened the passions' moral dimension[130] and seems to take a first step in a more secularized approach of the emotions.

Descartes's most important adaptation is his physiological approach. He even wrote that his book "will reveal that my purpose has not been to explain the Passions as an Orator, or even as a moral Philosopher, but only as a Physicist."[131] Although so trying to hide his role as moral philosopher, the emphasis on physiology is incontestable. Descartes argues that all mental conflicts occur on the same level in the relationship between soul and body while "the body's physiology causes our initial behavioral response, as well as causing the passion [in the soul, JD] that affects the will."[132] Caused by the body they are labeled as passions of the soul and distinguished into three types: sense perceptions referring to external bodies that cause passions, for example, when encountering a bear;[133] internal sensations referring to our own bodies, for example, hunger or bodily warmth; finally "passions proper" referring to our mind or soul, for example, love, sadness, desire, and fear. When using the example of the bear, he argues that although "the will cannot simply banish the fear, it can override the bodily action of running."[134] For the rest, a natural philosophical approach was not unusual in early modern Europe with authors such as Francis Bacon (1561–1626), Thomas Wright (c. 1561–1623), Herman Boerhave (1668–1738),[135] and Edward Reynolds (1599–1676). But Descartes was original in making natural philosophy corpuscular and mechanistic and in explaining the cause of the passions by considering the body a "purely mechanical organism" that worked like a "clockwork."[136]

Descartes, the philosopher of rationalism, was aware of the exceptional power of the passions that even could disturb the rational self. That's why passions must be trained and controlled and, therefore, the Cartesian body and soul seem to play a complex balance act. While "there is no soul so weak that it cannot, when well guided, acquire an absolute power of its passions,"[137] there is also "no subject that acts more immediately upon our soul than the body it is joined to."[138] With the body performing "the inner state" and producing "intimate and consumable knowledge of the individual person,"[139] passions that belong to the extended world could be "exceptionally powerful and unsettling."[140] This in particular regards bodily emotions caused by the body itself or by external things that give rise to joy, anger, love, sadness, desire, and wonder. In almost Augustinian terms he speaks of controlling the passions by the will and of the struggle within the soul with daily life examples as the struggle between fear for death and infamy of fleeing from the enemy. Therefore, people "in whom the will can naturally conquer the passions most easily and stop the accompanying movements of the body have the strongest souls."[141] If trained well by habituation, the soul would dominate and during this process bodily sources of passion should not be suppressed but shifted into morally sanctioned paths, so that "even those who have the weakest souls could acquire a quite absolute dominion over all their passions if one employed enough skill in training and guiding them."[142]

This makes education in emotional literacy so important. Although Descartes only very occasionally speaks about children,[143] he gives throughout his text practical advice on how to train the control of specific passions, for example, in Article 211: "The most general remedy for all the excesses of the Passions and the easiest to put into practice,

is this: when one feels the blood stirred up like that, one should take warning, and recall that everything presented to the imagination rends to deceive the soul, and to make the reasons for favoring the object of its Passion appear to it much stronger than they are, and those for opposing it much weaker."[144] This advice in a philosophical text that is also a psychological helpbook could be applied to the emotion education of children too, for he "included learning, memory, and adaptive behavior within his machine psychology."[145] If a child by training would acquire emotional literacy, the passions would be governed by the soul. That would be crucial, for Descartes like Aquinas "fears uncontrolled emotions" as "untamed emotions"[146] that could threaten the rational human subject. Both philosophers understood that mapping of passions "cannot elide the reality that emotions erupt, and seem to have their own volition." While insisting on emotional self-control both philosophers understood that all categorization and rationalization could not prevent the passions from destabilizing the self, be it the Aquinas Christian or the Cartesian rational one.[147] Eventually, Descartes remains optimistic in "overthrowing the tyranny of the emotions and deriving value from each of them,"[148] for you should be aware that "all the good and evil of this life depend on them [passions, JD] alone." This means "that the men they can move the most are capable of tasting the most sweetness in this life," and that wisdom "teaches us to render ourselves such masters of them, and to manage them with such ingenuity, that the evils they cause can be easily borne, and we even derive Joy from them all."[149]

With Descartes we are entering a new world in which the soul "speaks to the world through the body," in contrast with Aquinas's world with the soul "aimed to incline itself towards God." But just like Aquinas also Descartes tried to "turn feelings into an ordered system that can be related to something outside of themselves, God for Aquinas and the reasoned mind for Descartes."[150]

Descartes was the most important author on the passions at his time, but not the only one who was passionate with the passions.[151] In this Big Talk on emotions most authors followed Descartes (and Aquinas) in considering passions as "not intrinsically harmful" if they could be controlled. Francis Bacon (1561–1626) warned for the power of passions and recommended support to control them "if one is not a moderate, prudent sage, and thus exempt from 'outrageous passions.'"[152] The English Jesuit Thomas Wright (c. 1561–1624) stated in *The passions of the minde in generall* (1601/4) that "God and Nature gave men and beasts these natural instincts or inclinations, to provide for themselves all those things that are profitable, and to avoid all those things which are damnifiable."[153] Wright's classification of eleven basic passions basically followed Aquinas's categorization with the opposite pairs of love and hate, desire and abomination, delight and sadness, hope and despair, fear and audacity, and ire, illustrated by referring "to the behaviour of the sheep and the wolf."[154] Also the English Protestant physician Walter Charleton (1619–1707) in *Natural History of the Passions* (1674) was positive about passions. They could made people "not therefore *less perfect* [original italics], but rather *the more capable of pleasure* from the right use of the good things of this life," if the passions would be trained to use them as best as possible.[155] Jean-Pierre Camus

(1584–1652) in *Traité des passions de l'âme* wrote that "the passions are necessary and inseparable from our soul, and even good and useful if they are trained well." Marin Cureau de la Chambre (1594–1669) in the five volumes numbering *Les caractères des passions* (1658–62) argued that if the passions "are well regulated, they form the virtues & preserve health," but if not "these are the sources from which the disorders of the soul and the body originate." The Cartesian philosopher Nicolas Malebranche (1638–1715) stated in *Search after Truth* (1674–5) that the "*passions* of the soul are impressions from the Author of nature that incline us toward loving our body and all that might be of use in its preservation."[156] Also according to the priest Jean-François Senault (1599–1672) in *De l'usage des passions* (1641) passions could still potentially contribute to a moral life "if we learn to control and properly direct" them.[157] In short, those authors considered passions positively on the condition that we would learn to control and channel them.

Others were more skeptical about this control of the passions. Among them was Thomas Hobbes (1588–1679). His pessimism about human nature was summarized as "homo homini lupus est" in *De Cive* (1642) in its natural state and described as presocial in *Leviathan* (1651).[158] Only strong central authority on the basis of a social contract[159] between the people could take man away from this natural state and avoid a "bellum omnium contra omnes" (*De Cive*, 1642), a "war of everyone against every one" (*Leviathan*, 1651). He explained the passions as motions within the body in a naturalistic, mechanistic and materialist way and listed them as usual in six simple passions, of which more than thirty could be composed. Not passions as such were the problem in the state of nature, but the lack of an internal guide "that will provide an appropriate common measure in the absence of a sovereign authority (Leviathan 46:32)." For the rest, "desires and other passions of man are in themselves no sin" (Leviathan 13:10) and they "can only be bridled by other passions—particularly, the passion of fear."[160] Hobbes was not so much interested in education and training of the emotions as in its submission by a sovereign authority. But like Descartes and most other theorists in his time he "recognized that the passions were important for individual and corporate wellbeing."[161] Also Baruch de Spinoza (1632–1677) made in his *Ethica* no educational turn with his mathematical theory of emotions instead of Descartes's physiological approach. This monist with one divine substance instead of Cartesian mind–body dualism distinguished three basic passions, namely desire, joy, and sadness, with other emotions, together forty-eight, following out of these three.[162] Only by liberating ourselves from emotions, thus following the Stoa, we could find true freedom and happiness and would no longer be "dominated by the passions." Training the emotions, therefore, means accepting the world as it is, for trying to control our passions would make us more subject to them.[163] Spinoza's monism made him a forerunner in trying to solve Augustine's problem of man on earth being dominated by the passions by accepting instead of controlling them.[164]

Notwithstanding the many different ideas about emotions that "fractured" early modern Europe, "they also united it."[165] There were three remarkable agreements over time. First, most authors distinguished roughly the same basic emotions as Augustine

and Aquinas already did.[166] Secondly, as a consequence of the Fall passions had to be brought under control of the reason and trained to direct them to the virtues instead of the vices.[167] Finally, most theologians and philosophers considered passions as positive if controlled and restrained. The exception formed the physicians. Following Hippocrates, physicians—until the nineteenth century reputed not so much for their medical knowledge as for their moral position—warned for the potentially negative impact of the passions on the body. According to Hippocrates (*c.* 400–*c.* 377 BC), passions "create 'disorders in the blood,' so subduing the passions with reason 'is the first and principal rule in which mankind ought to be trained up, to secure a good state of health in all the periods of life.'"[168] In that respect the (medical) discourse did not really change in this period.

The Educational Turn

Ideas behind the educational turn came from two spiritual movements, Christian humanism and the Reformation. Augustine's approach of the passions became "the patristic foundation" of ideas of Reformer Luther, "an Augustinian monk," and of the humanist and "Augustinian canon" Erasmus, and this approach "proffered Christians an emotional anchor in righteous fear of God's judgment."[169] The two movements shared this theological foundation and belief in the necessity of educating emotional literacy.

Erasmus and Other Christian Humanists on Emotional Literacy

Children occurred more frequently in late medieval medical and philosophical texts with a "preoccupation, even an obsession, with early life stages."[170] Authors translated the Christian discourse in texts and manuals on education in emotional literacy with practical advice on parental styles and on children's behavior and emotion regulation.[171] Among them were Jean Gerson (1393–1429) with *Traktatus de parvulis trahendis ad Christum* (1410), Baldassare Castiglione (1478–1529) with *Il Libro del Cortegiano* (1528) for the elite, Juan Luis Vives (1493–1540) with *De institutione feminae christianae* (1523) on education of girls,[172] Pier Paolo Vergerio (1370–1444) with *Ad Ubertinum de Carraria de Ingenuis Moribus et Liberalibus Adulescentiae Studiis Liber* (1472), Leon Battista Alberti (1404–1472), well known through his *Della Pittura* (1435)[173] but also the author of *I Libri della famiglia* (1433–40), Vittorino da Feltre (1378–1446), considered the greatest humanist schoolmaster of the Renaissance but did not leave texts,[174] and Michel de Montaigne (1533–1592) about fatherhood and boy's education in *Essais*. They all considered the child as *animal educandum* with a *tabula rasa*, and both heterodox and orthodox authors were indebted to Erasmus of Rotterdam, probably the most influential author on emotional literacy for children in early modern Europe.[175]

Desiderius Erasmus of Rotterdam (1466–1536) is generally considered as the most important Northern European Humanist, a star among scholars as Michelangelo (1475–1564) among artists, and portrayed by famous painters such as Albrecht Dürer

(1471–1528), Hans Holbein the Younger (1497/8–1543), and Quentin Massys (1466–1530).[176] He was educated at the Deventer Latin School, earlier attended by Thomas à Kempis (1380–1471) and inspired by the *Devotio Moderna*, the movement of the *Fratres Vitae Communis* or Brethren of the Common Life of Geert Groote (1340–1384) who recommended to live piously and follow the Christian virtues as an individual responsibility.[177] Erasmus studied extensively daily life emotions and described in his ironically in Dutch written parody *Praise of Folly* (1509), published in Latin as *Stultitiae laus* (1511), how people believed to be ruled by reason but were often driven by trivial and foolish emotions. He so showed that the Augustinian ideal of the rational will ruling the emotions was often not feasible.[178]

The realist of *Praise of Folly* emerged as an idealist in his belief in the power of education in learning to let the rational will rule the emotions and people live according to the virtues.[179] Among his texts on education and the family are *Concio de puerio Jesu* (1510), *Institutio Christiani Matrimonii* (1526), *De pueris statim ac liberaliter instituendis declamatio* [A Declamation] (1529), and *De civilitate morum puerilium* [On Good Manners] (1530).[180] Assuming that only the cooperation between intellect and emotion could result into an integrated personality, he recommended teaching children in emotional literacy according to the current emotional standards that could differ according to nation, region, time, and social group. Erasmus's texts explore issues such as why education is a parental duty, how to fulfill this duty rightly, and why education is decisive for child's future. His educational texts were focused on daily life and combined philosophical-theological reflections with precise and practical advice.

His most influential educational texts are *A Declamation* [*De pueris*], one big plea for the teaching of control of the passions by the ratio, and *On Good Manners* [*De civilitate*], a detailed manual on good manners. *A Declamation*, with a first draft from 1509, was dedicated to the thirteen years old son of the Duke of Cleves, to his father, and to the count of La Marck and Ravensburg. In its introduction Erasmus writes that the "method of education it describes is especially appropriate for children of rulers."[181] *On Good Manners* was dedicated to the eleven years old son of another noble man, Henry of Burgundy, a "youth of outstanding promise," and the son of Adolf, Prince of Veere. Those dedications could suggest that Erasmus intended to write for a very small public only. He however had a much greater public in mind and hoped that, while Henry as son of a Prince is "not in any great need of these rules" because of his outstanding education, the dedication of his rules "to a boy of such momentous destiny and of such outstanding promise" will "encourage all boys to learn these rules more willingly."[182] To this he adds at the text's end: "my dearest Henry, I wish to be imparted through you to the entire fellowship of boys, so that by this donation you may win the hearts of your fellow troops and commend to them the pursuit of good letters and morals."[183] Anticipating such broad and young readership he wrote *On Good Manners* in an easy style, "adapted to the youthful reader," with less reference to philosophers and less difficult words than in *A Declamation*, and his recommendations were detailed and easily understandable.[184] Moreover, with his own modest origins in mind he proposed

that "the rich ought to be generous and come to the aid of gifted children who, because of their family's poverty, are unable to develop their natural talents." He added that they are "not a few in number, who are called from a humble state to a high office, indeed sometimes to the supreme dignity of the papacy," no doubt referring to Pope Adrian VI (1459–1523). While admitting that "not all men rise to such distinction," he made a remarkable appeal for social rise, for "all should be educated towards that end."[185]

On Good Manners resembles the medieval manuals on courtesy such as *Boke of Nurture* (*c.* 1450) by John Russell and the romance *Jehan et Blonde*,[186] with *Il libro del Cortegiano* (1526) by Erasmus's contemporary Baldassare Castiglione being a late example of this tradition. Castiglione's popular text provided a guideline of the medieval ideal of courtesy and looked back. Humanists such as Erasmus and Melanchthon, the Protestant educational reformer about whom more below, looked forward with new ideas that would dominate schooling and education "for over two centuries." They shifted "away from the social aspects of the medieval doctrine of courtesy ... towards literary and scholarly pursuits" within the "restitution of Christian piety in practical life." This inner piety, familiar to Erasmus since his stay at the Deventer Latin School, embedded learning good manners within "the sanctity of Christ's presence: *illic adesse Christum*."[187] This shifted the focus from the external side of good manners to practicing them within Christian inner piety,[188] and this approach inspired many child-rearing and advice manuals.

Erasmus used three main sources for his ideas on liberal—*liberaliter*—education. Not surprising for a famous philologist, his first source consisted of classic Greek and Latin philosophical and literary texts, among them texts by Quintilianus (*c.* 34–*c.* 100), Plutarchus (46–120) with *De liberis educandis* and the other usual suspects quoted by almost all Renaissance authors on education, but also passages on education by, among others, Plato (*c.* 427–347 BC), Aristotle (384–322 BC), Hesiodes (*c.* 750–650 BC), Homer (born eighth century BC), the popular Ovidius (43 BC–17 AD), Galenus (129–216), Plinius (61–100), Seneca (*c.* 4 BC–65 AD), Cicero (106–43 BC), and Cato the Elder (234–149 BC). Secondly, the theologian Erasmus, also author of the Greek edition of the New Testament and of editions of the work of Hieronymus and other church fathers,[189] referred frequently to fundamental Christian texts on the necessity of controlling the emotions, among them St Paul's epistles, and texts by Augustine. Any reference to Aquinas was missing, not because of lack of knowledge but of his sharp criticism of scholastic theology and of Aquinas in particular. A third source formed his personal experience as a child together with later by him observed examples of bad education. With those very diverse sources he wrote about the potential of education in making the ratio rule the passions. His texts were reprinted in the original and translated in many languages, among them *A Declamation* in French (1537), Italian (1545), Dutch (1546) and English (1551), and *On Good Mannerse* in English (1532), German (1536), French and Czech (1537), Dutch (1559), Swedish (1620), and Finnish (1670).[190] His liberal educational theory, embedded in a Christian frame of emotion regulation, influenced the discourse on education in the family and at school during several centuries.[191] We now

turn to the fundament of Erasmus's view on education and the passions: the relationship between nature and nurture, and the struggle between passions and ratio. His precise recommendations built on this fundament will be discussed in Chapter 4.

According to Erasmus "human happiness depends on three prerequisites: nature, method and practice." Nature means "man's innate capacity and inclination for the good;" method means "learning, which consists of advice and instruction;" and practice is "the exercise of a disposition." The transformation of a not yet molded creature into a man—"man certainly is not born, but made man"—goes together with "numerous errors and pitfalls." Only education, that is, nurture, could develop the qualities and talents given by nature, for "a man without education has no humanity at all."[192] Nature should be supported already before education could start. A father-to-be should, therefore, "choose as his wife a woman who comes from a good family, who is well educated and in good health."[193] Moreover, intercourse should be avoided when the man "is inebriated or in a state of emotional upheaval," because "any such disturbance will be passed on by a mysterious kind of contagion to the embryo." Finally, the child should be nursed by the mother or by a healthy wet nurse "of good morals, not given to quarrelling, drinking, or indecent behaviour." For "any physical or mental harm that is inflicted on a child during the earliest stages of his life will continue to affect him well into his adult years," and it "makes a difference with whom a child shares the breast or with whom he plays."[194] Nurture thus can be decisive and it is neither true "to think that the character we are born with is all-determining," nor "to believe that we can become wise through practical experience, without the benefit of education."[195] Man's real nature is "to live according to reason," which "sets him apart from the animals."[196] By giving "to man alone ... the faculty of reason, ... [nature] has thrown the burden of human growth upon education." For "the total sum of man's happiness ... [is] founded upon a good upbringing and education." Erasmus demonstrates this with the well-known story of Lycurgus, King of Sparta about two dogs, one bad educated and the other well educated, to show that "while nature is strong, education is more powerful still."[197] Bad education is dangerous, for while "nature has given small children as a special gift the ability to imitate ... the urge to imitate evil is considerably stronger than the urge to imitate good."[198] Parents should, therefore, behave in such a way that their children would imitate the good instead of the evil: this is the Erasmian message one hundred years later visualized by Jan Steen.[199]

Good education means teaching children how to let the ratio prevail over the passions. Original sin brought man under the spell of passions, described by Erasmus in an Augustinian way as "bestial impulses."[200] While Erasmus believed in the doctrine of original sin, which means that "since Adam ... a disposition to evil has been deeply engrained in us," he saw this also as an educational challenge: "we cannot deny that the greater portion of this evil stems from corrupting relationships and a misguided education, especially as they affect our early and most impressionable years."[201] Eventually not nature but the parents should be blamed if it goes wrong with the child. The tabula rasa can be filled by good or bad examples, for "nothing clings more

tenaciously than something that is poured into empty minds."[202] Erasmus in an almost Augustinian style concludes that man if not well educated "is at the mercy of impulses that are worse than those of a wild beast." No beast is "more savage and dangerous than a human being who is swept along by the passions of ambition, greed, anger, envy, extravagance, and sensuality." Parents are warned: "Unless you mould and shape the mind of your child, you will be the father of a monster, not of a human being.[203]

According to Erasmus we should worry much more about bad education. When parents expose "their children and abandon them in some forest to be devoured by wild animals," severe laws punish such behavior. But lack of parental control is not punished. The passions that are given every opportunity because of that lack of parental control are lust, "a hideous brute," extravagance, "a devouring and insatiable monster," drunkenness, "a savage beast," anger, "a fearful creature," and ambition, "a ghastly animal." They make your child a "destructive monster" that stays in your home and eventually ruins you. While the great crime of infanticide only kills the body, exposing children to the passions kills the spirit. That is even worse, for then "children are taught evil before they actually understand what in fact it is."[204] The passions of anger and lust are most in need of control and regulation, but fortunately education could make the difference. While the child is initially "nothing but a shapeless lump, ... the material is still pliable, capable of assuming any form, and you must so mould it that it takes on the best possible character." It then becomes "a godlike creature."[205] In that sense his view did fit also the Reformer's view.

The Reformers' Belief in the Power of Education

The Reformation was a revitalization of the Christian faith, prepared spiritually in fifteenth-century *Devotio Moderna*. Its most famous member, Thomas à Kempis wrote *De Imitatione Christi* (c. 1418–27) for "private devotional practices,"[206] but thanks to the printing press it became "the most popular spiritual handbook in Christendom after the Bible." It was "an emotional platform of denial, appealing to individual conscience and prescribing exercises to inculcate feelings of guilt, humility, low self-esteem, and self-abnegation as visible reenactments of Christ's passion," and it encouraged the virtues of love and compassion for Christ.[207] The Reformation went further than the *Devotio Moderna*: it ended unintentionally into a church schism and into institutional reform and it played a decisive role in the educational turn by the Further Reformation of the believer's emotional inner life. The focus on the individual believer was the consequence of Luther's theological approach of salvation through *sola fide, sola gratia, sola scriptura*, that is, only by faith, grace, and scripture. Not by good works, but only by building a direct relationship with God in reading God's word, you could hope on grace and salvation.[208] With the focus on the Word only instead of also on art and ritual as in the Roman Catholic liturgy, "the reformed churches interiorized their emotional regimes, leaving salvation a matter for each individual believer to face alone."[209] Luther's struggle against the indulgence trade in which he proclaimed that

sola gratia by God was possible, was only that successful through the printing press. Also other Protestant reformers such as Ulrich Zwingli (1484–1531) and Jean Calvin (1509–1564) profited from the new invention, as did their Roman Catholic counterparts, the Jesuits Ignatius of Loyola (1491–1556) and Petrus Canisius (1521–1597).[210]

In contrast with the Protestant reformers, the Roman Catholic ones believed in the power of images. The counter-Reformation's view on the proper use of art, as stated in a decree (1563) of the Council of Trent, said that "great profit is derived from all sacred images" so that the faithful would be "excited to adore and love God, and to cultivate piety." The condition was that art stimulated the religious belief and not profane things such as lust.[211] Cardinal Gabriele Paleotti (1522–1597) elaborated this decree in an applicable way in *De sacris et profanis imaginibus* [Discourse on Sacred and Profane Images] (1582). He argued that images were "illuminating the intellect ... and arousing devotion and heartfelt contrition," and he considered painters as "mute theologians" who should "delight, teach, and move." So the church continued the Renaissance ambition of making art that "explicitly evoked responses like horror, fear, amusement, veneration, and grief,"[212] now for a large public. According to Paleotti, "pictures ... serve as a book open to the capacities of everyone, because they are composed in a language common to persons of every sort."[213]

While the strive for the right Christian doctrine led also to more schooling,[214] the best place for the reform of emotions and behavior was neither school nor church, but the Christian family and the individual's interior, thus the emotional domestic. When Luther as a former Augustinian monk in 1525 married the former nun Katharina von Mora, celibacy went down with marriage and family going up. It became "the primary emotional building-block of modern society."[215] The inner life of the believer, young and adult alike, within the family was the focus of the Further Reformation. Augustine was of great influence on this movement, for example, "in the emphasis placed by Puritan writers on the need for selfabasement and the constructive role of passions such as self-hatred and despair."[216] Those manuals focused, in line with Augustine who warned in particular against lust and anger, on the control of emotions.[217] Luther reinforced the Augustinian image of man in constant struggle with his passions. He saw man as a creature without any free will or influence on his possible grace, a view spelled out in *De Servo Arbitrio*, or *On the Un-free Will* (1525), an answer to Erasmus's *De libero arbitrio diatribe sive collatio* or *On Free Will* (1524), with some space for a free will.[218]

Using or not using violence in the regulation of children's emotions and behavior was a hot topic in the Reformation and beyond. Love between child and parents did not exclude violence and this was justified theologically by the doctrine of original sin and educationally by the goal to harden the child. But it should not be used "arbitrary ... but rather as an instrument for the implementation of the divine will."[219] Orthodox Protestant authors among them Jacobus Koelman (1631–1695) in *The Duties of Parents to Educate Their Children for God* (1679), influenced by British Puritan texts among them *A Manual for Parents* (1660) from Thomas White (?c. 1672), and Petrus Wittewrongel (1609–1662) with *Oeconomia christiana* (1655–61), a Dutch adaptation of William

Gouge's (1578–653) *Of Domesticall Duties: Eight treatises* (1622), emphasized strict education of emotion, which should start with the breaking of the disobedient child's will.[220] They reflected seriously about how to approach child's nature without force (see Chapter 4), for physical force as an educational instrument should be a last resort, only to be used after all other educational instrument had failed.[221]

Other authors applauded educationally physical chastisement not only as last resort. In *Institutiones Principales* [The Education of Princes], Michael Tarchaniota Marullus (1458–1500), an Italian Renaissance poet and soldier from Greek descent, preferred a Spartan education with physical chastisement over education by speak. He considered the prince's child "as a boisterous horse," to be controlled by his teacher. According to Marullus, "adequate corporal punishment" would "not be harmful if it did not exceed a certain level." This recommendation of education by corporal punishment corresponded with other Renaissance authors such as the above discussed Vergerio in the chapter on "De Corporis Exercitio et Armorum Studio" from *Ad Ubertinum*, and Bartholomäus Metlinger (after 1440–1491) in *Regiment der jungen Kinder* (1474).[222]

There were also those who were against violence in education. Most prominent was Erasmus. He rejected education by physical force as simply sadism.[223] Child maltreatment was criminal, morally awful, and educationally ineffective. It should be punished as a criminal act against human law that "places restrictions on parental authority and permits even servants to take legal action against masters for maltreatment."[224] It was against Christian morality according to the epistles of St Paul and could not be justified by original sin and Bible proverbs such as "He that spareth his rod hateth his son: but he that loveth him chasteneth him betimes," or "Bend your son's neck in his youth and bruise his sides while he is a child." According to Erasmus, "nowadays we must interpret these sayings from the Old Testament more liberally" than literally.[225] Finally, child maltreatment was educationally ineffective: it did not fit child's nature, for: "Prima cura est amari."[226] Among his allies were, apart from seventeenth-century authors like Jacob Cats, contemporaries such as Montaigne, who not excluded in his *Essais* the "disciplining and healing effect of educational violence," but then only in extraordinary situations and never just to harden the child; and Jacopo Sadoleto (1477–1547), an Italian humanist and cardinal who in *De liberis recte instituendis* (1533) made a plea for the power of persuasion and education.[227] Loyd DeMause's interpretation of childhood history characterized by child maltreatment as daily practice, "a nightmare from which we have only recently begun to awaken," does not fit the variety of opinions about this phenomenon in the Renaissance.[228]

A Classic Discourse in a Modernizing Emotional and Educational Space

The classic Christian discourse on emotions with its contrast between vices and virtues and its emphasis on the control of the passions by the will, was adapted, visualized,

popularized, and educationalized.[229] People "could experience emotions in a variety of ... ways," for which "religion and spirituality retained their value as codifiers of emotions as Christian signifiers."[230] Religion was also a strong engine of an educational turn. A sense of urgency united heterodox and orthodox believers alike, notwithstanding their major differences in their view on man, in their belief in the power of education. The orthodox image of man as "incapable of any good and inclined to all evil" even resulted into an extra stimulus of starting this mission of training the control of the passions when initiating children in the emotional culture. The expanding educational space offered now possibilities through economic modernization but the results were modest, for the new opportunities were limited by the continuing almost unsurmountable limits of social inequality and high infant and child mortality.[231]

In the next two chapters we turn to the visualization of the expression of emotions by coming face to face of children's and parent's emotions, and to the visualization of the mission for education in emotional literacy.

3

The Expression of Children's Emotions in the Age of Renaissance and Reformation

Introduction: Looking through the Changing Eye of the Artist

Children scarcely occurred in the visualization of capital sins and virtues, due to the insight that in childhood the development of moral and emotional literacy just got started. But from the late Middle Ages, children's emotions were visualized by an increasing number of artists in various styles. We can observe those emotions by looking through the eye of those artists and so combine different theories of mind.[1] Studying children's emotions goes together with adult emotions when they are related with or evoked by children's emotions, as in Rembrandt's *The Naughty Child*.[2] Before looking at children's emotions, we first briefly turn to contemporary ideas on the visualization of emotions, the impact of sacral art, and the role of symbols.

Renaissance Ideas on Visualizing Emotions

Renaissance painters such as Jan Van Eyck (*c.* 1390–1441), Jean Fouquet (*c.* 1420–1481), and Piero della Francesca (*c.* 1415–1492) made emotions more visible. And painters such as Michele Savonarola (1384–1468) with *Speculum Physionomiae* (*c.* 1450) and Leonardo da Vinci (1452–1519) with *A Treatise on Painting* also wrote about how to do this. According to Leonardo, a good painter must represent both "the figure and the state of his mind," and the last is the most difficult to do "through the gestures and movements of the members."[3] Artists thus made affects and passions visible by showing their expression by the body, in particular the face and the gestures of the hand. Those introductions on painting, often translated in other languages, aimed at promoting the craft for new generations. According to Leon Battista Alberti (1404–1472) in *Della pittura* (1435), the "movements of the soul are made known by movements of the body ... Thus all the movements of the body should be closely observed by the painter."[4] He thus explicitly assumes that emotions were only visible through the body. Almost all authors of influential tractates on painting, among them also Cardinal Gabriele Paleotti (1522–1597) in *De sacris et profanis imaginibus* (1582), Giovanni Paolo Lomazzo (1538–1600) in *Trattato dell'arte de la pittura* (1584), and the already mentioned Ripa in *Iconologia* (1593) and Van Mander in *Schilderboeck* (1604), considered the

body, in particular the face and the eyes, as the privileged seat of emotions: the "mirror of emotions."[5] Lomazzo distinguished eleven *moti* or emotions, namely love, hate, desire, horror, happiness, pain, hope, desperation, courage, fear, and anger, thus the basic emotions. Viewers should believe in and share the emotions they saw depicted on canvas in order "to be stirred with disdain and wrath, at the sight of shameful and dishonest actions."[6] The artists considered mouth, brow, and eyes as the "most important instruments for communicating feeling." They, for example, "used crying to depict grief or sorrow," realized "either through physiognomy (the widening of mouths, the narrowing and reddening of eyes, the prominence of wrinkles in the corners of the eye) ... or by gestures such as the wiping away of tears."[7] They aimed at "anatomically naturalistic emotionality," and with that, they differed from the "unrealistic grandeur, rigidity, and idealized formality of the dominant Byzantine style." From now, the Virgin, the saints, and Christ got "realistic expressions of affective states in non-verbal poses."[8]

As Renaissance artists they as a matter of fact referred to the classics, in particular *Aeneid* by Virgil (70–19 BC) and *Metamorphoses* by Ovid (43 BC–17 AD), for "a repertoire of physical images and gestures of intense passion."[9] They saw it as a challenge to confront the viewer with "true feelings from external bodily signs and appearances," such as "wonder, sorrow, calm, envy, hatred, happiness, anguish, shame, and anger,"[10] which writers such as Dante Alighieri (1265–1321) in *Divina Commedia*, Canto V about the love between Paolo and Francesca, which "eventually condemns them to hell," did before.[11] Just as the writers already did, now also painters would bring their public "toward a correct love, hatred, hope, and fear." Those visualized basic emotions became "powerful and ubiquitous cultural factors ... in daily ordinary life ... [and] high theology," in order to, argues Erasmus, transform the "frigidity of academic theology" into a theology that reached the heart.[12]

Theorizing about emotion's bodily manifestation continued in the transition to the Baroque[13] with famous painters such as Rubens and Rembrandt highly interested "in the passions of the soul." The "general consensus among art critics" was "that the goal of art was to emotionally affect its audience."[14] Even more than before the focus was on the face, as with Girolamo Cardano (1501–1576) in *Métoposcopie* (Paris, 1658), Richard Saunders (1613–1675) in *Physiognomie and Chiromancie, Metopocospie, the Symmetrical Proportions and Signal Moles of the Body* (London, 1653), Nicolas Coëffeteau in *Tableau des passions humaines, de leur causes et de leurs effets* (1620), Marin Cureau de la Chambre, adviser of Louis XIV, in *Les caractères de passions* (1640), Jean-François Senault in *De l'usage des passions* (1641), and with Descartes.[15]

Charles Le Brun (1619–1690), first painter at the court of Louis XIV, "taught a generation of French artists to depict the passions" on the basis of Descartes's ideas.[16] He was influenced and impressed by Nicolas Poussin's way of painting and Descartes's analysis of the passions.[17] In "A Pictorial Lexicon of the Passions of the Soul and Accompanied by the Theoretical Justifications Based on Current Philosophical Treatments" (1688),[18] a reading to the French *Académie de Peinture* and posthumously published as *Méthode pour apprendre à dessiner les passions* (1698), Le Brun analyzed

the movements of the body that accompanied passions such as wonder, sadness, and fright. He considered a passion in a Thomistic way as a "movement of the sensitive part of the soul, which is designed to pursue that which the soul thinks to be for its good, or to avoid which it believes to be hurtful to itself."[19] This was most clearly expressed in the face, particularly in the eyebrows. Its up-and-down movements "represent respectively the two appetites of the soul—the concupiscible and the irascible"—and they "reflect the complexity and intensity of the underlying passion." Following artists such as Alberti and authors such as Erasmus, Descartes, and Thomas Wright, Le Brun saw the face as the primary locus of the manifestation of emotions and the eyes as the keys to the secret motions of the soul.[20]

The many family and child portraits sustained by those ideas about the passions and how to depict them have found their origin earlier in the adoption and adaptation of Christian art.

From Sacral to Profane

In the late Middle Ages, sacral art humanized and became, with its topics and configurations, the breeding ground for profane family and child portraiture. Instead of almost freezing emotions in the byzantine tradition, sacral art started to show the bodily expression of unpleasant emotions such as sadness, grief, loss, pain, and fear, as with the suffering of Christ and the compassion and grief of the Virgin,[21] and of pleasant ones such as joy and happiness. In the late medieval and Renaissance, emotional culture assessment of those emotions happened primarily through the lists of capital sins and virtues. Those lists "provided a theological and moralizing filter through which good and evil might be evaluated, of monumental significance at the time of the Last Judgment."[22]

Humanization concerned in particular the emotions of the child and the family in configurations such as mother and child in Madonna's, young children together in pictures of the child Jesus accompanied by future John the Baptist and infant angels, the family portrait in portraits of the Holy Family, and the rescue of young children in miracles in Lives of the Saints. Humanization and its accompanying psychological approach asked for more differentiation of emotions along sex and age, as Leonardo remarked in *A Treatise on Painting*.[23] A precursor in this development was Giovanni Pisano's (1248–1315) *Natività* (1301) in which a child occurs with realistic new-born-child movements. This was special, for during a long time it was usual to represent the infant Jesus as a two- or three-year-old child, able to control hands and fingers to make the very complex blessing movement, in other words as a perfect and precocious child, even if not yet born.[24] The turning point in the humanization of Jesus as an infant took place in fifteenth-century Flemish painting with, among others, *Saint Luke Drawing the Virgin* (1435–40) by Rogier van der Weijden (1400–1464) with an infant that can't sit up or hold his head up yet and is happy, smiling near the motherly breast and satisfied after the feeding; *Virgin and Child* (c. 1455–60), a real infant in a loving relationship with his mother, by Dirk Bouts (c. 1415–1475); and with *Worship of the Shepherds, or, Portinari*

Triptych (1476) by Hugo van der Goes (1440–1482) and commissioned by Tommaso Portinari (1432–1501), the representative of the Medici Bank in Bruges. From the left and right parts of this triptych, the Portinari family looks at "a baby lying on the ground ..., with a thin body, wrinkled skin, a long bust, unable to raise his back from the ground or his head, but who tenses up and brings his feet together to rub them" (Figure 4).[25]

This humanization of sacral art mirrors the increasing attention for a more realistic representation of childhood, in particular infancy, and made sacral art the breeding place for secular, in particular portrait, painting. This secularization started within the framework of sacral triptychs such as the Portinari triptych. In that painting the commissioner, Tmmaso Portinari, allows himself to be placed together with his wife in the triptich's side panels of what appears to be a completely religious painting. Such side parts of triptychs with commissioners and their family joining a religious event developed into profane family portraits in Flanders, Germany, Italy, the Dutch Republic, and elsewhere. Initially the father played the dominant role in such family portraits, with the children mostly added for genealogical reasons.

FIGURE 4 Hugo van der Goes, *Worship of the Shepherds/Portinari Triptych* (1476), oil on wood (Florence: Galleria degli Uffizi). Credit: Universal History Archive/Contributor (Universal Images Group Editorial).

From the late Middle Ages this changed. The well-to-do increasingly wanted to show not only themselves and their family but also their unique children when still young. The children's importance increased compared with earlier family portraits in which father and family's genealogy dominated. Now people want to show parental pride and love to themselves and others by putting their children literally in the picture. All sacral topics with children, such as the Holy Family, the Madonna, the child Jesus, the massacre of the Innocents, and the rescue of young children through miracles in Lives of the Saints, were adopted and, together with their original configuration, adapted into secular subjects.

This process of secularization of art happened everywhere in the European Megalopolis, with a special focus on child and family in the Northern Netherlands.[26] Dutch artists increasingly focused on emotions of daily life. They produced *c.* 70,000 paintings each year, both highly and modestly priced with, around 1650, approximately seven hundred active painters within a good working art market for customers from both the elite and the broad middle class. Ownership of pictures was normal furniture, even with surprise observed in farms by foreign visitors. Looking at the visualization of daily-life emotions and, when in portraits, those of oneself and one's children was part of the lifestyle of Dutch burghers, and this lifestyle was connected with a moral appeal to teaching emotional literacy.[27]

Apart from becoming the breeding place for profane art, the humanization of sacral art remained also important for its own purpose. The visual expression of Christ's suffering, starting in the twelfth century under the influence of Anselm of Canterbury, remained for centuries "an emotional mode of devotion of Christ's human form."[28] The painting of religious subjects remained core business for top artists also when this was no longer financially necessary because of an increasing demand for secular art from the aristocracy and the bourgeoisie. Among those artists are Albrecht Dürer (1471–1528),[29] Leonardo da Vinci (1452–1519), Raphael (1483–1520), Pieter Bruegel the Elder (1526–1569), Peter Paul Rubens (1577–1640), and Rembrandt (1606–1669). They worked in Roman Catholic countries with Baroque art inspired by the contra-Reformation[30] and in religiously mixed or Protestant regions, as the Dutch Republic. While secularization in art was intensified in this country by the *Beeldenstorm* and while, in Calvinistic regions, church's interiors remained sober and painted white, for artists such as Rembrandt and his pupil Nicolaes Maes (1634–1693), the Old Testament and the stories of the saints were inexhaustible resources for their artistry. Rembrandt's portraying of highly recognizable human emotions in "his many sketches of biblical subjects" testified "to his genius as a storyteller."[31]

The Visualization of Children's Emotions

Renaissance artists improved significantly the portraying of the bodily expression of emotions, and this was stimulated by strong artistic competition in an expanding market with more wealthy commissioners.[32] They packed their portraying of families and

children often in religious and classic mythological symbols,[33] but also, as in the Dutch Republic, in daily-life scenes, in four main categories: by drawing, by painting family and children's portraits, by genre painting, and by making emblems, all those products being important sources for this study. The first, drawing, "a way of reasoning on paper"[34] without pressure of a customer and without investment in expensive material as with painting, is an excellent source for insight in the expression of children's emotions, with often remarkably realistic pictures in particular of very young children. An example is *Non-identified Child of Henry II and Catherine de Medicis* (*c.* 1555), made in François Clouet's studio as a health bulletin to inform the king that the child was in good health.[35] Besides drawings of real people, there were also genre drawings. The second category, family and children's portraits, shows real faces and emotions. The third category, genre painting, shows patterns of behavior through either people who behave according to the preferred emotional standards, or against those standards. Those pictures are often part of the mission to point to good parenting in emotional literacy. This was also the case with the fourth category, emblems, an important source for insight in the mission for emotional literacy (see Chapter 4), and a combination of image and text. For the rest, a considerable number of family and children's portraits that depict real people do also contain suggestions to preferred standards of emotional and educational behavior.

All those pictures can contain symbols, and its interpretation is sometimes a real challenge and forms a topic of discussion among art historians. One of them, Jan Baptist Bedeaux, in *The Reality of Symbols* warns to not overinterpret symbols and to always take into account the reality present in the pictures.[36] The sixteenth- and seventeenth-century symbol language with its references to Antiquity and Christianity was well known among contemporary connoisseurs for whom it was a play to decode it. For religious subjects, main sources were stories from the Old Testament such as Adam and Eve, Judith, and Suzanne, and from the New Testament stories such as the Annunciation, the baptism of Jesus in the River Jordan, and the scourging and crucifixion.[37] For subjects from ancient Greece and Rome, Ovidius's *Metamorphoses* was the painter's bible. The Dutch painter Karel van Mander (1548–1606) wrote an explanatory text with *Wtlegginghe op den Metamorphosis*. Other popular sources were Virgil's *Aeneid*, Plutarch's *Parallel Lives*, Livius's (59 BC–17 AD) *Ab urbe condita*, and Homer's *Iliad* and *Odyssey*.[38] A popular topic for the visualization of anxiety, danger, and death of a child was the frightening story of Ganymede, on which I will return later in this chapter.

In the following we turn to the visualized expression of a number of emotions of children and, connected with them, also of their parents. We will look at the bodily expression of their time-bound basic emotions, both the positive or pleasant and the negative and unpleasant ones, and to their affective or emotional tone.[39] For children we expect positive emotions such as happiness-exaltation, joy, and curiosity, and negative and unpleasant emotions such as anger-rage, fear-horror, pain-agony, and sadness-grief, and concern. For parents we expect emotions such as love, care, affection, and concern, which depend on the virtues, and emotions such as impatience, depending on the vices. Through the artists' eyes, we first look at the educational and emotional relationship

within the domestic as a breeding ground for child's and parents' emotions. Then we turn to the child's world: of children together and of the child alone.

The Educational Relationship: Breeding Ground for Children's and Educator's Emotions

Introduction: "Melancholic Turn" or Focus on Pride and Joy?

Emotions of male adults get more attention in this period than those of, according to Haemers, "women, young people, the poor, and urban commoners."[40] Moreover, Barbara Rosenwein characterizes this period as a "melancholic turn," due to a stricter Christian discourse in Reformation Europe. Calvin in his predestination doctrine emphasized fear of "an arbitrary and all-powerful God, constantly and directly active, according to a providential but mysterious plan," and the Catholic humanists Erasmus and More concentrated on fear as "Christ' agony in the Garden" prior to his arrest and crucifixion.[41] This "melancholic turn" found easier cultural expressions of negative feelings such as "desire, anger, fear, disgust, and sadness, or at least solemnity" than of joy and happiness, although, for more intimate emotions, "one might look to the continuing everyday rituals of birth, baptism, and marriage."[42]

Visualization could open the way to those intimate emotions, the pleasant as well as the unpleasant, and of mothers and girls and fathers and boys within the educational relationship in the family or domestic. This was an emotional space based on "ties of blood and of marriage:" a model for "emotional ideals of love, authority, and obedience," with the pater–familias–servant relationship almost similar to the parent–child one.[43] In Reformation Europe, this emotional community was considered and so described in numerous household manuals as a small church with the pater-familias also fulfilling religious responsibilities. Apart from an emotional and religious community, the family or domestic also was an educational community for the education of the children and, when present, also apprentices and servants.[44] This community model varied across Europe with sending children into service outside the family uncommon in southern but usual in northwestern Europe. It was the educational place for "schooling young people in emotional restraint and controlled expression" as a preparation for "the prudent, moderate, and industrious management of households of their own." The household became a "training ground in emotional values and practices" to realize "the ideal of emotional control."[45]

In the following we will look at the emotional relationship between parents and children inside the domestic and occasionally also outside, for the family and the community crossed each other's borders frequently. Special attention is given to, respectively, the emotional relationship between child and mother and between child and father. Mothers were more frequently portrayed with daughters than with sons, and fathers more with sons than with daughters. But this was not a matter of fact, as *A Genuese Noblewoman and Her Son* (c. 1626) by the Flemish painter Anthony van Dyck (1599–1641) shows a pride mother and a seriously looking son.[46]

The Family Together

We will show positive emotions varying from religious devotion to parental pride and children's happiness and joy within the family at dinner and during family celebrations, but also negative emotions such as fear, sadness, and grief when parents were confronted with risks for the child from outside and when children became sick or even passed away. Those situations characterized the family as an emotional space. Initially they were depicted in sacral and then increasingly also in profane ways.

Devotion, Pride, Joy, and Happiness

The family portrait became popular in Europe in the sixteenth and seventeenth centuries.[47] It started literally within the sacral mode as we saw in Van der Goes's *Worship of the Shepherds, or, Portinari Triptych* (1476). In *Triptych Moreel* (1484) by the German/Flemish painter Hans Memling (*c.* 1435/40–1494), the middle panel shows Saint Christophorus with the child Jesus on his shoulder. The side panels show the male and the female part of the family Moreel. In, for the viewer, the left panel is Willem Moreel (1424–1501), commissioner of the triptych, with his five sons who kneel and pray devoutly together with their father who, with a religious book before him, expresses devotion but also self-satisfaction. Portrayed in this way he could impress the other churchgoers, for the triptych was placed in the family altar of the Moreel family in Bruges's St. James Church. In the right panel are mother with her ten daughters, showing not so much a satisfied as a modest and serene expression. Father is accompanied by a disguised devil, symbol for what could go wrong, while mother and daughters are protected by the elegantly dressed Saint Barbara. All children are portrayed individually with expressions that vary from curiosity for the youngest boys to devoutness for the girls.[48]

In *Portrait of Konrad Rehlinger of Augsburg with His Eight Children* (1517), the Swiss painter Bernhard Strigel (*c.* 1465–1528) takes a further step in the adaptation of the religious model. Konrad, one of the most prestigious patricians of Augsburg, is depicted on the left panel with his eight children still alive on the right-hand panel almost serving as wallpaper. The opening in the heaven, a reference to the hereafter, shows the children who already passed away. His wife, not in the portrait, died two years previously. This is a demonstration of family genealogy instead of an addition to a religious topic as in the pictures by Van der Goes and Memling, with devoutness the dominant emotion of the children (Figure 5).[49]

Again genealogy, but now focused on a child instead of on the father, shows *Las Meninas, or The Family of Philip IV* (1656) by Velázques (1599–1660). The little girl, who looks like a child, attracts all the attention. True, it is the *infanta*, Margarita Teresa (1651–1673), and the portrait presents her as the person she is destined to become.[50] Her parents, the Spanish royal couple, remain at the background, like two ladies-in-waiting and a boy who plays with a big dog. Normally, when dogs are added in a picture they are small in girl's portraits and bigger in boy's portraits because of the reference, apart

FIGURE 5 Bernhard Strigel, *Portrait of Konrad Rehlinger of Augsburg with His Eight Children* (1517), oil on wood, 209 × 98 cm (Munich: Alte Pinakothek). Credit: colaimages/Alamy Stock Photo.

from good education, to future power. But future power is also at stake for the *infant* (Figure 6).[51]

In bourgeois families, the combination of lineage, parental pride, and children's joy increasingly went together. In *The Family of the Amsterdam Burgomaster* (c. 1663) by the Dutch painter Gabriel Metsu (1629–1667), the father, Jan Hinlopen, looks proud and mighty, surrounded by his family. The portrait has a clear gender configuration with, in the left part, the father with his son, then aged seven and depicted as a prince, and, in the right part, the mother and the wet nurse (or the unmarried sister of Hinlopen's wife) together with three daughters, the two youngest on the arms of, respectively, their mother and the wet nurse. The circa four-year-old eldest daughter sits on the ground with a well-trained dog before her, metaphor for good education.[52] We are face to face with one of many posing families with pride parents and joyful children.[53] Such images became popular among well-to-do burghers in the northern part of the European Metropolis who, earning money in the booming economy and imitating the example of princes, let portray themselves proudly looking in the midst of their family.

FIGURE 6 Diego Velázques, *Las Meninas, or The Family of Philip IV* (1656), oil on canvas, 318 × 276 cm (Madrid: Museo del Prado). Credit: brandstaetter images/Contributor (Hulton Fine Art Collection).

Cornelis de Vos (1584/5–1651) focused on family intimacy in *Portrait of Anthony Reyniers and His Family* (1631), a rich Flemish merchant depicted together with his two sons and with his wife Maria with the three daughters. On the wall are the portraits of Anthony's parents. The eldest girl has cherries and peaches, which refer to springtime and youth. She holds a peach in front of her youngest sister, still a baby on mother's lap. The boys are presented more seriously with their hats. The youngest looks like a prince, while the eldest, destined to succeed his father one day, seems disturbed in his reading.[54] And *Portrait of an Unknown Family* (*c.* 1647/50) by Frans Hals (1582/3–1666) shows happy children and adults almost at a picnic party.[55] Those portraits focus much more on family's intimacy and emotional expressions of child and parent than on the family lineage and were produced in dozens by painters such as Jan Mijtens, Gabriel Metsu, and Frans Hals.[56]

The family as an emotional community was portrayed by Rembrandt in sacral and profane representations. In the drawing *The Holy Family Asleep with Angels* (*c.* 1645), Joseph is exhausted and stretched out on the floor. Maria seems to sleep next to the cradle where Jesus sleeps peacefully. But she looks as if she will wake

up immediately if necessary. Two angels observe and protect the family. Rembrandt portrays recognizable young parents, exhausted but satisfied and with affection and concern for the happy sleeping infant in the center of the picture.[57] Also the cozy *The Holy Family in the Carpenter's Shop* (c. 1645) shows "with a few decisive scribbles" and with "a few hasty lines" the humanization of emotions with the Virgin keeping watch with motherly attention to her child, invisible for the viewer, in the cradle, and with Joseph diligently working with an axe.[58] Rembrandt's profane *Portrait of a Family* (c. 1668) on a still unknown family combines pride with happiness, affection, and love. It manifests a strong attachment between the members of the family in a late Rembrandt style comparable in color splendor to *The Jewish Bride*. Father, mother and the three children are presented as a close-knit group bound together by affection and family intimacy. Two happy children joke with each other. The smallest sits on mother's lap and stands out because of a finer stroke. The proud father and the youngest child look at the viewer, the other children look at each other while mother is lost in thought with her youngest. Father and mother present themselves in their roles as successful founders of a happy family. A basket of fruit in the hands of one of the children also hints at this.[59] It refers symbolically to fertility and good education, but not, as we now would expect, to health advice. In the popular medical advice book *Schat der Gesontheyt* ("Treasury of Health") the Dordrecht physician Johan van Beverwyck (1594–1647) warned parents that "not only apples but all soft-skinned tree-fruit" were particular harm to the child's health. Following Galen of Pergamum, he advised parents to let their children "refrain from eating fruit."[60] Fruit and flowers, together with trained dogs, formed the most popular educational metaphors among the incidental elements in early modern Europe family portraits. In their formative period during the sixteenth century, these portraits were profoundly influenced by Psalms 1 and 128 with metaphors of women as fertile grapevines and children as olive branches.[61] But Rembrandt's painting goes further in emphasizing the family as an intimate emotional space, intended by both the artist and the—unknown—commissioner.

In genre painting, not so well-to-do families were depicted also. *The Dooryard Cottage* (1673) by the Haarlem painter Adriaen van Ostade (1610–1684/5), a genre painting that, however, breathes realism, shows not so much an emotional unity as a family with adults and children who each have their own world. Father comes home but this does not attract any family members' attention. All go on with what they are doing. Mother is very concentrated peeling fruit and the eldest daughter, whose face remains invisible, takes like a young mother care of the youngest member of the family, still a baby and very satisfied. A little further up the son, about six years old, with a proud and cheerful face, trains the dog, symbol of good education. He looks at his younger sister, sitting on the ground and full of admiration. Together, they create their own child's world.[62] Strigel in *Saint Mary Clephas and Her Family* (1520–8) also observed a child's world. Three children with a halo, symbol of holiness or spiritual significance, try to attract the attention of their mother, Saint Mary Clephas. Downstairs is a boy, also with a halo. He sits on the ground, does not care about anyone and creates his own child's

FIGURE 7 Bernhard Strigel, *Saint Mary Clephas and Her Family* (1520–8), oil on panel, 125.4 × 65.8 cm (Washington, DC: National Gallery of Art). Credit: Heritage Images/ Contributor (Hulton Archive).

world. He seriously and concentrated, as if he could do this for hours, plays with a dog while using a long stick in which the dog can bite (Figure 7).[63]

The emotional family space was often depicted through the topic of dining at table, "an important ... rite of household life"[64] for the expression of emotions such as devotion, pride and joy. As an art topic it started in sacral art. The Netherlandish *Book of Hours of Catharina van Kleef* (c. 1440) commissioned by Catharina, Duchess of Gelre and Countess of Zutphen (1417–1479), contains devotional texts and beautiful illuminations. It includes images of the high nobility as Catharina devoutly kneeling, but also of simply living people as in *The Holy Family at Table*. We enter in the emotional space of a cozy family with Maria feeding her child and Joseph eating his soup in pictures that anticipate seventeenth-century Dutch painting and which were "inspired by the experiences of ordinary life."[65] 'Nativity' in *Book of Hours of Kunera van Leefdael* (c. 1415) offers a similar experience. A family is together in a cozy and relaxed atmosphere, with Maria relaxed in bed, the child in the manger, and Joseph preparing the porridge. Those illuminations, the product of the *Devotio Moderna* and intended for a market of pious burghers in the Netherlands and German Westphalia,

anticipate profane family portrait painting in the way they depicted the family as an emotional unity.[66]

In the anonymous *The Family at Meal* (1627) an average Dutch seventeenth-century family with father, mother, and four children sits around the table. The youngest child sits on mother's knee with a twig in her arm, the other three sit next each other. All have their hands joined in prayer and express emotions of piety (pietas) and devotion.[67] Jan Steen, well known for his ironic moralist genre paintings, also made the devotional *Prayer before Meal* (1660) on a family that expresses simplicity, affection, and devotion, and does not want the "abundance of the treasure of richness," a passage from the Book of Proverbs, 30: 7–9, which is depicted on the canvas.[68] Another *Prayer before Meal* (*c.* 1663–5) by Jan Steen shows an emotionally diverging wealthy family during the same event. While the mother educates her youngest child emotional literacy by teaching her how to pray and with that learn obedience, virtuousness, and piousness, he father, his hands piously joined, and his son are attracted primarily to the food and perhaps also to the maid. Moreover, there is a mysterious guest, a girl or a young fashionable dressed woman, with her face not visible and ignored by the family around the table. Steen contrasts the virtues of the pious mother and the child with the vices of the father and the son.[69]

During family celebrations the family as an emotional space stimulated emotions from happiness to sadness, as with the most popular feast for children in Western Europe with varying regional traditions, the Feast of Saint Nicholas. This is celebrated at the evening of December 5, eve of the name day of St Nicholas (270–343), bishop of Myra.[70] Already in an account from 1360 of the Dutch city of Dordrecht its celebration is evidenced. The document states that children received a day off school and some money to celebrate the feast. It is true that in this same city in 1657 orthodox Protestants forbade the celebration of this "remainder of Catholic traditions," supported by anti-St Nicholas texts from the Rev. Abraham Magyrus (1634–1702).[71] But due to religious heterogeneity and the broad part view that play and feasts were important for children's development, the Feast did persist as the main children's feast celebrated in the domestic. It had special rhymes and the children with proven good behavior got presents supposedly given by St Nicholas, but in reality by the child's (grand-)parents. Those with supposed bad behavior, however, got the Black Peter's birch.[72] Steen's visualization from *c.* 1665 to 1668 offers a range of emotions from happiness and enjoyment for mother and daughters to sadness and shame for the son (Figure 8).[73]

The girls are rewarded for their well-behaving with presents. The little happy girl, with in her hands traditional sweets like *speculaas* and *taaitaai*, watches the chimney where the presents should come from. Her elder sister, however, is the star of the evening. Radiant from happiness, she enjoys the presents while her happy mother, knowing where the presents come from—her absent husband is probably right now supporting St Nicholas—gives her a tender look. Quite different is the emotional state of her brother. He cries for he did not get a present but a rod in his shoe as symbol of punishment for his bad behavior. By showing this contrast Steen warned for the

FIGURE 8 Jan Steen, *The Feast of St Nicholas* (*c*. 1665–8), oil on canvas, 82 × 70.5 cm (Amsterdam: Rijksmuseum). Credit: Sepia Times/Contributor (Universal Images Group Editorial).

negative consequences of favoritism, part of the Dutch educational discourse by, among others, Cats and Wittewrongel.[74]

Another popular family feast was Epiphany, the Christian feast on January 6, which celebrates the manifestation of Christ to the Magi from the east who visited the newborn Jesus after seeing a star, the star of the kings and God's message of Christ's birth. The topic was frequently depicted with mostly the focus on happy children with one of them dressed as the king, as in Jan Steen's *The Feast of Epiphany* (1662). In the midst of a joyful family feast, without any reference to bad adult behavior imitated by children as in so many other Steen paintings, the king, still a little child and adorned with a beautifully decorated paper crown on his head, takes the first sip from the cup. His head is held by a beguine, a lay Catholic woman and perhaps his sister, as for the Catholic Steen to demonstrate the feast's Catholic character.[75] Also in Rembrandt's *The Star of the Kings* (*c*. 1645), children play the main role. A group of younger and older children, accompanied by a cheerful looking mother with her baby, goes from house to house to ask for money for the poor. An older boy holds a lantern in the shape of a star in a "magical" made night scene with the lantern illuminating the group and

FIGURE 9 Rembrandt van Rijn, *The Star of the Kings* (signed *c*. 1645), drawing, 20.4× 32.3 cm (London: The British Museum). Credit: Heritage Images/Contributor (Hulton Archive).

letting the boy's back in the shadow. The children are cheerful and excited, although at the back of the group an older girl points to the star while pulling a smaller child who is frightened and cries. At a short distance two men with hats watch the event with amazement and surprise. In front two dogs sniff each other, evidence for the fact that the meaning of symbols, apart from dogs also other animals like birds, diminished strongly in the seventeenth century: this dog has no relationship with good education, but is simply part of the street view. In the half-open door of the house the group stands for two women who lean over the half-open door. One of them holds a baby who looks curiously at the crowd in the street while a toddler comes just above the half-open door. Although on the street, the children in this very realistic picture are focused on mothers and other children at their houses' threshold (Figure 9).[76]

Fear, Sadness, and Grief

THE CHILD IN DANGER

To show a family in danger, religious topics such as the Flight to Egypt and the Massacre of the Innocents were popular. Also the Adoration of the Magi, usually portrayed positively, could indicate great danger, as in Bruegel's *The Adoration of the Magi* (1564), in its imminent atmosphere preceded by Hiheronimus Bosch's *The Adoration of the Magi* (*c*. 1490–500). At first sight we see a smiling and happy Christ Child. But the general atmosphere is one of bewildering, imminence, and intimidation, anticipating what would happen later. This can be seen from the soldier with his weapons just above Maria's

head and from the white cloth around Jesus that "evokes a shroud." While some people around mother and child look friendly, others have an intimidating and angry face.[77] This imminence became reality in *Flight to Egypt* in Book of Hours of Kunera van Leefdael. The illumination brings us into the intimate world of something that is recognizable also now, namely a young couple on the run for soldiers who want to kill their child. Maria holds her child tenderly while sitting on the donkey led by Joseph, who full of concern looks back to Maria and Jesus. People could watch this emotional scene at home or in a monastery in a devout atmosphere.[78] The topic became popular in early modern Europe among the greatest artists, such as Albrecht Dürer with *Rest on the Flight into Egypt* (1511). In this drawing Dürer shows the intimate emotional world of a family on the run for danger with Maria and her child, pictured older than his age as was then usable according to the religious tradition, sitting at the food of a group of trees. They look to each other respectively loving and longing, for Maria seems to want to breastfeed her child in a moment. In contrast with Maria and Jesus, drawn in great detail, Joseph is only just visible for depicted with no more than a few pen strokes. He is busy looking for food and drink, for he carries a kind of leather bag with him on a rope (Figure 10).[79]

FIGURE 10 Albrecht Dürer, *Rest on the Flight into Egypt* (1511), drawing, 27.9 × 20.8 cm (Berlin: Kupferstichkabinett der Staatlichen Museen zu Berlin, KdZ 3866; credit: Staatliche Museen zu Berlin, Kupferstichkabinett/Jörg P. Anders Public Domain Mark 1.0).

A further humanized version made the Spanish painter Francisco de Zurbarán (1598–1664) two centuries later with *The Rest during the Flight to Egypt* (1659) Amidst a terrifying flight Zurbarán lets us enter into the intimate and emotional world of a young couple, full of tenderness and parental happiness looking at their baby, who manifestly enjoys sucking on mother's breast. With no reference to any sacral element, it is an almost profane image of parents with a baby on the run.[80]

The reason for this flight was the imminent murder of the child because Herod, King of Judea, ordered his soldiers to slaughter all boys under the age of two after learning that the future king of the Jews would be born in Bethlehem. When danger had passed, the family could return home. In Rembrandt's *Departure to return from Egypt to Israel* (c. 1652), the family rests for a while during the exhausting journey. Joseph supports Maria with, in her arms, the child Jesus of whom only some contours are visible including chin, mouth, and eyes. Maria's right hand's size emphasizes the child's smallness. The infant appears to be asleep, is calm and satisfied, does not cry out for hunger or feels uncomfortable. Maria is jaded and exhausted with her mouth closed and her eyes lowered. Joseph seems to have more energy left and looks concerned, determined, and concentrated with a serious look and clenched mouth, while supporting Maria. She can hardly stand on her feet anymore. With his right hand and arm he supports her in carrying the child. Although on the way back, there is no sign of relief yet for it is still a dangerous and tiring journey.[81]

The risk of losing your child to daily accidents was visualized frequently in a mix of profane and secular art, with often a happy ending because of a miraculous intervention by a saint. This was mostly about boys because of their value for the family lineage.[82] In *Stories of Blessed Agostino Novello: Miracle of the Child Falling from the Balcony* (1328), part of a triptych by the Sienese painter Simone Martini (c. 1284–1344), such an accident is packed in the story of Saint Agostino Novello (1240–1309). A child falls from a wooden balcony through a broken plank almost to the ground. The mother on the balcony screams in despair. Just in time Saint Agostino, who also saved a child from an aggressive wolf and a baby that fell from the cradle, as is visible in Martini's triptych,[83] jumps forward from another window. While meanwhile taking the broken plank with his left hand along, he flies after the child. In the image, his right hand is almost at the child, who is eventually miraculously rescued and, as the painting also shows, is caught by the bystanders. Safely on his feet again, he calmly waves to his mother on the balcony as a sign that everything ended well (Figure 11).[84]

A very special prevention of a children's danger was told in *Saint Nicholas of Bari with Three Young Girls* (before 1348) by Ambrogio Lorenzetti (1290–1348). Saint Nicholas, who was the bishop of Myra, managed to avoid by a miracle that the three girls should lose their chastity by being prostituted, an idea of their father, a widower who was sunk into poverty and did not see another way of feeding the family.[85]

GRIEF ABOUT CHILDREN'S SICKNESS AND DEATH

Parental sadness and grief were often caused by infant and child mortality, omnipresent in early modern Europe. Historians in the debate on the *sentiment de l'enfance* discussed

FIGURE 11 Simone Martini, *Stories of Blessed Agostino Novello. Miracle of the Child Falling from the Balcony* (1328), part of triptych, tempera on poplar, 200 × 256 cm (Siena: Pinacoteca Nazionale). Credit: Print Collector/Contributor (Hulton Archive).

about the existing or nonexisting reluctance of parents to affectionately commit to their very young children because of the consciousness of their fragility and the fear of losing them early (see Chapter 1). It now almost generally is accepted that fear of and sadness when losing a child were part of the emotional culture. Hanawalt described "poetics of grief and consolation in the Middle English Pearl" as "the most famous and eloquent lament of the death of a daughter from the medieval period,"[86] and Chaucer's

Summoner's Tale and *Prioress's Tale* emphasize parental grief.[87] For the rest, infant and child mortality were part of daily life, and parental sadness about this left, therefore, often few traces in the sources, which asks for more source creativity.[88] Jarzebowski studied personal documents and *Leichenpredigten* (funeral sermons), a typically Lutheran genre in sixteenth and seventeenth century about a love triangle between child, parents, and God. They show parents' grief about their children passed away and how they continued to regard them as family members belonging to the family's emotional capital and to whom they would eventually be united in heaven.[89] Also personal documents show parental sadness about the death of their children, but in a style different from what we now perhaps would expect. The passages in the diary of Peter Hagendorf, a German soldier during the devastating Thirty Years War, about the death of several of his children show parental love and sadness about a shocking event, but expressed in a restrained, concise and compact style.[90] Many other personal documents show how acceptance of harsh reality and resigning to the will of God went together with attachment to, affection for, and grief about the beloved child.[91]

Family grief and sadness were also visualized, probably most frequently in Northern Europe, with initially strong symbols such as blowing bubbles or a skull added, through seemingly deep sleeping babies, or in a combination as with *Memento Mori* (before 1657) by Luigi Miradori (1605–1656), which shows a deep sleeping baby holding in its right hand a big terrifying and scary looking skull.[92] In the seventeenth century, this became in particular in Northern Europe a genre, evidence for the increasing expression of emotions with children passing away. Sidèn analyzed seventeenth-century portraits of children from the royalty and nobility including children passed away prematurely to show the important role of those children not only for the family's genealogy but increasingly also for the family's emotional culture.[93] Christian boy martyr legends in late medieval England, very similar to the body of a young boy martyr in an early fourteenth-century Cologne bust (*c.* 1310–25), represent a longer tradition of texts as "a space for grief," in particular mother's grief.[94] The *Portrait of Bia de Medici* (*c.* 1542) by Agnolo Bronzino (1503–1572), made after her death aged six year, shows how important it was for her father Cosimo to keep a memory of his beloved daughter who was born before his marriage, not his wife's daughter, and not included in family images.[95]

Parents knew the harsh reality and often panicked when their children became sick. They were aware of the fatal effects of regular epidemics of the plague, smallpox, typhoid and dysentery to list only some of the most common of disasters that could hit their children, they showed deep grief when they died, and they wanted to keep a memory of them. Also the Dutch Republic, albeit at the time one of the richest countries in the world, was subjected to the *Ancien régime*'s demography with about half of newborn children never reaching adulthood and mostly dying at a young age, in poor and well-to-do families alike.[96] Well-to-do Dutch seventeenth-century parents, realistic about their children's chances of survival, commissioned portraits of their children while still very young because of the high risk of premature death. As a result, almost

half of the children in Dutch seventeenth-century child portraits were aged between zero and twelve months. The anonymous *Dordrecht Quadruplets* (1621) with four children of Jacobus Pietersz. Costerus and Cornelia Jans Coenraadsdochter, is evidence of letting portray your children as soon as possible. One girl, Elisabeth, died soon after her birth and in a postmortem portrait she is lying on a cushion with around palm branches and rosemary. This was a Catholic tradition, continued by many Calvinists because the Calvinist doctrine of predestination was applied differently for the very young in the articles of the Calvinistic Synod of Dordrecht (1618–19). God was not condemning children to "eternal damnation" and "God-fearing parents ought not, therefore, to doubt the election and salvation of their children, whom God has taken from this life in their infancy." This made it easier to bear the grief and to give space to let depict dead children, sometimes even as angels.[97]

Indeed, also funeral portraits of girls and boys on their deathbed were commissioned, a tradition starting in Flanders at the end of the sixteenth century, with the most still preserved portraits, several dozens, produced in the Dutch Republic. *Girl from the Van Valkenburg Family on Her Deathbed* (1682) by Johannes Thopas (c. 1620–after c. 1682) shows the daughter, aged about two years, of either Christoffel or his brother Mattheus van Valkenburg who belonged to the ruling elite of Haarlem. The moving *Young Boy on His Deathbed* (1645) by Bartholomeus van der Helst (1613–1670) evokes sadness and grief of parents and other members of the family. It shows a peaceful looking child, probably a boy, on a bed of straw, so that his soul would not attach itself to the bed (Figure 12).[98] Those "most terrible pictures" that "show the body of a dead child" continue to move the viewer.[99]

Grief and sadness were also visible in many family portraits with children already deceased. The death of children became an important painting genre and is evidence for the affective value of children in this period.[100] The negative idea about infancy by Aquinas who compared children until seven years with an insane and the fact that infancy was a very fragile stage, did not prevent parents from cherishing this stage and from mourning when this stage suddenly ended. Those parents' emotional standards thus seem to follow the more child-oriented humanistic discourse.[101] This was visible in family portraits such as the anonymous *The Great Elector Frederick of Brandenburg and His Wife Louise of Orange and Their Children*, with three of them already passed away and depicted as angels in the background, and with from the three surviving children Wilhelm Heinrich passing away about twelve months later.[102] Also *Three Children from the Tjarda van Starckenborgh Family* (1654) by Jan Jansz. de Stomme (c. 1615–1657/8), so called because he was deaf and thumb, is a mix of pride and sadness in this rich and mighty Groningen family. Two girls from the three children portrayed died very young; in the clouds at the background is a head probably referring to a previously deceased child, named Lambert. The children look rather startled and gloom and the painting shows next to family and parental pride parental sadness. It resembles fifteenth-century paintings in showing restrained emotions.[103]

FIGURE 12 Bartholomeus van der Helst, *Young Boy on His Deathbed* (1645), oil on canvas, 63 × 90 cm (Gouda: Museum Gouda, object no. 55322; reproduced by kind permission of Museum Gouda, photograph by Tom Haartsen).

Mother and Child

The visualization of the emotional relationship between mother and the young child shows a loving and protecting relationship with several ways of coping with child's nature.

A Loving and Caring Relationship

Visualization of motherly love started with the humanization of the Madonna, with *Virgin and Child* (1310–20) by the Sienese painter Pietro Lorenzetti (*c*. 1280/5–1348) as an early example, made before the outbreak of The Plague. In this painting the virgin is still depicted in the thirteenth century dominating traditional byzantine style. But the relationship between mother and child is already more humanized and thus emotionalized. Maria looks lovingly at her child while holding hands with him and the child reacts in the same way.[104]

A further step in humanization shows *Nativity* (*c*. 1420) from Book of Hours by the Master of the Morgan Infancy Cycle. This illumination shows the birth of Jesus in a cozy atmosphere of motherly love with the holy figures just human beings. Maria hands the baby over to the midwife, an adaptation of the original story to make it more

attractive for contemporary readers. Joseph sits beside the fire and in the background are the ox and the donkey.[105] Striking in Jan Van Eyck's *The Virgin with the Canon Van der Paele* (1436), about the future passion and resurrection of Christ, is the humanization of the relationship between Maria and Christ. He looks anxiously with in his right hand a parrot and gives flowers to his mother who holds him tenderly with her right hand. While several adults, including canon Joris (George) Van der Paele, Saint George, and Saint Donatianus van Reims, the patron of the city (Bruges), chapter and church, are depicted too, the life-like small and naked Jesus plays the main role. Van Eyck had a keen eye for showing the childish emotions (Figure 13).[106]

The Madonna's humanization continued with the subject of *Maria lactans*. It was developed in Italy and soon also occurred in the Southern Netherlands as in *Maria with the Child Jesus* (c. 1500), one of many Madonnas by Jan Gossaert (c. 1478–c. 1535). This Flemish devoutly looking Madonna with almost Boticelli-like transparency looks endearing to her child, while holding him with her right hand. The child, with in his hand an apple, holds his head to Maria's right breast, but is not interested in drinking, while Maria is not offering her breast to him either.[107] *Nocturnal Nativity* (c. 1527–8) by

FIGURE 13 Jan Van Eyck, *The Virgin with the Canon Van der Paele* (1436), oil on panel, 122.1 × 157.8 cm (Bruges: Groeningemuseum). Credit: Heritage Images/Contributor (Hulton Fine Art Collection).

Lorenzo Lotto (1480–1557) shows the child just after birth with his umbilical cord visible, a further step into a more realistic portraying of the very young, to which, among others, also Albrecht Dürer's *Four Books on Human Proportion* (*c.* 1527–8) contributed.[108] In Hans Holbein the Elder's (1460–1524) *Madonna with Sleeping Child Jesus* (*c.* 1520), one of the earliest examples in southern Germany, Maria sits on a couch in an aristocratic-like blue dress with "the naked, half-sleeping Christ Child placed on her exposed breasts."[109]

The humanized Madonna remained also after the Reformation important in Catholic regions[110] but it also prepared the way for its profane counterpart of caring and loving mothers, often with the baby in a crib. Such pictures were produced in great numbers, as by the seventeenth-century Dutch Republic painters such as Nicolaes Maes, Gerard Ter Borch, Pieter De Hooch, Frans van Mieris, and many others. Their portraits were about real people and their genre paintings a mix of observation of real life and mission (see Chapter 4). Mission was not the intention of Rembrandt in the drawing *Woman Sitting Up in Bed with a Baby* (*c.* 1635), possibly a portrait of his wife Saskia with their first and early deceased son Rumbartus. It shows a loving mother with a sleeping baby who looks directly to the observer, probably the artist, and also father and husband.[111] Another drawing by Rembrandt, *Baby Sleeping in a Cradle* (*c.* 1645), shows the emotion of satisfaction.[112] Infants in a cradle and mothers feeding their child were frequently observed and visualized by Rembrandt as in *Two Sketches of an Infant in Swaddling Clothes Fed from a Bottle* (*c.* 1635) with "only a suggestion of fingers holding the bottle" and with satisfaction being the dominant emotion.[113] In *Sheet of Studies of Heads and Three Sketches of a Woman Holding an Infant* (*c.* 1635) we see three breastfeeding mothers with affection nurturing their almost sleeping babies.[114] The profane version of breastfeeding was thus popular and sometimes connected to a mission of recommending breastfeeding by mothers or choosing a good wet nurse.

The wet nurse in *Catharina Hooft with Her Nurse* (*c.* 1619–20), with her identity still unknown, must have been a very good one. Portraits of nurse and child were not rare in the seventeenth century,[115] but this portrait was made by no less than Frans Hals. Catharina, the only daughter of Geertruyd and Pieter Jansz Hooft, was born on December 28, 1618, in Amsterdam, and married sixteen-year-old with Cornelis de Graeff, the later burgomaster of Amsterdam. In portraying Catharina when about one-year-old Frans Hals observed a variety of pleasant emotions of the couple: happiness and enjoyment, love and care, cheerfulness together with a convincing pose that expresses: here we are. They were positioned along the sacral model including the presentation of an apple as in Gossaert's Madonna, but the Christian symbolic meaning of the apple referring to Eve eating the forbidden food in the Paradise seems less important. Catharina, ignoring the apple, plays with a golden instrument with bells, choosing pleasure instead of food (Figure 14).[116]

The secular version of mother and child became popular. It often combined observation of a reality with a message about good motherhood. Without message is *The Sick Child* by Gabriel Metsu (1629–1667), characterized by care, love, and concern, and according to Brown "the most touching image of maternal love" of the seventeenth century with the "tenderness of the mother for her child echo[ing] … the theme of the Virgin Maria

FIGURE 14 Frans Hals, *Catharina Hooft with Her Nurse* (c. 1619–20), oil on canvas, 86 × 65 cm (Berlin: Gemäldegalerie Staatliche Museen). Credit: Print Collector/Contributor (Hulton Fine Art Collection).

and the Holy Child."[117] This image fits Hannah Newton's observation about "emotional experiences of both parents and children in times of childhood illness in early modern England."[118] Rembrandt's *Four Sketches of Saskia* (c. 1635–6) brings us face to face with an observed emotional relationship between child and mother. The child is probably Rumbartus as little baby, whose expression is not visible while lying in the arms of his loving and cherishing mother.[119] *Mother with Child on Her Arm* (s.a.) by Nicolaes Maes (1634–1693) shows the essentials of the emotional relationship between mother and child with only a number of stripes to show the subject. The about twelve-month-old child with the usual crash helmet looks somewhat distracted or perhaps nervous and anxious, surprised about what it could expect, while the happy mother is not looking at the child but together with the child to something or someone we cannot see.[120]

Protection against Danger

Herod's order to slaughter all boys under the age of two became as *Massacre of the Innocents* a popular theme for numerous paintings and drawings to portray mothers who desperately but in vain attempted to save their babies and toddlers. Giotto's *Massacre of the Innocents* (1303–5) in Padua's Arena Chapel shows courageous mothers who risk

their life to protect their children by fighting with their bare hands against long, strong and well-armed soldiers. Eventually, however, their desperate emotions dominate and "tears appear as streaks running down the faces of weeping mothers." Their panic, fear and deep sadness evoke feelings of compassion and indignation on the viewer's side.[121] In an illumination in *Book of Hours* of the Master of the Morgan Infancy Cycle (c. 1415), Herod, King of Judea (c. 72 BC–c. 4 AD), sits on his throne while one of his soldiers impales one of the ignorant children, embraced desperately and affectionately by his mother who looks at the soldier with a pleading look. When another soldier plans to hack into another child, the child's mother stops him for a moment by countering the sword with her bare hands. The child looks almost surprised at the soldier who is confronted by the child's protecting mother. The intensive emotions of motherly love and courage during this violence against children could hardly be portrayed more intensely.[122] The resistance of the mothers next to their emotions of panic and desperation became even more prominent in later pictures. In *The Massacre of the Innocents* (c. 1486–90) by Domenico Ghirlandaio (1448–1494) a woman pulls a soldier's hair, and *The Massacre of the Innocents* (1590) by Cornelis van Haarlem (1562–1638), shows extreme violence by soldiers such as cutting through a child's throat and mothers who resist fiercely, for example, by gouging out "the eyes of a soldier they have brought to the ground." Also in *Massacre of the Innocents* (1625–9) by Nicolas Poussin (1594–1665) the story is depicted very physical with a fiercely resisting mother who tries to protect her child while a soldier with his foot already set upon the child is about to cleave it with his sword (Figure 15).[123]

In another story, depicted in *Salomon's Judgment* (c. 1537) by Lucas Cranach The Elder (1472–1553), Salomon's test of motherhood became a test of motherly love. Cranach visualized the crucial moment when the executioner was ready to divide the child into two parts at the direction of judge Salomon who is sitting in the back. Then, one of the two women, the real mother, was ready to protect her child and implored Salomon to save her child even if she had to cede it to the other woman forever, a clear evidence of mother love.[124]

Coping with Child's *Sui Generis*

Coping with child's specific nature and showing a *sentiment de l'enfance* could invoke and could be initiated by a variety of emotions of mother and child, from extreme rage, contrarian behavior, fear, and anxiety to curiosity and satisfaction in the child, and from anger, impatience, and control to affection and happiness in the mother. Rembrandt's *The Naughty Boy* (1635), the imaginational drawing at the start of this book, shows a young mother successfully struggling to keep her emotions under control while trying to manage typically young child's rage. A similar situation with less intensive emotions in *Hasdrubal's Wife and Her Children* (c. 1490–3) is packed by Ercole de' Roberti (c. 1450–1496) in a historic story inspired by the Carthaginian Hasdrubal family, symbol for the rivalry between Carthage and Rome. Two naked naughty boys lament, are contrarian, and do not obey their mother, who, however, succeeds in controlling her temper and in letting them eventually do what she wants them to do.[125]

FIGURE 15 Nicolas Poussin, *Massacre of the Innocents* (1625–9), oil on canvas, 147 × 171 cm (Chantilly: Musée Condé). Credit: Heritage Images/Contributor (Hulton Fine Art Collection).

Rembrandt's prosaically titled drawing *Sample Sheet with an Old Woman and a Screaming Child and Five Half Figures* (c. 1638–9) shows how a child copes with its fear. A woman and a toddler are in an austere room, certainly not that of a well-to-do family. The woman, perhaps the child's grandmother or a maidservant, with an empty basket on her right arm, wants to go outside to buy something. She prepares to open the door and reaches with her left hand to the right hand of the toddler, whose sex cannot be determined.[126] The child, in the center of the drawing, wants to come along. But the child is insecure, anxious, frightened and sad, wiggles on his legs, cries, and asks for support from the adult. Those emotions are expressed by its face and by the design of the hands. To go outside together with the woman, it has to go down a threshold or step, but it may have just tripped over that. It is dressed in a thin cap instead of the usual drop hat, and the disheveled hair and the stripes on the face may indicate injuries. The child presses its left hand against the inner wall for support, afraid to take the step without support. But the woman barely turns and doesn't seem to intend to lift the child off the step. Her features express impatience for she wants to go outside, but she does not want to abandon the frightened and sad child (Figure 16).

FIGURE 16 Rembrandt van Rijn, *Sample Sheet with an Old Woman and a Screaming Child and Five Half Figures* (*c.* 1638–9), drawing, 218 × 185 mm (Berlin: Staatliche Museen zu Berlin, Kupferstichkabinett, KdZ 2316; credit: Staatliche Museen zu Berlin, Kupferstichkabinett/Volker-H. Schneider Public Domain Mark 1.0).

In a quite similar situation in Pieter de Hooch's (1629–1684) *The Courtyard of a House in Delft* (1658), a maidservant going outside with a young girl takes a few steps down together with the child. Both look joyfully and affectively to each other while the mother with her back turned to them looks a little bit impatient, like the woman in Rembrandt's drawing.[127]

Rembrandt's *Mother with a Crying Child That Is Afraid of a Dog* (c. 1635) (see the book's front cover) shows motherly guidance, comfort, and consolation in reaction to the child's anxiety and curiosity in a picture in which the three faces of the mother, the child, and the dog come closely together. No wonder that the toddler is afraid when looking straight into the eyes of a curious dog. But the child, while afraid, is curious too. The mother embraces the child lovingly and protectively with her arms, but does not chase the dog away. Apparently she tries to put the child at ease: it is not that scary, she seems to say, for the curious dog is not aggressive and does not make any barking movements. Protection and affection go together with an understanding of child's *sui generis*.[128] Rembrandt laid down emotions of real people in hundreds of drawings with special attention for children.[129]

Support and guidance also characterize *Woman Carrying a Child Downstairs* (c. 1635). A mother, carrying her rather heavy baby who clings and surrenders completely to her, goes down a spiral staircase, anxious not to trip. They hold each other tightly with care, love, and trust.[130] Two other drawings deal with teaching a child how to walk. *Two Women Teaching a Child to Walk* (c. 1635–7) shows the emotions of a determined woman supporting an anxious, insecure and scared child with a protective hat against falling.[131] *Woman Teaching a Child to Walk* (c. 1640–5) shows with just a few stripes an obviously very happy mother as the eyewitness of her little child that, secured to a string, takes its first steps.[132] *Woman with a Pissing Boy* (c. 1657–60) shows the very daily life scene of motherly concentration, attention and support for a boy who does what his body says he must do, pissing in an Amsterdam canal.[133] From the sixteenth century, pissing boys were frequently painted under influence of the medical sciences and classic physiological theories based on the four humors. Semen would, argues Laneyrie, metaphorically be designated by urine and the emphasis on boy's sexuality would explain that early manifestations were welcomed and in this way visualized.[134] But this seventeenth-century drawing tells first of all how a mother supports the purely physiological urge of a small child who needs to pee.

Another form of motherly support, the preparation of reading, emerged as motif of a mother in the twelfth century as an allegoric representation of Grammar, one of the seven *artes liberales*. The drawing *Mother and Child with a Picture Book* (c. 1620) by Jacques de Gheyn II (1565–1629) was one of the first in the transformation of the allegoric figure into "a flesh-and-blood mother" with the expression of motherly care and child's attention and curiosity while "reading" pictures. A caring mother holds the child and the drawn picture book with her left hand and so allows the child to carefully follow the pictures with the index finger: cultural transmission from one generation to the next within an emotional mother–child relationship.[135]

Father and Child

There are also visualizations of caring and protecting fathers.[136] An early example is *The Beheading of Saint George* (c. 1380–5) by Altichiero da Zevio (1330–1390). A boy stands with a curious and anxious face in front of the audience with his father

at the imminent beheading of Saint George. He seems not to realize at first what is really happening. But just when the executioner with his sword is ready and the saint is kneeling with bowed head, his protecting father takes him by the arm to pull him away from this terrifying spot.[137] Initially, most paintings of father and child emphasized family's lineage and fatherly pride as emotional expression of his household position in contrast to motherly love, affection, and care. An example is *Portrait of Federico da Montefeltro and His Son Guidobaldo* (c. 1475) by the Spanish painter Pedro Berruguete (1450–1504)/the Netherlandish painter Justus van Genth (c. 1410–c. 1480), who both worked for Federico. The duke seats on a throne and reads a voluminous book, a reference to his reputation as a humanist. He is clothed in his armor over which he wears a fine cloak, a reference to his reputation as an army commander, further emphasized by the symbols of military power in the room. His son Guidobaldo stands next to him. He is clothed as a noble man with, in his hand, a baton referring to his future destination as duke and military commander. Seriousness and determination characterize father and son.[138]

In the sacral and profane *The Confirmation of the Rule of St. Francis* (1483–6) by Domenico Ghirlandaio emphasis on the family lineage goes together with space for typically childish behavior. None less than Lorenzo Magnifico (1449–1492) is through a Renaissance time-machine together with his three sons the witness of a religious event in 1223, the confirmation of the Regula Bullata and the foundation of the order of the Franciscans by the pope. While Lorenzo seemingly devoutly looks ahead, two of his sons look to the right, away from the main event and curiously interested in what happens elsewhere, as children normally do.[139] In *Francesco Sassetti and His Son Teodoro* (c. 1466 or 1485) and in *A Grandfather with His Grandchild* (c. 1490), Ghirlandaio brought the (grand-)father–son relationship nearer to the portraying of mother and child when showing reciprocal tenderness, trust, and affection between generations (Figure 17).[140]

Almost two hundred years later, Rembrandt, as draughtsman the frequent observer of daily life, sketched a relaxed and cheerful (grand-)father–child relationship for the less well-to-do in *Sketches of an Old Man with a Child* (c. 1640), with in one sketch a small child, standing on perhaps grandfather's lap, tugs at his skullcap while in another "the child has triumphantly removed the cap," causing a moment of pleasure and happiness for both.[141]

In contrast a complete lack of fatherly responsibility through an irrational belief and addiction happens in the *Alchemist* (c. 1558), an engraving by Pieter Bruegel the Elder. Father tries fanatically to transform ordinary metal into gold and silver and in the end no money is left for his wife and three children. In the picture a scholar warns against the belief in alchemy. The three children, a boy with two girls, desperate from hunger, help each other to climb into the cupboard to search for some food with the boy unsuccessfully trying to get off his head the pot in which he was searching. Eventually we see in the picture's right corner the children, now resigned and led by their parents, walk to the local workhouse. With neither money nor food the community takes over the parental responsibility.[142] Anthony van Dyck's *A Genoese Nobleman with His Two*

FIGURE 17 Domenico Ghirlandaio, *A Grandfather with His Grandchild* (*c.* 1490), oil on panel, 62 × 46 cm (Paris: Musée du Louvre). Credit: DEA/G. DAGLI ORTI/Contributor (De Agostini Editorial).

Children (1625–7) with the father and his children alone shows responsibility and affection. While the father holds with his hand his little son, next to him stands his slightly older sister, dressed in mourning like her father. Mother has passed away and the father, now alone responsible for the upbringing, wanted to be portrayed in this way together with his children in an emotional unity of restrained sadness, affectivity, and seriousness.[143]

In the Child's World

Portraits with the main focus on the child became more frequent from the sixteenth century in Italy and Flanders and became a popular genre in the European Megalopolis. It started with showing parental pride instead of family lineage, but it was more. Also children's emotions became visible and this means an increasing interest in understanding them. This started in family portraits with the central position of father slowly taken over by one or more children. Portraits of only children strengthened this development, which was directed by an increasing awareness of the child's specific stage of life, notwithstanding the often seemingly adult clothing and physical posture.

Portrait painting was a privilege of the well-to-do, but genre painting and even more drawing, based on the observation of daily life, often depicted also the less fortunate. We first look at pleasant and positive emotions including happiness, enjoyment and exaltation, exploration, curiosity, and seriousness, surprise, and shyness,[144] then at unpleasant ones such as sadness and grief, pain and agony, fear and horror, and anger and rage.

From Happiness and Joy to Satisfaction, Curiosity, and Seriousness

From the sixteenth to the seventeenth centuries, increasingly portraying children's happiness and joy was the intention of upper-class parents and artists. Those children's portraits served initially often also for possible future connections or marriage deals, and children's joyfulness, therefore, was partly posed. But through all that rich stuff, such as good clothes, good food, proud parents, and a plenty of toys, were visible both happiness and joy as sadness and fear.[145] An exhibition with a sample representing the most beautiful child portraits in the Netherlands and Flanders titled *Pride and Joy* in 2000–1 in Haarlem and Antwerp showed that the children's parents preferred their children to be joyful and intended to let "record the features of a specific child."[146] They, in contrast with Peter Stearns's assumption that this was a modern in the late nineteenth-century emerging parental ambition, aimed at making their children happy, an aspect of parental responsibility not incompatible with other intentions such as making them pious believers in this profoundly religious culture.[147] We first will look at children together, then to individual children.

Children Together

Happiness, Curiosity, and Seriousness

Fra Angelico (*c.* 1395–1455) shows in *Saint Lawrence Giving Alms to the Poor* (*c.* 1447–51) happiness through a very small detail of the painting. A girl and a boy walk away after receiving alms from Saint Lawrence, patron of the poor and the painting's central figure. The girl, holding the alms, tenderly places her hand on the right shoulder of the boy who places his left hand on the girl's left hand. They look happy and almost delighted (Figure 18).[148] Raphael's *Sistine Madonna* (*c.* 1512–13) became famous because of the marketing of a small detail, the two little angels below, now to be found on almost all Italian tourist knickknacks. Apart from that, the painting shows the expressive curiosity of little children in their own emotional world within an adult environment of adults (Figure 19).[149]

Much later Peter Paul Rubens's strongly humanized *Christ with Little John and Two Angels* (1615–20) contains sacral elements like two putto angels, a boy and a girl, and the lamb as attribute of John. It however first of all shows four little innocent nude children, two rather chubby little friends with happy almost secularized putto angels participating in this pleasant, happy, and tender togetherness.[150]

FIGURE 18 Fra Angelico, *Saint Lawrence Giving Alms to the Poor* (c. 1447–51), fresco, 410 × 271 cm (Vatican: Cappella Niccolina). Credit: Print Collector/Contributor (Hulton Fine Art Collection).

Portrait of the Three Brothers Hendrick, Johannes and Simon (c. 1631) by Thomas de Keyser (1596–1667), a much-in-demand Amsterdam portrait painter, shows two proud brothers, elegantly dressed in beautiful collars around their necks, with their youngest brother seated between them instead of in a highchair. They all look at the viewer, the oversized baby, naked with a cross on his chest, a bit uncomfortable. On the wall is a piece of paper with the boys' first names and ages, but their identities have not yet been identified.[151] Cornelis de Vos, who excelled in portraying happy children, in *Magdalena and Jan Baptist De Vos, Children of the Painter* (c. 1621–2), one of the first of his series of children portraits, depicted his two eldest children, three-year-old Magdalena with crown together with her younger two-year-old brother Jan Baptist, in a life-sized portrait, normally reserved for the aristocracy. The two children look happy, childlike, and innocent. They seem to be surprised by the painter as if he was taking a photograph while they were concentrating and nicely playing with cherries and a peach. The children are dressed beautifully because of parental pride but also of public relations; the portrait would have hung in his house to show potential customers his reputation.[152] The *Group of Four Children* (1641) by Pieter Claesz. Soutman (c. 1585–1657) shows a dense group of two boys aged respectively eight and five years

FIGURE 19 Raphael, *Sistine Madonna* (*c.* 1512–13), oil on panel, 265 × 196 cm (Dresden: Gemäldegalerie Alte Meister, Staatliche Kunstsammlungen). Credit: Fine Art/ Contributor (Corbis Historical).

and two girls about seven and three years, probably from a wealthy Haarlem Family. The artist focused on the little girl, who is placed on a cart and so well visible behind her brothers. She looks at everything with a curious face while her elder brothers and sister are clearly posing.[153]

Artists such as Soutman and De Vos portrayed the well-to-do bourgeoisie; others focused on the wealthy aristocracy. In *The Children of Habert de Monmort* (1649), the Flemish-French painter Philippe de Champaigne (1602–1674) portrayed the eleven children of man of letters and supporter of Descartes Henry Louis Habert de Monmort (1600–1679) in a side-by-side placed children's group. The youngest, a little girl, is with her sisters and brothers on both sides purposely placed on a platform to draw the viewer's attention. Against the platform a dog is sitting up as a sign of good education. All look delighted and are joyful, some looking at each other, some others at the viewer. Commissioning a picture with the youngest girl that way in the center is evidence of fatherly pride, love and satisfaction about the child's happiness.[154] Anthony van Dyck depicted *The Balbi Children* (1625–7), so called because the canvas was owned by the wealthy Balbi family from Genoa. The children, anonymous, are linked to another rich

FIGURE 20 Anthony van Dyck, *The Balbi Children* (1625–7), oil on canvas, 219 × 151 cm (London: The Trustees of the National Gallery). Credit: Print Collector/Contributor (Hulton Fine Art Collection).

Genovese family, the Franchi, and their garments betray their well-to-do and aristocratic background. Three brothers, standing on the step of an Italian palace, look at the world with bright eyes. The eldest looks while proudly pointing to his tame crows while his younger brother stands on the stairs, lips together, and shoulders straight. He looks concentrated while protecting with his left arm his little brother, the youngest of the three boys, who with some effort holds a bird that wants to fly away. Van Dyck lets us enter in the world of three young self-conscious boys (Figure 20).[155]

Much more posed, with restrained emotions that fit royalty, is Van Dyck's *The Three Eldest Children of Charles I* (1636), commissioned by the queen. Five-year-old Charles, the future king Charles II (1660–1685) but not yet knowing that he would succeed his father after his decapitation during Oliver Cromwell's regime, looks like a future king, determined and conscious of his dignity. Next to him is three-year-old James, the later King James II of Scotland (1633–1701), and on the right four-year-old Maria (1602–1694), the only one looking straight to the viewer. She would become the wife of William of Orange, Dutch stadtholder (1650–1702), and together king and queen of England and Scotland. They wear beautiful clothes and pose with at their feet two dogs as a symbol of power.[156]

FIGURE 21 Bartolomé Esteban Murillo, *Children Eating Grapes and a Melon* (1645–50), oil on canvas, 145.9 × 103.6 cm (Munich: Alte Pinakothek). Credit: Print Collector/Contributor (Hulton Archive).

In contrast with those well-to-do children Bartolomé Esteban Murillo (1618–1682) in *Children Eating Grapes and a Melon* (1645–50) shows Sevillian boys in the margin of society. In this remarkably romantic image of childhood the children notwithstanding their poorness seem to be happy instead of sad while eating grapes and a melon (Figure 21).[157] Inspired by Caravaggio (1571–1610) and, among others, Frans Hals, a genre developed that made the well-to-do acquainted with children's poverty by depicting them as poor but also happy children. Another example is Jusepe de Ribera's (1591–1652) *The Club-Foot* (1642) about a happy and cheerful looking boy notwithstanding his deformed foot.[158] In the late Middle Ages poor and marginal children were seldom visible in art with the exception of orphans as in the façade of *Ospedale degli Innocenti* in Florence, and of poor children in stories of the saints. From the sixteenth century with more attention for the rural community in Bruegel's pictures this changed, in particular in genre painting and in drawings, as by Rembrandt. A special topic form paintings of dark colored child slave servants in wealthy aristocratic or bourgeois families, as in *Portrait of Elena Grimaldi Cattaneo with a Servant Holding Her Umbrella* (*c.* 1632) by Van Dyck with emphasis on the color difference between the lady's pale face and hands and the servant's dark color.[159]

Playing Outside

Children's Games (1560) by Pieter Bruegel the Elder forms an encyclopedia of children's emotions.[160] This *Wimmelbild*, an encyclopedic picture full of people and situated around a tavern and a church, is in its style comparable with *The Battle between Carnival and Lent*, the one hundred nineteen *Netherlandish Proverbs*, and *Kermis at Hoboken*, all made the year before. But while children also occur in such drawings, *Children's Games* is extraordinarily "in the history of painting" in creating a world of childhood, "a town in the hands of children," and a painting that inspired Bruegel's successors.[161] Bruegel shows the child's world in all four seasons with a great number of games during Epiphany, Carnival, and midsummer bonfire, including "learning to swim with the aid of an inflated ox-bladder."[162]

Face to face on the canvas, the first impression is one of an encyclopedic story of the child's world with a variety of children's emotions packed in more than ninety different games. The scene is the main square of a town with an Italian-like town hall and houses in Flemish style, with on the background a "bucolic landscape" with a pool and farmhouses.[163] The vast surface is occupied with children who play knucklebones, leapfrog, blind man's buff, with marbles and with dolls, doing handstands, roly-poly, exercises around a beam, hop-scotch, spin with their tops, twirling like dervishes by the river, paddling, and learning to swim, and even marrying.[164] The games vary from imitating adults with weddings, altar-dressing, baptismal processions, a girl playing at shop and scraping bricks for pigments—a reference to Antwerp's reputation for the best red pigment in Europe—to reflective ones among them the whirligig. Among them are also physical abilities like swimming, games for simply fun such as playing with a hoop, and games resulting into dispute and fighting.[165]

This is also an encyclopedia of children's emotions whose affective tone varies in connection with specific games from happiness to enjoyment, from concentration to lust, from exuberance to restrained joy, from calm to aggression, from uncertainty to self-confidence. Laneyrie-Dagen interprets the image as "anarchic agitation, a frenetic exercise of the body excluding that of reason." But it could also be seen as a typically children's way of spontaneous play.[166] Bruegel gives the children "a clearly legible expression ... well beyond stock characterization, through the play of facial features and body language." This led to individualization of the children with their emotions.[167] This enigmatic painting got a multiple interpretation, starting with Karel van Mander's description in *Schilderboeck* (1604) as a picture "of all kinds of children at games" and of "innumerable little allegories."[168] In modern literature three approaches dominate: a folkloristic and encyclopedic one, a positively educational one, and a warning moralistic one.[169]

The folkloristic and encyclopedic approach, reminiscent of Van Mander's focus on the games, approaches the painting as a compendium of children's behavior and related emotions, visible by their games. Fitting the humanistic and Renaissance discourse, the painting does have remarkable "affinity with ... François Rabelais's (1483/94–1553) enumeration of games in Chapter 22 of his Gargantua," published in 1535, twenty-five years before Bruegel's painting, which "finds a pictorial equivalent to Rabelais's exuberant language and creative wit."[170] This shows the broader discourse about childhood represented by Bruegel and his successors. Moreover, playing was not only discourse, but also reality. It was part of daily child life in the late Middle Ages and early modern Europe. Evidence for this form, apart from the many toys described in texts such as those by Rabelais and from the images before Bruegel in fifteenth-century Dutch books of hours and after him in sixteenth- and seventeenth-century paintings and drawings, the results of archaeological research. That's why we know that many kinds of games occurred in great numbers from the late Middle Ages in Europe.[171]

It was not just that children played, but also that they were stimulated to do it, by humanists like Erasmus but also by leading orthodox Protestants such as the Dutch orthodox-Calvinist Wittewrongel, on which more below, who emphasized in *Oeconomia Christiana* that children, in particular the youngest, needed "considerable pleasure" and that it was a particular blessing that boys and girls could play on the street. In recommending playing on the street, he referred to the Bible, Zach. 8:5 and assumed that "the limits of Christian moderation and decency were not exceeded." Child's play was thus considered necessary for the young child's development.[172] This educational approach, for the rest compatible with the folkloristic one, puts the painting "in the positive light of humanist ideals of education." The playing of children did fit the idea that play and playground were essential for the development of children.[173] By letting one of the children "peering through an adult mask" to the viewer, the painting enables us to enter into the child's world as a specific part of the life cycle.[174] This positive perspective mirrors the contemporary innovative educational discourse and the role of

education and children's development, and differs from "moralistic, negatively oriented readings" of the same humanistic discourse.[175]

According to this moral approach Bruegel is "holding up a mirror to us," possibly in allusion to Sebastian Brant's (1457/8–1521) *Ship of Fools*: "What you do, that your child will do, / In evil children copy you." Or, the child as imitator of adults, well known in many Jan Steen's paintings.[176] The painting as a whole would illustrates the popular adage *it is child's play*, meaning in Dutch that something is easy to do. This interpretation would make Bruegel compatible with Erasmus's *The Praise of Folly* in accepting all aspects of the human character, its strengths as well as its weaknesses.[177] This approach, popular in the 1970s and 1980s iconography, interpreted the painting "through the prism of Netherlandish proverbs" present in emblem books such as by Jacob Cats. But the painting's adaption in seventeenth-century emblems "cannot ... be applied without qualification to a painting that was made a century earlier."[178] Indeed, transforming Bruegel into a moralizing Protestant Cats *avant la lettre* would be anachronistic.[179]

Without moral or educational layers, *Children Making Music* (s.a.) by the Rotterdam artist Cornelis Saftleven (1607–1681) expresses happiness, exaltation, and enjoyment in the child's world. Four children walk past the houses and attract attention with their music. They're just doing it for fun, for nothing indicates that they want to raise money or anything like that. The carnival-like parade is opened by a boy of about ten years old. He plays on the *rommelpot*, an instrument that requires "little musical skill," consists of "a pig's bladder stretched taut over an earthenware pot and pierced with a thick piece of straw," and produces sound "by moving the straw back and forth with moistened fingers." A second, slightly younger boy, dressed as a clown, closes the group. Two girls walk between them, the youngest who can barely walk, accompanied by the eldest. A toddler enthusiastically goes to meet the four children. Saftleven and colleagues such as Adriaen Brouwer (1605–1638) and Adrian van Ostade (1610–1685) depicted in such drawings children often somewhat caricatured, with extra round faces, flat noses, and exaggerated grimaces. But it remains a typically children's costume party without any adults visible, not even looking from a house's window: the shutters of the only visible window are closed (Figure 22).[180]

Initially, playing was often packed in complex symbolic and allegoric meanings like the *homo bulla* (man is a bubble) motif, used since classical times to indicate the frailty of human nature. This symbolic meaning faded to the background in the seventeenth century and the visualization of the purely childish play of blowing bubbles, practiced until nowadays, as in *Boy Blowing Bubbles* (1663) by Frans van Mieris (1635–1681), prevailed.[181] Also the depiction of the happy and joyful girl and boy who play bowl around their house in *The Bowlplayers* (c. 1660–2) by Pieter de Hooch is without such symbolism.[182]

Happy and curious children were also visualized individually, alone in their child's world. The genre was exceptional before 1500, but became popular in the sixteenth and seventeenth centuries.

Children's Emotions in Renaissance/Reformation

FIGURE 22 Cornelis Saftleven, *Children Making Music* (s.a.), drawing, 28.5 × 20 cm (Berlin: Kupferstichkabinett, Staatliche Museen zu Berlin, KdZ 13801; credit: Staatliche Museen zu Berlin, Kupferstichkabinett/Jörg P. Anders Public Domain Mark 1.0).

The Child Alone

Girls alone were initially mostly linked to the family lineage, as with the Spanish infant discussed above, or in *Young Princess (Perhaps Dorothea of Denmark)* (c. 1520) by the Flemish painter Jan Gossaert (c. 1478–c. 1535). This painting was probably made to present her on the marriage market of aristocrats and royalties, which explains the girl's serious and devotional look.[183] But increasingly, a child-oriented approach prevailed. In *Girl Opening a Door* (s.d.) by Paolo Veronese (1528–1588), situated in a luxurious house, a girl about ten or twelve years old looks through the opening of a huge door with excitement, curiosity and a cheerful smile. She is in an imaginary doorway, painted by Veronese in a fresco inside the Villa Barbaro in Veneto built by Andrea Palladio.[184] Titian (c. 1488–1576) portrayed children's fun in *Clarissa Strozzi* (1542), the two-year-old daughter of Roberto Strozzi and Maddalena de' Medici, who lived temporarily in exile in Venice, also Titian's city. Clarissa looks very cheerful and is lavishly dressed in jewelry around her neck and wrists. In that outfit she feeds the dog that sits nicely upright as a symbol for good education. Clarissa, however, looks the other way right, perhaps because another person enters the room. The girl's cheerfulness is strengthened by two naked angels who dance under the table on which the dog is sitting (Figure 23).[185]

Portraits by artists of their own children can bring us even more into the child's world, for the artist has not to take account a client's preference.[186] Famous examples are Rembrandt with his son (see at the end of this section) and the two Flemish fathers and painters Peter Paul Rubens and Cornelis de Vos. As a loving father Rubens depicted his daughter as a five-year-old cheerful looking girl in *Clara Serena Rubens* (c. 1616), not knowing that Clara (1611–1623) would pass away some years later.[187] With *Susanna De Vos* (1627) her father seems to have depicted a miniature adult because of her adult clothes. But close observation shows a posture of a child ready to start playing again after posing (Figure 24).[188]

Earlier her elder sister Magdalena was portrayed by her father in *Magdalena de Vos, the Artist's Daughter* (c. 1623–4). Family man De Vos portrayed his children individually, together, and as a family. Magdalena was portrayed threefold, individually, with her brother Jan Baptist (see above in section on children together), and within the family portrait. Magdalena, about five years old, looks invitingly at us as a happy and friendly young girl. The canvas might also have "served in the artist's home as a kind of advertisement," as the first portrait in a series of child's portraits made with a *sentiment de l'enfance* in mind.[189] Judith Leyster (1609–1660), the most famous female painter of the Dutch Golden Age, with *Head of a Girl* (c. 1630–40) in a style reminiscent to Frans Hals shows a young girl who shines and smiles in the sun light in a "masterpiece of happiness."[190] With *Girl by a High Chair* (1640) Govaert Flinck (1615–1660) shows a hitherto anonymous girl, probably the daughter of a wealthy Amsterdam citizen given the stately clothes and her golden rattle. She poses and looks like a lady. But her round ruddy cheeks and her hand on the child's chair, the same height as the girl herself, shows a happy, satisfied and cheerful toddler.[191] One of the most famous child portraits from the Dutch Golden Age, *Girl in Blue*

FIGURE 23 Titian, *Clarissa Strozzi* (1542), oil on canvas, 115 × 98 cm (Berlin: Gemäldegalerie Staatliche Museen). Credit: Francis G. Mayer/Contributor (Corbis Historical).

(1641) by Johannes Verspronck (*c.* 1603–1662), shows a six–eight-year-old anonymous girl as a dignified adult woman. But the "hint in her eyes and mouth" gives away that the girl, who looks self-conscious and satisfied, can barely contain her laughter, so providing a childish contrast to the grown-up gentility (Figure 25).[192]

In *Helena van der Schalcke* (*c.* 1648) Gerard ter Borch (1617–1681) portrays the daughter of the Haarlem cloth merchant Gerard van der Schalcke when aged two years. All attention goes to this toddler painted in full in a completely empty space and disguised as an elegantly dressed lady with a gold chain with jewels over her shoulders. She doesn't almost laugh like the *Girl in Blue*, but looks very cheerful and seems to enjoy posing.[193] A very exceptional girl's portrait is *A Girl as Huntress* (*c.* 1665) by Caesar van Everdingen (*c.* 1617–1678). Traditionally in history paintings boys, not girls were painted as hunters. Here a girl with pearl earrings and pearls around her neck holds a hunting dog by his collar and looks at us from an Italy-like landscape with a cheerful and determined glance.[194]

Also the first boy portraits primarily intended to show their place in the family lineage, as in the family portraits discussed above. But this did not prevent commissioner

Children's Emotions in Europe, 1500–1900

FIGURE 24 Cornelis de Vos, *Susanna de Vos* (1627), oil on panel, 80 × 55.5 cm (Frankfurt am Main: Städelsches Kunstinstitut, Städel Museum).

and artist from portraying them as happy children too, as in *A Boy Who Laughs* (c. 1498), attributed to Guido Mazzoni (1450–1518) and perhaps a portrait of the future Renaissance English King Henry VIII. When you do not think about his royal destination, you only see a fully smiling, cheerful and happy boy.[195] His only son Edward looks more serious in *Edward VI as a Child* (c. 1538) by Hans Holbein the Younger (1497/8–1543). The twelve-month-old Prince of Wales is already clothed as a king, his destined role (he became King Edward VI (1537–1553) at age nine, but died at age fifteen), and waves to his future subjects and perhaps is also blessing to them as the destined head of the Anglican church. But he looks like a dressed-up child with his chubby cheeks and the rattle in his right hand, which refers to his age.[196] Agnolo Bronzino, the painter of the Medici family, depicted with *Giovanni de' Medici* (1545) the probably second son of the wealthy and mighty Italian couple Cosimo and Eleonora de' Medici. The boy is clearly an aristocratic boy with, in his right hand, a goldfinch and with his body largely hidden under luxurious clothing. But his smiling, almost laughing eyes and his full and very round face show a typical two-year-old toddler who looks cheerful and happy.[197] Child's happiness is also the dominant emotion in *Two-Year-Old Boy* (1581) by Jacob Willemsz. Delff I (c. 1540–1601). The anonymous boy, from a rich family because of

FIGURE 25 Johannes Verspronck, *Girl in Blue* (1641), oil on canvas, 82 × 66.5 (Amsterdam: Rijksmuseum). Credit: Heritage Images/Contributor (Hulton Fine Art Collection).

his costume, holds a basket of fruit, a reference to his parent's fertility, in his left hand and in his right one a biscuit that he holds out to the dog as symbol of good education. But behind this symbolic outfit we see a young boy with a happy face. And that is how the parents and artist must have wanted it.[198] In short, it was perfectly possible to show the family lineage together with the *sui generis* expression of young children.

In the seventeenth century, however, the young boy was also increasingly portrayed without reference to the family lineage. The drawing *Willem Paets in His Cradle* (1665) by Frans van Mieris and commissioned by Father Cornelis Paets, who was Leiden's burgomaster, gives an almost timeless image of a three-month-old baby who sleeps satisfied with closed eyes. In another drawing the same baby is combined with his nurse who turns to him with a loving face.[199] Bartholomeus van der Helst portrayed with *Boy with Spoon* (*c.* 1644) a baby, probably his son Lodewijk, naked as was not unusual to emphasize his masculinity, and surrounded by symbols such as a dog, but fully realistic and a typically artist-father product.[200] In *Boy with a Basket of Fruit* (1685) by Jan de Bray (1627–1697) a cheerful boy with childish cheeks befitting his age is visible behind the symbols of fruit and ivy.[201] *Unidentified Boy* (1638) by Willem van der Vliet (*c.* 1584–1642) is characterized by a same double layering. The anonymous boy, probably

from a well-to-do Delft Catholic family because of his fancy and expensive clothes and the crucifix round his neck, is eighteen months old. Equipped with well-known symbols such as a basket of flowers—some already fallen on the ground, referring to what would happen after youth—the picture has the allure of an adult portrait, almost of a general because of the panorama behind the child. But face and expression are not that of a chastened general but of a cheerful and friendly toddler with chubby cheeks.[202]

In *The Taste (Boy with a Glass)* (1625–8), Frans Hals shows happiness and joy of a smiling and laughing boy by an innovative, almost impressionist style without references to the symbols of nurture, maturity, and impermanence. The still young child has a pitcher in his right hand, while he brings a glass to his mouth with the left hand. However, the boy is not yet drinking and the liquid in the glass is more reminiscent of water than of wine. Alone the pose of drinking is already able to make the boy happy.[203] The same artist shows happiness by making music with *Singing Boy with Flute* (c. 1623–5), one of many paintings by Hals of singing or laughing boys. All details of the painting, as the silver-colored feather on his beret, the suggested movement of his head, and the movement of his hand to the beat of the music, contribute to the joyful atmosphere.[204]

Next to happiness and joy also satisfaction, curiosity, and seriousness were shown in portraits of boys. The very young pickpocket in *The Pickpocket* (c. 1475) by Hieronymus Bosch (c. 1450–1516) expresses satisfaction mixed with a mean look. While the victim looks concentrated at a wizard who tries to cheat him, he is under the eye of the onlookers pickpocketed by an at least as concentrated boy, dressed in the robes of a Dominican by the artist to put those hunters of heretics and conjurers together in the same category.[205] Typically baby's satisfaction is visible in *Boy Sleeping in a High Chair* (1654), a child-oriented baby-boy painting by Johannes Verspronck (c. 1603–1662). This is an example of a long-term tradition, even more child-oriented than Flinck's seemingly lady-like *Girl by a High Chair*, and rather similar to a nineteenth-century painting by Jozef Israëls (Chapter 6).[206]

Curiosity dominates *Child Next to a Horse's Head* (1635–40) by the Roman artist Giuseppe Cesari (1568–1640). A boy aged five years and the horse look straight and inviting at the viewer. The child with its right index finger almost in the horse's mouth shows no sign of fear, as if this gesture is quite normal for him. He is determined and curious (Figure 26).[207]

With *Willem van Loon* (1636) Dirck Dircksz. Santvoort (1610–1680), in the 1630s–1640s the leading painter of children in Amsterdam, portrayed a thirty-month-old toddler who belonged to a rich Amsterdam family that made a tradition of letting portray their members by successful painters. The boy was clearly the pride of his family as is visible through his expensive golden medallion with his initials. He looks seriously and "intensely," but although a bit oldish through his black mourning costume, perhaps because of the death of an aunt, his face and gaze show the curiosity of a thirty-month-old child.[208] Rembrandt as a father and artist depicted Titus, the only child he saw grow up, several times. With *Titus at His Desk* (1655) he portrayed a boy aged fourteen

Children's Emotions in Renaissance/Reformation

FIGURE 26 Giuseppe Cesari, *Child Next to a Horse's Head* (1635–40), 42 × 28 cm (Berlin: Staatliche Museen zu Berlin, Kupferstichkabinett, KdZ 22376; credit: Staatliche Museen zu Berlin, Kupferstichkabinett/Volker-H. Schneider Public Domain Mark 1.0).

with his dreaming eyes and a thumb under his chin: the world of a dreaming, reflecting, serious and content happy child during his homework.[209]

Fear, Sadness, and Panic

Positive and pleasant emotions of children were frequently visualized and this seems not immediately refer to a so-called melancholic turn. But sadness and other negative and unpleasant emotions were far from absent, on the contrary. Again the sacral model offers the first examples of its visualization, as for anxiety, and primarily for boys. The child Jesus, often accompanied by the future John the Baptist, became "an ideal model of the little one we wish to have," as in *The Circumcision* (1461) by Andrea Mantegna (1431–1506). The anxious baby-child Jesus seeks protection from his caring mother during his circumcision. In the public, a little boy is very curious but eventually cannot bear to keep watching: as little children mostly should do, he turns with a finger in his mouth away to his mother.[210] Childish anxiousness is also present in the profane and nongenealogical *Study of an Infant* (1525) after Albrecht Dürer. It is a beautiful portrait of a sitting, very young toddler with on its left side an elementary drawn head of an older man, perhaps Dürer. Because of its big head the child is probably a girl, with her dress leaving the right shoulder free and with wide, bloused sleeves. With both hands that barely touch each other she holds an oval-shaped object, probably a pear. It is large for her small hands of which the fingers including the phalanges are very precisely drawn. Her hair is wildly curled and her face is explicitly drawn with the eyes looking anxious, pointing to a mix of emotions consisting of fear, sadness, and unsafety. Only by holding the pear she seems to get some security (Figure 27).[211]

Matthias Grünewald (1470–1528), like Dürer a contemporary of Hans Holbein the Elder and of Erasmus, visualized in two drawings extreme emotions of small children. The two drawings, titled *Head of a Crying Child* (1515–20), were perhaps made as a preliminary study for weeping Angels and based on the observation of living persons. The most expressive second drawing shows an extremely upset child with emotions that range from sadness to fear and from anxiousness to rage. Very excited and with squinting eyes the child throws his head back and keeps the mouth wide open so that the upper teeth and tongue are clearly visible. The skin of the neck and cheeks are puffed up from the extreme emotions (Figure 28).[212]

A deathly pale heartbroken girl is visible in *Girl with a Dead Bird* (c. 1520) from an anonymous Flemish artist. The girl in this intriguing painting mourns about the death of a sparrow, probably her pet that she holds in her hands. The topic can be referred to a poem by Catullus, familiar among humanist circles, about the death of a pet sparrow. The girl's face mirrors her emotions with her eyes wide open, the pupils contracted, and her lips pressed together. This picture, apart from referring to death generally, enters in the emotional world of a young girl's emotion about the death of a pet animal, which also nowadays is very palpable (Figure 29).[213]

FIGURE 27 (After) Albrecht Dürer, *Study of an Infant* (1525), drawing, 262 × 170 mm (Berlin: Staatliche Museen zu Berlin, Kupferstichkabinett, KdZ 17658; credit: Staatliche Museen zu Berlin, Kupferstichkabinett/Dietmar Katz Public Domain Mark 1.0).

Panic and fear of a child in unexpected and dismaying danger was often visualized through the popular classic story of *Ganymede*. The probably most expressive visualization of Ganymede's panic is Rembrandt's *The Rape of Ganymede* (*c.* 1635) in a preliminary drawing and in the final painting. In the classic version Ganymede is a handsome and innocent boy, according to Homer the most beautiful of all mortal man (*Illiad* 20.232–4). Ovid tells that Jupiter is that coveted about the boy's beauty that the supreme head of all Olympic Gods turned into an eagle and flew the little boy to the Olympus. This story was visualized by many Renaissance and Baroque artists among them Caravaggio. But Rembrandt transformed the story into a violent abduction. The boy became a panicking toddler who, anxious and frightened, screams in horror while being kidnapped. In the painting, argues Slive, "Rembrandt adds an understandable physiological reaction Ganymede had to his abduction. As the little boy is raised sky-high, he is pissing." This interpretation seems to be more convincing than Laneyrie-Dagen's suggestion of a child with his whims, comparable with Rembrandt's *Naughty Boy*. This becomes even more apparent from the disbelief and horror of the child's parents who look at the terrible event, the father even through a telescope. They see

FIGURE 28 Matthias Grünewald, *Head of a Crying Child* (1515–20), drawing, 24.7 × 20.2 cm (Berlin: Staatliche Museen zu Berlin, Kupferstichkabinett, KdZ 12319; credit: Staatliche Museen zu Berlin, Kupferstichkabinett/Jörg P. Anders Public Domain Mark 1.0).

their son disappear into the sky, an aspect of the drawing omitted in the final painting.[214] Panic and fear were also visualized in daily-life scenes as in Caravaggio's *Boy Bitten by a Lizard* (1594–5). While reaching for some fruit the boy is bitten by a lizard, and when he jerks back his hand, "the lizard [is] still attached to his finger." He reacts "violently" and "his face with its emphatic frown and open mouth reflects shock, pain,

FIGURE 29 Anonymous, *Girl with a Dead Bird* (*c.* 1520), oil on panel, 36.5 × 29.5 cm (Brussels: Musées Royaux des Beaux-Arts de Belgique). Credit: Culture Club/Contributor (Hulton Fine Art Collection).

and surprise."[215] For the rest, children in the margin of society got often in problems and danger because of not acting according to the community's emotional standards, but their emotions mostly were not visualized.[216]

Conclusion: Child's Emotions to the Forefront

In early modern Europe children's emotions were increasingly visualized. This started in sacral art with the Holy Family as a cozy and happy family but also as a family on the run for threats and dangers. Also happiness, joy, and anxiousness of the child Jesus, and the emotional mother–child relationship were visualized. Out of the sacral model the profane portrait was born, first within sacral triptychs, then in profane family and individual portraits. Initially, the family portrait focused on family genealogy and was centered around the father as the head of family. Then within the family portrait the attention moved from father to child, and in parent–child portraits more and more to portraits of mother and child. Moreover children, first mainly boys but in the course of the sixteenth century also often girls, were also depicted in their child's world, alone

or together with other children. Children were often depicted as happy and joyful boys and girls. This shows the intention of their parents to try to make their children happy and they were able to show that in portraits thanks to the increasing prosperity in the European Megalopolis. This visualization of happy children and proud and loving parents does not indicate a culture that was emotionally dominated by melancholy. But nor fear, panic, sadness, and anxiety were far away and those emotions of children and their parents were also visualized. The hard realities in the life of children and their parents, in particular caused by the often-devastating effects of demography, made parents realistic about the fragility of their children. But this did not prevent them from loving them and letting them portray at an early age.[217]

4

The Birth of a Mission: Educating Emotional Literacy in the Age of Renaissance and Reformation

A Mission Born

People in the Renaissance were almost daily confronted with emotions such as anger, envy, and lust. Those emotions were in their emotional culture considered as passions, vices, or capital sins, to be controlled instead of evoked.[1] Living in such a community meant regulating and controlling one's emotions and channeling one's passions in order to "avoid hurting others physically or psychologically."[2] For this purpose in the sixteenth century, a missionary movement of warning, advising, and recommending started to educate children and youngsters in emotional literacy, in particular in good manners and in the control of the passion of lust.[3] The mission was based on the classic framework of virtues to follow and of vices to avoid, and on the humanistic belief in the power of education. It translated the classic discourse's main tenets into daily life-tailored rules and recommendations. The mission varied from orthodox to heterodox, but all varieties remained within the borders of the Christian framework: virtues to follow and capital sins or vices to control or avoid as general dispositions of the character, with specific virtues such as domesticity and specific sins to be derived from those general dispositions.[4]

This mission was driven by belief in the power of education and in the strength of the parental example. Parents should teach their children emotional literacy bearing in mind the popular Europe-wide proverb "As the Old Sing, so Pipe the Young," visualized in Jan Steen's paintings. Only by showing that they can control their own passions and follow the virtues, they could advise successfully to their children to do the same. Jacob Cats summarized this belief as follows: "When the youth is no good, do not blame the youth. The father himself, who did not educate them better, deserves punishment."[5] This opinion was also shared by orthodox authors such as the Dutch Reformed Rev. Willem Teellinck (1579–1629) who belonged, together with Wittewrongel and Koelman (see Chapter 2), to the vanguard of the Further Reformation. This movement strived for the application of the Calvinistic faith in all aspects of daily life. Teellinck described the child as "a blank sheet of paper" that would move inevitably into the wrong direction because of its "natural depravity" unless parents intervene.[6] Cats used almost the same

words: "A child is like a blank sheet of paper."[7] This idea of the child as *tabula rasa* is mostly connected to the optimistic Enlightenment discourse in *Some Thoughts Concerning Education* (1693) by John Locke (1632–1704). However, it existed earlier in connection with the pessimistic Calvinist dogma of "natural depravity," which did not result into educational fatalism but into educational activism: the blank sheet of paper should be filled properly.[8]

The mission became possible through the printing press and the flourishing painting and drawing culture, indispensable tools of the Renaissance communication and knowledge society. The resulting supply responded to a high demand from broader middle-class parents, who formed a motivated market for the mission's products, made by moralists from orthodox to heterodox, medical doctors, and artists.[9] The supply consisted of serious texts in advice-and-conduct manuals, and in seducing paintings, drawings, and emblem books, for the mission used two styles: instruction and seduction. After a brief introduction of instruction by texts, we turn to the mission's visualization.

Instruction by Textualization

Instructional texts remained within the Christian religion and varied from more to less orthodox. They treated behavior, character, and physical health. Among the medical advisory manuals were Metlinger's *Regiment der jungen Kinder* (1474), probably the first German-language work on pediatrics, Van Beverwyck's *De schat der gezondheid* (1636), and *Verhandelinge van de opvoedinge en ziekten der kinderen* (1684) by Steven Blankaart (1650–1704), who advised the crash helm for a child when taking its first steps so that when falling it would "not injure itself as the impact will be softened by the cap."[10] Those manuals focused on the body, while orthodox manuals focused on the soul. Based on Augustinian ideas about the regulation of the passions, they were an intensification of the catechistic offensive of Reformation and the Roman Catholic Counter-Reformation. That offensive produced, apart from catechisms for adult believers, also catechisms for children, such as Martin Luther's *Der kleine Katechismus* (1529) with 100,000 copies sold before 1563, Philipp Melanchton's (1497–1560) *Catechismus puerilis* (1540), Jean Calvin's (1509–1564) *Formulaire d'instruire les enfants en la Chrestienté* (1541), Marnix van St Aldegonde's (1540–1598) *Cort begrijp, inhoudende de voornaemste hoofd-stucken der christelijcker religie gesteld vrage ende antwoordischer wijse* (1599), and *Parvus Catechismus Catholicorum* (1558) by the Jesuit Petrus Canisius (1521–1597).[11] Among the orthodox manuals were *De geestelijcke queeckerije* [The Spiritual Nursery] (1621) by Johannes de Swaef (1594–1653),[12] and *Oeconomia christiana* (1655) by Petrus Wittewrongel (1609–1662) and *The Duties of Parents to Educate Their Children for God* (1679) by Jacobus Koelman (1631–1695), both adaptations of British puritan manuals by, respectively, William Gouge (1578–1653) and Thomas White (?–c. 1672) and examples of the international scope of this Calvinistic movement of Further Reformation.[13] Those manuals recommended parents to teach their child obedience and restraint of emotions by following the Ten Commandments.

Also humanists such as (in Chapter 2 discussed) Vives, Vergerio, Alberti, Da Feltre, Montaigne, and Erasmus translated their scholarly discourse into practical advice.[14] Erasmus was the ideal mediator between discourse and daily practice, and between theological and educational approaches. He translated his philosophical, educational, and theological ideas into educational recommendations for parents and teachers. He theologically remained within the borders of the Christian discourse on passions and affections; educationally he considered the young child as flexible, to be bent in any desirable direction. While orthodox authors rejected Erasmus's liberal approach of original sin, for them the untouchable starting point of any education, they followed his idea of the child as a *tabula rasa*, explained in *De pueris* (1529) about the control of the passions by the human ratio, and in *De civilitate morum puerilium* (1530) on good manners (Chapter 2). At the end of *De pueris*, Erasmus summarized the essence of his educational message. A father should first understand "how dear a possession your son is; how many-sides and exacting, and yet also how glorious, is the pursuit of knowledge; consider the agility of a child's mind for absorbing every kind of teaching, and the flexibility of the human mind in general." Fathers should approach learning as playing, search after a wise and sympathetic instructor, and "reflect how precious time is." You should start with education as soon as possible, for "time is fleeting, youth is always busy, and old age is beyond instruction."[15] Erasmus's ideas and advice on liberal education formed during more than three centuries the fundament of numerous child-rearing advice manuals in Protestant and Roman Catholic Europe.[16] Two conditions for properly teaching and acquiring emotional literacy stood out: first good parenting, which means acting by understanding the child's specific developmental stage; second, understanding the risks and pitfalls of coming of age. This core content was popularized and visualized in emblem books, genre paintings, and drawings.

Seduction by Visualization

Next to instruction, visual seduction was used to transmit the message on emotional literacy in paintings, drawings, engravings, and emblem books. Artists who captured children's emotions in their bodily expression (Chapter 3) often also contributed to the mission. In Chapter 3 we saw that looking at the visualization of daily-life emotions became possible as a lifestyle, a *habitus*, for not only mainly royalty and aristocracy but also increasingly for the European burghers. This was made possible through the modernizing economy with its well-functioning art market and its mass production of paintings and drawings. While many pictures could serve as a source for the observation of daily-life emotions (see Chapter 3), a great part, in particular genre paintings, also contained a moral story and message. The adapted moral emblem books even fully concentrated on that goal. The pictures told parents how to raise their children properly in educating them in emotional literacy. This was not simply propaganda. The art market could, in contrast with visual propaganda by institutions like the (Catholic) church and the state, not dictate its mission. It could only try to

seduce potential buyers, for consumers decided themselves about buying or not buying paintings and drawings. Its commercial success shows that the message in the pictures, often packed in symbols, matched the mindset of many people who would use their visual competence for decoding and understanding messages about teaching emotional literacy for children.[17]

The audience and impact of emblems were even greater. This was primarily because they were printed in large quantities and widely distributed. It was also because they differed from paintings and drawings through their highly didactic triple structure of an image, an epigram, and a lemma. Andrea Alciati's (1492–1550) *Emblematum Liber* (1531) was the first triple-structure emblem book and the genre became popular in Europe. Between the sixteenth and seventeenth centuries, about 2,500 books were published, the majority in the Netherlands (about 750) and Germany (about 675). Emblem books dealt initially mostly with the *ars amatoria* with erotic allusions by Dutch authors such as Daniël Heinsius (1580–1655) and Pieter Cornelisz. Hooft (1581–1647), and also with politics and religion. Seventeenth-century authors such as George Wither (1588–1667) with *Book of Emblems* (1635) and Jacob Cats (1577–1660) transformed the emblem's content from erotic stories into educational recommendations that aimed at avoiding the vices and following the virtues. Its content was thus rather similar with Christian advice manuals, but with a different, nondoctrinal style.[18] It was a challenge for the contemporaries, and still now for historians, to decode the emblem's enigma by combining its three elements, image, caption, and text, for those elements "make not only a unity of design but contain a unity of meaning, sometimes not immediately recognizable."[19]

Most attention will be given to three emblem books by Cats. Apart from being one of the richest and most powerful men of the Dutch Republic as a long-time Grand Pensionary of the States of Holland and Zeeland, a kind of "prime minister," Cats had a moral and educational mission. For that he wrote his emblem books. He filled them with erotic allusions like in the traditional *ars amatoria* emblems, but only in order to seduce the reader with language games and emblematic enigmas to take note of the necessity of education in emotional literacy.[20] In his emblem books, long-term bestsellers, and after the Bible and Thomas à Kempis's *De Imitatione Christi*, the most popular books within the Dutch Republic, he advised people to adopt an active parenting style combined with patience for child's temporal weaknesses. Part of his oeuvre was translated into English and German.[21] The main topics such as a good marriage and family life as necessary conditions for good education, parental duties, and coming of age properly are comparable with the doctrinal instructional books, together with its Christian embedding. Its overwhelming popularity was, therefore, due to other reasons. While a Calvinist, his books were not doctrinal. They recommended an almost Erasmian style to teach children and youngsters to control their emotions and behave according to the virtues, which made his books acceptable for Protestant and Roman Catholic readers alike.[22] The emblem books were also attractive through the accompanying images, appreciated in the visual Dutch culture and thanks to Adriaen van de Venne (1589–1662), his regular draughtsman, and by using easy-to-learn rhymes.[23]

Most popular was the Dutch-written *Houwelick* [Marriage] (1625), a marriage and child-rearing manual for mothers and mothers-to-be.[24] Two other emblem books, with a variety of languages, aimed at fathers and at fathers-to-be. *Spiegel Van den Ouden ende Nieuwen Tijdt* [Mirror of Old and New Times] (1632) consists of 127 emblems made by Van de Venne. The book contains more than 1,600 proverbs in many languages, including Dutch, Italian, French, German, Greek, Latin, and Turkish. Each emblem is titled after a proverb and explained through quotes from a variety of sources, including the Bible and Ovid's *Metamorphoses*. Seven emblems are about *Opvoedinghe van kinderen* [Child-rearing] and forty-five about *Eerlicke Vryage* [Fair Courtship].[25] The third emblem book, *Sinne- en minnebeelden* [Images of Passions and Love] (1637), deals with fifty-two emblems completely with the pitfalls and risks of coming of age. It follows a lifecycle model of three stages: pleasures of the youth, awareness of the risks of the capital sin of lust, and finally learning to live according to the virtues.[26]

The buyers of the three emblem books preferred to acquire knowledge about moral and emotional literacy through funny illustrated texts in a mix of fun, beauty, and morality over reading doctrinal instructional texts. The emblems are excellent sources for the mission on emotional literacy, first because they were exceptionally popular transmitters of the mission's message and reached, as long-term bestsellers, a large audience of the broad middle class. Secondly, while emblem books were written for a national readership, they were European in design and content. Being the product of Humanism and Reformation, they translated educational discourses from Ancient Greece and Rome and from the Bible into recommendations for daily life and used a variety of European languages (except in *Marriage*). Finally, emblems have a high reliability when subjecting them to historical source criticism. Determination of authenticity is easy, for authors' and draughtsman's name, publishing house, and year of publication are known, while paintings often do miss its production date, and also sometimes both names of artist and of people depicted remain anonymous. Also author's intentions are mostly clear through the combination of image and text, something that is often less clear with genre paintings or drawings.[27] For the rest, genre paintings and emblem books often deal with the same themes and are often based on the same proverbs. The popularity of both is evidence of a widespread and strong belief in the necessity of education, not only of interest to a small circle of philosophers, theologians, and moralists.

Two topics dominated the mission: good parenting in filling child's *tabula rasa* while understanding child's *sui generis*, and learning to cope with gender-specific risks of coming of age, in particular the passion of lust.

Good Parenting by "Natural Instinct, Parental Love, Divine Law, and Custom"

According to the mission, good parenting was founded on a good marriage and understanding child's *sui generis*, and it knew specific responsibilities for mother and father.

A Good Marriage

Good parenting was based on a good, that is, Christian marriage.[28] Manuals on child-rearing, therefore, often started with advice about partner choice. For the Protestant moralist Koelman, most important was to avoid major differences between partners in religion and morality for the purpose of good education, for a religiously mixed marriage would be confusing for children.[29] Also differences in age, a favorite topic of mocking in genre painting and emblems, in social class, and in wealth were discouraged.[30] Most of all partners should love each other, something also O' Hara and Fletcher observed for early modern England.[31] Cats's *Marriage* popularizes this educational ideal of a couple loving each other with the same religion, morality, and sociocultural status, and roughly the same age. It was mirrored by numerous family portraits (see Chapter 3).

Such a bond between marriage partners should guarantee the coexistence of "mutual aid and affection ... with hierarchal relationships of authority and obedience."[32] This was recommended in numerous manuals and observed in personal documents such as letters, among others, in early modern England recently studied by Fletcher and O' Hara. It differed from the evolutionistic assumption in historiography of a marriage without affection and a deal between families until the birth of romantic love in the eighteenth century, discussed in Chapter 1.[33] Romantic love was an important subject of emerging vernacular literature in canonical works such as Dante's *Divina Comedia* and Petrarch's *Rime sparse* and *Canzoniere*, and already prepared in medieval troubadour lyric.[34] Erasmus, whose work prepared and influenced the seventeenth-century manuals, considered parental love as an important source of good parenting. He advised that "especially during the period of conception and pregnancy ... both father and mother should have a good conscience and be unburdened by any feelings of guilt" in guaranteeing a favorable environment for a good start of their offspring. Then already "parents should begin to think seriously of their child's education rather than wait until he [Erasmus focused on boys, JD] is nine or even, as many do, until he is sixteen years old."[35]

Good Parenting

According to Erasmus, parenting was determined by four sources, namely "natural instinct, parental love, divine law, and custom." Good parents followed their instinct. Just as other animals do care their young, they obeyed divine law, loved each other, and adapted their behavior to time's and place's standards. His ideal of parenting corresponds to Ariès's concept of the sentiments of family and child.[36] Referring to various animals as a Darwinian *avant-la-lettre*, Erasmus argued "that each animal not only gives its young life and sustenance but also trains them to carry out their natural functions." Human beings would instinctively do the same.[37] Following divine law would promote the child to become a man who lives virtuously, that is, controls the passions by the ratio. Parenting is "a heavy responsibility" and "a duty which you owe to God and nature ...

You became a father [his intended reader, JD], not only for your own benefit, but also for that of the community; or to speak in Christian terms, it was for God's sake and not just for yourself." When they do not their best "God will punish the parents for the sins of their children."[38] Less intimidating also, Cats concluded that child's misbehavior was the result of bad parenting.[39] Blaming parents for child's misbehavior was due to the conviction that the parental example determined what was written on the child's blank piece of paper.

This belief in the parental example, expressed in popular proverbs such as "As the Old Sing, so Pipe the Young," was often visualized and most eloquently by Steen. He was inspired by Jacob Jordaens (see Chapter 3), himself inspired by Cats's emblem books.[40] Steen adapted the genre into unruly three-generation households where children are encouraged to imitate adult's bad behavior like smoking and drinking. The message, as in *The Dissolute Household* (c. 1661–4), is that emotional literacy should be taught by parents who do not lose emotional self-control. Lack of parental responsibility would make children unrestrained.[41] More complex is *When Living in Wealth, Beware* (1663), also by Steen. This painting shows bad parental behavior together with people who warn against it, a combination that results in a variety of emotions from happiness, enjoyment, and lust to disgust and shame. When the story starts, mother is falling asleep, not from drinking too much as often in Steen's unruly households but from exhaustion because of all her duties, and no longer able to keep order. Immediately adults and children alike let slacken the reins. The baby plays with money and valuables while throwing bowl and an important sealed document on the floor. A boy smokes a pipe and eats out of the pantry. A couple in the painting's center shows impertinent and erotic behavior. The reason behind is wealth, so warns the proverb, title of the painting, visible in the little slate in the painting's right corner. This warning about wealth and what could happen when control and discipline disappear is strengthened by the old, pious couple situated just behind the couple with the indecent behavior. The man, according to Perry Chapman a Quaker, reads a religious book, while the woman, probably a beguine, throws up her hand to warn the young man of the couple. But he laughs at her (Figure 30).[42]

Probably, customers would not always so much buy those paintings to be warned regularly about their bad parental acting as they enjoy the funny scenes, with Steen frequently acting as "laughing narrator" in the painting. It also could appeal to some nostalgia "among high-born viewers for an earlier era in which civilizing codes were less evolved."[43]

Steen and his colleagues followed Erasmus in understanding the complexity of parenting. The humanist distinguished three main parental mistakes, neglecting the child's education, starting too late, and handing over the children to "unworthy teachers"[44] While the first was mother's responsibility and the third father's, the second, starting as soon as possible, was a joint responsibility. This properly filling the child's *tabula rasa* asked for a *sentiment de l'enfance*, the skill of understanding child's *sui generis*.

FIGURE 30 Jan Steen, *When Living in Wealth, Beware* (1663), oil on canvas, 105 × 145 cm (Vienna: Kunsthistorisches Museum, Gemäldegalerie, KHM-Museumsverband). Credit: Leemage/Contributor (Corbis Historical).

Understanding Child's Sui Generis

Erasmus distinguished between the stages of "childhood, adolescence, and adulthood." With that he stood in a very long tradition. Quoting Pliny the Younger (61–100 AD) who wrote that "your pupil is still only a youth and that you were once young yourself,"[45] he recommended approaching a child as a human being *sui generis* instead of a small adult. Only good parenting could transform the child as it was delivered by nature into a man, that is, a rational animal. This meant filling the child's blank slate in a way that the child would use its ratio, so overcoming "ignorance," the "most harmful influence upon man," and training the child in good moral behavior. "Nothing will the child learn more readily than goodness, nothing will it learn to reject more than stupidity, if only parents have worked to fill the natural void [*tabula rasa*, JD] from the start." It is true that many complain "that children are inclined by nature to evil" but "these accusations against nature are unfair." Child's evil is not mainly due to nature but "largely due to ourselves; for it is we who corrupt young minds with evil before we expose them to the good."[46]

The impact of original sin, essential for Augustine, Luther, and Calvin, was, according to Erasmus, limited when compared with the impact of education. Education should start "immediately, while his [child's, JD] mind is still uncorrupted and free from distractions" and "in this most formative and impressionable years," with a memory

stronger than in any other stage of life and with a mind that will soon become "less receptive and more subject to grave temptations." Learning covers both knowledge and morality, "something that engages the entire person." Moral education should start early to "avoid the common pitfalls of youth" in following the passions.[47] Very young children will learn by imitation because of their "natural flexibility which enables them to bend in any direction" when they "are not as yet enslaved by bad habits." But "once a certain pattern of behaviour has been imprinted upon a young and receptive mind, that pattern will remain."[48] This belief in the young child's natural flexibility was visualized by Cats in Emblem I, "A young twig can be bent, but old trees not," from *Mirror*. The emblem, accompanied by quotes in Italian, Dutch, Turkish, Greek, Latin, Spanish, and French, some derived from the Bible, shows how difficult it is to bend old trees. Its message is: "The youth, the tender youth / must be bent to virtue from the beginning." The man on the ladder, frustrated because bending the tree fails, nevertheless continues to try it, which is visible by his concentrated face and working arms. The standing man, however, knows that his colleague will fail. He shows astonishment, which is visible from his pointing hands and open mouth, and speaks the words of the proverb: "Young twig can be bent, but old trees not" (Figure 31).[49]

Teaching should follow the child's individual talents, for, argues Erasmus: "As it is easier to sail a ship when the sea is calm and wind and time are favorable, so it is also easier to be taught in a discipline that agrees with our personal inclination."[50] Because there is a "nature unique to each individual being … [,] one child may have an aptitude for mathematics, another for theology, a third for poetry and rhetoric, and again another for military life." This aptitude could be that strong that "he may be so averse to a certain course of study that he would rather go through fire than apply himself to the hated discipline." Therefore, you should at an early state recognize the individual "inclination in young children." It is true that "human nature is amenable to almost any form of learning" through instruction and practice, but we only "can reinforce to some extent what nature has given us." Apart from recognizing the contribution of nature, education should be approached as "play more than work," in particular for young children who "not as yet appreciate the benefits of profit, prestige, and pleasure that education will bring them." For children "play and childhood go naturally together." They consider learning "as play rather than exertion" and therefore "love of study may be instilled in children" by considering learning as if it was a game. He gives the example of learning the alphabet with a set of bow and arrows "decorated all over with the letters of the alphabet."[51]

The importance of play for child's development was generally recognized in Erasmus's time, but learning by playing had its limitations. Erasmus recommended, perhaps surprisingly, to also make use of child's emotions of "fear of disgrace and desire for praise" to develop a spirit of "victory and competition."[52] The limit was physical force. Erasmus fiercely rejected this as criminal, morally awful for its long-lasting impact on the child, and educationally ineffective because it did not fit child's nature. He preferred "Prima cura est amari." Many humanists and moralists shared his view; others

FIGURE 31 Jacob Cats, Emblem I, "Rami correcti rectificantur, trabsminimè," or "A young twig can be bent, but old trees not" (1632), *Spiegel Van den Ouden ende Nieuwen Tijdt*, 1–3 (Rare Books Department, University Library, University of Groningen; photograph by Dirk Fennema).

applauded physical chastisement or, as in the case of orthodox Protestants, considered it an educational instrument as a last resort (see Chapter 2).

Erasmus and his fellow humanists advised about how to approach the child and what content would be appropriate for the child's blank slate. Initially aimed at sons of princes, his recommendations were also intended for burghers. From age five or six children should be taught the virtues by following the good parental example. The cardinal and Christian virtues were supplemented for fathers and boys with specific princely virtues of mercy, piety, equity, and magnificence,[53] and for mothers and girls with virtues such as domesticity. On top of this moral content Erasmus developed, apart from advice about a good way to coming of age in *On Good Manners*, on which below, an intellectual curriculum with fixed and variable subjects to be taught by parents or by parents selected teachers.[54]

The fixed part of this curriculum aimed at "acquire not only fluency in speaking but also intellectual judgment and a mastery of all the branches of knowledge," to be taught jointly by parents, "nurses, teachers, and playmates." Hereafter came "training

in the use of the classical languages," a "skill which children will acquire without any effort, whereas adults will scarcely accomplish it even with the greatest application." This would contribute to "a wide vocabulary and the skills of reading and writing," but also to control of the passions, for "persons who refuse to be guided by the dictates of right reason" and are "swept along by the whims of the passions are not truly human but are only brutes." Moral development was strengthened by reading pastoral poetry and comedy, texts that contained "an immense amount of moral teaching" as well as "almost all proverbs and sayings of famous men." Through those proverbs "moral truths were passed on to the common people," and they were frequently visualized in paintings and emblems.[55]

The variable part of the curriculum consisted of subjects such as music, arithmetic and geography. So "each individual talent ... should be helped to follow its own spontaneous inclinations." He emphasized, preceding Johann Amos Comenius's (1592–1670) *Orbis sensualim pictus* (1658), the didactic significance of visualization. Learning would become more effective "if the contents are displayed before their eyes by means of skillful illustrations, and if every story is presented through pictures."[56] A combination of useful and pleasant content worked out well, but moral or intellectual "rubbish" should be avoided. This category not only included "vulgar ballads, ridiculous old wives' tales, and all sorts of tedious womanish gossip," but also "dreams, insane riddles, silly nursery rhymes about phantoms, specters, ghosts, screech-owls, vampires, bogeymen, fairies and demon." For "a young child's mind will be overgrown with moral failings unless it is exposed as early as possible to an instruction that promises fruitful results," including good manners, on which below.[57]

Good parenting by understanding the child's *sui generis* was a joint responsibility of both parents, but there were also specific tasks for the mother and the father. The mother, if necessary supported by a good wet nurse, was responsible for the very young child's physical development; the father, if necessary supported by a good teacher to be trained by state and church, was responsible for child's intellectual development.

Mother's Task

Motherhood involved getting children and breastfeeding them, caring for and educating them until the age of seven, and meanwhile stay at home as much as possible. In a fictional discussion in *Marriage* by Cats between two young women, bold Phyllis and modest Anna, the latter says: "Thou, wilt thou be of good praise, / Stay at home, that is the Maiden's Garden," echoing a long tradition, expressed by fourteenth-century Florentine Merchant Paolo da Certaldo as "keep females in the house," expressing the "anxiety of men for the virtue of the women over whom they had authority."[58] Mother's task was immense and decisive when you remember the popular assumption that a child "absorbs all things like a blank piece of paper." The child would learn emotional literacy and practice the virtues most effective if it would follow mother's example and if the mother would not overestimate child's age-related capacities. Mother should warn her

children against contact with bad peers, while boasting about the children should be left to the father.[59] Moreover, she should not favor one child over another, a warning also visible in Steen's painting on the feast of St Nicholas (see Chapter 3) and shared by orthodox moralists such as Wittewrongel.[60] Also physical chastisement should be avoided as much as possible. If considered really necessary, it should only be done by beating on the buttocks, for misbehavior of the child resulted from misbehavior of the parents.[61]

While Cats followed Erasmus in many ways, he did not share his rather negative appreciation of motherhood. Erasmus blamed mothers almost systematically for educational neglect and compared them with people "who abandon and expose their children" and "therefore deserve to be punished by the existing laws" on abandoning and exposing.[62] He blamed their educational style as "soft and permissive upbringing—gentleness is their word for it, but its effects are totally corruptive," and asked rhetorically if mothers not should "be prosecuted for maltreatment of their children."[63] Cats, however, applauded motherhood, and with him many other authors of emblem and advice books and the producers of a vast iconography on motherhood duties and virtues.[64] The connection between good motherhood and his advice was explicitly visualized in *Family Portrait with Mother Who Reads in Houwelick* by Jacob Cats (1650), with both the Dutch artist and the probably also Dutch family remaining anonymous. While father stands and looks satisfied and pride about his children, the focus is on the mother, who sits in the picture's center. Her eldest child, a girl, points with her left hand to mother's right hand, in which she holds an open copy of *Marriage*. In the meanwhile, she looks at her husband on the right while pointing with her left hand to her youngest child, a baby in an infant's chair, apparently educated according to advice from *Marriage*. The youngest daughter gives the baby some grapes symbolizing good education and fertility (Figure 32).[65]

Motherly breastfeeding was a big issue and discussed passionately. Erasmus attached less importance to motherly breastfeeding and emphasized the paternal responsibility of searching after a good wetnurse.[66] Many physicians and moralists, however, applauded motherly breastfeeding for health and for a better emotional mother–child relationship, now mostly described as "attachment." According to Sadoleto (see Chapter 2) drinking milk from mother's breast strengthened "the bond of mutual love" and would connect the "physical experience of security, of nourishing care, with the intellectual requirements."[67] Sadoleto's view about the resulting loving relationship between mother and child differed from Erasmus but was part of a Europe-wide campaign for motherly breastfeeding. Also according to the Dutch moralist Marnix van Aldegonde (1540–1598) in *Ratio instituendae iuventutis* (1584) this was "according to nature." It "cherished and strengthened the natural loving relationship between parents and children." Cats, noting that children from less wealthy families had an advantage because there were breastfed, warned in *Marriage*: "A woman who gives birth to her children is half a mother, only when she breast-feeds them she is a complete mother." For the rest, he understood that motherly breastfeeding was not always an option and enumerated the precise requirements a good

FIGURE 32 Anonymous, *Family Portrait with Mother Who Reads in Houwelick by Jacob Cats* (1650), oil on canvas, 85.5 × 107.5 cm (Budapest: Museum of Fine Arts/Szépművészeti Múzeum, inv. no. 3928).

wet nurse should meet.[68] This motherly task was visualized as a profane adaptation of the *Maria lactans* by Pieter Fransz de Grebber (*c.* 1600–1652/3) in *Mother and Child* (1622).[69] Earlier, as a side effect in *A Lady in Her Bath* (1571) by François Clouet (*c.* 1510–1572) about Diane de Poitiers as powerful and seductive woman and mistress of Henry II of France (1519–1559), in the background a wetnurse is visible. She feeds a baby, probably a child of Henry II, with a breast filled with milk (Figure 33).[70]

Steen's *The Fat Kitchen* (*c.* 1650) about a well-fed mother breastfeeding her baby contrasts with *The Meagre Kitchen* (*c.* 1650) about a mother all skin and bone who cannot offer her child her abundance.[71] Gerrit Dou (1613–1675) in *Young Mother* (*c.* 1660) visualized the balance between motherly virtues and child's *sui generis*. In a well-furnished bourgeois interior, a mother in a chair in front of an empty crib tries to breastfeed her baby. The infant is distracted from the breast by her sister who holds a shiny rattle, a symbol for earthly enjoyments. The mother is not angry about the behavior of her happy children, for she understands the baby's distraction, aware that she eventually must correct the child's natural inclinations of preferring a pleasure (distracted by a toy) to a natural necessity (being fed by mother's breast).[72]

FIGURE 33 François Clouet, *Diane de Poitiers* (1571), oil on panel, 92.1 × 81.3 cm (Washington, DC: National Gallery of Art). Credit: Print Collector/Contributor (Hulton Fine Art Collection).

For the rest, most upper-class mothers did not seem to be impressed by the recommendations by male moralists, for in majority they did not breastfeed their children. The aforementioned Constantijn Huygens (1596–1687) was the only one out of six children to be breastfed by his mother. This, so he wrote, resulted into a special relationship between him and his mother, but for his own children he emphasized a good relationship between baby and wetnurse.[73] Visualized alternatives of breastfeeding were also prepared in sacral painting, as in *Virgin and Child with a Bowl of Pap* (*c.* 1515) by Gheeraert David (*c.* 1460–1523). A beautiful Madonna tries to feed with porridge her baby whose satisfied looks concentrated on the "juicy cherries" in his right hand. The virgin is adapted into an elegantly dressed lady in a stylish room. This mix of sacral and profane enabled the customer to show his devotion to a Madonna who resembled his wife like several Madonna's by Raphael his mistress.[74]

This visualization of feeding was part of a popular genre of motherly virtues as in *Young Mother* (1658) by Gerrit Dou (1613–1675). The young upper-class mother expresses happiness, love, affection and care. She sits on a chair, her shoes off for staying at home with needlework on her knees symbolizing the motherly virtues of domesticity

The Birth of a Mission

and diligence and with in front of her a crib with her baby. Her elder daughter leans over the crib and gives the child a tender look. Symbols such as a globe, a sword, and a coat tell that father has responsibilities outside. A cupid refers to the erotic relationship between the spouses. This idealizing domesticity and maternal love were popular in the seventeenth century.[75] In *The Mother* (c. 1661–3) by the Delft master of domesticity Pieter De Hooch (1629–c. 1683), a mother wearing an elegant cloak is about to or has just breastfed her baby. In the background a young girl is looking outside, perhaps intended by the artists as a warning against potential dangers coming from outside. The atmosphere and the harmonious relationship between mother and the satisfied child express the message of domestic virtues.[76]

Motherly virtues for older children were frequently visualized by hair-combing, often connected with the preparation for school, a popular topic in a period of increasing school attendance among seventeenth-century customers and painters. Among them were Caspar Netscher (1639–1684), Gerard Ter Borch (1617–1681), Frans Hals's younger brother Dirck Hals (1591–1656), Querijn van Brekelenkam (c. 1620–1668), and again De Hooch. *Motherly Cares* (c. 1652–3) by Ter Borch shows emotions like motherlove, motherly care, and dedication as evidence of domestic virtue.[77] *Motherly*

FIGURE 34 Pieter de Hooch, *The Pantry* (c. 1660), oil on canvas, 64 × 60 cm (Amsterdam: Rijksmuseum). Credit: Print Collector/Contributor (Hulton Archive).

Cares (1669) by Netscher contrasts emotions and behavior of adults and children. While the elegantly dressed mother seriously combs the long hear of her son, evidence of the domestic virtue of cleanliness, which is further strengthened by the maidservant in the doorway with her bowl and jug for washing, her daughter is joyful and happy. She pulls funny faces while sticking her tongue in the mirror. Her behavior, emphasized by the toys and a cat, is accepted as typically childish by her mother who does not disapprove of it. Eventually the girl would become a prudent woman too, thanks to mother's prudence, a cardinal virtue.[78] Visualization of domesticity symbolized girl's initiation in motherly duties and virtues of domesticity inside the house. This transmission of domesticity from mother to daughter was perfectly visualized by De Hoogh in *The Pantry* (*c.* 1660), where a mother gives her daughter a jug in an atmosphere of affection and happiness. While mother is the example of the virtue of domesticity, the child is training the virtue of obedience in order to learn the virtue of domesticity (Figure 34).[79]

Father's Task

As head of the family fathers frequently were portrayed together with their wife and children, and also, although less than mothers, together with one or more of their children (see Chapter 3). Increasingly, not only fatherly pride but also their educational activism was emphasized.[80] In emblem IV, "When the swine is pampered, she goes lying in the manure" from *Mirror*, Cats let women warn against fatherly educational passivism. In the middle of the emblem stands a man who caresses a swine that goes lying in the manure. Right behind him stand two women who watch the man and the swine, the younger with arms crossed and the elder with a face full of disdainfulness. With her strained mouth and lowered eyebrows, expressing abomination according to the contemporary artist Le Brun, she points with her right hand and piercing index finger to man and swine. Outside another woman is also looking at the man and the swine, but her face shows no expression. The emblem's enigma is decoded by the accompanying text. With the swine representing the child and the man the parent, the message is that pampering is not similar to educating. It makes children lazy just as the swine. Child's development needs parental discipline and activism.[81]

In the emblem book *Mirror*, Cats also showed how fathers tried to influence their children in the choice between passions and virtues. In emblem V, "Everybody should look in the mirror," father's daughter looks in the mirror to her body. She is satisfied how her clothes and ornaments look like, but the message is that she should learn to live according to the virtues. That means more looking at her inside. In her heart should shine her beauty, for: "The virtue, the real virtue is elevated above all else." Father understands the importance of his daughter's outside beauty, but he emphasizes that eventually inside's beauty, the soul, is the most important. The daughter is not amused: her body and eyes turn away from her father and express avoidance, for she was totally unexpected interrupted in her intimate activity by her father's arrival, whose head appeared suddenly in the mirror next to her own face. His eyes and the crowfeet

around them together with the direction of his body express hope and dedication to urge his daughter into the right direction. Without explicitly referring to theology, the emblem refers to the Augustinian idea about the direction of the will in controlling the passions.[82]

A crucial educational responsibility for fathers was teaching. The best choice was according to Erasmus to do it yourself: "Any father who finds it a burden to raise his son loves his son only superficially."[83] Otherwise, you should select a good teacher with "a rich variety of experience," preferably only one to avoid different instructors for your child. With young children you should keep an eye on teacher and child. A teacher should be excellent in school subjects but also able to make "the studies pleasant and keeping the child from feeling any strain." He should motivate by "inspire affection in his pupils, so that gradually, instead of fear, a spontaneous feeling of respect may grow from him." Pupils "should be induced to grow fond of their studies." Therefore, the teacher should adopt "a fatherly attitude towards his pupils." He even should "become a child again and thus win the affection of his students."[84] Erasmus was outspoken about affection and the absence of violence in education. A good teacher, therefore, had to be gentle, affective and nice, and should possess excellent capabilities in the curriculum's subjects. But, so the realist Erasmus, "it is much easier to specify the qualities of the ideal schoolmaster than to find any who actually correspond to that ideal." Therefore, teacher training should become "a public responsibility entrusted to the secular magistrates and the ecclesiastical authorities." But those "public authorities are neglectful" and thus a father should "assume this responsibility within his own home."[85]

It was also a crucial father's responsibility to select the right partners for his children. A good marriage was the ultimate result of coming of age properly. Seduction and courtesy were permitted if a marriage rather than mere pleasure was intended, as Cats over and again formulated in his emblem books.[86] Parents should encourage their sons and daughters to curb licentiousness before marriage and help them to select a good partner.[87] This primarily father's task was justified by orthodox moralists such as Thomas White, Jacobus Koelman, William Gouge, and Petrus Wittewrongel by the Bible, Jeremiah 29: 5–6: "Plant gardens and eat what they produce. Marry and have sons and daughters; find wives for your sons and give your daughters in marriage, so that they too may have sons and daughters." Although Cats referred not explicitly to the Bible, he was well versed in the Scriptures and must have this quote in mind when telling Dutch women in *Marriage*: "it is only the father who can marry off his daughters."[88] In *Mirror*, Emblem XXX, "Better sitting with the owl than flying with the falcon," father advises his daughter who is torn between two lovers. The first, compared with a falcon, is the more exciting and sexy one; the second, compared with an owl sitting together with a pigeon, is calm, but perhaps even boring. The girl hesitates but seems to be more inclined to pleasant moments with the falcon-like lover than to calm moments with the owl-like lover. Her father, however, considers sitting with the owl a better guarantee of a good marriage than risky flying with the falcon, in the image very explicitly pierced while fighting with a heron. The girl expresses anger and doubt, with her downwards

FIGURE 35 Jacob Cats, Emblem XXXI, "Met onwillige honden ist quaet hasen vangen" ["With unwilling dogs it is difficult to catch hares"] (1632), *Spiegel Van den Ouden ende Nieuwen Tijdt*, 96 (Rare Books Department, University Library, University of Groningen; photograph by Dirk Fennema).

eyebrows, depressed lower lip, dropped jaws, and closed body. She is turned away from her father, who, notwithstanding the neutral expression of his face, is determined. This is visible from his forcing finger and from the accompanying text. He tries to persuade his daughter to marry the calm instead of the exciting and adventurous boy.[89]

Still Cats was also aware that there should be a limit in how far a father could go in managing partner matters for his children. In emblem XXXI from *Spiegel* titled "With unwilling dogs it is difficult to catch hares," a father considers his son, named Claes, too passive in paying court. He compares him with an unwilling dog and the anonymous girl he should pay court to with a hare. This girl would be an excellent match for the son and for the family, for she will expect a major inheritance from her godmother Griet, "when she will become a dead body." The image shows that Claes resists his father's plan to serve the family's interest. He may be pleasantly surprised through the support of his mother, who rhetorically asks herself: "Is paying court not a free activity to which nobody should be forced?" According to her it is better to wait until Claes himself would find a girl attractive for him. The emblem is thus about the effectiveness of paying court, the subject the emblem's title refers to, but also about

freedom of partner choice. The three actors underline its meaning by their different emotions. Father looks angry because of his son's opposition to his plan. The son's body language, his stepping back, his withdrawing his hands, and his almost showing abomination, make clear that he would not even think of paying court to the girl. Father and son are compared with hunter and unwilling dog, visible in the image's background. Mother looks content—her emphasis on free partner choice is applauded in the emblem—and determined with the catch, a bird, in her hands, and a disciplined, not unwilling dog next to her.[90]

That partner selection was not simply a father's job is also shown by O' Hara study on early modern England,[91] and by the case of Christiaan Huygens (1551–1624), secretary of the Prince of Orange, and father of four daughters and two sons. In 1623, he wrote a letter to his cousin Susanne van Baerle (1599–1637) to bring to her notice that she could not choose anyone more kind and sincere and a better husband than his elder son Maurits (1595–1642). Although Maurits tried to court her for a year, Susanne was not persuaded to marry him. Then Maurits suggested his younger brother, Constantijn, to try it himself. The emergence of emotions of love took some time for Constantijn, but after three years he fell in love. With his strongest weapon, poetry, he did cause similar emotions to Susanne. The marriage took place on April 6, 1627, three centuries after Petrarch and Laura did meet each other, a choice of marriage date that was typical for the *honnête home* Constantijn was educated in. The marriage is an example of a balance between girl's preference and family interests.[92]

Coming of Age Properly

Youngsters coming of age should learn to behave properly, that is, to behave with good manners in company. In particular controlling the passion of lust and following the virtue of chastity was crucial. Before turning to that, we look at ways of teaching good manners, that is, emotional literacy.

Good Manners through Emotional Literacy

In *Alexander, Jan-Cornelis and Maria-Aldegonda Goubau* (1663) by Justus van Egmont (1601–1674), a portrayal of the children of the Antwerp burgher Jan Goubeau and his Amsterdam-born wife Maria-Cornelia Croock, two-year-old Jan-Cornelis holds a perch in the direction of a proximate bird. This symbol, like the training of a dog, means that "children had to learn how to conform with the adult worlds."[93] Getting emotional literacy to conform to the adult world was central in Erasmus's educational discourse. In 1530, shortly after the publication of *A Declamation* [*De pueris*], Erasmus wrote *On Good Manners* [*De civilitate morum puerilium*] for youngsters, adolescents, and their parents. He stood in a tradition of medieval conduct manuals on courtesy such as *Livre du Corps de Policie* and *Livre de Trois Vertus* by Christine de Pïsan (*c.* 1364/5–1430), which focused on emotion control, sometimes even through "virtuous hypocrisies" or

feign emotions in the words of De Pïsan.[94] Erasmus's text, decisive for several centuries of manuals on good manners and the "summit" of the genre according to Norbert Elias, differed from those manuals. He aimed at a broader readership than only aristocracy and pursued literary and scholarly knowledge. While relating his recommendations to Christian piety in daily life, he connected good manners with the regulation of children's emotions (see also Chapter 2). The reasons for "fashioning the young" by "training in good manners right from the very earliest years" were threefold: morally by "implanting the seeds of piety in the tender heart," intellectually by "instilling a love for, and thorough knowledge of, the liberal arts," and socially in "giving instruction in the duties of life." After discussing in detail how to control the body and how to dress, he turns to ways of behaving properly as a youngster in common situations and places such as the church, banquets, meeting people or participating in plays, and the bedroom. As a frequently traveling humanist aware of differences in social customs between countries, regions, and social groups, he recommended social flexibility for we should "adapt ourselves to the customs of the region" where you are staying.[95]

Erasmus advised in detail about the control of emotions by controlling the body, in particular the eyes as the manifestation of the mind, "the seat of the soul," thus of the emotions. Therefore, "the eyes should be calm, respectful, and steady: not grim, which is a mark of truculence; not shameless, the hallmark of insolence; not darting and rolling, a feature of insanity; nor furtive; … nor gaping like those idiots; nor should the eyes and eyelids be constantly blinking, a mark of the fickle; nor gaping as in astonishment …; not too narrowed, a sign of bad temper; nor bold and inquisitive, which indicates impertinence; but such as reflects a mind composed, respectful, and friendly." This advice would help you to control your emotions and present yourself as a rational human being. As an empirical psychologist he described in stunning detail how to control your eyebrows and with that the expression of your emotions. Eyebrows should be restrained so that they are neither contracted, "which denotes fierceness," nor arched, "a sign of arrogance," or "pressed down over the eyes like those of an evil schemer." They should be "cheerful and smooth, indicating a good conscience and an open mind" in contrast with eyebrows "lined with wrinkles, a sign of old age," or "menacing like a bull's."[96]

He also treated other parts of the body of importance for expression of emotions, including nostrils, cheeks, and mouth. "Puffing out the cheeks is a sign of arrogance, while deflating them is a sign of mental despair"; referring to the Bible he adds that "the former is the characteristic of Cain, the latter of Judas the betrayer." Controlling the mouth during laughing is important, for to "laugh at every word or deed is the sign of a fool," while "to laugh at none the sing of a blockhead."[97] Also recommendations on body care and hygiene are embedded in Erasmus's advice about good manners, as in the following example: "It is boorish to go about with one's hair uncombed: it should be neat, but not as elaborate as a girl's coiffure." Moreover, "constantly tossing the hair with a flick of the head is for frolicsome horses,"[98] by the way one of many references to animals in showing what not to do in presenting and posture.

Erasmus warns for rigidity, for "standard or propriety and impropriety vary from people to people" and also "from age." An example is how to bow, to keep your knees, and of shuffling your feet while sitting, "the mark of fouls just as gesticulating with the hands is the sign of an unsound mind." Variety is also the case with clothing, "the body's body" from which "one may infer the state of a man's character." Pictures, also by Erasmus used as sources for history of bodily expression of emotions, show variation of the bodily expression of the inner mind over time and place, for example, with "tightly closed lips" that once "were taken as evidence of honesty" but not anymore.[99]

Armed with this knowledge, a youngster could participate in a variety of situations in social life. In the church you should always be aware of "the presence there of Christ together with countless thousands of angels," you should listen with great concentration to the preacher with the mind "concentrated on him in total reverence, as if you were listening not to a man, but to God speaking to you through the mouth of a man," and you should not "murmur nonsense in the ear of your neighbour" as "people who do not believe that Christ is present there."[100] Eating together asked for "appropriate forms of emotional expression."[101] Erasmus explained the do's and don'ts for youngsters sitting at a banquet, from the technique of carving meat to not drinking alcohol, from not nudging the person beside you with your elbow to breaking the bread properly and to not eating too much or too fast. Also bad banquet habits are constantly compared with habits of animals. So the consuming of "whole pieces of food at a gulp is for storks and buffoons" and gnawing bones "is for a dog."[102] You also should avoid gossip and not "defame the character of those not present." Finally, "if someone through inexperience" would "commit some *faux pas* at a banquet," this "should be politely passed over," for all "should feel at ease during a party." Equipped with those recommendations the youngster would "control his expression" and regulate his emotions.[103]

When meeting people you should show "respect for the elderly," in particular "your parents" and "teachers" who are "in a sense" your "intellectual parents." You should speak "soft and calm," not "ungentlemanly" converse "with the entire body," and remain polite and diplomatic "by the way of polite circumlocution" in order to "win praise without envy and gain friends." When participating in a play, let this remain fun, for the person "who yields in a contest achieves a nobler victory than he who grasps victory at any cost." When "competing against less experienced players and you can win time after time, occasionally allow yourself to be defeated in order to make the game more exciting." After dinner, when going to sleep, you should follow the bedroom etiquette, which means not making "noise and chatter" and practicing the basic rules of hygiene. Also you should "not unveil to another's sight what custom and nature require to be covered."[104]

Such advices manifest a changing body culture. Sharing beds and sleeping spaces for adults became less obvious and while at the end of the Middle Ages children still normally shared beds, Jean Gerson already urged the use of single beds also for them. This need for more bodily privacy became apparent through the introduction in higher social circles of nightwear and separate sleeping rooms, part of a broader tendency of

separate rooms for specific use such as eating, sleeping, and working, enabling more privacy inside the home.[105] Learning emotional literacy through good manners was crucial, for while a boy cannot "choose his parents or nationality," he "can mould his own talents and character for himself."[106]

The societal interest of following Erasmus's advice is well illustrated by some letters of Leonhart Tucher, a German sixteenth-century merchant who "continuously instilled in his sons the criteria for becoming a successful merchant: the desire to be industrious, always to dress appropriately and never to get carried away by emotions." When his son Sixtus did not behave that way, in letters that function "as personalized educational treatises" Sixtus "was ordered to improve his life immediately and to report on his progress in letters on a regular basis."[107] Following Erasmus's manual, the child would learn to regulate its infantile impulse release and be initiated into an elaborated code of manners and emotional standards with "cognition and feeling in a peculiarly creative tension."[108]

Control of the Passion of Lust

Luxuria, or lust, was by far the most dangerous passion according to Augustine. As one of the seven capital sins, *Luxuria* should kept under control and chastity should be guarded until marriage.[109] *Luxuria*, by Bruegel personified in a naked woman accompanied by a cock and seduced by a male monster, was described by Augustine as "a usurper, defying the power of the will and playing the tyrant with man's sexual organs," one of the "defective parts of the soul," to be managed by "mental and rational control" and "bridled and checked by the restraining force of wisdom." Augustine's view influenced Protestants and Catholics alike, with also Erasmus staying close to his description of lust as "a hideous brute" (see Chapter 2). Texts and images about the control of lust varied in styles from instruction to seduction, and in assessment from a gloomy picture of human emotions to the offering of hope with some empathetic understanding of youngster's missteps.

Cats combined the empathetic and seductive style with the Augustinian framework of moving the will in the right direction. He encouraged parents to understand the sensual needs of the youth and to teach them how to cope with lust's risks. Numerous examples of this strategy occur in *Mirror*. The emblem book *Images of Passions and Love* is even all about control of lust. Empathetic is emblem VI, "One must wear a pair of shoes from a jester, before one is truly wise" from *Mirror*. Youth is described as a time of trial and error and enjoying life does include its sensual pleasures. This message returns to the first part of all fifty-two emblems of *Images of Passions and Love*. With the popular proverb *Quand on est jeune, on aime en fol*, "When young, one loves foolishly," he refers to the style of the *ars amatoria*.[110] But eventually you should become wise instead of remaining foolish, a typical Erasmian view. Getting the will in the right direction for the control of lust was in line with Augustine no natural process: active parents should support this while also allow youngsters a while to walk on jester's shoes, that is, to behave stupid instead of wise. The image of the emblem only

shows joy. The accompanying text, however, makes clear that joy and trial and error have no value in itself and that they should result into moral wisdom, that is, control of the passions and living according to the virtues.[111]

Cats's understanding of the youth made him start each emblem from *Images of Passions and Love* with an explicitly erotic story. He so seemingly followed the classic *ars amatoria* as practiced by poets like Pieter Cornelisz. Hooft (1581–1647) and Johan van Heemskerck (1597–1656), present in songbooks for the youth inspired by Ovidius's *Ars Amatoria*, and the continuation of a tradition on romantic love by canonical authors such as Dante Alighiero (1265–1321), Francisco Petrarch (1304–1374), and Giovanni Boccaccio (1313–1375). This tradition got its visualization from the fifteenth century in numerous Renaissance paintings and drawings and in seventeenth-century Dutch genre painting.[112] But Cats only used the erotic story as first step. Within each emblem he transformed soon from entertainer into the moralist who emphasized that chastity was the girl's and the family's main asset, to be preserved when coming of age. In *Marriage*, intended for older girls and young women, prudent Anna warned Phyllis who represents the promiscuous youth with the words: "Be not fast in love, but restrain your stupid passions," for: "When the bride is in the boat, / the lovely words are over." The safest way to come of age properly and preserve chastity was Anna's clear advice to Phyllis: "Remain at home, that's the virgin's court."[113]

Most emblems thus eventually warn against the dangers of lust and transform from a play of erotic seduction into a game about the risk of losing one's virginity and respectability. That stage of the story is mostly visualized in the emblem's image. Emblem XXV, "Qui captat, capitur" [Who chases is caught] from *Images of Passions and Love* tells about the risks for boy and girl. A blackbird symbolizing a lustful boy is stuck in an oyster shell, which symbolizes a seductive girl. In this awkward situation the blackbird is prisoner of the oyster, who is not happy either for she cannot get away from the blackbird. The message, explained in detail over several pages, is for both to never end up in such an awkward situation (Figure 36).[114] In emblem XL, "Non intrandum, aut penetrandum," lovemaking is compared with a cobweb. When get caught into it, you become a victim of Venus. Therefore, the emblem starts with the warning: "Who is not able to play the game should keep off."[115] In short, girls should be conscious of their chastity's value and boys should strive for a harmonious marriage rather than a wild erotic life. Coming of age could be pleasant if sensual and sexual passions were under control.[116]

Many seventeenth-century genre painters visualized the same theme with often more subtle suggestions on courtship, lust and the play of seduction, as in Steen's *Girl Eating Oysters* (1658–60). A girl sprinkles salt on the oysters while looking seductively toward the viewer with the suggestion of offering herself. In the background, a man and a woman are preparing even more oysters, fitting Johan van Beverwijck's advice about the positive sexual benefits of eating oysters from a medical point of view in his popular medical manual (1651).[117] In *Two Children with a Lamb* (1638) by Jacob Gerritsz. Cuyp (1594–1652), a boy and a girl fondle a lamb, a traditional symbol of innocence, in

FIGURE 36 Jacob Cats, Emblem XXV, "Qui captat, capitur," *Sinne- en minnebeelden.* In *Alle de wercken* (Amsterdam: Schipper, 1665; Rare Books Department, University Library, University of Groningen; photograph by Dirk Fennema).

an Arcadian context without any guilt or sin but, so the message, when leaving this Arcadia of innocent childhood, they should preserve chastity and virtue (Figure 37).[118] *Four-Year-Old Girl with Cat and Fish* (1647), also by Cuyp, is about the suppression of sexual lust symbolized by the cat trying to eat the fish but hold back by a four-year-old girl who encourages chastity and virtue. This is a message intended for a loving couple in the garden on the background.[119]

In this Christian culture, life on earth was no more than a transition period. Therefore, Cats tells in the concluding part of the emblems of *Images of Passions and Love* about life after death in an Augustinian-like style. He sees youth as only the very beginning of a long path to moral progress with as the final stage passing away and leaving all earthly things. Both the *ars amatoria* from the beginning and the warnings against erotic passions in the middle of the emblem were only the run-up to the way to God. Cats shared his ultimate educational goal with orthodox moralists, and his view on passions, vices and virtues was not basically different from that by Hieronymus Bosch, Bruegel, or other artists that visualized this theme. But his approach was not that frightening. Moreover, he differed from contemporary orthodox Protestant clergymen such as

FIGURE 37 Jacob Gerritsz. Cuyp, *Two Children with a Lamb* (1638), oil on panel, 78.5 × 107.5 cm (Cologne: Wallraf-Richartz-Museum). Credit: PHAS/Contributor (Universal Images Group Editorial).

Wittewrongel, De Swaef, and Willem Teellinck, for whom only the very beginning of voluptuousness was sin and who recommended strict education instead of accepting the stage of youth as one of trial and error.[120]

Conclusion: A Mission by Instruction and Seduction

In the Renaissance, a stronger educational and emotional focus on child and family went together with a call for more regulation of emotions from the main agencies in this modernizing society. More regulation would suit the true faith and thus was a church's interest, suit governments longing after more disciplined citizens and thus was a ruler's interest, and suit the booming early modern capitalist economy, and thus was an economy's interest. Also Erasmus, the most fiercely opponent of physical punishment in education, recommended discipline as a necessary instrument to let the ratio dominate the passions and let the expressions of emotions and impulses follow time-bound emotional codes and standards. Discipline belonged together with shame to the adequate "instruments for bringing out our children's natural abilities."[121]

This call was answered and translated by artists in a vast supply of genre paintings, drawings, and also in portraits with moral messages, and by moralists in popular advice books and emblem books. This vast supply was only possible when it answered a vast

demand. This demand came from a growing bourgeoisie, eager to buy texts and images, with the market winner being the mix of image and text, that is, the emblem book. In Chapter 3 the Augustinian tension between regulating and controlling the passions and pursuing the virtues, on the one hand, and real life, on the other, turned out to be mirrored in rather realistic paintings and drawings as by Rembrandt, and also in personal documents. That visualization of children's emotions even seemed to support, notwithstanding time-bound used symbols, styles, and configurations, the idea of some basic human emotions. The mission of regulating children's emotions, translated in texts and images on emotional literacy for children, seems, however, to be much more time-bound. It was an answer on the above formulated call by the church with its intensification of religious life to all parts of life, the state, and the economy.

The mission originated in the European movements of Renaissance, Humanism, and Reformation, and its images and texts were European notwithstanding national peculiarities. Emblem books such as those by Cats used many European languages, contained examples from the Bible and from texts of ancient Greece and Rome, and used Europe-wide proverbs. Instructional manuals such as the Protestant Dutch marriage and child-rearing advice manuals were often remarkably similar to British puritan ones. Erasmus, the most influential author in this respect, was a full-bloody European humanist. Artists in the European Megalopolis made use of the same symbolic codes and rules, based on Christianity and antique Greece and Rome to strengthen their messages, and they often worked for an international market.

Channeling the passions and controlling the emotions went by letting the will manage the body in the good direction. From the sixteenth century the body and its sensorial, emotive, and physical expressions were increasingly, at least intentionally, framed within rules of containment, self-control, and restraint of one's emotional manifestations within socially acceptable boundaries, both intended from a humanistic, more optimistic and from a Protestant, more pessimistic view on man.[122] This process has been connected with the rise of the individual, that seducing view of Burckhardt about the individual growing up in cultures with stronger control of emotions in an increasingly more civilized and rationalized world. Such interpretations, also inspired by Norbert Elias and Max Weber, however, are increasingly questioned by historians of ancient Greece and Rome, the Middle Ages, and early modern Europe, and also in studies on non-European cultures, who reject the idea of less "civilized" management of emotions in those periods and cultures than in "rationalized" Europe.[123] But also without that argument of civilization it is clear that the age of Renaissance and Reformation asked for more containment of emotions. New potentialities of the educational space made it easier to bring this mission into practice.

PART 2

Between Child and Education: Children's Emotions in the Age of Enlightenment, Romanticism, and Science

5

The Big Talk on Education and Emotions in the Age of Enlightenment, Romanticism, and Science

From Playing to Learning: A Crucial Transition in Child's Development

In *Boy with a Spinning-Top* (1738), the French painter Jean-Baptiste Siméon Chardin (1699–1779), inspired by Van Dyck in portraying children in their child's world, portrayed a real person, Auguste-Gabriel Godefroy (1728–1813), the son of goldsmith Charles Godefroy. But his intention was to portray a type, namely a child during a crucial passage into self-discovery and development. Chardin's main subject is not the elegantly dressed Auguste-Gabriel but his passage to adulthood. Around the desk where the ten-year-old boy stands before are all kinds of toys such as a set of cards, a top, and rackets. But the child does no longer have the appetite to play with them. He is observing the toys as objects from his own past, which ended perhaps just one day before. No longer toys but serious books do ask for his attention. The books lay on the desk together with the quill to write down what was learned, as evidence of the passage from playing to learning. The boy is observed by the painter in the same way the boy observes his former life as a playing child. The painting shows the transition in the development of the child without explicit moralization (Figure 38).[1]

Some decades later, the Dutch solicitor and writer Hieronijmus van Alphen (1746–1803) visualized the same transition and turning point in child's development as Chardin's painting did with *Joyful Learning* (1778), a drawing with a poem quite similar to seventeenth-century emblems and part of *Little Poems for Children* published in three volumes (1778–82). The child in the image and in the accompanying poem is not a real person but a type, namely a child fitting the moral criteria of child development that Van Alphen believed in. The poem reads as follows:

> My playing is learning, my learning is playing,
> So why should learning be boring?
> Reading and writing are fun.
> I will swap my top and hoop for books;

I will pass my time with my prints,
Wisdom and virtues are what I long for (Figure 39).[2]

The picture alone enables already young children who cannot yet read to understand the message by contrasting learning and playing in a configuration similar to Chardin's painting. The boy is sitting on his chair behind a desk with books and a piece of paper, a quill pen in his right hand and already put on the paper. Meanwhile, he turns to the left, pointing with his left hand to the toys on the floor, which refer to play. "Joyful Learning" became one of the most popular examples from *Little Poems for Children*. Those poems became a long-term bestseller for teaching and learning of emotional literacy and belonged to the emerging genre of child's literature instead of child-rearing manuals. Intended for young children, the poems were, depending on their age, suitable to read to and to read themselves. Like Chardin, Van Alphen thought that the young child could itself make the transition to moral and emotional literacy.

FIGURE 38 Jean-Baptiste Siméon Chardin, *Boy with a Spinning-Top (Auguste-Gabriel Godefroy (1728–1813))* [L'Enfant au toton] (1738), oil on canvas, 67 × 76 cm (Paris: Musée du Louvre). Credit: Christophel Fine Art/Contributor (Universal Images Group Editorial).

The Big Talk in Enligthenment/Romenticism/Science

FIGURE 39 Hieronijmus van Alphen, *Joyful Learning* [Het vrolijke leren]. From: Hieronijmus van Alphen, *Kleine gedichten voor kinderen* (Utrecht: Wed. J. van Terveen en Zoon, 1787, pp. 10–11; Rare Books Department, University Library, University of Groningen, 2L 1579; photograph by Dirk Fennema).

Chardin and Van Alphen shared the same attention for this crucial transition in child's development. They were part of a long tradition of visualizing the contrast between playing and learning in images such as Gerard Ter Borch's *Boy Picking Fleas Off His Dog* (1655), a popular and often copied painting. But there are some main differences between the seventeenth and eighteenth centuries. In the sixteenth and seventeenth centuries, meanings of images were often implicit and a puzzle to unravel. The boy in Ter Borch's painting, sitting relaxed while picking fleas off his dog with his school things at the table, is practicing the virtues of diligence, order, and cleanliness. But he is also warned to not neglect his schoolwork.[3] While Ter Borch juxtaposes the two activities, Chardin and Van Alphen are explicit in their emphasis on the crucial transition in child's development from playing to learning.

Relative to each other, Chardin and Van Alphen differed in their approach. Firstly, the destination of their products differs: a painting for adults versus an image with a poem for children. Secondly, while Chardin observes the child, Van Alphen encourages and supports it in making the necessary transition by delivering for young children

appealing images and understandable texts. Further, while religion was not present in Chardin's painting, Van Alphen's Christian-Pietistic mindset formed the foundation of *Little Poems for Children*. Finally, while in Chardin's painting the child is alone and in that situation in search of a new identity, all *Little Poems for Children* assume a strong emotional relationship between child and parent, in particular the father. The two pictures show the diversity of the Enlightenment approach to education and childhood. From radical to moderate, and from secular to Pietistic and Catholic movements contributed to educational Enlightenment.[4] Moreover, a focus on feelings and emotions, traditionally connected with Romanticism and not with the Age of Reason as the Enlightenment is often described, characterized the Enlightenment too.

In this chapter we will discuss changing ideas on education and emotions in the growing educational and emotional space of an increasingly modernizing Europe from mid-eighteenth to late nineteenth century. The main changes in the discourse behind childhood, education, and emotions were prepared and inspired by cultural movements of Enlightenment and Romanticism, and this made the outcome ambivalent. For the rest, also within the Enlightenment rationality that was essential for the scientific disenchantment of emotions and the child, went together with emphasis on feelings and sensibility, something mostly attributed to Romanticism, a movement behind educators such as Fröbel and a source of inspiration for the late nineteenth-century Progressive Education. Before discussing the development of this complex and ambivalent discourse, a brief sketch will be given of the expanding educational space in this period of accelerated modernization.

Educational and Emotional Space in a Continuously Modernizing Society

Europe's educational and emotional space developed in a changing world that modernized in the direction of an industrializing society.[5] In particular two cultural movements, the Enlightenment and Romanticism, gave shape to the making of a new culture with a decisive impact on education, childhood, and the emotions. At first sight for the Enlightenment it was education first, with the child approached as *tabula rasa*; for Romanticism it was the child first, approached as a human being with innate knowledge, energy, and emotions. In reality, the distinction is not always that clear. The Enlightenment inspired also artists and authors such as Chardin and Van Alphen who focused explicitly on the child and fitted a more child-oriented approach, while Romantic authors such as Fröbel were explicitly interested in the child but also in the role of education and schooling.

This shared interest in education and the child occurred within an educational space with diminishing limits and increasing potentialities and opportunities. This process took place in a different pace within the European Megalopolis and definitively permeated in the century's last quarter. In particular demographic limits, frustrating many early modern Europe's educational ambitions, improved through better water and sewerage

infrastructure, better personal hygiene, and eventually also better medical care.[6] This demographic transformation was mainly due to the combination of economic growth and emerging social policy. This economic growth did have, until far in the nineteenth century, two different faces in its effect on the child's world.

With one face it provided the means for the increase of schooling, which eventually resulted into the introduction of compulsory education, an educational ambition built on Enlightenment ideas about schooling and citizenship and, around 1900, turned into practice. Economic growth also resulted into more material welfare of the domestic space, making it for an increasing number of families of the bourgeoisie the emotional space par excellence through "material changes in the level of comfort in the home, taste, manners, fashion, and consumerism."[7] While this face was to the benefit of upper-class children, in particular the bourgeoisie, the other face resulted into child exploitation on a large scale under the lower social classes. This was for many children, until far in the nineteenth-century, a hard reality, driven by purely economic profit motives instead of the beautiful ideals of Enlightenment and Romanticism about education and child. Industrialization, starting in England in the second half of the eighteenth century and spreading across Europe in the course of the nineteenth century, stimulated new and massive forms of child abuse through industrial child labor. This was heavier and more risky than before because of the increasing number of working hours and the disciplined work pace determined by machines. It meant for many children a shorter and more disciplined childhood instead of a longer and more child-oriented one. Ideas about childhood and education from Enlightenment and Romanticism, also part of Europe's modernization, formed the beginning of the weakening of this other face of modern economic growth. Resistance emerged first in England where the modern industrialization started with everywhere industrial chimneys rising from the ground. For its cleaning it was thought to be most convenient and cheap in the entrepreneur's often only profit-oriented logic to have the job done by small children, for adults were too big—and too expensive—for this work. The emotions of those children, whose childhood was scarred by extremely dangerous child labor because of falling or inhalation of toxic substances, were touchingly expressed from the perspective of the child in *The Chimney Sweepers* by the romantic poet William Blake (1757–1827), with the starting sentences:

> When my mother died
> I was very young,
> And my father sold me while yet my tongue
> Could scarcely cry "Weep! Weep! Weep! Weep!"
> So your chimneys I sweep, and in soot I sleep.[8]

This practice eventually ended by the introduction of child labor acts at a pace following that of industrialization, in England from 1819 but, for example, in the Netherlands not earlier than from 1874. With, at roughly the same time, the introduction of school acts, child labor acts and school acts became communicating vessels. The

main place for a child between six and twelve years became the school instead of the factory, the workshop, and eventually also the farm.[9] Behind this development were, as we will see in the next two sections, different ideas about childhood and education with different educational styles, from filling the *tabula* to child-centeredness in a Copernican educational turn.

Filling the *Tabula Rasa*

John Locke (1632–1704), philosopher but also "Protestant physician and pediatrician, epistemologist, and sympathizer of liberal republicanism" after the post-Glorious Revolution (1688–9), published two important texts on education: the posthumously published *On the Conduct of the Understanding*, and *Some Thoughts Concerning Education* (1693), "one of the milestones in educational history," soon translated in other languages, with an Erasmian belief in the power of education. This belief was summarized by him as follows: "Of all the Men we meet with, Nine parts of Ten are what they are, Good or Evil, useful or not, by their Education."[10] Locke made the concept of *tabula rasa*, the child as a still blank piece of paper, a common educational concept. For the rest, Locke was interested not only in the educational way of filling the *tabula rasa* but also in the child's world, apparent from his emphasis on the necessity of pleasure during learning and on learning by playing.[11] His ideas about the child as white paper went back to Erasmus and can be considered as an adaptation of concepts of *tabula rasa* and *animal educandum* from Renaissance and Reformation that were common in child-rearing manuals and emblem books. But while orthodox Protestant child-rearing advice manuals were based on a pessimistic image of man, now those ideas were part of a Europe-wide optimistic educational discourse, practiced by individual parents in the domestic and by schoolmasters in model schools like the *Philanthropinum* in Dessau in Germany.

It remained that the child was considered a creature to be raised from the ground up by education. But the emphasis on original sin was missing. Locke started *Some Thoughts Concerning Education* (1693) by writing about the passions, the mental aspects of human beings. He followed the contemporary medical discourse by concluding that "physical health is necessary for spry, enlivening thought" and emphasized "the use of the management of the passions."[12] Locke thus underlined the importance of training into emotional literacy. His ideas about education and the child became popular all over Europe. Also Locke's ideas about the connection between knowledge and virtue became popular and did fit one of the main educational maxims of the Enlightenment, namely that knowledge creates virtue. Van Alphen's "Joyful Learning" connected child's intellectual with its moral development and was an example of the more compelling and didactic way of coping with children's emotions that became typical for the Enlightenment discourse. With the new ambition of inclusive citizenship, which meant that in principle all children should be prepared for citizenship, the new educational discourse resulted in more effective educational tools for both the family and the school.

Around 1800 "nation" and "people" in Enlightenment Europe merged into "nation," which "became the principle of cultural cohesion" with a major position for the school in preparing children for citizenship of the nation.[13] In the eighteenth and nineteenth centuries, the public interest and the belief in education grew. This resulted, around 1800, into an "educationalized culture" that translated a multitude of social questions such as "crime, poverty, or corruption" into "educational questions." This made education "the engine of both progress and stability."[14] Making children virtuous citizens of the emerging nation-state became raison d'état. In 1755, during the French Enlightenment, the entry on "education" in the *Encyclopédie* expressed this ambition as follows: "It is evident that there is no order of citizens in a state for which there should not be a kind of education that is proper to them; education for the children of sovereigns, education for the children of the great, for those of the magistrates."[15]

In this process, apart from the family and the domestic, on which educational environment this book is primarily focused, the school should play a crucial role. While schooling as such corresponded with late eighteenth-century ideas about the "pursuit of happiness," mass education was not focused on the "happiness of the individual," but on the happiness of the nation: the "purpose of a national education system was to meet the needs of the nation."[16] Three roads in the form of three school models to achieve this goal existed in the nineteenth century. The first was the denominational school founded by the Roman Catholic national church or by one of the Protestant denominations. The second model, by Williams described as "nondenominational Christian educational institutions," was the initiative of non-orthodox Protestant adherents of the Enlightenment as "an alternative to that of the established church." Schools, according to this model, were in principle intended for all pupils. They were not connected to any specific denomination but were founded on a general interpretation of the Christian doctrine, based on the Bible. The third model was the public school, founded by the state and also intended for all pupils.[17] Ideological discussions and power play on education resulted in many countries, among them France, Germany, and the Netherlands, into long-lasting political struggles about which model or which combination of models of the school, in particular the primary school for mass education, would prevail. This led to varying outcomes with, in France, the public school getting the upper hand with the laic public school introduced in the educational Jules Ferry Acts (1881); in Germany, the German *Kulturkampf* by Otto Von Bismarck (1815–1898) resulting into the expulsion of Catholic congregations; and in the Netherlands, a political compromise between the confessional and liberal parties resulting into a mixed system of denominational Protestant and Roman Catholic schools and the public school, from the 1920s fully financed by the state.[18] This model was an example of the "moral education and formation of children in the elementary schools" as, argues Williams, a "response to modernity in these Christian-majority countries."[19]

The issue of how to reach happiness of the nation and with which approach of the students led to different approaches. One of the preferred approaches was "pedagogies of fear." This means frightening pupils about a number of topics such as crime, sexuality,

hedonism, and alcoholism by picture and text. But it also included corporal punishment, already fiercely rejected by Erasmus (see Chapter 2), frequently used "for misdemeanors including talking or laughing in class, inattention, disobedience, and lateness," as well as "constant surveillance of pupils" in order to "ensure both high standards of behavior and achievement."[20] Philippe Ariès was one of the first to give attention in *L'enfant et la vie familiale sous l'ancien régime* (1960) to discipline and surveillance in the classroom as an increasing process from the seventeenth century. In 1975 Michel Foucault (1926–1984) in *Surveiller et punir* focused on the working of discipline in education of at-risk and risky adults and youngsters (see Chapter 1).[21] Training of children's emotional literacy for future citizenship became crucial for society and state, and mass schooling was, so believed, only doable with control and, if necessary, suppression of emotions in the classroom in order to make the learning process possible. Discipline became an essential framework for a compelling and didactic approach of children.[22]

Moreover, discipline was essential in the reeducation of children at risk. This got a boost by the work of an expanding network of secular and Christian philanthropists, inspired by the Enlightenment and the Protestant Evangelical Movement[23] and later joined by Roman Catholic initiatives.[24] They set up a European-wide system of residential homes, and this resulted, at the end of the nineteenth century, into several thousands of residential institutions that provided out-of-home placements for two categories of children at risk: juvenile delinquents and neglected children.[25] As with the compulsory education acts around 1900, child protection acts were introduced as a legal umbrella above the already existing homes. They authorized the state to intervene into parental authority, if necessary, "in the best interest of the child," a formulation literally included in the contemporary legal texts.[26] Both mass education and residential reeducation contributed to the longing, already starting in the late sixteenth century, for more discipline in education and for more control of the emotions of children. At the same time, however, the culture of discipline was attacked fiercely by the Progressive Education Movement. This movement aimed at the happiness of the individual child instead of the happiness of the nation, and it made use of strategies like "scientific pedagogies, and pedagogies of love." It was inspired by the Copernican turn in educational theory.[27]

"To Awaken and Develop … All the Powers and Natural Gifts of the Child"

Those alternative ideas about childhood intended to stimulate the development of the innate forces of the not-so-empty mind of the child. As a radical alternative of the emphasis on filling the *tabula rasa*, it was described as a Copernican turn in educational thinking: instead of the child the educator was placed in the center of the educational process. In philosophy, the arts, and *belles-lettres*, new ways of exploring the world of childhood developed, and almost a century later, this romantic approach of childhood inspired the Progressive Education Movement, or *Reform Pädagogik*, that took off in late nineteenth-century Europe and soon became a global movement.

The philosopher Jean-Jacques Rousseau (1712–1778) emphasized in *Émile, ou de l'Éducation* (1762), often considered the most important source of this Copernican turn in educational thinking, the uniqueness of the child's world. This world should as long as possible not be affected by culture. Rousseau's radical approach was most manifest in his ideas about learning and of the nature–culture dichotomy.[28] Learning should happen through the child's personal experience rather than through education by parents or teachers. And about culture, he wrote in an almost Romantic longing tone: "I want to raise Émile in the country, far from the rabble of servants ..., far from the black mores of the cities, which the veneer with which they are covered makes them seductive and contagious for children; whereas the vices of the peasants ... are more apt to repel than to seduce, when one has no interest in imitating them." The city was depicted by Rousseau as a hell and a depraved society, wholly unfit for the upbringing of children. As Alain Corbin made clear, there was indeed an enormous stench in eighteenth-century European cities, and the starting industrial revolution did make the living environment not healthier, rather the reverse. Children, therefore, had to grow up in an idyllic natural environment.[29]

In Rousseau's time the sentimental novel became popular with bestsellers such as Goethe's *Die Leiden des Jungen Werthers* (1774). Those novels should contribute to the "civilizing of the bourgeois passions," in other words to emotional literacy. Also Rousseau was the author of a sentimental novel, *Julie, ou la nouvelle Heloïse* (1761), an epistolary and very successful work. He however rejected such stuff for children and youngsters. He strongly opposed the Renaissance-born and by humanists such as Erasmus recommended strategy of letting children study and translate the classics and he rejected "learning through their words how to express and experience affective states." On the contrary, he recommended having "a child raised in nature and outside human community" and recommended that only when a child became an "adolescent does his tutor allow him to experience sympathy and read novels with their dangerous pleasures," starting this transition with the reading of Daniel Defoe's (1660–1731) *Robinson Crusoe* (1719). While earlier in *Émile* already recommending to "take away the instruments of their greatest misery, namely books," he starts the stage of Émile's reading with the sentence: "I hate books." This had to do with the control of passions, for he claimed "that by keeping Emile from experiencing particular passions too soon, he can inculcate feelings of love for humanity in general rather than uncontrollable passions for a single, and possible unworthy, person."[30]

Until *Robinson Crusoe*, the book of *Émile* was thus the book of nature. Rousseau's contrast between nature and culture was highly moral. He opened *Émile* by contrasting the "(corrupt) *bourgeois*" to the "(virtuous) *citoyen*" and concluded that the contemporary educational institutions could not educate children into free virtuous citizens. In fact, "the true aim of Emile's education turns out to be to prevent passions (except for the fatherland), to use practical rationality, to prefer country life, and to admire the virtuous Roman citizens."[31] While Erasmus started from the premise that passions came from nature, did belong to the child and should be tempered, tamed and controlled as soon

as possible by culture, more precisely the vehicle of classic literature, or, Renaissance education, Rousseau, philosopher and man of letters, saw the cause of the passions in culture and recommended to keep children away from that as long as possible.

Notwithstanding his radical approach, Rousseau became popular among many parents around 1800, partly by a deradicalization and educationalization of his ideas, as in the Netherlands where *Émile* was printed and published, through German educationalists. Among them were Johann Bernhard Basedow (1724–1790), founder of the Philanthropinum in Dessau (1774), which grew into the model school of the European Enlightenment, a nondenominational institution with moral education within a general Christian discourse, Joachim Heinrich Campe (1746–1818), and Christian Gotthilf Salzmann (1744–1811).[32] This educationalization was far from Rousseau's intention: he was interested in his mental experiment about child and education in the tension between nature and culture and not at all in school organization or curriculum building.

The Copernican turn placed the child in the center of the educational relationship and moved away from John Locke's idea of the *tabula rasa*. Launched on a philosophical level as a mental experiment with a nonexisting boy in *Émile*, it was expressed in poetry and brought into practice by pedagogues. The British poet William Blake discovered the child as a unique and almost holy human being and wrote: "And I wrote my happy songs / Every child may joy to hear." He also confronted, as told above, in "Chimney Sweeper" from *Songs of Innocence* (1789) the romantic ideal with the harsh reality of the English chimney sweepers. His colleague William Wordsworth (1770–1850), who defined poetry as "the spontaneous overflow of powerful feelings" in the preface to *Lyrical Ballads* (1802),[33] put the child on the throne of innocence in his *Ode on Intimations of Immortality from Recollection of Early Childhood*. He regarded childhood as the best part of life and the child itself as a unique and almost holy human being: "Though inland far we be, / Our Souls have sight of that immortal sea / Which brought us hither, / Can in a moment travel thither, / And see the Children sport upon the shore."[34]

But most of all the Copernican turn became the breeding ground for pedagogues such as the Swiss pedagogue Johann Heinrich Pestalozzi (1746–1827) and Friedrich Wilhelm August Fröbel (1782–1852).[35] Pestalozzi focused his whole life on education and social work. He wrote extensively about the mother–child relationship and was the "undisputed star of this expansive educationalized culture."[36] He considered as main role of the educator stimulating the natural development of the child and stimulated Fröbel, who visited Pestalozzi in his educational institute in the castle of Burgdorf near Bern, to develop that approach further. While Pestalozzi was a pedagogue in between German Enlightenment and Romanticism, Fröbel was a full-blooded romantic with his focus on the young child. In *The Education of Man* [*Die Menschenerziehung*] (1828) he did not focus on the child as a *tabula rasa*, but on children's inner energy and potential. Child's development should be stimulated by trusting on this individual potential and play would be the best way of developing for young children. "Let us learn from our

children," he wrote, and he emphasized the role of play: "Play is the highest phase of child-development ... [,] for it is self-active representation of the inner ... The plays of childhood are the germinal leaves of all later life." Parental responsibility for young children was, therefore, not so much adequately and methodically filling the *tabula rasa* of the child, but rather, and albeit seemingly more modest considered as radical in his time, "to awaken and develop, to quicken all the powers and natural gifts of the child."[37]

The ideas about the child in the center, launched by Rousseau's *Émile* and brought in practice by German pedagogues such as Pestalozzi and Fröbel, inspired late nineteenth-century *Vom Kinde aus* or *Reformpädagogik*, in the Anglo-Saxon world Progressive Education, with, among others, the Swedish educationalist Ellen Key (1849–1926) who applauded a century of the child with her popular book *The Century of the Child* from 1900, and the progressive school reformers Maria Montessori (1870–1952) and Ovide Decroly (1871–1932).[38] Key's book "will be returned to time and again ... it will be quoted and refuted," wrote Key's admirer and poet Rainer Maria Rilke (1875–1926) in a review, and he was not wrong. Key did have a talent for propaganda of her ideas and she traveled around the world for presentations about that new century of the child. While the book became an icon for Progressive Education, Key performed a balancing act by embracing at the same time a Romantic child view and a social Darwinist and eugenic approach, then rather popular all over Europe.[39] According to Key "the first right of the child is to select its own parents." To protect this right she proposed premarriage tests by the state in order to restrict marriage "where there are diseases which can certainly be transmitted." She also followed the romantic discourse when predicting: "The time will come in which the child will be looked upon as holy." That was in her opinion clearly not the case with children at school, for her judgment of the primary school was damning. While Key did never attend school, her "first dream is that the kindergarten and the primary school will be everywhere replaced by instruction at home," a revolutionary proposal exactly in the time of introduction of compulsory education, but according to her necessary because of the "results of the present-day school." Those results were exceptionally negative and led to "exhausted brain power, weak nerves, ... paralysed initiative, ... idealism blunted under the feverish zeal of getting a position in the class."[40] Progressive Education inspired also artists in the last decades of the nineteenth century in, argues Pernoud, painting "children without reference to educational expectations" and with only little educational appearance. But, as often in this period, this development went together with Romantic artists who remained, when portraying the child, searching as with Mary Cassatt "the secret of the first glance, of the virginity of the senses" (see Chapter 6).[41]

The Disenchantment of the Child

Child Sciences aspired to get insight into all aspects of the child's world and they so did fit Max Weber's theory about the disenchantment of the world (see further below).[42] The

disenchanting, scientific approach to the child started with authors such as Alexander Bain (1818–1903), who also wrote about emotions, on which below, with *Education as a Science* (1879), and A. H. Garlick with the popular *New Manual of Method* (1896), helpful for teachers when confronted with "poor behavior such as inattention, laziness, stupidity, or truancy."[43] Child sciences were developed under various names, such as developmental psychology, child study, pedagogical pathology, *Sonderpädagogik*, child psychiatry, experimental pedagogy, school pedagogy, pedagogy, and developmental psychology. Sigmund Freud (1856–1939) wrote in 1897 in a letter to Wilhelm Fliess (1858–1928): "It is interesting that the literature is now turning so much to the psychology of children."[44] Indeed a new field developed in Europe and America with foundational texts such as Wilhelm Preyer's (1841–1897) *The Mind of the Child* [*Die Seele des Kindes*] (1882), Bernard Perez's (1836–1903) *The First Three Years of Childhood* (1885), James Sully's (1842–1923) *Studies of Childhood* (1895), James Mark Baldwin's (1861–1934) *Mental Development in the Child and the Race* (1894), and the article "The Content of Children's Mind" (1883) by Granville Stanley Hall (1844–1924).[45]

An important inspiration for child study lay also in Darwinism, just like for the physical turn in emotion research, on which below. Although Charles Darwin (1809–1882) cannot be labeled as a social Darwinist, his ideas about the "survival of the fittest" and his general law, namely "let the strongest live and the weakest die," from *On the Origins of Species by Means of Natural Science* (1859) were widely applied to society as a whole to explain social conflicts and personal amelioration in a culture characterized by a liberal economic competition.[46] Significant texts for the influence on child study were, among others, Hippolyte Taine's (1828–1893) *On the Acquisition of Language by Children* (1877) and *Babies and Science* (1881) by James Sully, in which the baby was regarded as "a biological specimen."[47] The Edinburgh psychiatrist Sir Thomas Clouston (1840–1915), author of *Morals and Brain* (1912), emphasized the control of passions and the necessity "to order impulse and desire, passion and temptation."[48] In the meantime, pedagogical pathology arose in Germany with Adolf Heinrich Ludwig Von Strümpell (1812–1899) as one of its pioneers with the focus on the study of child deficiencies.[49]

They all represented a more disenchanting approach for the child in a period in which also the traditional way of looking at emotions as passions of the soul changed radically, and in the same disenchanting direction.

Complementary and Competing: The Discourse on Emotions

In this period a radical change in defining feelings, namely from passions and affections into emotions, went together with a more gradual change in emotional cultures. In the discourse, the radical change was initiated in the Enlightenment and culminated at the end of the nineteenth century in William James's psychology of emotions. In the eighteenth century the word emotion began slowly but surely to overrule the longtime

dominating concepts of passions and affections. Moreover, feelings seemed to lose its moral foundation and "from being considered moral, and at least to some extent mental and volitional, to being regarded as physical, bodily experiences that were involuntary."[50] In his soon-to-be classic article "What Is an Emotion?" in *Mind* (1884), William James (1842–1910) made clear that "it was the perception of one's bodily physical changes that precipitated an emotion,"[51] and not the other way around. This idea "gradually took hold across Europe" and resulted into more universal, that is, nonhistoric claims about emotions, namely to consider them as "part of the standard physical make-up of humans." This did not happen in the same pace everywhere and faster in Britain than on the European continent, in particular Germany.[52] This was because the transformation of the set of passions, appetites, affections, and sentiments into one single concept, emotion, happened mainly outside the common people, namely among theologians, humanists, and philosophers, then physicians and biologists like Darwin, and finally psychologists. The theologian approach of emotions did not disappear and it remained fundamental for the churches. As a result, the distance between the intellectual elite and the common man and woman, and between an exclusively theologian and an exclusively scientific approach, could be very large, and as a result Weber's assumed disenchantment as part of the process of rationalization thus only applied for a small scientific minority.[53]

This was also the case with the emotional culture. According to Katie Barclay the Enlightenment "is perhaps distinctive in the history of Western Europe in having an emotional culture that ... was remarkably coherent across Europe," namely the "culture of sensibility" with a "particular emotional style in a broad domain of fields" including the *belles-lettres* and the visual arts, and "practiced by individuals, largely of the social elite and middling sorts."[54] It might, however, be perhaps better to take too literally neither "distinctive in the history of Europe" nor "coherent." If there would have been a dominant and coherent emotional culture in Europe, then the best chance should make the Christian culture of passions and affections in early modern Europe. As to culture's assumed coherence, "the domestic environment, to an even greater extent than the 'family,' was not a coherent emotional community" but characterized by different experiences regarding privacy and intimacy by "father, servant, child or apprentice."[55] Moreover, this connection of a culture of feeling with the domestic was not that new, for "many historians were "tracing a much longer history of affection" with "mutual attraction and affection ... always considered essential during the process of courtship in the sixteenth century" (see Chapter 1).[56]

Not new does not mean not important. On the contrary, this emotional culture did suit well the increasing importance of the domestic as a space of feeling between spouses and between parents and children. It gained extra influence through an increasing literacy level and the supply of cheap print for a growing group of "urban audiences and those who had access to reading materials." While people were seemingly giving a "coherent emotional vision for the experience of feeling," in practice many "learned their emotional rules from more local emotional cultures," in the "families, workplaces, associations

and communities." Those local cultures, perhaps better mentioned communities, "could intersect, inform, and even challenge dominant emotional cultures."[57]

In the next pages we will first turn to the encouragement of stronger expression of feelings, mostly connected to the domestic and still mostly within a Christian albeit often not ecclesiastical culture. The participants of this emotional culture, inspired by the Enlightenment attention for sensibility and the Romantic emphasis on *Ausdruck*, belonged mostly to the in numbers and wealth growing bourgeoisie. Then we will discuss the development of emotion into a covering concept and eventually a scientific psychological category for the whole variety of which was earlier described as passions and affections, and discuss the physicality of emotions as the manifestation of the late nineteenth-century disenchantment of the emotions.

The Expression of Emotions

The "ideals of sensibility ... and presented perceptions of specific emotional behaviour," especially "loving motherhood," arrived at the domestic by the expanding print culture.[58] Those ideals profited from the philosophical reflection on the connection of reason and sentiment that "legitimized the sentiments in the developing novel"[59] and ideals inspired a major literary movement, called sentimentalism, with its most important branches in the Anglo-Saxon and German world. This movement did also have impact on humanitarian reform such as the abolitionist movement in England and on politics about striving for a unified German state. This *belle-lettres* movement remained important throughout the nineteenth century, also when the naturalistic style, inspired by Darwin who "studied the observable, physical manifestations of emotions" and "sought a naturalistic explanation of those emotions and expressions," gained popularity. So Charles Dickens (1812–1870) with his realistic characters from social life in the London metropole during the industrial revolution indebted to the sentimentality's legacy, of which he, for example, in *The Old Curiosity Shop* (1840–1) "powerfully deployed sentimental conventions."[60] In Britain the literary star of this emotional culture is no doubt Jane Austin (1775–1817) in whose work the explicit expression of emotions dominate, for example, in *Sense and Sensibility* (1811), since its appearance always available as a book and later reworked for the stage, film, and television, and *Emma* (1815), until nowadays popular as television series. The German star was Johann Wolfgang von Goethe (1749–1832) with *The Sorrows of Young Werther*, part of the *Sturm und Drang* movement.[61] Also major impact came from the originally British genre of *Spectators* of Joseph Addison (1672–1719) and Richard Steele (1672–1729), with several national variants among them the Dutch Spectators, characterized as spectators of passion by Sturkenboom, with authors such as Betje Wolff (1738–1804), Hieronijmus van Alphen, and Petronella Moens (1762–1843), who above all emphasized the virtuous citizen as the ideal result of education.[62]

Romanticism is often considered as the opposite of the Enlightenment and a popular reaction across Europe against rational disenchantment and the impact of industrialization

on culture, nature and environment: "a counterpoint to the demands of capitalism and industrialism."[63] The movement developed a more child-oriented approach of children, as discussed above, and emphasized "the primacy of individual feelings and the creative imagination over coercive reason and authority."[64] Romanticism focused on a number of emotions with romantic love the primary one. This was of course not new, as only the literary example of the twelfth-century love affair between *Abélard and Héloïse* shows. But it became a more frequently pursued ideal, just as the already longer existing companionate marriage. Next to romantic love, also family and domestic love was more explicitly expressed, "celebrated and described in terms of affectionate coziness"[65] and visualized in paintings and drawings. Family love included mother love, visualized in great numbers in Europe and America (see Chapter 6), inspired by seventeenth-century genre and family portrait painting, but often put in new and often more realistic and explicit outfit. Also other emotions were more explicitly expressed in word and image, such as patriotism or loyalty to the nation in an age of emerging nation-states, and grief, sadness, and happiness, the latter growing "in importance in the nineteenth century," both as a reality and as hope and aspiration.[66]

However, we should not exaggerate the differences between Enlightenment and Romanticism when it comes to emotions. Goethe's *Die Leiden des Jungen Werthers* (1774) "embodies the German *Sturm und Drang* movement, which celebrated extremes of emotions against the Enlightenment rule of reason," including an extreme way of melancholy. But this state of mind was praised by none other than Enlightenment philosopher par excellence Immanuel Kant (1724–1804) "for its sensitivity to the aesthetic and moral: 'He whose feelings tend towards the melancholic … has above all a feeling for the sublime.'" Kant saw also melancholy's potential danger of "leading him [the melancholic person, JD] to the 'blackest dejection … if they were to be increased above a certain degree or to take a false direction through some causes,'" in other words which did happen with tragic Werther.[67] Romanticism was "often starkly contrasted with those of the preceding era [the Enlightenment, JD] 'in binary oppositions, such as reason versus emotion; objectivity versus subjectivity; spontaneity versus control; limitation versus aspiration; empiricism versus transcendentalism; society versus the individual; public versus private; order versus rebellion; the cosmopolitan versus the national, and so on.'" Goethe's sensibility-like novel shows, however, that it was not always that binary. On the contrary, "many of the themes that shaped sentimentalism (emotion, compassion, sympathy) endured their significance and became enlarged, complicated, and sometimes paradoxical during the Romantic era."[68] It was a reinforcement of the discourse's change in the Enlightenment as visible in the redefinitions of "émotion, sentiment, and sensibilité" in the *Encyclopédie*. This late Enlightenment, according to Reiner Koselleck (1923–2006) a "period of transition," could, argue Frevert et al., "by no means be reduced to an 'age of reason.'" It was according to Dixon "an age of reason, conscience, self-love, interests, passions, sentiments, affections, feeling and sensibility."[69]

Enlightenment and Romanticism were in important areas, such as education and childhood and feelings and emotions, to a significant extent complementary and they

reinforced each other. One reason behind this was the revitalization of religion. Religion seemed in the late eighteenth century to be "put onto the defensive intellectually, culturally, and politically" by the Enlightenment. Churches, with the suppression of the Jesuits as most outstanding example, were challenged strongly, and it even seemed that religions were no longer more than "one of the many categories of thought."[70] This, however, was only something for the elite. For most people it could be doubted that there was a "decrease of religion in the making sense of the cultural and social aspects of life, in particular when it comes to education."[71] On the contrary, all over Europe in the nineteenth century a *Wendung zur Religion* took place, the concept with which the German historian Thomas Nipperdey (1927–1992) described the phenomenon of the intensification of the impact of religion after 1800.[72] This movement was not coherent in its assessment of the Enlightenment. The orthodox wing, which became manifest in the Protestant Réveil in Switzerland, Germany, the Netherlands, and under the name of Evangelicals in Great Britain, considered the Enlightenment as a very dangerous threat for their religion. But the heterodox, moderate wing, both Protestant and Catholic, was more positive about the Enlightenment.[73]

The other way around, from the point of view of the Enlightenment a similar twofold assessment of religion took place. While the Enlightenment in France was openly anticlerical, in countries such as Great Britain, in particular in Scotland, and also in Germany, Switzerland, and in the Netherlands, a Protestant Christian variant of the Enlightenment flourished with often philanthropic societies, which with a mix of rationality and morality focused on a variety of social problems that could be solved by education only.[74] Also as to science, the relationship with religion was complex. The going together of science and religion was a matter of fact for most scientists also in the eighteenth century, who still did not differ from the seventeenth-century biologist Jan Swammerdam (1637–1680) who investigated the "book of nature" to better understand the "wonders of God's creation" and who considered science as "a way to God."[75]

The Enlightenment was thus not automatically against religion as religion was not automatically against the Enlightenment. So the ideas of the Jansenists, inspired by Cornelius Jansen (1585–1638), author of *Ratio atque Institutio Studiorum Societatis Jesu* (1598), in the seventeenth century treated as heresy, got major impact on the Catholic Enlightenment, for example, in Italy and in Habsburgian Austria, where Catholicism and state reform went together in creating "good citizens as well as good Christians." And Pietism inspired the Prussian Enlightenment.[76] While Romanticism is often associated with the revitalization of faith,[77] the Enlightenment seems to be more "heresy than a denial of faith," more antichurches than antireligion. In Rousseau's *Émile* (1762) the Savoyard vicar is as critical about "the perceived weaknesses of the established churches" as about "the anti-religious tendencies of the *philosophes*."[78] This "institutional but not necessarily cultural secularization" resulted into attempts to decrease the institutional clerical might while maintaining religion's cultural impact.[79] Also the Enlightenment inspired culture of sensibility was not anti-Christian. While it "drew on scientific observation of the sensate body, where people received and

interpreted information through sight, touch, hearing, smell, and taste," this culture was also characterized by "anxiety about the excesses of pleasure and luxury" based on traditional Christian morality and "classical notions of virtue."[80]

The Disenchantment of Emotions

The concept of disenchantment, in German *Entzauberung*, was developed by the sociologist Max Weber (1864–1920). In a lecture titled "Wissenschaft als Beruf" [Science as a Profession] on November 7, 1917, for students at the University of Munich, he criticized the irrational movements of his time and emphasized the task of science to turn this development. Science was the most important aspect of the process of rationalization that started with the emergence of the great so-called book-religions, pushing back the magic worldview. From the Renaissance, science started to play that role in further pushing back irrational ways of thinking.[81] Rationalization meant that there "are in principle no mysterious incalculable powers that play a role" and "that means: *the disenchantment of the world* [my italics]."[82] This development seemed, next to creating so-called child studies as discussed above, also to get hold of the study of emotions. First "emotion" was born as a concept that covers a variety of classic concepts including passions, appetites, and affections. Then, at the end of the nineteenth century, a theory of emotion was born that focused on emotion's physicality.

The Birth of a Covering Concept

The discussion about "the proper relationship of reason with the passions, sentiments and affections" was characteristic for the eighteenth-century discourse on emotions.[83] A Galenic medical model still dominated medical science and psychic disorders were understood as "disorders of the body," and in that way described and advised in "learned texts" and "'self-help' manuals."[84] Although Descartes occasionally used "emotion" as a synonym for passions in *Les Passions de l'Âme* (1649), topics such as the nature of emotions, emotion's engine, its control, and how to stimulate children's accommodation to emotional standards began only to change fundamentally from the end of the eighteenth century.[85] A driving force for the discourse was *Lectures on the Philosophy of the Human Mind* (1820) by Thomas Brown (1778–1820), professor of Moral Philosophy at the University of Edinburgh. He introduced "the term 'emotion' as a major psychological category to the academic and literate worlds during the first half of the nineteenth century," and his approach "tied together several features of affective psychologies."[86] Typologies such as appetites, passions, affections, sentiments, lusts, and desires, part of a theological and moral discourse that understood emotions as states of the soul, transformed in the nineteenth century into a seemingly neutral and scientific understanding of emotions as states of the mind, with the overarching category of "emotions" emerging in the Enlightenment.[87] Earlier other Scottish moral philosophers such as David Hume (1711–1776) in *Treatise of Human Nature* (1739–40) and Adam Smith (1724–1804) in *Theory of Moral Sentiments* (1759) made the word "emotion"

more common and "bridged the gap between thinking and feeling."[88] In *An Inquiry Concerning the Principles of Morals* (1751) Hume asked "whether they [morals, JD] be derived from REASON, or from SENTIMENT." He refuted the traditional view that "virtue is nothing but conformity to reason" and he stated in *Treatise of Human Nature* (1738–40): "Morals excite passions, and produce or prevent actions. Reason of itself is utterly impotent in this particular. The rules of morals, therefore, are not conclusions of our reason," but, as he formulates in *Enquiry Concerning the Principles of Morals*, "morality is determined by sentiment. It defines virtue to be *whatever mental action or quality gives to a spectator the pleasing sentiment of approbation*; and vice the contrary."[89]

In Britain both so-called revivalists, that is, evangelicals near the Réveil movement on the European continent and part of the *Wendung zur Religion*, and moral philosophers who were not anti-Christian but manifested a more secularized view on emotions, participated in the debate on emotions. The Augustinian Revivalists, such as Jonathan Edwards (1703–1758) with *Treatise Concerning Religious Affections* (1746) and Isaac Watts (1674–1748) with *Doctrine of the Passions Explained and Improved* (1729) and *Discourse of the Love of God, and Its Influence on All the Passions* (1729), were influenced by Descartes's division between "soul or mind" and the "animal body."[90] Revivalists limited themselves not to theological reflection. The "Passion's [Jesus Christ's Passion, JD] imperative for active engagement of affect, body, mind, and soul" could led to social activism, comparable with the German *Innere Mission* within the Protestant Réveil, and could be combined with a view on passions to be controlled on the basis of a pessimistic image of man, inspired by Augustine and the political philosopher Thomas Hobbes.[91]

At the same time moral philosophers reflected about passions, affections and emotions with a basically optimistic idea of the human nature as good and virtuous. Influenced by Anthony Ashley Cooper, Third Earl of Shaftesbury's (1671–1713) *Characteristics of Men, Manners, Opinions, Times* (1711) and by John Locke, moral philosophers such as the Scottish Francis Hutcheson (1694–1746), professor of Moral Philosophy in Glasgow with *Essay on the Nature and Conduct of the Passions and Affections* (1728), the British Joseph Butler (1692–1752) with his anti-Deistic *Fifteen Sermons* (1726), and Scottish Thomas Reid's (1710–1796) *Essays on the Active Powers of Man* (1788)[92] put God on a great distance of man.[93] For them, the "'general' object of the rational appetite was not now goodness, virtue or truth per se, nor even union with God, but, *one's own* [italics by Dixon] happiness, enjoyment and satisfaction."[94] In contrast with the Evangelical revivalists, the Augustinian emphasis on the role of the will "from sin and the world to God" went to the background for those moral philosophers.[95]

Then in the nineteenth century in several steps the discourse of passions such as "love, hate, hope, fear and anger," appetites or "movements of the lower animal soul" such as "hunger thirst, and sexual desire,"[96] and potentially positive affections changed into the discourse of emotion with its origins no longer in the mind or in the soul, but in the body. Charles Bell (1799–1842), Scottish physician, anatomist, and a skilled

draftsman, in *The Nervous System of the Human Body* (1830) stated that something was an emotion if it produced what he termed an "outward sign—a facial expression or bodily movement."[97] In *Essays on the Anatomy of Expression in Painting* (1806) he connected art and anatomy in search of a more exact representation of expression in art, in a way a refinement of Le Brun's seventeenth-century method. In *Essays on the Anatomy and Philosophy of Expression* (1824) he focused on the investigation of expression as such from the assumption that human beings were made "in God's image."[98]

Herbert Spencer (1820–1903) and Alexander Bain (1818–1903), most influential in the field before Darwin took over the lead, went further on this research, but they did no longer use God as an explanation. Spencer, with his hypothesis of social Darwinism, believed in the explanatory power of evolution for both biological and societal developments. Bain however was not enthusiastic about evolutionistic theories and rejected Darwin's ideas about the "evolutionary origins of behaviours now associated with certain emotions ... [as] 'a total failure.'" Bain contributed very substantially to the creation of a covering concept of emotion.[99] His emotion theory was based on an idea about body and mind contrary to Darwin's, namely that the "fact, or property, named Feeling, is totally distinct from any physical property of matter." In moral issues, he agreed with Smith, Hume, and Darwin that there was "no absolute morality, but only specific contexts of feeling where right and wrong were, long before being rationalized or intellectualized, experienced as part of a social emotional dynamic."[100]

Charles Darwin (1809–1882) wrote with *The Expression of the Emotions in Man and Animals* (1872) a "foundational text in evolutionary psychology."[101] His research was based on two empirical methods: responses on questionnaires about the expression of emotions of human beings and animals that he did circulate in Britain and the Empire among "missionaries, colonists, zookeepers and asylum directors," and the observation of his own children as a father and a scientist. Like a century later Jean Piaget (1896–1980) observed his young children for his work on a theory of intellectual development, Darwin was between 1838 and 1840 observing and "meticulously recording the facial expressions and behaviours of his infant son William." Both sources, the result of the questionnaires and of the observations, were used in *The Expression* (1872); his observations were also used for *A Biographical Sketch of an Infant* (1877), retrospectively a founding text for developmental psychology and child studies. In that text, he followed the development of his son and infant Doddy. He compared his emotions with those of animals and tested him when he was nearly thirteen months on moral sense: "I said 'Doddy ... won't give poor papa a kiss,-naughty Doddy.' These words, without doubt, made him feel slightly uncomfortable; and at last when I had returned to my chair, he protruded his lips as a sign that he was ready to kiss me."[102]

As an evolutionary psychologist Darwin in *The Descent of Man* (1871) and *The Expression of the Emotions in Man and Animals* (1872) believed just as Spencer "that infants were born with innate ideas and mental faculties ... inherited from generations of evolving ancestors," a position against the adherents of John Locke, including John Stuart Mill (1806–1873) who "would explain all mental faculties as the products of

experience." Darwin's position was more "in tune with traditional Christian psychology than Enlightenment mental science," but although influenced by Christian psychology, the "challenge Darwin set himself was to explain psychological adaptations, as well as anatomical ones, without reference to a designing God." Darwin was mainly interested in the "physiology ... [of] a range of mental states [named by him 'emotions,' JD] such as fear, anger, pride, shame and the like." He suggested also: "Most of our emotions are so closely connected with their expression, that they hardly exist if the body remains passive. ... So a man may intensely hate another, but until his bodily frame is affected he cannot be said to be enraged," in other words without bodily expression no emotion.[103]

For the rest, in line with his idea about innate mental faculties inherited from generations of evolving ancestors, Darwin saw no communicative significance for emotions. He therefore considered the emotion's expression as useless. Spencer, Bain, and Darwin built "a new psychological framework where physiological and evolutionary explanations were sought in preference to Bell's natural theological ones." Darwin attacked Bell's natural theology meaning that "the communicative functions of our expressions were divinely contrived" and denied "that expressions had an expressive function, or indeed any useful function."[104] He therefore concluded that expression was not "an evolved form of communication" and that "facial expressions associated with anger or fear, for example, were perhaps commonly held, but their purpose was not to communicate anger or fear."[105] It seems, argues Dixon, that because of his "anti-theological agenda" Darwin not only denied "the utility of expression," but also missed "the (to us) obvious fact that most expressions are very useful (because socially communicative)."[106] Darwin connected physical expression and inner feeling and so laid the foundations for the birth of emotion as a scientific category in modern psychology, a natural science-to-be, away from theology and philosophy.[107]

The Birth of a Theory: The Focus on Emotion's Physicality

Darwin's ideas inspired and influenced James's theory of emotions, which was "in one way merely a more explicit and more simple version of the theories suggested by writers such as Bain, Spencer and Darwin."[108] James "thrust physiology to the forefront of emotions research" in his classic article "What Is an Emotion?" (1884) in *Mind* (where also Darwin's "Biographical Sketch of an Infant" was published) with the following answer: "Common sense says, we lose our fortune, are sorry and weep; we meet a bear, are frightened and run; we are insulted by a rival, are angry and strike. The hypothesis here to be defended says that this order of sequence is incorrect, that the one mental state is not immediately induced by the other, that the bodily manifestations must first be interposed between, and that the more rational statement is that we feel sorry because we cry, angry because we strike, afraid because we tremble, and not that we cry, strike, or tremble, because we are sorry, angry, or fearful, as the case may." The same formulation was used in *The Principles of Psychology* (1890).[109] In other words, there could "be no such thing as a 'purely disembodied emotion,'" and only emotions if bodily could

be examined in the psychological laboratory, in the same period in Germany initiated by Wilhelm Wundt (1832–1920).[110] Almost simultaneously the Danish physician Carl Lange (1834–1900) came to the same conclusion.[111] James's approach was nomothetic. It focused on general laws about human behavior and aimed at turning psychology into a natural science. James wrote in the methodological chapter of *The Principles of Psychology* that, when studying the mind, "mind" should be understood as "only a class name for *minds*," which are "*objects*, in a world of other objects." This would implicate a "natural-science point of view" for the science of psychology.[112] From now, no longer philosophers or theologians, but psychologists considered themselves as the emotion experts. Also when James proposed "to preclude emotions from having any direct influence on the will," this was part of the transformation of emotion studies from moral philosophy into science.[113]

James, aiming at nomothetic science, also distanced himself from philosophers such as Locke and Hume, for their taxonomic studies on emotion did not interest him. He was interested in explanation instead of description of emotions and he believed in the value of introspection.[114] Taxonomies were throughout the history of emotions usual, as we saw with Augustine, Aquinas, Descartes, Hobbes, Spinoza, Locke, and Hume, among many others. Also the selection of some basic passions was not something new. Those classifications of emotions and the kinds of expression varied across time[115] and also Darwin in *The Expression of Emotions in Man and Animals* "believed that there were distinctly different kinds of emotional expression," with the "'chief' expressive actions ... inherited or innate," which emotions should be understood as basic emotions.[116]

But James saw "the merely descriptive literature of the emotions" as "one of the most tedious parts of psychology." On the contrary, emotions have to be explained instead of described: "if we regard them as products of more general causes (as 'species' are now regarded as products of heredity and variation), the mere distinguishing and cataloguing becomes of subsidiary importance." Based on his assumption that "the general causes of the emotions" are "indubitably physiological," he concludes: "My theory ... is that *the bodily changes follow directly the perception of the exciting fact, and that our feeling of the same changes as they occur* IS *the emotion*," and thereafter literary uses the already above quoted words from the article in *Mind* from 1884.[117] James's theory was thus incompatible with those taxonomies of mental states. Locke and Hume and many others classified emotions and passions and affections under "the category of states of mind," but "James's account of human psychology, [was that] there are no such mental states."[118] He therefore had to remove passions from psychology and his approach was in sharp contrast with the classic Christian discourse that understood passions as fundamental.[119]

The philosophers, biologists and psychologists who were responsible for the nineteenth-century "invention" of emotion as a scientifically intended overarching category for states of mind followed a scientific, evolutionary and physiological approach. The introduction of "emotion" as such a category for states of the mind went together with a change from a theological and moral understanding of passions

and affections into a seemingly neutral and scientific understanding of emotions.[120] By founding emotions on evolutionary and physiological fundaments, emotions were disenchanted and made an object of empirical, scientific research. Notwithstanding this radical change in paradigm in the approach of emotions, the romantic approach of emotions, by which people "often described [them] as moral and mental experiences, feeling states they could actively cultivate," remained a view that "flourished into the late nineteenth century, even while physiologists and psychologists were redefining emotion, transforming it into a physical category, rather than a mental one."[121]

Conclusion: A Discourse Marked by Incompatibilities

Two main ideas about childhood and education dominated this period. The first was inspired by the Enlightenment, in particular by John Locke with his idea of the child as a *tabula rasa* and the essential role of the educator in filling this. His ideas contributed to a more didactic way of coping with children's emotions in a Europe-wide optimistic educational discourse. His ideas were popular among parents and schoolmasters, and fitted the development of mass education through the eventually compulsory primary school. The second idea started with putting the child in the center. The idea almost immediately took off after the publication of Rousseau's radical educational turn in the *Émile* and intended, in the words of Fröbel, "to awaken and develop, to quicken all the powers and natural gifts of the child." This turn inspired also parents, and at the end of the nineteenth century the Progressive Education Movement, aiming at a next century as a Century of the Child, and at a new school.

With David Hume and utilitarian-minded philosophers such as Adam Smith and Jeremy Bentham (1748–1832), the first steps were taken in making emotion a covering category and in looking at them in a more empirical way. The dominance of the classic Christian discourse decreased with the birth of a competing discourse by philosophers, biologists and psychologists, but the radical transformation of the discourse had to wait until Darwin and in particular William James. Then, passions were, at least within the scientific domain, definitively replaced by emotions[122] and no longer approached morally but scientifically. This category belonged to another network of words than the classic discourse. It missed words such as states of the soul and sin, grace, Spirit and Satan, but was characterized by new words such as states of mind, psychology, law, observation, evolution, organism, brain, nerves, expression, behavior, and viscera.[123] This was a revolution of paradigm in slow motion: not only a transformation from a variety of typologies into one single category, but also from a theological and moral understanding of states of the soul into a seemingly neutral and scientific understanding of emotions as states of the mind. By the impact of "scientific psychology—which preached that emotions were physical, located in the brain rather than the mind or the soul—and social Darwinian ideas about race and evolution, emotions seemed to be beyond individual control and become the mysterious product of biological forces rather than of the will and cognition."[124] But the discourse about passions and affections did not disappear.[125]

Strengthened and partly secularized by Romanticism, it continued notwithstanding the fact that eventually also "lay people adopted academic notions about feelings and described their emotions in more physical terms."[126] The result was a discourse marked by incompatibilities.

The discourse about childhood, education and emotion in this period was also marked by incompatibilities. On the one hand it slowly became dominated by a longing for the disenchantment of childhood and of emotions through science, namely child sciences and emotion science, both emerging at the end of the nineteenth century. On the other hand, there continued a romantic and enchanting image of childhood, developed by Rousseau and the romantic poets, adopted by Key and the *Vom Kinde aus* movement, and embraced by many artists. In the same way, in the Enlightenment and Romanticism a discourse on sensibility and feelings originated that considered emotions not as physical entities but continued to feel them as states of the mind. This ambivalent discourse made the period from *c.* 1750 to *c.* 1900 an age of tensions between belief in the autonomous talents and energy of the child and the belief in the necessary regulation of a not yet restrained child, and between belief in disenchantment of emotions and in emotions as states of the mind, or also, among Christians, the soul.

The discourse on childhood and education had to cope with the hard reality test of a world of high infant and child mortality and of emerging industrialization with child labor in a new, more disciplined and child-exhausting form. Those realities made Enlightenment and Romantic ideas about childhood initially difficult to realize. The breakthrough came later, through better infrastructure for water and sewerage, better medical care, more emphasis on hygiene and later on the invention of antibiotics, in other words through the growth of educational space because of its economic and demographic indicators.[127] The educational space increased rather early at the level of the discourse, but rather late on the demographic, social, and economic levels. The transformation of the discourse in the direction of disenchantment of childhood and emotion together with the revitalization and intensifying of the classic Christian discourse was also of influence on the artist's eye in the depicting of child's emotions. The first seems to have influenced the increasing realism in painting, for example, with Alexander Bell's *Essays on the Anatomy of Expression in Painting* (1806). Christianity was in particular manifest in family paintings, specifically in mother–child representations, again popular in the second half of the nineteenth century as we will see in the next chapter.

6

The Expression of Children's Emotions in the Age of Enlightenment, Romanticism, and Science

Introduction: Looking at an Adapting, Innovating, and Almost Evaporating Source

In a Europe with major changes in culture and society, the visualization of childhood could profit from an again—as in the sixteenth and seventeenth centuries—increasing art market in Europe (and also North America) for a bourgeoisie that grew in number and in wealth.[1] This visualization was characterized by continuity but also adaptation and even radical innovation. Three trends seem to stand out: more attention for a stronger emotional response[2] by more explicit and realistic visualization, a greater variety of coexisting images of childhood that inspired the artists, and, finally, the coinciding of the end of this period with the slow evaporation of the value of the main source for this book.

Aiming at arousing emotions by showing them explicitly was part of Western Christian iconography and got a boost with Baroque painting in the Roman Catholic Church. By carrying out the decisions on the use of images in churches at the Council of Trent (1545–63), many churches were filled with frescos and paintings with explicitly pictured emotions of sadness, grief, and fear, to arouse emotions among the worshipers and to strengthen their faith. Also outside the Catholic Church, more "people engage emotionally with paintings and other forms of art on an unprecedented scale." In mid-eighteenth-century Enlightenment, it was generally believed that "the emotions aroused by art could act as an important catalyst for the free play of the imagination."[3] Feeling became one of the most important guidelines for art, an idea formulated in Jean-Baptiste du Bois's (1670–1742) *Réflexions critiques sur la poésie et sur la peinture* (1719) and in Immanuel Kant's (1742–1804) *Kritik der Urteilskraft* (1790). So the expression of emotions "in transmitting examples of virtues" became even more important for art.[4] The role of feeling in transmitting virtues was also central for writers such as the aforementioned Anthony Ashley Cooper, Third Earl of Shaftesbury, Jean-Jacques Rousseau, and Johann Gottfried von Herder (1744–1803). With them morality became less associated with church and theology although not disconnected

"from theological assumptions."[5] Moving reader's and viewer's emotions morally now happened increasingly in a profane instead of a sacral guise. The distinction made in the *Encyclopédie* by *Philosophe* and art critic Denis Diderot (1713–1784) between "sensibilité naturelle" and "sensibilité maîtrise" mirrors his moral ideal of painting by which "honesty and true feelings should be transferred to the canvas." His favorite painter was Jean-Baptiste Greuze (1725–1805) of whom he wrote: "If he is thinking about a subject, he is obsessed by it ... It infiltrates his own personality ... [and] he is brusque, gentle, guileful, acerbic, flirtatious, sad, gay, cold, serious or insane depending on the subject he is preparing." Through this new style, "the painting stirs the viewer to tears through gentle feelings." This would result into "moral validity by proclaiming truth," referred to both the painting and the painter, and would make art "the higher moral authority because of its capability of transmitting feelings."[6] Diderot's ideal was comparable with Rousseau's distinction between the "(corrupt) *bourgeois*" and the "(virtuous) *citoyen*," for painting was specified as the replacement of pathos by genuine sentiment.

Next to this strive for moving the emotions of the viewer of fine art, the visualization of children's emotions became influenced by a greater variety of images of childhood. Across time, perhaps the first influential iconographic image of childhood was the innocent child, pictured as the holy child in Madonna's, triptychs, and portraits of the Holy Family, and from the sixteenth century in profane portraits of mother and child, the family, and the child. Although it is often argued that the second part of the eighteenth century "invents early childhood as the stage of innocence,"[7] this seems to be a rather bold interpretation when looking at the many examples of child's innocence in early modern Europe's iconography. This seemingly new image of the innocent child probably could be considered better as a next step in the adaptation of the originally sacral model, now put in a romantic jacket and across time infused with new knowledge about child development and mother–child relationship. In this way it became the typically romantic child image with major impact during the nineteenth century. An image of childhood that contrasted with this optimistic image of childhood was the rather pessimistic idea of child starting its life with the burden of original sin.[8] This view on childhood strengthened its influence through the Protestant Reformation. Seemingly notwithstanding its belief in a start of life for the child with a one–zero morally deficit, namely that burden of original sin, it turned out to become an extra stimulation for active parenting and continued its influence among orthodox Protestant movements during the *Wendung zur Religion*.

The image of the child considered as a family asset due to its genealogical position in upper-class families, in particular among the aristocracy, was popular in early modern Europe. It was intended for the eldest son although exceptionally in aristocratic and royal families also for girls, and did not disappear in modern Europe. It, however, became much less important, as did its social class. Moreover, such paintings were increasingly educationalized, with the child, apart from being the family heir, also considered as an *animal educandum* as such. The belief in this concept of *animal educandum* was

the leading concept of childhood during Humanism and Renaissance and got a firm theoretical boost through the popularity of John Locke's ideas about the *tabula rasa*. It got definitive realization by the introduction at the end of the century of compulsory mass schooling.

Two mutually different images of childhood contrasted with the image of the innocent child, one with a major and often devastating impact on children's well-being, the other a popular image of childhood among artistic circles. The first was the factory child, during the first phase of the industrial revolution the reality for children of the poor, and from the beginning defended and exploited, but also rejected. Many entrepreneurs looked at the child of the poor merely economically and considered the use of a child as laborer a matter of course: an efficient and cheap solution for work that could be done better and cheaper by children than by adults, as the chimney sweeper in William Blake's poem showed. For people such as Blake, however, nothing could be a more flagrant contrast with the Romantic image of the innocent child as such forms of child labor. In the course of the nineteenth century, a simultaneous introduction of school laws and child labor laws meant a win of the child as school child over the child as child laborer.

A second image of childhood contrasting with the image of the innocent child was the ideal of the autonomous child, inspired by a more radical romantic educational discourse around 1800. Although it goes too far to claim that the child was from then portrayed as "an autonomous being" instead of before primarily as "a would-be adult," it is true that iconography now gave more attention to the child's world.[9] In a special way this was done by Gustave Courbet (1819–1877), the pioneer of realistic painting. Courbet—as Théodore Géricault (1791–1824) and Philipp Otto Runge (1777–1810), on whom more below—showed in his paintings not so much childhood's fragility as "the inner forces that agitate it,"[10] for example, in his famous and notorious *The Workshop of the Artist* (1854–5). At first sight, the viewer's attention of this enormous and "without doubt Courbet's most mysterious composition" goes to the artist. He sits in the center of the canvas before his easel, working on a landscape. He is "flanked by ... a female muse, naked like the Truth, a child and a cat" and surrounded with a company of people. On the right are his friends—among them Pierre-Joseph Proudhon (1809–1865), a founding father of anarchism, and poet and art critic Charles Baudelaire (1821–1867), plus other art lovers; and on the left a kind of mirror of society.[11] Those adults present are obviously posing. But the four children, who surprisingly are also present here, are not. Although seemingly part of the adult world, the children create their own autonomous world, with the exception of the youngest child on the right sight, still a baby breastfed by an Irish mother, which refers to poverty then prevalent in Ireland. Lying on the ground just behind the female muse is a boy. He does not look up or back while making a drawing, according to Allard a reference to the purity of child's artistry. On the left, as a second reference to poverty, a girl is begging. The fourth child in the painting, the boy in the center, stands in front of artist and female muse and concentrates at the artist's work-in-progress. The emotions of the two boys

are seriousness and attentiveness, while the begging girl is dominated by grief. All are present in a world that in this Victorian nineteenth century should not be considered as suitable for young children, and the three children, therefore, each in their own way, fit the image of childhood as "an autonomous being."

With this variety of images of childhood, artists visualized the expression of children's emotions within the emotional relationship and the child's world, mostly in a secular but still also in a sacral guise. This happened in portrait painting but also again in genre painting that experienced a revival. Traditionally genre painting was located at the bottom of the classicist hierarchy in the arts, with history painting at the top. An important exception was the seventeenth-century Dutch Republic, without a monarchical court and a Catholic Church, which elsewhere did act as an important sponsor for the arts.[12] Around 1800 also outside the Netherlands genre painting's prestige rose through the "personalization of feelings" with its outstanding capacity of producing emotions "close to the artist's everyday feelings."[13] Examples from the Northern and Southern Netherlands would be of major influence for one of the most important genre painters, Jean-Baptiste Greuze, who painted many scenes of the emotional space of the domestic and of the child's world. In the second half of the century, the *Haagse School* painters were also internationally successful with genre paintings of the child's world by combining realism with a romantic image of childhood, characterized by innocence.

At the end of the century, artists such as Paul Gauguin (1848–1903) wanted instead of rather painting children paint as if they were again a child themselves.[14] The child now became for the artist "the key of his own emancipation" by avoiding "academism" and working "overly educated." Childhood emotions more and more became an inspiration for the artistic development and style, rather than a subject to portray. This however also meant that with the artist's interests and emotions becoming central, the resulting artistic products as historical sources for insights into child's emotions started to lose their validity.[15] So the mostly rather pessimistic view on the child by painters such as Gustav Klimt (1862–1918), Egon Schiele (1890–1918), and Paula Modersohn—Backer (1876–1907) seems to be more a contribution to the artist's self-portrait than a portray of the emotions of the child.[16] Those paintings would serve well as a source for insight into the artist's inner, but less and less in children's emotions. Although other painters continued to depict children with a more observational approach, painting as a source for the history of childhood became anyway less important through the slow at first and then fast-growing popularity of photography for the representation of the family and the child. After a history of many centuries of painting and drawing, photography took over, and with that, the representativeness and validity of paintings and drawings as a historical source for the subject of this book dropped dramatically.[17]

The focus goes now to the variety of emotions expressed within the emotional relationship and in the child's world in its diversity along class, gender, religion, and region, and inside and outside the domestic.

Children's Emotions within an Educational and Emotional Relationship

The Family Together

The home became, through a "cult of domesticity," "*the* ideal emotional community by the late eighteenth century," and it was, argue Alston and Harvey, during this period that "the concepts of privacy, the individual, and the domestic ... became linked to one another."[18] According to Stearns the family was redefined in this period from a production unity into an emotional one with major consequences for courtship, marriage, and parenting. This was "a core response to the change in family function associated with industrialization" with, before 1778, "the fuller flowering of family emotionality ... still to come."[19] Although the family as an emotional unit of sensibility, love, and affection, with within the educational relationship a breeding ground for children's and educator's emotions, was demonstrably much older than the late eighteenth century (see Chapters 2 and 3), this emotional dimension of family life got no doubt much more space for a larger part of the population. It became more than before explicitly visible in texts and images, in particular in the many sensibility and sentimental novels about love, tenderness, sorrow, and jealousy—books that were in particular read by women.

This culture was not so much new as enforced, and it now slowly became accessible for more people. Stearns describes the improvement of the middle-class woman's domestic status as being considered "as the family's leading emotional agent," but this status was also advised, admittedly without this modern formulation, in popular seventeenth-century emblem books such as Cats's *Houwelick*.[20] Also the emergence of a new image of childhood—the "figure of the innocent child, cute and lovable" instead of the now-weakening "notions of original sin," which implicated "the notion of trying to scare children into obedience through references to death and damnation"—would make it more appropriate to look at children as "responsive to loving treatment by adults" and thus would contribute to the new emotional domestic culture.[21] Stearns puts this in perspective by pointing to the sources behind this argument, namely child-rearing advice manuals, which are sources that reflect what should be done: "the new normal, at least at the level of recommendation."[22] For indeed the notion of original sin was in early modern Europe as such no obstacle for active and lovingly parenting.

Smaller families no doubt could stimulate the emotional domestic space. The point, however, is that this demographic development happened rather slowly with major regional and also religious variations. A lower birthrate as a major contribution to an intensified and more emotional relationship between parents and children had to wait for a lower infant and child mortality rate. That happened only in the course of the nineteenth century. The complexity of those demographic developments is evident from the Dutch example with, in the seventeenth century, majority nuclear and rather small families and, from the end of the nineteenth century until the 1960s, relatively large nuclear families. Another development was, again with major variation across regions,

the staying at home of more women through the separation of work that could support making the house the center and source of emotions, with furniture including the piano. This development started in the middle class, but spread over the society generally not earlier than from *c.* 1900.[23] For the rest, while the family and the domestic no doubt became the emotional space par excellence for more people, this was countered by stronger discipline in other pedagogical institutions, namely the school and the family-replacing residential institutions, which excelled in disciplining, controlling, and constraining children's emotions.[24]

In this period, the family portrait changed through a more realistic style, in the words of Sébastien Allard a "quête du naturel," in particular from the second half of the century.[25] Not new was "the introduction of nursing mothers and children in the domain of family portraits of the later eighteenth century,"[26] a very popular topic within sacral art from the late Middle Ages and in secular art in the sixteenth and seventeenth centuries, and not new were proud and loving parents and happy children occurring in family portraits. Laura Alston and Karen Harvey, therefore, rightly concluded that the abundant historiography on the family now available "has allowed historians to complicate the generalized narratives that discuss widespread shifts from one single emotional landscape to another."[27] This, however, does not mean that, apart from a change in artistic style, nothing did change. On the contrary, while in early modern Europe the vertical family lineage longtime dominated in aristocratic family portraits and often also in bourgeois families who imitated the aristocratic example, the configuration of a loving and affectional relationship between parents and children now became the standard within the aristocracy. In other words, while before burghers used to imitate aristocratic behavior, now the opposite happened.[28] In the following we look at family pride and children's happiness in the domestic with special attention to the family around the table and the first steps of a child under parental guidance.

Family Pride and Children's Happiness

In the aristocratic family portrait, the balance between family's genealogical future and parenting changed. In *The Family of Thomas Bradshaw* (*c.* 1769) by Johann Zoffany (1733–1810), the head of the family explicitly shows his role as father, albeit with only attention for his three sons. This happens in a vertical structure of the canvas that reflects the family hierarchy with father together with his youngest son, being offered an apple by father's sister, standing at the top, while mother with her youngest daughter sitting below looks at her eldest son, family heir Robert. He looks as if he is already the next lord Bradshaw, in contrast to his brother Barrington who plays as a child with a kite. According to Allard, this picture would refer to Rousseau's second book of *Émile* in suggesting an educational transition from absolute obedience to persuasion.[29] Zoffany's *John, 14th Lord Willoughby of Broke with His Family* (*c.* 1766) more explicitly visualizes this changing balance between genealogy and education. Again the father is at the top of the configuration of the family. He stands against the chair in which his wife is sitting,

but he points in an educational and friendly way at his son, still a toddler. The boy wants to take some food from the table on which his youngest sister is standing, held by her mother who meanwhile looks to the other side at her oldest daughter who plays with a wooden horse. There is much posing in the painting to show an educationally attentive couple with children who do childish things in a happy domestic atmosphere.[30]

An even happier family seems to be *The Family of Sir William Pepperrell* (1778) by John Singleton Copley (1738–1815). Copley moved to London after remaining loyal to the crown during the start of the American Revolution. In a dynamic configuration, the parents tenderly touch the three girls and a boy of about twelve months, who are happy and very nice to each other. Only the mother looks somewhat vaguely into the distance. She doesn't seem to be quite there with her mind. Family genealogy is apparent from the position of the son, the family's heir. He points excitedly with his right hand to his father who stands and looks friendly and endearing, forming the highest point in the painting, with mother sitting. Genealogy goes together with family affection and happiness, accompanied by a calmly radiating dog. There is something else. Mother had already died before the family came to London. She was put in the center of the painting to emphasize that she was and remains a family member, just as often done in early modern Europe. Future motherly care for the family heir is guaranteed by the feelings of his eldest sister, visible in the way she embraces her little brother and in her gaze when looking lovingly at the viewer to make the message clear.[31] The genealogical relationship between father and family did not prevent the intended visualization of fatherly affection.[32]

Turning from British to Spanish aristocracy, we look at *The Duke of Osana, Pedro de Alcantara, and His Family* (1788), a vast canvas by Francisco Goya (1746–1828) on a very upper-class family. The portrait looks like an affective and emotional unity without emphasis on the family's genealogy. At top of the configuration the duke stands right behind his wife while softly touching her right shoulder. Both look at the viewer. With his left hand the father holds the right hand of his eldest—still very young—daughter and not the hand of his eldest son, the family heir. The other girl—dressed in the same style as her sister—and the two boys are under their mother's care. All children have a toy in their hand, and all, except the eldest son, look at the viewer. All children stand except the youngest son. He seems the most important member of the family. Sitting on the ground before the rest of the family, with a ribbon in his hands with which he can pull a toy carriage, he looks at us with open eyes, full of amazement at what he is now experiencing and seeing—not visible on the canvas—as children of his age do in their exploration of the world, an emotion fantastically visualized by the artist. There is restrained tenderness between the family members. According to Allard, the posing of the father is a visual translation of parental investment in modern educational principles. Indeed, compared with the paintings that started with the family genealogy and focused on the relationship between father and eldest son, this painting is modern in visualizing the family of this high-ranking duke as a close affective knit with no special fatherly attention to the duke's future successor but with, above all, parental tenderness and explicit children's innocence (Figure 40).[33]

FIGURE 40 Francisco Goya, *The Duke of Osana, Pedro de Alcantara, and His Family* (1788), oil on canvas, 225 × 174 cm (Madrid: Museo Nacional del Prado). Credit: Photo Josse/Leemage / Contributor (Corbis Historical).

Philipp Otto Runge (1777–1810), the most important German Romantic painter of family and childhood, combined the child's world and the family in *Portrait of the Artist's Parents* (1806). It shows the family lineage and the succession of generations. Daniel Nikolaus und Magdalena Dorothea Runge are portrayed together with their two grandchildren, Otto Sigismund, Philipp's son, and Friedrich, the son of Philipp's elder brother Jacob, before their house in Wolgast in eastern Germany. This was Philipp's parental house where he was fled because of Napoleon's occupation of Hamburg, where he lived. The grandparents look strict to the viewer as a close arm in arm couple with mother having a rose in her left hand as symbol of marital love. At the background the wharf where Runge senior worked is visible. The contrast between the huge adults and the little children is enormous. The grandchildren play with a large lily and while the elder child looks full of expectation to his grandparents the younger seems to be fully concentrated on the flower.[34] Another, cozy visualization by Runge of the family was the drawing *Holy Family with John* (1798). Mother has Jesus on her lap while he holds the face of the little future John the Baptist, standing naked against Maria who holds him by his lower back. The two boys are giggling while Joseph excited and satisfied from outside the room watches the scene from a window. Runge humanizes the religious *topos* with family happiness and children's joy and so joins a long tradition that goes back to fifteenth-century Holy Family illuminations of *Books of Hour*.[35]

Contemporary Dutch painters visualized domesticity with emphasis on moral and social virtues. Among them were Abraham van Strij (1753–1826), inspired by Pieter de Hooch (1629–1684) and according to the English art connoisseur Murray "the modern Peter de Hooch," Adriaan de Lelie (1755–1820), and Willem Bartel van der Kooi (1768–1836). In particular Van Strij and Van der Kooi combined the idealizing family scenes with simplicity, virtue, and an inclusive civic ideal. They saw themselves not as romantic artists but as models of virtue-oriented citizenship.[36] For the rest, contrary to the end of the century when seventeenth-century Dutch painting was praised and the most famous painter of the *Haagse School*, Jozef Israëls, regarded himself as a second Rembrandt,[37] around 1800 the famous seventeenth-century painters played a marginal role in literary texts and schoolbooks. They were not considered as suitable moral examples. Rembrandt was considered uncivilized, Frans Hals as a drunkard and Jan Steen as a joker who constantly crossed the line of decency. In a booklet (1791) intended for education and reprinted many times under the title *Life Sketches of Dutch Men and Women*, stories about, among others, Jacob Cats and Jan Steen were combined to contrast the frivolous life of Jan Steen with the virtuous life of Cats with the words that "a virtuous conduct wins a man more honor and esteem than other abilities, when coupled with debauchery."[38] An exemplary picture of such a virtuous and decent family, *Shoemaker and His Family in an Interior* (s.a.) by Van Strij, is a secular variant on the Holy Family. It was inspired by a painting by Aert de Gelder (1645–1727) and showed emotions of satisfaction. The scene is situated around the cradle with a baby full in the light that comes from the window. The mother stands by the washtub and the father repairs the shoes in a messy interior. He works hard for ensuring a future for their young

child.³⁹ While containing a restrained moral message about virtues,⁴⁰ it also showed the observation of real family happiness.

Since the fifteenth century, the family around the table was a theme in European iconography, from the poor but Holy Family in illuminations of fifteenth-century Books of Hours to sixteenth- and seventeenth-century paintings of upper-class burghers. When later again depicting this theme, the late nineteenth-century painters of the *Haagse School* preferred simple families of fishermen, poor farmers, and simple craftsmen.⁴¹ To the *Haagse School* belonged a group of painters who worked in The Hague, including Jozef Israëls (1824–1911),⁴² the brothers Jacob Maris (1837–1899), Willem Maris (1844–1910) and initially also Matthijs Maris (1839–1917),⁴³ Albert Neuhuys (1844–1914), and Bernard Blommers (1845–1914). They started from the impressions given by nature, for the "visible reality" was their "exclusive source of inspiration."⁴⁴ Their new realism, inspired by Gustave Courbet (1819–1877) and Jean–François Millet (1814–1875), focused on the family and childhood in the daily life of fishermen, mostly in the Dutch village of Scheveningen, and in daily life of peasants. Their work was seen by much more people than just their owners and admirers, for countless reproductions of their well-sold paintings and watercolors were made and printed as engravings, etchings and lithographs in almanacs and magazines. This increased the paintings' impact but also the reputation of its makers and it led to rising prices for new work.⁴⁵

One of those paintings was *Lunch in a Farmhouse in Carelshaven near Delden* (1885) by Jozef Israëls, painted during a stay there with his friend the German impressionist Max Liebermann (1847–1935). A couple prays before meal to thank God for the food. They sit in front of their separate plates in a simple interior, with a view of a cow's head from the part. But all attention goes to the baby in the cradle in the middle of the room, at the painting's front with all the light going to the head of the satisfied and innocently sleeping baby. The painting is an ode to the innocence and loveliness of young children. It shows restrained emotions of satisfaction and parental love and is an arcadia-like image of the emotions of family and child of the lower classes in which the contemporary art market was interested.⁴⁶ This was one out of a series of paintings by Israëls of lower-class families around the table. He started with this genre in the 1870s and the dinner mostly existed of potatoes, the staple food of poor Europeans since Napoleonic times. In all versions the youngest, innocent child is in the center and the light and the family is not so much characterized by pride and joy as by satisfaction and gratitude.⁴⁷ Israëls's depiction of the family became exemplarily for Vincent van Gogh's (1853–1890) famous *The Potato Eaters* (1885) about the hard life of peasants in the village of Nuenen in North Brabant, made before his leaving for France in search of the Mediterranean light, but without the same attention for the young child as Israëls did have.⁴⁸

Taking the first steps under parental guidance is a turning point in the development of the little child. It was depicted earlier by Rembrandt and became popular around 1800 with different interpretations. While the frontispiece of William Blake's *Songs of Innocence and of Experience* (1794) connects this major experience in the life of child

and parents with child's fragility, Marguerite Gérard's (1761–1837) *The First Steps* (c. 1788) makes the great event almost a celebration, characterized by pride and joy. Present are five children and five women, probably all mothers. They enthusiastically and with pride encourage the little and naked child—a reference to contemporary criticism about the swaddling of young children that would prevent their movements—to make his first steps. The child almost literally standing in the starting blocks to move forward is also encouraged with welcoming gestures by the still very young children who already reached this stage of development.[49] The painting no doubt functions as an encouragement for parents but it also shows typically child's life reality. Almost a century later, Jozef Israëls made a painting about the same topic, which he also included in an album of engravings, *Children of the Sea: Sketches after the Life at Our Dutch Beaches* (1861). The album consisted of twelve engravings by J. H. Rennefeld (1832–1877) after Israëls's paintings and of accompanying moral texts that contrasted the moral purity of the fishing community with the modern behavior of the well-to-do on the beach by the Protestant theologian Nicolaas Beets (1814–1903). It was reprinted several times and made the pictures visible for a large audience.[50] *The First Trip* was made after a painting exhibited in 1860 as *Little John*. A toddler starts his first trip. He still stands against his mother and hesitates whether to dare without support bridging a distance of maybe five feet, a lot for a toddler, between him and his father. His father is in front of him and crouches and encourages him, his hands turned toward him, to come to him. The scene is put in a beach environment with a seagull sitting on a fence. Beets's companying poetic text says: "a boy is no girl," referring to the fear of falling and assuming that a girl would be more afraid than a boy, and repeats in each verse: "walk like a man, small John."[51] The picture shows childish uncertainty and hesitation, which is answered by parental care and responsibility that show an understanding of the childish development.

Sadness and Grief

Sadness and grief dominate a coherent pair of equal size paintings by Louis-Léopold Boilly (1761–1845), *Christophe-Philippe Oberkampf and His Family before His Factory in Jouy* (c. 1803) and *The Family Oberkampf: The Mother with Two Children* (c. 1803). Entrepreneur Oberkampf, from German descent, was the founder of the famous royal factory of printed fabrics in Jouy-en-Josas, and one of the pioneers of French industrialization. The first painting with the family as a whole suggests the planned future transfer of the factory to his eldest son. Father points to the factory at the background while looking sadly to his eldest son and family's heir who is crucial for the future of the family and the factory and as the Intended successor of his father already dressed as an entrepreneur. But the boy's face is not visible, a reference to his premature death and the reason for his father's sadness. The two other children, a boy and a girl, still too young to take over the factory, sit on the ground and look around with a sad and a bit dazed gaze together with their mother. The second painting centers on the grief and mourning of a mother and her two remaining children. Father is absent.

Mother embraces her daughter and the boy contemplates a butterfly, which refers to brother's death. On the background at the other side of the river the eldest son's tomb is visible.[52] That the father is absent might suggest that he mostly would mourn about the thwarting of his plans of transfer of the company, but this would not exclude him from mourning about the death of his child too.

In early modern Europe, the death of children was often referred to in family portraits by keeping them in the portrait and by remembering them in the special genre of funeral portraits. There also existed a genre of deathbed scenes with model deathbed accounts.[53] In the nineteenth century, funeral portraits were again produced, although in modest numbers, and they resumed that sixteenth- and seventeenth-century iconographic tradition. In *Dead Baby* (1885) by the Catholic painter Anton Derkinderen (1859–1925) the dead child, his four-month-old nephew Henri Molkenboer, lies devoutly with his hands crossed on the deathbed. The harsh reality is softened by the Catholic suggestion of ascending to heaven.[54] Infant mortality decreased only drastically at the end of the century, although with a regionally very different rate. Then, also countries that initially lagged behind saw a major decrease, with, for example, Dutch infant mortality until 1873 regularly exceeding 200 per 1000, but then falling rapidly from 206 to 150 in the mid-1990s, with also mortality of children above the first year of life decreasing.[55]

Jozef Israëls visualized the grief of families without wealth and with only a low and uncertain income. While belonging to the *Haagse School* he was the exception to the rule in not only painting innocent and happy children with content and responsible parents from the Scheveningen fishing community or the Noord-Brabant peasants, but also people's grief and sadness. About the death of a fisherman, a risky profession with small fragile ships where you always had to hope that father was not surprised by storm on the North Sea but came back safely to shore, he made four large-format paintings. They tell a story of successive emotions of fear and anxiety while waiting for father's return, dismay when the worst comes out, finally sadness and grief and mourning when reality sets in. In the first painting, *After the Storm* (1858), a young woman is sitting and waiting between hope and fear together with her young child still in the highchair and an older woman, probably her mother or mother-in-law. The fear and anxiety can be read on their faces. Also the child seems to feel that there is something wrong with the father. The worst comes out in *The Shipwrecked Person/The Drowned Fisherman* (1861). The grieving widow with her two small children by the hand walks in front of a mournful procession. Behind her are two fellow fishermen who carry the body of their deceased colleague over the dunes to the village of Scheveningen with the wrecked boat in the background. They are followed by the fisherman's mother and the rest of the boat's crew. On *The Day before Divorce* (1862), the widow, with her hand over her head and immersed in grief, sits on a chair with a book, probably a religious text, with her daughter sitting on the floor in front of her; in the background is the coffin on some chairs. The sadness of mother and child is evident in the posture of the figures rather than in their facial expressions. In *The Funeral/From Darkness to Light* (1871), the

coffin is carried out of the house. Behind the coffin, carried by a few men, the mourning widow walks with her son.[56]

Father's sadness was visualized by Israëls too, as in *The Sick Mother* (c. 1869). The woman, a fisherman's wife, is lying in the box bed. She is fed by her eldest daughter while father sits on a chair some distance away. He watches the scene with concern and resignation, for he knows his wife is that sick that she would soon die. A young girl of about six is sitting on his knee. In the center of the painting, a small child is playing on the floor in front of her father as if nothing had happened. This is a family with emotions of concern and resignation for awaiting the fatal outcome, with the youngest child seemingly remaining in her own world of childhood.[57] Father's and children's grief on the death of wife and mother was also the topic of *Along Mother's Grave* (1856), a large canvas with a mix of realism and a moral message, the result of his visit one year earlier to the Paris World Exhibition of 1855, where Israëls became impressed by the new realistic style of painters such as Courbet. The painting's fame increased through the ninth engraving made after it in the booklet *Children of the Sea* and because it was one of his most reproduced paintings. A young father, a fisherman, walks past the simple wooden cross of the grave of his wife together with his two children, a toddler on his arm and a boy about ten years old next to him. Father looks straight ahead while the boy desperately tries to make eye contact with him. But the father is upset because of the news of his wife's death that he received just after arriving from the sea. The family is filled with grief and with supporting love. In the painting the classic topic of the waiting widow was replaced by the returning widower. In the accompanying poem by Beets the boy, already aware of his mother's death, tells his father that they will visit the grave instead of going straight home.[58]

Estrangement between partners resulting in child's sadness is visible in *The Divorce* (1846) by genre and history painter Hendrik van de Laar (1807–1874) from Rotterdam. Although the formal divorce's incidence slightly increased in this period because of slightly more legal room for divorce after the introduction of the French civil code in many European countries including the Netherlands, it remained low. Exceptional in this painting was the artist's attempt to enter into the emotional world of the child. In this Van de Laar was triggered through a poem by Hendrik Tollens (1780–1856), in his time honored as the Dutch folk poet although at the end of the century ridiculed for his bombastic language in his poems on domestic life. The painting depicts a father and a mother before the judge. Standing between them their about eight-year-old son holds them tightly by their hands. The boy looks desperate. He seems to undergo the conflict described a century later by psychiatrist Ivan Böszörményi-Nagy (1920–2007) as the loyalty conflict, which means that the child of divorcing parents is emotionally unable to make a choice between both parents. Through the poem that inspired the painter we know exactly what the painting intends to tell. When the judge is asking the child to choose between both parents, the child almost begs him to do the opposite, namely preventing the parents to divorce, with the words: "They do not mean it. / Let me hold my parents."[59]

Family estrangement was also visualized in the large *Portrait of the Family Bellelli* (in-between 1858 and 1869) by Edgar Degas (1834–1917). It shows the emotional tensions of a family including emotions of sadness and grief. The painting looks like two panels in medieval religious art, but then brought into one canvas. One part shows the mother, Laura, the sister of Degas's father, together with her two daughters Giulia aged seven and Giovanna aged ten. The children with their white dresses in the painting's front attract most attention. Behind the mother is a portrait of her father, recently deceased, on the wall. Mother is dressed in black because of her father's death; this could explain her sad look, for she is mourning. She also looks rather stern and gloomy, so there seems to be more to it. Giovanna looks rather sadly to the viewer and stands against her mother who puts her arm around her. Only her sister Giulia seems rather relaxed. She sits in the middle of the canvas on a chair against a table where her father is and she looks in his direction. But although he tries there is no eye contact. Her father, Baron Gennaro Bellelli, an Italian patriot living in exile in Florence, is depicted in the painting's other part. The family is portrayed in the maternal line, different from the traditional patriarchal-hierarchic configuration, and with now the father literarily set

FIGURE 41 Edgar Degas, *Portrait of the Family Bellelli* (in-between 1858 and 1869), oil on canvas, 200 × 250 cm (Paris: Musée d'Orsay). Credit: Photo Josse/Leemage / Contributor (Corbis Historical).

aside. He looks rather sadly and resignedly at his daughter, perhaps because he knows that he cannot fulfill adequately his responsibilities as a father and a husband. This is estrangement in a family with the tensions visible and almost palpable (Figure 41).[60]

The Emotional Tone between Child and Parent

In research on parenting, several parenting styles are distinguished with the next four in a now classic classification: the authoritarian-autocratic, the indulgent-permissive or libertarian, the now mostly recommended authoritative-reciprocal, finally the indifferent uninvolved style.[61] Also during the Enlightenment and beyond parenting styles of both the mother and the father got attention, as we saw in the above shown family portraits. While attention given to parenting styles during the Enlightenment was not new, parenting ambitions adapted under influence of the new educational and emotional culture. Two aspects seem to be characteristic, namely the explicitness by which styles of good parenting were expressed, and its variety that fits the ambiguity of the contemporary educational and emotional discourse and has major similarities with the above distinguished ones. In this context we look at the visualizing of one specific aspect of the educational relationship, namely the affective tone between child and mother, and child and father.

Child and Mother

According to Stearns "new interest in mother-love also emerged in the eighteenth century, but it was carried much further from the early nineteenth century onward" in the form of an "almost religious treatment of mother love."[62] This would at the end of the eighteenth century led to an "iconography of passive childhood" where "the child is above all an object of the love of his parents, of education, and of adults' gaze," is "subject to natural desires and without knowledge of the virtues."[63] It however seems that much that at first sight looks new was rather the adaptation of a longer existing idea. The religious dimension of mother love became popular in the iconographic tradition of the Madonna from the late Middle Ages with its highly popular profane version from the late sixteenth century, and the same happened with the adaptation of the sacral model of the Holy Family in the family portrait. Also in the discourse in seventeenth-century Protestant circles in Scotland and the Netherlands, mother love was a matter of fact. The newness of eighteenth-century visualization of domestic mother love was an admittedly sometimes radical adaption of a much longer tradition.

In *Elisabeth Herbert, Lady Pembroke and Her Son George, Lord Herbert* (1764–7) by Joshua Reynolds (1723–1792), a loving, proud and determined mother touches tenderly her eldest son. At the threshold of coming under paternal rule, he looks with a mix of childish innocence and the determined gaze of a future earl. The commission by the lord of the portrait, part of a double of Henry Tenth Earl of Pembroke and his wife Elisabeth with their eldest son George, was due to the temporal reconciliation after a marital crisis because of the lord cheating his wife in a scandalous adventure

that resulted into an illegitimate child. The reconciliation remained temporal, for after more escapades the lady left her husband. Motherly love of the lady who is aware of her importance as instrument of stability for family lineage's future is the main emotion visualized.[64]

Willem Bartel van der Kooi (1768–1836) belonged to the Enlightenment-inspired moderate Protestants and took an active part into the 1795 Dutch political upheaval. He became an acting member of the Provincial Executive of Friesland where he was born and raised, and he voted in the Dutch National Assembly for the unified state. However, he was more artist than politician. Next to portraits, both paintings and drawings in which he visualized emotions of family members, he produced genre paintings on large format, brightly painted in the educational spirit of the Dutch Enlightenment. With contemporary Dutch painters such as Adriaen de Lelie he built a new Dutch school of portrait and genre painters around 1800.[65]

The intimate drawing *Jetske Hayes with Child* (*c.* 1807) shows his wife Jetske Hayes (1779–1809), who died after a marriage of only four years. Jetske is dressed in Frisian style with an ear iron with her baby standing on her lap. The picture evokes endearment through the affective tone between mother and child with care, motherlove, and affection of the child who kisses his mother on the cheek and holds her chin with his left hand.[66] The *Portrait of Hyke Sophia Mulder-Saagmans and Children* (1801) is a counterpart to a portrait of her husband Johannes Mulder (1769–1810), professor of medicine at the University of Franeker, friend of the painter and also a convinced supporter of the Enlightenment. It shows Hyke (1770–1806) as a respectable thirty-one-year-old lady but above all as the mother of son Claas, aged four and a half, and daughter Aaltje, one year old. Apart from parental pride the painting shows motherly love and children's satisfaction with the girl on her lap feeling safe and secure with her mother, and the boy standing against her and looking at his little sister.[67]

In a romantic *Biedermaier* style, the German Adrian Ludwig Richter (1803–1884) painted *St. Anna's Church in Krupka in Bohemia* (1836). At first sight this small panel shows a village church in a pastoral environment. But the main subject forms the rather small depicted mother with her three children in the left foreground just before the church. Mother sits on a rock with one daughter standing against her, the other sitting on the ground, her son standing before with a stick over his shoulder. Whether she wants to go to the church or just came from is not clear. In a peaceful and pastoral environment, she gives some food to the dog and seems to initiate her children in nature. Perhaps inspired by sixteenth- and seventeenth-century pastoral genre paintings, the bright style, resembling Van der Kooi's in his didactic paintings (see Chapter 7), enables Richter "to evoke an idyllic, endearing dream atmosphere" with a perfect harmony between man and nature.[68]

In the second half of the nineteenth century, the topic of the relationship between mother and child both in upper and lower classes was visualized in new stylistic ways. Pierre Bonnard (1867–1947) with Édouard Vuillard (1868–1940), Félix Vallotton (1865–1925) and others founded *Les Nabis* [The Prophets], a group of postimpressionist

The Expression of Children's Emotions in Enlightenment/Romanticism/Science

French painters who propagated emotion in the painter's mindset and color and flatness in the final product as the translation of the painter's idea. Most of the expression of the persons should be deduced from their action instead of their face in paintings where "space and persons without clear outlines ... merge into an amorphous whole, whose tonal unity creates a dense emotionally charged atmosphere."[69] In Bonnard's *Grandmother and Child* (1897), a grandmother gives concentrated a spoon full of porridge to her grandchild who sits upright in a high chair and looks straight at the spoon. Just above the chair are visible the girl's large head, normal for her age, and her shoulders and arms with her dress in bourgeois style. This *Belle Époque* Parisian scene remembers similar pictures from fifteenth-century *Books of Hour*: an almost timeless scene is adapted into a late nineteenth-century French style with broad strokes and deep colors.[70] Claude Monet's (1840–1926) *The Cradle: Camille with the Artist's Son Jean* (1867) visualized the affective tone between his wife Camille and their son Jean in an almost timeless intimate atmosphere of tranquil happiness and innocence with "baby's dark eyes ... wide open" and with mother looking at him with attention and care. It resembles seventeenth-century paintings on mother and child in a modern jacket, but stylistically it is very different through Monet's impressionist style. The painting depicts children's innocence and subdued motherly happiness. This turned out to last only a short time because both mother and child died young (Figure 42).[71]

The *Haagse School* preferred simple families of fishermen, poor farmers and simple craftsmen to portray the emotional relationship between mother and child. The often very small paintings by Matthijs Maris (1839–1917), influenced by symbolism and the most innovative painter of the three brothers Maris, betray a great empathy for the child's world. In *Woman with Child and Little Goat* (*c.* 1866), the almost completely swaddled child looks with great interest, curiously and also a little bit anxiously at the goat and feeds it a blade of grass. The child dares to do so because it relies on the protection, affection and encouragement of its mother. The painting is simple in design and its schematic, almost cubist structure that makes the little goat almost look like a toy animal reminds me to Dick Bruna's children's books made a hundred years later (Figure 43).[72]

Jozef Israëls's *Birthday Party, or, The Pancake Baker* (1872) is the earliest size representation among many versions made for the Anglo-Saxon market of a theme also popular in sixteenth- and seventeenth-century genre painting. In this Romantic and realistic painting with clear contours the mother is pouring the batter into a frying pan with a ladle for Jeanne, the girl whose birthday it is. Sitting on the ground together with her older brother she watches the miracle happen and the pancakes come into being in a tranquil atmosphere of happiness and joy, reminiscent of seventeenth-century genre paintings by De Hooch.[73]

In portraying mother and child in drawings with exact and sharp lines also Carl Gottfried Pfannschmidt (1819–1887), a Lutheran, sought inspiration in the sacral iconographic tradition,[74] in particular in the model of the Madonna that he must have seen in abundance when traveling through Italy and making drawings there. His

Children's Emotions in Europe, 1500–1900

FIGURE 42 Claude Monet, *The Cradle: Camille with the Artist's Son Jean* (1867), oil on canvas, 116.2 × 88.8 cm (Washington, DC: National Gallery of Art). Credit: Heritage Images / Contributor (Hulton Fine Art Collection).

mother-and-child drawings are a nineteenth-century profane version of this sacral topic. Most of them express children's innocence and motherly happiness, some also fear and anxiety. *Mother with a Child on Her Lap* (1875), a fairly sharply drawn image of mother with child, made in Rome, at first view seems to be a sixteenth-century Madonna with her sharply drawn robe and her devout look. The mother looks at her child, which she holds with her right hand, with maternal attention. Different from a Madonna is the attitude of the baby, a girl. With its chubby legs and arms, she lies relaxed stretched out for a long time, almost undressed on mother's lap, with the arms back and the right hand on the forehead, against the already quite lush hair. She seems satisfied with her mother's eyes looking at her face. While looking up into the air so that there is no eye contact, she feels her position on mother's lap and mother's protective hand. The pose of the child makes the drawing a nineteenth-century adaption of the classic Madonna, influenced by the romantic idea of the free, innocent child.[75]

The drawing *Children's Games Outdoor* (1849) is different. Mother, a baby on her left arm and on her right side a young girl who holds a wooden horse in her hand, has raised her right hand up in admonishment in the direction of a boy who, a small child

FIGURE 43 Matthijs Maris, *Woman with Child and Little Goat* (*c.* 1866), oil on panel, 14.5 × 19 cm (The Hague: Kunstmuseum Den Haag). Credit: Heritage Images / Contributor (Hulton Fine Art Collection).

on his back whose hands he holds, meets the (probably his) mother with the two young children. Probably the mother is concerned that the child could fall off her brother's back. While the baby on mother's arm looks curiously at the somewhat frightened looking child on the boy's back, mother looks admonishing at the boy while the girl with the wooden horse looks at the boy, who in turn looks proudly at his mother. While the nature looks pastoral, the admonishing behavior of the mother makes it more educational.[76] In *Mother Kissing Her Child* (1875), made in Italian Gubbio, mother stands with her child, a toddler who sits on a platform. She holds her child with her right hand, presses it against her, and kisses her on the right cheek. The child turns to the mother. While intimacy and reciprocal affection dominate this drawing, the emotions are not so much pleasant ones. The child looks rather gloomy and probably a little frightened and the mother, not happy either, kisses the child as if she thinks that she has to protect it against danger from outside (Figure 44).[77]

Girl Begging with Woman with the Distaff (*c.* 1740) by the eighteenth-century Italian painter Giacomo Ceruti (1698–1767), who portrayed poverty frequently, shows an emotional relationship in the midst of poverty. The girl, her face not visible, holds an empty basket without food and shows this in disappointment to her mother, who looks

FIGURE 44 Carl Gottfried Pfannschmidt, *Mother Kissing Her Child; Gubbio* (1875), drawing, 14.1 × 15.9 cm (Berlin: Staatliche Museen zu Berlin, Kupferstichkabinett, SZ Pfannschmidt 5; credit: Staatliche Museen zu Berlin, Kupferstichkabinett / Volker-H. Schneider Public Domain Mark 1.0).

desperately at the viewer. While seemingly in the tradition of Murillo and Ribera this picture is more realistic in showing bitter poverty, desperation, and disappointment instead of joy.[78] Also *Les Errants* (1848–9) by Jean-François Millet (1814–1875), a French pioneer in portraying hard life on the country instead of glorifying pastoral life or poverty and social inequality over the life of the well-to-do, is about mother and child in poverty. A mother with her daughter walks against the stormy wind in a desolate landscape. She meanwhile looks at her child who moves with difficulty with her cane, exhausted and miserable. The mother watches with a worried look over her tired child and hopes to find a temporary shelter and care for her child.[79] Around 1900 Käthe Kollwitz (1867–1945) pictured in a realistic and naturalistic style, often within a context of class struggle, moments of sadness, illness, death, and disaster in the life of mother and child. She changed from revolutionary woman into a committed pacifist because of the death of her youngest son at the beginning of World War I. *Woman with Dead Child* (1903), a drawing with coarse strokes, evokes despair, horror, and unfathomable sadness. The mother encloses with her body the dead child aged four or five years old.[80]

The emotional tone between child and mother was in the most examples above characterized by love and affection in an emotional relationship between mother and child that followed a reciprocal and sometimes also authoritative style, in happy and unpleasant or even dangerous circumstances. In that relationship motherly care fitted the emotional and developmental needs of the child and child's emotional world.

Child and Father

The emotional tone between child and father was also visualized, although less than with mother and child, and influenced by the educational and emotional discourse. Below follow visualizations of different fatherhood styles, varying from authoritarian to emotionally aloof, and from reciprocity to indifferent. An authoritarian and strongly educational style, with paternal pride and happiness and child's expectance, pride, and relief shows Willem Bartel van der Kooi in *Father's Happiness/The Award* (1816). The son enters the well-furnished room with a beautifully engraved wooden satchel in his left hand and a booklet in his right, hoping for a word of praise. He has received a prize at school for good performance, a booklet with "honorary prize" on the back, which he expectantly hands over to his father, who looks delighted and proud at the prize. Awards had been given according to regulations at school since the seventeenth century for good performances.[81] An aloof, indifferent and uninvolved emotional relationship shows Edgar Degas's *Place de la Concorde: The Viscount Lepic and His Daughters* (*c.* 1875). Lepic makes a promenade on Place de la Concorde with his two daughters. This is a high society walking, distinguished and fashionable with a seriously looking who is aware of his upper-class reputation, and with the children looking conceited, as if already high-class ladies, which they are already in a sense.[82]

Far from aloof, but reciprocal, rather stimulating and also a little bit authoritative, was the emotional relationship between father and child in drawings made by Jacob de Vos (1774–1844) about his children and himself. De Vos was an Amsterdam trader in assurance with neither an educational nor an artistic background. His father Willem De Vos (1739–1823), an Amsterdam Anabaptist clergyman, belonged to the moderate Protestant dissenters in the Dutch Republic and wrote *The Best Means to Make the Marriage Happy* (1771), a marriage advice manual with references to Rousseau's *Émile*.[83] Also his son Jacob became inspired by the new child-oriented discourse on education and childhood. In 1803–1809 he made a series of *Drawn Diaries for His Children* with drawings and very short texts, mostly just captions, on everyday activities of his four little sons, purpose-made for them and only for them, as a mirror of their youth in a domestic environment of playing and coming of age. The diaries were found only two hundred years later in the family archives and then eventually published. He thus had no pedagogical mission whatsoever, which makes his drawings close to the lived and experienced reality, and thus a strong source for the expression of emotions, in particular in the emotional relationship between children and their father. De Vos makes fun with his children and he enjoys their fun. The main subject

of his booklets is the world of his sons, rather than education as such.[84] Apart from two drawings showing the family as a whole,[85] the children dominate, sometimes together with their mother,[86] who was often sick and when recovered drawn together with her four children[87] and sometimes with their father who praised his wife as a mother in the short texts.[88]

De Vos let his children look at their own world by pictures with descriptive captions in a child-oriented style, instead of didactically and moral poems, neither focused on virtues and vices, as in van Alphen's *Little Poems for Children* (see Chapter 7) nor on the usual Enlightenment-inspired didactic approach. He observed them, he was curious about their world, and he let them grow up. Sometimes he included himself in the drawings, joining in his children's play, dancing together, playing with them on the sledge in wintertime, or, among others, playing doctor with his children while himself being the patient.[89] Even when he seemed to play a moral and strict educator, it is with a touch of irony in a drawing where he seemed to get ready for chastising his children with a cake with the following caption: *Papa Spanks the Boys with a Slice of Cake*, and with the eldest son supposedly with tears in his eyes and the other two looking expectantly at what father is going to do, no doubt hoping for a piece of the cake (Figure 45).[90]

De Vos was showing the importance of children's play for their development in anticipation of Fröbel's some decades later (1828) published *The Education of Man*. Perhaps he was inspired by an old tradition of popular illustrated books, published to give pleasure to the readers, young and old alike without moralizing or educational message.[91] He also initiated the children in the adult world by drawing scenes from his own adult life so that his children first could play these scenes and afterwards do it in reality. We see De Vos in wintertime on his sledge[92] or on a horse, after which the children are riding horse in the living room.[93] He also depicted how he went to church after which the children were playing that in the living room. From 1805 they themselves went to church too, together with their father.[94] Several times, he through the drawings also showed his emotional life to his children. When, in a drawing with the caption *Oh Papa, Do Not Be Sad, Mama Will Surely Get Well*, he sat looking sadly ahead because of the illness of his wife, leaning on his left elbow, the two eldest boys Willem and Gerrit were standing against him to comfort him and the eldest tried to kiss him. When father twisted his arm out of his socket, he let bandage himself by his children and later on made a drawing of that incident.[95] There is reciprocity in the emotional relationship with his children, characterized by children's happiness and father's enjoyment, and there is the intention to enter into the child's world. The variety of emotions shown by children and father stimulated to learn to feel in a very natural way.[96]

Pierre-Joseph Proudhon did not only participate in Courbet's presentation of self in *The Workshop* but also in Courbet's *Pierre-Joseph Proudhon and His Children* (c. 1865). The man who introduced the concept of anarchism and so frightened and scared the hell out of the body of many European bourgeois people is now visible in his fatherly role.

The Expression of Children's Emotions in Enlightenment/Romanticism/Science

FIGURE 45 Jacob de Vos Wzn., "Papa spanks the boys with a slice of cake" ["Papa geeft de jongens plakken met een koek"], drawing F.5 from Jacob de Vos Wzn, *The Fourth Book of Willem & Gerrit de Vos* (1805), HS 73 (book 4), 180 × 115 mm (Amsterdam: Koninklijk Oudheidkundig Genootschap (Royal Historical Society), De Vos Family Archives, with permission of Koninklijk Oudheidkundig Genootschap, Amsterdam).

He is surrounded by his books but gives not attention to them. He sits relaxed on a stone staircase outside the house in the garden. He looks seemingly serious to the observer, for with a bit of irony. Next to him are his two little daughters, one reading attentively in a book, and the other laying on the ground playing with a jug of water. There is no playing together of children and parent, as with in De Vos's drawings, but letting play. Proudhon seems to be a proud and happy father. The scene looks like a very idyllic and romantic scene of a happy father and his children with not so much a reciprocal but rather a permissive or even libertarian style of a not indifferent but uninvolved father. It is Proudhon who is posing, and his children are present to make clear that he is also a father.[97]

As a matter of fact, the several parental styles distinguished did not appear in their exact description in the paintings and drawings. But elements of those styles did so and this resulted into images with an authoritarian father–child relationship with emphasis on an educational aim, an aloof, indifferent and uninvolved emotional relationship, a relationship of emotional reciprocity, finally a permissive and uninvolved relationship.

In the Child's World

Inside the Domestic

The visualization of the child's world inside the domestic included very young and somewhat older children. Dominant for very young is the exploration of the world by peering full of wonder, sometimes mixed with insecurity and anxiety, or looking joyfully into the world. This happens while the child is in the guise of an adult, observes the world from an adult size of high chair, studies picture books, and explores together with other children. Dominant for elder children are domestic scenes such as piano playing and posing.

With Francisco Goya's *Portrait of Don Luis María de Cistué at the Age of Two Years and Eight Months* (1791) we enter in the world of a toddler who explores the world by peering into it with a fixed, very serious gaze and wide, searching eyes, full of wonder and also with some anxiety. The child is accompanied by a dog sitting up straight seemingly as a classic sign of good parenting, with in his hands a band tied around the collar of the dog.[98] In *Portrait of Catharina Elisabeth Rente Linsen (1830–1890)* (1831) by Jan Adam Kruseman Jz. (1804–1862), one-year-old Catharina looks joyfully into the world. She is in the guise of an adult and dressed as a lady with red coral jewelry around her neck and wrists. Behind that lady-like outfit to show parental pride a real plump baby is visible.[99] Several decades later, Pierre Auguste Renoir (1841–1919), an expert in depicting the emotional expression of children, in the little bit impressionistic *Marguerite-Thérèse (Margot) Berard* (1879) shows the complexity of the girl's seemingly piercing but in fact smiling gaze that invites the viewer to communicate (Figure 46).[100]

The Belgian symbolic painter Fernand Khnopff (1858–1921) tried to suggest with "a uniformly muted color palette"[101] the seemingly mysterious and inscrutable inner world of four-year-old *Jeanne Kéfer* (1885). Jeanne looks like she's about to go out or coming in. She is dressed in a nice cloak with her head fashionably covered and stands in front of a half visible closed door with the key opening just visible. She looks with a seemingly inscrutable gaze, which according to Pernoud hardly shows any emotion. But she seems to control her emotions when she stands before the door looking cheerfully and resolutely. It seems that she, although young, is posing and following the instructions of the artist, and that she likes this, neatly dressed and standing straight up.[102] At the end of the century and in a very different style of magnifying and exaggerating the childlike features, Vincent van Gogh's (1853–1890) *Portrait of Marcelle Roulin* (1888) shows the initial exploration of a somewhat anxiously looking baby, the ten-month-old youngest daughter of Joseph Roulin, a friend of Vincent, and portrayed several times, alone and with her mother. The portrait was appreciated as realistic in a letter by Vincent's pregnant sister-in-law Jo, wife of his brother Theo, to whom Vincent sent the portrait: "I like to imagine that ours will be as strong, as healthy, and as beautiful as that one—and that his uncle will want to do his portrait someday!" (Figure 47).[103]

The Expression of Children's Emotions in Enlightenment/Romanticism/Science

FIGURE 46 Auguste Renoir, *Marguerite-Thérèse (Margot) Berard* (1879), oil on canvas, 41 × 32 cm (New York: The Metropolitan Museum of Art; credit line: Bequest of Stephen C. Clark, 1960).

Runge's artistic ambition "to become children if we want to achieve the best in us"[104] seemed to be realized by approaching the child's world without any educational strategy of changing that world, and by literally get down on his knees to imagine what precisely was happening in the child's mind. In *Portrait of Luise Perthes* (1805), the two-year-old daughter of the commissioner and also a friend, Hamburger bookseller Friedrich Perthes, has climbed on an adult measured chair to look out the window. Runge shows what a child normally would do with this challenge during exploration: not trying to sit, but climbing on and standing on.[105] In contrast in Courbet's *Portrait of the Little Béatrice Bouvet* (1864) the girl sits on a big armchair, which shows how small she still is. She looks at ease, cheerful, and very friendly. Instead of Géricault's seemingly insolently looking Louise Vernet as "autonomous" child with a dangerous looking cat (see below in section "In a (Pastoral) Nature"), Béatrice plays with a toy sheep.[106] In *Otto Sigismund in a Highchair* (1805), the baby with chubby cheeks and round arms looks expectantly to the left where something is happening or to be expected. Otto sits in a highchair that fits his age for he is not yet able to climb on an adult measured chair as Luise Perthes.[107] Also in a highchair sits *Little John in His Chair* (1873) by

177

FIGURE 47 Vincent van Gogh, *Portrait of Marcelle Roulin* (1888), oil on canvas, 35.2 × 24.6 cm (Amsterdam: Rijksmuseum Vincent van Gogh/Vincent van Gogh Stichting). Credit: Heritage Images / Contributor (Hulton Fine Art Collection).

Jozef Israëls. This painting brings us right into the child's world with its own rules and activities. Put in the armchair to eat, Little John is from his high position in charge of the world around him with the spoon in hand, meanwhile luring the cat who looks for food toward him.[108] Such pictures stand in a long tradition with, for example, Verspronck's *Boy Sleeping in a High Chair* (1654) and Flinck's *Girl by a High Chair* (1640). *Ellen Mary with a White Coat* (*c.* 1896) by Mary Cassatt (1844–1926) has similarities with Courbin's *Béatrice*: we see a little girl with still round cheeks elegantly dressed up as a little lady in a vast chair, with each of her hands on a rail, looking intently at someone or something to her left.[109] Cassatt was American by birth but soon became in Europe an important impressionist painter. She excelled in mother-and-child portraits for the European bourgeoisie as examples for good education (see Chapter 7) and made portraits of children alone in a realistic and naturalistic style.[110]

As a progressive educator *avant la lettre* Jacob Maris (1837–1899), who belonged to the *Haagse School*, had a romantic image of childhood in mind: no *tabula rasa* to be filled by education but a human being with its own content and capacity to learn. In *The Picture Book* (*c.* 1873), a toddler, possibly his eldest four-year-old daughter Henriëtte,

concentrates at a picture book and tries to acquire knowledge of a new world. There are no parents or other educators visible as in comparable images such as De Gheyn's *Mother and Child with a Picture Book* (*c.* 1620) or Chardin's *The Young Governess* (1737) (see Chapter 7).[111]

Runge depicted young children together in the famous and innovative painting The *Children Hülsenbeck* (1806). Again, the artist seemed to get down on his knees at the three children of Friedrich August Hülsenbeck, a business partner of Runge's brother Daniel. We can see them at eye level with a lot of light falling on them, positioned in the garden of the family's country house that is visible on the right just outside Hamburg. They are placed in the order of their physical and psychological stage of development and according to Allard also of their moral stage of development of the virtues, which should refer to the Protestant background of the artist. We see two-year-old Friedrich, sitting in a kind of goat cart, according to Allard a little monster but rather just a chubby boy who looks forward expectantly, four-year-old Augustin looking directly at the observer and full of energy and power when swinging a whip and meanwhile seeming to pull the goat cart forward, finally five-year-old Maria who exudes calm and responsibility while tempering Augustin and protecting Friedrich (Figure 48).[112]

Children together are also the subject of the drawings made for the family inner circle by Jacob de Vos. As Runge also he got down on his knees, which resulted into numerous pictures of typically child scenes with happy and joyfully playing children who, while imitating adult-like situations, did initiate themselves into the adult's world. Examples are "The big boys play with the cradle" (1803) after the birth of their youngest brother Koo, and three years later "The boys are shaving Koo" (1806).[113]

Piano playing was a favorite domestic scene for elder children. Part of the increasing consumerism from the late eighteenth century among the growing middle class was buying a piano as "a new but increasingly imperative consumer item for middle-class families" with "a clear role in focusing a loving family gathering." The latter was not really happening in van der Kooi's typically childish scene in *The Disrupted Piano Playing* (1813). A girl about sixteen years old in her long dress with jewelry and her hair pinned up and already almost a lady tries to play the piano. She is disrupted by her two younger brothers behind her. Sitting on the piano chair, she turns to them, watching not angrily but with pleasure her brothers who look mischievously at each other, the youngest about to climb the piano chair to try out the keys while the eldest tries to stop him. The carefree looks of the brothers, depicted with sharp contours and bright colors, contrast with the girl who should be serious but in a moment of nostalgia would like to return to that carefree childhood (Figure 49). Renoir visualized at the end of the century several times piano playing as a loving children's gathering, as in *Two Girls at the Piano* (1892) with two girls about fourteen years old joyful and concentrated, without disruption, studying the score with one hand on the keys.[114]

Renoir did let also pose his son Jean for *The Artist's Son, Jean, Drawing* (1901). With that he stepped into a long tradition of painters including seventeenth-century Cornelis de Vos and Rembrandt. The elementary portrait shows a boy concentrated in his drawing.

FIGURE 48 Philipp Otto Runge, *The Children Hülsenbeck* (1806), oil on canvas, 131 × 141 cm (Hamburg: Kunsthalle). Credit: DE AGOSTINI PICTURE LIBRARY / Contributor (De Agostini Editorial).

It "draws the viewer's eye into the space of the young boy's creative effort" as a "simple and innocent activity." Jean Renoir, who became a well-known international filmmaker, later wrote: "I was myself exactly seven …. I had caught a cold and could not go to school, and my father took the opportunity to use me as a model. To keep me quiet, he suggested that a pencil and piece of paper should be given to me and he convinced me to draw figures of animals while he himself was drawing me."[115] Fernand Khnopff created an organized and posed happening with *The Children of Mr. Nève* (1893) with four girls posing on and around the stairs, all with a rather indecipherable gaze. The youngest, clearly visible at the top, looks to the viewer like her little sister, while the two older sisters as if they were instructed look to the left.[116]

For the *Portraits of Édouard and Marie-Louise Pailleron* (1881) by John Singer Sargent (1856–1925), the two children had to pose no less than eighteen times. Sargent, the son of American parents, was born in Florence and died in London. He became the portrait painter for Europe's *Belle Époque* children.[117] The frequent posing in *Portraits* is visible in the children's attitudes and faces. Sitting stiffly, unable to smile, they do not like posing. Precisely by letting pose them again and

The Expression of Children's Emotions in Enlightenment/Romanticism/Science

FIGURE 49 Willem Bartel van der Kooi, *The Disrupted Piano Playing* (1813), oil on canvas, 147 × 121 cm (Amsterdam: Rijksmuseum). Credit: Sepia Times / Contributor (Universal Images Group Editorial).

again, Sargent makes their typically children's emotions visible, whether it was intended or not.[118] Posing is even more noticeable in *The Daughters of Edward Darley Boit* (1882), also by Sargent. We see four girls in a classic configuration as if we are set back into the Spanish Golden Age in this "most Velazquez-like of

Sargent's paintings," which probably refers to *Las Meninas* (1656). In this somewhat magical painting, the children have been taken for a while out of their child's world to stand or sit up in a predetermined spatial arrangement. Three of them, not that impatient as brother and sister Pailleron, look determined to the viewer as if they are suggesting that they want to get on with their own business as quickly as possible. In the center, the youngest, sitting on the ground, for a while stops playing with her doll. All children make clear that they by posing are taken for a moment out of their child's world.[119]

In a (Pastoral) Nature

Depicting the children's world in a pastoral environment, mostly with for the artist the innocent child as mindset, became popular in the eighteenth century, in particular in the center of the European Megalopolis. An example is *The Brothers Allen, or Portrait of James and John Lee Allen* (c. 1790) with two confident and self-conscious in nature playing and posing aristocratic boys by Scottish Henry Raeburn's (1756–1823), a specialist in children's portraying. *The Blue Boy* (c. 1770) by Thomas Gainsborough (1727–1788) shows the same confidence and self-consciousness.[120] Joshua Reynolds (1723–1792) in *Master Hare* (1788) lets enter us into the child's world of then two-year-old Francis George Hare, situated in a romantically expressed nature. The child points in the distance with his right arm and index finger to a not visible object or person. It is innocence, self-consciousness, seemingly in a world without adults. A pendant to this boy portrait is *The Age of Innocence* (c. 1788), perhaps about the then three-year-old artist's great-niece Theophila Gwatkin. As one of the most popular works by Reynolds it was copied many times, as a painting and as an image in popular magazines and almanacs, also outside of Great Britain, resulting in a large viewership. The girl is not that self-conscious as Francis George Hare. With her hands crossed and sitting on the ground in the middle of nature, she looks innocent and diligent as if having an apparition in a seemingly religious configuration. Reynold's pictures bring us on the threshold of childhood and manifest the confusing emotion of adults who strive after adulthood for the child with a nostalgic view on an in those years increasingly idealized age.[121] Caspar David Friedrich (1774–1840), the great German romantic painter and friend of Runge, Goethe, and Novalis, in the drawing *The Spring. The Morning. Childhood (from the 1803 Cycle of Seasons, Times of Day, and Ages)* put the innocent world of five nude children in a romantic pastoral landscape with trees coming out on a spring morning. Two children embrace each other while sitting like two angels. Elsewhere two other children, one lying in the grass, the other standing, are looking upwards at the tree in bloom. A fifth child standing alone points to the same tree and admires the miracle of nature. This depiction of innocent childhood in a mystical relationship with nature shows emotions of happiness, elation, and curiosity.[122]

Géricault, a French Romantic painter, portrayed children also in nature but not within a pastoral environment. Moreover, he disconnected childhood and innocence.

He emphasized "the inner forces" in the child and built the relationship between children's and adult's worlds not on nostalgia but on competition. In *Portrait of Alfred and Elisabeth De Dreux* (*c.* 1818), brother and sister look to the viewer with a self-assured gaze, nor afraid neither innocent, and with an air of: here we are, we do not need any support by adults in this rugged landscape.[123] *Louise Vernet enfant* (*c.* 1818) and *Portrait of Olivier Bro/A Child with a Dog* (1818–19) show the same emotions. The paintings' darkness contributes to the firm expression of the children who are not accompanied with a toy-sheep as in Courbet's *Portrait of the Little Béatrice Bouvet*, or a another toy or book in Chardin's *Boy with a Spinning-Top*, but by a cat for the girl, according to Allard "foreshadowing of her coming sexuality," and a fierce-looking dog for the boy that emphasizes his inner strength and symbolizes that "human nature would be more powerful than education," which would implicate a position against the child as *animal educandum*. The use of animals in children's portraits and genre painting knew a long tradition, but Géricault's domestic animals have when compared to the proportions of the children "colossal proportions which transform them into veritable monsters." Yet the children are not afraid at all in this Rousseau-like nature without any innocence and "evoking a world before civilization."[124] For the rest, also those paintings of little children were as a matter of fact commissioned by their parents. This makes the assumed radical gap and competition between child and adult rather theoretical. Still the message—in the world of childhood nature and passions do dominate over education and the virtues—is contra Enlightenment ideas and at least as radical as Rousseau's *Émile*. Pastoral and certainly not radical is Jean-Baptiste Camille Corot's (1796–1875) *Children at the Edge of a Stream in the Countryside in Lormes* (1840–3). Two girls and a boy, perhaps brother and sisters, concentrate on the flowers. While Allard sees children with "a problematic relationship with their environment," the paintings seem to show, first of all, curious children who are looking seriously to the flowers in the landscape, and instead of the suggestion that the children are separated of adults because they are not in the painting, it seems to me that the children are walking alone in nature with however nearby visible a farm, probably that of their parents.[125]

In the last decades of the nineteenth century, with in other educational institutions than the domestic, the school and the residential reeducation institutions, more emphasis on a disciplinary approach,[126] the image of the innocent child kept a prominent place in art. It was popularized by, among others, the Dutch August Allebé and Jacob and Matthijs Maris and the German Max Liebermann and Fritz von Uhde. They anticipated the child-oriented Progressive Education, inspired by the Romantic educational discourse and against the educational regime in compulsory mass schooling. In *The Butterflies* (1871) by August Allebé (1838–1927), son of the medical doctor and hygienist G. A. N. Allebé and influential director of the Amsterdam State Academy of Art,[127] a boy and a girl about eight and ten years old lie relaxed in the grass, with next to them a book, perhaps a nature guide, turned upside down. The boy

looks at two butterflies while the girl turns her face to the viewer. The children pay no attention to the chicken with chicks in the foreground. In a sketch pencil drawing, only the children are visible; probably the artist spontaneously drew the children when seeing them in the grass and later added butterflies and chickens. Happiness and innocence dominate. Learning in and by nature is not so much connected to a transition from playing to learning as usual in Enlightenment-inspired art, but rather something coming from innate forces of the child.[128] Matthijs Maris (1839–1917) excelled in depicting the dreamy and fairytale world of young children, especially girls. Nature was used as a means of depicting child's inner world.[129] *Butterflies* (1874) symbolizes through a girl in nature with some butterflies the unconstrained children's innocent and happy world, together with the paradise lost, both "frequent subjects" in Maris' letters."[130]

Fritz von Uhde (1848–1911), inspired by seventeenth-century Dutch genre painting and like the *Haagse School* by the "in open air" painting of the School of Barbizon, in *Heather Princess* (1889) shows a girl's satisfaction and happiness in nature in a romantic atmosphere rather similar to pictures by Matthijs Maris.[131] In Adoration III, *The Enchanted Boy* (1893) the Swiss realistic-symbolic painter Ferdinand Hodler (1853–1918) depicted a boy who looks away from the viewer in a fantasy nature. Meanwhile he dreams and communicates within his own world and looks concentrated at the two flowers he holds in both hands. It is a portrayal of an enchanted boy in a period also characterized by the disenchantment of childhood.[132]

At the Beach and along the Waterside

The visualization of children on the beach and along the waterside happened in two approaches. The first was inspired by Romanticism, sometimes with a moral tone. With this approach were mostly depicted rather young, innocent and happy children who played along the waterside and on the beach. The second approach focused on the bodily force of mostly somewhat older children. It emphasized physical struggle and competition around swimming instead of during sitting and playing calmly and innocently at the beach. Both approaches show children's happiness and joy but they depart from different images of childhood with a focus on respectively innocent playing and bodily autonomy and competition.

The first approach became very popular in the Anglo-American art market in the course of the nineteenth century with paintings by, among others, *Haagse School* artists Bernard Blommers and Jozef Israëls, and Mary Cassatt. It started earlier with, for example, *Conversation at Ashdon House* (mid-eighteenth century) by the British painter Arthur Devis (1711–1787). Three young children from the English aristocracy are along the waterside. The oldest boy stands, almost ready with his dress after swimming in the river. His younger brother sits, together with his sister, on the ground and starts dressing while pulling up a sock. The girl just has begun to take off her dress to go for a swim too. The painting expresses happiness and innocence around a physical activity with

both sexes involved, to become rather exceptional one hundred years later with sharper distinction in gender expectations.[133]

In the second half of the century, depicting children's happiness and innocence on the beach became popular. Longing for the coast and the beach became part of European elite's lifestyle in places such as Dutch Scheveningen, French Calais and Dieppe, English Brighton, German Rügen, and Belgian Oostende.[134] A new and in particular Anglo-American market for paintings with children on the beach emerged and this brought several *Haagse School* painters to specialize in this genre. Main stage for their paintings became Scheveningen where they often stayed for extended periods.[135] Originally a fishing village, Scheveningen developed into the beach of The Hague, a fast-growing city in the second half of the nineteenth century with seat of government and Crown and with a large presence of the upper class suitable for a nearby seaside resort.[136] The painters of the *Haagse School* transformed the Romantic fishing genre, originating in England around 1800 among painters such as George Moreland (1763–1804), into a more realistic genre. To that end they combined the image of childhood as stage of "ignorance, incapacity and innocence" and visible by playing with the image of children as members of the traditional fishing community. They followed a popular literary genre in family magazines, almanacs, and pictorial books, which romanticized the fishing community as the place where bourgeois family values, such as piety, domesticity, maternal love, conjugal fidelity, hard work, and satisfaction with one's way of life were still practiced.[137]

Scheveningen was frequently painted in the Golden Age by, among others, Simon De Vlieger (1600–1653) and Adriaan van de Velde (1636–1672). This happened again, but with one main difference: instead of ships they now painted children.[138] Bernardus Johannes Blommers, Philip Sadée (1837–1904), Willem Maris and Jozef Israëls made Scheveningen one of the most children-focused painted Dutch locations. Blommers excelled in painting numerous beach scenes with children's and child-and-mother happiness on the beach.[139] A striking example is *Sailing in a Boat* (*c.* 1885). On the front a toddler plays with a boat in a puddle along the beach, protected by his somewhat older sister, while further on two children are playing with a boat too. As in most of those paintings, children's happiness and enjoyment and for the older children's care and protection can be read from the atmosphere and the configuration, but only limited from the facial expressions.[140]

Painting children and the family on the beach also became one of the favorite themes of Jozef Israëls. He started his career with history painting but after visiting the 1855 Paris World Exhibition he understood that realistic genre painting would be more profitable. He made his successful debut in the fishing genre with the above discussed *Along Mother's Grave* (1856).[141] With this genre he won many prizes in the Netherlands, France, and in England, which made him the highest paid Dutch painter of his time.[142] His pictures offer a realistic view of children's life. The first engraving in the album *Children of the Sea: Sketches after the Life at Our Dutch Beaches* (1861), titled *The Cot*, a reproduction of a painting from 1858, shows two children who are playing at the

seaside, while a small boat and a cot float on the water. It is about children's joy with playing and also refers symbolically to the start of life by comparing it with the start of a sea journey, so often made by their fathers.[143] Another engraving, *Dolce far niente*, a reproduction of a painting also titled *Dreams*, shows a girl who lies stretched out in the dunes. She looks at the sea while two black birds dot the horizon, and she daydreams: "I should prefer to lie flat on the water / rocking to-and-fro / So she speaks and lies flat on the sand / and watches the sunlight playing."[144]

Children on the beach as a subject was for Jozef's son Isaac (1865–1934) first of all pleasant beach entertainment on a sunny summer day without reference to the fishing community, and painted in an expressive light and airy style, as in *Donkey Ride along the Beach* (c. 1898–1900). The two Pauw sisters together with their girlfriend ride on donkeys, followed by a walking boy, perhaps the donkey's guide. It is simply beach fun, enjoyment and child's happiness and it differs from Isaac's father's pictures because of the absence of the fisherman's life, and from Blommers in depicting little bourgeois ladies, similar to the French iconography of the Parisian squares, on which below, instead of fishermen's children (Figure 50).[145]

FIGURE 50 Isaac Israëls, *Donkey Ride along the Beach* (c. 1898–1900), oil on canvas, 51 × 70 cm (Amsterdam: Rijksmuseum). Credit: Universal History Archive / Contributor (Universal Images Group Editorial).

Earlier, in a rather similar style and also focused on upper-class children in their own world, Mary Cassatt, who's "interest increasingly turned to the feelings themselves, their specific qualities, and the expression of these in art,"[146] portrayed in *Two Children on the Beach* (1884) two young girls. With ships in the distance, they are playing on the beach in the sand with their bucket and spade with a content and serious expression.[147]

The second approach shows not children's innocence, but bodily force, physical struggle, courage, and competition during and around swimming, and mainly about boys. Gauguin's *Young Wrestlers: Brittany* (July 1888) shows three playing, wrestling and competitively swimming boys. According to Gauguin this is "a fight of two kids near the river," with one coming out of the water while two are pushing each other into the water at the Pont Aven. Pernoud considers this as the renaissance of youth, the opposite of lovely romantic innocent childhood and, perhaps over interpreting, "closer to a Baudelaire who, quoting Delacroix, described childhood as 'incendiary and animally dangerous like the monkey,'"[148] Such paintings "exalt the physical expression of childhood" and so "the body makes a spectacular breakthrough in the representation

FIGURE 51 Paul Gauguin, *Bathing Breton Boys* (1888), oil on canvas, 92 × 72 cm (Hamburg: Hamburger Kunsthalle, inv.no. HK-5063; credit line bpk / Hamburger Kunsthalle).

of children." Among those paintings are also *Bathing Breton Boys* (1888) with two boys just coming out of the water and being dried by the sun and *A Breton Boy* (1889) by Gauguin. In those paintings the body is apart from its partial or full nudity visible by "a struggle which, unrelated to any disciplined gymnastics ... associates childhood with the archaism of the game," a "game of childhood, devoid of educational intentionality." According to Pernoud, Gauguin and his colleagues were aiming at "finding in the distractions of childhood the image of a sovereign body, removed from the ... discipline of 'good practices'" (Figure 51).[149]

Many artists painted children and youngsters in such a way, and, although Pernoud does not distinguish boys and girls, most were boys. Only exceptionally girls were portrayed with the same physical and bodily expression as in Edgar Degas's *Peasant Girls Bathing in the Sea at Dusk* (1875–6) where girls' naked bodies "enter the sea in a jerky yet choreographic movement, facing the setting sun."[150] When girls were physically visualized, this was not so much connected with sport and struggle as with, following the tradition from the first part of the nineteenth century, starting seduction or with bodily visualized innocence as in Renoir's *Young Girl Bathing* (1892).[151]

On the Squares and the Streets

The physically visualized wrestling and swimming boys came from the peasantry. In contrast, in the 1880s and 1890s painters such as Félix Vallotton (1865–1925) depicted the bourgeois child, mostly a girl, on the squares and the streets. In *The Ball, or Corner of the Park with a Child Playing with a Ball* (1899) in the midst of the park on the front a little girl almost runs across the painting while playing with a ball. In the background, two women, very small but still clearly visible due to the light, are visible. They are motionless in contrast with the running child but ready to support the child if necessary. Vallotton, together with Vuillard and Bonnard belonging to the above-described group of *Les Nabis*, shows childish enjoyment and happiness, visible through the girl's movement (Figure 52).

The Finish painter Albert Edelfelt (1854–1905) shows in *Jardin du Luxembourg in Paris* (1887) how this most bourgeois square of Paris is full of children, elegantly dressed and with joy playing under the supervision of pleasantly chatting mothers, perhaps also nannies. In Édouard Vuillard's *Public Gardens* (1894) children play in a series of images among them "Playing girls," "The interrogation" of a girl by her mother, "The Nannies," "The Conversation" between mothers, "The Red Umbrella," and "The walk" of girls in the park. Most scenes are in a two-way enclosed environment by the physical barriers and vegetation of the park and by a human barrier through mothers and nurses, "who surround childhood with their watchful gaze."[152] These were girls "from the Parisian bourgeoisie," playing "hoop" instead of "wrestling," and rarely left to their own devices with "nanny of mother not far away." The reach of their work was great with the images "available in painting, engraving, illustration or postcards."[153]

FIGURE 52 Félix Vallotton, *The Ball, or Corner of the Park with a Child Playing with a Ball* (1899), oil on canvas, 48 × 61 cm (Paris: Musée d'Orsay). Credit: DEA PICTURE LIBRARY / Contributor (De Agostini Editorial).

The children on the street who Adolph Menzel (1815–1905) depicted in *Children Sitting on Barrier Chains in Utrecht* (1876) were neither supervised nor upper class. Menzel made two almost identical sketches about four children he happened to see sitting on a barrier while walking through the center of Utrecht. The children sit on barriers with chains, three on one and one more on the next. Emotions are barely visible from the faces, but their attitude shows that they are having a good time with no adult to urge them to get off the fence (Figure 53).[154] In *Playing Children* (1881), a daily life impression of children's joyful play without adults in an unknown location, sketch thirty-six shows four children about eight years old jumping over each other; on sketch thirty-seven, a boy arrives to also join in, while a younger child, probably a girl, is sitting on the floor.[155]

The century of beautiful city squares with elegantly dressed girls, nicely playing children on the beach, competitively swimming boys, or innocently playing children on the street, was also the century of children's dark reality, as with William Blake's *Chimney Sweeper*. This was not fully neglected in *Haagse School* pictures of children when losing their father or mother or with their life dominated by poverty, however

FIGURE 53 Adolph Menzel, *Children Sitting on Barrier Chains in Utrecht* (1876), drawing, 15.0 × 8.8 cm (Berlin: Staatliche Museen zu Berlin, Kupferstichkabinett, SZ Menzel Skb.51, S.81/82, Sketchbook; credit: Staatliche Museen zu Berlin, Kupferstichkabinett / Wolfram Büttner Public Domain Mark 1.0).

mostly done in a romantic way. In England, leader of the economic modernization, the social question put poverty on the artistic agenda with Joshua Reynolds who in *Cupid as Torchbearer* (1774) portrayed a gloomy and sadly looking boy, depicted as a modern British-dressed cupido with in his hands "a torch evoking an erect phallus." Reynolds so referred to young boys "who, at nightfall, led visitors through the dark and dangerous streets of London for a few coins to places of bad life."[156] In the much later industrializing Netherlands, *The Match Girl* (c. 1890) by Floris Arntzenius (1864–1925) shows the reality of child labor. In the painting, inspired by Hans Christian Andersen's (1805–1875) fairy tale, a disabled girl aged about ten years old, looking quite cold and sad in the evening, leans against a wall, her basket of matchboxes still half full, waiting for possible customers leaving after dinner the well-heated restaurant in the center of The Hague.[157] *The Little Merchant of Violets* (1885) by Fernand Pelez (1843–1913) depicts in a "photographic naturalism" the street children of Montmartre after the Commune (1871) during the economic and urban modernization of Paris. The reverse of the *Belle Époque* girls on the squares, it resembles Ribera's and Murillo's seventeenth-century pictures, albeit with a crucial emotional difference. Instead of cheerfulness and

happiness there is sadness in a hopeless situation. The boy seems to have fallen asleep with around his neck a wooden box with some violets he should sell. He is wrapped in rags and with bare feet he sits against the front of a closed house door, expressing exhaustion and hopelessness.[158] For him life was no training in emotional literacy, the subject of the next chapter: for him life was training in survival.

Conclusion: Children's Emotions and Images of Childhood

In a dynamic educational and emotional culture, the expression of child's emotions within the family, the emotional tone between child and parent, and child's emotions in the child's world were visualized with various images of childhood in mind. Two of them dominated during this period. The first is the secularized image of the innocent child, increasingly realistically painted in the emotional child–parent relationship and in the emotional child's world with both pleasant and unpleasant emotions. The second is the image of the child as an *animal educandum*. This image was enforced through the Enlightenment and explicitly present in Chardin's transition paintings. This classic image of childhood became, through the development of mass schooling, a reality for almost every child at the end of the century. New was the image of the child in competition with adults as the so-called autonomous child. It was developed in circles inspired by Rousseau and preferred by several important painters such as Géricault and writers such as Baudelaire. However, the paintings resulting from this view on childhood tell another story than the used image of childhood would expect. Autonomy for young children was not that realistic, and those children should never have ended up on the canvas without adult's cooperation. Moreover, they had to pose and often several times on the request of their parents and the artist. And yet, the visualization of this view on childhood by painters resulted in a remarkably realistic entry into the emotional world of young children. The child as a family asset remained important for family portraits of upper-class families, but those portraits became educationalized from around 1800 with the child less considered as a family asset and more as an *animal educandum*. This was realized by a more dynamic setup of the family group than before, which also resulted in a greater variety of visible emotions.

In the visualization remarkable gender and social differences were common. Notwithstanding exceptions as Jacob de Vos's drawings, mostly the father–child relationship was focused on teaching the emotions, while mothers were first of all caring and loving their children. In specific places of the child's emotional world like on the beach, boys and girls were portrayed in playing together as innocent happy children in the realistic and romantic approach of the *Haagse School*. In the same period in French and German painting, however, boys and girls were often depicted differently, with boys as "wild children" from the lower classes in the countryside with a physical look expressing and suggesting struggle, sport, and activity in and around the water, and with upper-class elegantly dressed happy girls, expressing civilization and innocence while walking and playing in parks and squares of the big cities such as Paris in its *Belle Epoque*.[159]

7

Training Children in Emotional Literacy in the Age of Enlightenment, Romanticism, and Science

Introduction

During the Enlightenment, training the emotions became core business in the emotional culture of sensibility, which "placed particular emphasis on emotional self-control." Avoiding "an excess of emotions" was important, for while a "lack of self-control could make people more humane and compassionate," it reduced "their ability to make good decisions."[1] This looks like a reverberation or even a continuation of the classic Augustinian view of passions as not as such negative but becoming so when the will is not able to control them. The British physician William Falconer (1744–1824) formulated the need for this training in *A Dissertation on the Influence of the Passions upon Disorders of the Body* (1788) in his answer to the annual question for 1787 by the Medical Society of London. This type of contest about social and moral issues was usual for eighteenth-century scientific and philanthropic societies. The question for 1787 was as follows: "What diseases may be mitigated or cured, by exciting particular affections or passions of the mind?" According to Falconer, a long range of illnesses was "caused or assuaged, intensified or remedied, by passion," including jealousy, anger, which "exhausts mental and physical strength," but also "gout and palsy" to be cured by outbursts of rage.[2] Training the emotions, in the Medical Society's annual question still described as passions, was thus necessary and the main subject in discourses and advice. While the moral approach seemed to be replaced by the medical one, the discourse of physicians was, until far in the nineteenth century, not so much respected for their "greater store of learning" as for their "moral authority."[3] Also reputed philosophers, among them David Hume, advised control of the emotions. In *A Treatise of Human Nature* (1739–40), he wrote that "serious attention to the sciences and liberal arts softens and humanises temper, and cherishes those fine emotions, in which true virtue and honour consists."[4]

The culture of sensibility with its emphasis on the control of the passions started as an upper-class phenomenon. But it was also the mission of the upper class to transform the behavior and the emotions of the people socially beyond them, and this mission should

start with the education of their children.⁵ An important instrument for this mission was a broad philanthropic movement across Europe to which belonged a Christian renewed charity wing including British Evangelicals and Swiss, German, and Dutch adherents of the *Reveil*, and also a secular wing as the product of the Enlightenment. This philanthropic and educational movement was active in a number of social areas, including education, poverty, and childcare.⁶

The next sections deal with the imaging of training children's emotional literacy within the domestic environment, and thus within the emotional relationship of child and parent. Examples come from three main categories of imaging, namely paintings, drawings, and finally the combination of a short text with an image for young children to both be read to and to read for training and self-training of the emotions. The acquisition of emotional literacy around crucial turning points in child's emotional development went by training through or under the guidance of adults and by self-training. The self-training material was strongly influenced by the more compelling and didactic Enlightenment approach of children. According to this approach, emotional literacy could be reached if the child should make a successful passage to rationality, in particular on the topic of playing versus learning. This passage to rationality went often together with a strong moral dimension in the self-training process in countries such as Germany, Great Britain, France, and the Netherlands. After approaching the training of the emotions through a visualized lexicon of emotions follows the visualization of the crossing of main turning points of emotional and moral development during three main topics of coming of age, namely successfully early childhood development, from playing to serious matters, and finally coping with the passion of lust.

Training the Emotions through a Visualized Lexicon of Emotions

Children's literature, as such not new, only really got its takeoff in the late eighteenth century. The moving and the channeling of children's emotions was an important aim of authors of children's books, in which entering the child's world went together with teaching emotional literacy in a mostly moral way.⁷ Special for several reasons were the three volumes of *Little Poems for Children* (1778, 1782) by the father of Dutch children's literature, the solicitor Hieronijmus van Alphen (1746–1803), whose *Joyful Learning* was discussed at the beginning of Chapter 5. Van Alphen, a moderate and devout Dutch Calvinist, was inspired by Lutheran Pietism founded by August Hermann Francke (1663–1727), who made the German city of Halle Pietism's internationally reputed center. This movement became an important force in the *Wendung zur Religion* when the institutional power of churches diminished in favor of the state, but the cultural and educational role of religion increased rather than decreased with a major role in Christian philanthropy and mass schooling. Although Pietism was often "understood as a movement working against anti-religious Enlightenment," its center in Halle "became a hub for Enlightenment ideas" and contributed to "modern education in its secular and

transformed religious character and aspirations." Van Alphen belonged to this Christian Enlightenment with its great attention for sensibility and emotions.[8]

The *Little Poems for Children* were initially written for Van Alphen's own little children only. In 1775 he became a widower and was left with three little children. He took at the time an extraordinary decision to raise his children himself, inspired by the Enlightenment educational ideas that he also practiced. In vain in search of good reading material for his little children, he wrote, inspired by them, a number of short poems. They were made and tested within the intimate relationship between father and his children. Some years later, in 1778, he published them anonymously. In 1782, with now three booklets of poems ready, they were published under his name and combined with illustrations for each poem by Jacobus Buijs (1724–1801).

In making the poems he adopted and adapted foreign examples, in particular poems by the German poets Christian Felix Weisse (1726–1804) and Gottlob Wilhelm Burmann (1737–1805). While adopting their themes and child's perspective, his style was more child-oriented and his poems were primarily situated within the domestic. It was in those poems family first. The domestic environment was recommended and applauded as an emotional space and the main center of emotional, moral, and civic development. Later, the poems were also recommended for use at school and included in the *General List of Books for Primary Schools in the Northern Provinces of the Kingdom of the Netherlands* (1815), a typically Enlightenment-inspired list made by the philanthropic Society for the Common Good.[9] The poems became long-term bestsellers far into the nineteenth century and were translated in many languages including German, French, English, and Malay. They did not stand alone, for they represent an "internationally acclaimed children's literary turn." This was because he brought together the ideas of Lock, Rousseau, and seventeenth-century authors, such as Jacob Cats, with the ideas of the Enlightenment that inspired people around the *Philanthropinum* in Dessau.[10]

The poems were intended for young children and could, depending on the child's age, be read to and be read by them. Because of this intended audience, the mostly short poems were combined with pictures that show the crucial moment of the transition about child's development as told in each poem. Both when read to and read by them, the picture, that focused on the crucial transition, was essential: the child could immediately understand the meaning of the poem and could be more easily affected emotionally and morally. Because Van Alphen was a widower with young boys raised by him, he focused more on the role of the father than that of the mother, which was with regard to young children exceptional in this period. In his approach of children, he combined child-oriented and authoritative styles. He aimed at training child's emotional and moral literacy in accordance with child's development. By entering into the child's world, Van Alphen was aware of the inside potential of the young child and encouraged the child to actively work on the realization of its moral and emotional transition. He thus greatly appealed to child's own abilities and activities for he considered neither the child as passive nor its emotions as passive feelings.[11]

Little Poems for Children served, apart from being a collection of poems with moral lessons in a general Christian language, also as a group of basic emotions to be learned by the children. It can be considered as a child centered lexicon of emotions to be used as an exercise book for emotional literacy. The emotions to pursue and learn are not shown in an abstract form, but made understandable for little children by putting them in compelling daily-life events that happen in places recognizable for them because of being part of their living environment. The specific emotion in each poem is often introduced as desirable, to pursue one, but sometimes also as undesirable, to avoid and change into another emotion. In many cases the children have to cope with a difficult emotional and moral dilemma. Faced with a crucial transition, they should make the right choice and take the right direction in view of the Cardinal and Christian virtues. In some cases, an adult either inside or outside the domestic is supporting this process, but in other cases the child is thrown back on himself, as in Chardin's *Boy with a Spinning-Top*. Then, the child has to figure it out for himself and to trust in his own moral and emotional compass. Anyway, the child has to get done the job of emotional and moral transition by being moved by the image, and for elder children also by the text. Now follow the main emotions present in *Little Poems* by way of appealing examples. We start with the emotion of sadness.[12]

Child's sadness is connected with the death of loved ones. In *Complaint of Little William on the Death of His Little Sister*, William mourns the death of his then fourteen-month-old sister Mietje. He sees her dead—and cold—body in the little coffin and stands leaning against the table in despair and disbelief as the open coffin is visible behind him through the open door. The poem ends as follows: "Yesterday she played with me; just yesterday! And now—already dead!"[13] By exception there is no emotional transition at stake, but only the representation of the emotional state of a sad and grieving child. That is different with *Claartje at the Painting of Her Deceased Mother*. Nine-year-old Claartje sits in front of the painting of her deceased mother and mourns her death. Tears roll down her cheeks and she must "weep bitterly, because I must miss her: I—not yet nine years." But it's not just sadness. Memories all come along, like when her sick mother said she would die soon and come to heaven with God and gave her one last kiss, whereupon Claartje says: "I went down crying; and it was a few hours before mother was dead." She then decides to "honor my father and take mother's lessons, then when I die I will come to you [God, JD] and mother. How wonderful that will be!"[14] In several poems, children had to learn compassion and empathize with people who are sad and try to cheer them up. In *The Compassion* there is a grieving woman, sitting by the sick bed of her husband. A boy has just come in who wants to support her in her grief, because her husband is sick. For: "To cheer up a man in sorrow / Is sweet even to children." The transition in the child would be to have learned to do this and that it would please him too.[15]

Fear and worry about what could go wrong, disgust with food when sick: Van Alphen also treated those kinds of states of minds and emotions. In *Pietje at His Sister's Bedside*, the boy is particularly concerned that his sister would die. He prays that this will not

happen, all the more because he expects that then his parents would die of grief and that he then would be left alone. No emotional transition here either, but a description of an emotional state, namely of fear and trembling.[16] In *The Sick Child*, a boy lies moaning and sick in bed, his mother bending over him and holding his arm. The child can no longer play because of a headache, is disgusted by the tastiest food, and wakes up from bad dreams. But that state of mind suddenly changes when he realizes how thankful you should be to God when you are well. So the text ends as follows: "God is good! He can heal me again." From disgust and misery, the emotions move to hope and trust, the transition Van Alphen wants to happen.[17] He also wanted to teach the children not to be afraid of a dead body. In *The Corpse*, father shows three small children a dead man lying in bed and tries to get them to overcome fear at the sight of that dead body through the Christian belief in the afterlife.[18]

Sadness, despair and disbelief, fear and worry and disgust: these emotions were represented as emotional states of mind, but also as starting points for learning hope, trust, and compassion for the grief of the other. There was also particular attention for happiness, enjoyment, love, and patriotism. In *Joyful Learning* (see Chapter 5) and several other poems, the outcome of the transition from playing to learning resulted into children's joyfulness. But there is also *Children's Happiness* about a playing child without any reference to learning. The girl says: "From playing tired, I close my eyes at night." In the picture she points to the toys on the floor while about to go to bed and thanking God for the enjoyment.[19]

A special position in *Little Poems for Children* has *Child's Love*. There are several poems and pictures about children's love for others—sister, brother, mother, or father—but this picture goes further. The child is encouraged not only to praise his father but also, if his father very occasionally chastises him, which he regrets and brings him (the father) to tears, to feel guilty and ask forgiveness to God at night for the fact that the child has caused father's sadness. Those poems became an object of criticism and ridicule in the second half of the nineteenth century and this contributed to its decreasing popularity. While the moral approach became less popular, the image of childhood as "a little bit naughty" then got more support.[20] Within the European emotional culture of sensibility, Van Alphen aimed at transitions in the emotional development of young children, and with his pictures with poems, he tried to move children's emotions to fulfil those transitions, and so to contribute to the training of children's emotional literacy.

We now turn to the visualization of the crossing of main turning points of emotional and moral development. This visualization was not, as with the poems by Van Alphen, intended for children, but made for adults as their approach of the process of letting children acquire emotional literacy along those turning points.

Crossing Turning Points of Emotional and Moral Development

In the process of acquiring emotional literacy, the crossing of some crucial turning points in the development of children and youngsters was essential. We focus on three

of those turning points: successfully cross the crucial transitions of early childhood development, the transition from playing to serious matters, and finally learning to cope with the budding passion of lust and with the loss of innocence as the "moment of transition to adulthood."[21] In its visualization, young children are during this process sometimes alone but mostly supported by adults, in most cases the mother or a governess. Growing up, boys and girls are mostly portrayed alone in their own world while coping or struggling with crossing over the crucial turning point with the suggestion of self-training and self-made decisions.

Successful Early Childhood Development

In the seventeenth century, breastfeeding was strongly advised as beneficial for child's development and for the child–mother relationship. This happened by morally playing on the mother's mind, as in Cat's *Houwelick* with the statement that a woman is only a complete mother when she also breastfeeds her children.[22] Around 1800 a new campaign for breastfeeding started, inspired by Enlightenment and Romantic texts such as Rousseau's *Émile*. Breastfeeding was now advised as a crucial first step in successful child development. As in the seventeenth century (see Chapter 3), also now the topic was frequently visualized both within family portraits and as a separate topic. A mix form is *Self-portrait of the Artist Together with His Wife and Son* (c. 1718), one of the self-portraits of the Czech portrait painter Jan Kupecky (1667–1740). Mother, child, and Kupecky as a father and painter look to the viewer. Kupecky sits with his palette and brushes on his left knee, his eyes dark under the shadow of his cap and with a proud view. Meanwhile, the mother sits relaxed and seriously looking in a lounge chair, with between them their son who looks with bright eyes. While mother holds her child's right hand, he is with his other hand touching his father's hand and with that also father's painting equipment. Although the child stands in the painting's center, most of the light falls on the mother's bare shoulder and chest. The picture tells about the parental tasks in the development of the child who is clearly not yet off the breast: mother should breastfeed and care him to bring him to a next stage of development as preparation for the final transition of becoming a painter, just as his father.[23]

The emotional and moral value of breastfeeding was depicted outstandingly in *The Visit to the Nursery* (c. 1775) by Jean-Honoré Fragonard (1732–1806), well known from his somewhat frivolous subjects but also excelling in paintings of the happy family. All persons look with open eyes at the baby in the crib in the center of the canvas. Father on his knees almost adores his own child, while mother, standing, lovingly places her arms around her husband and joyfully looks to her child. An older woman next to the crib, probably the midwife, with at her foot a cat lying, contributes to the happy atmosphere. Three children just entering the room look surprised and with open eyes and mouth at the newborn. Next to happiness are visible fatherly gratitude, tenderness of the mother for baby and spouse, surprise and almost unbelief with the boy, and determination to go to the crib with the girl, both just entering the room. According to Philip Conisbee, the

painting could be based on Jean François de Saint Lambert's *Sara Th* ..., a sentimental tale from 1765 of "a beautiful and well-bred young English woman" who falls in love with a "humble but educated Scottish farmer" and "breastfeeds her children" to show "natural" child's care, essential for an "intimate familial bonding." That is precisely what Fragonard's painting shows, what Rousseau propagated, and what sensibility novels suggested (Figure 54).

The same happiness dominates in Fragonard's *The Happy Family* (1775) about a humble family. Father returns from his work and looks from outside over the small house's half-open door, over which a donkey is leaning, to his family with pride and happiness. He sees his happy wife, mother of four children, sitting with her youngest in her arms just after breastfeeding it, and surrounded by the other children. One child plays with a dog, while another child gives hay to the monkey. At the background, a third child is a little bit shy in approaching the scene. This is all happiness and joy in an emotionally close-knit family of obvious poverty. Fragonard shows patterns of preferred emotional and affective behavior, which are not basically different from seventeenth-century genre paintings in the Southern and Northern Netherlands.[24]

FIGURE 54 Jean-Honoré Fragonard, *The Visit to the Nursery* (c. 1775), oil on canvas, 73 × 92 cm (Washington, DC: National Gallery of Art). Credit: Print Collector/Contributor (Hulton Fine Art Collection).

Van der Kooi's *Breastfeeding Mother* (1826), a profane *Caritas*, is fully focused on breastfeeding. The painting was intended as an encouragement for women from the upper class to breastfeed their infants and followed the advices given by eighteenth-century writers on education, such as Rousseau, about breastfeeding as natural and healthy. Moreover, it was considered urgent given the still existing very high infant mortality. It was part of the mission to start as soon as possible with proper upbringing. As a model, Van der Kooi, himself a Frisian painter, chose a Frisian farmer's wife who breastfed her child with dedication, care, and love, dressed with golden ear iron and lace cap to emphasize breastfeeding's naturalness.[25] Van der Kooi's *Mother's Happiness* (1818) is situated in a simple environment, exceptional for the painter who usually portrayed well-to-do people. It points again to the message that civilian women should follow the example of a baby at mother's breast. The baby is completely swaddled and sits on the lap of mother who sits on a chair in a simple interior. While a cloth over the child's head covers both baby's head and mother's breast, an older son of about eight years old watches the scene with delight, his gaze falling precisely on the invisible face of the child.[26]

The early training of girls for the motherly task was popular among *Haagse School* painters. In Blommers's *The Doll* (s.a.) are a mother, two little girls, and a doll. The doll has fallen into disarray, so mother is busy in repairing it with a radiant, joyful, and happy face. The owner, a toddler, looks on while leaning on mother's lap and is convinced that everything will be fine again. Her little sister meanwhile eats her plate full of enthusiasm. In the right corner is an empty toy crib waiting for the baby doll.[27] Also *Mother's Assistant* (1866) by Jozef Israëls is about early training of mother's task, including her domestic duties. While mother sits in an easy chair with mending work on her lap, a toddler, mother's assistant, comes up with a footrest for her; the painting shows emotional harmony.[28] Fritz von Uhde's (1848–1911) *Children's Room* (1889) is characterized by emotional harmony with zeal and joyfulness, and work and play going together. Under the watchful eye of a happy mother, engaged in needlework or sewing and apparently making dolls, two young girls play with dolls and a cradle, while an older girl is just, like her mother, engaged in sewing. The painting is not as several *Haagse School* paintings reminiscent of seventeenth-century genre painting. But with the impressionistic use of cheerful colors that are typical for *fin de siècle* painting, its message is similar: early training of girls for the motherly task.[29]

Chardin stepped into a long tradition with *The Morning Toilet* (1741) on a girl about five years old who, while her mother takes care of her daughter's hair, looks in the mirror and discovers and enjoys herself. While René Démoris's description of "a narcissistic enjoyment" is overdone, the comment in *Mercure de France* on the occasion of the painting's exhibition at the Salon of 1741 seems to well touch the emotional state of mind of the girl, expressed by the painter "through the eye that the young girl sends stealthily to the mirror, so as to satisfy her own little vanity." The caring mother is inspired by earlier genre paintings about dressing up in the morning, while the mirror was present in sixteenth-century Bruegel's work, in Cats's seventeenth-century *Mirror*,

in genre paintings by Netscher, and in the *Little Poems for Children* by Van Alphen. But while Cats and Van Alphen disapproved girl's looking in the mirror as making vain and advised to find true beauty not in the body but in the soul, Chardin observes the looking in the mirror as the natural turning point of discovery of oneself, nothing to worry about (Figure 55).[30]

Louise-Élisabeth Vigée-Lebrun (1755–1842), the portrait painter of the French aristocracy including Marie-Antoinette, treated the discovery of oneself at a turning point of emotional development in *Julie Lebrun Holding a Mirror* (1787). She observed and depicted her young daughter, who with great interest studies her joyful face, through the mirror also sent to the viewer. Allard interprets this less convincing as "the prefiguration of her seduction as a woman."[31]

At the end of the nineteenth century, painters such as Mary Cassatt were influenced by the new child studies that encouraged parents to better understand their child's development. Wilhelm Preyer and Bernard Perez, among others, advised (future) parents to observe their children, to keep a baby diary, and to seriously follow the advisers' recommendations. Cassatt changed the portraying of European bourgeoisie families

FIGURE 55 Jean-Baptiste Siméon Chardin, *The Morning Toilet* (1741), oil on canvas, 49 × 41cm (Stockholm: Nationalmuseum). Credit: DEA PICTURE LIBRARY/Contributor (De Agostini Editorial).

through her realistic way of depicting the intense emotional communication between mother and child. In *Baby's First Caress* (1891), the little naked child with its left hand touches the mouth of its mother, who with her right hand holds the left foot of the child and with her view and gestures accompanies child's exploration. She shows an "adventure for both" with "full interaction" between mother and child, also in *Sketch of Mother Looking down at Thomas* (*c.* 1893), in which the loving and caring mother bends over the child whose eyes look slightly to the right, at ease in mother's arms.[32] A similar pastel is *Young Thomas and His Mother* (1893), one of a series on the subject, showing in a mix of naturalism and Romanticism the emotional mother–child relationship. The caring and loving mother kisses her child on the right upper arm. The child, standing on a table or chair, the hands crossed, holding something resembling a small bracelet and with chubby cheeks, looks to the object in her hands in a concentrated way, clearly at ease.[33] Cassatt's models were painted from very near and are in that respect reminiscent of Van der Kooi's, Runge's and Courbet's paintings. Her mother–child portraits were a motherhood course in images, a "do it yourself" and "childcare lesson."[34] A caring and loving emotional attitude to a happy child now were encouraged with the support of scientific evidence, and Cassatt just as her predecessors visualized a contemporary discourse. She did with

FIGURE 56 Berthe Morisot, *The Cradle* (1872), oil on canvas, 56 × 46 cm (Paris: Musée d'Orsay). Credit: Photo Josse/Leemage/Contributor (Corbis Historical).

images what numerous child rearing advice manuals did with text.[35] One of the most famous paintings of mother and child, which at the time could not find a buyer and was hold within the family of the model until the Louvre bought the canvas in 1930, is *The Cradle* (1872) by Berthe Morisot (1841–1895), who belonged to the impressionistic French circle. *The Cradle* shows a combination of attention and observation together with motherly love of the little girl Blanche and her mother Edma, one of the artist's sisters. New is not so much "the place given to early childhood, to the newborn"— Metsu, De Hoogh, Maes, among others, frequently painted the same subject—as that it is "not about a mother cradling or hugging her baby, but contemplating him, intriguing, fascinated, not in the contact of effusion but in the distance of questioning" (Figure 56).[36]

From Play to Serious Matters

In Chardin's *The Young Governess* (1737) a teenager, rather an elder sister than a governess as the title suggests, is teaching a little child, probably a boy, to read in a picture book. The girl looks concentrated at the eyes of the boy who equally concentrated follows with his right index finger the lines on the page. The scene is situated in a typically French bourgeois environment, the social class that admired Chardin's work about childhood and education and "owned [it] as engravings of the original paintings." We enter into the world of a child just at its initiation into the serious world of literacy, in this initiation supported by another, elder child. The picture belongs to a long tradition to which also belongs De Gheyn II's *Mother and Child with a Picture Book* (*c.* 1620) (Figure 57).[37]

In Chardin's *Grace* (1740) the end of playing is at stake with the child's mother in a stern role. As often in Chardin's paintings, there are toys like a rattle on the floor and a drum hanging from the chair next to which a boy is straight up kneeling with the intention to thank for the meal. Detachment of playing is part of his learning process. Chardin emphasizes in his approach of the ritual of thanksgiving, frequently painted from the late middle ages, in this painting not the religious origins but its role in the transition from child's joyfulness connected with playing to seriousness connected with praying. For this the young boy needs support from adults, in this case mother's radiating authority. She puts his plate on the table, meanwhile looking straightly at the child who cannot avoid her compelling gaze and is encouraged or psychologically forced to detach from his toys and to thank for the meal. His eldest sister, sitting straight up at the table, has already gone through this passage and does no longer need her mother's compelling gaze. Chardin's painting show the "ultimate moment of this renunciation, in the face-to-face of a child and his games ..., as in *Boy with a Spinning-Top*," but with the difference that in that painting an elder boy in a moment of self-discovery and alone realizes that he is ready to cross this crucial border.[38] Chardin portrayed the same passage for girls in *Girl with a Racquet* (1741). A girl with in her right hand the racket and in the other the shuttles stands up straight with a serious looks, elegantly dressed in a hoop skirt that does not invite to the game. This passage from playing to serious matters has a crucial

FIGURE 57 Jean-Baptiste Siméon Chardin (1699–1779), *The Young Governess* (c. 1737), oil on canvas, 61.6 × 66.7 cm (London: National Gallery). Credit: Print Collector/Contributor (Hulton Fine Art Collection).

gender difference: while the boy should from now study books, the girl should train her behavior and emotions as if she was already a young lady (Figure 58).[39]

In Chardin's *The Governess* (1739), a stern and serious governess, taking over mother's role and probably sitting in mother's chair, with a brush in her hand bends forward to the boy who stands in front of her, eyes downcast and hands folded with a booklet clutched between his arm and side. There are still all kinds of toys on the floor and the boy would clearly continue his playing. But now it is time for learning. It is the governess' task to make this transition done by moving him to change his emotional mindset to be able to cross this border.[40]

In *Family Portrait of Hendrik Louis Wijchgel van Lellens with His Wife and Two Daughters* (1796) by the Dutch painter Gerardus de San (1754–1830) the stage of learning seems to have already been reached, for there are no references to playing. Father as pride head of family sits at a small table, surrounded left and right by his two little daughters in a dignified interior with on the background a painting showing the family's country estate. With a dip pen in his hand, he holds his right arm around the shoulder of one daughter who is meanwhile following the lines in a book with

Training Children in Emotional Literacy

FIGURE 58 Jean-Baptiste Siméon Chardin, *Girl with a Racquet* (1741), oil on canvas, 82 × 66 cm (Florence: Galleria degli Uffizi). Credit: DEA/A. DAGLI ORTI/Contributor (De Agostini Editorial).

her fingers, and with his left hand his other daughter's hand. She holds the hand of her mother, standing next to her. While father looks at his wife, she and her reading daughter look at the viewer.[41] Also diligent drawing by children around 1800 was a sign of a successful transition from play to serious matters. In *The Drawing Lesson* (s.a.) by Abraham van Strij (1753–1826) a boy is drawing diligently and seriously while the draftsman calmly awaits the result. Instead of his own toys still on the floor waiting for him to play, playing—his former stage of development—is symbolized by a little girl who plays with a windmill on the floor.[42] Also *Binne and Haye van der Kooi* (c. 1830), painted by their father, are studiously and diligently drawing at the table. They are absorbed in their work, one of them in the candlelight, the other in the shadow, a well-known symbol of knowledge and education going back to Ripa.[43]

Learning by playing was an alternative route to serious matters. In Sir Thomas Lawrence's (1769–1830) *The Angerstein Children* (1807) four children play gardening: three girls, dressed in elegant white dresses, two of them busy with a shovel, the third girl sitting on the ground watching it all, and a boy in a dark red suit with a white collar holding a broom and standing next to it. The children are busy, jostling each other to handle the shovel, and concentrated. This playing was learning by doing (Figure 59).[44]

FIGURE 59 Sir Thomas Lawrence, *The Angerstein Children* (1807), oil on canvas, 184.3 × 148.8 cm (Berlin: Gemäldegalerie-Staatlichen Museen zu Berlin). Credit: Picturenow/ Contributor (Universal Images Group Editorial).

Training Children in Emotional Literacy

Learning by playing was central for the aforementioned Jacob de Vos in his between 1803 and 1809 made *Drawn Diaries for His Children* on everyday activities of his four little sons, purpose-made for them and looked at by them when still a child. The drawings became a mirror of their youth in a domestic environment of playing and coming of age. By playing, the children initiated themselves in the adult world and trained themselves for the emotional literacy, which was necessary for that world. While much of their play was about positive emotions such as happiness, joyfulness, and satisfaction, they also learned about sadness and anxiousness as normal part of their children's life and of adult's life. Their father showed his emotional life to them, as his sadness when his wife was seriously ill. His drawings disclose De Vos's great pleasure in looking at his four sons when growing up. His imagination of the child's world is special for his time as was his capturing this world over a series of years in naturalistic drawings. In Blommers's late nineteenth-century *Playing School* (1868) three girls and a boy are sitting on a bench in front of their house, a farm, probably in a North Brabant village. They look seriously and intently at their textbooks. In front of them is an older girl who plays for a teacher and to that end looks into a textbook while holding a baton with her right hand. Blommers shows how children by playing prepare for serious matters, that is, school (Figure 60).[45]

FIGURE 60 Bernard Blommers, *Playing School* (1868), oil on canvas, 92.7 × 112.4 cm, VBL/13 (Dordrecht: Dordrechts Museum, in loan from RCE/collection Van Bilderbeek, 1951).

207

Coping with the Passion of Lust

As with crucial passage in children's emotional life from innocently playing to seriously learning, also the visualization of the transition from innocence to budding sexuality continued, but now different from early modern European emblem books. The emblems translated the classic Christian view about the direction of the will in curbing such emotions in pictures, which warned for the budding passion of lust of boys and girls and advised about the training of moral and emotional literacy to get the passion in the right direction. In this period, however, the unavoidability of the often lamentable consequences of the transition got more attention, as also the role of the body instead of the will. This resulted into more attention for coping with than for controlling this passion. The greater emphasis on early childhood as period of innocence—Allards even speaks of "invention"—went together with interest for its "definitive loss" during the transition to adulthood through "socialization and the discovery of puberty sexuality."[46] While in this period neither children's innocence nor adolescence were invented, for part of the mind set also in early modern Europe, adolescence was longtime limited to a rather small social group and became part of life for wider social groups only with mass schooling and the resulting postponement of the start of a labor career. The following images are thus initially mostly focused on well-to-do children, but during the nineteenth century, the social spectrum broadened.

In addition to depicting how things could go well in *The Happy Family*, Fragonard also, in *Advantage Taken of the Absence of Father and Mother* (1765), showed what could happen if parents were absent. In the foreground two plainly dressed little children, full in the light, are playing with two big dogs. They look forward at the viewer. To the right sits a slightly older boy watching past the two children to the background. There, two young adolescents, a boy and a girl, visible in the twilight, are making love. The message is that such things unavoidably happen when parents are absent.[47] Also Jean-Baptiste Greuze (1725–1805) visualized this transition. He focused on the sentiments and emotions of girls close to adolescence and the discovery of sexuality. He depicted the scenes in a sometimes rather erotic style, also practiced by Fragonard and Boucher. Inspired by Diderot's theory of art (see Chapter 6) according to which "art must appeal to the public's morally good emotions, and thus inculcate virtue,"[48] and strongly influenced by seventeenth-century Dutch genre painting like also Chardin and Boucher, his style of painting aimed at "stirring the emotions of his public."[49] Loss of innocence, manifest in the loss of virginity, was connected with sadness in *Young Girl Mourning Her Dead Bird* (1765), with in its symbolic a striking resemblance with *Girl with a Dead Bird* (c. 1520) (Chapter 3). While *Young Girl Mourning Her Dead Bird* shows sadness after the loss, in *The Broken Jug* (1773) the transition does not so much lead to sadness as to astonishment and amazement. Holding against her body the rose petals that should have filled the jug, she "stares as if dazed at the spectator" with her breast uncovered. While the "adult—the spectator—knows what is really happening, … the teenager

perceives it only vaguely," for knowledge of sex is "what separates children from adults," especially during this period.[50]

Those paintings resemble symbolically sixteenth- and seventeenth-century pictures, in particular emblems, and this is no coincidence as Greuze was influenced by seventeenth-century genre painters such as Mieris and Metsu. The girl in *Broken Eggs* (1756) sits dejectedly on the floor, with next to her a basket of eggs, some of which are lying broken on the floor. Behind stands her mother with defeated and angry eyes. She points at the broken eggs while looking at the boy to be blamed for the moral drama, holding him tight by his left wrist with her accusingly looking eyes turned to him. In the right corner, the girl's little brother is busy with his bow as if he is a *putto*. He tries in vain to put the broken egg back together, for the stick contents drips down his fingers. As with seventeenth-century emblems by Jacob Cats, this painting contains erotic suggestions together with warnings, in this case by the mother who blames the boy. But while Cat's warning was moral in his advice to combine pleasure with lust's regulation, Greuze observed the scene as a necessary and unavoidable event that simply happened as the passage from innocent childhood to adulthood (Figure 61).[51]

Exceptionally, Greuze also depicted a boy's love desire in *Young Shepherd Who Tempts Fate to Find Out if He Is Loved by His Shepherdess* (1760–1). A young shepherd in a pastoral environment "concentrates on his love wish, before blowing out the dandelion candle he is holding in his hands."[52] While in emblem books in early modern Europe the control of lust was both a boy and a girl thing and responsibility, French eighteenth-century art did only exceptionally refer to boys' sexual desire.[53] Referring to the seventeenth iconographic tradition of love letters is Van der Kooi's *Love Letter* (1808), an erotically suggestive subject popular among Dutch Golden Age genre painters such as Vermeer, De Hooch, Jan Steen, and Ter Borch, but in this period an exception, because Dutch painters and clients were not interested in the subject. Van der Kooi's painting is not explicitly suggestive as Greuze's pictures, but is focused on girl's inner emotions. In a classically decorated interior, the face of an adolescent girl, elegantly dressed in a light yellow, rustling, low-cut dress, with earrings and a smooth gold ring on her ring finger, expresses expectation and a certain fear. She takes a letter, sealed with a red wax seal, which passes to her hand from the hand of a young deliverer who acts as messenger for the letter's writer and looks coyly past the young woman at the letter (Figure 62).[54]

The story in Edgar Degas's *Young Spartans Exercising* (c. 1880) is set in classical Greek antiquity, but is actually a timeless story about courtesy. According to Pernoud, it should be included in the group of paintings that show "in the distractions of childhood the image of a sovereign body, removed from ... the discipline of 'good manners,'" in short swimming and wrestling children as depicted by Gauguin, among others.[55] But the story tells more. Visible are in the foreground four topless girls taking the initiative in flirting with five naked boys in front of them. The front one girl defiantly moves her left arm and upper body in the direction of the boys, who seem to be intimidated.

FIGURE 61 Jean-Baptiste Greuze, *Broken Eggs* (1756), oil on canvas, 73 × 94 cm (New York: Metropolitan Museum of Art; credit line: bequest of William K. Vanderbilt, 1920).

Tension dominated. Four boys face the girl head-on, the fifth is on all fours, as if in the starting position to run towards them. Behind the leftmost boy are two dogs, a sign of good upbringing and indeed, upbringing is also at stake. The painting refers to the life of the King of Sparta, Lycurgus, and shows an episode of his life "by the Roman historian Plutarch." This text also describes "how Spartan girls were ordered to engage in [physical, JD] exercise ... and to challenge boys." Challenging is what they do, not so much running or wrestling or other physical exercises, but flirting and courtship. But instead of youngsters liberated from "the discipline of 'good manners,'" this seemingly autonomous world of childhood is supervised by adults. In the background the mothers of the girls and boys are visible. They stand around Sparta's king with behind them the city of Sparta. The adults watch the children during their courtesy meeting and manage to channel the passions of the girls and boys, who only seemingly create an unchained and autonomous world of childhood, towards the benefit of state and society (Figure 63).[56]

In the last quarter of the nineteenth century, courtesy became a popular topic among Dutch painters too, partly due to the interest from the Anglo-American market. This happened, in contrast to Dutch seventeenth-century and French and English

FIGURE 62 Willem Bartel van der Kooi, *Love Letter* (1808), oil on canvas, 131 × 108 cm (Leeuwarden: Fries Museum, in loan from Rijksmuseum Amsterdam). Credit: Sepia Times/ Contributor (Universal Images Group Editorial).

eighteenth- and nineteenth-century painting, in a restrained manner. The focus was on childlike innocence that matched well with contemporary child rearing and marriage advice manuals, equally restrained in giving advice to nubile girls and young men who entered the relationship market, and in mainly dealing with the dangers of temptation and courtesy's significance for establishing a good marriage. The exception on the rule were the recommendations influenced by Progressive Education pedagogues, who wanted to inform children about sexuality at a much younger age than Protestant or Catholic pedagogues thought correct.[57] Most painters focused on the innocent side of temptation and seduction. Among them Jozef Israëls was trendsetter. He made a number of courtesy paintings, mostly situated in the open air, as in *The Timid Lover* (1883) with a boy and girl walking side by side in the field without looking at each other, and expressing shyness and expectation rather than controlled lust or seduction. In *Courtship* (1899) the atmosphere was more relaxed and homely with the boy lying in the dune grass, probably at Scheveningen beach, and the girl knitting. They do not look out to the sea at the inevitable sailing boat, but at each other, not timidly and distantly but expressing love (Figure 64).[58]

FIGURE 63 Edgar Degas, *Young Spartans Exercising* (c. 1860), oil on canvas, 109.5 × 155 cm (London: The National Gallery). Credit: Print Collector/Contributor (Hulton Archive).

FIGURE 64 Jozef Israëls, *The Timid Lover* (1883), aquarelle, 83.4 × 63.3 cm (Montreal: The Montreal Museum of Fine Arts). Credit: Print Collector/Contributor (Hulton Fine Art Collection).

Conclusion: Emotion Training around Turning Points of Emotional and Moral Development

The acquisition of emotional literacy around crucial turning points in child's emotional development went by training through adults and by self-training. Self-training material was influenced by the more compelling and didactic Enlightenment style in which emotional literacy could be reached if the child should make a successful passage to rationality. This passage to reality often went together with moralization in the self-training process in countries such as Germany, Great Britain, France, and the Netherlands. A striking example was the training of emotions through a collection of poems with pictures, part of the emerging genre of children's literature and to be used alone or together with an adult, mostly a parent. This collection could be read as a visualized lexicon of emotions. By reading and looking through these texts and pictures children could learn both about the basic emotions and about the direction to follow when standing on a crucial turning point of development.

Visualization was shown around three of those turning points, successful early childhood development, the transition from playing to serious matters, and coping with the passion of lust. For the transition during early childhood the caring and loving and reciprocal emotional relationship between mother and child stood out in particular in the second part of the century, while the mission addressed to mothers to breastfeed their children, inspired by the *Émile*, was strong around 1800. With Chardin, the turning point from playing to serious matters, mostly learning, became again popular with rather similar configurations as he created also chosen by other artists in depicting this transition. While mostly an abrupt demarcation between playing and learning was visualized, playing was also visualized as core and daily business of a child. Exceptional was De Vos for whom the contrast between playing and learning seemed not to exist, because playing was considered as the most effective way of learning child's own emotions and the emotional standards of the adult world. The visualization of the passion of lust in the context of children on the verge of adolescence gradually changed, in particular in French painting. Instead of morally warnings, as in seventeenth-century paintings and emblems, those painters observed the coping with this passion as a phenomenon that could cause sadness but was unavoidable in crossing the crucial turning point that led to adolescence.

For the rest, also outside the domestic, the place this book is focused on, the training of children's emotions took place. This happened, among others, at the workplace for child laborers, over the course of the period at school and in residential institutions for reeducation, and for boys in the army through the new phenomenon of conscription, from *c.* 1800 a welcome measure for nation states to expand their military in a rather cheap way. This nuances the family and the domestic as the backbone of emotion training in this period not so much for the very young but certainly for elder children and youngsters. State and society came to take on and claim a larger part of this task and realized this increasingly within a legal and forcing framework.

8

Conclusion: Changing Discourses, Continuing Emotions

The expression and the training of children's emotions in Europe from *c.* 1500 until *c.* 1900 were made visible for us by the artists who depicted them in a variety of styles. Those children and their parents lived in an emotional and educational space with lively discussions about emotions and about childhood and education.

In the Renaissance, this Big Talk on emotions and how to teach or learn to channel them resulted into a coherent discourse on the emotions. The phenomenon dealt with was, however, not described as states of the mind but as states of the soul. And those states of the soul were not described with the overarching concept of emotion, but with a variety of words, in particular passions to be controlled and affections to be developed and cherished. This discourse was built on a Christian fundament with founding texts by the church father Augustine and the scholastic Thomas Aquinas. It resulted into theological, philosophical, and moral texts, often written in Latin, until the eighteenth-century Europe's intellectual language, but also in the vernacular. The discourse's emphasis on the control of emotions inspired during the Reformation both Protestant reformers like Martin Luther and Jean Calvin, and Roman Catholic Reformers like the Jesuits Ignatius of Loyola and Petrus Canisius. They insisted on more discipline in daily emotional behavior and promoted a lifestyle that suited true faith. The theological and philosophical discourse was accessible for only a very small minority. But it was transformed into popular texts and images as instruments to teach the regulation and control of emotions to an increasing number of people, strongly stimulated by growing literacy levels. That's why for the common people "religion and spirituality retained their value as codifiers of emotions as Christian signifiers."[1] In the seventeenth century, philosophers such as René Descartes continued this Big Talk. Descartes adapted the classical Christian discourse substantially in *Les passions de l'âme* and gave more attention to emotion's physicality. While passions remained also for him the main concept, he sporadically, and perhaps almost unnoticed, used that initially absent category of emotion. Moreover, by adding "wonder" in his classification of basic emotions, he made the discourse on emotions less moral. He so made a first step in making thinking about emotions more secular and empirical. One century later, David Hume and utilitarian-minded philosophers such as Adam Smith and Jeremy Bentham introduced the category

of emotion in the English-speaking Enlightenment literature. Eventually this became the overarching concept for a new mental framework on feelings, summarized as states of the mind instead of states of the soul. While the influence of the classic Christian and moral discourse thus decreased, a radical transformation had to wait until Charles Darwin and William James. They replaced, at least for the scientific elite, the variety of words used for centuries by the now-overarching concept of emotion. Moreover, they approached emotions no longer morally and theologically, but empirically. This was a revolution of paradigm in slow motion. It disenchanted the emotions and made them "the mysterious product of biological forces rather than will and cognition."[2] It was, however, not a revolutionary change in specific emotions, for the states of the soul and the states of the mind seem to refer across time to roughly the same emotions. The numerous classifications of emotions across time point to this continuity. From Augustine to Aquinas and from Descartes to Thomas Hobbes and David Hume, there are major differences in numbers but also remarkable similarities in what in modern psychology is summarized as basic emotions, in particular happiness, sadness, fear, surprise, disgust, and anger. This seems to indicate a mental frame of emotions along a surprisingly *longue durée*. For the rest, the classic Christian discourse did not disappear. Strengthened by the religious revival in the late eighteenth and nineteenth centuries and with a strong boost by Romanticism, this moral framework on the emotions continued. It often even dominated the educational world among the broad strata of the population. This meant a greater distance between the scholarly discourse and the belief of the common people across time. In early modern Europe, the main tenets of the scholarly discourse also directed the common people in paintings and drawings about passions, affections, virtues and vices or capital sins, and in manuals and emblem books about emotion control. But when from the eighteenth century the moral distinction between passions and affections slowly changed into a seemingly neutral scientific concept of emotion, the gap between this scholarly discourse and the view about emotions of the common people widened. In this period the common people were hardly influenced by the scientific and seemingly neutral concept of emotion as a physical entity. They continued, supported and stimulated by the churches, to follow the classic Christian and moral view about emotions and its control and regulation.

The other Big Talk, about education and childhood, was in early modern Europe during the Renaissance and the Reformation narrowly connected with the discourse on emotions, which was popularized and educationalized. This made religion a strong engine of an educational turn that led to a mission to train the control of the passions in order to initiate children in the emotional standards of their time. This educational discussion was dominated by the image of the child as an *animal educandum* with a *tabula rasa*, to be found in influential texts by Christian humanists, among them, above all, Desiderius Erasmus. This image of childhood turned out to become stronger than the—in the same period—influential image of childhood under the burden of original sin. This was also the case among orthodox Protestants. They saw the belief in original sin not as a reason to remain educationally passive but, on the contrary, rather as an extra

stimulation to actively educate their children. The concept and the word *tabula rasa* with its emphasis on the crucial role of the educator in filling this blank paper became popular in the Enlightenment by John Locke, but was thus used already before in popular texts and in child-rearing manuals as a foundational concept. In the Enlightenment it was theoretically modernized and so became more sophisticated to contribute to a more didactic way of coping with child's development, including its emotions. It became part of a Europe-wide optimistic educational discourse, was popular among parents and schoolmasters alike, and fitted the development of mass education of children, realized around 1900 with the introduction of the compulsory primary school.

At the same time Romanticism challenged this focus on education with the child considered as a *tabula rasa*. This movement put the child in the center, an idea that almost immediately took off after the publication of Jean-Jacques Rousseau's radical educational turn in *Émile*. It intended, in the words of Friedrich Fröbel, "to awaken and develop, to quicken all the powers and natural gifts of the child," and it decisively influenced the Progressive or New Education Movement at the end of the nineteenth century, widely known through the proclaiming in 1900 of the twentieth century as *The Century of the Child* by Ellen Key. This Swedish pedagogue insisted that children's emotions should be stimulated instead of regulated, let alone suppressed.

The discourses on emotions and on education and childhood during the Renaissance and the Reformation knew many different opinions, but they were built on a shared ideological fundament, that is, the Christian discourse on vices and virtues. This changed from the second part of the eighteenth century with the impact of the Enlightenment, Romanticism, and child science and modern psychology. Then the discourse about childhood, education, and emotions became more ambivalent. On the one hand, it slowly became dominated by a longing for the disenchantment of childhood and of emotions through child sciences and emotion science, a manifestation of the process of rationalization according to Max Weber. On the other hand, a strong counter movement developed under the influence of Romanticism and the *Wendung zur Religion*, the intensifying impact on daily life of religion after 1800, which in a different way also contributed to society's modernization. The resulting ambivalence in the discourse made the period from *c.* 1750 to *c.* 1900 an age of tensions. On the one hand, an enchanting belief in the child with its autonomous talents and energy emerged. It was developed by philosophers such as Rousseau, poets such as William Blake, and pedagogues such as Pestalozzi and Fröbel, and it did have a major impact on artists who depicted childhood. On the other hand, a disenchanting belief in the child was manifested in the considered-as-necessary regulation of the not-yet-restrained child at school and in the, in great numbers, emerging residential reeducation institutions. The ambivalence of the discourse on emotions was apparent by, on the one hand, the increasing emphasis on cherishing the individual and often strong feelings of sensibility, which should not be reduced to physical entities, and, on the other hand, the strong longing after the scientific disenchantment of emotions in the way of Darwin and James.

In the whole period the two discourses had to cope with the available educational space. That puts the discourse's effective impact, in particular that of the educational discourse from the Enlightenment and Romanticism, often in a rather disappointing reality of desirable rather than feasible ideas. Admittedly, it is incontestable that the continuing Big Talk on childhood contributed substantially to a more child- and education-oriented mindset, that is, the mental dimension of the educational space. Moreover, it is clear that economic modernization made new educational initiatives possible. But the ambitions because of this changing mindset remained until far into the nineteenth century, often frustrated by strong limits of social inequality and by the impact of a continuing *Ancien Régime* demography. People had to cope with the hard reality test of a world of high infant and child mortality, and emerging industrialization caused child labor in a new, now more disciplined and child-exhausting form. The real breakthrough and the implementation of the new ideas, therefore, came much later, when the limits of the educational space weakened through a change of its socioeconomic and demographic indicators. Then, although with major differences along countries and regions and also social class, infant and child mortality rates decreased fastly and structurally and were followed some decades later by lower birth rates and thus smaller families. The educational space's level of the mindset thus changed earlier than its demographic, social, and economic levels.

Within the context of this changing educational space and influenced by the two Big Talks, the visualization of children's emotions went into two directions: an observational approach of the expression of emotions, and a missionary approach of suggesting and recommending ways of teaching and learning emotional literacy, often also by showing what could happen and go wrong if such literacy was not learned. While many pictures concentrated on one of those two approaches, a number of them combined both.

In early modern Europe, children's emotions became increasingly visualized in paintings, frescos, and drawings. This made it possible for us to come almost face to face with the bodily expression of those emotions. This visualization started in sacral art with the depiction of family as an emotional space, the emotions of the young child, and the emotional mother–child relationship. Out of the sacral models of the Holy Family, the Child Jesus, and the Madonna the profane portrait was born. Initially, the family portrait focused on family genealogy and was centered on the father as the head of family. But then the attention moved from father to child and from paintings of father with child to more and more paintings and drawings of mother and child. In portraits of parent and child and in family portraits, children have a more central place. Moreover, increasingly portraits were made of children in their child's world, alone or together with other children, with first mainly boys but in the course of the sixteenth century also often girls. Children were often depicted as happy and joyful boys and girls, evidence for the intention of their parents to show that they tried to make their children happy. But also fear, panic, sadness, and anxiety were visualized by artists such as Albrecht Dürer and Rembrandt. Such pictures are evidence of their consciousness of the *sui generis* of the child, of the hard realities of those children and their parents, and of the existence of

affectionate attachment. Parents had their children often portrayed already at an early age because they knew they could die very young. In short, in early modern Europe's visual culture, the emotional dimension of childhood came to the forefront.

This continued in modernizing and industrializing Europe with the impact of Enlightenment and Romanticism with changing styles and with the significant adaptation of two already existing images of childhood. The innocent child, already known from fifteenth- and sixteenth-century sacral art, was secularized and increasingly realistically painted within the emotional child–parent relationship and within the emotional child's world, with both pleasant and unpleasant emotions. This became the Romantic image of childhood par excellence. This mix of Romanticism and realism was in particular popular in the second half of the nineteenth century, among others, by painters of the *Haagse School* and by Mary Cassatt. The second image of childhood, the *animal educandum*, was enforced through the Enlightenment. It was provided with a new scientific basis and explicitly present in paintings about crucial transitions in child's development, as by Jean-Baptiste Siméon Chardin. This classic image of childhood became eventually, at the end of the century through the development of mass schooling, the reality for almost every child. In this period also, a new image of childhood developed, that of the so-called autonomous child, that is, the child in competition with adults. Inspired by Rousseau it was preferred by important painters such as Théodore Géricault and by writers such as Charles Baudelaire. Although not always that realistic, in particular for young children who depend on adults to survive and grow up, it enabled painters to realize an often-striking realistic entry into the emotional world of young children. Next to this image of childhood, the child as a family asset and part of the family lineage, important in the fifteenth and sixteenth centuries, remained an option for family portraits of upper-class families. But in those portraits the child became less depicted as a family asset and more as an *animal educandum*.

In the visualization of the emotions of children, remarkable gender and social differences were common. With some exceptions as in Jacob de Vos's drawings, mostly the father–child relationship was focused on teaching the emotions, and the mother–child relationship on care and love. In specific places of the child's emotional world as on the beach, boys and girls were portrayed in playing together as innocent happy children in a realistic and romantic approach of the *Haagse School*. But in particular in French and German paintings, artists such as Paul Gauguin and Max Liebermann depicted children in those places differently, with boys as "wild children" from the lower classes in the countryside with a physical look that expressed struggle, sport, and activity, and with upper-class happy girls expressing civilization and innocence in parks and squares of the big cities, as by Édouard Vuillard.

Next to this observational approach of the expression of emotions, the teaching and learning of emotional literacy was visualized, in particular in genre painting and genre drawing, and in emblems and other text-image genres. This visualization was part of a broader mission that was manifested in images and in texts. Those texts mostly followed a strategy of instruction while visualization often used the strategy

of seduction to make clear how important emotional literacy was for children and youngsters. In the dynamic society of the Renaissance and the Reformation, the main European agencies asked for more regulation of the emotions. When the ratio would dominate the passions and channel and control them, the expression of emotions and impulses could and would follow the contemporary emotional codes and standards. This call for emotional discipline was an interest of the reformed church, which would enter more intensively into daily life of its members, of the modernizing rulership that needed disciplined citizens, and of entrepreneurs in an early modern capitalist economy with great need of disciplined laborers. This call was answered by artists in sacral and profane art with frescos in churches, drawings, and with genre paintings, among them the most appealing by Jan Steen, and also in a part of family and children's portraits. It was also answered by moralists in long-term bestsellers: first of all emblem books and also marriage and child-rearing advice manuals. Those images and texts formed a translation and popularization of the classic Christian discourse on the passions, now brought down to earth and reworked into visual lessons in moral and emotional literacy. The mission originated in the European movements of Renaissance, Humanism, and Reformation, and its images and texts were European notwithstanding their national peculiarities. Emblem books as those by Jacob Cats used many European languages, contained examples from the Bible and ancient Greece and Rome, and used Europe-wide proverbs. Instructional manuals such as Protestant Dutch marriage and child-rearing books were often remarkably similar to British puritan ones. Erasmus, the most influential author in this respect, was a full-blood European humanist. Artists in the European Megalopolis not only often worked for an international market, but all of them used the same symbolic language, which was based on texts from Christianity and from antique Greece and Rome. All details of this language could be found in extensive and detailed guidebooks that were tailored to the needs of artists, among which Ripa's *Iconologia* was the most famous.

As a result, from the sixteenth century, the body and its sensorial, emotive, and physical expressions were, at least intentionally, increasingly framed within rules of containment, self-control, and restraint of one's emotional manifestations in order to remain within socially acceptable boundaries. This process has been connected with the rise of the individual in an increasingly civilizing and rationalizing world. Whether or not such interpretations, inspired by first Jacob Burckhardt and then Max Weber and Norbert Elias, are tenable is increasingly questioned by historians of Antiquity and of the Middle Ages and also by historians of non-European cultures. They reject the idea of less "civilized" management of emotions in those periods and those cultures when compared with the practice of increasingly "civilizing and rationalizing" Europe.[3] Anyway, the age of Renaissance and Reformation asked for more containment of emotions, and the new potentialities of the educational space made it easier to bring this mission in practice.

The mission did not stop with the start of the Enlightenment, but got even an extra boost. The acquisition of emotional literacy through training by adults and through

self-training by the child could now become more effective through the more compelling and didactic Enlightenment style that would support or, if considered as necessary, force the child in making a successful passage to rationality and thus to the control of its emotions. This passage around crucial turning points in child's emotional development went together with a more moralizing strategy in the self-training process. Visualization was in particular shown around three of those turning points: successful transitions in early childhood development, the transition from playing to serious matters, and the transition to coping with the passion of lust at the verge of adolescence. Chardin made the turning point from playing to serious matters, mostly learning, again popular. But while in this period mostly an abrupt demarcation between playing and learning was visualized, playing was also visualized in this period as core business of a child and a strategy of learning. The visualization of the passion of lust of children on the verge of adolescence gradually changed, in particular in French painting. Instead of warning, controlling, and moralizing, as was usual in seventeenth-century paintings and emblems, painters such as Jean-Baptiste Greuze observed the dealing with this passion as a phenomenon that could cause sadness and confusion but was unavoidable in crossing the crucial turning point that would lead to adolescence. Some decades later, the painters of the *Haagse School* such as Jozef Israëls in their art left behind the warnings and admonitions that were usual for their seventeenth-century predecessors and raised the spotlight on the innocent side of temptation and seduction instead of on the unavoidable risks.

When we look at continuity and change across time of the discourse, of the ways of expression, and of the mission, it turned out that the discourse started as a homogeneous framework but manifested, from the seventeenth and increasingly from the eighteenth century, more incompatibilities. This happened both in the discussion about childhood and education and in the discussion on emotions. As a result, in the nineteenth century a revitalized classic Christian idea on emotions and its regulation among Protestants and Catholics went together with a disenchanting, nonmoral, and empirical view on emotions. Moreover, the longing during the Enlightenment after more control of child's development went together with the Romantic longing after a more child-oriented approach of child's learning and development.

The longing for more control and restraint of emotions was longtime based on the idea that passions would have a negative potential, increased during the Renaissance. This development, earlier noticed by Philip Ariès and Michel Foucault, continued during the Enlightenment. The Copernican turn in education tried to reverse this process in the direction of cherishing the emotional potential of the child rather than focusing on the channeling of this potential. This movement influenced the emotional space of the family and stimulated the movement of Progressive Education. But outside the domestic—the emotional space this book is mainly about—the state and the society came to take on and claim a larger part of the task of the training of emotions for children from about six years old. Eventually this process would take place within a legal framework with more disciplinary methods at school, in residential institutions for reeducation, and, although

exclusively for boys, in the army through the phenomenon of conscription, introduced from *c.* 1800. This development nuances the importance of the family and the domestic as the backbone of emotion training at least for elder children in this period.

The expression of emotions in the form it was visualized during the five centuries covered by this book shows a variety of emotions that was not basically different from the main basic emotions now distinguished, notwithstanding the often-enormous differences across time in artistic style and in the configuration and hierarchy of the main persons within the space of paintings and drawings. Also across time, a great variety in the affective tone of emotions was visible: from constrained to extremely strong. This book is first of all based on visual sources about the emotions of children. The peculiarities of those sources—as regards its relationship to reality, its selection, the interests of artists and commissioners behind the images, and last but not least the interpretation of the meaning of the images—naturally limit the scope of the claims in this conclusion. This said, the long-term continuity in all kinds of children's emotions and in its affective tone, which results from the analysis of those visual sources, seems to point to a rather strong continuity of so-called basic emotions, at least for children and their parents. This continuity existed notwithstanding major changes over time about the way emotions were discussed, explained, and assessed in theological, philosophical, and scientific discourses, and notwithstanding major changes over time about the way they should be channeled and controlled.

Notes

1 The Making of a Visual History of Children's Emotions in Europe

1 Rembrandt van Rijn, *The Naughty Boy* (*c.* 1635), drawing, 207 × 142 mm (Berlin: Kupferstichkabinett Berlin, Staatliche Museen zu Berlin, KdZ 3771); Dekker, "The Restrained Child," 32–3. Rembrandt's drawing was probably inspired by a real scene, but he mixed his primary observation with existing drawings, including Michelangelo's *Bruger Madonna*, and he used, not unusually in his time, his observation for several other pieces of art, including the drawing *Abduction of Ganymede*, now in the Dresden Kupferstich-kabinett; see Bevers, *Rembrandt. Die Zeichnungen*, 64–7, 67n2, and Slive, *The Drawings of Rembrandt*, 87–9; cf. Gersdorff, *Kinderbildnisse*, 20, and Simons and Zika, "The Visual Arts," 97–8. Slive, *The Drawings of Rembrandt*, vii–viii, assumes a number of about eight hundred drawings, with only seventy having Rembrandt's signature, autograph, or inscription.
2 Cf. Sobe, "Researching Emotion"; Jarzebowski, *Kindheit*, 26, about age as a category of differentiation.
3 Education refers here to *Bildung* and child-raising; Benner, "Erziehungs- und bildungstheoretische Überlegungen," 13–17. On the change in contents over time, see the first generation of academic journals in this area, among them *History of Education Quarterly* (1960–), *Paedagogica Historica* (1961–); see Dekker and Simon, *Shaping*; Rogers, "*Paedagogica Historica*: Trendsetter or Follower," 11–30, *History of Education*, the *Journal of Family History* (1975–), and *Histoire de l'éducation* from 1978; the programs of international conferences, organized by the International Association for the History of Education (1971–), and of the academic societies ISCHE (1978–; see Lüth, "Entwicklung") and the Society for the History of Childhood and Youth (2001–).
4 See Dekker and Groenendijk, "Philippe Ariès's Discovery of Childhood." Cf. Duncun, *Images of Childhood*.
5 Ariès, *Un historien du dimanche*; Hutton, *Philippe Ariès*, xxii.
6 On the Annales school, Burguière and Todd, *The Annales School*; Alten et al., "Braudel"; Born, "Neue Wege," 298–308; Hutton, *Philippe Ariès*; Dekker and Groenendijk, "Philippe Ariès," 134; Jarzebowski, *Kindheit*, 2; Ariès, *Western Attitudes toward Death*; Ariès, *L'Homme devant la mort*; Ariès, *Images de l'homme devant la mort*; Ariès and Duby, *Histoire de la vie privée*.
7 Ariès, *L'Enfant*, introduction.
8 Ibid., 134. On the biological aspects of parental love and care, Bedaux and Cooke, *Sociobiology*. A historiographic overview of the debate about *L'Enfant* in Dekker and Groenendijk, "Philippe Ariès."
9 Goody, *The Development*, 154; Ariès, *L'Enfant*, 27.

Notes

10 Bedaux, "Introduction," 13; Mount, *The Subversive Family*, 144.
11 Cunningham, *Children and Childhood*, 27; Shahar, *Childhood in the Middle Ages*. On ancient Greece and Rome, Golden, *Childhood in Classical Athens*; Laes, *Kinderen bij de Romeinen*; Rawson, *Children and Childhood in Roman Italy*; see more extensively in Dekker and Groenendijk, "Philippe Ariès's Discovery of Childhood."
12 Dekker, "Educational Space in Time," 5–6.
13 Cremin, "The Family as Educator," 79.
14 Frijhoff, "Emoties," 285.
15 Duby, "Preface."
16 Cf. Febvre, "La sensibilité et l'histoire," 5–20.
17 Santing, "Vergeet," 270; Frijhoff, "Emoties," 286; Reddy, "Historical Research," 302–5; Jarzebowski, *Kindheit*, 2. Cf. Soares, "Emotions, Senses, Experience and the History of Education."
18 Delumeau, *La peur en Occident*; Delumeau, *Rassurer et protéger*.
19 Gélis, *La sagefemme*; Gélis, "L'individualisation"; Gélis, *L'arbre et le fruit*.
20 Elias, *Über den Prozeß der Zivilisation*; Reddy, "Historical Research," 304 on Elias; Corbin, *Le Territoire du vide*; Corbin, *La douceur de l'ombre*; Gay, *The Bourgeois Experience*, vol. I; Darton, *The Great Cat Massacre*; Ginzburg, *The Cheese and the Worms*; Deploige, "Studying Emotions," 3–24.
21 Reddy, "Historical Research," 304; Stearns and Stearns, "Emotionology"; Stearns, "Defining Happy Childhoods"; Stearns, "Children and Emotions History."
22 Reddy, "Historical Research," 304, 311. Cf. Frijhoff, "Emoties," 286; Plamper, *The History of Emotions*, chapter 2.
23 Among the pioneering historians of emotions are Frevert, *Emotions in History*; Frevert et al., *Emotional Lexicons*; Frevert et al., *Learning How to Feel*; Bantock, "Educating the Emotions"; Oatley, *Emotions: A Brief History*, 141–2; Rosenwein, *Generations of Feeling*. For an overview, see Plamper, *The History of Emotions*. See Goleman, *Emotional Intelligence*; Goleman, *Working with Emotional Intelligence*. Cf. Frevert, *Historicizing Emotions*, website of the Max Planck Institute for Human Development.
24 Deploige, "Studying Emotions?" 3–24.
25 Among the book series are *Emotions in History* and *Studies in the History of Emotions*; a journal is *Emotions: History, Culture, Society*.
26 Frijda, *The Emotions*; Mesquita, "Obituary."
27 Plamper, *The History of Emotions*, 32–3.
28 Jarzebowski, *Kindheit*, 3–4, 25, 36, 296–7.
29 James, "What Is an Emotion?"; Plamper, *The History of Emotions*, 9–10.
30 Frijhoff, "Emoties," 285; James, *The Principles of Psychology*, vol. 1, 183–4.
31 Cf. Plamper, *The History of Emotions*, 5, 7.
32 Dekker, "Images as Representations," 706–7; Plamper, *The History of Emotions*, 75–146.
33 Oatley, "Emotions," 141–2; Dixon, *From Passions*, 13. "Emotion" was used in the late Middle Ages as a synonym for agitation and rebellion, something now described by "commotion." Haemers, "In Public," 141, 145.
34 Oatley, "Emotions," 135.

35 Dixon, *From Passions*, 5, 9; cf. Mulligan and Scherer, "Toward," 346–7.
36 Dixon, "Emotion," 339–40; cf. Deigh, "William James," 5–8.
37 Dixon, *From Passions*, 16, quoting Ellison, *Cato's Tears*; also Dixon, *From Passions*, 11.
38 Plamper, *The History of Emotions*, 11–12, uses "emotion" also as a meta-concept.
39 Cf. Bantock, "Educating the Emotions," 122.
40 James, "What Is an Emotion?" 190; Dixon, "Emotion," 338.
41 Cunningham and Kirkland, "Emotion, Cognition," 369.
42 Dixon, "Emotion: The History of a Keyword in Crisis," 342–3.
43 Cf. Olsen, *Juvenile Nation*; Albano, "The Puzzle," 494–7; Downes and Trigg, "Editors' Introduction," 8, 3–11.
44 Mulligan and Scherer, "Toward," 353, have "not included *feeling* as a necessary condition in our list of features or criteria for a working definition of emotion," while Wierzbicka, "On Emotions," 380, thinks that the "reference to feelings in this formula is a crucial part of the concept."
45 Cf. Frijda, *The Emotions*; Plamper, *The History of Emotions*, 240–50.
46 Izard, "The Many Meanings," 363, 368–9; Izard, "More Meanings and More Questions," 385.
47 Davidson et al., *Handbook of Affective Sciences*.
48 Hilgard and Atkinson, *Introduction to Psychology*, 334–6.
49 Plamper, *The History of Emotions*, 147.
50 Mason and Capitanio, "Basic Emotions," 239, referring to Ortony and Turner, "What's Basic about Basic Emotions?" Cf. Barrett, "Are Emotions Natural Kinds?"; Russell, "Core Affect"; Russell and Barrett, "Core Affect, Prototypical"; Frijda, *The Emotions*, 72–5.
51 Selvaraj et al., "Classification," and Ekman and Cordaro, "What Is Meant by Calling Emotions Basic"; roughly the same classifications of basic emotions in Sykora et al., "Emotive Ontology," 19–26; Cambria et al., "The Hourglass of Emotions," 144–57.
52 Tracy and Randles, "Four Models of Basic Emotions," 399, contra Ekman.
53 Levenson et al., "Emotion," 444.
54 Rieffe, *The Child's Theory*; Fodor, "A Theory"; Wellman, *The Child's Theory of Mind*; Meerum Terwogt et al., "'Theory of Mind'-redeneren."
55 Mitchell, "Acquiring"; Miller, "Developmental Relationships."
56 Premack and Woodruff in "Does the Chimpanzee Has a Theory of Mind?" answer with a careful "yes"; De Waal, *Zijn we slim genoeg*, 116, 125, 230, implicating that also babies have an incipient and budding theory of mind.
57 Santing, "Vergeet," 274–5.
58 Jarzebowski, *Kindheit*, 295, 34.
59 Dekker, *Educational Ambitions*, 11–15; cf. Loughman and Montias, *Public and Private Spaces*.
60 Plamper, *The History of Emotions*, 268–70.
61 Olsen, *Childhood*; Frevert et al., *Learning*; Olsen, *Juvenile Nation*.
62 Levenson, "The Intrapersonal Functions," 491. Cf. Meerum Terwogt et al., "Emoties," 49.
63 Rutherford et al., "Emotion Regulation," 1–14.
64 Dekker, "Educational Space in Time," 6–10; cf. Dekker, *Educational Ambitions*, 11–15; Spiecker, "The Pedagogical Relationship."

Notes

65 On "culture," Frijhoff, *Cultuur*; Ginzburg, *Miti Emblemi Spie*; Dekker, "Educational Space in Time," 6n10.
66 Stearns, *Childhood in World History*, 55; Dekker, *Uit de schaduw*, 31.
67 Dekker, "Educational Space in Time," 6–7; Braudel, "Histoire et sciences sociales: La longue durée," 71–2; Dekker, "Educational Sciences," 248–51.
68 Braudel, "Histoire et sciences sociales," 43–5, 50–1; Bloch, *Apologie pour l'histoire*, 158: social conditions are "donc, dans leur nature profonde, mentales"; Roeck, *Der Morgen*, 20; Jarzebowski, *Kindheit*, 3. English translations of quotations are by the author unless otherwise indicated.
69 Weber, "Die protestantische Ethik," 213–492; Weber, "Wissenschaft als Beruf," 593–4.
70 Alston and Harvey, "In Private," 141–4; Suzuki, "Literacy"; Olsen, *Childhood*, 13.
71 Olsen, *Childhood*, 15–16, and Stearns, quoted in Olsen, *Childhood*, 3; cf. Santing, "Vergeet," 271, on Stearns's idea of "Emotionology."
72 Reddy, "Historical Research," 312; Rosenwein, *Emotional Communities*; Santing, "Vergeet," 274; Rosenwein, *Generations of Feeling*; Rosenwein, "Worrying"; Rosenwein and Cristiani, *What Is History of Emotions*; Rosenwein, *Anger's Past*; cf. Haemers, "In Public," 150–1; cf. Barclay, "Introduction," 5–6: "The idea of an emotional culture overlaps in important ways with both the idea of emotional communities and regimes."
73 Barclay, "Introduction," 5, referring to Stearns and Stearns, "Emotionology."
74 Broomhall, *Spaces for Feeling*; cf. Alston and Harvey, "In Private," 141.
75 Olsen, *Childhood*, 20–2; cf. Scheer, "Are Emotions a Kind of Practice?"
76 Cf. Suzuki, "Literacy," 151–2.
77 Holme, *Literacy*, 1–2.
78 Carr, *Educating the Virtues*, 1, 6; cf. Carr and Steutel, *Virtue Ethics*; Steutel, *Deugden*, 13; Dekker, *Het gezinsportret*, 14–15.
79 Olsen, *Childhood*, 22–6; Peter Burke quoted in Olsen, *Childhood*, 25; cf. Plamper, *The History of Emotions*, 204.
80 Dekker, "Rituals," 121–44.
81 More extensive in Dekker, *Educational Ambitions*, 17–21; quotation from Meijer, "Cultural Transmission," 185; Benner, "Erziehungs- und bildungstheoretische Überlegungen," 13–17; Dekker, "Cultural Transmission"; Sturm et al., *Education*; Siegel, "Education," 28, 37–8; Dekker, *Het gezinsportret*, 12–13.
82 Dekker, "Cultural Transmission"; Olson and Astington, "Cultural Learning," 531; Tomasello et al., "Cultural Learning," 500–2; Steutel and Spiecker, "Authority"; Meijer, "Cultural Transmission," 186; Spiecker, "The Pedagogical Relationship."
83 Bruner, *The Culture of Education*, 57 (quote); Scarr, "Developmental Theories," 2–3; Scarr and McCartney, "How People"; Plomin et al., "Nature and Nurture"; Homer, "Transmission of Human Values," 348.
84 Jarzebowski, *Kindheit*, 295.
85 Reddy, "Historical Research," 311; Bloch, *Apologie pour l'histoire*.
86 Frevert, "Historicizing Emotions," 5; Koolhaas-Grosfeld, *Father& Sons*. Examples are Beauvalet, "Life Histories"; Woods, *Children Remembered*; Jarzebowski, *Kindheit*, 20–22n103,

75–88; Kuhn, "Generational Discourse"; Kaborycha, *A Corresponding Renaissance*; Fass, "Childhood and Memory"; McNamer, "Literature," 107; Rudolf Dekker, *Children*; Baggerman and Dekker, "De gevaarlijkste van alle bronnen," 8–9; Baggerman and Dekker, *Kind van de toekomst*; Ruberg, "Children's Correspondence"; Roberts, *Through the Keyhole*; Kooijmans, *Vriendschap*.

87 See Dekker, "Images as Representations," 702–15, and Dekker, "Mirrors of Reality." Also Ankersmit, *Meaning*; Ankersmit, "Representatie," 250, 252; De Jongh and Luijten, *Mirror of Everyday Life*; cf. Blaas, "Op zoek naar een glimp van het verleden."

88 Ankersmit, "Representatie," 246–9; Ankersmit, *Meaning*, 64–86; Chartier, "Le monde comme représentation," 1505–20. Ginzburg, *Miti Emblemi Spie*, 160, compares the art historian's craft with that of the detective Sherlock Holmes; Ginzburg, *Clues*, 97–8. Cf. Ankersmit, *De navel*, 50–1, 57; see further Dekker, "Mirrors of Reality?" 31.

89 Sturkenboom, *Spectators van hartstocht*, 84n202, 86, 88; Frevert, "Historicizing Emotions," 1; Chartier, *Les usages de l'imprimé*; Jouhaud, "Littérature et histoire"; Chartier, "Le monde comme représentation"; Meek and Sullivan, *The Renaissance of Emotion*.

90 Johnston, "How Women Really Are," about eighteenth-century fiction with soaps; cf. Lacey, *Image and Representation*, 146–89.

91 McNamer, "Literature," 115, 117. See Bourdieu, *The Logic of Practice*.

92 See Dekker, "Dangerous, Seductive, or Normal?"; Dekker, "Mirrors of Reality?" 35–6.

93 Huizinga, "De taak der cultuurgeschiedenis," 69–73.

94 Ankersmit, *Sublime*, 126; Huizinga, *The Autumn*; Dekker, "Images as Representations"; Haskell, *History and Its Images*, 433–95, on Huizinga and the "Flemish Renaissance"; Kempers, "De verleiding"; Krul, "In the Mirror"; cf. Hugenholtz, "Huizinga's historische sensatie."

95 Translation by Ankersmit, *Sublime*, 120–1.

96 Ibid., 121.

97 Cf. Wachelder, "Chardins Touch," 31.

98 Haskell, *History and Its Images*, 496–7n21; Dekker, "Mirrors of Reality?" 33–4; Depaepe et al., *The Challenge of the Visual*; cf. Schama, *The Embarrassment of Riches*, 486, 541, and Dekker and Groenendijk, "The Republic of God or the Republic of Children?" 317–35.

99 Cf. Plamper, *The History of Emotions*, 33–9.

100 Cf. Haskell, *History and Its Images*, 112–27, on "The Issue of Quality"; Braider, *Refiguring the Real*, 199–220, on reading and misreading Rembrandt's art.

101 Bogart, "Reconstructing Past Social Moods from Paintings," 124.

102 Beaven, "The Visual Arts," 85; cf. Haskell, *History and Its Images*, 131–58; Schwartz, "Emotions," 37.

103 Dekker, "Looking."

104 Beaven, "The Visual Arts," 98.

105 Panofsky, *Studies in Iconology*; Franits, *Dutch*, 4; Panofsky, "Iconography and Iconology," 26–41; Van Straten, *Inleiding*, 14; Gombrich, "Icones symbolicae," 123–91.

106 Hall, *Dictionary*, x.

107 Franits, *Dutch*, 4.

108 Hall, *Dictionary*, 254.

Notes

109 Bedaux, *The Reality of Symbols*.
110 Dekker, *Looking*, 27–46.
111 Santing, "Vergeet," 274–5, proposes, instead of Peter and Carol Stearns's "emotionology," an "aesthesiology" for the study of feelings.
112 Kohler et al., "Differences," 235–44; Elfenbein and Ambady, "On the Universality," 203–38; Frijhoff, "Emoties," 285, about the importance of codes of expression; De Waal, *Zijn we slim genoeg*, 281.
113 Ripa, *Iconologia*; Van Straten, *Inleiding*, 22, 53.
114 Honour and Fleming, *A World History of Art*, 604.

2 The Big Talk on Education and Emotions in the Age of Renaissance and Reformation

1 Jan Steen, *The Merry Family/"As the Old Sing, so Pipe the Young"* (1668), oil on canvas, 110 × 141 cm (Amsterdam: Rijksmuseum). Cf. Dekker, *Verlangen*, 44–5; Dekker, *Educational Ambitions*, 42–3; Braider, *Refiguring*, 129–73; Chapman, *Jan Steen*, 172; Franits, *Dutch Seventeenth Century*, 211–12; Durantini, *The Child*, 59–61; Chapman, "Jan Steen's Household Revisited," 183–96; Brown, "… Niet ledighs," 83–8; Palacios, "Proverbs as Images," 79, 94. Cf. Jan Steen, *Soo voer gesongen, soo na gepepen* (c. 1663–5), oil on canvas, 134 × 163 cm (The Hague: Mauritshuis); Chapman, *Jan Steen*, 172–5.
2 Cf. De Jongh and Luijten, *Mirror*, 253–6n12, on influence of Jordaens and Jacob Cats. Cf. Dekker, "The Restrained Child," 33–4.
3 Based on Dekker, "Introduction." In German: "Europas großes Gespräch"; Roeck, *Der Morgen der Welt*, 17.
4 Roeck, *Der Morgen*, 18.
5 Braider, *Refiguring*, 20–36; Bedaux, *The Reality*; Bedaux, "From Normal to Supranormal."
6 Roeck, *Der Morgen*, 667–83.
7 Burckhardt, *Die Kultur*, 161–200; Huizinga, "The Problem of the Renaissance," 278–80; Roeck, *Der Morgen*, 318.
8 Huizinga, *Herfsttij der middeleeuwen*, 13; Roeck, *Der Morgen*, 488, 569; cf. Krul, *Historicus tegen de tijd*; Krul, "In the Mirror."
9 Roeck, *Der Morgen*, 383, 612–14.
10 Ibid., 745–52; MacCulloch, *Reformation*.
11 Fagan, *The Little Ice Age*; Parker, *Global Crisis*; Roeck, *Der Morgen*, 835–40; Belich, *The World the Plague Made*; Thomas Malthus, *An Essay on the Principle of Population*.
12 Braudel, *Civilisation*, vol. 1, 55–67; vol. 3, 148–9; Van Zanden, *The Long Road*, 244–51, 256.
13 Benner, *Machiavelli's "Prince"*; Schilling, *Die Neue Zeit*, 385–6; Roeck, *Der Morgen*, 42–648; Israel, *The Dutch Republic*.
14 Roeck, *Der Morgen*, 662, 676, 679.
15 Marquaille, "Art," 46–7.
16 Van Zanden, *The Long Road*, 239–51.
17 Prak, *Citizens*, 163–225; Braudel, *Civilisation*, vol. 1, 421–91.

18 Schilling, *Die Neue Zeit*, 184.
19 Braudel, *Civilisation*, 145–234; Van Zanden, *The Long Road*, 262–3.
20 Roeck, *Der Morgen*, 509.
21 Braudel, *Civilisation*, vol. 1, 404–6; Roeck, *Der Morgen*, 635.
22 Dekker, "In Search," 172; Lederer, "Religion," 32–3.
23 Ryrie, *Being Protestant*; Groenendijk, "De pedagogisering"; Groenendijk, "Advies."
24 Burckhardt, *Die Kultur*, 160; Reddy, "Historical Research," 302; Dekker, *Het Gezinsportret*, 17; Gélis, "L'individualisation," 311–29; Goldberg and Tarbin, "In Private," 139, limit this increasing individualism to male householders, head of a household functioning "as an emotional community ... that demanded that its members conformed to certain vales and mores."
25 Kaborycha, *A Corresponding Renaissance*; Gélis, "L'individualisation," 311–29.
26 Alston and Harvey, "In Private," 143.
27 Spaans, "Reform," 130–1; Knippenberg, *De Religieuze Kaart*, 9–62.
28 Green, "Bridging"; Frijhoff, "Église wallonne," 222–4.
29 Van Eijnatten, "Knowledge," 56–9; Van Zanden, *The Long Road*, 69–91; cf. Pettegree and Der Weduwen, *The Bookshop*; Roeck, *Der Morgen*, 16.
30 Braudel, *Civilisation*, vol. 1, 348–9.
31 Roeck, *Der Morgen*, 580–1; van Eijnatten, "Knowledge," 56.
32 Cf. Roeck, *Der Morgen*, 579.
33 Van Zanden, *The Long Road*, 184. Cf. Van Zanden, "De timmerman," 114.
34 Jorink, *Het "Boeck der Natuere"*; Febvre, *Le problème*.
35 McBrien, "St. Augustine of Hippo," in *Encyclopedia of Catholicism*, 113–18.
36 Max Weber, "Wissenschaft," 597; Dekker, "In Search," 172.
37 Hatfield, "The Passions," 6; cf. Revel, *Histoire*, vol. I, 271; Dixon, "Church," 31; Nauta, "Early Modern Philosophers"; Miner, *Thomas Aquinas on the Passions*.
38 As stated by Plamper, *The History of Emotions*, 17, 73.
39 Cf. McBrien, "St. Thomas Aquinas," in *Encyclopedia of Catholicism*, 83–9; *Summa Theologiae*, 1a-75-83 (natural philosophical context) and Ia.2ae.22–48 (moral context).
40 James, *Passion and Action*, 24f, quoted by Dixon, *From Passions*, 27.
41 Cf. McNamer, "Literature," 116–17, on love and compassion for Christ in devotional religious texts, and 108–9 on romantic love in texts by, among others, Dante and Petrarch.
42 Dixon, *From Passions*, 60–1.
43 Ibid., 41; Augustine, *City of God*, XIV.9; Plamper, *The History of Emotions*, 17: Augustine "welcomed emotionality in life," if "subordinated to the will."
44 Dixon, *From Passion*, 40, based on Augustine, *City of God*, XIV.3.
45 Monagle, "Emotions and the Self," 65; Miner, *Thomas Aquinas*.
46 Dixon, *From Passions*, 42, 44 (table 4). The odd number of five irascible passions is because *ira* did not have its contrary passion. Cf. James, *Passion and Action*, 58, on Aquinas's classification showing the conflicts in the soul in coping with the passions; cf. Hatfield, "The Passions," 10. Cf. Bobier, "Thomas Aquinas," 31, argues that it "remains unclear what counts as an arduous good or evil, and why arduousness is the defining feature of the division."
47 Monagle, "Emotions," 66.

Notes

48 Hatfield, "The Passions," 7, referring to Aquinas, ST II-1.24.1–4.
49 Augustine, *City of God*, XIV.6, quoted by Dixon, *From Passions*, 47.
50 Dixon, *From Passions*, 29, 56, 46–7, 54 (quote), 17.
51 Ibid., 55–6 (quote); cf. Plamper, *The History of Emotions*, 17.
52 Monagle, "Emotions and the Self," 65, referring to Aquinas, *Summa Theologiae*, IaIIae.22.1, 226.
53 Dixon, *From Passions*, 59, 57; Augustine, *City of God*, XIV.3 and XIV.5, quoted by Dixon, *From Passions*, 33, cf. 56.
54 Before his conversion to Christianity, being a Manichean, Augustine wrote *Against the Manicheans*. Dixon, *From Passions*, 33, referring to Augustine, *City of God*, XIV.2
55 Dixon, *From Passions*, 31, referring to Augustine, *Confessiones*, XII.16.
56 Dixon, *From Passions*, 49, 29, based on Augustine, *Confessiones*.
57 Dixon, *From Passions*, 29, based on Augustine, *The Trinity*.
58 Augustine, *The Free Choice of the Will*, 93f., quoted by Dixon, *From Passions*, 49.
59 Dixon, *From Passions to Emotions*, 50–1, referring to Augustine, *City of God*, IX.4, IX.5.
60 Augustine, *City of God*, XIV.20, XIV.16–17, 26, XIV.19, quoted by Dixon, *From Passions*, 51.
61 Dixon, *From Passions*, 51 n.100; McBrien, *Encyclopedia of Catholicism*, 302–3, 637–8, 821–7, 841, 1187.
62 Augustine, *Confessions*, IX.12, quoted by Dixon, *From Passions*, 49; cf. sadness with a friend's death, IV.8, quoted by Dixon, *From Passions*, 55.
63 Augustine, *City of God*, XIV.3, quoted by Dixon, *From Passions*, 49.
64 Dixon, *From Passions*, 52, and Aquinas, ST Ia.2ae.24, 3, and Aquinas, 24, 3, quoted by Dixon, 52.
65 Monagle, "Emotions and the Self," 66, quoting Aquinas, *Summa Theologiae*, IaIIae.22.3, 229, referring to John the Damascene; cf. Hatfield, "The Passions," 9.
66 Dixon, *From Passions*, 48 (table 5).
67 Monagle, "Emotions and the Self," 62.
68 Porter, "Virtue," 1316; Porter, "Cardinal Virtues," 227; Bejczy, *The Cardinal Virtues*.
69 Porter, "Cardinal Virtues," 228; Spronk, "The Seven Virtues," 110.
70 Spronk, "The Seven Virtues," 110.
71 Simons and Zika, "The Visual Arts," 100.
72 Himes, "Capital Sins," 225.
73 Lederer, "Religion," 41; cf. Taylor, *The Culture of Confession*; Foucault, *La volonté de savoir*, 82; Le Roy Ladurie, *Montaillou*, on Jean Fournier, bishop of Pamiers, and later Pope Benedict XII (1285–1342), a member of the episcopal inquisition, who meticulously questioned potential heretics in the Pyrenean village of Montaillou with established heresy mostly leading to the pyre; Dekker, "Montaillou."
74 Lederer, "Religion," 42.
75 Ibid., 45.
76 Dekker, "Beauty," 169.
77 Cival, *The Palazzo Pubblico*, 18–25.
78 McNamer, "Literature," 107, 109.

79 Himes, "Capital Sins," 225; McNamer, "Literature," 116, on parental grief in *Summoner's Tale* and *Priores's Tale*.
80 Lederer, "Religion," 34–6. Cf. Laneyrie-Dagen, *L'Invention*, 60–6.
81 Lederer, "Religion," 34–5.
82 Hall, *Dictionary*, 336.
83 Ibid., 254.
84 Laneyrie-Dagen, *L'Invention*, 217–49; Van Straten, *Inleiding*, 29–34.
85 Spronk, "The Seven Virtues," 110; Pye, *Antwerp*; Braider, *Refiguring*, 71–99. On the changing reputation of Bruegel, by Burckhardt considered as an artist who mainly portrayed the burlesque peasant culture, see Pénot, *The Rediscovery*, 317; Haskell, *History and Its Image*, 464.
86 Spronk, "The Seven Virtues," 98, 110–14; Spronk, "The Seven Capital Sins," 76–87; Sellink, "The Last Judgement," 88–90.
87 Spronk, "The Seven Virtues," 114–15.
88 Ibid., 114; Spronk, "The Seven Capital Sins," 85. The personification of *Ira* resembles Bruegel's famous painting *Dulle Griet*, full of demons and monsters typically for Bruegel and inspired by Hieronymus Bosch; Sellink, "Dulle Griet," 168–71.
89 Spronk, "The Seven Virtues," 115, 113.
90 Spronk, "The Seven Capital Sins," 76–87; Sellink, "The Last Judgement," 88–90.
91 Lynch, "Introduction," 3.
92 Lederer, "Religion," 31; Broomhall, "Medical," 25.
93 Broomhall, "Medical," 26.
94 Ibid., 27; Lederer, "Religion," 32, 36.
95 Lederer, "Religion," 32; Delumeau, *La peur*.
96 McNamer, "Literature," 111–12.
97 Lederer, "Religion," 33.
98 Broomhall, "Medical," 27.
99 Lynch, "Introduction," 3–4; McNamer, "Literature," 119–20.
100 Lynch, "Introduction," 5.
101 Goldberg and Tarbin, "In Private," 132.
102 McNamer, "Literature," 117.
103 Broomhall, "Medical," 20; Knoeff, *Histories*, 112–28.
104 Smith, "Science and Taste," 421–61.
105 Dekker, "In Search," 172; Weber, "Wissenschaft," 597; Jorink, *Het "Boeck der Natuere."*
106 Broomhall, "Medical," 21; Laneyrie-Dagen, *L'Invention*, 77.
107 Broomhall, "Medical," 22, quoting Tagliacozzi.
108 Ibid., 27–8.
109 Descartes, *Discours de la méthode*, 38. In *Principles of Philosophy* (1644), Part 1, article 7, he used the formulation "ego cogito, ergo sum."
110 Descartes, *The Passions*, article 1, 18; Schmitter, "17th and 18th Century Theories of Emotions: Descartes."
111 Hatfield, "The Passions," 4.
112 Cowan, "In Public," 161.

Notes

113 Dixon, *From Passions*, 18.
114 Descartes, *The Passions*, article 1, 19; article 16, 27. Smith, "350th Anniversary," 223; James, *Passion and Action*, 89.
115 Descartes, *The Passions*, article 31: 36; articles 32–5: 36–8. Cf. article 30: 35: "That the soul is jointly united to all the parts of the body."
116 Kambouchner, *L'homme des passions*; Talon-Hugon, *Les passions*; Deploige, "Studying Emotions," 3–4.
117 Hatfield, "The Passions," 2; Damasio, *Descartes' Error*, quoted by Plamper, *The History of Emotions*, 18, 214–19, 297–8.
118 Dixon, *From Passions*, 59; Hatfield, "The Passions," 4; Plamper, *The History of Emotions*, 18, concludes that Descartes's physiological approach was new.
119 Voss, "Translator's Introduction," viii.
120 Hatfield, "Did Descartes," 93; Hatfield, "The Passions," 5.
121 Descartes, *The Passions*, article 4: 20.
122 Ibid., articles 27 and 10 on, respectively, pages 20, 34, and 24; Hatfield, "The Passions," 3.
123 Descartes, *The Passions*, article 148: 101.
124 Ibid., article 212: 134–5; article 211: 132–3. Cf. Pender, "Medical," 19.
125 Descartes, *The Passions*, article 138: 93.
126 Ibid., article 69: 56; in 1584, Gian Paolo Lomazzo numbered one hundred (Simons and Zika, "The Visual Arts," 85–6), Hobbes forty-six, and Spinoza forty-eight. Ever increasing numbers made William James quite annoyed (see Chapter 5); Dixon, *From Passions*, 18.
127 Descartes, *The Passions*, article 92: 70; López-Muñoz et al., "Sadness," 42–53.
128 Hatfield, "The Passions," 11; Descartes, *The Passions*, article 68: 55–6.
129 Descartes, *The Passions*, article 53: 52.
130 Hatfield, "The Passions," 11. Descartes, *The Passions*, articles 52 and 75: 52, 59.
131 Hatfield, "The Passions," 10; Descartes, *The Passions*, 17 (quote), articles 175–6: 116, and articles 144 and 161: 97–8, 108–9. Cf. Miner, *Thomas Aquinas*.
132 Dixon, *From Passions*, table 4, 44. Cf. James, *Passion and Action*, 58; Smith, "350th Anniversary," 224; Hatfield, "The Passions," 9, 11 (quote); Descartes, *The Passions*, article 38: 40.
133 Descartes, *The Passions*, articles 35–6: 38–9.
134 Descartes, *The Passions*, articles 22–5: 30–2, and article 46: 44; Hatfield, "The Passions," 12, 15.
135 Pender, "Medical," 18.
136 Hatfield, "The Passions," 11–12n24, 11, 16–21.
137 Descartes, *The Passions*, article 50: 47–50.
138 Ibid., article 2: 19.
139 Monagle, "Emotions and the Self," 68.
140 James, *Passion and Action*, 95.
141 Descartes, *The Passions*, article 48: 46–7.
142 Ibid., article 50: 47–8.

143 Descartes, *The Passions*, articles 133–4, 211, explains why most children cry easily for physical reasons, "very little from Joy, but much more from Sadness," but that some turn pale instead of crying when being upset because of their inclination to Hatred or Fear, which are both "passions that diminish the stuff of tears." Cf. Hatfield, "The Passions," 27.
144 Descartes, *The Passions*, article 211: 134.
145 Hatfield, "The Passions," 30; Dijksterhuis, *De mechanisering*, 444–61.
146 Monagle, "Emotions and the Self," 68.
147 Ibid., 69.
148 Voss, "Translator's Introduction," ix.
149 Descartes, *The Passions*, article 212: 134–5.
150 Monagle, "Emotions and the Self," 67, 69.
151 James, *Passion and Action*; Lloyd, "The Emotions"; Gaukroger, *The Soft*.
152 Pender, "Medical," 18.
153 Hatfield, "The Passions," 7, 8n20; Barclay and Soyer, *Emotions in Europe*, chapter 42; Pender, "Medical," 18.
154 Wright, *Passion of the Minde in Generall*, 41, quoted by Gaukroger, *Descartes' System*, 214. Cf. on Wright: Sullivan, "The Passions of Thomas Wright"; cf. Bynum et al., *The Anatomy of Madness, Volume I*. Cf. Cowan, "In Public," 161.
155 Pender, "Medical and Scientific Understandings," 21.
156 Hatfield, "The Passions," 8n20 (quotes); Schmitter "17th and 18th Century Theories of Emotions: Malebranche." On Cureau, also Pender, "Medical," 20–1.
157 Hatfield, "The Passions," 7–8; cf. Laneyrie-Dagen, *L'Invention*, 77.
158 Dixon, *From Passions*, 70; Plamper, *The History of Emotions*, 21–2; Starkstein, "Thomas Hobbes and Fear."
159 This idea was developed further by John Locke and Jean-Jacques Rousseau.
160 Based on Schmitter, "Hobbes on the Emotions"; Dijksterhuis, *De mechanisering*, 473–4, 485, 487.
161 Barclay et al., "Introduction," 3.
162 Garber, "Disciplining Feeling," 19–34; Schmitter "17th and 18th Century Theories of Emotions: Spinoza"; Dixon, *From Passions*, 72.
163 Garber, "Disciplining Feeling," 25.
164 Plamper, *The History of Emotions*, 19–21, referring to Damasio's *Descartes' Error* and *Looking for Spinoza*, in which Damasio, 217, describes Spinoza as "the protobiologist"; Israel, *Radical Enlightenment*.
165 Lynch, "Introduction," 12.
166 Hatfield, "The Passions," 9n23; Dixon, *From Passions*, 43.
167 Dixon, *From Passions*, 22.
168 Pender, "Medical," 23, quoting a contemporary English translation of Hippocrates's writings, *Hippocrates' Treatise on the Preservation of Health*, 73.
169 Lederer, "Religion," 32; Frijhoff, "Emoties," 287, on the impact of the Bible on the emotion of "God's wrath" (Old Testament) and on "Christ's compassion" (New Testament).

Notes

170 Hanawalt quoted by Jarzebowski, *Kindheit*, 18. Cf. Paris, "Through the Looking Glass," 106–13.
171 An overview in Garin, "L'image de l'enfant."
172 Cf. Roeck, *Der Morgen*, 861–2; Papy, "Juan Luis Vives"; Verbeke, "A Call for Sobriety."
173 Braider, *Refiguring*, 21–36.
174 *Encyclopedia Brittanica*, "Vittorino da Feltre," www.britannica.com/biography/Vittorino-da-Feltre (accessed December 29, 2021); Roeck, *Der Morgen*, 500–1.
175 Langereis, *Erasmus dwarsdenker*; Verbeke, "A Call for Sobriety"; Van Herwaarden, "Mensen …"; Dekker and Wichgers, "The Embodiment," 52–3; Roeck, *Der Morgen*, 499–503; Exalto, "De vader."
176 Roeck, *Der Morgen*, 698; Langereis, *Erasmus dwarsdenker*, 38, 674,
177 Lynch, "Introduction," 5; Le Cam, "Teachers," 142.
178 Oatley, "Emotions," 141–2; Bantock, "Educating the Emotions," 130; Langereis, *Erasmus dwarsdenker*, 407–36.
179 Jarzebowski, *Kindheit*, 56n81; Bejczy and Nederman, *Princely Virtues*, 177–201; Bejczy, *The Cardinal Virtues*, 135–223.
180 Roeck, *Der Morgen*, 499–503.
181 Erasmus, *A Declamation*, 296. The text was, 295, intended for Konrad Heresbach, William's teacher and a humanist at the Düsseldorf court; see Jarzebowski, *Kindheit*, 50–1.
182 Erasmus, *On Good Manners*, 273. The text was written in the Catholic German city of Freiburg after Erasmus left Basel in 1529 because of the Protestant Reformation, about which he wrote in a letter of 1530: "I have seen them return from hearing the sermon, as if inspired by an evil spirit, the faces of all showing a curious wrath and ferocity." McGregor, "Introductory Note," in Erasmus, *On Good Manners*, 270.
183 Erasmus, *On Good Manners*, 289.
184 McGregor, "Introductory Note," in Erasmus, *On Good Manners*, 271.
185 Erasmus, *A Declamation*, 333–4.
186 McGregor, "Introductory Note," in Erasmus, *On Good Manners*, 271.
187 McGregor, "Introductory Note," in Erasmus, *On Good Manners*, 271.
188 Writing for fathers on the education of their sons, he was rather negative about women, for example, about selecting a good instructor; Erasmus, *A Declamation*, 325.
189 McGregor, "Introductory Note," in Erasmus, *On Good Manners*, 270.
190 Verstraete, "Introductory Note," in Erasmus, *A Declamation*, 294; McGregor, "Introductory Note," in Erasmus, *On Good Manners*, 272.
191 Julia, "L'enfance," 333–4; Becchi, "Humanisme et Renaissance," 160–99; Revel, "Les usages de la civilité," 172–3; Groenendijk, *Jong gewend*; Van Herwaarden, "Mensen …."
192 Erasmus, *A Declamation*, 304, 311, 298.
193 Ibid., 314.
194 Ibid., 315.
195 Ibid., 311.
196 Ibid., 312.
197 Ibid., 301.

198 Ibid., 308–9.
199 Jarzebowski, *Kindheit*, 57.
200 Erasmus, *A Declamation*, 307.
201 Ibid., 321.
202 Ibid., 309.
203 Ibid., 305; Lindeman, "Macropedius' Rebelles," 137–46.
204 Erasmus, *A Declamation*, 307–8.
205 Ibid., 305.
206 Lynch, "Introduction," 5.
207 Lederer, "Religion," 40–1; McNamer, "Literature," 116; Dekker, *Het verlangen*, 32.
208 Lederer, "Religion," 45; cf. Dixon, "Church," 25–30; Roeck, *Der Morgen*, 732–62.
209 Lederer, "Religion," 47; on iconoclasm in the Low Countries, see Van Bruaene et al., "*Beeldenstorm*."
210 Dixon, "Church," 25–7; Huizinga, *Erasmus*; Colb et al., *Oxford Handbook*.
211 Beaven, "The Visual Arts," 97, quoting the decree of the Council of Trent.
212 Simons and Zika, "The Visual Arts," 86 (quoting Paleotti) and 87–8.
213 Paleotti quoted by Beaven, "The Visual Arts," 98.
214 MacCulloch, *Reformation*, 591–607; Roeck, *Der Morgen*, 757–62, 776, 791, 848–50; Salvarani, "Wie einen feinen jungen Baum," 22–31; Grendler, "Jesuit Schools," 8; Carlsmith, *A Renaissance Education*, 179–93.
215 Lederer, "Religion," 46.
216 James, *Passion and Action*, 24f., quoted by Dixon, *From Passions*, 27.
217 Roper, *Martin Luther*, 16; Jarzebowski, *Kindheit*, 30–1; Lynch, "Introduction," 8–9.
218 Massing, *Erasmus, Luther*; Roeck, *Der Morgen*, 845–50; Karant-Nunn, *Reformation of Feeling*, 130.
219 Jarzebowski, *Kindheit*, 295, 57n85.
220 Koelman, *De pligten*; Groenendijk, *De pedagogiek van Jacobus Koelman*, 61, 219; Groenendijk, *De Nadere Reformatie*; Groenendijk, "De worstelinge Jacobs"; Groenendijk, "Piëtistische opvoedingsleer"; Dekker et al., "Proudly Raising," 10.
221 Groenendijk, "De vaderlijke kastijding"; Dekker et al., "Proudly Raising," 50–1.
222 Jarzebowski, *Kindheit*, respectively, 60, 69, and 45 and 48.
223 Ibid., 69.
224 Erasmus, *A Declamation*, 329.
225 Ibid., 328, 332.
226 Jarzebowski, *Kindheit*, 57, quoting Erasmus, *De pueris*, 54 (Latin version).
227 Jarzebowski, *Kindheit*, 66–7, 60–1, 57 (referring to Sadoleto, *De liberis*, 372). On Sadoleto: McBrien, *The HarperCollins*, 1152.
228 The opening sentence of Loyd DeMause, *The History*; Jarzebowski, *Kindheit*, 62.
229 Simons and Zika, "The Visual Arts," 103.
230 Lederer, "Religion," 47.
231 Braudel, "Histoire," 43–5, 50–1; Roeck, *Der Morgen*, 20.

3 The Expression of Children's Emotions in the Age of Renaissance and Reformation

1. Pernoud, "Le fifre," 24: "le regard est celui de l'artiste."
2. Jarzebowski, *Kindheit*, 28–9, speaks of "gefühlskommunikativen Interaktion."
3. Laneyrie-Dagen, *L'invention*, 67, 69.
4. Alberti quoted by Beaven, "The Visual Arts," 86.
5. Laneyrie-Dagen, *L'invention*, 57–8; Simons and Zika, "The Visual Arts," 85, 86–93.
6. Lomazzo quoted by Beaven, "The Visual Arts," 87.
7. Simons and Zika, "The Visual Arts," 94.
8. Lederer, "Religion and Spirituality," 33–4.
9. Lynch, "Introduction," 6.
10. Ibid., 7, and quoting Rosenwein, *Generations of Feeling*, 186–7.
11. McNamer, "Literature," 119 (quote); Simons and Zika, "The Visual Arts," 100.
12. Lynch, "Introduction," 5.
13. Jarzebowski, *Kindheit*, 181; Werner, *Visualität*, 147–67.
14. Beaven, "The Visual Arts," 85.
15. Descartes, *The Passions*, article 113, 79.
16. Honour and Fleming, *A World History*, 604; Chisholm, "Le Brun," 351–2.
17. Beaven, "The Visual Arts," 96.
18. Laneyrie-Dagen, *L'invention*, 77; Descartes, *The Passions*; Voss, "Translator's Introduction," xii.
19. Dixon, *From Passions*, 27.
20. Harrison, "Reading the Passions," 59, 61; Honour and Fleming, *A World History*, 604; Le Brun's taxonomy was used until the nineteenth century; Plamper, *The History of Emotions*, 19; Chisholm, "Le Brun," 351–2; cf. Beaven, "The Visual Arts," 96; Haskell, *History and Its Images*, 148–9.
21. Simons and Zika, "The Visual Arts," 94–5; Megna, "Dreadful Devotion," 72.
22. Simons and Zika, "The Visual Arts," 100.
23. Laneyrie-Dagen, *L'Invention*, 60–2, 19, 65.
24. Laneyrie-Dagen, "Lorsque l'enfant paraît," 33–7, 53–8. Giovanni Pisano, *Natività* (1301), marble, pulpit (Pistoia: Sant'Andrea); Jacques Le Brun, "La dévotion."
25. Laneyrie-Dagen, *L'Invention*, 146–9, quote on 149; Rogier van der Weijden, *Saint Luke Drawing the Virgin* (1435–40), oil and tempera on panel (Boston: Museum of Fine Arts); Dirk Bouts, *Virgin and Child* (c. 1455–60), oil on panel (New York: Metropolitan Museum of Art); Hugo van der Goes, *Worship of the Shepherds/Portinari Triptych* (1476), oil on wood (Florence: Galleria degli Uffizi); Laneyrie-Dagen, "Lorsque l'enfant paraît," 29–41; Laneyrie-Dagen, "Enfant réel," 98–9. Cf. Le Brun, "La dévotion à l'Enfant Jésus."
26. Schama, *The Embarrassment*, 486; Dekker and Groenendijk, "The Republic of God"; Dekker et al., "Proudly Raising," 59n7; Cunningham, *Children*, 4–18.
27. De Vries and van der Woude, *Nederland 1500–1815*, 147, 404, 701; Luijten et al., *Dawn*; van der Woude, "De schilderijenproductie," 239, estimates the painting production on between 5 and 10 million pieces; Frijhoff and Spies, *1650*, 496, 637n60; Loughman and Montias, *Public*

and Private Spaces; Montias, *Artists and Artisans in Delft*; Montias, *Art and Auction*; De Jongh and Luijten, *Mirror*; Dekker, "Looking," 27–46; Goldberg and Tarbin, "In Private," 136, about the exceptional dissemination of paintings on daily life.

28 Southern, *The Making*, plates II, III, coined the concept of dreadful devotion. Cf. Megna, "Dreadful Devotion," quote on 72; Schmitt, "La culture de l'imago," 25–6.
29 Mielke, *Albrecht Dürer*, 3.
30 Simons and Zika, "The Visual Arts," 94.
31 Slive, *The Drawings*, 96, 205; Van Suchtelen et al., *Nicolaes Maes*, 23–53.
32 Laneyrie-Dagen, *L'Invention*, 62.
33 Jan van Bijlert (1597/8–1671), *Family Group as Cornelia, Mother of the Gracchi, Showing Her Children* (c. 1635), oil on canvas, 110.8 × 116.8 (Orléans: Musée des Beaux-Arts d'Orléans), about an unidentified family with mother portrayed as Cornelia—daughter of Scipio and mother of the Gracchi; Bedeaux and Ekkart, *Pride and Joy*, 152–3.
34 Saul Steinberg, http://saulsteinbergfoundation.org (accessed August 28, 2018).
35 François Clouet (studio), *Non-identified Child of Henry II and Catherine de Medicis* (c. 1555), drawing, 33.4 × 22.5 cm (Chantilly: Musée Condé); Laneyrie-Dagen, "Enfant réel," 136–7.
36 Dekker, "Mirror of Reality?" 38–40; Bedaux, *The Reality*.
37 *Dictionary of the Bible* (Edinburgh, 1963); Duchet-Suchau and Pastoureau, *La Bible et les saints*.
38 Van Mander, *Schilder-boeck*; Van Straten, *Inleiding*, 53.
39 In this approach, the discrete and the dimensional models are combined; see Chapter 1. Cf. Walton, *A Natural History*, xiv, on the Darwinian emotions of happiness, sadness, fear, anger, disgust, and surprise.
40 Haemers, "In Public," 154–5 (quotation).
41 Megna, "Dreadful Devotion," 79–80, quoting More, *De tristitia Christi* (1535), influenced by Erasmus's *De taedio Jesu* (1503).
42 Rosenwein, *Generations of Feeling*, 182, referred to by Lynch, "Introduction," 10–11.
43 Goldberg and Tarbin, "In Private," 124–7. On servants and apprentices, see Santing and Van Steensel, "Family," 86–94.
44 Dekker, *Het verlangen*, 67–9; Klapisch-Zuber, *La maison*, 249–330.
45 Goldberg and Tarbin, "In Private," 127, 137–9 (quotes).
46 Anthony Van Dyck, *A Genuese Noblewoman and Her Son* (c. 1626), oil on canvas, 189 × 139 cm (Washington, DC: National Gallery of Art); Laneyrie-Dagen, "Enfant," 128–9.
47 De Jongh, *Portretten*; Smith, *Masks of Wedlock*; Bedaux and Ekkart, *Pride and Joy*, 221–3; Southern, *The Making of the Middle Ages*, 229; Duby, *L'émergence*, 506.
48 Hans Memling, *Triptych Moreel* (1484), oil on oak (Bruges: Groeningemuseum); Autin Graz, *Children*, 114–17. See also family pride in fifteenth-century miniatures, for example, *Queen Isabella of Bavaria in Her Chamber Receiving a Manuscript from Christine de Pizan* (c. 1410–15); Goldberg and Tarbin, "In Private," 133.
49 Bernhard Strigel, *Portrait of Konrad Rehlinger of Augsburg with His Eight Children* (1517), oil on wood, 209 × 98 cm (Munich: Alte Pinakothek); Steingräber, *Alte Pinakothek*, 514–16; Braunstein, "Approches de l'intimité," 554–5; Dekker, *Het verlangen*, 11; Laneyrie-Dagen,

Notes

"Enfant réel," 115–16, on Bernhard Strigel, *Epitaph for the Family Funk* (*c.* 1513), oil on wood (Schaffhausen: Museum zu Allerheiligen), with father passed away as also eight of the twelve children depicted and mother in mourning. Cf. Erich August (1591–1670) (assigned), *Landgrave Maurice of Hesse-Kassel* (*c.* 1618), oil on canvas (Darmstadt: Hessische Landesmuseum), with a proud Landgrave together with his second wife and fourteen children, grouped by age instead of gender, with everyone looking unmoved except the Landgrave; Laneyrie-Dagen, "Enfant réel," 115–17.

50 Pernoud, "Le fifre," 24.
51 Velázques, *Las Meninas, or The Family of Philip IV* (1656), oil on canvas, 318 × 276 cm (Madrid: Museo del Prado); Autin Graz, *Children*, 146–7; Laneyrie-Dagen, "Enfant réel," 151–2; Foucault, *Les mots et les choses*, chapter 1. Cf. Velázquez's *Portrait of the Infanta Margarita* (*c.* 1635), oil on canvas, 70 × 58 cm (Paris: Louvre), showing Margarita as a serious and determined child.
52 Gabriel Metsu, *The Family of the Amsterdam Burgomaster Gillis Valckenier* (*c.* 1657), oil on canvas, 72 × 79 cm (Berlin: Gemäldegalerie Staatliche Museen Preußischer Kulturbesitz); von Gersdorff, *Kinderbildnisse*, 86–7; www.wikiart.org/en/gabriel-metsu/the-family-of-jan-jacobsz-hinlopen (accessed October 14, 2021); Dekker, *Beauty and Simplicity*, 172. Traditionally the canvas is titled *The Family of the Amsterdam Burgomaster Gillis Valckenier*, but art historians hesitated about which family was represented. Now it is mostly accepted that it is another family, that of Jan J. Hinlopen, both Amsterdam families with wealth and power.
53 Bedaux and Ekkart, *Pride and Joy*, 221, referring to Jan Mijtens, *Willem van den Kerckhoven and His Family* (1652–5), canvas, 134 × 182 cm (The Hague: Haags Historisch Museum).
54 Cornelis de Vos, *Anthony Reyniers, Maria Le Witer and Their Five Children* (1631), oil on canvas, 170.2 × 245.1 cm (Philadelphia: The Philadelphia Museum of Art); Laneyrie-Dagen, "Enfant réel," 117; Bedaux and Ekkart, *Pride and Joy*, 144–5.
55 Frans Hals, *Portrait of an Unknown Family* (*c.* 1647–50), oil on canvas, 148.5 × 251 cm (London: The National Gallery); Laneyrie-Dagen, "Enfant réel," 117–18.
56 De Jongh, *Portretten*; Smith, *Masks of Wedlock*; on Jan Mijten, see Bedaux and Ekkart, *Pride and Joy*, 221–3; Owen Hughes, *Representing*, 25; Laneyrie-Dagen, "Enfant réel," 117–18; Laarmann, *Families in beeld*, and Laarmann, *Het Noord-Nederlandse familieportret*.
57 Rembrandt van Rijn, *The Holy Family Asleep with Angels* (*c.* 1645), drawing, 17.3 × 21.1 cm (Cambridge: Fitzwilliam Museum, Louis C.G. Clarke Collection); Slive, *The Drawings*, 197, 199.
58 Rembrandt van Rijn, *The Holy Family in the Carpenter's Shop* (*c.* 1645), drawing, 16 × 15.8 cm (Bayonne: Musée Bonnat); Slive, *The Drawings*, 196–8. The drawing served as a preliminary study for *The Holy Family with Angels* (1645), oil on canvas, 117 × 91 cm (Saint Petersburg: Hermitage), in which the Virgin reads an edifying text while reaching for the baby with her hand. Cf. the cozy Rembrandt, *The Holy Family with the Curtain* (1646) (Kassel: Staatliche Kunstsammlungen); Haak, *The Golden Age*, 297; Haak, *Rembrandt*, 195; Tümpel, *Rembrandt*, 245.
59 Rembrandt van Rijn, *Portrait of a Family* (*c.* 1668), oil on canvas, 126 × 167 cm (Braunschweig: Hertzog Anton Ulrich-Museum); Schwarz, *Rembrandt*, 342; Schama, *Rembrandt's Eyes*, 663–4; Frijhoff and Spies, *1650*, 519–21; Tümpel, *Rembrandt*, 418, 337;

Haak, *Rembrandt*, 326–7; Gerson, *Rembrandt*, 452, 507; Leymarie, *Dutch Painting*, 142; Dekker, *Het gezinsportret*, 5–7; Dekker, "A Republic," 167–70; Bedaux, *The Reality*, 71–108; Bedaux, "Introduction," 21.

60 Bedaux, *The Reality*, 71–108; Van Beverwyck quoted by Bedaux and Ekkart, *Pride and Joy*, 240.
61 Bedaux, *The Reality*, 83–4, 89–93, 103, 127–32, 104.
62 Adriaen van Ostade, *The Dooryard Cottage* (1673), oil on canvas, 44 × 39.5 cm (Washington, DC: National Gallery of Art); Autin Graz, *Children*, 98–9.
63 Bernhard Strigel, *Saint Mary Clephas and Her Family* (1520–8), oil on panel, 125.4 × 65.8 cm (Washington, DC: National Gallery of Art); Autin Graz, *Children*, 78–9; www.nga.gov/collection/art-object-page.46187.html (accessed April 22, 2022).
64 Goldberg and Tarbin, "In Private," 134–5.
65 Master of Catharina van Kleef, "The Holy Family at Table," *Book of Hours of Catharina van Kleef* (c. 1440) (New York: The Pierpont Morgan Library), M.945 and M.917; Defour, *The Golden Age*, 152–7, quote 156. Cf. picture of Maria and Joseph at work, Defoer, *The Golden Age*, 156; Alexandre-Bidon, *L'enfant*, 210; Dekker, *Het verlangen*, 32–6.
66 Master of the Morgan Infancy Cycle, "Nativity," *Book of Hours of Kunera van Leefdael* (c. 1415), ff. 1–192, Ms. 5.J.26, f. 53ʳ (Utrecht: University Library); Defoer, *The Golden Age*, 64, figure II 15a.
67 Anonymous, *Family at Meal* (c. 1627), panel, 122 × 191 cm (Amsterdam: Rijksmuseum on loan to Rijksmuseum Het Catharijneconvent, Utrecht); Bedaux, *The Reality*, 85–7; De Jongh, *Portretten*, 295–9; Dekker, "Beauty and Simplicity," 172–3; Durantini, *The Child*, 3, 53–4. Pictures of the family at meal are mostly related to the abovementioned Psalm 128: 1–3; De Jongh and Luijten, *Mirror*, 124–8.
68 Jan Steen, *Prayer before Dinner* (1660), oil on panel, 52.7 × 44.5 cm (Sudeley Castle, Gloucestershire: Walter Morrison Collection). Perry Chapman, *Jan Steen*, 139–41, compares Steen's painting with Adriaen van Ostade, *Prayer before Dinner* (1653), etching (Washington, DC: National Gallery of Art). Cf. Gruschka, *Der heitere Ernst*, 85–6; Dekker, "Beauty and Simplicity," 173; Dekker, *Educational Ambitions*, 51.
69 Jan Steen, *Grace before Meal* (c. 1663–5), oil on canvas, 98.4 × 79.4 cm (Belvoir Castle, Grantham: The Duke of Rutland); Perry Chapman, *Jan Steen*, 190–2; Gruschka, *Der heitere Ernst*, 82–5; Dekker, "Beauty and Simplicity," 173.
70 Dekker, "A Republic," 387; Dekker, *Het verlangen*, 135–7.
71 Schotel, *Het Oud-Hollandsch Huisgezin*, 193, 196; see Magyrus, *Almanachs heiligen*, referred to in Mooij et al., *Kinderen*, 138.
72 Rooijakkers, "De rituele wereld," 71.
73 Jan Steen, *The Feast of St Nicholas* (c. 1665–8), oil on canvas, 82 × 70.5 cm (Amsterdam: Rijksmuseum); Perry Chapman, *Jan Steen*, 197–9; Brown, "… Niet Ledighs," 156; Schotel, *Het Oud-Hollandsch Huisgezin*, 193–9; De Jongh, "Jan Steen, dichtbij en toch veraf," 42.
74 Groenendijk, *De nadere reformatie*, 154.

Notes

75 Jan Steen, *The Feast of Epiphany* (1662), oil on canvas, 131 × 164.5 cm (Boston: Museum of Fine Arts); cf. Jan Steen, *The Feast of Epiphany* (1668), oil on canvas, 82 × 107.5 cm (Kassel: Staatliche Museen). See Perry Chapman, *Jan Steen*, 157–9, 206–8; Schotel, *Het Oud-Hollandsch Huisgezin*, 205, on the Protestant acceptation of this Catholic feast.

76 Rembrandt van Rijn, *The Star of the Kings* (signed *c.* 1645), drawing, 20.4 × 32.3 cm (London: The British Museum); Slive, *The Drawings*, 101–3.

77 Pieter Bruegel the Elder, *The Adoration of the Magi* (1564), oil on panel, 112 × 85 cm (London: The National Gallery); Hoppe-Harnoncourt et al., *Bruegel*, 190–3 and note 13, on Hieronimus Bosch's *The Adoration of the Magi* (*c.* 1490–1500) (Madrid: Museo Nacional del Prado). For other versions by Bruegel, see Hoppe-Harnoncourt et al., *Bruegel*, respectively, 186–9 and 60–3.

78 Master of the Morgan Infancy Cycle, "Flight to Egypt," *Book of Hours of Kunera van Leefdael* (*c.* 1415), ff. 1–192, Ms 5.J.26,f. 98r (Utrecht: Universiteitsbibliotheek); Defoer, *The Golden Age*, 64–5; cf. Wüstefeld, *Middeleeuwse boeken*, 115.

79 Albrecht Dürer, *Rest on the Flight into Egypt* (1511), drawing, 27.9 × 20.8 cm (Berlin: Staatlichen Museen zu Berlin, Kupferstichkabinett, KdZ 3866); Anzelewsky and Mielke, *Albrecht Dürer*, 69 Kat. 67. See Dückers, *Das Berliner Kupferstichkabinett*, 115 Kat. III.35, description by Hans Mielke; www.smb-digital.de/eMuseumPlus (accessed February 23, 2022). In Caravaggio, *Rest during the Flight to Egypt* (*c.* 1594), oil on canvas, 130 × 160 cm (Rome: Galleria Doria Pamphili), Joseph, dressed too well for a man on the run, holds a score for an angel who plays the violin within a beautiful Italian landscape; Laneyrie-Dagen, "Enfant réel," 80–2.

80 Francisco de Zurbarán, *The Rest during the Flight to Egypt* (1659), oil on canvas, 121 × 97 cm (Budapest: Museum of Fine Arts/Szépművészeti Múzeum); Autin Graz, *Children*, 142–3.

81 Rembrandt, *Departure to Return from Egypt to Israel* (*c.* 1652), drawing, 194 × 242 mm (Berlin: Staatliche Museen zu Berlin, Kupferstichkabinett); Bevers, *Rembrandt*, 155–8n4.5.

82 Laneyrie-Dagen, "Lorsque l'enfant paraît," 49–50.

83 Ibid., 51.

84 Simone Martini, *Stories of Blessed Agostino Novello: Miracle of the Child Falling from the Balcony* (1328), part of triptych, tempera on poplar, 200 × 256 cm (Siena: Pinacoteca Nazionale); Autin Graz, *Children*, 32–3. Cf. Domenico Ghirlandaio, *Cycle of the Life of Saint Francis: The Miracle of the Child or the Resurrection of the Son of the Spini Family* (1485), fresco (Florence: Santa Trinità, Cappella Sassetti); Laneyrie-Dagen, "Lorsque l'enfant paraît," 76–7.

85 Lorenzetti, *Saint Nicholas of Bari with Three Young Girls* (before 1348), tempera on panel, 29 × 20 cm (Paris: Musée de Louvre); Laneyrie-Dagen, "Lorsque l'enfant paraît," 58.

86 Hanawalt, "Medievalists," 454, quoted by McNamer, "Literature," 116.

87 McNamer, "Literature," 116, referring to Lynch, "he nas but seven yee olde," 38; Klapisch-Zuber, "L'enfant," 208–17.

88 Jarzebowski, *Kindheit*, 71–3; Lynch, "he nas but seven yee olde," 25–44; Barclay et al., *Death*.

89 Jarzebowski, *Kindheit*, 74, 88.

90 Ibid., 77–8.

91 Christiaan and Constantijn Huygens, *De jongelingsjaren*, 79–8, 91, 96–101; Gerbenzon, *Het aantekeningenboek*, 140; Blaak, *Hermanus Verbeeck*, 91–2, 159–60, 209; Dekker, *Children*; Dekker, *Het verlangen*, 138–46; Roberts, *Through the Keyhole*, 213; Dekker, *Educational Ambitions*, 36–7, 40–1; Beauvalet, "Life Histories," passim.

92 Luigi Miradori, *Memento Mori* (before 1657), oil on canvas, 76 × 61 cm (Cremona: Museo Civico); Laneyrie-Dagen, "Enfant réel," 183, 185.

93 Sidèn, *Den ideala barndomen*; Jarzebowski, *Kindheit*, 158; Goldberg and Tarbin, "In Private," 133.

94 Lynch, "he nas but seven yee olde"; on the Cologne bust, see McNamer, "Literature," 114–16.

95 Agnolo Bronzino, *Portrait of Bia de Medici* (c. 1542), oil on panel, 63 × 48 cm (Florence: Galleria degli Uffizi); Laneyrie-Dagen, "Enfant réel," 136–8.

96 Becchi, "Humanisme," 161. On the Dutch case, see De Vries and van der Woude, *Nederland 1500–1815*, 97; Van Deursen, *Mensen*; Vandenbroeke, "Zuigelingensterfte," 133–63; Vandenbroeke et al., "De zuigelingen- en kindersterfte"; van der Woude, "Variations," 299–318; Dekker, "Images as Representation."

97 Anonymous, *The Children of Jacobus Pietersz: Costerus and Cornelia Jans Coenraadsdochter ("The Dordrecht Quadruplets")* (1621), panel, 75 × 104 cm (Dordrecht: Dordrechts Museum); Bedaux and Ekkart, *Pride and Joy*, 130–2; Dekker, *Het verlangen*, 144. On the Dordrecht Synod, see Bedaux, "Introduction," 24. Cf. Nicolaes Maes (1634–1693), *Two Angels Bearing a Dead Infant up to Heaven* (c. 1675), canvas, 64 × 52 cm (The Hague: Hoogsteder & Hoogsteder art dealers); Bedaux and Ekkart, *Pride and Joy*, 276–8; Nicolaes Maes, *George de Vicq as Ganymede* (1681), canvas, 97 × 82 cm (Cambridge, MA: Fogg Art Museum, Harvard University Art Museums); Bedaux and Ekkart, *Pride and Joy*, 289–91; Anonymous, *Portrait of the Triplets De Reuver* (1660), oil on canvas, 95.4 × 130.3 cm (Utrecht: Centraal Museum), https://hdl.handle.net/21.12130/collect.F8C69228-17E3-4305-B903-ED7F88B70ACE (accessed May 3, 2022); Laneyrie-Dagen, "Enfant réel," 134n75; Bedaux, "Funeraire kinderportretten," 102–5.

98 Johannes Thopas, *Girl from the Van Valkenburg Family on Her Deathbed* (c. 1682), oil on panel, 58 × 71.5 cm (Van Valkenburg Foundation, on loan to the Mauritshuis, The Hague); Bartholomeus van der Helst, *Young Boy on His Deathbed* (1645), oil on canvas, 63 × 90 cm (Gouda: Museum Gouda). See Bedaux and Ekkart, *Pride and Joy*, 292–3; Bedaux, "Funeraire kinderportretten," 88–114; Dekker et al., "Proudly Raising," 56–7; Dekker, "Images as Representation," 709–12; Dekker, *Het verlangen*, 143–6.

99 Laneyrie-Dagen, "Enfant réel," 87–91.

100 Bedaux, "Funeraire kinderportretten," 92–9; Laneyrie-Dagen, "Lorsque l'enfant paraît," 47.

101 Cf. Laneyrie-Dagen, "Lorsque l'enfant paraît," 29.

102 Anonymous, *The Great Elector Frederick of Brandenburg and His Wife Louise of Orange and Their Children* (Berlin: Schloss Oranienburg); Jarzebowski, *Kindheit*, 44. See also Anonymous, *Family Group, Probably the Family of Jan Gerritsz. Pan* (1638), panel, 87 × 178 cm (Enkhuizen: Collection Stichting Portret van Enkhuizen/Thade van Doesburgh), with nine died children including twins or also triplets in the foreground, with, in the background, two still living and serious and sad-looking children aged two and three with their sad-looking parents, Bedaux and Ekkart, *Pride and Joy*, 162–3; Dekker, "Images as Representation,"

Notes

712–13; Autin Graz, *Children*, 106. Jan Mijtens (*c.* 1614–1670), *Willem van den Kerckhoven and His Family* (1652/5), canvas, 134 × 182 cm (The Hague: Haags Historisch Museum); Bedaux and Ekkart, *Pride and Joy*, 221–3, with no less than five children depicted as angels; Jan Mijtens, *Govert van Slingelandt and His Family* (1657) (Amsterdam: Rijksmuseum); De Jongh, *Portretten*, 241–3; Dekker, "Message et realité," 382–3: mother and child on her knee were dead before the painting was made, but remain part of the family.

103 Jan Jansz. de Stomme, *Three Children from the Tjarda van Starckenborgh Family* (1654), panel, 123 × 147.5 cm (Groningen: Groningen Museum); Bedaux and Ekkart, *Pride and Joy*, 230–2.

104 Pietro Lorenzetti, *Virgin and Child* (1310–20), tempera on panel, 71 × 41 cm (Pienza: Museo Diocesano). See http://palazzoborgia.it/museo/ (accessed August 27, 2023); Autin Graz, *Children in Painting*, 30–1.

105 Master of the Morgan Infancy Cycle, "Nativity," Book of Hours (*c.* 1420), Ms. Add. 50.005, f. 22v (London: British Library); Defoer, *The Golden Age*, 63, image II 14. Cf. on nativity in Books of Hours Alexandre-Bidon, *L'enfant*, 62–71; see also Gélis, *L'arbre*.

106 Jan Van Eyck, *The Virgin with the Canon Van der Paele* (1436), oil on panel, 122.1 × 157.8 cm (Bruges: Groeningemuseum); cf. Autin Graz, *Children*, 112–13; https://vlaamse primitieven.vlaamsekunstcollectie.be/nl/onderzoek/webpublicaties/madonna-met-kanun nik-joris-van-der-paele/ (accessed March 6, 2022); Koster, "De uitwisseling," 234.

107 Jan Gossaert, *Maria with the Child Jesus* (*c.* 1525), oil on panel, 47.7 × 37.8 cm (Berlin: Staatlichen Museen zu Berlin), https://smb.museum-digital.de/index.php?t=objekt&oges=227011 (accessed April 5, 2023).

108 Lorenzo Lotto (1480–1557), *Nocturnal Nativity* (*c.* 1527–8), oil on canvas, 55.5 × 47.5 cm (Siena: Pinacotea Nazionale); Laneyrie-Dagen, "Enfant réel," 87–91.

109 Hans Holbein the Elder, *Madonna with Sleeping Child Jesus* (*c.* 1520), panel, 74.1 × 56.2 cm (Berlin: Gemäldegalerie Staatliche Museen); Kemperdick and Roth, *Holbein in Berlin*, 82–5, quote on 82. Cf. Gheeraert David (*c.* 1460–1523), *Virgin and Child with a Bowl of Pap*, oil on panel, 33 × 27.5 (New York: Aurora Trust); Autin Graz, *Children*, 120–1, an everyday scene of a mother feeding her baby with a spoon of porridge.

110 Cf. Tobey, *L'art d'être mère*.

111 Rembrandt van Rijn, *Woman Sitting Up in Bed with a Baby* (*c.* 1635), drawing, 14 × 10.6 cm (London: The Courtauld Gallery, Seilern Collection); Slive, *The Drawings*, 85 and figure 7.6 on 84.

112 Rembrandt van Rijn, *Baby Sleeping in a Cradle* (*c.* 1645), drawing, 7.5 × 11.3 cm (London: Formally Heirs of Henry Oppenheimer, present whereabouts unknown); Slive, *The Drawings*, 197, figure 15.4, 199.

113 Rembrandt van Rijn, *Two Sketches of an Infant in Swaddling Clothes Fed from a Bottle* (*c.* 1635), 10.4 × 12.6 cm (Munich: Staatliche Graphische Sammlung); Slive, *The Drawings*, 84 (figure 7.5), 85.

114 Rembrandt van Rijn, *Sheet of Studies of Heads and Three Sketches of a Woman Holding an Infant* (*c.* 1635), 22 × 23 cm (Birmingham: The Barber Institute of Fine Arts, University of Birmingham/The Bridgeman Art Library); Slive, *The Drawings*, 44–6, figure 4.3.

115 Buvelot et al., *Frans van Mieris 1635–1681*, 172, on a drawing of William Paets in his cradle by Frans Van Mieris as preliminary study for a drawing of William and his nurse.

116 Frans Hals, *Catharina Hooft with Her Nurse* (c. 1619–20), oil on canvas, 86 × 65 cm (Berlin: Gemäldegalerie Staatliche Museen); Luijten et al., *Dawn*, 601: in 1975, S. A. C. Dudok van Heel uncovered the identity of the child and concluded that the woman was not her mother, but her nurse; Gersdorff, *Kinderbildnisse*, 162; Dekker, *Beauty and Simplicity*, 177–8. According to Beavan, "The Visual Arts," 106–8, the wide-open mouth showing the teeth "was usually restricted to the depiction of children, too innocent to have learned the conventions, or prostitutes, drunks, and gypsies who were perceived to be outside of societal norms." But on this painting, both mouths are closed.

117 Gabriel Metsu (1629–1667), *The Sick Child* (c. 1660), oil on canvas, 32 × 27 cm (Amsterdam: Rijksmuseum). Brown, "...Niet ledighs," 147. Cf. See De Jongh, *Tot lering*, 171; Durantini, *The Child*, 22; Dekker and Groenendijk, "The Republic," 332n40; Haak, *The Golden Age*, 489; Schama, *Embarrassment*, 522.

118 Alston and Harvey, "In Private," 145.

119 Rembrandt van Rijn, *Four Sketches of Saskia (recto)* (c. 1635–6), 20 × 15 cm (Rotterdam: Museum Boijmans-Van Beuningen, Koenigs Collection); Slive, *The Drawings*, 15.

120 Nicolaas Maes, *Mother with Child on Her Arm* (s.a.), pen drawing, 7.5 × 5.6 cm (Berlin: Staatliche Museen zu Berlin, Kupferstichkabinett, KdZ 4289); Gersdorff, *Kinderbildnisse*, 31; Dekker, *Het verlangen*, 100.

121 Laneyrie-Dagen, *L'Invention*, 115–16.

122 Master of the Morgan Infancy Cycle, "The Massacre of the Innocents," *Book of Hours* (c. 1415) (Liège: Bibliothèque de l'Université), Ms. Wittert 35, f. 67[r]; see Defoer, *The Golden Age*, 61–2 and plate 13.

123 Simons and Zika, "The Visual Arts," 95–7; Domenico Ghirlandaio, *The Massacre of the Innocents* (c. 1486–90), fresco (Florence: Torbanuoni Chapel, Santa Maria Novella); Cornelis van Haarlem, *The Massacre of the Innocents* (1590), oil on canvas, 245 cm × 358 cm (Amsterdam: Rijksmuseum); Nicolas Poussin, *Massacre of the Innocents* (1625–9), oil on canvas, 147 × 171 cm (Chantilly: Musée Condé); Laneyrie-Dagen, "Enfant réel," 85–7; on Poussin, see Braider, *Refiguring*, 221–48, 253–4, and 226; Beavan, "The Visual Arts," 93.

124 Lucas Cranach the Elder, *Salomon's Judgment* (c. 1537), oil on panel, 206.5 × 142 cm (Berlin: Staatlichen Museen zu Berlin).

125 Ercole de' Roberti, *Hasdrubal's Wife and Her Children* (c. 1490–3), oil on panel, 47.1 × 30.6 cm (Washington, DC: National Gallery of Art); Autin Graz, *Children in Painting*, 44–5. Cf. Tomasso Massacio (1401–1428) and Tomasso Masolino (1383–1447), who in *The Healing of the Cripple and the Raising of Tabitha* (c. 1425), fresco (Florence: Capella Brancacci, Santa Maria del Carmine), put a similar daily-life scene in this famous sacral image about a mother who moves from the background in the direction of the main scenes with a struggling child; Laneyrie-Dagen, "Lorsque l'enfant paraît," 74–6.

126 Bevers, *Rembrandt. Die Zeichnungen*, 91–3.

127 Rembrandt van Rijn, *Sample Sheet with an Old Woman and a Screaming Child and Five Half Figures* (c. 1638–9), drawing, 218 × 185 mm (Berlin: Staatliche Museen zu Berlin,

Kupferstichkabinett, KdZ 2316); Bevers, *Rembrandt: Die Zeichnungen*, 91–3; Slive, *The Drawings*, 49; Dekker, *De pedagogische ruimte in de tijd*, 5–6. Cf. Pieter De Hooch, *The Courtyard of a House in Delft* (1658), oil on canvas, 74 × 60 cm (London: National Gallery); Jansen, *Pieter de Hooch*, 154–5; Autin Graz, *Children*, 104–5. Children got a protective cap when starting to walk, ending around the third or fourth birthday; Kuus, "Children's Costume," 77–8.

128 Rembrandt van Rijn (1606–1669), *Mother with a Crying Child That Is Afraid of a Dog* (c. 1635), drawing, 182 × 145 mm (Budapest: Museum of Fine Arts); Dekker, "Looking," 38; Fila et al., *De Kunst*, 99.

129 According to Bevers (*Rembrandt*, 64), Rembrandt often observed "in der Wirklichkeit" (in reality).

130 Rembrandt van Rijn, *Woman Carrying a Child Downstairs* (c. 1635), 18.7 × 13.2 cm (New York: The Pierpont Morgan Library); Slive, *The Drawings*, 86–7.

131 Rembrandt van Rijn, *Two Women Teaching a Child to Walk* (c. 1635–7), 10.5 × 12.8 cm (London: The British Museum); Slive, *The Drawings*, 85–6.

132 Rembrandt van Rijn, *Woman Teaching a Child to Walk* (c. 1640–5), 16 × 16.56 cm (Stockholm: Nationalmuseum); Slive, *The Drawings*, 85–6.

133 Rembrandt van Rijn, *Woman with a Pissing Boy* (c. 1657–60), 13.3 × 9 cm (Dresden: Kupferstich-Kabinett, Staatliche Kunstsammlungen Dresden); Slive, *The Drawings*, 89.

134 Laneyrie-Dagen, "Enfant réel," 93.

135 Jacques de Gheyn II, *Mother and Child with a Picture Book* (c. 1620), drawing (Berlin: Staatliche Museen zu Berlin, Kupferstichkabinett); Dekker, *Het verlangen*, 13–14; cf. Wheelock Jr., *Gerard ter Borch*, 87–91; Gerard ter Borch, *The Reading Lesson* (c. 1625), oil on panel, 27 × 25 cm (Paris: Musée du Louvre, Département des Peintures); Frans van Mieris (1635–1681), *The Child's Lesson* (c. 1656–7), oil on panel, 29.2 × 21.6 (New York: private collection), with an elder boy learning to read text; Buvelot et al., *Frans van Mieris 1635–1681*, 104–6.

136 This occurrence makes questionable the thesis by Lawrence Stone and others about the absence of such fatherhood until the late eighteenth century; see Alston and Harvey, "In Private," 144, referring to Baily, "Reassessing Parenting."

137 Altichiero da Zevio, *The Beheading of Saint George* (c. 1380–5), fresco (Padua: Oratorio di San Giorgio); Laneyrie-Dagen, "Lorsque l'enfant paraît," 74.

138 Pedro Berruguete or/and Justus of Genth, *Portrait of Federico da Montefeltro and His Son Guidobaldo* (c. 1475), panel, 134 × 77 cm (Urbino: Galleria Nazionale delle Marche); Laneyrie-Dagen, "Enfant," 100, 103.

139 Domenico Ghirlandaio, *The Confirmation of the Rule of St. Francis* (1483–6), fresco (Florence: Santa Trinità, capella Sassetti); Laneyrie-Dagen, "Enfant reel," 98, 100–5.

140 Domenico Ghirlandaio, *Francesco Sassetti and His Son Teodoro* (c. 1466 or 1485), panel, 84 × 64 cm (New York: The Metropolitan Museum of Art), and Domenico Ghirlandaio, *A Grandfather with His Grandchild* (c. 1490), panel, 62 × 46 cm (Paris: Musée du Louvre); Laneyrie-Dagen, "Enfant réel," 103–7; Braunstein, "Approches," 554; Owen Hughes, "Representing the Family," 25; Dekker, *Het Verlangen*, 91.

141 Rembrandt, *Sketches of an Old Man with a Child* (c. 1640), drawing, 18.9 × 15.7 cm (London: The British Museum); Slive, *The Drawings*, 102.

142 Pieter Bruegel the Elder, *The Alchemist* (*c.* 1558), engraving, 325 × 441 mm (Vienna: Albertina); Hoppe-Harnoncourt et al., *Bruegel*, 91–3.
143 Anthony van Dyck, *A Genoese Nobleman with His Two Children* (1625–7), oil on canvas, 223 × 148.5 cm (Abercorn: Trustees of Abercorn settlement); Laneyrie-Dagen, "Enfant réel," 126.
144 Schinkel, *Wonder and Education*; Verstraete, "Het verlegen kind."
145 Snoep and Huvenne, "Foreword," 6; Bedaux and Ekkart, *Pride and Joy*, 8.
146 Bedaux and Ekkart, *Pride and Joy*, 8.
147 Stearns, "Happy Children."
148 Fra Angelico, *Saint Lawrence Giving Alms to the Poor* (*c.* 1447–51), fresco, 410 × 271 cm (Vatican: Cappella Nicollina); Autin Graz, *Children*, 36–7.
149 Raphael, *Sistine Madonna* (*c.* 1512–13), oil on panel, 265 × 196 cm (Dresden: Gemäldegalerie Alte Meister, Staatliche Kunstsammlungen), https://gemaeldegalerie.skd.museum/en/exhibitions/sistine-madonna/ (accessed April 24, 2022); Autin Graz, *Children*, 50–1.
150 Peter Paul Rubens, *Jesus Christ with Little John and Two Angels* (1615–20), oil on panel, 76.5 × 122.3 cm (Vienna: Kunsthistorisches Museum), https://www.khm.at/objektdb/detail/1623 (accessed April 6, 2023).
151 Thomas de Keyser, *Portrait of the Three Brothers Hendrick, Johannes and Simon* (*c.* 1631), oil on panel, 121.5 × 88.4 cm (Amsterdam: Rijksmuseum); Laneyrie-Dagen, "Enfant réel," 132–3. For details, see Van Thiel, "Catholic Elements."
152 Cornelis De Vos, *Magdalena and Jan Baptist De Vos, Children of the Painter* (*c.* 1621–2), oil on canvas, 81 × 95 cm (Berlin: Staatlichen Museen zu Berlin), www.smb-digital.de/eMuseumPlus (accessed April 22, 2022).
153 Pieter Claesz. Soutman, *Group of Four Children* (1641), canvas, 140 × 173 cm (UK: private collection); Bedaux and Ekkart, *Pride and Joy*, 177–9.
154 Philippe de Champaigne, *The Children of Habert de Monmort* (1649), oil on canvas, 122.5 × 186.4 cm (Reims: Musee des Beaux-Arts); Laneyrie-Dagen, "Enfant réel," 132–3.
155 Anthony van Dyck, *The Balbi Children* (1625–7), oil on canvas, 219 × 151 cm (London: The Trustees of the National Gallery), www.nationalgallery.org.uk/paintings/anthony-van-dyck-the-balbi-children (accessed April 24, 2022); Autin Graz, *Children*, 136–7.
156 Antony Van Dyck, *Van Dyck's The Three Eldest Children of Charles I* (1635), oil on canvas, 133.8 × 151.7 cm (Windsor: Windsor Castle, Queen's Gallery), www.rct.uk/collection/404403/the-three-eldest-children-of-charles-i (accessed April 7, 2023).
157 Bartolomé Esteban Murillo, *Children Eating Grapes and a Melon* (1645–50), oil on canvas, 145.9 × 103.6 cm (Munich: Alte Pinakothek); cf. Bartolomé Esteban Murillo, *The Pie Eaters* (*c.* 1670), 140 × 104 cm (Munich: Alte Pinakothek); Autin Graz, *Children*, 152–3.
158 Jusepe de Ribera, *The Club-Foot* (1642), oil on canvas, 164 × 93 cm (Paris: Musée du Louvre); In *The Young Beggar* (*c.* 1648), oil on canvas, 134 × 100 cm (Paris: Musée du Louvre), Murillo also depicted a clearly not happy but hungry boy who sits on the ground with a depressed and resigned look; Laneyrie-Dagen, "Enfant réel," 180–2.
159 Anthony Van Dyck, *Portrait of Elen Grimaldi Cattaneo with a Servant Holding Her Umbrella* (*c.* 1632), oil on canvas, 246 × 173 cm (Washington, DC: National Gallery of Art); Laneyrie-Dagen, "Enfant réel," 170–82, 169–70.

160 Pieter Bruegel the Elder, *Children's Games* (1560), oil on panel, 118 × 161 cm (Vienna: Kunsthistorisches Museum). See Dekker, *Het verlangen*, 125–7; Autin Graz, *Children*, 124–5; Laneyrie-Dagen, "Enfant réel," 94, 96–7.

161 Pieter Bruegel the Elder, *The Battle between Carnival and Lent* (1559), oil on panel, 118 × 164 cm (Vienna: Kunsthistorisches Museum, Picture Gallery); Pieter Bruegel the Elder, *Netherlandish Proverbs* (1559), oil on panel, 117 × 164 cm (Berlin: Gemäldegalerie, Staatliche Museen zu Berlin); Pieter Bruegel the Elder, *Kermis at Hoboken* (1559), pen drawing, 265 × 394 (London: The Courtauld Gallery). See Hoppe-Harnoncourt et al., *Bruegel*, 130–4n7.

162 Hoppe-Harnoncourt et al., *Bruegel*, 130–4; cf. Simons and Zika, "The Visual Arts," 101–2.

163 Hoppe-Harnoncourt et al., *Bruegel*, 130–4.

164 Autin Graz, *Children*, 124–5.

165 Hoppe-Harnoncourt et al., *Bruegel*, 130–4.

166 Laneyrie-Dagen, "Enfant réel," 94.

167 Hoppe-Harnoncourt et al., *Bruegel*, 130–4; Autin Graz, *Children*, 124.

168 Hoppe-Harnoncourt et al., *Bruegel*, 130–4; Van Straten, *Inleiding*, 53.

169 Snow, "'Meaning' in *Children's Games*," 27–60; Snow, *Inside Bruegel*, 14–18; Hoppe-Harnoncourt et al., *Bruegel*, 130–4.

170 Hoppe-Harnoncourt et al., *Bruegel*, 130–4; cf. Huizinga, *Homo Ludens*. On Rabelais in early modern Europe's history of emotions, see McNamer, "Literature," 307.

171 Willemsen, *Kinder delijt*, 295–6, 298; Willemsen, "Images of Toys," 61–72; Willemsen, "Out of Children's Hands," 297–303; Eiselin, *Iene miene mutte*; cf. Peeters, *Kind en jeugdige*, 113; Durantini, *The Child*, 179: "An interest in children's games in their everyday context … is first found in works such as the Hours of Adelaide of Savoy"; Dekker, *Het verlangen*, 30–6; Snow, "'Meaning' in *Children's Games*," 27–60; Schotel, *Het Oud-Hollandsch Huisgezin*, chapter 9; Manson, "La poupée"; Hindman, "Pieter Bruegel's Children's Games."

172 Groenendijk, *De nadere reformatie*, 145; Van Deursen, *Mensen*, 154–7.

173 Orrock, "Homo Ludens," 22, quoted by Hoppe-Harnoncourt et al., *Bruegel*, 130–4.

174 Snow, Inside Bruegel, 14, referred to in note 26 by Hoppe-Harnoncourt et al., *Bruegel*, 130–4.

175 Hoppe-Harnoncourt et al., *Bruegel*, 130–4; cf. Snow, *Inside Bruegel*.

176 Hoppe-Harnoncourt et al., *Bruegel*, 130–4. On Brant's *Ship of Fools* (1494), see Lederer, "Religion and Spirituality," 43–4, in the 1498 edition of the text with "stunning illustrations by Renaissance artist Albrecht Dürer."

177 Durantini, *The Child*, 179, 181–3; Brown, "… Niet ledighs of ydels," 152.

178 Hoppe-Harnoncourt et al., *Bruegel*, 130–4. Cf. Schama, *Embarrassment*, 497–516, in particular 500, proposing the use of a seventeenth-century emblematic text from Cats to decode this sixteenth-century painting.

179 Durantini, *The Child*, 176, 185, 191; De Jongh, *Tot lering*, 199; Schama, *Embarrassment*, 498, 5; Dekker, "Message et réalité," 388–90. Cf. Adriaen van de Venne (1589–1662), *Playing Children on a Market Place*, drawing in Cats, *Alle Wercken*, an illustration to the introductory poem "Children's Game" of *Houwelick*, seemingly an imitation of Bruegel's *Children's Games*, but a mirror of society, as Cats's accompanying poem makes clear. Although kids are playing,

it is no catalogue of children's games, but a lesson for parents about the education of their children; Dekker, *Het verlangen*, 127–9.

180 Cornelis Saftleven, *Children Making Music* (s.a.), drawing, 28.5 × 20 cm (Berlin: Staatliche Museen zu Berlin, Kupferstichkabinett, KdZ 13801). See De Jongh and Luijten, *Mirror*, 230–2; cf. Gersdorf, *Kinderbildnisse*, 123; Dekker, *Het verlangen*, 132–3.

181 Frans van Mieris, *Boy Blowing Bubbles* (1663), oil on panel, 18.3 × 15.2 cm (The Hague: Mauritshuis); Buvelot et al., *Frans van Mieris 1635–1681*, 160–2; Brown, "…Niet ledighs," 38 and further; Schama, *Embarrassment*, 512–16: those images "seem to linger more innocently on the … playful aspects of bubbles … than on its more somber connotations." Dekker, "Message et réalité," 391. Cf. Bartholomeus van der Helst, *A Boy as Cupid* (c. 1644), canvas, 93 × 106 cm (private collection), with a toddler blowing bubbles; Bedaux and Ekkart, *Pride & Joy*, 184–5.

182 Pieter de Hooch, *The Bowlplayers* (c. 1660–2), oil on panel, 63.5 × 46.4 cm (Great Bookham: National Trust Collection, Polesden Lacey, The McEwan Collection); Jansen, *Pieter de Hooch in Delft*, 162–5.

183 Jan Gossaert, *Young Princess (Perhaps Dorothea of Denmark)* (c. 1520), oil on panel, 38 × 29 cm (London: The National Gallery); Laneyrie-Dagen, "Enfant réel," 139–40.

184 Veronese, *Girl Opening a Door* (s.d.), fresco (Maser: Villa Barbaro); Autin Graz, *Children*, 66–7.

185 Titian, *Clarissa Strozzi* (1542), oil on canvas, 115 × 98 cm (Berlin: Gemäldegalerie, Staatliche Museen); Autin Graz, *Children*, 56–7; Laneyrie-Dagen, "Enfant réel," 145, 150.

186 Laneyrie-Dagen, "Enfant réel," 155 on "enfants d'artistes."

187 Peter Paul Rubens, *Clara Serena Rubens* (1616), oil on panel, 33.5 × 27 cm (Vaduz: Collection of the Prince of Liechtenstein); Autin Graz, *Children*, 128–9; www.liechtensteincollections.at/en/collections-online/portrait-of-clara-serena-rubens-the-daughter-of-the-artist-1611-1623 (accessed April 12, 2022). Cf. Laneyrie-Dagen, "Enfant réel," 155–6.

188 Cornelis De Vos, *Susanna De Vos* (1627), oil on panel, 80 × 55.5 cm (Frankfurt am Main: Städelsches Kunstinstitut, Städel Museum); Bedaux and Ekkart, *Pride and Joy*, 142–3; https://creativecommons.org/licenses/by-sa/4.0/deed; Dekker, "Story Telling," 166.

189 Cornelis De Vos, *Magdalena de Vos, the Artist's Daughter* (c. 1623–4), oil on canvas, 103 × 77 cm (Bakewell: The Duke of Devonshire and the Chatsworth House Trust); Bedaux and Ekkart, *Pride and Joy*, 137–9.

190 Judith Leyster, *Head of a Girl* (1630–40), oil on panel, 36.2 × 31 cm (Paris: Collection of Doctor Rau); Autin Graz, *Children*, 96–7; cf. Biesboer and Welu, *Judith Leyster*, and Hofrichter, *Judith Leyster, 1609–1660*.

191 Govaert Flinck, *Girl by a Highy Chair* (1640), oil on canvas, 114.2 × 87.3 cm (The Hague: Koninklijk Kabinet van schilderijen Mauritshuis); Bedaux and Ekkart, *Pride & Joy*, 168–9; Dekker, *Het verlangen*, 119.

192 Johannes Verspronck, *Girl in Blue* (1641), oil on canvas, 82 × 66.5 (Amsterdam: Rijksmuseum); Bedaux and Ekkart, *Pride and Joy*, 174–6; Dekker, *Het verlangen*, 119.

193 Gerard ter Borch, *Helena van der Schalcke* (c. 1648), oil on panel, 34 × 28.5 cm (Amsterdam: Rijksmuseum); Bedaux and Ekkart, *Pride and Joy*, 196–7; Wheelock Jr., *Gerard ter Borch*, 75–7.

Notes

194 Caesar van Everdingen, *A Girl as Huntress* (c. 1665), oil on canvas, 126 × 106 cm (Antwerp: Koninklijk Museum voor Schone Kunsten); Bedaux and Ekkart, *Pride and Joy*, 264–5; examples of boys as hunters on 171–2, 198–9, 210–12.

195 Guido Mazzoni (attributed to), *A Boy Who Laughs* (c. 1498), polychrome terracotta, height 31.8 cm (London: The Royal Collection); Laneyrie-Dagen, "Enfant réel," 108–11.

196 Hans Holbein the Younger, *Edward VI as a Child* (c. 1538), oil on panel, 57 × 44 cm (Washington, DC: National Gallery of Art); cf. Autin Graz, *Children*, 82–3; Laneyrie-Dagen, "Enfant réel," 140–41.

197 Bronzino, *Giovanni de' Medici* (1545), tempera on panel, 58 × 45.6 cm (Florence: Galleria degli Uffizi); Autin Graz, *Children*, 64–75; Laneyrie-Dagen, "Enfant réel," 127, 145, 149. Whether the boy is Francesco (born 1541), Giovanni (born 1543), or Garzia (born 1547) remains uncertain.

198 Jacob Willemsz. Delff I, *Two-Year-Old Boy* (1581), panel, 61.5 × 47.5 cm (Amsterdam: Rijksmuseum). See Bedaux and Ekkart, *Pride and Joy*, 102–3. Cf. Ludolf de Jongh (1616–1679), *Boy Training His Dog* (1661), oil on canvas, 97.8 × 71.4 (Richmond: Virginia Museum of Fine Arts); Bedaux and Ekkart, *Pride and Joy*, 243–5.

199 Frans van Mieris, *Willem Paets in His Cradle* (1665), drawing, black chalk, 10 × 13 cm (Paris: Institut Néerlandais), and Frans van Mieris, *Portrait of Willem Paets as a Child* (1665), drawing, black chalk on vellum, 29.4 × 23.3 cm (London: British Museum); Buvelot et al., *Frans van Mieris 1635–1681*, 172–4.

200 Bartholomeus van der Helst, *Boy with Spoon* (c. 1644), canvas, 100 × 130 cm (private collection); Bedaux and Ekkart, *Pride and Joy*, 182–3; cf. on masculinity in child portraits, see Laneyrie-Dagen, "Lorsque l'enfant paraît," 43–5.

201 Jan de Bray, *Boy with a Basket of Fruit* (1685), oil on panel, 67 × 56 cm (Boston: Museum of Fine Arts, Charles H. Bayley Picture and Painting Fund); Bedaux and Ekkart, *Pride and Joy*, 240–2.

202 Willem van der Vliet, *Unidentified Boy* (1638), oil on panel, 93 × 76 cm (Amsterdam: Rijksmuseum); Bedaux and Ekkart, *Pride and Joy*, 164–5.

203 Frans Hals, *The Taste (Boy with a Glass)* (c. 1625–8), oil on panel, diameter 38 cm (Schwerin: Gemäldegalerie Staatliches Musem); Autin Graz, *Children*, 90–1. See also Frans Hals, *Laughing Boy* (1625), oil on panel, diameter 38 cm (The Hague: Mauritshuis).

204 Frans Hals, *Singing Boy with Flute* (c. 1627), oil on canvas, 62 × 54.6 cm (Berlin: Gemäldegalerie Staatliche Museen); Gersdorff, *Kinderbildnisse*, 145–6.

205 Hieronymus Bosch, *The Pickpocket* (c. 1475), oil on panel, 53 × 65 cm (Saint-Germain-en-Laye: Muséé Municipal); Autin Graz, *Children*, 118–19; cf. Nicolaes Maes, *Sleeping Man Having His Pockets Picked* (c. 1656), panel, 34.3 × 29.2 (Boston: Museum of Fine Arts); Van Suchtelen et al., *Nicolaes Maes*, 88–91.

206 Johannes Verspronck, *Boy Sleeping in a High Chair* (1654), panel, 96 × 75.7 cm (Belgium: private collection); Bedaux and Ekkart, *Pride and Joy*, 227–9; Laneyrie-Dagen, "Enfant réel," 155.

207 Giuseppe Cesari, *Child Next to a Horse's Head* (1635–40), 42 × 28 cm (Berlin: Staatliche Museen zu Berlin, Kupferstichkabinett, KdZ 22376). Mostly a horse occurs in a portrait of a boy and only occasionally in that of a girl; Laneyrie-Dagen, "Enfant réel," 152–4.

208 Dirck Dircksz. Santvoort, *Willem van Loon* (1636), oil on panel, 62.5 × 52 cm (Amsterdam: Museum Van Loon); cf. Dirck Dircksz. Santvoort, *Boy in White (Probably Simon van Alteren)* (*c.* 1641), oil on panel, 87.5 × 68 cm (Netherlands: private collection); Bedaux and Ekkart, *Pride and Joy*, 158–9, 180–1; Dekker, *Het verlangen*, 118–19.

209 Rembrandt van Rijn, *Titus at His Desk* (1655), oil on canvas, 77 × 63 cm (Rotterdam: Museum Boijmans-Van Beuningen); Schama, *Rembrandt's Eyes*, 610; Autin Graz, *Children*, 94–9; Laneyrie-Dagen, "Enfant réel," 166–7. Cf. Rembrandt van Rijn, *Titus Reading Aloud* (1656), oil on canvas, 71 × 64 cm (Vienna: Kunsthistorisches Museum).

210 Andrea Mantegna, *The Circumcision* (1461), tempera on panel, 86 × 43 (Florence: Galleria degli Uffizi); Laneyrie-Dagen, "Lorsque l'enfant paraît," 43–4.

211 (After) Albrecht Dürer, *Study of an Infant* (1525), drawing, 262 × 170 mm (Berlin: Staatliche Museen zu Berlin, Kupferstichkabinett, KdZ 17658); Anzelewsky and Mielke, *Albrecht Dürer*, 139. The drawing was probably a preliminary study for Dürer's Uffizi Madonna.

212 Matthias Grünewald, *Head of a Crying Child* (1515–20), drawing, 24.7 × 20.2 cm (Berlin: Staatliche Museen zu Berlin, Kupferstichkabinett, KdZ 12319); Roth, *Matthias Grünewald*, no. 25, 69–70, 181 (quote). The child in another drawing with the same title, *Head of a Crying Child* (1515–20) (Berlin: Staatliche Museen zu Berlin, Kupferstichkabinett, KdZ 1070); Roth, *Matthias Grünewald*, no. 24, 67–8, seems to be angry rather than sad and shows less extreme emotions than the child in drawing numbered KdZ 12319.

213 Anonymous, *Girl with a Dead Bird* (*c.* 1520), oil on panel, 36.5 × 29.5 cm (Brussels: Musées Royaux des Beaux-Arts de Belgique); Bedaux and Ekkart, *Pride and Joy*, 88–9. Laneyrie-Dagen, "Lorsque l'enfant paraît," 145, 148, gives a funereal interpretation of the image that either would refer to a girl already passed away or warn for the announcement of death generally and of children in particular.

214 Rembrandt van Rijn, *The Rape of Ganymede* (*c.* 1635), drawing, 18.3 × 16 cm (Dresden: Staatliche Kunstsammlungen Dresden, Kupferstich-Kabinett, inv. C1357), and Rembrandt van Rijn, *The Rape of Ganymede* (1635), oil on canvas, 171 × 130 cm (Dresden: Gemäldegalerie Alte Meister, Staatliche Kunstsammlungen). See Slive, *The Drawings*, 184–6, who connects parents and telescope with a passage in Karel van Mander's *Schilder-boeck* (1604). Cf. Correggio, *Ganymede* (*c.* 1531–2), 163 × 70 cm (Vienna: Kunsthistorisches Museum), www.wga.hu/html_m/c/corre ggi/mytholog/ganymede.html (accessed April 8, 2023). Cf. Laneyrie-Dagen, "Enfant réel," 95, 188. Cf. Royalton-Kisch and Schatborn, "The Core Group of Rembrandt Drawings, II," 331, 333; Bevers, "Review," 72–3; cf. several versions by Nicolaes Maes, for example, *George de Vicq as Ganymede* (1681), canvas, 97 × 82 cm (Cambridge, MA: Fogg Art Museum, Harvard University Art Museums); Bedaux and Ekkart, *Pride and Joy*, 289–91.

215 Caravaggio's *Boy Bitten by a Lizard* (1594–5), oil on canvas, 66 × 49.5 cm (London: The National Gallery); Beavan, "The Visual Arts," 87; www.nationalgallery.org.uk/paintings/miche langelo-merisi-da-caravaggio-boy-bitten-by-a-lizard (accessed April 8, 2023).

216 Jarzebowski, *Kindheit*, 172–3, 215–18; Farge, "Marginaux"; Geremek, "Le marginal"; Dekker, "The Fragile Relation."

217 Cf. Mareel et al., *Renaissance Children*, 170–1, *Fragment of a Funerary Monument of a Swaddled Infant* (*c.* 1550–600), marble (Paris: Louvre).

Notes

4 The Birth of a Mission: Educating Emotional Literacy in the Age of Renaissance and Reformation

1. Simons and Zika, "The Visual Arts," 100.
2. Haemers, "In Public," 145, referring to Rosenwein, *Anger's Past*, 3.
3. See also Dekker, *Educational Ambitions*, 43–66; Dekker, "The Restrained Child"; Dekker, "Images as Representations"; Dekker, "Beauty and Simplicity"; Dekker, "Moral Literacy."
4. See Nicolaes Maes (1634–1693), *Group Portrait as Mirror of Virtue* (c. 1670–5), oil on canvas, 152 × 175 cm (Italy: private collection); Bedaux and Ekkart, *Pride and Joy*, 279–80. The virtues are personified by children, one of them already died and depicted as an angel. Virtues were mostly not depicted in portraits.
5. Cats, *Alle de wercken*, III, 173, and V, 55, quoted by Kluiver, "Het gezin," 94n61. Cf. Frijhoff and Spies, *1650*, 464–6.
6. Teellinck quoted by Dekker et al., "Proudly Raising," 44; Groenendijk, *De Nadere Reformatie*, 20, 23, 25–34.
7. Cats, *Alle de wercken* (1655 edition), 55, quoted by Kluiver, "Het gezin," 94n61. Dekker and Groenendijk, "The Republic of God," 317–35.
8. Dekker, *Educational Ambitions*, 33–41.
9. Becchi, "Humanisme," 66.
10. Manzke, *Remedia pro infantibus*, 31–2, Jarzebowski, *Kindheit*, 45, 48, and Becchi, "Humanisme et Renaissance," 166, on Metlinger; Blankaart, *Verhandelinge*, 28, quoted in Bedaux and Ekkart, *Pride and Joy*, 77; Roberts, *Through the Keyhole*, 84–7.
11. Revel, "Les usages de la civilité," 169–209. Cf. Dixon, "Church," 35–41; Groenendijk, "Marnix' kindercatechismus," 76–86; Dekker et al., "Proudly Raising," 45–6; Frijhoff and Spies, *1650*, 370; Julia, "L'enfance," 286–373.
12. Groenendijk, "Piëtistische opvoedingsleer"; Roberts, "Jacob Cats (1577–1660)," 19–20; Groenendijk, "Continuïteit en verandering," 137–42; Kruithof, *Zonde en deugd*, 37, 41–2.
13. Groenendijk, *De pedagogiek van Jacobus Koelman*, 219; Groenendijk, "The Sanctification of the Household"; Fleming, *Children and Puritanism*.
14. Roeck, *Der Morgen*, 499–503; Becchi, "Humanisme et Renaissance"; 165–70; Garin, "L'image de l'enfant," 232–47.
15. Erasmus, *A Declamation*, 346.
16. Dekker, *Educational Ambitions*, 31–42; Jarzebowski, *Kindheit*, 55; Revel, "Les usages de la civilité," 172–3; Becchi, "Humanisme et Renaissance," 173–84; Bierlaire, "Colloques scolaires," 257–80; Groenendijk, "De humanistische achtergrond," 11–118; Todd, *Christian Humanism*; Julia, "L'enfance," 342–61; Groenendijk, *Jong gewend, oud gedaan*, on Erasmus's *De pueris*.
17. Tuttle Ross, "Understanding Propaganda," 16, 18; Dekker, "Beauty and Simplicity," 169.
18. Van Straten, *Inleiding*, 38–46. Cf. Daly, *The European Emblem*; De Jongh, *Zinne- en minnebeelden*; Porteman, *Inleiding*; Hekscher and Wirth, "Emblem," 85–228. On the birth of the emblem in Italy, Van Stipriaan, *Het volle leven*, 129; Dekker, "The Restrained Child," 25–7.

19 Hall, *Dictionary*, x; Dekker, "Dangerous," 393–5; Dekker, "The Restrained Child," 25–7; Franits, *Dutch Seventeenth Century*, 4.
20 On Cats: van Deursen, "De raadspensionaris"; Van Stipriaan, *Het volle leven*, 129, 133; Grootes, "Literatuurhistorie," 9–28; Dekker, "Woord en beeld."
21 Jansen, "The Emblem Theory."
22 Cats, *Sinne- en minnebeelden* (1996 edition), vol. 2, 8, 11; Jansen, "The Emblem Theory," 227–42; Dekker, *Het verlangen*, 151–3; Dekker, "Woord en beeld," 54–7; Porteman, "Miscellanea emblematica," 161–4; Porteman, "Het embleem als 'genus iocosum,'" 184–96; Porteman, "Ey, kijckt toch," 732–46; Dekker, *Educational Ambitions*, 45–6, 55–66.
23 Huizinga, *Nederland's beschaving*, 89–91, had to admit that Cats—and not Vondel, Hooft, or other famous Dutch poets—was the most widely read author; Dekker, *Het verlangen*, 50.
24 Cats, *Huwelijk*; Kluiver, "Het gezin," 56–61.
25 Cats, *Spiegel*; van den Broek, *De spreekwoorden*; Dekker and Wichgers, "The Embodiment," 58–65. Editions published after the seventeenth century differ slightly; for all editions, Bos and Gruys, *Cats Catalogus*.
26 Cats, *Sinne- en minnebeelden* (1996 edition), vol. 2, 8, 11. Cats, *Alle de wercken*, 281, quoted by Drees, "'Burgerlijke' zeventiende-eeuwse literatuur," 151; Dekker, "Woord en beeld," 47–65.
27 Dekker, "Dangerous," 390–9; Dekker, "Mirrors of Reality," 42–6.
28 Dekker, *Educational Ambitions*, 48–9.
29 Groenendijk, *De pedagogiek*, 672ff.; Dekker et al., "Proudly Raising," 51. Religious mixed marriages were exceptional in the Dutch Republic. Frijhoff and Spies, *1650*, 358; Knippenberg, *De Religieuze Kaart*, 9–62.
30 Cats, *Huwelijk*, 134; De Jongh and Luijten, *Mirror*, 80–4, on genre drawings.
31 O'Hara, *Courtship*; Fletcher, *Gender*, 185, 173–91.
32 Goldberg and Tarbin, "In Private," 128.
33 Dekker et al., "Proudly Raising," 59n7; Dekker, *Educational Ambitions*, 15–17; Fletcher, *Gender*; O'Hara, *Courtship*.
34 McNamer, "Literature," 108–10.
35 Erasmus, *A Declamation*, 315.
36 Ibid., 299; Ariès, *L'Enfant*, 44.
37 Erasmus, *A Declamation*, 310.
38 Ibid., 306; Jarzebowski, *Kindheit*, 53.
39 Cats, *Alle de wercken*, III, 173, V, 55, quoted by Kluiver, "Het gezin," 94n61. Frijhoff and Spies, *1650*, 464–6; Kruithof, *Zonde en deugd*, 36–9; Morel and Rollet, *Des bébés et des hommes*.
40 Perry Chapman et al., *Jan Steen*. On Steen: Franits, *Dutch Seventeenth Century*, 203–14. On Steen and education, Gruschka, *Der heitere Ernst*; Durantini, *The Child*, 59–61; Chapman, "Jan Steen's Household Revisited," 183–96; Brown, *Sources of Everyday Life*, 83–8. Among his many paintings on the proverb are also *Family Scene* (*c.* 1660–79), oil on panel, 48.5 cm × 40 cm (Amsterdam: Rijksmuseum), which shows happiness, exaltation, enjoyment, and lust; *As the Old Sing, So Pipe the Young* (*c.* 1663–5), oil on canvas, 134 × 163 cm (The Hague: Koninklijk Kabinet van Schilderijen, Mauritshuis); Chapman et al., *Jan Steen*, 172–3; van Suchtelen, *Jan Steen's Histories*, 56ff.; *Light Come Light Go* (1661), oil on canvas, 79 ×

Notes

104 cm (Rotterdam: Museum Boijmans-Van Beuningen); *As the Old Sing, so Twitter the Young* (The Hague: Galerij Willem V, Mauritshuis). On Cats's influence on Jordaens, see De Jongh and Luijten, *Mirror*, 256n12, and Franits, *Dutch Seventeenth Century*, 206, 208; De Jongh's *Zinne- en minnebeelden*; Brown, *Sources*, 83–8.

41 Jan Steen, *The Dissolute Household* (*c.* 1661–4), oil on canvas, 80.5 × 89 cm (London: The Board of Trustees of the Victoria & Albert Museum); according to Franits, *Dutch Seventeenth Century*, 212, 206–8, figure 194, it is "a scene of utter chaos and parental abandon"; cf. Jordaens, *Soo d'Oude songen, Soo Pypen de Jonge* (1640), canvas, 165 × 235 cm (Paris: Collection Galerie Jean-François Heim); De Jongh and Luijten, *Mirror*, 253–6, on Jordaens's influence on Dutch genre prints.

42 Jan Steen, *When Living in Wealth, Beware* (1663), canvas, 105 × 145 cm (Vienna: Kunsthistorisches Museum, Gemäldegalerie, KHM-Museumsverband); Dekker, "The Restrained Child," 34–6; Franits, *Dutch Seventeenth Century*, 206; Dekker, *Het verlangen*, 94; Perry Chapman, *Jan Steen*, 166–8.

43 Franits, *Dutch Seventeenth Century*, 213–14.

44 Erasmus, *A Declamation*, 313.

45 Ibid., 317, 335.

46 Ibid., 312.

47 Ibid., 298.

48 Ibid., 318.

49 Cats, Emblem I, "Rami correcti rectificantur, trabsminimè," or "A young twig can be bent, but old trees not," *Spiegel*, 1–3; quote in Dutch: "de jeugth, de teere jeught / Dient van den eersten afgebogen tot de deught." Cf. Dekker and Wichgers, "The Embodiment," 60.

50 Erasmus, *A Declamation*, 315–16; Parrish, "Education," 594.

51 Erasmus, *A Declamation*, respectively, 316, 317, 324, 341, and 339.

52 Ibid., 340.

53 Jarzebowski, *Kind*, 58–9.

54 Cf. the education at home in the family of Constantijn Huygens; Dekker, *Het verlangen*, 69–75.

55 Erasmus, *A Declamation*, respectively, 320, 336, 342, 336.

56 Ibid., 337; on Comenius, see Szórádová, "Contexts and Functions"; Norlin, "Comenius"; Gyeong-Geon and Hun-Gi, "John Amos Comenius." On Comenius and visual culture, see Frijhoff, *Comenius, the Dutch, and Visual Culture*.

57 Erasmus, *A Declamation*, 338, 343.

58 Cats, *Huwelijk*, 21; Goldberg and Tarbin, "In Private," 138.

59 Cats, *Huwelijk*, 118–20; Dekker, *Educational Ambitions*, 52–5.

60 Groenendijk, *De Nadere Reformatie*, 154; Durantini, *The Child*, 80–5; Kloek in Perry Chapman, *Jan Steen*, 197; De Jongh, "Jan Steen," 42.

61 Cats, *Alle de wercken*, III, 127, III, 173, V, 57, quoted by Kluiver, "Het gezin," 95n119, 120.

62 Erasmus, *A Declamation*, 313.

63 Ibid., 309. Cf. Lynch, "Introduction," 10, on sixteenth-century misogyny.

64 Lynch, "Introduction," 10; Franits, *Paragons of Virtue*.

65 Anonymous, *Family Portrait with Mother Who Reads in Houwelick by Jacob Cats* (1650), oil on canvas, 85.5 × 107.5 cm (Budapest: Museum of Fine Arts/Szépmüvészeti Múzeum); cf. Dekker, "Looking at Filtered Realities," 36–7.
66 Erasmus, *A Declamation*, 68.
67 Sadoleto, *De liberis*, 359, 370–1, quoted by Jarzebowski, *Kindheit*, 58n91, 89.
68 Marnix van St Aldegonde, *Ratio instituendae iuventutis*, 35; De Rycke, "A Pedagogical Treatise," 203–10; Duits and van Strien, *Een intellectuele activist*; Frijhoff, "Marnix," 59–75. Cats, *Huwelijk*, 113–15; Fildes, *Breasts, Bottles*, and Fildes, *Wet Nursing*; Groenendijk, "Piëtisten en borstvoeding."
69 Pieter Fransz de Grebber, *Mother and Child* (1622), oil on panel, 99 × 73 cm (Frans Hals Museum, Haarlem, acquired with support from the Vereniging Rembrandt); Dekker, "Looking at Filtered Realities," 39.
70 François Clouet, *Diane de Poitiers* (1571), oil on panel, 92.1 × 81.3 cm (Washington, DC: National Gallery of Art); Autin Graz, *Children*, 202.
71 Jan Steen, *The Fat Kitchen* (c. 1650), oil on panel, 71 × 91.5 cm (private collection); Jan Steen, *The Meagre Kitchen* (c. 1650), oil on panel, 69.7 × 92 cm (Ottawa: National Gallery of Canada); Chapman, *Jan Steen*, 103–8; Dekker, "Beauty and Simplicity," 176–7.
72 Gerrit Dou, *Young Mother* (c. 1660), oil on canvas, 49.1 × 36.5 cm (Berlin: Gemäldegalerie Staatliche Museen); Durantini, *The Child*, 7–11; Sutton, *Masters*, 185–6; Gersdorff, *Kinderbildnisse*, 14–16; Dekker, "A Republic of Educators," 165–6; Dekker, "Beauty and Simplicity," 178.
73 Huygens, *Mijn leven verteld*, vol. 1, 21–2, 140–3; Huygens, "De jongelingsjaren," 89, 91, 93.
74 Gheeraert David, *Virgin and Child with a Bowl of Pap* (c. 1515), oil on panel, 33 × 27.5 cm (New York: Aurora Trust); Autin Graz, *Children*, 120–1. Cf. Gheeraert David, *Virgin and Child in a Landscape* (c. 1520), oil on panel, 24.7 × 42.6 cm (Rotterdam: Museum Boijmans-Van Beuningen), showing Mary with bare breast and Jesus on her lap, www.boijmans.nl/en/collection/artworks/3726 (accessed May 25, 2022).
75 Gerrit Dou, *Young Mother* (1658), oil on panel, 73.5 × 55.5 cm (The Hague: Mauritshuis); Wheelock, *Gerrit Dou*, 106–7, 140, 145; Boersma, "Dou's Painting"; Dekker, *Beauty and Simplicity*, 174–5. Cf. Gerard Dou, *Young Mother* (c. 1654–5) (Berlin: Staatlichen Museen zu Berlin), which shows care and tenderness of a mother with her baby on her arm with an empty crib. Cf. Samuel van Hoogstraten, *Mother with Child in a Crib* (1670), oil on canvas, 69.8 × 56.5 cm (Springfield, MA: Museum of Fine Arts): Brown, "… *Niet ledighs of Ydels* …," 140–1; Dekker, *Beauty and Simplicity*, 175.
76 Pieter de Hooch, *The Mother* (c. 1661–3), oil on canvas, 92 × 100 cm (Berlin: Gemäldegalerie Staatliche Museen); Jansen, *Pieter de Hooch*, 174–5; Dekker, *Beauty and Simplicity*, 176; Dekker, *Het verlangen*, 102–3; Gersdorff, *Kinderbildnisse*, 19. De Jongh and Luijten, *Mirror*, 268–71, on a series of engravings by Geertruyt Roghman (1625–c. 1651–7) about female domestic duties (Amsterdam: Rijksprentenkabinet, Rijksmuseum). See other examples in Jansen, *Pieter de Hooch*, 160, 176.
77 Gerard Ter Borch, *Motherly Cares* (c. 1652–3), oil on panel, 33.5 × 29 cm (The Hague: Mauritshuis); Wheelock, *Gerard Ter Borch*, 90–1; Dekker, "A Republic," 164; Dekker, *Het verlangen*, 101–2;

Notes

Durantini, *The Child*, 29; Brown, "... *Niet ledighs*," 143–7; De Jongh et al., *Tot lering en vermaak*, 42. On Dirck Hals, see Sutton, *Masters*, 143. Schama, *Embarrassment*, 395, characterizes such paintings as "some of the most affecting family scenes in Dutch genre painting." Cf. Pieter de Hooch, *Motherly Cares* (c. 1660–1), oil on canvas, 52.5 × 61 cm (Amsterdam: Rijksmuseum in loan from Municipality of Amsterdam); Jansen, *Pieter de Hooch*, 172–3.

78 Caspar Netscher, *Motherly Cares* (1669), oil on panel, 44 × 38 cm (Amsterdam: Rijksmuseum); De Jongh, *Tot lering en vermaak*, 197–9; Durantini, *The Child*, 231; Dekker, *Verlangen*, 105. Cf. Quirijn van Brekelenkam, *Woman Combing a Child's Hair* (1648), oil on panel, 57 × 53 cm (Leiden: Municipal Museum De Lakenhal); Durantini, *The Child*, 47; Sutton, *Masters*, 158; Dekker, *Beauty and Simplicity*, 175. On hair combing in drawings, see De Jongh and Luijten, *Mirror*, 257–9n5; Dekker, "Message et réalité," 384.

79 Pieter de Hooch, *The Pantry* (c. 1660), oil on canvas, 64 × 60 cm (Amsterdam: Rijksmuseum); Brown, "... *Niet ledighs*," 143.

80 Fathers were, in contrast to mothers, permitted to boast about their children; Cats, *Huwelijk*, 118–20.

81 Jacob Cats, Emblem IV, "Wann man die Sauer kutzelt, so legt sie sich im dreck" ["When the swine is pampered, she goes lying in the manure"], *Spiegel* (1657); Dekker and Wichgers, "The Embodiment," 60–1; Dekker, "Dangerous," 395–7.

82 Cats, Emblem V, "Elck spiegle hem selven" ["Everybody should look in the mirror"], *Spiegel* (1657), 13; Dekker and Wichgers, "The Embodiment," 61.

83 Erasmus, *A Declamation*, 322–3. Cf. Jarzebowski, *Kindheit*, 54–5, on Erasmus. See Maarten van Heemskerck, attributed to (1498–1574), *Twelve-Year-Old Boy* (1531), oil on panel, 46.5 × 35 cm (Rotterdam: Museum Boijmans Van Beuningen), showing a cheerful and serious boy sitting at his desk with a text by Erasmus on the Christian virtues; Bedaux and Ekkart, *Pride and Joy*, 92–3; Laneyrie-Dagen, "Enfant réel," 165–6.

84 Erasmus, *A Declamation*, 315, 324–5, 334.

85 Ibid., 333.

86 Cats, *Sinne- en minnebeelden* (1996 edition), vol. 1, 138–43, vol. 2, 363; Nevitt, *Art*, 225–6.

87 Cats, *Huwelijk*, 24; Cats, *Sinne- en minnebeelden* (1996 edition), fn. 31, vol. 1, 138–43, vol. 2, 363; Roberts, *Sex and Drug*; Groenendijk and Roberts, *Losbandige jeugd*; Groenendijk and Roberts, "Vader Cats," 82; Nevitt, *Art*, 2003, 8, 18; Dekker, "Moral Literacy," 148–51.

88 Cats, *Huwelijk*, 24.

89 Cats, Emblem XXX, "Better sitting with the owl than flying with the falcon," *Spiegel*, 90–2; Dekker and Wichgers, "The Embodiment," 63.

90 Cats, Emblem XXXI, "Met onwillige honden ist quaet hasen vangen" ["With unwilling dogs it is difficult to catch hares"], *Spiegel*, 96; Dekker and Wichgers, "The Embodiment," 63–4.

91 O'Hara, *Courtship and Constraint*.

92 Huygens, *Dagh-werck*, quoted in *Mijn leven*, vol. 2, 259–64; Dekker, *Educational Ambitions*, 59–60.

93 Justus van Egmont (1601–1674), *Alexander, Jan-Cornelis and Maria-Aldegonda Goubau* (1663), oil on canvas, 140 × 269 cm (Belgium: private collection); Bedaux and Ekkart, *Pride and Joy*, 249–51.

94 Quoted by McNamer, "Literature," 118; cf. Burger, *Conduct Becoming*.
95 Erasmus, *On Good Manners*, 273–4.
96 Ibid., 274. Cf. the ambition of Renaissance painters to express the emotions of the portrayed person, in particular through the eyes and gestures (see Chapter 3).
97 Erasmus, *On Good Manners*, 275. Cf. Beauvalet, "Children," 73.
98 Erasmus, *On Good Manners*, 277.
99 Ibid., 278, 274.
100 Ibid., 280.
101 Goldberg and Tarbin, "In Private," 134.
102 Erasmus, *On Good Manners*, 283–4.
103 Ibid., 284–5.
104 Ibid., 286–8, 289.
105 Goldberg and Tarbin, "In Private," 128–9, 136–7.
106 Erasmus, *On Good Manners*, 289.
107 Santing and van Steensel, "Family," 92.
108 Bantock, "Educating the Emotions," 135.
109 Cf. Goldberg and Tarbin, "In Private," 123; Laneyrie-Dagen, "Lorsque l'enfant paraît," 58.
110 Cats, *Sinne- en minnebeelden* (1996 edition), vol. 1, Emblem I, *Quod perdidit, optat*, 39, vol. 2, 160; Nevitt Jr., *Art*, 101; van Stipriaan, *Het volle leven*, 140–8.
111 Dekker, "The Restrained Child," 37–8. Cats, Emblem VI, "Es musz ein ieder ein par narren Schuhen vertretten, wo nicht mer," *Spiegel*, 15–18. Cf. Dekker, *Het verlangen*, 151–3; Dekker and Wichgers, "The Embodiment," 61. The jester refers to Bruegel's painting on carnival.
112 Van Stipriaan, *Het volle leven*, 140–8. For songbooks, see Nevitt, *Art*, 7–8, 227, 233–4. On literature on romantic love, see McNamer, "Literature," 108–10; Simons and Ziksa, "The Visual Arts," 105–6; Laneyrie-Dagen, *L'Invention du corps*, 97–139.
113 Cats, *Huwelijk*, 16, 18, 21; Nevitt, *Art*, 9–10; Groenendijk and Roberts, *Losbandige jeugd*; Dekker, "Moral Literacy," 149–50.
114 Cats, Emblem XXV, "Qui captat, capitur," *Sinne- en minnebeelden*. In *Alle de wercken* (Amsterdam: Schipper, 1665). See Cats, *Sinne- en minnebeelden* (1996 edition), fn. 31, vol. 1, 180–5, vol. 2, 439–49. See Dekker, "Moral Literacy," 140.
115 Cats, *Sinne- en minnebeelden* (1996 edition), vol. 1, Emblem XL, *Non intrandum, aut penetrandum*, 270–5, vol. 2, 603–15. Roberts and Groenendijk, "Wearing Out," 39–156, emphasize the popularity of Cats's sexual advice. Cf. Cats, *Sinne- en minnebeelden* (1996 edition), vol. 1, Emblem XXIV, *Fac sapias et liber eris*, 174–9, vol. 2, 427–38.
116 Cats, *Sinne- en minnebeelden* (1996 edition), vol. 3, 124–5, for iconographic examples.
117 Jan Steen, *Girl Eating Oysters* (*c.* 1658–60), oil on panel, 20.5 × 14.5 cm (The Hague: Stichting Koninklijk Kabinet van schilderijen Mauritshuis); Chapman, *Jan Steen*, 126–8, 126 (on Van Beverwijck); Dekker, *Het verlangen*, 149–51; Dekker, *Educational Ambitions*, 62; Dekker, *Beauty and Simplicity*, 7; Gruschka, *Der heitere Ernst*, 51. Other examples are Frans van Mieris, *The Oyster Meal* (1659), 44.5 × 34.5 cm (Saint Petersburg: Hermitage); Frans van Mieris, *The Oyster Meal* (1661), 27 × 20 cm (The Hague: Mauritshuis) with the man as seducer; Buvelot et al., *Frans van Mieris*, 129–31, 146–7; De Jongh, *Tot lering en vermaak*, 114, 236–9.

Notes

118 Jacob Gerritsz. Cuyp, *Two Children with a Lamb* (1638), oil on panel, 78.5 × 107.5 cm (Cologne: Wallraf-Richartz-Museum); Bedaux and Ekkart, *Pride and Joy*, 160–1. The children are anonymous in this painting in-between portrait and genre painting. See Dekker, "Beauty-and-Simplicity," 181–2.

119 Jacob Gerritsz. Cuyp, *Four-Year-Old Girl with Cat and Fish* (1647), oil on canvas, 108 × 80 cm (The Netherlands: private collection); Bedaux and Ekkart, *Pride and Joy*, 194–5.

120 Cats, *Sinne- en minnebeelden* (1996 edition), vol. 2, 56–75, 79–88; Groenendijk and Roberts, "Vader Cats: een piëtistisch pedagoog," 82; Nevitt, *Art*, 8; Groenendijk, "Jeugd en deugd," 95–115; Schotel, *Het Oud-Hollandsch Huisgezin*, 214–48; Groenendijk, *Jacobus Koelman*; Dekker et al., "Proudly Raising," 10.

121 Erasmus, *A Declamation*, 332. Cf. Haemers, "In Public," 153 on shame.

122 Albano, "The Puzzle," 495.

123 Deploige, "Studying Emotions," 16; Oatley, Emotions, 16; Elias, *Über den Prozeß*, vol. 1, 89–109; Cowan, "In Public," 158n1, 179, on Weber's *The Protestant Ethic*; Plamper, *The History of Emotions*, 49–53; Dekker and Wichgers, "The Embodiment," 53–4.

5 The Big Talk on Education and Emotions in the Age of Enlightenment, Romanticism, and Science

1 Jean-Baptiste-Siméon Chardin, *Boy with a Spinning-Top (Auguste-Gabriel Godefroy (1728–1813))* [L'Enfant au toton] (1738), oil on canvas, 67 × 76 cm (Paris: Musée du Louvre); Allard, "La quête," 237–8; Wachelder, "Chardins Touch," 36–7 (in that article he pointed out to me the significance of Chardin); Rosenberg, *Chardin*, 12, 17, 71, 84–8, 97, 117, 251–3, illustration 8, n°121; cf. Roland-Michel, *Chardin*. See also John Singleton Copley, *A Boy with a Flying Squirrel, or, Henry Pelham* (1765), oil on canvas, 77.1 × 63.8 cm (Boston: Museum of Fine Arts), www.khanacademy.org/humanities/art-americas/british-colonies/colonial-period/ (accessed September 6, 2022); Allard, "La quête," 201.

2 Hieronijmus van Alphen, *Kleine gedichten voor kinderen (Proeve)*, "Het vrolijke leren," 24–5; Parlevliet and Dekker, "A Poetic Journey," 750–1.

3 Gerard Ter Borch, *Boy Picking Fleas Off His Dog* (1655), oil on panel, 35 × 27 cm (Munich: Alte Pinakothek); Dekker, *Het verlangen*, 129–30; Durantini, *The Child*, 29, 267–8; Steingräber, *Alte Pinakothek*, 77; Wheelock, *Gerard Ter Borch*, 118–19.

4 Buchardt, "Church," 35–9; Israel, *Radical Enlightenment*.

5 Cf. Osterhammel, *Die Verwandlung der Welt*; Dekker, "Looking at the Voices."

6 Osterhammel, *Die Verwandlung*, 197–8; Mitchell, *International Historical Statistics*, 117–18.

7 Alston and Harvey, "In Private," 145; cf. Osterhammel, *Die Verwandlung*, 909–28, on industrialization.

8 Blake, *The Chimney Sweeper*, www.poetryfoundation.org/poems/43654/the-chimney-sweeper (accessed October 10, 2021). See Dekker, "Educational Space," 8; Dekker, "Looking at the Voices."

9 Chassagne, "Le travail des enfants"; Westberg et al., *School Acts*; Dekker, *Het verlangen*, 369–77; Osterhammel, *Die Verwandlung*, 410, 118–1122.

10 Tröhler, "Introduction," 9 quoting Locke.
11 Buijnsters, "Nawoord," 178; Cunningham, *Children*, 62–7; Los, "Locke in Nederland," 173–86; Dekker, *Het verlangen*, 194, 266.
12 Pender, "Medical," 24.
13 Tröhler, "Introduction," 22.
14 Ibid., 3; cf. Depaepe, *Between Educationalization*, 121–38.
15 Tröhler, "Introduction," 17–18 (quote).
16 Williams, "Church," 18.
17 Ibid., 25.
18 Westberg et al., *School Acts*; Frijfhoff, *L'Offre d'école*, on France; Dekker et al., "Education in a Nation Divided"; Dekker, "From Imaginations to Realities."
19 Williams, "Church," 17.
20 Ibid., 28–30.
21 Dekker and Lechner, "Discipline and Pedagogics in History."
22 Westberg et al., *School Acts*; Osterhammel, *Die Verwandlung*, 1128–32: Dunne, "Learners and Learning"; Horlacher, "Teachers and Teaching."
23 Dekker, "Entre Rousseau et péché originel," 27–42.
24 Dekker, "Philanthropic Networks," 235–44; Dekker and Becker, *Doers*.
25 Mettray, a reeducation colony near Tours in France (1839), was described by Michel Foucault as "the most intensive disciplinary model, concentrating all behavioral coercive technologies": Foucault, *Surveiller et punir*, 300 (my translation); Dekker, "Admiration et inspiration," 225–38.
26 Dupont-Bouchat et al., *Enfance et justice*; Dekker, *The Will*, 41–55; Dekker, "Children at Risk."
27 Williams, "Church," 28.
28 Buijnsters and Buijnsters, *Lust en leering*, 10; Grandière, *L'idéal pédagogique*; Py, *Rousseau*; Rosenberg, "Rousseau's Emile"; Dekker, *The Will*, 43; van Crombrugge, "Émile en Sophie"; van Crombrugge, "Rousseau on Family and Education"; Lüth, "Staatliche und private Erziehung"; Dekker, *Het verlangen*, 194–5.
29 Rousseau, *Émile*, 77 (my translation); Dekker, *The Will*, 43; Carlier, *La prison*, 131; Grandière, *L'idéal pédagogique*, 129–46; Py, *Rousseau*; Rosenberg, "Rousseau's Emile"; Corbin, *Le miasme*.
30 Rousseau, *Émile*, 189, 104 (my translation); Staines, "Literature," 134–5; cf. Tröhler, "Rousseau's *Emile*, or the Fear of Passions," 477–89.
31 Tröhler, "Introduction," 19; Caruso et al., "Education and Nature."
32 Gobbers, *Jean-Jacques Rousseau in Holland*, 30–6; Dekker, *Verlangen*, 195–6.
33 Quoted by Eiselein, "Literature," 127; cf. Staines, "Literature," 135.
34 Baader, *Die romantische Idee*; Cunningham, *Children*, 73–4; Dekker, "Mystification," 29; Willinsky, "Lessons from the Wordsworths"; McLane, *Romanticism*, 2, 43–83.
35 Andresen and Baader, *Wege*, 91; Heiland, "Fröbel en de Fröbelbeweging."
36 Tröhler, "Introduction," 3; Tröhler, *Pestalozzi*.
37 Fröbel, *The Education of Man*, 21, 8–9, 11; Dekker, "Looking at the Voices"; cf. Luc, *L'invention du jeune enfant au XIXe siècle*; Tschurenev, "Knowledge," 46–9.

38 Brehony, "Progressive and Child-Centred Education," with contributions on Fröbel, Pestalozzi, Montessori, Dalton, and Jean Piaget; Brehony, "Early Years Education"; cf. the classic Oelkers, *Reformpädagogik*; Oelkers, "Break and Continuity"; on Decroly, see Depaepe et al., *Ovide Decroly (1871–1932)*.
39 Hawkins, *Social Darwinism*, 216–48; Wooldridge, *Measuring*, 19–20; Dekker, "The Century"; Carol, *Histoire de l'eugénisme en France*; Carol, "Médecine et eugénisme en France"; Lowe, "Eugenicists"; Dekker, *Het verlangen*, 309.
40 Key, *The Century of the Child*, 46, 59–60, 44, 231, 275; Dekker, "The Century"; Dekker, "Demystification in the Century of the Child"; Dekker, "Looking at the Voices"; Andresen and Baader, *Wege*; Dräbing, *Der Traum*; Rilke, *Briefwechsel mit Ellen Key*.
41 Pernoud, "Au centre," 309, 418n19, referring to *L'Art à l'école* (Paris: Bibliothèque Larousse, 1908). Cf. Hofstetter and Schnewley, "Teaching Culture and Emotions."
42 Dekker, "Demystification," 31–3.
43 Williams, "Church," 34.
44 Quoted by Wooldridge, *Measuring*, 27.
45 Leahy, *A History*, 54; Blumenthal, "Leipzig, Wilhelm Wundt"; Dekker, *Het verlangen*, 308; Wooldridge, *Measuring*, 27–48; Depaepe, *Zum Wohl*; Depaepe, *De pedagogisering*, 135–42.
46 Leahy, *A History*, 114; Wooldridge, *Measuring*, 20n5; Hawkins, *Social Darwinism*, 25, quote from *Origin*; Weikart, "Laissez-Faire Social Darwinism," 17–30; Rosenberg, *Darwinism in Philosophy*; Masterton, "Charles Darwin," 17–29.
47 Hendrick, *Child Welfare*, 33–4; Wooldridge, *Measuring*, 26–7, on Darwin; Dekker, *Het verlangen*, 305, 308–9.
48 Wooldridge, *Measuring*, 30–41; Heywood, *Children in Care*, 105; Clouston quoted in Hendrick, *Images*, 110.
49 On von Strümpell, Ballauf, *Pädagogik*, III, 838; Dekker, *The Will*, 274; Dekker, "An Educational Regime," 268.
50 Matt, "Introduction," 1.
51 Ibid., 3.
52 Ibid., 3–4.
53 Cf. Dixon, *From Passions*, 66; Barclay et al., "Introduction," 2.
54 Barclay et al., "Introduction," 6.
55 Alston and Harvey, "In Private," 150–1; cf. Broomhall, *Emotions*, 14.
56 Alston and Harvey, "In Private," 145–6.
57 Barclay et al., "Introduction," 9, 11.
58 Alston and Harvey, "In Private," 145.
59 Staine, "Literature," 127; cf. Matt, "Introduction," 5.
60 Eiselein, "Literature," 133, 130.
61 Ibid., 124–5.
62 Sturkenboom, *Spectators*, 57, based on Buijnsters, *Nederlandse literatuur*, 183–99; about representative of sentimentalism, the Dutch writer Rhijnvis Feith (1753–1824), see Kloek and Mijnhardt, *1800*, 547; Koolhaas and De Vries, "Terug," 111–12; Dekker, *Verlangen*, 185.

63 Matt, "Introduction," 8; Wulf, *The Invention of Nature*, on Alexander von Humboldt's attention for nature and environment.
64 White, "Romanticism," 274, quoted by Matt, "Introduction," 7.
65 Matt, "Introduction," 9.
66 Ibid., 9–11.
67 Staines, "Literature," 131–2.
68 Eiselein, "Literature," 128 (quoting Kitson, "Beyond the Enlightenment," 15), 129.
69 Thomas, "The Visual Arts," 95, referring to, respectively, Koselleck et al., *Geschichtliche Grundbegriffe*, and Frevert, *Emotions in History*; Dixon, *From Passions*, 66.
70 Hunt, "The Enlightenment," 12, quoted by Tarantino, "Religion and Spirituality," 51.
71 Tröhler, "Introduction," 21; cf. Buchardt, "Introduction," 45.
72 Nipperdey, *Deutsche Geschichte 1800–1866*, 405; McLeod, *Religion*, 1–21, 75–97; Dekker, *The Will*, 19–24.
73 Lehner, *The Catholic Enlightenment*.
74 Duprat et al., *Philanthropies*.
75 Weber, "Wissenschaft als Beruf," 597; Jorink, *Het "Boeck der Natuere"*; Dekker, "In Search," 171–5.
76 Buchardt, "Introduction," 33, 35, 41; Frijhoff, "Jansénius et le Jansénisme."
77 Osterhammel, *Die Verwandlung*, 1272–6, 1248–50, 1251–8, 1268–9; Talmon, *Romanticism and Revolt*, 28–9.
78 Tarantino, "Religion and Spirituality," 48, quoting Beales, "Religion and Culture."
79 Tröhler, "Introduction," 4; Dekker, "In Search."
80 Barclay et al., "Introduction," 6.
81 Dassen, *De onttovering*, 195. See Dekker, "Demystification," and Dekker, "The Century."
82 Weber, "Wissenschaft als Beruf," 593–4 (English translation by Mitzman, *The Iron Cage*, 226). Dassen, *De onttovering*, 193, 369; Wax, "Magic," 59–65. Cf. Neuenhaus, *Max Weber und Michel Foucault*.
83 Dixon, *From Passions*, 17.
84 Pender, "Medical," 17.
85 Oatley, "Emotions: A Brief History," 141–2; Dixon, *From Passions*, 13.
86 Dixon, *From Passions*, 109–10, and in more detail 111–27.
87 Monagle, "Emotions and the Self," 61; Dixon, "Emotion," 339–40. If used before the Enlightenment, "emotion" was mostly a synonym for agitation and rebellion. Haemers, "In Public," 141, 145. It was neither used in classical Latin or Greek nor in the Bible; the word "motus" meant a movement of the soul; Dixon, *From Passions*, 39, 48n84.
88 Dixon, *From Passions*, 104–9, 17.
89 Quoted in Eiselein, "Literature," 122; more in detail: Dixon, *From Passions*, 98–134; Schmitter, "17th and 18th Century Theories of Emotions."
90 Dixon, *From Passions*, 76, 80.
91 Ibid., 66–7; Barclay et al., "Introduction," 5 (quote); Dekker, *The Will*, 19–23, 55–60.
92 Dixon, *From Passions*, 67–68.

Notes

93 Ibid., 83; Schmitter, "17th and 18th Century Theories of Emotions"; Schmitter, "Hutcheson on the Emotions."
94 Dixon, *From Passions*, 84.
95 Ibid., 70.
96 Ibid., 21–2.
97 Matt, "Introduction," 13; www.britannica.com/biography/Charles-Bell-British-anatomist (accessed January 30, 2023); for his influence on Darwin, see Dixon, *From Passions*, 164, 173–5.
98 Boddice, "Medical and Scientific Understandings," 19, referring to Bell, *Essays on the Anatomy of Expression in Painting*, and Bell, *Essays on the Anatomy and Philosophy of Expression*.
99 Quoted from the first edition of *The Emotions* (1859) by Dixon, *From Passions*, 156, 155, 159.
100 Boddice, "Medical and Scientific Understandings," 27–8.
101 Dixon, *From Passions*, 159, 163.
102 Ibid., 160; Darwin, "Biographical Sketch of an Infant," 291.
103 Dixon, *From Passions*, 159, 163–4, 166 (quote from Darwin, *The Expression* (1998 edition), 234).
104 Dixon, *From Passions*, 169.
105 Boddice, "Medical and Scientific Understandings," 21.
106 Dixon, *From Passions*, 172.
107 Matt, "Introduction," 2.
108 Dixon, *From Passions*, 178, 204–30.
109 James, "What Is an Emotion?" 190; James, *The Principles*, II, 449–50.
110 Boddice, "Medical and Scientific Understandings," 30. James, *The Principles*, vol. 2, 449–50.
111 Plamper, *The History of Emotions*, 177.
112 James, *The Principles of Psychology*, vol. 1, 183–4.
113 Deigh, "William James," 6.
114 Plamper, *The History of Emotions*, 147.
115 Dixon, *From Passions*, 18.
116 Mason and Capitanio, "Basic Emotions," 238. See Darwin, *The Expression of Emotions in Man and Animals*.
117 James, *The Principles of Psychology*, II, 448–9; James, "What Is an Emotion?" 190. Cf. Deigh, "William James," 9; Plamper, *The History of Emotions*, 175.
118 Deigh, "William James," 10.
119 James's answer to the question "What is an Emotion?" led to an endless discussion among psychologists that falls outside the scope of this book. It might be due to "the very category of 'emotions' that is the problem": Dixon, "Emotion," 338, because (342–3) this category is "so broad as to cover almost all of human mental life including, as Bain (1859) had put it, all that was previously understood by the terms 'feelings, states of feeling, pleasures, pains, passions, sentiments, affections'" (quoting Bain, *The Emotions and the Will*, 3).
120 Dixon, "Emotion," 339–40; Deigh, "William James," 5–8.
121 Matt, "Introduction," 12.
122 Cf. Pender, "Medical," 33.
123 Dixon, *From Passions*, 4.

124 Matt, "Introduction," 14.
125 Cf. also Barclay et al., "Introduction," 5.
126 Matt, "Introduction," 12; Albano, "The Puzzle," 495.
127 Dekker, "Educational Space," 7.

6 The Expression of Children's Emotions in the Age of Enlightenment, Romanticism, and Science

1 Barclays, "Introduction," 12; Osterhammal, *Der Verwandlung*, 1079–98.
2 Cf. Freedberg, *The Power of Images*, 1–26.
3 Beaven, "The Visual Arts," 110.
4 Thomas, "The Visual Arts," 96.
5 Buchardt, "Introduction," 44.
6 Diderot, *Essais sur la peinture, salon de 1759* [1763], quoted by Thomas, "The Visual Arts," 97–8.
7 Allard, "La quète," 238.
8 Hwang et al., *Images*; Cunningham, "The History of Childhood," 29–35; cf. De Wilde et al., *Een beeld*, 40–2.
9 Allard, "La quète," 270, 195.
10 Ibid., 252.
11 Gustave Courbet, *L'atelier du Peintre* [The Workshop of the Artist] (1854–5), oil on canvas, 361 × 598 cm (Paris: Musée d'Orsay), www.musee-orsay.fr/fr/oeuvres/latelier-du-peintre-927 (accessed November 22, 2022). Cf. Autin Graz, *Children*, 216.
12 Dekker, *Verlangen*, 185; Kloek and Mijnhardt, *1800*, 542; Volkmar Heyen, "Amtsrationalität und Malerei," 337–54.
13 Thomas, "The Visual Arts," 98–9.
14 Ibid., 118; Pernoud, "Au centre," 309–10, 418n22.
15 Pernoud, "Au centre," 310–11.
16 Ibid., 324, 341.
17 Ibid., 364.
18 Alston and Harvey, "In Private," 141; cf. Barclay, "Introduction," 13; Moran, *Domestic Space*.
19 Stearns, "In Private," 137, 157, 139, 138.
20 Ibid., 142, 150; cf. Alston and Harvey, "In Private," 149–50: from the seventeenth century "relations between children and parents were apparently transforming from authoritarian to affectionate."
21 Stearns, "In Private," 140.
22 Ibid., 153, 150.
23 Ibid., 140–1, 156; cf. Dekker, "Vrouw en opvoeding," 70–91.
24 Stearns, "In Private," 144–8; Dekker and Lechner, "Discipline," on Ariès and Foucault (see Chapter 5); Dekker, *The Will*.
25 Allard, "La quète du naturel," 195.
26 Rosenblum, *The Romantic Child*, 12.
27 Alston and Harvey, "In Private," 139, 148.

Notes

28 Pernoud, *L'Enfant obscur*; Germer, "Peurs plaisantes."
29 Johann Zoffany, *The Family of Thomas Bradshaw* (c. 1769), oil on canvas, 133.9 × 176.3 cm (London: Tate); Allard, "La quète," 196–203.
30 Johann Zoffany, *John, 14th Lord Willoughby of Broke with His Family* (c. 1766), oil on canvas, 100.3 × 125.7 cm (Los Angeles: The J. Paul Getty Museum); Allard, "La quète," 204–6.
31 John Singleton Copley, *The Family of Sir William Pepperrell* (1778), oil on canvas, 228.6 × 274.3 cm (Raleigh: North Carolina Museum of Art); Allard, "La quète," 199–200.
32 Cf. Joshua Reynolds, *Family of the 4th Duke of Marlborough* (1777–8), oil on canvas, 332.7 × 238.8 cm (Woodstock: Blenheim Palace); Allard, "La quète," 200–2.
33 Francisco Goya, *The Duke of Osana, Pedro de Alcantara, and His Family* (1788), oil on canvas, 225 × 174 cm (Madrid: Museo Nacional del Prado); Allard, "La quète," 206–7; Graz, *Children*, 154–9.
34 Philipp Otto Runge, *Portrait of the Artist's Parents* (1806), oil on canvas, 196 × 131 cm (Hamburg: Hamburger Kunsthalle), https://online-sammlung.hamburger-kunsthalle.de/de/objekt/HK-1001 (accessed November 17, 2022), text by Amelie Baader.
35 Philipp Otto Runge, *Holy Family with John* (1798), drawing, 195 × 326 mm (Hamburg: Hamburger Kunsthalle, Kupferstichkabinett, Inv. No.: 1938-138), https://online-sammlung.hamburger-kunsthalle.de/de/objekt/1938-138/ (accessed November 17, 2022).
36 Hoogeboom, *De stand*, 7; Sluijter, "In wedijver met de Gouden Eeuw," 119 quoting Murray, based on Dekker, *Het verlangen*, 183.
37 See Conrad Busken Huet (1826–1886), *Het land van Rembrandt* [Rembrandt's Land] (1882–4), the famous trilogy and praise of seventeenth-century Dutch painting.
38 Quoted from *Levensschetsen van Nederlandsche mannen en vrouwen* by Kloek, 'Naar het land van Rembrandt', 143, 142, 147; Dekker, *Het verlangen*, 185–6.
39 Abraham van Strij (after Aert de Gelder), *Shoemaker and His Family in an Interior* (s.a.), drawing, 38.8 × 44.6 cm (Amsterdam: Rijksmuseum, Rijksprentenkabinet); Dumas, *In helder licht*, 160–2; Hoogenboom, "De stand," 107–31; De Groot, "Traditie en vernieuwing," 30; Sluijter, "In wedijver," 129–30, 133; Dumas, "De decoratieve schilderkunst," 45–100; Dekker, *Het verlangen*, 183, 205.
40 De Leeuw, "Inleiding," 8.
41 Dekker, *Het verlangen*, 323.
42 On the Haagse School, see Dekker, *Het verlangen*, 320–2. About Jozef Israëls, see Dekkers et al., *Jozef Israëls 1824–1911*, 9; De Leeuw, "Jozef Israëls en Rembrandt," 42–53; Tempel, "Ingewijden in de kunst," 87–100.
43 On Willem Maris, see Dekkers, *Jozef Israëls*, 24; Janssen and van Sinderen, *De Haagse School*, 132–9.
44 Tempel, "Ingewijden in de kunst," 90–2; De Leeuw, "Inleiding," 9.
45 Verhoogt, "De uitgaanskleren van Israëls kinderen," 71.
46 Dekkers, *Jozef Israëls: Een succesvol schilder*, 281–2; Dekkers, 'The Frugal Meal', 75–84; Jozef Israëls, *Lunch in a Farmhouse in Carelshaven near Delden* (1885), oil on canvas, 170 × 212 cm (Dordrecht: Dordrechts Museum); Dekkers et al., *Jozef Israëls 1824–1911*, 208–9; for

similar paintings by Bernardus Blommers, see De Gruyter, *De Haagse School* I, 107–8; Janssen, *De Haagse School*, 145; Dekker, *Het verlangen*, 324–5.

47 Braudel, *Civilisation matérielle, I*, 139–43. See Jozef Israëls, *Frugal Meal* (1876), oil on canvas, 88.9 × 138.7 cm (Glasgow: Glasgow Museums, Art Gallery & Museum, Kelvingrove); Dekkers et al., *Jozef Israëls 1824–1911*, 191–3; Jozef Israëls, *Peasant Family at Table* (1889), oil on canvas, 130 × 150.3 cm (private collection), Dekkers et al., *Jozef Israëls 1824–1911*, 222–4; Jozef Israëls, *The Potato Eaters* (1903), oil on canvas, 86 × 116 cm (Den Haag: Kunstmuseum). See Dekker, *Het verlangen*, 321–5.

48 Van Tilborgh, *The Potato Eaters by Vincent van Gogh*, 79; Janssen, *De Haagse School*, 42; Vincent van Gogh, *The Potato Eaters* (1885), oil on canvas, 82 × 114 cm (Amsterdam: Van Gogh Museum/Vincent van Gogh Stichting); De Leeuw, "Inleiding," 9–10, and www.vangoghmuseum.nl/nl/collectie/s0005V1962 (accessed February 16, 2023).

49 William Blake, *The First Steps*, frontispiece of "Song of Innocence and of Experience" (1794), gravure, 11.5 × 7 cm (private collection); Marguerite Gérard, *The First Steps* (c. 1788), oil on canvas, 45.5 × 55 cm (St. Petersburg: Hermitage); Allard, "La quête," 229–30.

50 Jozef Israëls, *De kinderen der Zee* [Children of the Sea]. Referred here is to the third edition (1889). Dekkers, "De Kinderen der Zee," 36–60, especially 36–7, 41, 42, could refer nine engravings to paintings or drawings by Israëls; cf. Dekkers, *Jozef Israëls*, 83n59–61, 119–20.

51 Jozef Israëls, *De Kinderen der Zee*, engraving 5, "The First Trip" (1861). See Dekkers, "De kinderen der Zee," 44; Dekker, *Educational Ambitions*, 99–100; Dekker, *Het verlangen*, 343–4.

52 Louis-Léopold Boilly, *Christophe-Philippe Oberkampf and His Family before His Factory in Jouy* (c. 1803), oil on canvas, 83 × 115 cm (private collection), and Louis-Léopold Boilly, *The Family Oberkampf: The Mother with Two Children* (c. 1803), oil on canvas, 83 × 115 cm (private collection); Allard, "La quête," 202–3.

53 See Groenendijk and Van Lieburg, *Voor edeler staat geschapen*; Groenendijk et al., "Away with All My Pleasant Things in the World …."

54 On the seventeenth century, see Dekker, "Images as Representations," 709–14, and Bedaux, "Funeraire kinderportretten." Anton Derkinderen, *Dead Baby* (1885), oil on canvas, 44 × 37 cm (Utrecht: Collection F.M. de Nie-Molkenboer); Trappeniers, *Antoon Derkinderen*, 106. Cf. Knipping and Gerrits, *Het kind* II, 130, 135; Dekker, *Het verlangen*, 366–7.

55 Ekamper et al., *Bevolkingsatlas*, 96, 106; Van Poppel, "Sociale ongelijkheid voor de dood"; Vandenbroeke et al., "De zuigelingen- en kindersterfte"; Mitchell, *International*, 117–18; Van Tijn, "Het sociale leven in Nederland 1844–1875," 141–2; Van Tijn, "Het sociale leven in Nederland 1875–1914," 78–89; Dekker, *Het verlangen*, 295, 366.

56 Based on Dekker, *Het verlangen*, 363–4. Jozef Israëls, *After the Storm* (1858), oil on canvas, 112 × 146 cm (Amsterdam: Stedelijk Museum); Dekkers et al., *Jozef Israëls 1824–1911*, 145–7; Jozef Israëls, *The Shipwrecked Person/The Drowned Fisherman* (1861), oil on canvas, 128.9 × 243.8 cm (London: National Gallery); Dekkers et al., *Jozef Israëls 1824–1911*, 150–1; Jozef Israëls, *The Day before Divorce* (1862), oil on canvas, 102.5 × 126.5 cm (Boston: Museum of Fine Arts); Dekkers et al., *Jozef Israëls 1824–1911*, 153–5; Jozef Israëls, *The Funeral/From Darkness to Light* (1871), oil on canvas, 129.5 × 199.4 cm (Tel Aviv: Tel Aviv Art Museum). An earlier version of this painting on panel (Jozef Israëls, *The Funeral* (1871), oil on panel, 30.5

Notes

× 46 cm (private collection)) shows a cradle with an infant at the front, Dekkers et al., *Jozef Israëls 1824–1911*, 178–80.

57 Jozef Israëls, *The Sick Mother* (c. 1869), aquarelle, 29.9 × 43.2 cm (Aberdeen: City of Aberdeen Art Gallery and Museums Collections); cf. the painted version titled *The Convalescent* (1869), oil on canvas, 93 × 133 cm (Jerusalem: The Israel Museum) and *An Old Woman Being Nursed by Her Children* (c. 1854), location unknown; Dekkers et al., *Jozef Israëls 1824–1911*, 294–5. Cf. Dekker, *Het verlangen*, 364.

58 Jozef Israëls, *Along Mother's Grave* (1856), 224 × 178 cm (Amsterdam: Stedelijk Museum); Dekkers, "De kinderen der zee," 49–50; Dekkers, *Jozef Israëls*, 199–204; Dekkers et al., *Jozef Israëls 1824–1911*, 137–40, De Gruyter, *De Haagse School* I, 49–50. See Dekker, *Het verlangen*, 364–5, and Dekker, *Educational Ambitions*, 101; Nicolaas Beets's accompanying poem in Israëls, *De kinderen der zee.*

59 Ekamper et al., *Bevolkingsatlas*, 88–90. Jan Hendrik van de Laar (1807–1874), *The Divorce* (1846), oil on panel, 90 × 114 cm (Rotterdam: Museum Rotterdam), https://museumrotterdam.nl/collectie/item/66447 (accessed February 20, 2023). On Tollens, https://literatuurmuseum.nl/nl/overzichten/activiteiten-tentoonstellingen/pantheon/hendrik-tollens (accessed February 20, 2023). On van der Laar, https://rkd.nl/nl/explore/artists/47172 (accessed February 20, 2023); Brandt Corstius and Hallema, *Moederschap*, 131, 39, cat. no. 44; on history of divorce, see Phillips, *Untying the Knot*; on the loyalty conflict, see Nagy, *Invisible Loyalties*. See Dekker, *Educational Ambitions*, 101–2; *Het verlangen*, 365–6.

60 Edgar Degas, *Portrait of the Family Bellelli* (in-between 1858 and 1869), oil on canvas, 200 × 250 cm (Paris: Musée d'Orsay); Pernoud, "Au centre," 286–8, www.musee-orsay.fr/en/artworks/portrait-de-famille-9998 (accessed April 18, 2023). Cf. Gay, *Schnitzler's Century*.

61 Maccoby and Martin, "Socialization," 37–49; cf. Skinner et al., "Six Dimensions of Parenting."

62 Stearns, "In Private," 144–5, refers to a text (1839) by the Protestant American minister John Todd.

63 Allard, "La quête," 252; cf. Gordon, "The Perils of Innocence."

64 Joshua Reynolds, *Elisabeth Herbert, Lady Pembroke and Her Son George, Lord Herbert* (1764–7), oil on canvas, 127 × 101 cm (Salisbury: Wilton House, Collection of the Earl of Pembroke); Allard, "La quête," 197–9.

65 Cf. Dekker, *Het verlangen*, 184–5, 206. Boschma, *Willem Bartel van der Kooi*, 12, 14–21, 62, 75, 77–81; Van Tilborgh and Jansen, *Op zoek*, 121–2; Boschma, *Willem Bartel van der Kooi, Fries Museum- Leeuwarden*; Loos et al., *Het Galante Tijdperk*, 92; Brandt Corstius and Hallema, *Moederschap*, 130.

66 Willem Bartel van der Kooi, *Jetske Hayes with Child* (c. 1807), black chalk drawing, 42.6 × 29.2 cm (Leeuwarden: Gemeentearchief); Boschma, *Willem Bartel van der Kooi*, 64, 180–1; Dekker, *Het verlangen*, 213–14.

67 Willem Bartel van der Kooi, *Portret van Hyke Sophia Mulder-Saagmans en kinderen* (1801), oil on canvas, 122 × 96 cm (Franeker: Museum 't Coopmanshûs, loan from Dommering); Boschma, *Willem Bartel van der Kooi*, 175–7; Van Tilborgh and Jansen, *Op zoek*, 121–2; Dekker, *Het verlangen*, 206–7.

Notes

68 Adrian Ludwig Richter, *St. Anna Church in Krupka in Bomemia* (1836), oil on panel, 55.5 × 69 cm (Hannover: Niedersächisches Landesmuseum Hannover); Autin Graz, *Children*, 84–5; quote in Bert Treffers, "De droomwereld van de Duitse romantici," NRC 18-08-1973.
69 Thomas, "The Visual Arts," 113. Also Paul Gauguin was shortly connected with *Les Nabis*.
70 Pierre Bonnard, *Grandmother and Child* (1897), oil on cardboard, 39.6 × 39 cm (Paris: Galerie Berès); Pernoud, "Au centre," 314–15.
71 Claude Monet, *The Cradle: Camille with the Artist's Son Jean* (1867), oil on canvas, 116.2 × 88.8 cm (Washington, DC: National Gallery of Art), www.nga.gov/collection/art-object-page.61375.html (accessed August 30, 2022); Autin Graz, *Children*, 222–3.
72 Matthijs Maris, *Woman with Child and Little Goat* (c. 1866), oil on panel, 14.5 × 19 cm (The Hague: Kunstmuseum Den Haag); De Gruyter, *De Haagse School* II, 38, 46; Dekker, *Educational Ambitions*, 95–6, Dekker, *Het verlangen*, 329.
73 Jozef Israëls, *Birthday Party, or, The Pancake Baker* (1872), oil on canvas, 96.5 × 135 cm (Great Britain: private collection); Dekkers et al., *Jozef Israëls 1824–1911*, 181–3. For other examples, Dekker, *Het verlangen*, 325–6.
74 See www.pfannschmidt.net/c.g.pfh.htm (accessed August 23, 2022).
75 Carl Gottfried Pfannschmidt, *Mother with a Child on Her Lap* (1875), drawing (Berlin: Staatliche Museen zu Berlin, Kupferstichkabinett, SZ Pfannschmidt 3). Similar love and care-showing drawings by Pfannschmidt are *Mother Caressing Her Child* (1875), drawing (Berlin: Staatliche Museen zu Berlin, Kupferstichkabinett, SZ Pfannschmidt 13); *Mother Carrying Her Child in Her Arms* (1875), drawing (Berlin: Staatliche Museen zu Berlin, Kupferstichkabinett, SZ Pfannschmidt 9 and 10); *Mother with Her Child in Her Lap* (s.a.), drawing (Berlin: Staatliche Museen zu Berlin, Kupferstichkabinett, SZ Pfannschmidt 16); *Mother Sitting on the Floor and Lifting Her Child* (1875), drawing (Berlin: Staatliche Museen zu Berlin, Kupferstichkabinett, SZ Pfannschmidt 11).
76 Carl Gottfried Pfannschmidt, *Children Games Outdoor* (1849), drawing (Berlin: Staatliche Museen zu Berlin, Kupferstichkabinett, SZ Pfannschmidt 1).
77 Carl Gottfried Pfannschmidt, *Mother Kissing Her Child; Gubbio* (1875), drawing, 14.1 × 15.9 cm (Berlin: Staatliche Museen zu Berlin, Kupferstichkabinett, SZ Pfannschmidt 5).
78 Giacomo Ceruti, *Girl Begging with Woman with the Distaff* (c. 1740), oil on canvas (private collection); Allard, "La quête," 276.
79 Jean-Francois Millet, *Les Errants* (1848–9), oil on canvas, 49 × 38 cm (Denver: Denver Art Museum, The William D. Lippitt Memorial Collection); Allard, "La quête," 273–5.
80 Achenbach, *Käthe Kollwitz (1867–1945)*, 18; Pernoud, "Au centre," 371–2; Käthe Kollwitz, *Woman with Dead Child (Frau mit toten Kind)* (1903), drawing, 60 × 40 m (Berlin: Staatliche Museen zu Berlin, Kupferstichkabinett, NG 27/64-67). Cf. Käthe Kollwitz, *Schlafender Knabe (Das tote Kind)* (1903), drawing (Berlin: Staatliche Museen zu Berlin, Kupferstichkabinett, SZ Kollwitz 1); Käthe Kollwitz, *Woman with Death Child* (1903), etching, 42.5 × 48.6 cm (London: British Museum); see Pernoud, "Au centre," 371.
81 Willem Bartel van der Kooi, *Father's Happiness/The Award* (1816), oil on canvas, 101 × 111 cm (Leeuwarden: Fries Museum, loan from Museum Boymans Van Beuningen); Boschma, *Willem Bartel van der Kooi*, 73–4, 79, 292–4; see Dekker, *Het verlangen*, 221–2.

Notes

82 Edgar Degas, *Place de la Concorde, The Viscount Lepic et ses filles* (c. 1875), oil on canvas, 79 × 118 cm (Saint Petersburg: Hermitage); Pernoud, "Au centre," 290–1.

83 The Dutch title is *De beste middelen om het huwelijk gelukkig te maken*; Koolhaas-Grosveld, *Father & Sons*, 11, 17. The children were Willem (1799–1876), Gerrit (1800–1831), Jacob (mentioned Koo) (1803–1878), and Christiaan (1805–1880). The following is based on Dekker, *Het verlangen*, 224–7.

84 Buijnsters and Buijnsters, *Lust en leering*, 47.

85 Koolhaas-Grosfeld, *Father & Sons*, HS.71 F.36R, HS.72 F.24.

86 Koolhaas-Grosfeld, *Father & Sons*, HS.71 F.14v-15R.

87 Koolhaas-Grosfeld, *Father & Sons*, HS.74 F.6, HS.74 F.14.

88 Koolhaas-Grosfeld, *Father & Sons*, HS.71 F.30V, 31R.

89 Koolhaas-Grosfeld, *Father & Sons*, HS.70 F.2R; HS.72 F.30; HS.70 F.11V; HS.70 F.47R.

90 Jacob de Vos Wzn, *Papa Spanks the Boys with a Slice of Cake*, drawing F.5 from Jacob de Vos Wzn, *The Fourth Book of Willem & Gerrit de Vos* (1805), HS 73 (book 4), 180 × 115 mm (Amsterdam: Koninklijk Oudheidkundig Genootschap, De Vos Family archives); see Koolhaas-Grosfeld, *Father & Sons*, 186.

91 Buijnsters and Buijnsters, *Lust en leering*, 47.

92 Koolhaas-Grosfeld, *Father & Sons*, HS.70 F.11V.

93 Koolhaas-Grosfeld, *Father & Sons*, HS.70 F. 28R, HS.70 F.24V.

94 Koolhaas-Grosfeld, *Father & Sons*, HS.70 F.15V, HS.73 F.16.

95 Koolhaas-Grosfeld, *Father & Sons*, HS.73 F.23, HS.76 F.10.

96 Cf. Frevert et al., *Learning How to Feel*.

97 Gustave Courbet, *Pierre-Joseph Proudhon and His Children* (c. 1865), oil on canvas, 91.9 × 73.2 cm (Cardiff: National Museum of Wales); Allard, "La quête," 268–9.

98 Francisco de Goya, *Portrait of Don Luis María de Cistué at the Age of Two Years and Eight Months* (1791), oil on canvas, 118 × 86 cm (Paris: Musée du Louvre); Allard, "La quête," 256. Cf. Goya, *The Countess of Chinchón* (1783), oil on canvas, 134.7 × 117.5 cm (Washington, DC: National Gallery of Art)—a young girl situated in an artificial landscape with a dog.

99 Jan Adam Kruseman Jz. (1804–1862), *Portrait of Catharina Elisabeth Rente Linsen (1830–1890)* (1831), oil on canvas, 77.2 × 66 cm (Haarlem: Teylers Museum); Plomp, "Jong in de 19e eeuw," 22; Dekker, "Story Telling," 171–2.

100 Auguste Renoir, *Marguerite-Thérèse (Margot) Berard* (1879), oil on canvas, 41 × 32 cm (New York: The Metropolitan Museum of Art); Pernoud, "Au centre," 294–5; see www.metmuseum.org/art/collection/search/437425 (accessed August 28, 2023).

101 Thomas, "The Visual Arts," 113.

102 Fernand Khnopff, *Jeanne Kéfer* (1885), oil on canvas, 80 × 80 cm (Los Angeles: The J. Paul Getty Museum); Pernoud, "Au centre," 297, 299.

103 Vincent van Gogh, *Portrait of Marcelle Roulin* (1888), oil on canvas, 35.2 × 24.6 cm (Amsterdam: Rijksmuseum Vincent van Gogh/Vincent van Gogh Stichting).

104 Allard, "La quête," 256, quoting Runge; cf. Philipp Otto Runge, *The Child* (1809), drawing, 15 × 20.5 cm (location unknown), reproduced in Rosenblum, *The Romantic Child*, 8, 9: "a symbol of … 'The Romantic Child'" in invoking "a state of natural innocence and religious purity."

105 Philipp Otto Runge, *Portrait of Luise Perthes* (1805), oil on canvas, 143 × 95 cm (Weimar: Stiftung Weimarer Klassik); Allard, "La quête," 255–6; Rosenblum, *The Romantic Child*, 24.
106 Gustave Courbet, *Portrait of the Little Béatrice Bouvet* (1864), oil on canvas, 91.9 × 73.2 cm (Cardiff: National Museum of Wales); Allard, "La quête," 268, 270.
107 Philipp Otto Runge, *Otto Sigismund in a Highchair* (1805), oil on canvas, 40 × 35.5 cm (Hamburg: Kunsthalle), https://online-sammlung.hamburger-kunsthalle.de/de/objekt/HK-1003 (accessed November 17, 2022).
108 Jozef Israëls, *Little John in His Chair* (1873), aquarelle, 43 × 31 cm (Rotterdam: Museum Boymans-van Beuningen); De Gruyter, *De Haagse School* I, 48; Dekker, *Het Verlangen*, 15–16; Dekker, "Pedagogiek in beeld: Jozef Israëls," 52.
109 Mary Cassatt, *Ellen Mary with a White Coat* (c. 1896), oil on canvas, 81.3 × 60.3 cm (Boston: Museum of Fine Arts); Pernoud, "Au centre," 302, 305.
110 Mary Cassatt, entering the Pennsylvania Academy at age sixteen, went six years later to Europe "for further study," www.pafa.org/museum/collection/item/young-thomas-his-mother (accessed December 6, 2022); Autin Graz, *Children*, 186.
111 Jacob Maris, *The Picture Book* (c. 1873), oil on panel, 25 × 19 cm (Montreal: The Montreal Museum of Fine Arts); De Gruyter, *De Haagse School* II, 20, figure 22; Dekker, *Het verlangen*, 374; Dekker, "Pedagogiek in beeld (Jacob Maris)," 52; cf. Auguste Renoir, *Jean and Geneviève Caillebotte* (1895), oil on canvas, 65 × 81 cm (Paris: private collection), with two little children reading a picture book.
112 Philipp Otto Runge, *The Children Hülsenbeck* (1806), oil on canvas, 131 × 141 cm (Hamburg: Kunsthalle), https://online-sammlung.hamburger-kunsthalle.de/de/objekt/HK-1012 (accessed November 17, 2022); Bertsch in Hamburger Kunsthalle, *Kunst*, 90–1; Allard, "La quête," 256–8. Cf. Rosenblum, *The Romantic Child*, 29–33.
113 Koolhaas-Grosveld, *Father & Sons*, HS.71 F.7V-8R; HS.5 F.21; cf. Dekker, *Het verlangen*, 228–9, 245.
114 Stearns, "In Private," 141; Willem Bartel van der Kooi, *The Disrupted Piano Playing* (1813), oil on canvas, 147 × 121 cm (Amsterdam: Rijksmuseum); M. van Heteren, *Poëzie der werkelijkheid*, 41–2; Boschma, *Willem Bartel van der Kooi*, 290–1; Dekker, *Het verlangen*, 233–324; Auguste Renoir, *Two Young Girls at the Piano* (1892), oil on canvas, 112 × 86 cm (New York: Lehman Collection).
115 Pierre Auguste Renoir, *The Artist's Son, Jean, Drawing* (1901), oil on canvas, 45 × 54 cm (Virginia: Virginia Museum of Fine Arts), https://vmfa.museum/piction/6027262-8123321/ (accessed November 30, 2022).
116 Fernand Khnopff, *The Children of Mr. Nève* (1893), oil on canvas, 49.5 × 40 cm (private collection); Pernoud, "Au centre," 297–300.
117 Pernoud, "Au centre," 289, 292; cf. Gallati, "Posing Problems"; see Gallati, *Children of the Gilded Era*, on *Belle Époque* painters like Sargent, Renoir, and Cassatt.
118 John Singer Sargent, *Portraits of Édouard and Marie-Louise Pailleron* (1881), oil on canvas, 152 × 175 cm (Des Moines: De Moines Art Center); Gallati, "Posing Problems," referred to by Pernoud, "Au centre," 417n5, 294.

Notes

119 John Singer Sargent, *The Daughters of Edward Darley Boit* (1882), oil on canvas, 221.9 × 222.6 cm (Boston: Museum of Fine Arts, gift of the artist's daughters); Pernoud, "Au centre," 293–4.

120 Henry Raeburn, *The Brothers Allen, or Portrait of James and John Lee Allen* (c. 1790), oil on canvas, 152.4 × 115.6 cm (Forth Worth: Kimbell Art Museum); Thomas Gainsborough, *The Blue Boy* (c. 1770), 179.4 × 123.8 cm (San Marino: The Huntington Library and Art Gallery); cf. Allard, "La quête," 195, 292; cf. Thomas Gainsborough (1727–1788), *John Heatcote* (1770–4), oil on canvas, 127 × 101.2 cm (Washington, DC: National Gallery of Art); Autin Graz, *Children*, 172–3.

121 Joshua Reynolds, *Master Hare* (1788), oil on canvas, 77 × 63 cm (Paris: Musée du Louvre), https://collections.louvre.fr/en/ark:/53355/cl010063598 (accessed October 25, 2022), and Allard, "La quête," 236–7. Joshua Reynolds, *The Age of Innocence* (c. 1785–8), oil on canvas, 76.5 × 63.8 cm (London: Tate), www.tate.org.uk/art/artworks/reynolds-the-age-of-innocence-n00307 (accessed August 5, 2022), quote from Martin Postle's description.

122 Caspar David Friedrich, *Der Frühling. Der Morgen. Die Kindheit (aus dem Jahresszeiten-, tageszeiten- und Lebensalterzyklus von 1803)* (1803), drawing, 12 × 5 cm (Berlin: Staatliche Museen zu Berlin, Kupferstichkabinett, KdZ 29941).

123 Théodore Géricault, *Portrait of Alfred and Elisabeth De Dreux* (c. 1818), oil on canvas, 99.2 × 79.4 cm (private collection); Allard, "La quête," 252, 270, 261.

124 Théodore Géricault, *Louise Vernet enfant* (c. 1818), oil on canvas, 60 × 50 cm (Paris: Musée du Louvre); Théodore Géricault, *Portrait of Olivier Bro/A Child with a Dog* (1818–19), oil on canvas, 62 × 51 cm (Cambridge, MA: Harvard Art Museums), https://harvardartmuseums.org/collections/object/342196 (accessed July 26, 2022); Allard, "La quête," 261–2, 264.

125 Jean-Baptiste Camille Corot, *Children at the Edge of a Stream in the Countryside in Lormes* (1840–3), oil on canvas, 43 × 73 cm (private collection); Allard, "La quête," 268; Pernoud, "Corot," 38–55.

126 Westberg et al., *School Acts*; Dekker, *The Will*; Dekker, *Het verlangen*, 322.

127 De Leeuw, "Inleiding," 10.

128 Augustus Allebé, *Butterflies* (1871), oil on panel, 35 × 50 cm (Amsterdam: Rijksmuseum); Van Heteren, *Poëzie der werkelijkheid*, 128–9; cf. the drawing in the Allebé collection, Rijksprentenkabinet of the Rijksmuseum; Knipping and Gerrits, *Het kind* II, 59–61; Dekker, *Het verlangen*, 348–9.

129 Cf. Ary Scheffer (1795–1858), *Sleeping Little Child* (c. 1850), oil on canvas, 30 × 40.6 cm (Dordrecht: Dordrechts Museum); Knipping and Gerrits, *Het kind* II, 45; on Matthijs Maris, see De Gruyter, *De Haagse School* II, 31–8; Loos, *Aquarellen*, 44; Blotkamp et al., *Kunstenaren der idee*.

130 Matthijs Maris, *Butterflies* (1874), oil on canvas, 64 × 97 cm (Glasgow: Glasgow Art Gallery and Museum); De Gruyter, *De Haagse School* II, 39, 41 (quote); Van Heeteren, *Poëzie*, 139–40. Other examples are Matthijs Maris, *Sleeping Girl with Butterflies* (s.a.), drawing, 14 × 20 cm (The Hague: Kunstmuseum); Janssen, *De Haagse School*, 123; Matthijs Maris, *Child's Head* (1858), drawing, 9.5 × 11 cm (The Hague: Kunstmuseum); Janssen, *De Haagse School*, 123. Cf. Matthijs's brother Jacob, *Feeding Chickens* (1866), oil on canvas, 33 × 21 cm

(Amsterdam: Rijksmuseum), painted in Maris's Parisian period (1864–71), cf. De Gruyter, *De Haagse School* II, 19; Van Heteren, *Poëzie*, 119–20; Dekker, *Het verlangen*, 346.

131 Fritz von Uhde, *Heather Princess* (1889), oil on canvas, 140 × 111 cm (Berlin: Staatlichen Museen zu Berlin, Alte Nationalgalerie), https://smb.museum-digital.de/object/143505 (accessed August 25, 2022). Cf. Von Uhde's *Two Girls* (1902–10) (Bremen: Kunsthalle Bremen) showing care and shyness in a room overlooking a garden.

132 Ferdinand Hodler, *Adoration III, Le Garçon enchanté* (1893), oil on canvas, 103 × 68 cm (Zürich: Kunsthaus); Pernoud, "Au centre," 296–7.

133 Arthur Devis, *Conversation at Ashdon House* (s.a.), oil on canvas, 195.6 × 138.5 cm (Washington, DC: National Gallery of Art): Autin Graz, *Children*, 168–9.

134 Corbin, *Le territoire du vide*, passim.

135 Dekkers, *Jozef Israëls*, 25, 41n4, 43–52.

136 Stokvis, *De wording van modern Den Haag*, chapter 7; Vermaas, *Geschiedenis van Scheveningen*, 428–32; Furnée, "Beschaafd vertier."

137 Hendrick, *Child Welfare*, 37 (quote); Van Crombrugge, "Rousseau," 445–80; Dekkers, "De kinderen der Zee," 36–7, 41; Dekkers, *Jozef Israëls*, 70–3, 83n59–61; Dekker, "Family on the Beach."

138 Haak, *The Golden Age*, 308–9; Corbin, *Le territoire*, 51–3.

139 Examples from mother and child: Bernardus Blommers, *Summer Evening on the Beach* (s.a.), 137 × 199 cm (Rotterdam: Boymans-van Beuningen), and Bernardus Blommers, *Paddling in the Sea* (s.a.), 48 × 67.5 cm (private collection); Jansen, *De Haagse School*, 151.

140 Bernard Blommers, *Sailing in a Boat* (c. 1885), gouache, 20 × 24.5 cm (The Hague: Kunstmuseum); Dekker, "Pedagogiek in beeld (Bernard J. Blommers)," 52.

141 Dekkers et al., *Jozef Israëls 1824–1911*; Dekkers, "Liefhebbers," 100–14; van Uitert, "Burgerlijke kunst"; Dekkers, *Jozef Israëls*, 35–9.

142 Dekkers, *Jozef Israëls*, 139–40. His main customer was the Scottish railway magnate James Staats Forbers (1823–1904).

143 Jozef Israëls, *The Children of the Sea*, engraving 1, *The Cot*.

144 Israëls, *The Children of the Sea*, engraving 2, *Dolce far niente*, situated at Zandvoort; Dekkers, "De kinderen der Zee," 42. Cf. Dekker, *Educational Ambitions*, 96–9; Dekker, "Family on the Beach," 286.

145 Isaac Israels, *Donkey Ride along the Beach* (c. 1898–1900), oil on canvas, 51 × 70 cm (Amsterdam: Rijksmuseum); Van Heteren et al., *Poëzie*, 190–1; Dekker, *Het verlangen*, 341–2.

146 Thomas, "The Visual Arts," 111.

147 Mary Cassatt, *Two Children on the Beach* (1884), oil on canvas, 98 × 74.5 cm (Washington, DC: National Gallery of Art); Autin Graz, *Children*, 186–7.

148 Paul Gauguin, *Young Wrestlers: Brittany Bretagne* (July 1888), oil on canvas, 93 × 73 cm (private collection); Pernoud, "Au centre," 305. Baudelaire used in "Morale du joujou" words such as "anger" and "superstition" to explain the "destruction by the child of his toy." He emphasized the destructiveness and "*terribillità* of childhood," undermining Rousseau's and Fröbel's image of childhood; Pernoud, "Au centre," 357. On the approach of the body, see

Notes

Laneyrie-Dagen, *L'Invention*; Corbin et al., *Histoire du corps*, vol. 2; Rousmaniere and Sobe, "Special Issue: Education and the Body."

149 Paul Gauguin, *Bathing Breton Boys* (1888), oil on canvas, 92 × 72 cm (Hamburg: Hamburger Kunsthalle); Paul Gauguin, *A Breton Boy* (1889), oil on canvas, 93 × 74 cm (Köln: Wallraf-Richartz Museum); Pernoud, "Au centre," 306, 309.

150 Edgar Degas, *Peasant Girls Bathing in the Sea at Dusk* (1875–6), oil on canvas, 65 × 81 cm (London: The National Gallery, private collection), www.nationalgallery.org.uk/paintings/hilaire-germain-edgar-degas-peasant-girls (accessed December 7, 2022). Cf. on boys, see Max Liebermann, *Bathing Boys in Zandvoort* (1896–8), oil on canvas, 122 × 151 cm (Munich: Bayerische Staatsgemäldesammlungen, Neue Pinakothek).

151 Pierre Auguste, *Young Girl Bathing*, oil on canvas, 81.3 × 64.8 cm (New York: The Metropolitan Museum, Robert Lehman Collection), www.metmuseum.org/art/collection/search/459110 (accessed December 12, 2022).

152 See Félix Vallotton, *The Ball, or Corner of the Park with a Child Playing with a Ball* (1899), oil on canvas, 48 × 61 cm (Paris: Musée d'Orsay); Albert Edelfelt, *Jardin du Luxembourg in Paris* (1887), oil on canvas, 146 × 188 cm (Helsinki: The Atheneum Art Museum); Édouard Vuillard, *Public Gardens* (1894), oil on canvas, images varying in measurement from 214 × 81 to 154 cm (Paris: Musée d'Orsay) for *The Walk*, *The Two School Boys*, and *Under the Tree*, respectively (Houston: The Museum of Fine Arts; Brussels: Musées Royaux des Beaux-Arts de Belgique; and Cleveland: Cleveland Museum of Art); Pernoud, "Au centre," 311–23, 319 (quote).

153 Cf. Pierre Bonnard, *Promenade des nourrices, frise des fiacres* (1897), 143.0 × 46.0 cm (Paris: Musée d'Orsay, www.musee-orsay.fr/en/artworks/promenade-des-nourrices (accessed August 12, 2022); Pernoud, "Au centre," 315, 318 (quote).

154 Adolph Menzel, *Kinder auf Absperrungsketten sitzend, in Utrecht* (1876), drawing, 15.0 × 8.8 cm (Berlin: Staatliche Museen zu Berlin, Kupferstichkabinett, SZ Menzel Skb.51, S.61/82, Sketchbook). Cf. Griesebach, *Adolph Menzel*.

155 Adolph Menzel, *Playing Children* (1881) (Berlin: Staatliche Museen zu Berlin, Kupferstichkabinett, SZ Menzel Skb.59, S.37/38, Sketchbook).

156 Joshua Reynolds, *Cupid as Torchbearer* (1774), oil on canvas, 30 × 254 cm (Buffalo: Albright-Knox Art Gallery, funds Seymour H. Knox); Allard, "La quête," 276–7.

157 Floris Arntzenius, *The Match Girl* (c. 1890), oil on canvas, 131 × 76 cm (The Hague: Haags Historisch Museum); Dekker, "Story Telling," 170–1.

158 Fernand Pelez, *Le Petit Marchand de violettes* (1885), oil on canvas, 87 × 100 cm (Paris: Petit Palais, Musée des Beaux-Arts de la Ville de Paris); Pernoud, "Au centre," 366–7.

159 Pernoud, "Au centre," 311.

7 Training Children in Emotional Literacy in the Age of Enlightenment, Romanticism, and Science

1 Barclay, "Introduction," 6.
2 Pender, "Medical," 15, quoting Falconer.
3 Ibid., 26–7.

4 Ibid., 27.
5 Barclay, "Introduction," 11.
6 Dekker and Becker, *Doers*; Duprat et al., *Philanthropies*.
7 On the development in the late nineteenth century, Frevert et al., *Learning How to Feel*; cf. Parlevliet, *Meesterwerken*; Pernoud, "Au centre," 362; Baggerman, "The Infinite Universe."
8 Buchardt, "Church," 36, 39; Parlevliet and Dekker, "A Poetic Journey," 746–8; Dekker, *Het verlangen*, 191–2.
9 Parlevliet and Dekker, "A Poetic Journey," 754–7, 767. On the contribution of educational texts on the self-training of children in nineteenth-century Germany, see Bruce, *Revolutions at Home*.
10 Parlevliet and Dekker, "A Poetic Journey," 746–7. Jacob Cats's emblem books got renewed popularity in the nineteenth century: Kloek, "Burgerdeugd of burgermansdeugd?"
11 Cf. Alston and Harvey, "In Private," 139: "to approach emotions not as passive feelings but as rational appraisals that are actively deployed by individuals within relationships."
12 Van Alphen clearly distinguished the different emotions, while in children's literature, "emotions usually occur in complex patterns. They are mixed rather than single," Frevert et al., *Learning How to Feel*, xi.
13 Van Alphen, *Kleine gedichten (Proeve)*, "Klacht van de kleine Willem op de dood van zijn zusje," 32–3.
14 Van Alphen, *Kleine gedichten (Tweede vervolg)*, "Claartje bij de schilderij van haar overladen moeder," 144–7.
15 Van Alphen, *Kleine gedichten (Proeve)*, "Het medelijden," 26–7.
16 Van Alphen, *Kleine gedichten (Vervolg)*, "Pietje bij het ziekbed van zijn zusje," 112–13.
17 Van Alphen, *Kleine gedichten (Vervolg)*, "Het zieke kind," 98–9.
18 Van Alphen, *Kleine gedichten (Tweede vervolg)*, "Het lijk," 166–7.
19 Van Alphen, *Kleine gedichten (Proeve)*, "Het kinderlijk geluk," 14–15.
20 Van Alphen, *Kleine gedichten (Proeve)*, "De kinderliefde," 18–19; Dekker, *Educational Ambitions*, 82–3, and 83–4 about the classic *Little John Once Saw Plums Hanging*; Van Alphen, *Kleine gedichten (Proeve)*, 59. On criticism about moralization in the 1850s, Buijnsters, "Nawoord," 190–2; Parlevliet and Dekker, "A Poetic Journey," 746–7.
21 Allard, "La quète," 238.
22 Cats, *Huwelijk*, 113–15. Cf. Fildes, *Breasts, Bottles and Babies*, and Fildes, *Wet Nursing*.
23 Jan Kupecky, *Self-Portrait of the Artist Together with His Wife and Son* (c. 1718), oil on canvas, 113 × 91.2 cm (Budapest: Szépművészeti); Laneyrie-Dagen, "Enfant Reel," 124, 126.
24 Jean-Honoré Fragonard, *The Visit to the Nursery* (c. 1775), oil on canvas, 73 × 92 cm (Washington, DC: National Gallery of Art), www.nga.gov/collection/art-object-page.32685.html (accessed September 8, 2022), originally published in Philip Conisbee et al., *French Paintings of the Fifteenth through the Eighteenth Century*, 182–7; Allard, "La quète," 228–9; Autin Graz, *Children*, 214–15. Cf. Jean-Honoré Fragonard, *The Happy Family* (1775), oil on canvas, 53.9 × 65.1 (Washington, DC: National Gallery of Art), www.nga.gov/collection/art-object-page.32685.html (accessed September 8, 2022). Cf. Jean-Honoré Fragonard, *Dites-donc, s'il vous plait* (1780), oil on canvas, 28.9 × 37.2 cm (London: The Wallace Collection);

Notes

see Allard, "La quête," 233–5, about ten young children in their physicality for "démaillotés," together with their proud and happy mother.

25 Willem Bartel van der Kooi (1768–1836), *Breastfeeding Mother* (1826), oil on canvas, 89 × 72 cm (Leeuwarden: Fries Museum); Brandt Corstius and Hallema, *Moederschap*, 17; Boschma, *Willem Bartel van der Kooi*, 74, 296–7; De Mooij, *Kinderen*, 88.

26 Willem Bartel van der Kooi, *Mother's Happiness* (1818), oil on canvas, 102 × 113 cm (Leeuwarden: Fries Museum, in loan from Museum Boymans Van Beuningen); Boschma, *Willem Bartel van der Kooi*, 74, 294; Dekker, *Het verlangen*, 211–12.

27 Bernard Blommers, *The Doll* (s.a.), aquarelle, 49 × 38 cm (private collection); Janssen, *De Haagse School*, 149; Dekker, *Het verlangen*, 332.

28 Jozef Israëls, *Mother's Assistant* (1866), oil on canvas, 91 × 124 cm (Brussels: King's Collection); De Gruyter, *De Haagse School I*, figure 55; Dekker, *Het verlangen*, 332.

29 Fritz von Uhde, *Children's Room* (1889), oil on canvas, 110.7 × 138.5 cm (Hamburg: Hamburger Kunsthalle, gift by Alfred Beit), https://online-sammlung.hamburger-kunsthalle.de/en/objekt/HK-1637/kinderstube (accessed February 25, 2023).

30 Jean-Baptiste-Siméon Chardin, *The Morning Toilet* (1741), oil on canvas, 49 × 41 cm (Stockholm: Nationalmuseum); Allard, "La quête," 238, quoting René Demoris, *Chardin, la Chair et l'objet*, 103; Autin Graz, *Children*, 210, quoting *Mercure de France*; Van Alphen, *Kleine Gedichten (Proeve)*, "De spiegel," 30–1.

31 Louise-Élisabeth Vigée-Lebrun, *Julie Lebrun Holding a Mirror* (1787), oil on canvas, 73.7 × 61 cm (private collection); Allard, "La quête," 238. Cf. Louise-Élisabeth Vigée-Lebrun, *Self-Portrait with Her Daughter, Jeanne-Marie Louise (1780–1819)* (1787), oil on canvas, 105 × 84 cm (Paris: Musée du Louvre), where the mother initiates her daughter in female rituals. Cf. Greuze, *The Broken Mirror* (1762–3), oil on canvas, 56 × 45.6 cm (London: The Wallace Collection), https://wallacelive.wallacecollection.org/eMP/eMuseumPlus?service=direct/ (accessed November 11, 2022).

32 Mary Cassatt, *Baby's First Caress* (1891), pastel on paper, 76.2 × 61 cm (New Britain: Museum of American Art, MarrietRussell Stanley Fund); Mary Cassatt, *Sketch of a Mother Looking Down at Thomas* (c. 1893), pastel on brown paper, 68 × 55 cm (Atlanta, GA: High Museum of Art); Pernoud, "Au centre," 302.

33 Mary Cassatt, *Young Thomas and His Mother* (1893), pastel on wove paper, 60 × 50 cm (Philadelphia: Pennsylvania Academy of the Fine Arts), www.pafa.org/museum/collection/item/young-thomas-his-mother (accessed December 6, 2022).

34 Pernoud, "Au centre," 302, 305 (quote).

35 Pernoud, ibid., 300, mentions Demesses's *Une journée d'enfant* (1889) with a drawing by Adrien Marie that shows a mother who under the supervision of a professional concentrating puts her child in a tub; on child-rearing advice manuals, see Bakker, *Kind en karakter*; Bakker, "The Meaning of Fear."

36 Berthe Morisot, *The Cradle* (1872), oil on canvas, 56 × 46 cm (Paris: Musée d'Orsay), www.musee-orsay.fr/en/artworks/le-berceau-1132 (accessed November 3, 2022); Pernoud, "Au centre," 300–1.

37 Jean-Baptiste Siméon Chardin (1699–1779), *The Young Governess* (c.1737), oil on canvas, 61.6 × 66.7 cm (London: National Gallery), www.nationalgallery.org.uk/paintings/jean-simeon-chardin-the-young-schoolmistress (accessed October 3, 2022); Autin Graz, *Children*, 208–9. Cf. Wachelder, "Chardins Touch," 34–5.
38 Jean-Baptiste-Siméon Chardin, *Grace* (1740), 49.5 × 38.5 cm (Paris: Musée du Louvre); Allard, "La quête," 242–5, 237–8.
39 Jean-Baptiste-Siméon Chardin, *Girl with a Racquet* (1741), oil on canvas, 82 × 66 cm (Florence: Galleria degli Uffizi); Allard, "La quête," 242. See also Anne-Louis Girodet (1767–1824), *Portrait of Benoit Romainville-Trioson* (1797), oil on canvas, 73 × 59 cm (Montargis: Musée Girodet). The boy is surrounded by toys and sits at a desk with an open bible, a typically Chardin configuration. His face shows the competing emotions of seriousness and of regretting that the time of simply playing is over; see Allard, "La quête," 244–5.
40 Jean-Baptiste-Siméon Chardin, *The Governess* (1739), oil on canvas, 46.7 × 437.5 cm (Ottawa: National Gallery of Canada); Allard, "La quête," 242–5.
41 Gerardus De San (Brugge 1754–Groningen 1830), *Family Portrait of Hendrik Louis Wijchgel van Lellens with His Wife and Two Daughters* (1796), oil on canvas, 250 × 177 cm (Groningen: Groninger Museum); Dekker, *Het verlangen*, 206–7.
42 Abraham van Strij, *The Drawing Lesson* (s.a.), oil on panel, 66 × 60 cm (Dordrecht: Dordrechts Museum); Dumas, *In helder licht*, 130–1; Dekker, *Het verlangen*, 208–9.
43 Willem Bartel van der Kooi, *Binne and Haye van der Kooi* (c. 1830), oil on panel, 26.3 × 34.5 cm (Leeuwarden: Fries Museum); Boschma, *Willem Bartel van der Kooi*, 67, 196. Cf. Abraham van Strij, *The Young Draftsman* (1820), oil on panel, 51.5 × 44 cm (Belgium: private collection); Dumas, *In helder licht*, 31, with a boy in a cap, sitting in a De Hooch-like interior, drawing diligently and not distracted by a girl looking at him in admiration.
44 Sir Thomas Lawrence, *The Angerstein Children* (1807), oil on canvas, 184.3 × 148.8 cm (Berlin: Gemäldegalerie-Staatlichen Museen zu Berlin); Autin Graz, *Children in Painting*, 178–9.
45 Bernard Blommers, *Playing School* (1868), oil on canvas, 92.7 × 112.4 cm, VBL/13 (Dordrecht: Dordrechts Museum, in loan from RCE/collection Van Bilderbeek, 1951); Dekker, "Pedagogiek in beeld (B. J. Blommers)," 52.
46 Allard, "La quête," 238.
47 Jean-Honoré Fragonard, *Advantage Taken of the Absence of Father and Mother* (1765), oil on canvas, 50 × 60.5 cm (Saint Petersburg: Hermitage); Allard, "La quête," 250–2.
48 Reddy, "Historical Research," 308. Cf. Fried, *Absorption and Theatricality*.
49 Beaven, "The Visual Arts," 110.
50 Jean-Baptiste Greuze, *Young Girl Mourning Her Dead Bird* (1765), oil on canvas, 53.30 × 46 cm (Edinburgh: National Gallery of Scotland); Jean-Baptiste Greuze, *The Broken Jug* (1773), oil on canvas, 108 × 86 cm (Paris: Musée du Louvre); Allard, "La quête," 246–50.
51 Jean-Baptiste Greuze, *Broken Eggs* (1756), oil on canvas, 73 × 94 cm (New York: Metropolitan Museum of Art, legacy of William K. Vanderbilt); Allard, "La quête," 245–6. Other examples of Greuze's paintings about girls on the threshold of adolescence are *Innocence* (before 1794), oil on mahogany panel, 63 × 53 cm (London: The Wallace Collection), https://wallacelive.wallacecollection.org/eMP/eMuseumPlus? (accessed November 11, 2022), and *The Letter Writer* (c.

Notes

1800–6), oil on canvas, 40.5 × 33.2 cm (London: The Wallace Collection), https://wallacelive.wallacecollection.org/eMP/eMuseumPlus? (accessed November 11, 2022).

52 Jean-Baptiste Greuze, *Young Shepherd Who Tempts Fate to Find Out if He Is Loved by His Shepherdess (Young Shepherd Holding a Flower)* (1760–1), oil on canvas, 72.5 × 59.5 cm (Paris: Petit Palais), https://collections.rothschild.inha.fr/fr/uvres/selection-d-oeuvres/toutes-les-oeuvres/jeune-berger-qui-tente-le-sort (accessed November 11, 2022); the pendant about a loving girl with a flower is *The Simplicity* (1768) (Fort Worth: Kimbell Art Museum).

53 Allard, "La quète," 252.

54 Willem Bartel van der Kooi, *Love Letter* (1808), oil on canvas, 131 × 108 cm (Leeuwarden: Fries Museum, in loan from Rijksmuseum Amsterdam); Van Heteren, *Poëzie der werkelijkheid*, 41; Boschma, *Willem Bartel van der Kooi*, 286–90; Sluijter, "In wedijver met de Gouden Eeuw," 128–9; Sutton et al., *Love Letters*; Dekker, *Het verlangen*, 255–6.

55 Pernoud, "Au centre," 306, 309.

56 Edgar Degas, *Young Spartans Exercising* (c. 1860), oil on canvas, 109.5 × 155 cm (London: The National Gallery), www.nationalgallery.org.uk/paintings/hilaire-germain-edgar-degas-young-spartans-exercising (accessed December 7, 2022), text by the conservator of the National Gallery; cf. Cecily Brown on "Young Spartans Exercising," www.youtube.com/watch?v=zkHpzk0o-R8.

57 Van Tilburg, *Hoe hoorde het?*; Bakker, *Kind en karakter*, 37–51, 75–104; Kemperink, *Het verloren paradijs*, chapter V; Röling, *Gevreesde vragen*, 12.

58 Jozef Israëls, *The Timid Lover* (1883), aquarelle, 83.4 × 63.3 cm (Montreal: The Montreal Museum of Fine Arts); see also Jozef Israëls, *Beau temps* (1883), oil on canvas, 106.8 × 171 cm (New York: Sotheby's Auction, November 2, 1999, nr. 21); Dekkers et al., *Jozef Israëls 1824–1911*, 318–19; Jozef Israëls, *Courtship* (1899), oil on canvas, 68 × 95 cm (Amsterdam: Rijksmuseum); Dekkers et al., *Jozef Israëls 1824–1911*, 136; Dekker, *Het verlangen*, 354–5.

8 Conclusion: Changing Discourses, Continuing Emotions

1 Lederer, "Religion," 47.
2 Matt, "Introduction," 14.
3 Deploige, "Studying Emotions," 16; Oatley, *Emotions*, 16; Elias, *Über den Prozeβ*, vol. 1, 89–109; Cowan, "In Public," 158, and note 1, 179 on the process of rationalization in Weber's *The Protestant Ethic*; Plamper, *The History of Emotions*, 49–53; Dekker and Wichgers, "The Embodiment," 53–4.

Bibliography

Achenbach, Sigrid, *Käthe Kollwitz (1867–1945). Zeichnungen und seltene Graphik im Berliner Kuperstichkabinett* (Berlin: Staatliche Museen zur Berlin–Preußischer Kulturbesitz, 1995).
Albano, Caterina, "The Puzzle of Human Emotions: Some Historical Considerations from the 17th to the 19th Centuries," *Developmental Medicine and Child Neurology* 50(7) (2008), 494–7.
Alexandre-Bidon, Danièle and Monique Closson, *L'Enfant à l'ombre des cathédrales* (Lyon: Presses Universitaires de Lyon and Éditions du CNRS, 1985).
Allard, Sébastien, "La quête du naturel. Des Lumières au réalisme," in Allard et al., *L'Enfant dans la peinture* (2011), 193–282.
Allard, Sébastien, Nadeije Laneyrie-Dagen, and Emmanuel Pernoud, *L'Enfant dans la peinture* (Paris: Citadelles et Mazenod, 2011).
Alpers, Svetlana, *L'art de dépeindre. La peinture hollandaise au XVIIe siècle* (Paris: Gallimard, [1983] 1990).
Alston, Laura, and Karen Harvey, "In Private: The Individual and the Domestic Community," in Claire Walker, Katie Barclay, and David Lemmings (eds.), *A Cultural History of the Emotions in the Baroque and Enlightenment Age* (London: Bloomsbury Academic, 2019), 137–53.
Alten, Michèle, Jean-Marie Baldner, Olivier Dumoulin, Christian Grataloup, François Dosse, Jean-Marc Goursolas, Jean-Louis Kreyts, and Jean-Michel Manivit (eds.), "Braudel dans tous ses états. La vie quotidienne des sciences sociales sous l'empire de l'histoire," *Espaces Temps* 34/35 (1986), 1–111.
Amsing, Hilda, Nelleke Bakker, Mineke van Essen, and Sanne Parlevliet (eds.), *Images of Education. Cultuuroverdracht in historisch perspectief* (Groningen: Uitgeverij Passage, 2018).
Andresen, Sabine, and Meike S. Baader, *Wege aus dem Jahrhundert des Kindes. Tradition und Utopie bei Ellen Key* (Neuwied: Luchterhand, 1998).
Ankersmit, Frank R., *De navel van de geschiedenis. Over interpretatie, representatie en historische realiteit* (Groningen: Historische Uitgeverij Groningen, 1990).
Ankersmit, Frank R., *Meaning, Truth, and Reference in Historical Representation* (Ithaca, NY: Cornell University Press, 2012).
Ankersmit, Frank R., "Representatie als cognitief instrument," *Algemeen Nederlands Tijdschrift voor Wijsbegeerte* 103(4) (2011), 243–62.
Ankersmit, Frank R., *Sublime Historical Experience* (Stanford: Stanford University Press, 2005).
Anzelewsky, Fedja, and Hans Mielke, *Albrecht Dürer. Kritischer Katalog der Zeichnungen. In serie: Die Zeichnungen alter Meister im Berliner Kuperstichkabinett* (Berlin: Staatliche Museen Preußischer Kulturbesitz. Kupferstichkabinett, 1984).
Ariès, Philippe, *Images de l'homme devant la mort* (Paris: Seuil, 1983).
Ariès, Philippe, *L'Enfant et la vie familiale sous l'Ancien Régime* (Paris: Éditions du Seuil, [1960] 1973). English translation: *Centuries of Childhood: A Social History of Family Life* (New York: Alfred A. Knopf/Vintage Books, 1962).
Ariès, Philippe, *L'Homme devant la mort* (Paris: Seuil, 1977).

Ariès, Philippe, *Un historien du dimanche*, ed. M. Winock (Paris: Seuil, 1980).
Ariès, Philippe, *Western Attitudes toward Death* (Baltimore, MD: Johns Hopkins University Press, 1974).
Ariès, Philippe, and Georges Duby (eds.), *Histoire de la vie privée*, vols. 1–5 (Paris: Seuil, 1985–7).
Ariès, Philippe, and Georges Duby (eds.), *L'histoire de la vie privée*, vol. 3, *De la Renaissance aux Lumières* (ed. R. Chartier) (Paris: Seuil, 1986).
Augustine, Saint, *The City of God* (trans. P. Levine) (London: Heinemann, 1966).
Autin Graz, Marie-Christine, *Children in Painting* (Milan: Skira Editore S.p.A., 2002).
Baader, Meike S., "Childhood and Happiness in German Romanticism, Progressive Education and in the West German Anti-authoritarian Kinderläden Movement in the Context of 1968," *Paedagogica Historica* 48(3) (2012), 1–15.
Baader, Meike S., *Die romantische Idee des Kindes und der Kindheit. Auf der Suche nach der verloren Unschuld* (Neuwied: Luchterhand, 1996).
Baggerman, Arianne, "The Infinite Universe of Enlightenment Century Children's Literature," in Claudia Jarzebowski and Thomas Max Safley (eds.), *Childhood and Emotion across Culture, 1450–1800* (London: Routledge, 2014), 106–20.
Baggerman, Arianne, "Keuzecompetentie in tijden van schaarste en overvloed. Het debat rond jeugdliteratuur voor en na Hiëronymus van Alphen (1760–1840)," in Gert-Jan Johannes, Jpsé de Kruif, and Jeroen Salman (eds.), *Een groot verleden voor de boeg. Cultuurhistorische opstellen voor Joost Kloek* (Leiden: Primavera Pers, 2004), 17–36.
Baily, Joanne, *Parenting in England, 1760–1830: Emotion, Identity and Generation* (Oxford: Oxford University Press, 2012).
Baily, Joanne, "Reassessing Parenting in Eighteenth-Century England," in Heleen Berry and Elizabeth Foyster (eds.), *The Family in Early Modern England* (Cambridge: Cambridge University Press, 2012), 209–32.
Bakker, Nelleke, *Kind en Karakter: Nederlandse pedagogen over opvoeding in het gezin 1845–1925* (Amsterdam: Het Spinhuis, 1995).
Bakker, Nelleke, "The Meaning of Fear: Emotional Standards for Children in the Netherlands, 1850–1950: Was There a Western Transformation?" *Journal of Social History*, 34(2) (2000), 369–91.
Ballauf, Theodor, and Klaus Schaller, *Pädagogik. Eine Geschichte der Bildung und Erziehung, Vol. 3, 19./20. Jahrhundert* (Freiburg: Alber, 1973).
Bantock, G. H., "Educating the Emotions: An Historical Perspective," *British Journal of Educational Studies* 34(2) (1986), 122–41.
Barasch, Moshe, *Gestures of Despair in Medieval and Early Renaissance Art* (New York: New York University Press, 1976).
Barclay, Katie, David Lemmings, and Clarie Walker, "Introduction: What Were Emotions? Definitions, Understandings, and Contributions," in Claire Walker, Katie Barclay, and David Lemmings (eds.), *A Cultural History of the Emotions in the Baroque and Enlightenment Age* (London: Bloomsbury Academic, 2019), 1–14.
Barclay, Katie, Kimberley Reynolds, and Ciara Rawnsley (eds.), *Death, Emotions and Childhood in Premodern Europe* (London: Routledge, 2016).
Barclay, Katie, and François Soyer (eds.), *Emotions in Europe, 1517–1914. Volume I: Reformations, 1517–1602* (London: Routledge, 2021).
Barker, Emma, *Greuze and the Painting of Sentiment* (New York: Cambridge University Press, 2005).
Barker-Benfield, Graham J., *The Culture of Sensibility: Sex and Society in Eighteenth-Century Britain* (Chicago: University of Chicago Press, 1992).

Barrett, Lisa F., "Are Emotions Natural Kinds?" *Perspectives on Psychological Science*, 1 (2006), 28–58.

Baxandall, Michael, *Painting and Experience in Fifteenth Century Italy: A Primer in the Social History of Pictorial Style* (Oxford: Oxford University Press, 1972).

Beales, Derek, "Religion and Culture," in Tim Blanning (ed.), *The Eighteenth Century: Europe 1688–1815* (Oxford: Oxford University Press, 2000), 131–77.

Beauvalet, Scarlett, "Life Histories," in Dekker (ed.), *A Cultural History of Education in the Renaissance* (2020), 173–92.

Beaven, Lisa, "The Visual Arts," in Claire Walker, Katie Barclay, and David Lemmings (eds.), *A Cultural History of the Emotions in the Baroque and Enlightenment Age* (London: Bloomsbury Academic, 2019), 85–110.

Becchi, Egle, "Humanisme et Renaissance," in Becchi and Julia (eds.), *Histoire de l'enfance en occident*, vol. 1 (1998), 160–99.

Becchi, Egle, and Dominique Julia (eds.), *Histoire de l'enfance en occident*, vol. 1: *De l'antiquité au XVIIe siècle*, vol. 2: *Du XVIIIe siècle à nos jours* (Paris: Éditions du Seuil, 1998).

Bedaux, Jan Baptist, "From Normal to Supranormal: Observations on Realism and Idealism from a Biological Perspective," in Jan Baptist Bedaux and Brett Cooke (eds.), *Sociobiology and the Arts* (Amsterdam: Rodopi, 1999), 99–128.

Bedaux, Jan Baptist, "Funeraire kinderportretten uit de 17de eeuw," in Bert C. Sliggers (ed.), *Naar het lijk. Het Nederlandse doodsportret 1500-heden* (Zutphen: Walburg Pers, 1998), 88–114.

Bedaux, Jan Baptist, "Introduction," in Bedaux and Ekkart (eds.), *Pride and Joy* (2000), 11–32.

Bedaux, Jan Baptist, *The Reality of Symbols: Studies in the Iconology of Netherlandish Art 1400–1800* ('s-Gravenhage: Gary Schwarz/SDU, 1990).

Bedaux, Jan Baptist, and Rudi E. O. Ekkart (eds.), *Pride and Joy: Children's Portraits in the Netherlands 1500–1700* (Ghent: Ludion Press/Harry N. Abrams, 2000).

Bejczy, István P., *The Cardinal Virtues in the Middle Ages: A Study in Moral Thought from the Fourth to the Fourteenth Century*, vol. 202 (Leiden: Brill's Studies in Intellectual History, 2011).

Bejczy, István P., and Cary J. Nederman, "Introduction," in Bejczy and Nederman (eds.), *Princely Virtues in the Middle Ages, 1200–1500* (2007), 1–8.

Bejczy, István P., and Cary J. Nederman (eds), *Princely Virtues in the Middle Ages, 1200–1500* (Turnhout: Brepols, 2007).

Belich, James, *The World the Plague Made: The Black Death and the Rise of Europe* (Princeton, NJ: Princeton University Press, 2022).

Bell, Charles, *Essays on the Anatomy of Expression in Painting* (London: Longman, Hurst, Rees, and Orme, 1806).

Bell, Charles, *Essays on the Anatomy and Philosophy of Expression* (London: John Murray, 1824).

Benesch, Otto, *Werkverzeichnis der Rembrandtzeichnungen* (London: Phaidon, [1954–5] 1973, enlarged and revised third edition).

Benner, Dietrich, "Erziehungs- und bildungstheoretische Überlegungen zum Ordnungsrahmen des 'Pädagogischen Dreiecks' und der 'triadischen Struktur der Erziehung,'" in Hilda T. A. Amsing, Bas Blom, Jeroen J. H. Dekker, and Mineke van Essen (eds.), *De kern van onderwijs: Liber Amicorum voor Wilna Meijer* (Groningen: Rijksuniversiteit Groningen, 2017), 13–17.

Benner, Erica, *Machiavelli's "Prince": A New Reading* (Oxford: Oxford University Press, 2014).

Bevers, Holm, *Rembrandt: Die Zeichnungen im Berliner Kuperstichkabinett. Kritischer Katalog* (Berlin: Staatliche Museen zu Berlin/Hatje Contz Verlag, 2006).
Bevers, Holm, "Review: Van Eyck, Bruegel, Rembrandt. Niederländische Zeichnungen des 15. bis 17. Jahrhunderts aus dem Kupferstich-Kabinett, Dresden (Exhibition Catalogue) by Christian Dittrich," *Master Drawings* 38(1) (2000), 70–3.
Beverwyck, Johan van, *Schat der Gesontheyt* (Dordrecht: Weduwe van Everhard Cloppenburgh, 1636).
Biesboer, Pieter, and James A. Welu, *Judith Leyster: A Dutch Master and Her World* (New Haven, CT: Yale University Press, 1993).
Blaak, Jeroen (ed.), *Hermanus Verbeeck: Memoriaal ofte mijn levensraijsinghe* (Hilversum: Verloren, 1999).
Blaas, Piet B. M., "Op zoek naar een glimp van het verleden. De geschiedfilosofie van Frank Ankersmit," *Tijdschrift voor Geschiedenis* 119(3) (2006), 377–86.
Blankaart, Steven, *Verhandelinge van de opvoedinge en ziekten der kinderen* (Amsterdam: Hieronymus Sweerts, 1684).
Bloch, Marc, *Apologie pour l'histoire ou métier d'historien* (Paris: Armand Colin, [1941] 1975).
Bloch, Marc, *Les Rois Thaumaturges* (Paris: Gllimard, [1924] 1983).
Blotkamp, Carel, A. M. Hammacher, and Dick Vreeze, *Kunstenaren der idee: symbolistische tendenzen in Nederland, ca. 1880–1930* (Den Haag: Gemeentemuseum/Staatsuitgeverij, 1978).
Blumenthal, Arthur L., "Leipzig, Wilhelm Wundt, and Psychology's Gilded Age," in Gregor A. Kimble and Michael Wertheimer (eds.), *Portraits of Pioneers in Psychology*, vol. 3 (Washington, DC: Psychology Press, 1998), 31–48.
Bobier, Christopher A., "Thomas Aquinas on the Basis of the Irascible-Concupiscible Division," *Res Philosophica* 97(1) (2020), 31–52.
Boddice, Rob, "Medical and Scientific Understandings," in Susan J. Matt (ed.), *A Cultural History of the Emotions in the Age of Romanticism, Revolution, and Empire* (London: Bloomsbury Academic, 2019), 17–32.
Boersma, A., "Dou's Painting Technique: An Examination of Two Paintings," in Arthur K. Wheelock Jr. (ed.), *Gerrit Dou 1613–1675: Master Painter in the Age of Rembrandt* (Washington, DC: National Gallery of Art/Yale University Press, 2000), 54–63.
Bogart, Leo, "Reconstructing Past Social Moods from Paintings: The Eye of the Beheld," *International Journal of Public Opinion Research* 15(2) (2003), 119–33.
Bok, M. Jan, "Het leven van Jan Steen," in H. Perry Chapman, Wouter Th. Kloek, and Arthur K. Wheelock Jr. (eds.), *Jan Steen:Painter and Storyteller* (Amsterdam: Rijksmuseum/National Gallery of Art, 1996), 25–37.
Bolgar, Robert R., "The Teaching of Letter-Writing in the Sixteenth Century," *History of Education* 12(4) (1983), 245–53.
Born, K. E., "Neue Wege der Wirtschafts- und Sozialgeschichte in Frankreich. Die Historikergruppe der 'Annales,'" *Saeculum* 15(3) (1964), 298–308.
Bos, Jan, and Jan Albert Gruys (eds.), *Cats Catalogus: De werken van Jacob Cats in the Short-Title Catalogue, Netherlands* (The Hague: Royal Library of the Netherlands, 1996).
Boschma, Cornelis, *Willem Bartel van der Kooi en het tekenonderwijs in Friesland* (Leeuwarden: DeTille, 1978).
Boschma, Cornelis, *Willem Bartel van der Kooi, Fries Museum-Leeuwarden* (Leeuwarden: Fries Museum, 1976).
Boszormenyi-Nagy, Ivan, and Geraldine M. Spark, *Invisible Loyalties: Reciprocity in Intergenerational Family Therapy* (New York: Harper & Row, 1973).

Bougher-Muckian, H. R., E. E., Root, G. Grygas Coogle, and F. K. Floyd, "The Importance of Emotions: The Socialization of Emotion in Parents of Children with Autism Spectrum Disorder," *Early Child Development and Care* 186 (2016), 1584–93.

Bowie, Bonnie H., Sybil Carrère, and Eve-Anne Doohan, "The Role of Culture in Parents' Socialization of Children's Emotional Development," *Western Journal of Nursing Research* 35 (2011), 514–33.

Braider, Christopher, *Refiguring the Real: Picture and Modernity in Word and Image 1400–1700* (Princeton: Princeton University Press, 1993).

Brandt-Cortius, Liesbeth, and C. Hollema (eds.), *De kunst van het moederschap: Leven en werk van Nederlandse vrouwen in de 19de eeuw* (Haarlem: Frans Halsmuseum, 1981).

Braudel, Fernand, *Civilisation matérielle, économie et capitalisme, XVe-XVIIIe siècle* (vol. 1, *Les structures du Quotidien: Le possible et l'impossible*; vol. 2: *Les jeux de l'échange*; vol. 3: *Le temps du monde*) (Paris: Armand Colin, 1979).

Braudel, Fernand, "Histoire et sciences sociales: La longue durée," in F. Braudel (ed.), *Écrits sur l'histoire* (Paris: Flammarion, [1958] 1969), 41–83.

Braudel, Fernand, *La Méditerranée et le monde méditerranéen à l'époque de Philippe II* (Paris: Armand Colin, [1949] 1982; 2 vols.).

Braunstein, Ph, "Approches de l'intimité," in G. Duby (ed.), *Histoire de la vie privée*, vol. 2: *De l'Europe Féodale à la Renaissance* (Paris: Seuil, 1985), 526–619.

Brehony, Kevin J. (ed.), "Early Years Education: Some Froebelian Contributions," *History of Education* 35(2: Special Issue) (2006), 167–295.

Brehony, Kevin J. (ed.), "Progressive and Child-Centred Education," *History of Education* 29(2: Special Issue) (2000), 97–170.

Brieler, Ulrich, "Foucaults Geschichte," *Geschichte und Gesellschaft* 24 (1998), 248–82.

Brockman, R., J. Ciarrochi, P. Parker, and T. Kashdan, "Emotion Regulation Strategies in Daily Life: Mindfulness, Cognitive Reappraisal and Emotion Suppression," *Cognitive Behaviour Therapy* 46 (2017), 91–113.

Broek, M. A. van den, *De spreekwoorden van Jacob Cats, alfabetisch gerangschikt en ingeleid* (Antwerpen: de Vries Brouwers, 1998).

Broomhall, Susan, "Cross-channel Conflict: The Challenge of Growing Up in Minority Huguenot Communities across the Channel," in L. Underwood (ed.), *Childhood, Youth and Religious Minorities* (Basingstoke: Palgrave, 2019).

Broomhall, Susan (ed.), *Early Modern Emotions: An Introduction* (London: Routledge, 2017).

Broomhall, Susan (ed.), *Emotions in the Household: 1200–1900* (Abingdon: Routledge, 2008).

Broomhall, Susan, "Medical and Scientific Understandings," in Andrew Lynch and Suan Broomhall (eds.), *A Cultural History of the Emotions in the Late Medieval, Reformation, and Renaissance Age* (London: Bloomsbury Academic, 2019), 13–29.

Broomhall, Susan (ed.), *Spaces for Feeling: Emotions and Sociabilities in Britain, 1650–1850* (Abingdon: Routledge, 2015).

Brown, Christopher, *Sources of Everyday Life: Dutch Genre Painting of the Seventeenth Century* (London: Faber and Faber, 1984). Dutch version: *"…Niet ledighs of ydels…": Nederlandse genreschilders uit de zeventiende eeuw* (Amsterdam: J.H. de Bussy, 1984).

Brown, Christopher, J. Kelch, and P. van Thiel (eds.), *Rembrandt: De Meester & zijn Werkplaats* (Amsterdam: Rijksmuseum/Waanders, 1991).

Bruce, Emily C., *Revolutions at Home: The Origin of Modern Childhood and the German Middle Class* (Amherst: University of Massachusetts Press).

Bruner, Jerome, *The Culture of Education* (Cambridge, MA: Harvard University Press, 1998).

Bibliography

Brunner, Gerhard, *Dürer, Holbein. Grünewald. Meisterzeichnungen der deutschen Renaissance aus Berlin und Basel* (Basel: Öffentliche Kunstsammlung Basel, and Staatliche Museen zur Berlin–Preußischer Kulturbesitz, 1997).
Bruyn, J., "A Turning-Point in the History of Dutch Art," in G. Luijten, A. van Suchtelen, R. Baarsen, W. Kloek, and M. Schapelhouman (eds.), *Dawn of the Golden Age: Northern Netherlandish Art 1580–1620* (Amsterdam: Rijksmuseum/Waanders, 1993), 112–21.
Buchardt, Mette, "Church, Religion, and Morality," in Daniel Tröhler (ed.), *A Cultural History of Education in the Age of Enlightenment*, vol. 4 (London: Bloomsbury Academic, 2020), 25–46.
Buijnsters, P. J., *Nederlandse literatuur van de achttiende eeuw* (Antwerpen: De Vries–Brouwers, 1984).
Buijnsters, P. J., and L. Buijnsters-Smets, *Lust en leering. Geschiedenis van het Nederlandse kinderboek in de negentiende eeuw* (Zwolle: Waanders, 2001).
Burckhardt, Jacob, *Die Kultur der Renaissance in Italien. Ein Versuch* (Stuttgart: Philipp Reclam/Universal-Bibliothek, [1860] 1987).
Burger, G., *Conduct Becoming: Wives and Husbands in the Later Middle Ages* (Philadelphia: University of Pennsylvania Press, 2017).
Burguière, A., and J. M. Todd, *The Annales School: An Intellectual History* (Ithaca, NY: Cornell University Press, 2009).
Buvelot, Quentin, Otto Naumann, and Eddy de Jongh, *Frans van Mieris 1635–1681* (The Hague: National Gallery of Art; Zwolle: Waanders, 2005).
Bynum, W. F., Roy Porter, and Michael Shepherd (eds.), *The Anatomy of Madness*, vol. 1: *People and Ideas* (London: Routledge, 1985).
Cambria, E., A. Livingstone, and A. Hussain, "The Hourglass of Emotions," in Anna Esposito, Antonietta M. Esposito, Allessandro Vinciarelli, Rüdiger Hoffmann, and Vincent C. Müller (eds.), *Cognitive Behavioural Systems* (Berlin: Springer, 2012), 144–57.
Camus, Jean-Pierre, *Diversitez, Tome 9: Traitté des passions de l'ame* (Paris: Claude Chappelet, 1614).
Carlier, Christian, *La prison aux champs. Les colonies d'enfants délinquants du nord de la France au XIXe siècle* (Paris: Les Éditions de l'Atelier, 1994).
Carlsmith, Ch., *A Renaissance Education: Schooling in Bergamo and the Venetian Republic, 1500–1650* (Toronto: University of Toronto Press, 2010).
Carr, David, *Educating the Virtues. An Essay on the Philosophical Psychology of Moral Development and Education* (London: Routledge, 1991).
Carr, David, and Jan Steutel (eds.), *Virtue Ethics and Moral Education* (London: Routledge, 1999).
Caruso, Marcelo, Sabine Reh, and Eckahrdt Fuchs (eds.), "Education and Nature," *Paedagogica Historica* 56(1–2: Special Issue) (2020), 1–216.
Catalogue, *Pieter Bruegel d.Ä. als Zeichner. Herkunft und Nachfolge* (Berlin: Staatliche Museen Preußischer Kulturbesitz. Kupferschichkabinett, 1975).
Cats, Jacob, *Alle de wercken* (Amsterdam: Schipper, 1665).
Cats, Jacob, *Huwelijk* (ed. A. A. Snekker and B. Thijs) (Amsterdam: Querido, 1993).
Cats, Jacob, *Sinne- en minnebeelden* [Images of Passions and Love] (ed. H. Luijten) (The Hague: Constantijn Huygens Instituut, 1996; 3 vols.).
Cats, Jacob, *Spiegel Van den Ouden ende Nieuwen Tijdt, Bestaende uyt Spreeck-woorden ende Sin-Spreucken, ontleent van de voorige ende tegenwoordige Eeuwe, verlustigt door menigte van Sinne-Beelden, met Gedichten en Prenten daer op passende; Dienstigh tot bericht van alle gedeelten des levens; beginnende van de Kintsheyt, ende eyndigende met het eynde alles*

vleech ('s Graven-Hage: Isaac Burchoorn, Boeck-drucker, 1632). Reprinted as facsimile similar in appearance and format: Amsterdam: Facsimile Uitgaven Nederland NV, 1968.

Chapman, H. Perry, "Jan Steen's Household Revisited," *Simiolus: Netherlands Quarterly for the History of Art* 20(2/3) (1990/1), 183–96.

Chapman, H. Perry, W. Th. Kloek, and A. K. Wheelock Jr. (eds.), *Jan Steen: Painter and Storyteller* (Amsterdam: Rijksmuseum/National Gallery of Art, 1996).

Charleton, Walter, *Natural History of the Passions* (London: James Magnes, 1674).

Chartier, Roger, "Le monde comme représentation," *Annales E. S. C.* 6 (1987), 1505–20.

Chartier, Roger (ed.), *Les usages de l'imprimé (XVe-XIXe siècle)* (Paris: Fayard, 1989).

Chassagne, Serge, "Le travail des enfants aux XVIIIe et XIXe siècle," in Egle Becchi and Dominique Julia (eds.), *Histoire de l'enfance en occident*, vol. 2 (Paris: Éditions du Seuil, 1998), 224–72.

Chisholm, Hugh (ed.), "Le Brun, Charles," in *Encyclopædia Britannica*, vol. 16 (11th ed.) (Cambridge: Cambridge University Press, 1911), 351–2.

Cival, Mauro, *The Palazzo Pubblico and the Civic Museum of Siena* (Siena: Betti Editrice, [1999] 2005).

Colb, R. I. Dingel, and L. Batka (eds.), *The Oxford Handbook of Martin Luther's Theology* (Oxford: Oxford University Press, 2016).

Conisbee, Philip, Richard Rand, and Joseph Baillio, "Jean-Honoré Fragonard: The Visit to the Nursery," in *French Paintings of the Fifteenth through the Eighteenth Century: The Collections of the National Gallery of Art Systematic Catalogue* (Washington, DC: National Gallery of Art, 2009), 182–7.

Corbin, Alain, *La douceur de l'ombre. L'arbre, source d'émotions, de l'Antiquité à nos jours* (Paris: Fayard, 2013).

Corbin, Alain, *Le miasme et la jonquille* (Paris: Flammarion, 1986).

Corbin, Alain, *Le Territoire du vide. L'Occident et le désir du rivage 1750–1840* (Paris: Aubier, 1988).

Corbin, Alain, Jean-Jacques Courtine, and Georges Vigarello (eds.), *Histoire du corps*, vol. 2: *Le triomphe de la virilité. Le XIX e siècle* (Paris: Seuil, 2005).

Cowan, Brian, "In Public," in Claire Walker, Katie Barclay, and David Lemmings (eds.), *A Cultural History of the Emotions in the Baroque and Enlightenment Age* (London: Bloomsbury Academic, 2019), 155–72.

Cremin, L. A., "The Family as Educator: Some Comments on the Recent Historiography," in H. J. Leichter (ed.), *The Family as Educator* (New York: Teachers College Press, 1974), 76–91.

Crutchley, Jody, Stephen G. Parker, and Sian Roberts, "Sight, Sound and Text in the History of Education," *History of Education* 47(2: Special Issue) (2018), 143–7.

Cunningham, Hugh, *Children and Childhood in Western Society since 1500* (Harlow: Pearson, 2005).

Cunningham, Hugh, "The History of Childhood," in Ph. Hwang, M. Lamb, and I. Sigel (eds), *Images of Childhood* (Mahwah NJ: Lawrence Erlbaum, 1996), 27–35.

Cunningham, William A., and Tabitha Kirkland, "Emotion, Cognition, and the Classical Elements of Mind," *Emotion Review* 4(4) (2012), 369–70.

Daly, Peter M., *The European Emblem: Towards an Index Emblematicus* (Waterloo: Wilfrid Laurier University Press, 1980).

Damasio, A., *Descartes' Error: Emotion, Reason, and the Human Brain* (New York: Avon, 1994).

Damasio, Antonio R., *Looking for Spinoza: Joy, Sorrow, and the Feeling Brain* (Orlando, FL: Harcourt, 2003).

Darton, Robert, *The Great Cat Massacre and Other Episodes in French Cultural History* (New York: Random House, 1985).

Darwin, Charles, "Biographical Sketch of an Infant," *Mind: A Quarterly Review of Psychology and Philosophy* 2 (1877), 285–94.

Darwin, Charles, *The Expression of Emotions in Man and Animals* (London: John Murray, 1872).

Dassen, P., *De onttovering van de wereld. Max Weber en het probleem van de moderniteit in Duitsland 1890–1920* (Amsterdam: Van Oorschot, 1999).

Davidson, Richard J., Klaus R. Scherer, and H. Hill Goldsmith (eds.), *Handbook of Affective Sciences* (Oxford: Oxford University Press, 2003).

Defoer, Henri L. M., Anne S. Korteweg, and Wilhelmina C. M. Wüstefeld, *The Golden Age of Dutch Manuscript Painting* (Stuttgart: Belser Verlag, 1989).

De la Chambre, Marin Cureau, *Les caractères des passions* (Amsterdam: Antoine Michel, 1658–62).

De Rycke, Robert M. E., "A Pedagogical Treatise of Marnix de Sainte-Aldegonde: The Ratio Instituendae Iuventutis," *History of Education Quarterly* 10(2) (1970), 203–10.

Deigh, John, "William James and the Rise of the Scientific Study of Emotion," *Emotion Review* 6(1) (2014), 4–12.

Dekker, Jeroen J. H., "Admiration et inspiration: Mettray dans le monde européen de l'éducation surveillée," in Luc Forlevisi, Georges-François Pottier, and Sophie Chassat (eds.), *Éduquer et Punir. La colonie agricole et pénitentiaire de Mettray (1839–1937)* (Rennes: Presses Universitaires de Rennes, 2005), 225–38.

Dekker, Jeroen J. H., "Beauty and Simplicity: The Power of Fine Art in Moral Teaching on Education in 17th Century Holland," *Journal of Family History* 34(2) (2009), 166–88.

Dekker, Jeroen J. H., "The Century of the Child Revisited," in M. Freeman (ed.), *Children's Rights: Progress and Perspectives. Essays from the International Journal of Children's Rights* (Leiden: Martinus Nijhoff/Koninklijke Brill NV, 2011), 477–95.

Dekker, Jeroen J. H., "Children at Risk in History: A Story of Expansion," *Paedagogica Historica* 45(1/2) (2009), 17–36.

Dekker, Jeroen J. H. (ed.), *A Cultural History of Education in the Renaissance* (London: Bloomsbury Academic, 2020; The Culturel History of Education Series, Vol. 3).

Dekker, Jeroen J. H., "Cultural Transmission and Inter-generational Interaction," *International Review of Education* 47(1) (2001), 77–95.

Dekker, Jeroen J. H., "Dangerous, Seductive, and Innovative: Visual Sources for the History of Education," in Sarah Van Ruyskensvelde, Geert Thyssen, Frederik Herman, Angelo Van Gorp, and Pieter Verstraete (eds.), *Folds of Past, Present and Future: Reconfiguring Contemporary Histories of Education* (Oldenbourg: De Gruyter, 2021), 383–404.

Dekker, Jeroen J. H., "De betekenis van 'Montaillou' voor historisch-pedagogische theorievorming; de inquisitie tussen opvoeding en onderzoek," in D. Papousek (ed.), *Montaillou in Groningen* (Groningen, 1981), 73–84.

Dekker, Jeroen J. H., "Demystification in the Century of the Child: The Conflict between Romanticism and Disenchantment in (Residential) Youth Care from the 1830s to 2000," in E. J. Knorth, P. M. van den Bergh, and F. Verhey (eds.), *Professionalization and Participation in Child and Youth Care. Challenging Understandings in Theory and Practice* (Burlington: Ashgate, 2002), 27–48.

Dekker, Jeroen J. H., *De pedagogische ruimte in de tijd* (Groningen: Rijksuniversiteit Groningen, 2019).

Dekker, Jeroen J. H., *Educational Ambitions in History: Childhood and Education in an Expanding Educational Space from the Seventeenth to the Twentieth Century* (Frankfurt am Main: Peter Lang, 2010).

Dekker, Jeroen J. H., "Educational Sciences and the History of Education: 'La longue durée' or the Short Timeliness," *Bildungsgeschichte: International Journal for the Historiography of Education* 3(2) (2013), 248–51.

Dekker, Jeroen J. H., "Educational Space in Time: Reflections on Limits and Options for Educational Ambitions in History," *Nordic Journal of Educational History* 9(1) (2022), 3–25.

Dekker, Jeroen J. H., "Éduquer et punir. Michel Foucault et l'histoire de l'éducation surveillée," *Sociétés et Représentations* 3 (1996), 257–68.

Dekker, Jeroen J. H., "Entre Rousseau et péché originel. Le modèle néerlandais de la protection de l'enfance au XIXème siècle," *Le Temps de l'histoire* 5 (2003), 27–42.

Dekker, Jeroen J. H., "Family on the Beach: Representations of Romantic and Bourgeois Family Values by Realistic Genre Painting of 19th-Century Scheveningen Beach," *Journal of Family History* 28(2) (2003), 277–96.

Dekker, Jeroen J. H., "The Fragile Relation between Normality and Marginality: Marginalization and Institutionalization in the History of Education," *Paedagogica Historica* 26(2) (1990), 13–29.

Dekker, Jeroen J. H., "From Imaginations to Realities: The Transformation of Enlightenment Pedagogical Illusions of the Dutch Republic into Late 19th-Century Realities of the Dutch Monarchy," in D. Tröhler, Th. Popkowitz, and D. Labaree (eds.), *Schooling and the Making of Citizens in the Long Nineteenth Century: Comparative Visions* (New York: Routledge, 2011), 50–69.

Dekker, Jeroen J. H., *Het Gezinsportret. Over de geschiedenis van opvoeding, cultuuroverdracht en identiteit* (Baarn: Ambo, 1992).

Dekker, Jeroen J. H., *Het verlangen naar opvoeden. Over de groei van de pedagogische ruimte in Nederland sinds de Gouden Eeuw tot omstreeks 1900* (Amsterdam: Bert Bakker, 2006).

Dekker, Jeroen J. H., "Images as Representations: Visual Sources on Education and Childhood in the Past," *Paedagogica Historica* 51(6) (2015), 702–15.

Dekker, Jeroen J. H., "In Search of Multiple Compatibility: Modernization, Secularization, Religion, and Education in History," *Bildungsgeschichte: International Journal for the Historiography of Education* 11(2) (2021), 171–5.

Dekker, Jeroen J. H., "Introduction: Education in an Emerging Communication and Knowledge Society," in Dekker (ed.), *A Cultural History of Education in the Renaissance* (2020), 1–17.

Dekker, Jeroen J. H., "Looking at Filtered Realities," in K. te Heesen (ed.), *Pädagogische Reflexionen des Visuellen* (Münster: Waxmann-Verlag, 2014), 27–46.

Dekker, Jeroen J. H., "Looking at the Voices of the Child: Ideas, Challenges, and Derailments in the Educational Space of the Past," *Children and Youth Services Review* 153 (2023), 1–8.

Dekker, Jeroen J. H., "Message et réalité. L'iconographie de l'éducation des enfants et sa signification morale dans la peinture de genre hollandaise du XVIIe siècle," in Egle Becchi and Dominique Julia (eds.), *Histoire de l'enfance en Occident, tome 1, De l'antiquité au XVIIe siècle* (Paris: Seuil/Collection Points H. 339, 2004), 397–425.

Dekker, Jeroen J. H., "Mirrors of Reality? Material Culture, Historical Sensation, and the Significance of Images for Research into Long-Term Educational Processes," in P. Smeyers and M. Depaepe (eds.), *Educational Research: Material Culture and Its Representation* (Dordrecht: Springer, 2014), 31–51.

Dekker, Jeroen J. H., "Moral Literacy: The Pleasure of Learning How to Become Decent Adults and Good Parents in the Dutch Republic in the Seventeenth Century," *Paedagogica Historica* 44(1/2) (2008), 135–49.
Dekker, Jeroen J. H., "Pedagogiek in beeld (Bernard J. Blommers: Kinderen aan het strand; schuitje laten varen)," *PIP–pedagogiek in praktijk* 20(85) (2015), 52.
Dekker, Jeroen J. H., "Pedagogiek in beeld (B.J. Blommers: Schooltje spelen)," *PIP–pedagogiek in praktijk* 21(90) (2016), 52.
Dekker, Jeroen J. H., "Pedagogiek in beeld (Jacob Maris: Het prentenboek)," *PIP–pedagogiek in praktijk*, 22(92) (2016), 52.
Dekker, Jeroen J. H., "Philanthropic Networks for Children at Risk in Nineteenth-Century Europe," *Paedagogica Historica* 43(2) (2007), 235–44.
Dekker, Jeroen J. H., "A Republic of Educators. Educational Messages in Seventeenth-Century Dutch Genre Painting," *History of Education Quarterly* 36(2) (1996), 163–90.
Dekker, Jeroen J. H., "The Restrained Child: Imaging the Regulation of Children's Behaviour and Emotions in Early Modern Europe: The Dutch Golden Age," *History of Education and Children's Literature* XIII(1: Special Issue) (2018), 17–39.
Dekker, Jeroen J. H., "Rituals and Reeducation in the Nineteenth Century: Ritual and Moral Education in a Dutch Children's Home," *Continuity and Change* 9(1) (1994), 121–44.
Dekker, Jeroen J. H., "Story Telling through Fine Art. Public Histories of Childhood and Education in Exhibitions in the Netherlands and Belgium c. 1980–c. 2020," in Frederik Herman, Sjaak Braster, and Maria del Mar del Pozo Andrés (eds.), *Exhibiting the Past: Public Histories of Education* (Oldenbourg: De Gruyter, 2022), 157–76.
Dekker, Jeroen J. H., *The Will to Change the Child: Re-education Homes for Children at Risk in Nineteenth Century Western Europe* (Frankfurt am Main: Peter Lang, 2001).
Dekker, Jeroen J. H., "Woord en beeld: Jacob Cats en de pedagogische cultuuroverdracht in de zeventiende eeuw," in J. W. Steutel, D. J. de Ruyter, and S. Miedema (eds.), *De gereformeerden en hun vormingsoffensief door de eeuwen heen* (Zoetermeer: Meinema, 2009), 47–65.
Dekker, Jeroen J. H., H. T. A. Amsing, and I. J. M. Wichgers, "Education in a Nation Divided: The Contribution of School Acts to the Development of Dutch Mass Schooling in the Long Nineteenth Century," in J. Westberg, L. Boser, and I. Brühwiler (eds.), *School Acts: The Rise of Mass Schooling. Education Policy in the Long Nineteenth Century* (Cham: Palgrave Macmillan/Springer Nature, 2019), 93–118.
Dekker, Jeroen J. H., and Peter Becker (eds.), "Doers: Philanthropists and Bureaucrats in the 19th Century," *Paedagogica Historica* 38(2/3: Special Issue) (2002), 413–795.
Dekker, Jeroen J. H., and Leendert F. Groenendijk, "The Republic of God or the Republic of Children? Childhood and Childrearing after the Reformation: An Appraisal of Simon Schama's Thesis about the Uniqueness of the Dutch Case," *Oxford Review of Education* 17(3) (1991), 317–35.
Dekker, Jeroen J. H., and Leendert F. Groenendijk, "Philippe Ariès's Discovery of Childhood after Fifty Years: The Impact of a Classic Study on Educational Research," *Oxford Review of Education* 38(2) (2012), 133–47.
Dekker, Jeroen J. H., L. F. Groenendijk, and J. Verberckmoes (2000), "Proudly Raising Vulnerable Youngsters: The Scope for Education in the Netherlands," in J. B. Bedaux and R. E. O. Ekkart (eds.), *Pride and Joy* ((Ghent: Ludion PressHarry N. Abrams, 2000), 43–60.
Dekker, Jeroen J. H., and Daniel M. Lechner, "Discipline and Pedagogics in History: Foucault, Ariès, and the History of Panoptical Education," *European Legacy* 4(5) (1999), 37–49.
Dekker, Jeroen J. H., and Frank Simon (eds.), *Shaping the History of Education? The First 50 Years of Paedagogica Historica* (London: Routledge, 2017).

Dekker, Jeroen J. H., and Inge J. M. Wichgers (2018), "The Embodiment of Teaching the Regulation of Emotions in Early Modern Europe," *Paedagogica Historica* 54(1/2) (2018), 48–65.

Dekker, Rudolf, *Children, Memory and Autobiography in Holland: From the Golden Age to Romanticism* (London: Macmillan, 1999).

Dekker, Rudolf, *Uit de schaduw in 't grote licht. Kinderen in egodocumenten van de Gouden Eeuw tot de Romantiek* (Amsterdam: Wereldbibliotheek, 1995).

Dekkers, Diewertje, "De Kinderen der Zee. De samenwerking tussen Jozef Israëls en Nicolaas Beets," *Jong Holland* 2(1) (1986), 36–60.

Dekkers, Diewertje, "The Frugal Meal," in Louis van Tilborgh (ed.), *The Potato Eaters by Vincent van Gogh* (Zwolle: Waanders, 1993), 75–84.

Dekkers, Diewertje, *Jozef Israëls. Een succesvol schilder van het vissersgenre* (Amsterdam: Universiteit van Amsterdam, 1994).

Dekkers, Diewertje, "Liefhebbers, collectioneurs en speculanten. Israëls en zijn verzamelaars," in Dekkers et al., *Jozef Israëls 1824–1911*, 100–14.

Dekkers, Diewertje, E. van Uitert, E. van Voolen, and R. Weiss-Blok (eds.), *Jozef Israëls 1824–1911* (Zwolle: Waanders, 1999).

Delumeau, Jean, *La peur en Occident, XIVe-XVIIIe siècles* (Paris: Fayard, 1978).

Delumeau, Jean, *Rassurer et protéger. Le sentiment de sécurité dans l'Occident d'autrefois* (Paris: Fayard, 1989).

DeMause, L. (ed.), *The History of Childhood* (New York: Psychohistory Press, 1974).

Depaepe, Marc, *Between Educationalization and Appropriation: Selected Writings on the History of Modern Educational Systems* (Leuven: Leuven University Press, 2012), 121–38.

Depaepe, Marc, *De pedagogisering voorbij: Aanzet tot een gnealogie van de pedagogische mentaliteit in de voorbije 250 jaar* (Leuven: Acco, 1998).

Depaepe, Marc, *Zum Wohl des Kindes? Pädologie, pädagogische Psychologie und experimentelle Pädagogik in Europa und den USA, 1890–1940* (Weinheim: Deutscher Studien Verlag, 1993).

Depaepe, Marc, B. Henkens, J. C. Albisetti, J. J. H. Dekker, Mark D'hoker, F. Simon, and J. Tollebeek (eds.), "The Challenge of the Visual in the History of Education," *Paedagogica Historica* 36(1: Special Issue) (2000), 1–505.

Depaepe, Marc, Frank Simon, and Angelo Van Gorp, *Ovide Decroly (1871–1932). Une approche atypique?* (Kingston, ON: The Theory and History of Education International Research Group, Queen's University, 2022).

Deploige, Jeroen, "Studying Emotions: The Medievalist as Human Scientist?" in Elodie Lecuppre-Desjardin and Anne-Laure Van Bruaene (eds.), *Emotions in the Heart of the City (14th–16th Century)* (Turnhout: Brepols, 2005), 3–24.

Descartes, René, *Discours de la méthode* (Paris: Librairie Larousse/Classiques Larousse, [1637] 1934).

Descartes, René, *The Passions of the Soul* (trans. and annotated Stephen Voss) (Indianapolis: Hackett, [1649] 2009).

Deursen, A. Th. van, *De last van veel geluk. De geschiedenis van Nederland, 1555–1702* (Amsterdam: Bert Bakker, 2004).

Deursen, A. Th. van, "De raadspensionaris Jacob Cats," in A. Th. van Deursen (ed.), *De hartslag van het leven. Studies over de Republiek der Verenigde Nederlanden* (Amsterdam: Bert Bakker, [1979] 1996), 362–74.

Deursen, A. Th. van, *Mensen van klein vermogen. Het "kopergeld" van de Gouden Eeuw* (Amsterdam: Bert Bakker, 1992).

Digby, Kenelm, *Two treatises: In the one of which, the nature of bodies; in the other, the nature of mans soule, is looked into: In the way of discovery of the immortality of reasonable souls* (London: John Williams, 1665; 2 vols. in 1).
Dijksterhuis, E. J., *De mechanisering van het wereldbeeld* (Amsterdam: Meulenhof, [1950] 1975).
Dixon, Scott, "Church, Religion, and Morality," in Dekker (ed.), *A Cultural History of Education in the Renaissance*, vol. 3 (2020), 19–42.
Dixon, Thomas, "'Emotion': The History of a Keyword in Crisis," *Emotion Review* 4(4) (2012), 338–44.
Dixon, Thomas, *From Passions to Emotions: The Creation of a Secular Psychological Category* (Cambridge: Cambridge University Press, 2003).
Downes, Stephanie, and Stephanie Trigg, "Editors' Introduction: Facing Up to the History of Emotions," *Postmedieval: A Journal of Medieval Cultural Studies* 8 (2017), 3–11.
Dräbing, R., *Der Traum vom "Jahrhundert des Kindes." Geistige Grundlagen, soziale Implikationen und reformpädagogische relevanz der erziehungslehre Ellen Keys* (Frankfurt am Main: Peter Lang, 1990).
Draguet, Michel, *Fernand Khnopff: Portrait of Jeanne Kéfer* (Los Angeles: Getty, 2004).
Drees, M. M., "'Burgerlijke' zeventiende-eeuwse literatuur," in J. Kloek and K. Tilmans (eds.), *Burger* (Amsterdam: Amsterdam University Press, 2002), 133–53.
Duby, Georges, "Preface," in Ph. Ariès and G. Duby (eds.), *L'histoire de la vie privée*, vol. 1: *De la Renaissance aux Lumières* (ed. Paul Veyne) (Paris: Seuil, 1985).
Duchet-Suchau, Gaston, and Michel Pastoureau, *La Bible et les saints. Guide iconographique* (Paris: Flammarion, 1990).
Dückers, Alexander (ed.), *Das Berliner Kupferstichkabinett. Ein Handbuch zur Sammlung 2. Auflage* (Berlin: Staatliche Museen zu Berlin, 1994).
Duits, Henk, and Ton van Strien (eds.), *Een intellectuele activist. Studies over leven en werk van Philips van Marnix van Sint Aldegonde* (Hilversum: Verloren, 2001).
Dumas, C., "De decoratieve schilderkunst van Abraham en Jacob van Strij," in Dumas (ed.), *In helder licht*, 45–100.
Dumas, C. (ed.), *In helder licht. Abraham en Jacob van Strij. Hollandse meesters van landsschap en interieur omstreeks 1800* (Zwolle: Waanders, 2000).
Duncun, Paul, *Images of Childhood. A Visual History from Stone to Screen* (London: Bloomsbury Visual Arts, 2023).
Dunne, Rachel, "Learners and Learning," in Tröhler (ed.), *A Cultural History of Education in the Age of Enlightenment*, vol. 4 (2020), 111–30.
Dupont-Bouchat, M.-S., E. Pierre, J.-M. Fecteau, J. Trépanier, J.-G. Petit, B. Schnapper, and J. J. H. Dekker, *Enfance et justice au XIXe siècle. Essais d'histoire comparée de la protection de l'enfance 1829–1914, France, Belgique, Pays-Bas, Canada* (Paris: PUF, 2001).
Duprat, Catherine, Jacques Petit, Colette Bec, and Jean-Noël Luc (eds.), *Philanthropies et politiques sociales en Europe (XVIIIe-XXe siècles)* (Paris: Anthropos-Economica, 1994).
Durantini, M. F., *The Child in Seventeenth Century Dutch Painting* (Ann Arbor, MI: UMI Research Press, 1983).
Eiselein, Gregory, "Literature," in Susan J. Matt (ed.), *A Cultural History of the Emotions in the Age of Romanticism, Revolution, and Empire* (London: Bloomsbury Academic, 2019), 121–36.
Eiselin, J., *Iene miene mutte. Over knikkeren, bokspringen en andere straatspelletjes* (Amsterdam: Prometheus, 1966).

Ekamper, P., R. van der Erf, N. van der Gaag, K. Henkens, E. van Imhoff, and F. van Poppel (eds.), *Bevolkingsatlas van Nederland. Demografische ontwikkelingen van 1850 tot heden* (Den Haag: NIDI, 2003).

Ekman, Paul, *Emotions in the Human Face* (Los Angeles: Malor Books, 2015).

Ekman, Paul, and Daniel Cordaro, "What Is Meant by Calling Emotions Basic," *Emotion Review* 3(4) (2011), 364–70.

Elder, G. H., J. Modell, and R. Parke (eds.), *Children in Time and Place: Developmental and Historical Insights* (Cambridge: Cambridge University Press, 1993).

Elfenbein, Hillary Anger, and Nalini Ambady, "On the Universality and Cultural Specificity of Emotion Recognition: A Meta-Analysis," *Psychological Bulletin* 128 (2002), 203–38.

Elias, Norbert, *Über den Prozeß der Zivilisation. Soziogenetische und psychogenetische Untersuchungen*, vols. 1 and 2 (Frankfurt am Main: Suhrkampf, [1939] 1981).

Ellis, Heather (ed.), *A Cultural History of Education in the Age of Empire*, vol. 5 (London: Bloomsbury Academic, 2020).

Ellis, Heather, "Introduction: Education in the Age of Empire 1800–1920," in Ellis (ed.), *A Cultural History of Education in the Age of Empire*, vol. 5 (2020), 1–15.

Ellison, Julie, *Cato's Tears and the Making of Anglo-American Emotion* (Chicago: University of Chicago Press, 1999).

Enterline, Lynn, *Shakespeare's Schoolroom: Rhetoric, Discipline, Emotion* (Philadelphia: University of Pennsylvania Press).

Erasmus, D., *A Declamation on the Subject of Early Liberal Education for Children/De pueris statim ac liberaliter instituendis declamatio* (trans. and annotated Beert C. Verstraete), in D. Erasmus (ed.), *Literary and Educational Writings, 3–4, Volume 26: Collected Works of Erasmus (CWE)*, based on *Opera omnia Desiderii Erasmi Roterodami* (Amsterdam, 1969–), ASD I-2, 23–78 (ed. J. K. Sowards) (Toronto: University of Toronto Press, [1529] 1985), 291–346.

Erasmus, D., *On Good Manners for Boys/De civilitate morum puerilium* (trans. and annotated Brian McGregor), in D. Erasmus (ed.), *Literary and Educational Writings, 3–4, Volume 25: Collected Works of Erasmus (CWE)*, based on *Opera omnia* (Leiden, 1703–6), LB I, 1033D-1042F (ed. J. K. Sowards) (Toronto: University of Toronto Press, [1530] 1985), 269–89.

Evangelisti, Silvia (2013), "Learning from Home: Discourses on Education and Domestic Visual Culture in Early Modern Italy," *History* 98(333), 663–79.

Exalto, John, "De vader, het kind en de appel: Erasmus door de ogen van Nederlandse Pedagogen," in A. L. H. Hage (ed.), *Desiderius Erasmus over opvoeding, Bijbel en samenleving* (Apeldoorn: De Banier, 2017), 129–59.

Exalto, John, *Van wie is het kind? Twee eeuwen onderwijsvrijheid in Nederland* (Amsterdam: Balans, 2017).

Exhibition of Portraits of the Reformation: Luther and Cranach in the Medici Collections at the Uffizi in Florence (2017–18). Retrieved February 6, 2019, from www.uffizi.it/en/eve nts/i-volti-della-riforma-lutero-e-cranach-nelle-collezioni-medicee.

Eyffinger, Arthur (ed.), *Huygens herdacht* (Den Haag: Koninklijke Bibliotheek, 1987).

Fagan, Brian, *The Little Ice Age: How Climate Made History, 1300–1850* (New York: Basic Books, 2000).

Farge, Arlette, *La vie fragile. Violence, pouvoirs et solidarités à Paris au XVIIIe siècle* (Paris: Hachette, 1986).

Farge, Arlette, "Marginaux," in A. Burguière (ed.), *Dictionnaire des Sciences Historiques* (Paris: Presses Universitaires de France, 1986), 436–8.

Fass, Paula S., "Childhood and Memory," *Journal of the History of Childhood and Youth* 3(2) (2010), 155–64.
Febvre, Lucien, "La sensibilité et l'histoire. Comment reconstituer la vie affective d'autrefois?," *Annales d'histoire sociale* III (1941), 5–20.
Febvre, Lucien, *Le problème de l'incroyance au XVIe siècle. La religion de Rabelais* (Paris: Albin Michel, [1942] 1947).
Fila, Jack, Jeroen J. H. Dekker, and Yolande Wildschut, *De Kunst van het opvoeden* (Walburg Pers: Zutphen, 2013).
Fildes, Valerie A., *Breasts, Bottles and Babies: A History of Infant Feeding* (Edinburgh: Edinburgh University Press, 1986).
Fildes, Valerie A., *Wet Nursing: A History from Antiquity to the Present* (Oxford: Basil Blackwell, 1988).
Fleming, S., *Children and Puritanism: The Place of Children in the Life and Thought of the New England Churches, 1620–1847* (New Haven, CT: Yale University Press, 1933).
Fletcher, A., *Gender, Sex and Subordination in England, 1500–1800* (New Haven, CT: Yale University Press, 1995).
Fodor, J. A., "A Theory of the Child's Theory of Mind," *Cognition* 44 (1992), 283–96.
Forlevisi, Luc, Georges-François Pottier, and Sophie Chassat (eds.), *Éduquer et Punir. La colonie agricole et pénitentiaire de Mettray (1839–1937)* (Rennes: Presses Universitaires de Rennes, 2005).
Foucault, Michel, *Dits et écrits: 1954–1988, III 1976–1979* (ed. D. Defert and F. Ewald) (Paris: Gallimard, 1994).
Foucault, Michel, *La volonté de savoir. Histoire de la sexualitie*, vol. 1 (Paris: Gallimard, 1976).
Foucault, Michel, *Les mots et les choses* (Paris: Gallimard, 1966).
Foucault, Michel, *Surveiller et punir. Naissance de la prison* (Paris: Éditions Gallimard, 1975).
Franits, Wayne, *Dutch Seventeenth Century Genre Painting* (New Haven, CT: Yale University Press, [2004] 2008).
Freedberg, David, *The Power of Images: Studies in the History and Theory of Response* (Chicago: University of Chicago Press, 1989).
Frevert, Ute, *Emotions in History: Lost and Found* (Budapest: Central European University Press, 2011).
Frevert, Ute, Pascal Eitler, Stephanie Olsen, Uffa Jensen, Margrit Pernau, Daniel Brückenhaus, Magdalena Beljan, Benno Gammerl, Anja Laukötter, Bettina Hitzer, Jan Plamper, Juliane Brauer, and Joachim C. Häberlen, *Learning How to Feel: Children's Literature and the History of Emotional Socialization, c. 1870–1970* (Oxford: Oxford University Press, 2014).
Frevert, Ute, Monique Scheer, Anne Schmidt, Pascal Eitler, Bettina Hitzer, Nina Verheyen, Benno Gammerl, Christian Bailey, and Margrit Pernau, *Emotional Lexicons: Continuity and Change in the Vocabulary of Feeling 1700–2000* (Oxford: Oxford University Press, 2014).
Fried, M., *Absorption and Theatricality: Painting and Beholder in the Age of Diderot* (Chicago: University of Chicago Press, 1980).
Frijda, Nico H., *The Emotions* (Cambridge: Cambridge University Press/Éditions de la Maison des Sciences de l'Homme, 1986).
Frijda, Nico H., "The Laws of Emotions," *American Psychologist* 5 (1988), 349–58.
Frijda, Nico H., *The Laws of Emotions* (Mahwah, NJ: Erlbaum, 2007).
Frijhoff, W. Th. M., *Cultuur, mentaliteit: illusies van elites?* (Nijmegen: SUN, 1983).
Frijhoff, W. Th. M., and M. Spies, *1650. Bevochten eendracht* (Den Haag: SDU, 1999). English edition: *1650. Hard-Won Unity* (Assen: Van Gorcum/Palgrave Macmillan, 2004).
Frijhoff, Willem, "Catholiques et identité catholique," in C. Secretan and W. T. M. Frijhoff (eds.), *Dictionnaire des Pays-Bas au siècle d'or* (Paris: CNRS Éditions, 2018), 121–5.

Frijhoff, Willem, *Comenius, the Dutch, and Visual Culture: An Interpretation* (Naarden: Stichting Comenius Museum, 2022).
Frijhoff, Willem, "Comenius, Jan Amos Komensky," in C. Secretan and W. T. M. Frijhoff (eds.), *Dictionnaire des Pays-Bas au siècle d'or* (Paris: CNRS Éditions, 2018), 151–3.
Frijhoff, Willem, "Emoties in het kwadraat," *BMGN: Low Countries Historical Review* 121(2) (2006), 284–91.
Frijhoff, Willem, "Historian's Discovery of Childhood," *Paedagogica Historica* 48(1) (2012), 11–29.
Frijhoff, Willem, "Jansénius et le Jansénisme," in C. Secretan and W. T. M. Frijhoff (eds.), *Dictionnaire des Pays-Bas au siècle d'or* (Paris: CNRS Éditions, 2018), 387–90.
Frijhoff, Willem, "Marnix over de opvoeding," in Duits and van Strien (eds.), *Een intellectuele activist* (2001), 59–75.
Fröbel, Friedrich, *The Education of Man* (New York: D. Appleton, [1826] 1893).
Gallati, Barbara Dayer, *Children of the Gilded Era: Portraits by Sargent, Renoir, Cassatt, and Their Contemporaries* (London: Merrell, 2004).
Gallati, Barbara Dayer (ed.), *Great Expectations: John Singer Sargent Painting Children* (Brooklyn: Brooklyn Museum, 2004).
Garber, Daniel, "Disciplining Feeling: The Seventeenth-Century Idea of a Mathematical Theory of Emotions," in Susan McClary (ed.), *Structures of Feeling in Seventeenth Century Cultural Expression* (Toronto: University of Toronto Press in association with UCLA Center for Seventeenth- and Eighteenth-Century Studies and the William Andrews Clark Memorial Library, 2003), 19–34.
Garin, Eugenio, "L'image de l'enfant dans les traités de pédagogie du XVe siècle," in Becchi and Julia (eds.), *Histoire de l'enfance en occident*, vol. 1 (1988), 231–54.
Gaukroger, Stephen, *Descartes' System of Natural Philosophy* (Cambridge: Cambridge University Press, 2002).
Gaukroger, Stephen (ed.), *The Soft Underbelly of Reason: The Passions in the Seventeenth Century* (London: Routledge, 1998).
Gay, Peter, *The Bourgeois Experience, Volume I: The Education of the Senses* (New York: Oxford University Press, 1984).
Gay, Peter, *The Enlightenment: An Interpretation* (New York: Knopf, 1966–9; 2 vols.).
Gay, Peter, *Schnitzler's Century: The Making of the Middle-Class Culture, 1815–1914* (New York: Norton, 2001).
Gélis, Jaques, *La sagefemme ou le médicin. Une nouvelle conception de la vie* (Paris: Fayard, 1988).
Gélis, Jaques, *L'arbre et le fruit. La naissance dans l'Occident moderne XVIe-XIXe siècle* (Paris: Fayard, 1984).
Gélis, Jacques, "L'individualisation de l'enfant," in Roger Chartier (ed.), *L'histoire de la vie privée*, vol. 3: *De la Renaissance aux Lumières* (Paris: Seuil, 1985), 311–29.
Gélis, Jaques, 'L'individualisation de l'enfant', in Ph. Ariès and G. Duby (eds.), *L'histoire de la vie privée. De la Renaissance aux Lumières*, vol. 3 (Paris: Éditions du Seuil, 1987), 311–29.
Gerbenzon, P. (ed.), *Het aantekeningenboek van Dirck Jansz* (Hilversum: Verloren, 1993).
Geremek, Bronislaw, "Le marginal," in J. Le Goff (ed.), *L'homme médiéval* (Paris: Seuil, 1989), 381–413.
Germer, Stefan, "Peurs plaisantes: Géricault et l'inquiétante étrangeté à l'aube du XIXe siècle," in Bruno Chenique (ed.), *Géricault, La Folie d'un monde* (Paris: Éditions Hazan, 2007), 30–1.
Gersdorff, Dagmar von, *Kinderbildnisse aus vier Jahrtausenden. Aus den Sammlungen Berliner Museen* (Berlin: Edition Hentrich, 1989).

Gerson, H., *Rembrandt Paintings* (London: Weidenfeld and Nicolson, 1968).
Ginzburg, Carlo, *The Cheese and the Worms: The Cosmos of a Sixteenth-Century Miller* (Baltimore, MD: Johns Hopkins University Press, 1980).
Ginzburg, Carlo, *Clues, Myths, and the Historical Method* (Baltimore, MD: Johns Hopkins University Press, 1989).
Ginzburg, Carlo, *Miti Emblemi Spie. Morfologia e storia* (Torino: Giulio Einaudi editore s.p.s., 1986).
Gobbers, W., *Jean-Jacques Rousseau in Holland. Een onderzoek naar de invloed van de mens en het werk (ca. 1760–ca. 1810)* (Gent: Secretariaat Koninklijke Vlaamse Academie voor taal- en letterkunde, 1963).
Goldberg, Jeremy, and Staphanie Tarbin, "In Private: The Individual and the Domestic Community," in Andrew Lynch and Suan Broomhall (eds.), *A Cultural History of the Emotions in the Late Medieval, Reformation, and Renaissance Age* (London: Bloomsbury Academic, 2019), 123–39.
Golden, Mark, *Childhood in Classical Athens* (Baltimore, MD: Johns Hopkins University Press, 1990).
Goldstein, J., *The Post-revolutionary Self: Politics and Psyche in France, 1750–1850* (Cambridge, MA: Harvard University Press, 2005).
Goleman, David, *Emotional Intelligence: Why It Can Matter More Than IQ* (London: Bloomsbury, 1996).
Goleman, David, *Working with Emotional Intelligence* (London: Bloomsbury, 1998).
Gombrich, E. H., "Icones symbolicae: Philosophies of Symbolism and Their Bearing on Art," in E. H. Gombrich (ed.), *Symbolic Images: Studies in the Art of the Renaissance* (London: Phaidon Press, 1972), 123–91.
Gombrich, E. H., *Norm and Form: Studies in the Art of the Renaissance I* (Oxford: Phaidon Press, [1966] 1985).
Gombrich, E. H., *The Story of Art* (Oxford: Phaidon Press, [1950] 1983).
Gómez Camacho, A., and J. Casado Rodrigo (2016), "Literacy Education and Orthography in the Spanish Golden Age, 1531–1631," *Paedagogica Historica* 52(6) (2016), 646–60.
Goody, J., *The Development of the Family and Marriage in Europe* (Cambridge: Cambridge University Press, 1983).
Gordon, Linda, "The Perils of Innocence, or What's Wrong with Putting Children First," *Journal of the History of Childhood and Youth* 1(3) (2008), 331–50.
Grandière, M., *L'Idéal pédagogique en France au dix-huitième siècle* (Oxford: Voltaire Foundation, 1998).
Green, M., "Bridging the English Channel: Huguenots in the Educational Milieu of the English Upper Class," *Paedagogica Historica* 54(4) (2018), 389–409.
Greenblat, S., *Renaissance Self-Fashioning: From More to Shakespeare* (Chicago: University of Chicago Press, 1980).
Grendler, P. F., "Jesuit Schools in Europa: A Historiographical Essay," *Journal of Jesuit Studies* 1 (2014), 7–25.
Griesebach, Lucius (ed.), *Adolph Menzel. Zeichnungen, Druckgraphik und illustrierte Bücher. Ein Bestandskatalog der Nationalgalerie, des Kupferstichkabinetts und der Kunstbibliothek Staatlichen Museen Preußischer Kulturbesitz* (Berlin: Staatlichen Museen Preußischer Kulturbesitz, 1984).
Grijzenhout, F., and H. van Veen (eds.), *De Gouden Eeuw in perspectief. Het beeld van de Nederlandse zeventiende-eeuwse schilders in later tijd* (Nijmegen: SUN/OU, 1992).
Groenendijk, L. F., "Advies voor opvoeding tot gehoorzaamheid ten tijde van de zeventiende-eeuwse Republiek," in Amsing et al. (eds.), *Images of Education* (2018), 72–83.

Groenendijk, L. F., *De Nadere reformatie van het gezin. De visie van Petrus Wittewrongel op de christelijke huishouding* (Dordrecht: J.P. van den Tol, 1984).

Groenendijk, L. F., *De pedagogiek van Jacobus Koelman. Inhoud en bronnen/grondslag en ambitie. "Een klaare bestiering om de kinderen voor den Heere op te voeden"* (Apeldoorn: Labarum Academic, 2017).

Groenendijk, L. F., "De pedagogisering van de kindertijd. Erasmus' invloed op de opvoedingsleer van gereformeerde moralisten in de zeventiende-eeuwse Republiek," in A. L. H. Hage (ed.), *Desiderius Erasmus over opvoeding, Bijbel en samenleving* (Apeldoorn: De Banier, 2017).

Groenendijk, L. F. "Jeugd en deugd. Een onderzoek van preken en andere stichtelijke literatuur uit de zeventiende en achttiende eeuw," in Groenendijk and Roberts (eds.), *Losbandige jeugd* (2004), 95–115.

Groenendijk, L. F., *Jong gewend, oud gedaan. Protestantse moralisten over de opvoeding van het jonge kind* (Amsterdam: Vrije Universiteit, 2005).

Groenendijk, L. F., "Marnix kindercatechismus," in Duits and van Strien (eds.), *Een intellectuele activist* (2001), 76–86.

Groenendijk, L. F., "Piëtisten en borstvoeding," *Pedagogisch Tijdschrift/Forum voor Opvoedkunde* 1 (1976), 583–90.

Groenendijk, L. F., "Piëtistische opvoedingsleer in Nederland. Balans van een kwarteeuw historisch-pedagogisch onderzoek," *Pedagogiek* 22 (2002), 326–37.

Groenendijk, L. F., "The Sanctification of the Household and the Reformation of Manners in English Puritanism and Dutch Pietism during the Seventeenth Century," in J. Beyer et al. (eds.), *Confessional Sanctity (c.1500–c.1800)* (Mainz: Philipp von Zabern, 2003), 197–218.

Groenendijk, Leendert F., *Seneca's lessen stoïcijnse levenskunt* (Soest: BoekXpress, 2021).

Groenendijk, Leendert F., and Benjamin B. Roberts, "Vader Cats: een piëtistisch pedagoog," *Pedagogiek* 21(1) (2001), 79–82.

Groenendijk, Leendert F., and Benjamin B. Roberts (eds.), *Losbandige jeugd. Jongeren en moraal in de Nederlanden tijdens de late Middeleeuwen en de Vroegmoderne Tijd* (Hilversum: Verloren, 2004).

Groenendijk, Leendert F., and Fred A. van Lieburg, *Voor edeler staat geschapen. Levens- en sterfbedbeschrijvingen van gereformeerde kinderen en jeugdigen uit de 17e en 18e eeuw* (Leiden: Groen, 1991).

Groenendijk, Leendert F., Fred A. van Lieburg, and John Exalto, "'Away with All My Pleasant Things in the World ...': Model Death-Bed Accounts of Two Young Victims of the Plague of 1644 in the Dutch Town of Leyden," *Paedagogica Historica* 46(3) (2010), 271–88

Groenveld, S., J. J. H. Dekker, and Th. R. M. Willemse, *Wezen en Boefjes. Zes eeuwen zorg in wees- en kinderhuizen* (Hilversum: Verloren, 1997).

Groot, J. M. de, "Traditie en vernieuwing in de kunst van Abraham en Jacob van Strij," in Dumas (ed.), *In helder licht* (2000), 25–44.

Grootes, E. K., "Literatuurhistorie en Cats' visie op de jeugd," in M. Spies and J. Jansen (eds.), *Visie in veelvoud. Opstellen van prof.dr. E.K. Grootes over zeventiende-eeuwse letterkunde ter gelegenheid van zijn zestigste verjaardag* (Amsterdam: Amsterdam University Press, 1996), 9–28.

Gross, J. J., "The Emerging Field of Emotion Regulation: An Integrative Review," *Review of General Psychology* 2 (1998), 271–99.

Gross, J. J., "Emotion Regulation: Current Status and Future Prospects," *Psychological Inquiry* 26 (2015), 1–26.

Gross, J. J., *Handbook of Emotion Regulation*, 2nd ed. (New York: Guilford, 2014).

Grosvenor, Ian, "'A Joyful Idea Reborn'. Aesthetic Education in a Time of Crisis," in Hilda Amsing et al. (eds.), *Images of Education* (2018), 208–19.

Grosvenor, Ian, and R. Watts (eds.), "Urbanisation and Education: The City as a Light and Beacon?" *Paedagogica Historica* 39(1/2: Special Issue) (2003), 1–253.

Gruschka, A., *Der heitere Ernst der Erziehung. Jan Steen malt Kinder und Erwachsene als Erzieher und Erzogene. Eine Entdeckungsreise durch die Bildwelten Jan Steens und seiner Zeit* (Wetzlar: Büchse der Pandora Verlag, 2005).

Gruyter, J. de, *De Haagse School* (Rotterdam: Lemniscaat, 1968).

Gyeong-Geon, Lee, and Hu-Gi Hong, "John Amos Comenius as the Prophet of Modern Ideas in Science Education: In the Light of Pansophia," *History of Education* 50(1) (2021), 1–26.

Haag, S., E. Oberthaler, S. Pénot, M. Sellink, and R. Spronk, *Bruegel: The Hand of the Master: Exhibition Catalogue of the Kunsthistorisches Museum Vienna* (Veurne: Hannibal, 2018).

Haak, B., *The Golden Age: Dutch Painters of the Seventeenth Century* (New York: Harry N. Abrams, 1984).

Haak, B., *Rembrandt: His Life, His Work, His Time* (New York: Abrams, 1969).

Haemers, Jelle, "In Public: Collectivities and Polities," in Andrew Lynch and Suan Broomhall (eds.), *A Cultural History of the Emotions in the Late Medieval, Reformation, and Renaissance Age* (London: Bloomsbury Academic, 2019), 141–55.

Hage, A. L. H. (ed.), *Desiderius Erasmus over opvoeding, Bijbel en samenleving* (Apeldoorn: De Banier).

Haitsma Mulier, E. O. G., "Kunsthistorici en de geschiedenis. Een verslag van enkele ontwikkelingen," *Bijdragen en Mededelingen betreffende de geschiedenis der Nederlanden* 101(2) (1986): 202–14.

Halkin, Léon-E., *Erasmus: A Critical Biography* (Oxford: Blackwell, 1993).

Hall, James, *Dictionary of Subjects and Symbols in Art* (London: John Murray, [1974] 1991).

Hamburger, Kunsthalle, *Kunst aus acht Jahrhunderten. Ein Führer durh die Sammlung* (Hamburg: Hamburger Kunsthalle, 2016).

Hanawalt, Barbara A., *Growing Up in Medieval London: The Experience of Childhood in History* (New York: Oxford University Press, 1995).

Hanawalt, Barbara A., "Medievalists and the Study of Childhood," *Speculum* 77 (2002), 440–60.

Hardtwig, W., "Der Historiker und die Bilder. Überlegungen zu Francis Haskell," *Geschichte und Gesellschaft* 24 (1998), 305–22.

Harrison, Peter, "Reading the Passions: The Fall, the Passions, and Dominion over Nature," in Gaukroger (ed.), *The Soft Underbelly of Reason* (1998), 49–78.

Haskell, Francis, *History and Its Images: Art and the Interpretation of the Past* (New Haven, CT: Yale University Press, 1993).

Hatfield, Gary, "Did Descartes Have a Jamesian Theory of the Emotions?" *Philosophical Psychology* 20 (2008), 413–40.

Hatfield, Gary, "The Passions of the Soul and Descartes's Machine Psychology," *Studies in History and Philosophy of Science* 38 (2007), 1–35.

Hawkins, Mike, *Social Darwinism in European and American Thought, 1860–1945* (Cambridge: Cambridge University Press, 1997).

Hecht, P., "The Debate on Symbol and Meaning in Dutch Seventeenth-Century Art: An Appeal to Common Sense," *Simiolus. Netherlands Quarterly for the History of Art* 16 (1986), 173–87.

Hecht, P., "Dutch Seventeenth-Century Genre Painting: A Reassessment of Some Current Hypotheses," *Simiolus: Netherlands Quarterly for the History of Art* 21(1/2) (1992), 85–95.

Heiland, H., "Fröbel en de Fröbelbeweging in de Duitse pedagogische historiografie," in *Jaarboek voor de geschiedenis van opvoeding en onderwijs* (Assen: Van Gorcum, 2003), 5–20.

Hekscher, W. S., and K. A. Wirth, "Emblem, Emblembuch," in O. Schmitt. (ed.), *Reallexikon zur deutschen Kunstgeschichte V* (Stuttgart: Alfred Druckmüller, 1967), 85–228.

Hendrick, Harry, *Images of Youth: Age, Class, and the Male Youth Problem, 1880–1920* (Oxford: Clarendon Press, 1990).

Herwaarden, Jan van, "'Mensen ... worden niet geboren maar gevormd': Erasmus en het principe van de opvoeding," *BMGN: Low Countries Historical Review*, 122(4) (2007), 519–37.

Heteren, M. van, G. Jansen, and R. de Leeuw, *Poëzie der werkelijkheid. Nederlandse schilders van de negentiende eeuw* (Zwolle: Waanders, 1989).

Heywood, Colin, *A History of Childhood: Children and Childhood in the West from Medieval to Modern Times* (Cambridge: Polity Press, 2001).

Heywood, Jean S., *Children in Care: The Development of the Service for the Deprived Child* (London: Routledge, 1978).

Hilgard, Ernest, Richard Atkinson, and Rita Atkinson, *Introduction to Psychology* (New York: Harcourt, 1971).

Himes, Kenneth R., "Capital Sins," in McBrien (ed.), *The HarperCollins Encyclopedia of Catholicism* (1995), 225.

Hindman, Sandra, "Pieter Bruegel's Children's Games, Folly, and Chance," *Art Bulletin* 63(3) (1981), 447–75.

Hippocrates, *Hippocrates's treatise on the preservation of health. Wherein is explained the salutary and pernicious effects, on different constitutions, of air, exercise, aliment, or food, rest, wakefulness, and sleep. To which he adds the passions of the mind, and repletion and evacuation* (London: J. Bell, 1776).

Hofrichter, Frima Fox, *Judith Leyster, 1609–1660* (Washington, DC: National Gallery of Art, 2009).

Hofstetter, Rita, and Bernard Schneuwly, "Teaching Culture and Emotions: The Function of Art in Vygotsky's Theory of Child Development (1920–1934)" in Amsing et al. (eds.), *Images of Education* (2018), 182–94.

Holme, R., *Literacy: An Introduction* (Edinburgh: Edinburgh University Press, 2004).

Homer, P. M., "Transmission of Human Values: A Cross-cultural Investigation of Generalization and Reciprocal Influence Effects," *Genetic, Social, and General Psychology Monographs* 119(3) (1993), 343–67.

Honour, H., and J. Fleming, *A World History of Art* (London: Laurence King, 2009).

Hoogeboom, Annemieke, *De stand des kunstenaars. De positie van kunstschilders in Nederland in de eerste helft van de negentiende eeuw* (Leiden: Primavera Press, 1993).

Hoogstraten, Samuel, *Inleyding tot de hooge schoole der schilderkonst: anders de zichtbaere werelt* (Rotterdam: Fransois van Hoogstraeten, 1678). Reprinted as facsimile similar in appearance and format by Davaco Publishers (s.l.), 1969.

Hoppe-Harnoncourt, Alice, Elke Oberthaler, Sabine Pénot, Manfred Sellink, and Ron Spronk, *Bruegel: The Hand of the Master: Exhibition Catalogue of the Kunsthistorisches Museum Vienna* (Veurne: Hannibal, 2018).

Horlacher, "Teachers and Teaching," in Tröhler (ed.), *A Cultural History of Education in the Age of Enlightenment*, vol. 4 (2020), 131–45.

Houlbrooke, R. A., *The English Family 1450–1700* (London: Longman, 1984).

Hugenholtz, F. W. N., "Huizinga's historische sensatie als onderdeel van het interpretatieproces," *Forum der Letteren* 20 (1979), 398–404.

Huizinga, J., "De taak der cultuurgeschiedenis," in J. Huizinga (ed.), *Verzamelde Werken 7: Geschiedwetenschap, Hedendaagsche Cultuur* (Haarlem: Tjeenk Willink, [1929] 1950), 35–94.

Huizinga, J., *Dutch Civilisation in the Seventeenth Century: And Other Essays* (New York: Harper & Row, 1968); or J. Huizinga, *Nederland's beschaving in de zeventiende eeuw. Een Schets* (Groningen: Tjeenk Willink, [1941] 1976).

Huizinga, J., *Erasmus and the Age of Reformation* (Princeton: Legacy Library, [1924] 2014).

Huizinga, J., *The Waning of the Middle Ages: A Study of the Forms of Life, Thought and Art in France and the Netherlands in the Fourteenth and Fifteenth Centuries* (Harmondsworth: Penguin, 1955); or J. Huizinga, *Herfsttij der middeleeuwen. Studie over levens- en gedachtenvormen der veertiende en vijftiende eeuw in Frankrijk en de Nederlanden* (Haarlem: H.D. Tjeenk Willink, 1919).

Huizinga, Johan, "The Problem of the Renaissance," in J. Huizinga (ed.), *Men and Ideas: History, the Middle Ages, the Renaissance* (Princeton: Princeton Legacy Library, [1920] 1984).

Hull, Isabel, *Sexuality, State, and Civil Society in Germany, 1700–1815* (Ithaca, NY: Cornell University Pres, 1996).

Hunt, D., *Parents and Children in History: The Psychology of Family Life in Early Modern France* (New York: Basic Books).

Hunt, Lynn, *The Enlightenment and the Origins of Religious Tolerance* (Amsterdam: Burgerhart Lectures, 2011).

Hutton, P. H., *Philippe Ariès and the Politics of French Cultural History* (Cambridge MA: University of Massachusetts Press, 2004).

Huygens, C., *Mijn jeugd [vertaling en toelichting C.L. Heesakkers]* (Amsterdam: Em. Querido's Uitgeverij, 1987).

Huygens, Christiaan, and Constantijn, "De jongelingsjaren van de kinderen van Christiaan en Constantijn Huygens," in E. de Heer and A. Eyffinger (eds.), *Huygens herdacht* (Den Haag: Koninklijke Bibliotheek, 1987), 75–165.

Huygens, Constantijn, *Mijn leven verteld aan mijn kinderen* (ed. F. Blom) (Amsterdam: Bert Bakker, 2003, 2 vols.).

Hwang, C. Philip, M. E. Lamb, and I. E. Sigel (eds.), *Images of Childhood* (Mahwah, NJ: Lawrence Erlbaum, 1996).

Israëls, J., *De kinderen der zee. Schetsen naar het leven aan onze Hollandsche stranden [gravures van J.H. Rennefeld, gedichten van Nicolaas Beets]* (Den Haag: Sijthoff, [1861] 1889).

Israel, J. I., *The Dutch Republic: Its Rise, Greatness, and Fall 1477–1806* (Oxford: Oxford University Press/Clarendon Press, 1995).

Israel, J. I., *Radical Enlightenment: Philosophy and the Making of Modernity, 1650–1750* (Oxford: Oxford University Press, 2001).

Izard, Carroll E., "The Many Meanings/Aspects of Emotion: Definitions, Functions, Activation, and Regulation," *Emotion Review* 2(4) (2010), 363–70.

Izard, Carroll E., "More Meanings and More Questions for the Term 'Emotion,'" *Emotion Review* 2(4) (2010), 383–5.

Jager, A., *"Galey-schilders" en "dosijnwerck": De productie, distributie en consumptie van goedkope historiestukken in zeventiende-eeuws* (Amsterdam: University of Amsterdam, 2016, PhD thesis).

James, Susan, *Passion and Action: The Emotions in Seventeenth-Century Philosophy* (Oxford: Clarendon Press, 1997).
James, William, *The Principles of Psychology* (New York: Dover, 1950, 2 vols.; facsimile edition of the original edition from 1890: Henry Holt).
James, William, "What Is an Emotion?" *Mind* 9(34) (1884), 188–205.
Jansen, Anita (ed.), *Pieter de Hooch in Delft. Uit de schaduw van Vermeer* (Zwolle: WBooks/Delft: Museum Prinsenhof, 2019).
Jansen, J., "The Emblem Theory and Audience of Jacob Cats," in J. Manning, K. Porteman, and M. van Vaeck (eds.), *The Emblem Tradition and the Low Countries* (Turnhout: Brepols, 1999), 227–42.
Janssen H., and W. van Sinderen, *De Haagse School* (Rotterdam: Waanders, 1997).
Jarzebowski, Claudia, *Kindheit und Emotion. Kinder und ihre Lebenswelten in der europäischen Frühen Neuzeit* (Berlin: Walter de Gruyter, 2018).
Johnston, Elizabeth, "How Women Really Are: Disturbing Parallels between Reality Television and 18th Century Fiction," in David S. Escoffery (ed.), *How Real Is Reality TV? Essays on Representation and Truth* (Jefferson, NC: McFarland, 2006), 115–32.
Jong, B. C. de, *Jan Ligthart (1859–1916). Een schoolmeester-pedagoog uit de Schilderswijk* (Groningen: Wolters-Noordhoff, 1996).
Jongh, E. de, "Jan Steen, dichtbij en toch veraf," in H. Perry Chapman, W. Th. Kloek, and A. K. Wheelock, Jr. (eds.), *Jan Steen: Painter and Storyteller* (Amsterdam: Rijksmuseum/National Gallery of Art, 1996), 39–51.
Jongh, E. de, *Portretten van echt en trouw. Huwelijk en gezin in de Nederlandse kunst van de zeventiende eeuw* (Zwolle: Waanders, 1986).
Jongh, E. de, *Zinne- en minnebeelden in de schilderkunst van de 17de eeuw* (Amsterdam: Nederlandse Stichting Openbaar Kunstbezit/Openbaar Kunstbezit in Vlaanderen, 1967).
Jongh, E. de, J. B. Bedaux, P. Hecht, J. Stumpel, Rik Vos, and Jochen Becker, *Tot lering en vermaak. Betekenissen van Hollandse genrevoorstellingen uit de zeventiende eeuw* (Amsterdam: Rijksmuseum, 1976).
Jongh, E. de, and G. Luijten, *Mirror of Everyday Life: Genreprints in the Netherlands 1550–1700* (Amsterdam: Rijksmuseum/Snoeck-Ducaju & Zoon, 1986).
Jorink, Eric, *Het "Boeck der Natuere" Nederlandse geleerden en de wonderen van Gods schepping 1575–1715* (Leiden: Primavera Pers, 2006).
Jouhaud, Chr. (ed.), "Littérature et histoire," *Annales, Histoire Sciences Sociales* 49 (1994), 271–457.
Julia, Dominique, "L'enfance aux débuts de l'époque moderne," in Becchi and Julia (eds.), *Histoire de l'enfance en occident*, vol. 1 (1998), 286–373.
Kaborycha, L., *A Corresponding Renaissance: Letters Written by Italian Women, 1375–1650* (Oxford: Oxford University Press, 2015).
Kambouchner, Denis, *L'homme des passions. Commentaires sur Descartes* (Paris: Albin Michel, 1995).
Kappas, A., "Emotion and Regulation Are One!," *Emotion Review* 3 (2011), 17–25.
Karant-Nunn, Susan, *The Reformation of Feeling. Shaping the Religious Emotions in Early Modern Germany* (New York: Oxford University Press, 2010).
Kemperdick, Stephan, and Michael Roth (ed.), *Holbein in Berlin. Die Madonna der Sammlung Würth mit Meisterwerken der Staatlichen Museen zu Berlin* (Berlin: Staatliche Museen zu Berlin-Preußischer Kulturbesitz/Michael Imhof Verlag, 2016).
Kemperink, M., *Het verloren Paradijs. De literatuur en de cultuur van het Nederlandse fin de siècle* (Amsterdam: Amsterdam University Press, 2001).

Kempers, Bram, "De verleiding van het beeld. Het visuele als blijvende bron van inspiratie in het werk van Huizinga," *Tijdschift voor Geschiedenis* 105(1) (1992), 30–50.
Key, Ellen, *The Century of the Child* (New York: G.P. Putnam's Sons, 1909).
Key, Ellen, *Das Jahrhundert des Kindes* (Berlin: S.Fischer, [1900] 1903].
Kitson, P., "Beyond the Enlightenment: The Philosophical, Scientific, and Religious Inheritance," in D. Wu (ed.), *A Companion to Romanticism* (Oxford: Blackwell, 1998), 39–52.
Klapisch-Zuber, Christiane, *La maison et le nom. Stratégies et rituels dans l'Italie de la Renaissance* (Paris: École des Hautes Études en Sciences Sociales, 1990).
Klapisch-Zuber, Christiane, "L'enfant, la mémoire et la mort," in Becchi and Julia (eds.), *Histoire de l'enfance en occident*, vol. 1 (1998), 200–30.
Kloek, J., "Burgerdeugd of burgermansdeugd? Het beeld van Jacob Cats als nationaal zedenmeester," in R. Aerts and H. te Velde (eds.), *De stijl van de burger. Over Nederlandse burgerlijke cultuur vanaf de Middeleeuwen* (Kampen: Kok Agora, 1998), 100–22.
Kloek, J., "Naar het land van Rembrandt. De literaire beeldvorming rond de zeventiende-eeuwse schilderkunst in de negentiende eeuw," in Grijzenhout and van Veen (eds.), *De Gouden Eeuw in perspectief* (1992), 139–60.
Kloek, J., and W. Mijnhardt, *1800. Blauwdrukken voor een samenleving* (Den Haag: SDU Uitgevers, 2001).
Kloek, J., and K. Tilmans (eds.), *Burger. Een geschiedenis van het begrip "burger" in de Nederlanden van de Middeleeuwen tot de 21ste eeuw* (Amsterdam: Amsterdam University Press, 2002).
Knippenberg, H., *De Religieuze Kaart van Nederland. Omvang en geografische spreiding van de godsdienstige gezindten vanaf de Reformatie tot heden* (Assen: Van Gorcum, 1992).
Knipping, J. B., and M. Gerrits, *Het kind in Neerlands beeldende kunst* (Wageningen: Zomer en Keuning, [1941] 1945, 2 vols.).
Knoeff, Rina (ed.), *Histories of Healthy Ageing* (Groningen: Barkhuis & University Museum Groningen, 2017).
Koelman, J., *De pligten der ouders, in kinderen voor Godt op te voeden* (Amsterdam: Wasteliers, 1679).
Koelman, J., *The Duties of Parents* (trans. from Dutch) (Grand Rapids, MI: Baker Academic, 2003).
Kohler, Christian G., Travis Turner, Neal M. Stolar, Warren B. Bilker, Colleen M. Brensinger, Raquel E. Gur, and Ruben C. Gur, "Differences in Facial Expressions of Four Universal Emotions," *Psychiatry Research* 128 (2004), 235–44.
Kohnstamm, Dolph, *The Extra in the Ordinary: The Children's Books by Dick Bruna* (Amsterdam: Mercis, 1991).
Kooijmans, L., *Vriendschap en de kunst van het overleven in de zeventiende en achttiende eeuw* (Amsterdam: Bert Bakker, 1997).
Koole, S. L., "The Psychology of Emotion Regulation: An Integrative Review," *Cognition and Emotion* 23 (2009), 4–41.
Koolhaas-Grosfeld, E., *Father & Sons. Jacob de Vos Wzn. (1774–1844) and the journals he drew for his children* (Hilversum: Verloren, 2001).
Koolhaas-Grosveld, E., and S. de Vries, "Terug naar een roemrijk verleden. De zeventiende-eeuwse schilderkunst als voorbeeld voor de negentiende eeuw," in Grijzenhout and van Veen (eds.), *De Gouden Eeuw in perspectief* (1992), 107–38.
Koops, W., *Gemankeerde volwassenheid. Over eindpunten van de ontwikkeling en doelen van de pedagogiek* (Houten: Bohn Stafleu Van Loghum, 2000).

Koselleck, Reinhart, Werner Conze, and Otto Brunner (eds.), *Geschichtliche Grundbegriffe. Historisches Lexikon zur politisch-sozialen Sprache in Deutschland* (Stuttgart: Klett-Cotta, 1972–97, 9 vols.).

Koster, Margaret L, "De uitwisseling tussen Noord en Zuid anders bekeken: Florence en Vlaanderen," in Till-Holger Borchert, Andreas Beyer, Paul Huvenne, and Dagmar Eichberger (eds.), *De eeuw van Van Eyck. De Vlaamse Primitieven en het Zuiden 1430–1530* (Gent: Ludion, 2002), 234n22.

Kruithof, B., B. Vanobbergen, J. J. H. Dekker, and F. Simon (eds.), "Discoveries of Childhood in History," *Paedagogica Historica* 48(1: Special Issue) (2012), 1–183.

Krul, W. E., *Historicus tegen de tijd: opstellen over leven en werk van J. Huizinga* (Groningen: Rijksuniversiteit Groningen, 1990).

Krul, W. E., "In the Mirror of Jan van Eyck: Johan Huizinga's 'Autumn of the Middle Ages,'" *Journal of Medieval and Early Modern Studies* 27(3) (1997), 353–84.

Kuus, Saskia, "Children's Costume in the Sixteenth and Seventeenth Centuries," in Baptist Bedaux and Ekkart (eds.), *Pride and Joy* (2000), 77–8.

Laarmann, Frauke K., *Families in beeld. De ontwikkeling van het Noord-Nederlandse familieportret in de eerste helft van de zeventiende eeuw* (Verloren: Hilversum, 2002).

Laarmann, Frauke K., *Het Noord-Nederlandse familieportret in de eerste helft van de zeventiende eeuw. Beeldtraditie en betekenis* (Amsterdam: Amsterdam University Press, 2002).

Lacey, N., *Image and Representation: Key Concepts in Media Studies* (Basingstoke: Palgrave Macmillan, 2009).

Laes, Christiaan, *Kinderen bij de Romeinen. Zes eeuwen dagelijks leven* (Leuven: Davidsfonds, 2006).

Laneyrie-Dagen, Nadeije, "Enfant réel ou adulte en devenir? La Renaissance et l'époque classique," in Sébastien Allard, Nadeije Laneyrie-Dagen, and Emmanuel Pernoud (eds.), *L'Enfant dans la peinture* (Paris: Citadelles et Mazenod, 2011), 79–191.

Laneyrie-Dagen, Nadeije, *L'Invention du corps. La représentation de l'homme du Moyen Âge à la fin du XIXe siècle* (Paris: Flammarion, 1997).

Laneyrie-Dagen, Nadeije, "'Lorsque l'enfant paraît'. La fin du Moyen Âge," in Sébastien Allard, Nadeije Laneyrie-Dagen, and Emmanuel Pernoud (eds.), *L'Enfant dans la peinture* (Paris: Citadelles et Mazenod, 2011), 27–77.

Laneyrie-Dagen, Nadeije, Sébastien Allard, and Emmanuel Pernoud, *LEnfant dans la peinture* (Paris: Citadelles et Mazenod, 2011).

Langereis, Sandra, *Erasmus dwarsdenker. Een biografie* (Amsterdam: De Bezige Bij, 2021).

Leahy, Thomas H., *A History of Modern Psychology* (Englewood Cliffs, NJ: Routledge, 1991).

Le Brun, Jacques, "La dévotion à l'Enfant Jésus au XVIIe siècle," in Becchi and Julia (eds.), *Histoire de l'enfance en occident*, vol. 1 (1998), 402–31.

Le Roy Ladurie, E., *Montaillou, village occitan de 1294 à 1324* (Paris: Gallimard, 1975).

Lederer, David, "Religion and Spirituality," in Andrew Lynch and Suan Broomhall (eds.), *A Cultural History of the Emotions in the Late Medieval, Reformation, and Renaissance Age* (London: Bloomsbury Academic, 2019), 31–47.

Leeuw, R. de, "Inleiding," in van Heteren et al. (eds.), *Poëzie der werkelijkheid*, 8–10.

Leeuw, R. de, "Jozef Israëls en Rembrandt," in Dekkers et al. (eds.), *Jozef Israëls 1824–1911*, 42–53.

Lehner, Ulrich, *The Catholic Enlightenment: The Forgotten History of a Global Movement* (Oxford: Oxford University Press, 2016).

Levenson, R. W., "The Intrapersonal Functions of Emotions," *Cognition and Emotion* 13 (1999), 481–504.

Levenson, Robert W., Sandy J. Lwi, Casey L. Brown, Brett Q. Ford, Marcela C. Otero, and Alice Verstaen, "Emotion," in John T. Cacioppo, Louis G. Tassinary, and Gary G. Berntson (eds.), *Handbook of Psychophysiology*, 4th ed. (Cambridge: Cambridge University Press, 2016), 444–64.

Leymarie, J., *Dutch Painting* (Geneva: Skira, 1976).

Lindeman, Yehudi, "Macropedius' Rebelles and Erasmus' Principles of Education," *European Medieval Drama* 13 (2009), 137–46.

Loos, W., *Aquarellen van de Haagse school. De collectie Drucker-Fraser* (Amsterdam: Waanders, 2002).

Loos, W., G. Jansen, and W. Kloek, *Het galante tijdperk. Schilderijen uit de collectie van het Rijksmuseum, 1700–1800* (Amsterdam: Waanders, 1995).

López-Muñoz, Francisco, Gabriel Rubio, Juan D. Molina, and Cecilio Alamo, "Sadness as a Passion of the Soul: A Psychopathological Consideration of the Cartesian Concept of Melancholy," *Brain Research Bulletin* 85 (2011), 42–53.

Loughman, J., and J. M. Montias, *Public and Private Spaces: Works of Art in Seventeenth Century Dutch Houses* (Zwolle: Waanders, 2000).

Luc, Jean-Noël, *L'invention du jeune enfant au XIXe siècle: de la salle d'asile à l'école maternelle* (Paris: Belin, 1997).

Luijten, G., A. van Suchtelen, R. Baarsen, W. Kloek, and M. Schapelhouman (eds.), *Dawn of the Golden Age, Northern Netherlandish Art 1580–1620* (Amsterdam: Rijksmuseum/ Waanders, 1993).

Lüth, Chr., "Staatliche und private Erziehung bei Rousseau," in O. Hansmann (ed.), *Seminar: Der pädagogische Rousseau. Deel 2: Kommentare, Interpretationen, Wirkungsgeschichte* (Weinheim: Beltz, 1997), 167–94.

Lüth, Christoph, "Entwicklung, Stand und Perspektive der internationalen Historischen Pädagogik am Beginn des 21. Jahrhunderts-am Beispiel der International Standing Conference for the History of Education (ISCHE)," in: P. Götte and W. Gippert (eds.), *Historische Pädagogik am Beginn des 21. Jahrhunderts. Bilanzen und Perspektiven. Christa Berg zum 60. Geburtstag* (Essen: Klartext-Verlag, 2000), 81–107.

Lynch, Andrew, "'He nas but seven yee olde': Emotions in Boy Martyrs Legends of Later Medieval England," in K. Barclay, K. Reynolds, and C. Rawnsley (eds.), *Death, Emotions and Childhood in Premodern Europe* (London: Routledge, 2016), 25–44.

Lynch, Andrew, "Introduction: Emotional Cultures of Change and Continuity, 1300–1600," in Andrew Lynch and Suan Broomhall (eds.), *A Cultural History of the Emotions in the Late Medieval, Reformation, and Renaissance Age* (London: Bloomsbury Academic, 2019), 1–12.

Lynch, Andrew, and Suan Broomhall (eds.), *A Cultural History of the Emotions in the Late Medieval, Reformation, and Renaissance Age* (London: Bloomsbury Academic, 2019).

Lynch, Andrew, and Susan Broomhall (eds.), *The Routledge History of Emotions in Europe, 1100–1700* (London: Routledge, 2020).

Maaz, Bernhard (ed.), *Adolph Menzel radikal real. Eine Ausstellung der Kunsthalle der Hypo-Kulturstifung München in Kooperation mit dem Kupferstichkabinett der staatlichen Museen zu Berlin* (München: Hirmer Verlag, 2008).

Maccoby, Eleanor E., and John A. Martin, "Socialization in the Context of the Family: Parent-Child Interaction," in P. H. Mussen (ed.), *Handbook of Child Psychology*, vol. 4 (New York: Wiley, 1983), 1–101.

MacCulloch, D., *Reformation: Europe's House Divided 1490–1700* (London: Allen Lane/ Penguin Books, 2003).

MacFarlane, A., *Marriage and Love in England: Modes of Reproduction 1300–1840* (Oxford: Basil Blackwell, 1986).

Malebranche, Nicolas, *Search after Truth* (trans. T. M. Lennon and P. J. Olscamp) (Cambridge: Cambridge University Press, [1674–5] 1997).

Malthus, Thomas, *An Essay on the Principle of Population* (London: J. Johnson, in St. Paul's Church-Yard, 1798).

Mander, Karel van, *Het schilder-boeck waerin voor eerst de leelustighe Iueght den grondt der edel vry schilderconst in verscheyden deelen wort voorghedraghen [...]* (Haarlem: Passchier Wesbusch, 1604).

Manson, Michel, "La poupée et le tambour, ou de l'histoire du jouet en France du XVIe au XIXe siècle," in Becchi and Julia (eds.), *Histoire de l'enfance en occident*, vol. 1 (1998), 432–64.

Manzke, Walter M., *Remedia pro infantibus. Arzneiliche Kindertherapie im 15. und 16. Jahrhundert, dargestellt anhand ausgewählter Krankheiten* (Marburg, 2008, PhD thesis).

Marchal, Guy P., "Jalons pour une histoire de l'iconoclasme au Moyen Age," *Annales Histoire, Sciences Sociales* 50(5) (1995), 1135–56.

Mareel, Samuel (ed.), *Renaissance Children. Art and Education at the Habsburg Court (1480–1530)* (Tielt: Lannoo, 2021).

Marnix van St. Aldegonde, P., *Cort begrijp, inhoudende de voornaemste hoofd-stucken der christelijcker religie gesteld vrage ende antwoordischer wijse* (Leiden: Pieter Louwick Alexandersz, 1599).

Marnix van St. Aldegonde, P., *Ratio instituendae iuventutis* (trans. and annotated H. de Wit-van Westerhuis/N. C. van Velzen: De opvoeding van de jeugd) (Kampe: De Groot Goudriaan, [1615] 1992).

Marquaille, L., "Art: Commande, marché et collection artistiques," in C. Secretan and W. T. M. Frijhoff (eds.), *Dictionnaire des Pays-Bas au siècle d'or* (Paris: CNRS Éditions, 2018), 46–7.

Mason, William A., and John P. Capitanio, "Basic Emotions: A Reconstruction," *Emotion Review* 4(3) (2012), 238–44.

Massing, Michael, *Erasmus, Luther and the Fight for the Western Mind* (New York: Harper, 2018).

Masterton, R. B., "Charles Darwin: Father of Evolutionary Psychology," in G. A. Kimble and M. Wertheimer (eds.), *Portraits of Pioneers in Psychology*, vol. 3 (Washington, DC: Psychology Press, 1998), 17–29.

Matt, Susan J., "Introduction," in Susan J. Matt (ed.), *A Cultural History of the Emotions in the Age of Romanticism, Revolution, and Empire* (London: Bloomsbury Academic, 2019), 1–15.

Maynes, Mary Jo, "Age as a Category of Historical Analysis: History, Agency, and Narratives of Childhood," *Journal of the History of Childhood and Youth* 1(1) (2008), 114–24.

McBrien, R. P. (ed.), *The HarperCollins Encyclopedia of Catholicism* (New York: HarperCollins, 1995).

McLane, Maureen N., *Romanticism and the Human Sciences: Poetry, Population, and the Discourse of the Species* (Cambridge: Cambridge University Press, 2000).

McNamer, Sarah, *Affective Meditation and the Invention of Medieval Compassion* (Philadelphia: University of Pennsylvania Press, 2010).

McNamer, Sarah, "Literature," in Andrew Lynch and Suan Broomhall (eds.), *A Cultural History of the Emotions in the Late Medieval, Reformation, and Renaissance Age* (London: Bloomsbury Academic, 2019), 107–21.

Mearns, James, "The Influence of Erasmus' Educational Writings on Nicolas Bourbons' Paidagogeion," *Bibliothèque d'Humanisme et Renaissance* 72 (2010), 65–81.

Meek, Richard, and Erin Sullivan (eds.), *The Renaissance of Emotion: Understanding Affect in Shakespeare and His Contemporaries* (Oxford: Oxford University Press, 2015).

Meerum, Terwogt, Carolien Rieffe, Sander Begeer, and Eva Potharst, "Theory of Mind-redeneren. De hoeksteen van het ocial-emotionele functioneren," in Mark Meerum Terwogt and Hans-Joachim Schulze (eds.), *Kijk op emoties. Theorie en praktijk in ontwikkeling en opvoeding* (Amsterdam: SWP, 2003), 23–33.

Meerum Terwogt, Mark, Hedy Stegge, and Albert Reijntjes, "Emoties. Regelsystemen die om regulatie vragen," in Mark Meerum Terwogt and Hans-Joachim Schulze (eds.), *Kijk op emoties. Theorie en praktijk in ontwikkeling en opvoeding* (Amsterdam: SWP, 2003), 49–61.

Megna, Paul, "Dreadful Devotion," in Andrew Lynch and Susan Broomhall (eds.), *The Routledge History of Emotions in Europe, 1100–1700* (London: Routledge, 2020), 72–85.

Meijer, W. A. J., "Cultural Transmission and the Balance between Tradition and Enlightenment: The Example of Islam," in W. A. J. Meijer, S. Miedema, and A. Lanser-van der Velde (eds.), *Religious Education in a World of Religious Diversity* (Münster: Waxmann, 2009), 181–94.

Mesquita, Batja, "Obituary: The Legacy of Nico H. Frijda (1927–2015)," *Cognition and Emotion* 30(4) (2016), 603–8.

Mielke, Hans, *Albrecht Dürer, 10 Meisterzeichnungen aus dem Berliner Kupferstichkabinett* (Berlin: Staatliche Museeen Preußischer Kulturbesitz Berlin, 1991).

Miller, C. A., "Developmental Relationships between Language and Theory of Mind," *American Journal of Speech-Language Pathology* 15(2), 142–54.

Miner, Robert C., *Thomas Aquinas on the Passions: A Study of Summa Theologiae, 1a2ae 22–48* (Cambridge: Cambridge Univ. Press, 2009).

Mitchell, B. R., *International Historical Statistics, Europe 1750–1988* (New York: Macmillan, 1992).

Mitchell, P., "Acquiring a Theory of Mind," in Alan Slater and Gavin Bremmer (eds.), *An Introduction to Developmental Psychology*, 2nd ed. (Oxford: BPS Blackwell, 2011).

Mitzman, A., *The Iron Cage: An Historical Interpretation of Max Weber* (New Brunswick: Transaction Books, [1969] 1985).

Moegaerts, Josephine, and Tine Van Osselaar (eds.), "De lichamelijkheid van emoties," *Tijdschrift voor Geschiedenis* 126(4) (2013), 452–563.

Monagle, Clare, "Emotions and the Self: Between Acquinas and Descartes," in Andrew Lynch and Susan Broomhall (eds.), *The Routledge History of Emotions in Europe, 1100–1700* (London: Routledge, 2020), 61–71.

Montias, J. M., *Art and Auction in 17th Century Amsterdam* (Amsterdam: Amsterdam University Press, 2002).

Montias, J. M., *Artists and Artisans in Delft: A Socio-economic Study of the Seventeenth Century* (Princeton: Princeton University Press, 1982).

Mooij, C. de, and B. Kruijsen (eds.), *Kinderen van alle tijden. Kindercultuur in de Nederlanden vanaf de middeleeuwen tot heden* (Zwolle: Waanders, 1997).

Moran, Claire (ed.), *Domestic Space in France and Belgium. Art, Literature and Design, 1850–1920* (London: Bloomsbury Academics, 2022).

Morel, Marie-France, and Catherine Rollet, *Des bébés et des hommes: tradition et modernité des soins aux tout-petits* (Paris: Albin Michel, 2000).

Moulton, I. F. (ed.), *Reading and Literacy in the Middle Ages and Renaissance. Arizona Studies in the Middle Ages and the Renaissance*, vol. 8 (Turnhout: Brepols, 2004).

Mount, F., *The Subversive Family: An Alternative History of Love and Marriage* (London: Jonathan Cape, 1982).

Mousseau, J., "The Family, Prison of Love," in J. Savells and L. J. Cross (eds.), *The Changing Family: Making Way for Tomorrow* (New York: Holt, Rinehart & Winston, 1978), 319–28.

Müller, Rebecca, *"Die Natur ist meine einzige Lehrer, meine Wohltäterin." Zeichnungen von Daniel Nikolaus Chodowiecki (1726–1801)im Berliner Kupferstichkabinett* (Berlin: Kupferstichkabinett, 2000).

Mulligan, K., and K. Scherer, "Toward a Working Definition of Emotion," *Emotion Review* 4(4) (2012), 345–57.

Nagel, Otto (ed.), *Käthe Kollwitz, Die Handzeignungen. Unter Mitarbeit von Sibylle Schallenberg-Nagel, Wissenschaftliche Bearbeitung Werner Timm* (Berlin (Ost): Henschelverlag [1972] 1980).

Nevitt Jr., H. Rodney, *Art and the Culture of Love in Seventeenth-Century Holland* (Cambridge: Cambridge University Press, 2003).

Newton, Hannah, *The Sick Child in Early Modern England, 1580–1720* (Oxford: Oxford University Press, 2012).

Norlin, Björn, "Comenius, Moral and Pious Education, and the Why, When and How of School Discipline," *History of Education* 49(3) (2020), 287–312.

ÓhAnnracháin, T., *Catholic Europe, 1592–1648* (Oxford: Oxford University Press, 2015).

O'Hara, D., *Courtship and Constraint: Rethinking the Making of Marriage in Tudor England* (Manchester: Manchester University Press, 2000).

Oatley, Keith, *Emotions: A Brief History* (Malden, MA: Blackwell, 2004).

Oberthaler, Elke, "Materials and Techniques Observations on Pieter Bruegel's Working Methods as Seen in the Vienna Paintings," in Alice Hoppe-Harnoncourt, Elke Oberthaler, Sabine Pénot, Manfred Sellink, and Ron Spronk (eds.), *Bruegel: The Hand of the Master: Exhibition Catalogue of the Kunsthistorisches Museum Vienna* (Veurne: Hannibal, 2018), 369–425.

Oelkers, J., "Break and Continuity: Observations on the Modernization Effects and Traditionalization in International Reform Pedagogy," *Paedagogica Historica* 31 (1995), 675–713.

Oelkers, J., *Reformpädagogik: eine kritische Dogmengeschichte* (Weinheim: Juventa Verlag, 1989).

Olsen, Stephanie (ed.), *Childhood, Youth and Emotions in Modern History* (Houndmills: Palgrave Macmillan, 2015).

Olsen, Stephanie, *Juvenile Nation: Youth, Emotions and the Making of the Modern British Citizen* (London: Bloomsbury, 2014).

Orrock, Amy, "Homo ludens: Pieter Bruegel's Children's Games and the Humanist Educators," *Journal of Historians of Netherlandish Art* 4(2) (2012), 1–42.

Ortony, A., and Turner, "What's Basic about Basic Emotions?" *Psychological Review* 97 (1990), 315–31.

Osterhammel, Jürgen, *Die Verwandlung der Welt. Eine Geschichte des 19.Jahrhunderts* (München: C.H. Beck, 2020).

Ozment, S., *Ancestors: The Loving Family in Old Europe* (Cambridge, MA: Harvard University Press, 2001).

Ozment, S., *When Fathers Ruled: Family Life in Reformation Europe* (Cambridge, MA, Harvard University Press, 2001).

Palacios, J., "Proverbs as Images of Children and Childrearing," in Hwang et al. (eds.), *Images of Childhood* (1996), 75–98.

Panofsky, E., "Iconography and Iconology: An Introduction to the Study of Renaissance Art," in Erwin Panofsky (ed.), *Meaning in the Visual Arts* (Chicago: University of Chicago Press, 1955), 26–41.

Panofsky, E., *Studies in Iconology: Humanistic Themes in the Art of the Renaissance* (New York: Harper and Row, [1939] 1972).

Panofsky, Erwin, *Early Netherlandish Painting: Its Origins and Character* (Cambridge, MA: Harvard University Press, 1958).
Papy, Jan, "Juan Luis Vives (1492–1540) on the Education of Girls. An Investigation into his Medieval and Spanish Sources," *Paedagogica Historica* 31(3) (1995), 739–65.
Paris, Leslie, "Through the Looking Glass: Age, Stages, and Historical Analysis," *Journal of the History of Childhood and Youth* 1(1) (2008), 106–13.
Parker, Geoffrey, *Global Crisis: War, Climate Change and Catastrophe in the Seventeenth Century* (New Haven, CT: Yale University Press, 2013).
Parlevliet, S., and J. J. H. Dekker, "A Poetic Journey. The Transfer and Transformation of German Strategies for Moral Education in Late Eighteenth-Century Dutch Poetry for Children," *Paedagogica Historica* 49(6) (2013), 745–68.
Parlevliet, Sanne, *Meesterwerken met ezelsoren. Bewerkingen van literaire klassiekers voor kinderen 1850–1950* (Hilversum: Uitgeverij Verloren, 2009).
Parrish, John M., "Education, Erasmian Humanism and More's Utopia," *Oxford Review of Education* 36 (2010), 589–605.
Pasulka, Diana, "A Somber Pedagogy: A History of the Child Death Bed Scene in Early American Children's Religious Literature, 1674–1840," *Journal of the History of Childhood and Youth* 2(2) (2009), 171–97.
Pauseback, Michael (ed.), *Max Liebermann in seiner Zeit. Eine Ausstellung der Nationalgalerie Berlin* (Berlin: Nationalgalerie Berlin Staatliche Museen Preußischer Kulturbesitz, 1979).
Peeters, H. F. M., *Kind en jeugdige in het begin van de moderne tijd (ca. 1500-ca. 1650)* (Hilversum: Paul Brand, 1966).
Pekrun, R., and L. Linnenbrink-Garcia, *International Handbook of Emotions in Education* (London: Routledge, 2014).
Pender, Stephen, "Medical and Scientific Understandings," in Claire Walker, Katie Barclay, and David Lemmings (eds.), *A Cultural History of the Emotions in the Baroque and Enlightenment Age* (London: Bloomsbury Academic, 2019), 15–33.
Peng, P.-Ch., "On Transnational Curriculum: Symbols. Languages, and Arrangements in an Educational Space," *Educational Studies* 45(3) (2009), 300–18.
Pénot, Sabine, "The Rediscovery of Pieter Bruegel the Elder. The Pioneers of Bruegel Scholarship in Belgium and Vienna," in Alice Hoppe-Harnoncourt, Elke Oberthaler, Sabine Pénot, Manfred Sellink, and Ron Spronk (eds.), *Bruegel: The Hand of the Master: Exhibition Catalogue of the Kunsthistorisches Museum Vienna* (Veurne: Hannibal, 2018), 317–29.
Pernoud, Emmanuel, "Au centre des regards. De Manet à nos jours," in Sébastien Allard, Nadeije Laneyrie-Dagen, and Emmanuel Pernoud (eds.), *LEnfant dans la peinture* (Paris: Citadelles et Mazenod, 2011), 283–409.
Pernoud, Emmanuel, "Corot: le modèle enfant, l'impression d'enfance/Corot: The Child Model and the Impression of Childhood," *Gradhiva Revue d'anthropologie et d'histoire des arts* 9 (2009), 38–55.
Pernoud, Emmanuel, "Le fifre et l'infante," in Sébastien Allard, Nadeije Laneyrie-Dagen and Emmanuel Pernoud (eds.), *L'Enfant dans la peinture* (Paris: Citadelles et Mazenod, 2011), 23–5.
Pernoud, Emmanuel, *L'Enfant obscur. Peinture, éducation, naturalisme* (Paris: Hazan, 2007).
Perrot, Michelle (sous la rédaction de), *L'impossible prison. Recherches sur le système pénitentiaire au XIXe siècle* (Paris : Seuil, 1980).
Pettegree, A., and A. der Weduwen, *The Bookshop of the World: Making and Trading Books in the Dutch Golden Age* (New Haven, CT: Yale University Press, 2019).
Pey, Michael, *Antwerp: The Glory Years* (New York: Allen Lane, 2022).

Phaire, Thomas, *The Boke of Chyldren* (facsimile of the first edition [1545] edited by Albert Victor Neale and Hugh R. E. Wallis) (Edinburgh: E. & S. Livingston, 1955).
Phillips, R., *Untying the Knot: A Short History of Divorce* (Cambridge: Cambridge University Press, 1991).
Plamper, Jan, *The History of Emotions: An Introduction* (Oxford: Oxford University Press, 2015).
Plomin, Robert, David W. Fulker, Robin Corley, and John C. DeFries, "Nature, Nurture, and Cognitive Development from 1 to 16 Years: A Parent-Offspring Adoption Study," *Psychological Science* 8(6) (1997), 442–7.
Plomp, Michiel, "Jong in de 19e eeuw. Het kind in de Nederlandse kunst van 1780 tot 1914," in Arianne Baggerman, Rudolf Dekker, and Michiel Plomp (eds.), *Het kind in de Nederlandse 19e -eeuwse kunst* (Bussum: Uitgeverij Thoth/Teylers Museum), 12–51.
Plutchik, R., *Emotions and Life: Perspectives from Psychology, Biology, and Evolution* (Washington, DC: American Psychological Association, 2013).
Pöggeler, Franz, "Bildung in Bildern. Versuch einer Typologie pädagogische relevanter Bildformen," in Franz Pöggeler (ed.), *Bild und Bildung. Beiträge zur Grundlegung einer pädagogischen Ikonologie und Ikonographie* (Frankfurt a.M.: Peter Lang, 1992), 11–52.
Pollock, L. A., *Forgotten Children: Parent-Child Relations from 1500 to 1900* (Cambridge: Cambridge University Press, 1983).
Pollock, L. A., *A Lasting Relationship: Parents and Children over Three Centuries* (London: Fourth Estate, 1987).
Pollock, Linda A., "Anger and the Negotiation of Relationships in Early Modern England," *Historical Journal* 47(3), 567–90.
Porteman, K., *Inleiding tot de Nederlandse emblemataliteratuur* (Groningen: Wolters-Noordhoff, 1977).
Porteman, Karel, "'Ey, kijckt toch, kijckt toch eens, geseelen ...' Vierhonderd jaar vader Cats (1577–1660)," *Ons Erfdeel* 20 (1977), 732–46.
Porteman, Karel, "Het embleem als 'genus iocosum'. Theorie en praktijk bij Cats en Roemer Visscher," *De zeventiende eeuw* 11 (1995), 184–96.
Porteman, Karel, "Miscellanea emblematica," *Spiegel der Letteren* 17 (1975), 161–4.
Porter, Jean, "Cardinal Virtues," in McBrien (ed.), *The HarperCollins Encyclopedia of Catholicism*, 227–8.
Porter, Jean, "Virtue," in McBrien (ed.), *The HarperCollins Encyclopedia of Catholicism*, 1316.
Prak, Maarten, *Citizens without Nations: Urban Citizenship in Europe and the World, c.1000–1789* (Cambridge: Cambridge University Press, 2018).
Prak, Maarten, *Gouden Eeuw. Het raadsel van de Republiek* (Nijmegen: SUN, 2002).
Premack, D. G., and G. Woodruff, "Does the Chimpanzee Has a Theory of Mind?" *Behavioral and Brain Sciences* 1(4) (1978), 515–26.
Priem, Karin, and Inés Dussel, "The Visual in Histories of Education: A Reappraisal," *Paedagogica Historica* 53(6: Special Issue) (2017), 641–9.
Przyrmebel, Alexandra, "Sehnsucht nach Gefühlen. Zur Konjunktur der Emotionen in der Geschichtswissenschaft," *L'Homme, Europäische Zeitschrift für feministische Geschichtswissenschaft* 16(2) (2005), 116–24.
Py, G., *Rousseau et les éducateurs. Etude sur la fortune des idées pédagogiques de Jean-Jacques Rousseau en France et en Europe au XVIIIe siècle* (Oxford: Voltaire Foundation, 1997).
Rawson, B., *Children and Childhood in Roman Italy* (Oxford: Oxford University Press, 2005).
Reddy, William W., "Historical Research on the Self and Emotions," *Emotion Review* 1(4) (2009), 302–15.

Reddy, William W., *The Navigation of Feeling: A Framework for the History of Emotions* (Cambridge: Cambridge University Press, 2001).

Reisenzein, Rainer, and Achim Stephan, "More on James and the Physical Basis of Emotion," *Emotion Review* 6(1) (2014), 35–46.

Revel, Jacques, "Les usages de la civilité," in Ariès and Duby (eds.), *L'histoire de la vie privée*, vol. 3: *De la Renaissance aux Lumières* (1987), 169–209.

Revel, Jean-François, *Histoire de la philosophie occidentale I. De l'Antiquité à la Renaissance, ou de la naissance de la philosophie à la naissance de la science* (Paris: Éditions Stock, 1960).

Revel, Jean-François, *Histoire de la philosophie occidentale II. La philosophie pendant la science* (Paris: Éditions Stock, 1970).

Reynolds, Edward, *A Treatise of the Passions and Faculties of the Soul of Man* (Gainesville, FL: Scholars' Facsimiles & Reprints, 1971; reprint original edition of 1640).

Reynolds, Pamela, "On Leaving the Young out of History," *Journal of the History of Childhood and Youth* 1(1) (2008), 150–6.

Rieffe, C., *The Child's Theory of Mind: Understanding Desires, Beliefs and Emotions* (Amsterdam: Vrije Universiteit, 1990, PhD thesis).

Rilke, R. M., *Briefwechsel mit Ellen Key* (ed. Theodore Fiedler) (Frankfurt a.M: Insel Verlag, 1993).

Ripa, Cesare, *Iconologia, of uytbeeldingen des verstands* (Amsterdam: Dirck Pietersz Pers, 1644; reprinted in facsimile, Soest 1971).

Ripa, Cesare, *Iconologia overo Descrittione Dell'imagini Universali cavate dall'Antichità et da altri luoghi* (New York: Garland, 1976; photomechanical reprint of the original edition, Padua 1611).

Roberts, B., *Through the Keyhole: Dutch Child-Rearing Practices in the 17th and 18th Century: Three Urban Elite Families* (Hilversum: Verloren, 1998).

Roberts, B. B., *Sex and Drugs before the Rock 'n' Roll: Youth Culture and Masculinity during Holland's Golden Age* (Amsterdam: Amsterdam University Press, 2012).

Roberts, B. B., and L. F. Groenendijk, "'Wearing Out a Pair of Fool's Shoes': Sexual Advice for Youth in Holland's Golden Age," *Journal of the History of Sexuality* 13 (2004), 139–56.

Roeck, Bernd, *Der Morgen der Welt. Geschichte der Renaissance* (München: C.H. Beck, 2017).

Rogers, Rebecca, "*Paedagogica Historica*: Trendsetter or Follower," in J. J. H. Dekker and F. Simon (eds.), *Shaping the History of Education? The First 50 Years of Paedagogica Historica* (London: Routledge, 2017), 11–30.

Roland-Michel, Marianne, *Chardin* (Paris: Hazan, 1994).

Roodenburg, Herman, and Catrien Santing (eds.), "Batavian Phlegm? The Dutch and their Emotions in Pre-modern Times," *BMGN: Low Countries Historical Review* 129(2) (2014), 3–191.

Roper, Luyndal, *The Holy Household: Women and Morals in Reformation Augsburg* (Oxford: Clarendon Press, 1991).

Roper, Luyndal, *Martin Luther: Renegade and Prophet* (London: Bodley Head, 2016).

Rose, N., *The Psychological Complex: Psychology, Politics and Society in England, 1869–1939* (London: Routledge and Kegan Paul, 1985).

Rosenberg, A., "Rousseau's Emile: The Nature and Purpose of Education," in J. Willinsky (ed.), *The Educational Legacy of Romanticism* (Calgary: Wilfried Laurier University Press, 1990).

Rosenberg, Alexander, *Darwinism in Philosophy, Social Science and Policy* (Cambridge: Cambridge University Press, 2000).

Rosenberg, Pierre, *Chardin* (Paris: Flammarion, 1999).

Rosenblatt, H., *Rousseau and Geneva: From the First Discourse to the Social Contract, 1749–1762* (Cambridge: Cambridge University Press, 1997).
Rosenblum, R., *The Romantic Child from Runge to Sendak* (London: Thames and Hudson, 1988).
Rosenwein, Barbara H. (ed.), *Anger's Past: The Social Uses of an Emotion in the Middle Ages* (London: Cornell, 1998).
Rosenwein, Barbara H., *Emotional Communities in the Early Middle Ages* (Ithaca, NY: Cornell University Press, 2006).
Rosenwein, Baraba H., *Generations of Feeling: A History of Emotions, 600–1700* (Cambridge: Cambridge University Press, 2016).
Rosenwein, Barbara H., "Worrying about Emotions in History," *American Historical Review*, 107(3) (2002), 821–45.
Rosenwein, Barbara H., and Riccardo Cristiani, *What Is History of Emotions* (Cambridge: Polity Press, 2018).
Ross, Stephanie, "Painting the Passions: Charles LeBrun's *Conference sur l'expression*," *Journal of the History of Ideas* 45 (1984), 25–47.
Roth, Michael, *Matthias Grünewald. Die Zeichnungen* (Berlin: Deutscher Verein für Kunstwissenschaft e.V./Hatje Cantz Verlag, 2008).
Roth, Michael, *Matthias Grünewald. Zeichnungen und Gemälde* (Berlin: Kupferstichkabinett Staatliche Museen zu Berlin/Hatje Cantz Verlag, 2008).
Rousmaniere, Kate, "Questioning the Visual in the History of Education," *History of Education* 30(2) (2001), 109–16.
Rousmaniere, Kate, and Noah W. Sobe (eds.), "Special issue: Education and the Body," *Paedagogica Historica* 54(1/2) (2018), 1–235.
Rousseau, Jean-Jacques, *Émile ou de l'education* (Paris: Garnier-Flammarion, [1762] 1966). https://philo-labo.fr/fichiers/Rousseau%20-%20Emile%20(Grenoble).pdf.
Royalton-Kisch, Martin, and Peter Schatborn, "The Core Group of Rembrandt Drawings, II: The List," *Master Drawings* 49(3) (2011), 323–46.
Ruberg, Willemijn, *Briefcultuur van de Nederlandse elite 1770–1850* (Nijmegen: Vantilt, 2005).
Ruberg, Willemijn, "Children's Correspondence as a Pedagogical Tool in the Netherlands (1770–1850)," *Paedagogica Historica* 41 (2005), 295–312.
Ruberg, Willemijn, "Je n'écris qu'en vue de m'amuser," *Tijdschrift voor Sociale Geschiedenis* 25 (1999), 157–82.
Russell, J. A. (2003), "Core Affect and the Psychological Construction of Emotion," *Psychological Review* 110 (2003), 145–72.
Russell, J. A., and L. F. Barrett, "Core Affect, Prototypical Emotional Episodes, and Other Things Called Emotion: Dissecting the Elephant," *Journal of Personality and Social Psychology* 7 (1999), 805–19.
Rutherford, H. J. V., N. S. Wallace, H. K. Laurent, and L. C. Mayes (2015), "Emotion Regulation in Parenthood," *Developmental Review* 36 (2015), 1–14.
Ryrie, A., *Being Protestant in Reformation Britain* (Oxford: Oxford University Press, 2015).
Salvarani, Luana, "'Wie einen feinen jungen Baum…': Nature, the Fallen Man, and Social Order in Martin Luther's Works on Education (1524–1530)," *Pedagogica Historica* 56(1/2) (2020), 22–31.
Santing, Catrien, "Vergeet de hartstocht niet', de zin van gevoeligheid in de politieke geschiedenis," *BMGN: Low Countries Historical Review* 121(2) (2006), 269–77
Santing, Catrien, and Arie Van Steensel,"Family, Community and Sociability," in Dekker (ed.), *A Cultural History of Education in the Renaissance*, vol. 3 (2020), 85–106.

Scarr, S., "Developmental Theories for the 1990s: Development and Individual Differences," *Child Development* 63 (1992), 1–19.
Scarr, S., and K. McCartney, "How People Make Their Own Environment: A Theory of Genotype à Environment Effects," *Child Development* 54 (1983), 424–35.
Schama, Simon, *The Embarrassment of Riches: An Interpretation of Dutch Culture in the Golden Age* (London: William Collins, 1987).
Schama, Simon, *Rembrandt's Eyes* (London: Allen Lane/Penguin Press, 1999).
Schatborn, Peter, Carel van Tuyll van Serooskerken, and Hélène Grollemund, *Rembrandt dessinateur. Chefs-d'oeuvre des collections en France* (Paris: Musée du Louvre Éditions, 2006).
Scheer, Monique, "Are Emotions a Kind of Practice (and Is That What Makes Them Have a History)? A Bourdieuian Approach to Understanding Emotion," *History and Theory* 51 (2021), 193–220.
Scheer, Monique, Nadia Fadil, and Birgitte Johansen Schepelern (eds.), *Secular Bodies, Affects and Emotions European Configurations* (London: Bloomsbury Academic, 2019).
Schilling, Heinz, *Die Neue Zeit. Vom Christenheitseuropa zum Europa der Staaten. 1250 bis 1750* (Berlin: Siedler Verlag, 1999).
Schilling, Heinz, *Martin Luther. Rebell in einer Zeit des Umbruchs. Eine Biographie* (München: C.H. Beck, [2012] 2016).
Schinkel, Anders, *Wonder and Education: On the Educational Importance of Contemplative Wonder* (London: Bloomsbury, 2021).
Schmitt, Jean-Claude, "La culture de l'*imago*," *Annales Histoire, Sciences Sociales* 51(1) (1996), 3–36.
Schmitter, Amy M., "17th and 18th Century Theories of Emotions: Descartes on the Emotions," *Stanford Encyclopedia of Philosophy* (ed. Edward N. Zalta). https://plato.stanford.edu/archives/sum2021/entries/emotions-17th18th/.
Schotel, G. D. J., *Het Oud-Hollandsch Huisgezin der Zeventiende Eeuw* (Leiden: Sijthoff, [1868] 1903).
Schücking, L. L., *Die puritanische Familie in literar-soziologischer Sicht* (Bern: Francke Verlag, [1929] 1964).
Schwartz, G., *Rembrandt. Zijn leven, zijn schilderijen* (Maarssen: Gary Schwarz, 1984).
Schwartz, Gary, *Emotions: Pain and Pleasure in Dutch Painting of the Golden Age* (Rotterdam: nai010 publishers, 2014).
Secretan, C., and W. T. M. Frijhoff (eds.), *Dictionnaire des Pays-Bas au siècle d'or* (Paris: CNRS Éditions, 2018).
Sellink, Manfred, "Dulle Griet," in Haag et al. (eds.), *Bruegel: The Hand of the Master* (2018), 168–71.
Sellink, Manfred, "The Last Judgement," in Haag et al. (eds.), *Bruegel: The Hand of the Master* (2018), 88–90.
Selvaraj, J., M. Murugappan, K. Wan, and S. Yaacob, "Classification of Emotional States from Electrocardiogram Signals: A Non-linear Approach Based on Hurst," *BioMedical Engineering OnLine* 12 (2013), article 44.
Shahar, Shulamith, *Childhood in the Middle Ages* (London: Routledge, 1990).
Shahar, Shulamith, "The First Stage of Childhood and the 'Civilizing Process,'" in *Paedagogica Historica*, Supplementary Series, vol. 2 (Gent: C.S.H.P., 1996), 163–78.
Sherington, G., "From Aries to Globalisation in the History of Childhood (Review Essay)," *Paedagogica Historica* 46(1/2) (2010), 251–5.

Sherman, Caroline, "Resentment and Rebellion in the Scholarly Household: Son and Amanuensis in the Godefroy Family," in Susan Broomhall (ed.), *Emotions in the Household, 1200–1900* (Abingdon: Routledge, 2008), 153–69.

Shorter, E., *The Making of the Modern Family* (New York: Basic Books, 1975).

Sidèn, Karen, *Den ideala barndomen. Studier i det stormaktstida barnporträttens ikonografi och funktion* (Stockholm: Raster, 2001).

Siegel, Harvey, "Education and Cultural Transmission/Transformation: Philosophical Reflections on the Historian's Task," *Paedagogica Historica Supplementary Series* 2 (1996), 25–46.

Simons, Patricia, and Charles Zika, "The Visual Arts," in Andrew Lynch and Suan Broomhall (eds.), *A Cultural History of the Emotions in the Late Medieval, Reformation, and Renaissance Age* (London: Bloomsbury Academic, 2019), 85–106.

Skinner, Ellen, Sandy Johnson, and Tatiana Snyder, "Six Dimensions of Parenting: A Motivational Model," *Parenting: Science and Practice* 5(2) (2005), 175–235.

Slive, Seymour, *The Drawings of Rembrandt: A New Study* (Los Angeles: Getty, 2009).

Sluijter, E. J., "In wedijver met de Gouden Eeuw: Abraham en Jacob van Strij en hun illustere voorgangers," in Dumas (ed.), *In helder licht* (2000), 101–38.

Smith, C. U. M., "350th Anniversary of Les Passions de l'Ame," *Journal of the History of the Neurosciences* 8(3) (1999), 221–6.

Smith, D. R., *Masks of Wedlock: Seventeenth-Century Dutch Marriage Portraiture* (Ann Arbor, MI: Umi Research Press, 1982).

Smith, Pamela H., "Science and Taste: Painting, Passions, and the New Philosophy in Seventeenth-Century Leiden," *Isis* 90 (1999), 421–61.

Smith Allen, J., "Navigating the Social Sciences. A Theory for the Meta-history of Emotions," *History and Theory* 42 (2003), 82–93.

Snoep, Derk P., and Paul Huvenne, "Foreword," in Bedaux and Ekkart (eds.), *Pride and Joy* (2000), 6–7.

Snow, E., "Meaning in *Children's Games*: On the Limitations of the Iconographic Approach to Bruegel," *Representations* 1(2) (1983), 27–60.

Snow, Edward, *Inside Bruegel: The Play of Images in Children's Games* (New York: North Point Press, 1997).

Soares, Claudia, "Emotions, Senses, Experience and the History of Education," *History of Education* 52(2–3) (2023), 516–38.

Sobe, Noah W., "Illustrating American Progressive Education: The Cover Illustration of John Dewey's 1899 *School and Society*," in Amsing et al. (eds.), *Images of Education* (2018), 141–54.

Sobe, Noah W., "Researching Emotion and Affect in the History of Education," *History of Education* 41(5) (2012), 689–95.

Southern, R. W., *The Making of the Middle Ages* (London: Hutchinson University Library, 1967).

Spaans, J., "Reform in the Low Countries," in R. Po-chia Hsia (ed.), *A Companion to the Reformation World* (Oxford: Blackwell, 2004), 118–34.

Spiecker, B., and L. F. Groenendijk, "Fantasies in Recent Historiography of Childhood," *British Journal of Educational Studies* 33 (1985), 5–19.

Spiecker, Ben, "The Pedagogical Relationship," *Oxford Review of Education* 10 (1984), 203–9.

Spronk, Ron, "The Seven Virtues," in Haag et al. (eds.), *Bruegel: The Hand of the Master* (2018), 98–116.

Staines, John D., "Literature," in Claire Walker, Katie Barclay, and David Lemmings (eds.), *A Cultural History of the Emotions in the Baroque and Enlightenment Age* (London: Bloomsbury Academic, 2019), 111–135.

Stearns, Peter N., "Challenges in the History of Childhood," *Journal of the History of Childhood and Youth* 1(1) (2008), 35–42.

Stearns, Peter N., *Childhood in World History* (New York: Routledge, 2006).

Stearns, Peter N., "Children and Emotions History," *European Journal of Developmental Psychology* 14(6) (2017), 659–71.

Stearns, Peter N, "Defining Happy Childhoods: Assessing a Recent Change," *Journal of the History of Childhood and Youth* 2(1) (2010), 165–86.

Stearns, Peter N., "Happy Children: A Modern Emotional Commitment," *Frontiers in Psychology* 10 (2019), 1–8.

Stearns, Peter N., "In Private: The Individual and the Domestic Community," in Susan J. Matt (ed.), *A Cultural History of the Emotions in the Age of Romanticism, Revolution, and Empire* (London: Bloomsbury Academic, 2019), 137–56.

Stearns, Peter N., *Jealousy: The Evolution of an Emotion in American History* (New York: New York University Press, 1989).

Stearns, Peter N., and Carol Z. Stearns, "Emotionology: Clarifying the History of Emotions and Structural Standards," *American Historical Review* 90 (1985), 813–36.

Steinert, H., *Max Webers unwiderlegbare Fehlkonstruktionen. Die protestantische Ethik und der Geist des Kapitalismus* (Frankfurt: Campus Verlag., 2010)

Steingräber, E., *Alte Pinakothek München* (München: Edition Lipp, 1986).

Steutel, J. W., *Deugden en morele opvoeding. Een wijsgerig-pedagogische studie* (Meppel: Boom, 1992).

Steutel, Jan, and Ben Spiecker, "Authority in Educational Relationships," *Journal of Moral Education* 29(3) (2000), 323–37.

Stipriaan, R. Van, *Het volle leven. Nederlandse literatuur en cultuur ten tijde van de Republiek (circa 1550–1800)* (Amsterdam: Prometheus, 2002).

Stone, Lawrence, *The Family, Sex and Marriage in England 1500–1800* (London: Weidenfeld & Nicholson, 1977).

Straten, Roelof van, *Inleiding in de iconografie* (Muiderberg: Dick Coutinho, 1987). English version: *An Introduction to Iconography* (Yverdon: Gordon and Breach, 1994).

Sturkenboom, D. M. B., *Spectators van hartstocht. Sekse en emotionele cultuur in de achttiende eeuw* (Hilversum: Verloren, 1998).

Sturm, J., J. J. H. Dekker, R. Aldrich, and F. Simon (eds.), *Education and Cultural Transmission: Historical Studies of Continuity and Change in Families, Schooling and Youth Cultures*, Paedagogica Historica Supplementary Series 2 (Gent: C.S.H.P., 1996).

Suchtelen, Ariane van (ed.), *Jan Steen's Histories* (Zwolle: Waanders; The Hague: Royal Picture Gallery Mauritshuis Foundation, 2018).

Suchtelen, Ariane van, Bart Cornelis, Marijn Schapelhouman, and Nina Cahill, *Nicolaes Maes* (Zwolle: Waanders; The Hague: Stichting Koninklijk Kabinet van Schilderijen Mauritshuis; London: National Gallery, 2019).

Sullivan, Erin, "The Passions of Thomas Wright: Renaissance Emotion across Body and Soul," in Richard Meek and Erin Sullivan (eds.), *The Renaissance of Emotion: Understanding Affect in Shakespeare and His Contemporaries* (Oxford: Oxford University Press, 2015), 25–44.

Sutton, P. C., *Masters of Seventeenth-Century Dutch Genre Painting* (London: Weidenfeld & Nicolson, 1984).

Sutton, P. C., L. Vergara, and A. Jensen Adams, *Love Letters: Dutch Genre Paintings in the Age of Vermeer* (Londen: Bruce Museum/National Gallery of Ireland, 2003).
Sykora M. D. et al., "Emotive Ontology: Extracting Fine-grained Emotions from Terse, Informal Messages," in *Proceedings of the International Conference Intelligent Systems and Agents 2013* (Prague, July 22–26, 2013), 19–26.
Szórádová, E., "Contexts and functions of music in the *Orbis sensualium pictus* textbook by John Amos Comenius," *Paedagogica Historica* 51(5) (2015), 535–59.
Talmon, J. L., *Romanticism and Revolt: Europe 1815–1848* (London: Thames and Hudson, 1967).
Talon-Hugon, Carole, *Les passion rêvées par la raison. Essai sur la théorie des passions de Descartes et de quelques-uns de ses contemporains* (Paris: Librairie Philosophique J. Vrin, 2002).
Taylor, Chloë, *The Culture of Confession from Augustine to Foucault: A "Genealogy of the Confessing Animal"* (New York: Routledge, 2009).
Tempel, B., "Ingewijden in de kunst. Israëls en zijn contacten met critici," in Dekkers et al. (eds.), *Jozef Israëls 1824–1911*, 87–100.
Thiel, Pieter J. J. van, "Catholic Elements in Seventeenth Century Dutch Painting, a Propos of a Children Prtrait by Thomas de Keyser," *Simiolus: Netherlands Quarterly for the History of Art* 20(1) (1990–1), 39–62.
Thomas, Joe A., "Fabric and Dress in Bronzino's Portrait of Eleanor of Toledo and Son Giovanni," *Zeitschrift für Kunstgeschichte* 57(2) (1994): 262–7.
Thomas, Kerstin, "The Visual Arts," in Susan J. Matt (ed.), *A Cultural History of the Emotions in the Age of Romanticism, Revolution, and Empire* (London: Bloomsbury Academic, 2019), 95–120.
Thompson, R. A., "Socialization of Emotion and Emotion Regulation in the Family," in J. J. Gross (ed.), *Handbook of Emotion Regulation* (New York: Guilford, 2014).
Tilborgh, L. van (ed.), *The Potato Eaters by Vincent van Gogh* (Zwolle: Waanders, 1993).
Tilborgh, L. van, and G. Jansen, *Op zoek naar de Gouden Eeuw. Nederlandse schilderkunst 1800–1850* (Zwolle: Waanders, 1986).
Tobey, Susan Bracaglia, *L'art d'être mère. La maternité dans l'art* (Paris: Éditions Abbeville, 1991).
Todd, M., *Christian Humanism and the Puritan Social Order* (Cambridge: Cambridge University Press, 1987).
Tomasello, Michael, Ann Kruger, and Hilary Ratner, "Cultural Learning," *Behavioral and Brain Sciences* 16(3) (1993), 495–511.
Tracy, J., and D. Randles, "Four Models of Basic Emotions: A Review of Ekman and Cordaro, Izard, Levenson, and Panksepp and Watt," *Emotion Review* 3(4) (2011), 397–495.
Traninger, Anita, "Whipping Boys: Erasmus' Rhetoric of Corporeal Punishment and its Discontents," in Jan Frans van Dijkhuizen and Karl Enenkel (eds.), *The Sense of Suffering: Constructions of Physical Pain in Early Modern Culture* (Leiden: Brill, 2009), 39–57.
Trappeniers, M., *Antoon Derkinderen 1859–1925* ('s-Hertogenbosch: Noordbrabants Museum, 1980).
Tröhler, Daniel, "Introduction: Learning, Progress, and the Taming of Change: The Educational Aspiration of the Age of Enlightenment," in Daniel Tröhler (ed.), *A Cultural History of Education in the Age of Enlightenment*, vol. 4 (London: Bloomsbury Academic, 2020), 1–23.
Tröhler, Daniel, *Pestalozzi and the Educationalization of the World* (New York: Palgrave Pivot/Palgrave Macmillan, 2012).

Tröhler, Daniel, "Rousseau's *Emile*, or the Fear of Passions," *Studies in Philosophy and Education* 31(5) (2012), 477–89.

Tschurenev, Jana, "Knowledge, Media, and Communication," in Ellis (ed.), *A Cultural History of Education in the Age of Empire*, vol. 5 (2020), 39–57.

Tümpel, Chr., *Rembrandt* (Amsterdam: Mercatorfonds, 1986).

Tuttle Ross, Sheryl, "Understanding Propaganda: The Epistemic Merit Model and Its Application to Art," *Journal of Aesthetic Education* 36(1), 2002, 16–30.

Uitert, E. van, "Burgerlijke kunst in een burgerlijke eeuw," in Kloek and Tilmans (eds.), *Burger* (2002), 277–312.

Ulbricht, Otto, "Der Einstellungswandel zur Kindheit in Deutschland am Ende des Spätmittelalters (ca. 1470–1520)," *Zeitschrift für Historische Forschung* 19(2) (1992), 159–87.

Ulbricht, Otto, *Kindsmord und Aufklärung in Deutschland* (München: De Gruyter, 1990).

Van Alphen, Hieronijmus, *Kleine Gedichten voor Kinderen* (I Proeve van kleine gedichten voor kinderen; II Vervolg der kleine gedichten voor kinderen, van Mr. Hieronijmus van Alphen; III Tweede vervolg der kleine gedichten voor kinderen, van Mr. Hieronijmus van Alhen) (ed. P. J. Buijnsters) (Amsterdam: Athenaeum-Polak & Van Gennep, [1778/1782] 1998).

Van Bruaene, Anne-Laure, Koenraad Jonckheere, and Ruben Suykerbuyk, "*Beeldenstorm*: Iconoclasm in the Low Countries," *BMGN Low Countries Historical Review* 131 (2016), 1–176.

Van Crombrugge, H., "Emile en Sophie wisselen boeken uit. Lectuur en meisjesopvoeding bij Rousseau," *Pedagogiek. Wetenschappelijk forum voor opvoeding, onderwijs en vorming* 21 (2001), 68–87.

Van Crombrugge, H., "Rousseau on Family and Education," *Paedagogica Historica* 31 (1995), 445–80.

Van Vaeck, M., and Johan Verberckmoes, *Trap op trap af. Zeventiende-eeuwse presentaties van feest en vermaak in en rond het kasteel* (Leuven: Peeters, 1988).

Vandenbroeke, Chris, "Zuigelingensterfte, bevallingsstoornissen en kraambedsterfte (17de-19de eeuw)," *Bijdragen tot de Geschiedenis* 60 (1977), 133–63.

Vandenbroeke, Chris, Frans van Poppel, and Ad M. van der Woude, "De zuigelingen- en kindersterfte in België en Nederland in seculair perspectief," *Tijdschrift voor Geschiedenis* 94 (1981), 461–91.

Vann, R. T., "The Youth of Centuries of Childhood (A Review of Reviews)," *History and Theory* 21(2) (1982), 279–97.

Verbeke, D., "A Call for Sobriety: Sixteenth-Century Educationalists and Humanist Conviviality," *Paedagogica Historica* 49(2) (2013), 161–73.

Verhoogt, R., "De uitgaanskleren van Israëls kinderen. Prenten naar zijn werk," in Dekkers et al. (eds.), *Jozef Israëls 1824–1911*, 71–86.

Verstraete, Pieter, "Het verlegen kind. Een pedagogische kijk op de geschiedenis van emoties," in Hilda Amsing, Nelleke Bakker, Mineke van Essen, and Sanne Parlevliet (eds.), *Images of Education* (Groningen: Uitgeverij Passage, 2018), 235–47.

Verstraete, Pieter, *Stilte in de klas: een geschiedenis van de pedagogische omgang met stilte op school* (Leuven: Leuvense Universitaire Pers, 2022).

Vierhaus, M., A. Lohaus, and E. Wild, "The Development of Achievement Emotions and Coping/Emotion Regulation from Primary to Secondary School," *Learning and Instruction* 42 (2016), 12–21.

Viñao, António, "Iconology and Education: Notes on the Iconographic Representation of Education and Related Terms," in Depaepe et al. (eds.), "The Challenge of the Visual" (2000), 75–91.

Vives, Juan Luis, *The Education of a Christian Woman: A Sixteenth-Century Manual* (ed. Charles Fantazzi) (Chicago: University of Chicago Press, 2000).

Volk, Anthony, "The Evolution of Childhood," *Journal of the History of Childhood and Youth* 4(3) (2011), 470–94.
Voss, Stephen H., "Translator's Introduction" (trans. and annotated Stephen Voss), in René Descartes (ed.), *The Passions of the Soul* (Indianapolis: Hackett, [1989] 2009), vii–xiv.
Vries, J. de, *The Dutch Rural Economy in the Golden Age, 1500–1700* (New Haven, CT: Yale University Press, 1974).
Vries, J. de, and A. van der Woude, *The First Modern Economy: Success, Failure and Perseverance of the Dutch Economy, 1500–1815* (Cambridge: Cambridge University Press, 1997).
Vries, J. de, and A. van der Woude, *Nederland 1500–1815. De eerste ronde van moderne economische groei* (Amsterdam: Balans, 1995).
Waal, Frans de, *Zijn we slim genoeg om te weten hoe slim dieren zijn?* (Amsterdam: Atlas Contact, 2016).
Wachelder, Joseph, "Chardins *Touch*. De kunst van het spelen," in Amsing et al. (eds.), *Images of Education* (2018), 28–42.
Wakefield, G. S., *Puritan Devotion: Its Place in the Development of Christian Piety* (London: The Epworth Press, 1957).
Walton, Stuart, *A Natural History of Human Emotions* (New York: Grove Press, 2004).
Wax, M. L, "Magic, Rationality and Max Weber," in P. Hamilton (ed.), *Max Weber: Critical Assessments 2* (London: Routledge, 1991), 59–65; or *Kansas Journal of Sociology* 3 (1967), 12–19.
Weber, Max, "Die protestantische Ethik und der Geist des Kapitalismus", in Wolfgang Schluchter and Ursula Bube (eds.), *Max Weber Gesamtausgabe, Band 18, Die protestantische Ethik und der Geist des Kapitalismus / Die protestantischen Sekten und der Geist des Kapitalismus. Schriften 1900–1920* (Tübingen: J.C.B. Mohr [Paul Siebeck], [1904] 2016), 213–492.
Weber, Max, "Wissenschaft als Beruf," in Johannes Winckelmann (ed.), *Gesammelte Aufsätze zur Wissenschaftslehere* (Tübingen: J.C.B. Mohr [Paul Siebeck], [1919] 1982), 582–613.
Weikart, Richard, "Laissez-Faire Social Darwinism and Individualist Competition in Darwin and Huxley," *European Legacy* 3 (1998), 17–30.
Wellman, H. M., *The Child's Theory of Mind* (Cambridge, MA: MIT Press, 1992).
Werner, Elke, "Visualität und Ambiguität der Emotionen. Perspektiven der kunst- und bildwissenschaftlichen Forschung," in Claudia Jarzebowski and A. Kwaschik (eds.), *Performing Emotions: Interdisziplinäre Perspektiven auf das Verhältnis von Politik und Emotion in der Frühen Neuzeit und in der Moderne* (Göttingen: V&P unipress), 147–67.
Westermann, M., "Steens komische ficties," in H. Perry Chapman, W. Th. Kloek, and A. K. Wheelock Jr. (eds.), *Jan Steen: Painter and Storyteller* (Amsterdam: Rijksmuseum/National Gallery of Art, 1996), 53–67.
Wetering, Ernst van de, and Josua Bruyn (eds.), *A Corpus of Rembrandt Paintings* (Stichting Foundation Rembrandt Research Project) (The Hague: The Springer, 1982–2011; 5 vols.).
Wheelock, A. K. (ed.), *Gerrit Dou 1613–1675: Master Painter in the Age of Rembrandt* (Washington, DC: National Gallery of Art/Yale University Press, 2000).
Wheelock, Jr., Arthur K., Alison McNeil Kettering, Arie Wallert, and Marjorie E. Wiereman, *Gerard ter Borch* (Zwolle: Waanders, 2004).
White, R., "Romanticism," in Susan Broomhall (ed.), *Early Modern Emotions: An Introduction* (London: Routledge, 2017), 273–6.
Wilde, Lieselot De, Michel Vandenbroeck, and Bruno Vanobbergen (eds.), *Een beeld van een kind. Inleiding in de pedagoiek* (Gent: OWL Press, 2023).

Willemsen, A., "Images of Toys: The Culture of Play in the Netherlands around 1600," in Bedaux and Ekkart (eds.), *Pride and Joy* (2000), 61–72.
Willemsen, J. M. F., *Kinder delijt. Middeleeuws speelgoed in de Nederlanden* (Nijmegen: Stichting Nijmeegse Kunsthistorische Studies, 1998).
Willemsen, J. M. F. "Out of Children's Hands. Surviving Toys and Attributes," in Bedaux and Ekkart (eds.), *Pride and Joy* (2000), 297–303.
Williams, Maria Patricia, "Church, Religion, and Morality," in Heather Ellis (ed.), *A Cultural History of Education in the Age of Empire*, vol. 5 (London: Bloomsbury Academic, 2020), 17–37.
Wilson, Adrian, "The Infancy of the History of Childhood: An Appraisal of Philippe Ariès," *History and Theory* 19(2) (1980), 132–53.
Wilson, Carolyn C., *St. Joseph in Italian Renaissance Society and Art: New Directions and Interpretations* (Philadelphia: Saint Joseph's University Press, 2001).
Wingens, M., "The Motives for Creating Institutions of Higher Education in the Dutch Republic during Its Formative Years (1574–1648)," *Paedagogica Historica* 34(2) (1998), 443–56.
Wither, George, *Book of Emblems* (London: Henri Touton, 1635).
Woods, R., *Children Remembered: Responses to Untimely Death in the Past* (Liverpool: Liverpool University Press, 2006).
Wooldridge, Adrian, *Measuring the Mind: Education and Psychology in England, c. 1860–c. 1990* (Cambridge: Cambridge University Press, 1994).
Woude, A. M. van der, "De schilderijenproductie in Holland tijdens de Republiek," in A. Schuurman, J. de Vries, and A. van der Woude (eds.), *Aards geluk. De Nederlandse en hun spullen van 1550 tot 1850* (Amsterdam: Balans, 1997), 223–58.
Woude, A. M. van der, "Demografische ontwikkeling van de Noordelijke Nederlanden 1500–1800," *Algemene Geschiedenis der Nederlanden* 5 (Haarlem: Fibula-Van Discoeck, 1980), 102–68.
Woude, A. M. van der, "Variations in the Size and Structure of the Household in the United Provinces of the Netherlands in the Seventeenth and Eighteenth centuries," in P. Laslett (ed.), *Household and Family in Past Time* (Cambridge: Cambridge University Press, 1974), 299–318.
Wouters, C., "Etiquette Books and Emotion Management in the 20th Century. Part One: The Integration of Social Classes," *Journal of social History* 29 (2007), 107–24.
Wouters, C., *Informalization. Manners and Emotions since 1890* (Los Angeles,: Sage, 2007).
Wright, Thomas, *The Passions of the Minde in Generall: Corrected, Enlarged, and with Sundry New Discourses Augmented* (London: Walter Burre, 1604).
Wüstefeld, Wilhelmina C. M., *Middeleeuwse boeken van het Catharijneconvent* (Zwolle: Waanders, 1993).
Wulf, Andrea, *The Invention of Nature* (London: John Murray, 2015).
Zanden, J. L. van, "De timmerman, de boekdrukker eb het ontstaan van de Europese kenniseconomie. Over de prijs en het aanbod van kennis voor de Industriële Revolutie," *TSEG: Low Countries Journal of Social and Economic History* 2(1) (2005), 105–20.
Zanden, J. L. van, *The Long Road to the Industrial Revolution: The European Economy in a Global Perspective, 1000–1800* (Leiden: Brill, 2009).
Zelizer, Viviana A., *Pricing the Priceless Child: The Changing Social Value of Children* (New York: Basic Books, 1985).
Zimmer-Gembeck, M. J., H. J. Web, C. A. Pepping, K. Swan, O. Merlo, E. A. Skinner, E. Avdagic, and M. Dubnbar, "Review: Is Parent–Child Attachment a Correlate of Children's Emotion Regulation and Coping?" *International Journal of Behavioral Development* 41 (2017), 74–93.

Index

Académie de Peinture 52
Addison, Joseph 142
affective tone 8, 87, 167–9, 222
Alberti, Leon Battista 43, 51, 53, 103
Alciati, Andrea 104
Allebé, August 183
Allen, James and John 182
Amsterdam 1, 59, 73, 78, 82, 90, 94, 119, 173
Amsterdam State Academy of Art 183
analogical literacies 12
Ancien Régime 69, 218
Ancient Greece and Rome 17, 56, 105, 126, 220
Andersen, Hans Christian 190
Angerstein children 206
animal 47, 96, 106, 108, 146, 169
animal educandum 12, 21–2, 43, 134, 154, 183, 191, 216, 219
animal farm 15
Ankersmit, Franklin Rudolf 14
Annales Économies Sociétés Civilisations 3
Anselm of Canterbury 55
Antwerp 33, 81, 119
Aquinas, Thomas 26–31, 36–7, 39, 41, 43, 45, 70, 149, 215–16
Ariès, Philippe 3–5, 136, 221
Aristotle 27, 30, 45
Armenini, Gian Battista 16
Arntzenius, Floris 190
August, Erich 238 n.49
Augustine of Hippo 22, 26–30, 35–6, 39, 42, 45, 48, 108, 122, 146, 149, 215–16
Augustinian 26–7, 32, 36, 40, 43–8, 102, 117, 122, 124, 126, 146, 193
Ausdruck 142
Austin, Jane 142
Austria 25, 144
Avaritia (Greed) 31, 35, 47

Bacon, Francis 40–1
Bain, Alexander 140, 147–8
Balbi family 83–4
Baldwin, James Mark 140

Baroque 52, 55, 97, 153
Basedow, Johann Bernhard 138
basic emotions 8–10, 17, 27–8, 36, 42, 52, 56, 149, 196, 213
Baudelaire, Charles 155, 187, 191, 219
Beets, Nicolaas 163, 165
Belgian 176, 185
Bell, Charles 146, 148, 151
Belle Époque 169, 181, 190–1
Bellelli, Baron Gennaro 166
belles lettres 25, 136, 141–2
Bentham, Jeremy 150, 215
Berard, Marguerite–Thérèse 176
Berruguete, Pedro 79
best interest of the child 136
Biedermaier 168
Big Talk 17, 21–4, 26, 41, 129, 215–16, 218
Bildung 33
Bismarck, Otto Fürst von 135
Blake, William 133, 138, 155, 162, 189, 217
Blankaart, Steven 102
Bloch, Marc 3, 5
Blommers, Bernard 162, 184–6, 200, 207
Boccaccio, Giovanni 123
bodily expression 3, 9–10, 13, 15, 17, 35–6, 53, 55–6, 103, 121, 148, 188, 218
Boerhave, Herman 40
Boilly, Louis–Léopold 163
Bonnard, Pierre 168–9, 188
Bosch, Hieronymus 23, 33–5, 94, 124
Böszörménui-Nagy, Ivan 165
Botticelli, Sandro 23
Bourdieu, Pierre 14
Bouts, Dirk 53
Bouvet, Béatrice 177, 183
Brant, Sebastian 31, 88
Braudel, Fernand 11
Brighton 185
Bro, Olivier 183
Bronzino, Agnolo 69, 92
Brouwer, Adriaen 88
Brown, Thomas 145

Index

Bruegel the Elder, Pieter 21, 33–4, 55, 65, 79, 86–8, 122, 124, 200
Bruges 14, 54, 58, 72
Bruna, Dick 169
Buijs, Jacobus 195
Burckhardt, Jacob 23, 25, 126, 220
Burmann, Gottlob Wilhelm 195
Busken Huet, Conrad 262 n.37
Butler, Joseph 146

Calais 185
Calvin, Jean / Calvinist 37, 48, 55, 57, 70, 87, 101–2, 104, 108, 194, 215
Campe, Joachim Heinrich 138
Camus, Jean–Pierre 41
Canisius, Petrus 48, 102, 215
Caravaggio 86, 97–8
Cardano, Girolamo 52
Cardinal 24, 48–9, 51
cardinal virtues 30, 32–4, 110, 116, 196
Caritas (Charity, Love) 16, 30, 34, 36, 194, 200
Carnival 86, 88
Cartesian 38, 40, 41–2
Cary, Elizabeth 37
Cassatt, Mary 139, 179, 184, 187, 201–2, 219
Castiglione, Baldassare 43, 45
Catharina, Duchess of Gelre and Countess of Zutphen 62
Cato the Elder 45
Cats, Jacob 21, 45, 49, 64, 88, 101, 104–13, 116–18, 122–6, 157, 161, 195, 200–1, 209, 220
Century of the Child 139, 150, 217
Ceruti, Giacomo 171
Cesari, Giuseppe 94
Chardin, Jean-Baptiste Siméon xv, 129–32, 179, 183, 191, 196, 200–4, 208, 213, 219, 221
Charles II, King of England 85
Charleton, Walter 41
Chaucer, Geoffrey 32, 68
child labor acts 133
child / infant mortality 11, 50, 67, 69, 151, 157, 164, 200, 218
child psychiatry 140
child sciences 11, 139–40, 151, 217
child study 140
children at risk 136
Christ child 52–3, 55–56, 58, 60, 64–7, 71–3, 81, 96, 99, 121, 161, 218
Christian Enlightenment 195

Christian philanthropy 194
Cicero, Marcus Tullius 45
civil code 165
Clouet, François 56, 113
Coëffetau, Nicolas 37
Comenius, Johann Amos 111
Commune (1871) 190
compulsory education 133, 136, 139
Cooper, Anthony Ashley, Third Earl of Shaftesbury 146, 153
Copernican turn 134–8, 221
Copernicus 23
Copley, John Singleton 159
Corot, Jean-Baptiste Camille 183
Council of Trent (1545–63) 27, 48, 153
Courbet, Gustave 155, 162, 165, 174, 177, 179, 183, 202
COVID-19 pandemic 36
Cranach the Elder, Lucas 75
Cromwell, Oliver 85
cuius regio eius religio 25
cultural transmission 10, 13, 78
Cusanus, Nikolaus 24
Cuyp, Jacob Gerritsz 123–4

D'Agramont, Jacme 38
Dante Alighieri 32, 52, 106, 123
Darwin, Charles 6, 8, 106, 140–2, 147–50, 216–17
David, Gheeraert 114
De Bray, Jan 93
De Champaigne, Philippe 83
De Chauliac, Gui 36
De Gelder, Aert 161
De Gheyn II, Jacques 78, 203
De Grebber, Pieter Fransz 113
De Hooch, Pieter 73, 77, 88, 115, 161, 169, 209
De Jongh, Ludolf 248 n.198
De Keyser, Thomas 82
De la Chambre, Marin Cureau 42, 52
De Lelie, Adriaan 161, 168
De Monmort, Habert Henry Louis 83
De Pisan, Christine 53, 119–20
De San, Gerardus 204
De Stomme, Jan Jansz. 70
De Swaef, Johannes 102, 125
De Troyes, Chrétien 37
De Vos, Cornelis 60, 82–3, 90, 180

De Vos, Gerrit 174
De Vos, Jacob 173–5, 179, 191, 207, 213, 219
De Vos, Jan Baptist 82
De Vos, Magdalena 82, 90
De Vos, Susanna 90
De Vos, Willem jr. 174
De Vos, Willem sr. 173
De Zurbarán, Francisco 67
De' Roberti, Ercole (Ercole da Ferrara) 75
desire 17, 27–9, 39–42, 52, 57, 109, 122, 140, 145–6, 167, 209
Decroly, Ovide 139
Defoe, Daniel 137
Degas, Edgar 166, 173, 188, 209
Delff I, Jacob Willemsz. 92
Della Francesca, Piero 51
Derkinderen, Anton 164
Descartes, René 17, 29, 38–42, 52–3, 83, 145–6, 149, 215–16
Desidia (Sloth) 31, 35
Dessau 134, 138, 195
developmental psychology 140, 147
Deventer Latin School 44–5
Devis, Arthur 184
Devotio Moderna 36, 44, 47, 62
Dickens, Charles 142
Diderot, Denis 154, 208
Dieppe 185
dimensional and discrete models of emotions 8, 10
disenchantment 132, 139, 141–2, 145, 151, 184, 217
domestic 5, 9–12, 25, 32, 48, 57, 63, 133–5, 141–3, 156–9, 165, 167, 173, 179, 183, 194–6, 207, 213, 221–2
Domesticity / domestic virtues 101, 110, 114–16, 157, 161, 185, 200
Don Luis María de Cistué 176
Dorothea of Denmark 90
Dou, Gerrit 113–14
Dreux, Alfred de 183
Dreux, Elisabeth de 183
Du Bois, Jean–Baptiste 153
Duby, Georges 4
Duke of Osana 159–60
Dürer, Albrecht 43, 55, 66, 73, 96, 218
Dutch Republic 24–5, 37–8, 54–6, 69–70, 73, 104, 156, 173

École des Hautes Études en Sciences Sociales (E.H.E.S.S.) 3
Edelfelt, Albert 188
Edict of Nantes (1598) 25
educational space 9–12, 19, 50, 126, 132, 151, 215, 218, 220
Edward VI, King of England and Wales 92
Edwards, Jonathan 146
Elias, Norbert 5, 120, 126, 220
Elisabeth Herbert, Lady Pembroke 167–8
Elisabeth, Queen of Bohemia 38–9
Emblem 13–15, 21, 31, 56, 88, 102–12, 116–19, 122–6, 129, 134, 157, 208–9, 213, 216, 219–21
emotional community 12, 57, 60, 141, 157
emotional culture 12, 14, 23, 32, 50, 53, 68–9, 101, 140–2, 167, 191, 193, 197
emotional formation 9–13, 15
emotional frontiers 12
emotional literacy 3, 9–13, 15, 17, 22, 26, 30–2, 35, 40–4, 50–1, 55–6, 63, 101–5, 107, 111, 119, 122, 126, 130, 134–7, 191, 193–7, 207–8, 213, 218–20
emotional regime 12, 31, 47
emotional space 11, 25, 57–8, 61–3, 132–3, 156, 158, 195, 218, 221
emotional standards 10, 12, 30–2, 35, 44, 56, 70, 99, 122, 145, 213, 216
England 11, 24–5, 36, 69, 74, 85, 106, 119, 133, 142, 185, 190
Enlightenment 10–12, 17, 102, 129, 132–6, 138, 140–5, 148, 150–1, 153, 167–8, 174, 183–4, 191, 193–5, 198, 213, 216–21
Epiphany 64, 86
Erasmus of Rotterdam 26, 29, 31, 43–9, 52–3, 57, 87–8, 96, 103, 106–12, 117, 119–22, 125–6, 134, 136–7, 216, 220
Erasmian 104, 122, 134
eugenic 139
European Megalopolis 11, 15, 17, 26, 55, 80, 100, 126, 132, 182, 220
Evangelical Movement / Evangelicals 136, 144, 146, 194
experimental pedagogy 140

Falconer, William 193
fear 5, 8, 12, 17, 23, 27–30, 32, 35–43, 47–8, 52–3, 56–8, 65, 68, 70, 75–6, 81, 94–8, 100,

109, 117, 135, 146, 148, 153, 163–4, 170, 196–7, 209, 216, 218
Febvre, Lucien 3, 5, 26
Feith, Rhijnvis 258 n.62
Fides (Faith) 30, 33
Flanders / Flemish 14, 23, 53–4, 57–8, 60, 70, 72, 80–1, 83, 86, 90, 96
Fliess, Wilhelm 140
Flinck, Govaert 90, 94, 179
Florence 86, 166, 181
Fortitudo (Fortitude) 30, 33–4
Foucault, Michel 5, 136, 221
Fouquet, Jean 51
Fourth Lateran Council (1215) 31
Fra Angelico 81
Fragonard, Jean–Honoré 198–9, 208
France 5, 11, 24–5, 33, 36, 113, 135, 144, 162, 185, 194, 200, 213
Francke, August Hermann 194
Franeker 168
Fratres Vitae Communis (Brethren of the Common Life) 44
Freiburg 234 n.182
Freud, Sigmund 140
Friedrich, Caspar David 182
Friesland 168
Fröbel, Friedrich Wilhelm August 132, 138–9, 150, 174, 217
Fugger, Jacob 25
Further Reformation 47–8, 101–2

Gainsborough, Thomas 182
Galen of Pergamum (Galenus) 45, 61
Galenic medical model 145
Galilei, Galileo 23
Ganymede 56, 97
Garlick, A. H. 140
Genoa 83
Gérard, Marguerite 163
Géricault, Théodore 155, 177, 182–3, 191, 219
Germany 11, 24, 54, 73, 104, 134–5, 140–1, 144, 149, 161, 194, 213
Gerson, Jean 31, 43, 121
Ghirlandaio, Domenico 75, 79–80
Ginzburg, Carlo 5, 14
Girodet, Anne-Louis 273 n.39
Godefroy, Auguste–Gabriel 129
Goethe, Johann Wolfgang von 137, 142–3, 182
Golden Age (Dutch) 21, 90, 185, 209

Golden Age (Spanish) 181
Gossaert, Jan 72–3, 90
Gouge, William 49, 102, 117
Goya, Francisco 159, 176
Grand Pensionary 104
Great Britain 141–2, 146–7, 182, 194, 213
Greuze, Jean–Baptiste 154, 156, 208–9, 221
Groote, Geert 44
Grünewald, Matthias 96
Gubbio 171
Gula (Gluttony) 31, 35
Gutenberg, Johannes 26

Haagse School (Hague School) 156, 161–4, 169, 179, 184–5, 189, 191, 200, 219, 221
Hagendorf, Peter 69
Halle 194
Hals, Dirck 115, 253–4 n.77
Hals, Frans 60, 73, 86, 90, 94, 115, 161
Hamburg 161, 177, 179
happiness / joy 5, 8, 14, 17, 21, 27–30, 37, 39, 40–2, 46, 52–3, 56–67, 73–7, 78–83, 86–91, 94, 96, 99–100, 107, 113–14, 116, 122–3, 129, 130–4, 135–8, 143, 146, 158–64, 169–76, 179, 180, 182, 184–6, 188–9, 191, 194, 197–203, 207–8, 216, 218–19
Hayes, Jetske 168
Heinsius, Daniël 104
Henry II, King of France 56, 113
Henry VIII, King of England 25, 92
Herder, Johann Gottfried von 153
Herod, King of Judea 67, 74–5
Hesiodes 45
Hinlopen, Jan van 59, 238 n.52
Hippocrates 43
historical sensation 3, 13–15
Hobbes, Thomas 42, 146, 149, 216
Hoboken 86
Hodler, Ferdinand 184
Holbein the Elder, Hans 73, 96
Holbein the Younger, Hans 44, 92, 97
Holy Family 53, 55, 60–2, 99, 154, 161–2, 167, 218
Holy Roman Empire of the German Nation 25
Homer 45, 56
Hooft, Catharina 73
Hooft, Pieter Cornelisz. 104, 123
Hülsenbeck, Augustin 179
Hülsenbeck, Friedrich 179

Hülsenbeck, Maria 179
Huizinga, Johan 8, 14, 23, 36
Humanism 11, 22, 26, 43, 105, 126, 155, 220
Hume, David 145–50, 193, 215–16
Hundred Years War 36
Hutcheson, Francis 146
Huygens, Christiaan 119
Huygens, Constantijn 39, 114, 119
Huygens, Maurits 119

Industrialization / Industrial Revolution 132–3, 137, 142–3, 151, 155, 157, 163, 190, 218–19
Innere Mission 146
innocence 123, 138, 154, 156, 159, 162, 167, 169–70, 182–8, 191, 198, 208, 211, 219
Invidia (Envy) 28, 31, 35, 47, 52, 101, 121
Ira (Anger or Wrath) 1, 8, 27–37, 40, 47–8, 52, 56–7, 75, 81, 101, 117, 146, 148, 171, 193, 216
Israëls, Isaac 186
Israëls, Jozef 94, 161–5, 169, 178, 184–5, 200, 211
Italy 11, 23–4, 54, 72, 80, 91, 144, 169

James II, King of Scotland 85
James, William 6–8, 39, 140–1, 148–50, 216–17
Jansen, Cornelius (Jansenists) 144
Jardin du Luxembourg 188
John the Baptist 53, 96, 161
Jordaens, Jacob 21, 107
Joseph (Maria's husband) 60–2, 66–7, 72, 161
Jules Ferry Acts (1881) 135
Justitia (Justice) 30, 33–4
juvenile delinquents 136

Kant, Immanuel 143, 153
Kempis, Thomas à 44, 47, 104
Kéfer, Jeanne 176
Key, Ellen 139, 151, 217
Khnopff, Fernand 176, 181
Kleef, Catharina van 62
Klimt, Gustave 156
Koelman, Jacobus 48, 101–2, 106, 117
Kollwitz, Käthe 172
Koselleck, Reiner 143
Kruseman Jz., Jan Adam 176
Kulturkampf 135
Kupecky, Jan 198

Laguna de Segovia, Andrés 37
Lange, Carl 149
Lebrun, Julie 201
Le Brun, Charles 17, 52–3, 116, 147
Les Nabis (The Prophets) 168, 188
Leonardo da Vinci 51, 53, 55
Leyster, Judith 90
Liebermann, Max 162, 183, 219
liminal events 12
Linsen, Catharina Elisabeth Rente 176
Little Ice Age 23–4, 36
Livius, Titus 56
Locke, John 102, 134, 138, 146–7, 149–50, 155, 217
Lomazzo, Giovanni Paolo 51–2
London 6, 142, 159, 181, 190, 193
longue durée 3, 10–12, 216
Loon, Willem van 94
Lord Willoughby of Broke 159
Lorenzetti, Ambrogio 32, 67
Lorenzetti, Pietro 32, 71
Lotto, Lorenzo 73
love / affection 4, 8, 17, 27–8, 36–7, 39–41, 48–9, 52, 55–7, 61, 69, 71, 73, 75, 78–9, 83, 105–6, 109, 112, 114–15, 117, 119, 122–3, 136, 137, 143, 146, 157, 161–2, 165, 167–8, 173, 185, 187, 196–200, 203, 208–9, 211, 219
Low Countries 11
Luther, Martin 23, 25–7, 29, 31, 43, 47–8, 69, 102, 108, 169, 194, 215
Luxuria (Lust) 31, 35, 47–8, 87, 101, 105, 107, 119, 122–4, 145, 194, 198, 208–9, 211, 213, 221
Lycurgus, King of Sparta 46, 210

Machiavelli, Niccolò 24
Madonna 4, 37, 53, 55, 71–3, 81, 114, 154, 167, 169–70, 218
Maes, Nicolaes 55, 73–4, 203
Magyrus, Abraham 63
Mainz 26
Malebranche, Nicolas 42
Malthusian 24
Mantegna, Andrea 96
Margarita Teresa 58
Maria / Virgin Mary 52–3, 60–2, 65–7, 71–3, 113–14, 161
Maris, Jacob 162, 179, 183
Maris, Matthijs 162, 169, 183–4

Maris, Willem 162, 185
Martini, Simone 67
Marullus, Michael Tarchaniota 49
Masolino, Tomasso 243 n.125
Massacio, Tomasso 243 n.125
mass-schooling 136, 155, 183, 191, 194, 208, 219
Massys, Quentin 44
Mazzoni, Guido 92
Medical Society of London 193
Medici Bank 54
Medici, Bia de' 69
Medici, Catharina de' 56
Medici, Cosimo de' 69
Medici, Eleonora de' 92
Medici, Giovanni de' 92
Medici, Lorenzo I (Il Magnifico) de' 79
Medici, Madalena de' 90
Melanchton, Philipp 45, 102
Memling, Hans 58
Menzel, Adolph 189
Metlinger, Bartholomäus 49, 102
Metsu, Gabriel 59, 60, 73, 203, 209
Michelangelo Buonarroti 43
Mill, John Stuart 147
Millet, Jean–François 162, 172
Miradori, Luigi 69
Modersohn–Becker, Paula 156
Moens, Petronella 142
Monet, Claude 169
Monet, Jean, 169
Monet–Doncieux, Camille–Léonie 169
Montaigne, Michel de 43, 49, 103
Montaillou 5, 230 n.73
Montefeltro, Federico da 79
Montessori, Maria 139
Montmartre 190
More, Thomas 31, 57, 237 n.41
Moreel, Willem 58
Morisot, Berthe 203
Mulder, Johannes 168
Mulder–Saagmans, Hyke Sophia 168
Murillo, Bartolomé Esteban 86, 172, 190

Nation 44, 135–6, 143, 213
nation-state 135, 143
nature 26, 37, 39, 41–2, 46, 49, 106, 108–9, 112, 121, 137–8, 143–4, 146, 162, 168, 171, 182–4
neglected children 136

(Neo–)Platonism 23, 26, 29, 36
Netscher, Caspar 115–16, 201
Neuhuys, Albert 162
Nipperdey, Thomas 144
North Sea 24, 164
Novalis, Georg Friedrich Philipp 182
Nuenen 162
nurture 45–6, 94

Oberkampf, Christophe–Philippe 163
Oostende 185
Orwell, George 15
Ospedale degli Innocenti 86
Ovidius, Publius Naso 45, 56, 123

Padua 32, 74
Paets, Cornelis 93
Paets, Willem 93
Pailleron, Édouard 181
Pailleron, Marie–Louise 181
Palazzo Pubblico 32
Paleotti, Cardinal Gabriele 48, 51
Palladio, Andrea 90
Paracelsus 23
parental pride 55, 57–9, 61–2, 70, 79–83, 94, 112, 116, 158, 162–3, 168, 173, 176, 199, 204
Paris / Parisian 3, 27, 165, 169, 185–6, 188, 190–1
Peace of Augsburg (1555) 25
pedagogical pathology 140
Pelez, Fernand 190
Pepperrell, William 159
Perez, Bernard 140, 201
Perthes, Friedrich 177
Perthes, Luise 177
Pestalozzi, Johann Heinrich 138–9, 217
Petrarch, Francesco 36, 106, 119, 123
Pfannschmidt, Carl Gottfried 169
Philanthropinum 134, 138, 195
Philanthropist / philanthropic 136, 144, 193–5
Philip IV, King of Spain 58
Piaget, Jean 147
Pico Della Mirandola, Giovanni 23
Pietism 144, 194
Pisano, Giovanni 53
Plato 45
Pliny the Younger (Plinius) 45, 108
Plutarchus 45, 56, 210

Poitiers, Diane de 113–14
Pope Adrian VI 45
Pope Benedict XII 230 n.73
Pope Boniface VIII 36
Pope Gregory I the Great 31
Portinari, Tommaso 54, 58
Poussin, Nicolas 52, 75
Predestination 57, 70
Preyer, Wilhelm 140, 201
Progressive Education 132, 136, 139, 150, 179, 183, 211, 217, 221
Protestant 25–6, 29, 32, 41, 45, 55, 63, 87–8, 103–4, 106, 110, 122, 124, 126, 134–6, 144, 146, 154, 163, 167–8, 173, 179, 211, 215–16, 220–1
protestant Réveil 144, 146, 194
Proudhon, Pierre-Joseph 155, 174–5
Prudentia (Prudence) 30, 32–3, 57, 116, 123
Prussian 144

Queen Mary Centre for the History of Emotions 6
Quintilianus 6

Rabelais, François 5, 87
Raeburn, Henry 182
Raphael 55, 81, 114
Reform Pädagogik 136
Reformation (Protestant) 10–11, 17, 22, 25–6, 29, 36–7, 43, 47–8, 57, 73, 102, 105, 126, 134, 154, 215–17, 220
Reformation (Roman Catholic Counter Reformation) 32, 48, 55, 102, 215
Regula Bullata 79
Reid, Thomas 146
Rehlinger, Konrad 58–9
Rembrandt van Rijn 1–3, 10, 15, 51–2, 55, 60–1, 64, 67, 73–9, 86, 90, 94, 97, 126, 161–2, 180, 218
Renaissance 10, 17, 21–4, 35, 37, 43, 45, 48–55, 79, 87, 92, 97, 101–2, 123, 125–6, 134, 137–8, 145, 155, 187, 215–17, 220–1
Rennefeld, Johann Heinrich 163
Renoir, Pierre–Auguste 176, 180, 188
Renoir, Jean 180–1
Representation (theory of) 14–16, 23
Revocation of Edict of Nantes (1685) 25
Reynolds, Edward 40
Reynolds, Joshua 167, 182, 190
Ribera, Jusepe de 86, 172, 190

Richter, Adrian Ludwig 168
Rijn, Titus van (Rembrandt's son) 94–5
Rilke, Rainer Maria 139
Ripa, Cesare 17, 33, 51, 206, 220
River Jordan 56
River Rhine 26
roman catholic 27, 29, 47–8, 55, 102–4, 135–6, 153, 215
Romanticism 10–11, 17, 129, 132–3, 138, 142–4, 151, 153, 184, 193, 202, 216–19
Rome 17, 56, 75, 105, 126, 170, 220
Rotterdam 26, 43, 88, 165
Roulin, Marcelle 176
Rousseau, Jean–Jacques 137–9, 144, 150–4, 158, 173, 183, 191, 195, 198–9, 200, 217, 219
Rubens, Clara 90
Rubens, Peter Paul 52, 55, 81, 90
Rügen 185
Runge, Daniel Nikolaus 161
Runge, Friedrich 161
Runge, Magdalena Dorothee 161
Runge, Otto Sigismund 161, 177
Runge, Philipp Otto 155, 161, 177, 179, 182, 202
Russell, John 45

sadness / grief 4, 8, 12, 14, 17, 28–30, 36–7, 39–42, 48, 52–3, 56–8, 63, 65, 67–70, 75–6, 80–1, 86, 96, 100, 143, 153, 156, 163–7, 172, 174, 190–1, 196–7, 207–8, 213, 216, 218, 221
Sadoleto, Jacopo 49, 112
Saftleven, Cornelis 88–9
Salomon 75
Salzmann, Christian Gotthilf 138
Santvoort, Dirck Dircksz. 94
Sargent, John Singer 181–2
Sassetti, Francesco 79
Sassetti, Teodoro 79
Saunders, Richard 52
Savonarola, Michele 51
Scheffer, Ary 268 n.129
Scheveningen 162, 164, 185, 211
Schiele, Egon 156
School of Barbizon 184
school pedagogy 140
Scrovegni or Arena Chapel 32, 74
Second Vatican Council (1962–5) 30–1
(self-)regulation of emotions 10, 13–14, 17, 22, 26, 28, 43, 45, 47–8, 102, 120, 125, 151, 209, 215–17, 220–1

319

Index

Senault, Jean–François 42, 52
Seneca, Lucius Annaeus 45
sensibility 7, 12, 132, 141–4, 151, 157, 193, 195, 197, 199, 217
sentiment / sentimental(ism) 4, 7, 137, 141–6, 157, 199, 208
sentiment de l'enfance 4, 67, 75, 90, 106–7
sentiment de la famille 4, 106
Sevillian 86
Sienna 32, 67, 71
sin (capital) 30–6, 51, 53, 101, 105, 122, 216
sin (mortal) 31
sin (original) 12, 29, 46, 48–9, 103, 108, 134, 154, 157, 216
Sir Thomas Clouston 140
Sir Thomas Lawrence 206
Smith, Adam 145, 147, 150
(Social) Darwinism 139–40, 147, 150
Society for the Common Good (Dutch) 195
Sonderpädagogik 140
Sorbonne 3, 27
Southern Netherlands 21, 24, 33, 72, 156, 199
Soutman, Pieter Claesz. 82–3
spaces of feelings 12
Spain 24–5
Spanish 37, 58, 67, 79, 90, 109, 159, 181
Spencer, Herbert 147–8
Spes (Hope) 27, 30, 34, 38, 41, 47, 52, 146, 164, 197
Spinoza, Baruch de 42, 149
St Agostino Novello 67–8
St George 78–9
St Ignatius of Loyola 48, 215
St Lawrence 81
St Mary Clephas 61–2
St Nicholas, bishop of Myra 63, 67
St Paul 30, 45, 49
Stanley Hall, Granville 140
Steele, Richard 142
Steen, Jan 21, 46, 63–4, 88, 101, 107, 112–13, 123, 161, 209, 220
Stoa 27, 36, 39, 42
Strigel, Bernhard 58, 61
Strozzi, Clarissa 90
Strümpell, Adolf Heinrich Ludwig von 140
Sturm und Drang 142–3
Sully, James 140
Superbia (Pride) 29, 31, 34

surprise 8, 39, 65, 74–5, 81–82, 99, 118, 198, 216
Swammerdam, Jan 26, 144
Switzerland 11, 144
Sylvius, Franciscus 37

tabula rasa 12, 43, 46, 102–3, 105, 107–8, 132, 134, 136, 138–9, 150, 155, 179, 216–17
Tagloacozzi, Gaspare 37
Taine, Hippolyte 140
Teellinck, Willem 101, 125
Temperantia (Temperance) 30, 33–4, 37
Ter Borch, Gerard 73, 91, 115, 131, 209
The Hague 162, 185, 190
The Netherlands 11, 81, 104, 133, 135, 138, 144, 156, 165, 167, 185, 190, 194–5, 213
The Plague (Black Death) 24, 32, 36, 69, 71
theological (Christian) virtues 30–1, 33–4, 44, 110, 196
theory of mind 8–9, 16
Thirty Years War 24, 69
Thopas, Johannes 70
Titian 90
Tjarda van Starckenborgh family 70
Tollens, Hendrik 165
triptych 54, 58, 67–8, 99, 154
Tucher, Leonhart 122

Uhde, Fritz von 183–4, 200
Utrecht 189
Uylenburgh, Saskia (Rembrandt's wife) 73–4

Vallotton, Félix 168, 188
Van St Aldegonde, Marnix 102, 112
Van Alphen, Hieronijmus 129, 131–4, 142, 174, 194–7, 201
Van Baerle, Susanne 119
Van Beverwyck, Johan 61, 102, 123
Van Bijlert, Jan 237 n.33
Van Brekelenkam, Querijn 115
Van der Goes, Hugo 14, 54, 58
Van der Helst, Bartholomeus 70, 93
Van der Kooi, Willem Bartel 161, 168, 173, 179, 181, 200, 202, 206, 209, 211
Van der Laar, Hendrik 165
Van der Paele, Joris 72
Van der Venne, Adriaen 104–5
Van der Vliet, Willem 93
Van der Weijden, Rogier 14, 53
Van Dyck, Anthony 57, 83–6, 129

320

Van Egmont, Justus 119
Van Everdingen, Caesar 91
Van Eyck, Jan 51, 72
Van Genth, Justus 79
Van Gogh, Vincent 162, 176, 178
Van Heemskerck, Johan 123
Van Heemskerck, Maarten 254 n.83
Van Leefdael, Kunera 62, 66
Van Mander, Karel 51, 56, 87
Van Mieris, Frans 73, 88, 93, 209
Van Ostade, Adriaen 21, 61, 88
Van Strij, Abraham 161, 206
Van Valkenburg family 70
Velázques 58, 181
Veneto 90
Venice 90
Vergerio, Pier Paolo 43, 49, 103
Veronese, Paolo 90
Verspronck, Johannes 91, 93–4, 178–79
Vesalius, Andreas 23
Victorian era 5, 156
Vigée-Lebrun, Louise–Élisabeth 201
Villa Barbaro 90
Virgil, Publius Maro 52, 56
Viscount Lepic 173
Vittorino da Feltre 43
Vives, Juan Luis 43, 103
Vom Kinde aus 139, 151

Vuillard, Édouard 168, 188, 219

Watts, Isaac 146
Weber, Max 11, 27, 126, 139, 141, 145, 217, 220
Weisse, Christian Felix 195
Wendung zur Religion 144, 146, 154, 194, 217
Western Germany 11
White, Thomas 48, 102, 117
William of Orange, Dutch stadtholder, King of England and Scotland 85
Wimmelbild 86
Windelband, Wilhelm 6
Wither, George 104
Wittewrongel, Petrus 48, 64, 87, 101–2, 112, 117, 125
Wolff, Betje 142
Wolgast 161
wonder 29, 40, 52–3, 144, 176, 215
Wordsworth, William 138
World Exhibition (1855) 165, 185
Wright, Thomas 40–1, 53
Wundt, Wilhelm 149

Zentrum für die Geschichte der Gefühle (Berlin) 6
Zevio, Altichiero da 78
Zoffany, Johann 158
Zwingli, Ulrich 48